THE INORDINATE EYE

THE UNIVERSITY OF CHICAGO PRESS *Chicago and London*

THE INORDINATE EYE

NEW WORLD BAROQUE
AND LATIN AMERICAN FICTION

Lois Parkinson Zamora

LOIS PARKINSON ZAMORA is professor of English, history, and art at the University of Houston. Among her publications are, most recently, *Image and Memory* (1998), *The Usable Past* (1997), and *Magical Realism* (1995).

The University of Chicago Press, Chicago 60637
The University of Chicago Press, Ltd., London
© 2006 by The University of Chicago
All rights reserved. Published 2006
Printed in China

15 14 13 12 11 10 09 08 07 06 1 2 3 4 5
ISBN: 0-226-97856-7 (cloth)

The University of Chicago Press gratefully acknowledges the generous support of the Program for Cultural Cooperation between Spain's Ministry of Culture and United States Universities toward the publication of this book.

Library of Congress Cataloging-in-Publication Data

Zamora, Lois Parkinson.
 The inordinate eye : New World Baroque and Latin American fiction / Lois Parkinson Zamora.
 p. cm.
 Includes bibliographical references and index.
 ISBN: 0-226-97856-7 (cloth : alk. paper)
 1. Arts, Baroque—Latin America. 2. Art, Latin American. 3. Latin American literature. 4. Hybridity (Social sciences) and the arts. I. Title.
 NX501.5.Z36 2006
 700.98—dc22

 2005026031

⊗ The paper used in this publication meets the minimum requirements of the American National Standard for Information Sciences—Permanence of Paper for Printed Library Materials, ANSI Z39.48–1992.

FOR PETER, CAMILLE, TOM, LANDON, AND THE TOPHE,
UNDER WHOSE BENEVOLENT EYES THIS BOOK TOOK SHAPE

Contents

Illustrations

FIGURES

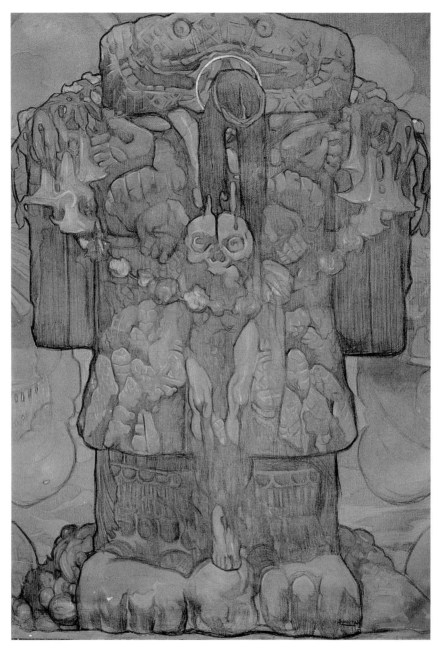

PLATE 1 Saturnino Herrán, *Coatlicue Transformed* (1918), Mexico. Museum of Aguascalientes. Instituto Nacional de Bellas Artes.

Coatlicue Transformed

Objects seen with both eyes appear rounder than objects seen with just one.

LEONARDO DA VINCI,
On the Human Figure

I begin with Leonardo's observation on bifocalism in art, and with the Mexican painter Saturnino Herrán's visual metaphor for cultural bifocalism in his painting titled *Coatlicue Transformed* (color plate 1). Leonardo reminds us that perspective in Western art dramatizes the act of seeing; Herrán reminds us that the act of seeing is culturally framed. Herrán depicts the monolithic sculpture of the Mexica (Aztec) earth goddess Coatlicue, whose name means serpent skirt and whose necklace is made of hands, hearts, and a pendant skull (fig. 0.1). Sculpted shortly before the European invasion in 1519, she is herself double; where her head should be, two serpent heads face each other, together representing ritual decapitation and thus, in Mexica cosmology, the complementary forces of death and life. To Coatlicue's formal and ritual duality, Saturnino Herrán adds another level: the outlines of a crucified Christ. His head hangs forward and his bleeding legs and feet rest lifelessly on Coatlicue's serpent skirt; his bleeding hands fall on either side of her necklaced hands, which support the arms of the fainting figure. This "transformed Coatlicue" represents emblematically the convergence of indigenous and European cultures in Mexico, and I take her to represent more generally the pro-

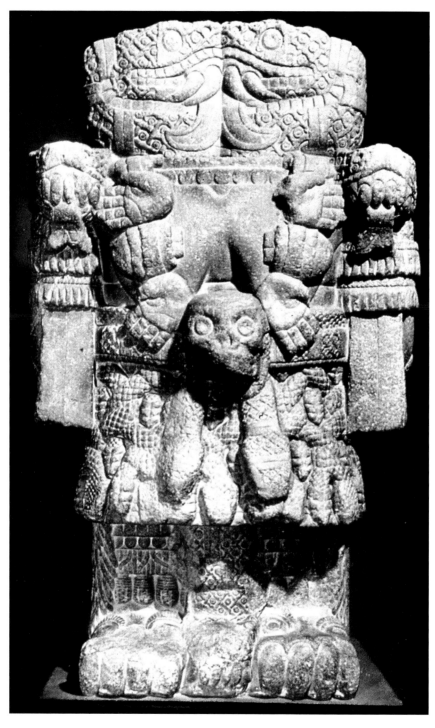

FIGURE 0.1 Coatlicue (sculpted figure), Mexica, central Mexico. National Museum of Anthropology, Mexico City. Photograph: Archivo Fotográfico Manuel Toussaint/Instituto de Investigaciones Estéticas/Universidad Nacional Autónoma de México.

cesses of cultural mixing throughout Latin America. This work was painted in 1918 as a study for the center panel of a mural to be titled *Nuestros dioses* (Our gods). Herrán's plan was to represent indigenous worshippers on the left panel and Spanish worshippers on the right, both groups facing the transformed Coatlicue on the central panel, both groups paying homage to the combined indigenous and Catholic gods that the image embodies. The mural was not completed because Herrán died the same year, in 1918, at the age of thirty-one.

The unfinished nature of Saturnino Herrán's project, as well as his visualization of cultural syncretism, makes this painting an appropriate emblem for my study and for the works of Latin American fiction that are my subject. By "cultural syncretism," I mean the simultaneous expression of distinct cultural systems in the same expressive forms or, put more generally, the accommodation of multiple (and often conflicting) cultural meanings in a shared expressive context. The related term "transculturation" refers to the processes by which meanings are produced from the contact of distinct cultural systems over time.[1] Transcultural conceptions of the visual image condition present ways of seeing in Latin America, and these ways of seeing condition contemporary fiction. The writers who concern us here portray cultures that are indigenous, European, and African, colonized and postcolonial, Western and otherwise. The ratios and quotients may vary from place to place and from novel to novel, but the experience of transculturation does not, whether it goes by the name of syncretism, cultural *mestizaje* or *métissage,* creolization, colonial semiosis, colonization of the imaginary, or whether it goes unnamed.[2] In the following chapters, I will refer to a number of cultural theorists and intellectual historians who have advanced these terms, and I will variously engage their methods to approach the relations among Latin American cultures and their forms of visual and verbal expression. Metaphorically speaking, then, the ongoing transformation of Coatlicue is my subject, and also the subject of the writers whom I discuss here. Their novels dramatize the cultural bifocalism embodied in Herrán's figure, and the "rounder" representation it allows.

BAROQUE, NEW WORLD BAROQUE, NEOBAROQUE

My purpose is to locate these transcultural energies in relation to New World Baroque aesthetics and ideology. The New World Baroque is hybrid and inclusive, and any accurate definition must include indigenous and African modes of conceiving and expressing the universe. Its transcultural energies move in many directions, of course, and as Spain and Portugal imposed their Counter-Reformation structures on America, America in turn fueled the imaginative energies of Europe in ways that are still visible from Seville to Rome to Antwerp, to name three centers of Baroque art and architecture. America also fueled their creation and construction. The gold and silver extracted from Zacatecas to Potosí weigh heavy upon

the altars of Baroque churches throughout Europe, as do the bodies of indigenous laborers who mined those metals and whose loss these altars silently commemorate. I stress the reciprocal nature of this transatlantic exchange because not to do so is to misunderstand the Baroque in both Europe and Latin America. Nonetheless, my focus in the following chapters is on the latter: I am interested in asymmetrical cultural relations in New World contexts, and how these relations continue to impel contemporary Latin American narrative.

My chapters trace the development of the Baroque in Latin America from a European colonizing instrument encoding Catholic and monarchical ideologies to an instrument of resistance to those same structures, and thus an instrument of postcolonial self-definition. Whereas European art historians designate the seventeenth-century as the Baroque age, this is far too limited a time frame to encompass the Baroque in Latin America. In fact, the production of New World Baroque art and architecture continued until nearly the end of the eighteenth century, when the Churrigueresque style reached its most flamboyant expression in Mexico. The colonizing clergy used indigenous artisans and laborers to build their Baroque churches and monasteries, to carve their images in wood and stone, and to decorate their walls inside and out. Chapter 1 will focus on the ideology of visual representation that resulted from this collision of cultures, and the syncretic ontology of seeing that emerged over three centuries of colonial rule. By the late sixteenth century, New World intellectuals and writers had already begun to adopt syncretic images as a means of projecting an American cultural identity against the colonizing power of Spain. The Virgin of Guadalupe is a prime example of this process, but it would be the mid-twentieth century before the decolonizing strategies of the New World Baroque were fully articulated.

Since then, the New World Baroque has become a self-conscious postcolonial ideology aimed at disrupting entrenched power structures and perceptual categories. This ideology, termed Neobaroque in the 1970s, has provided Latin American writers the means by which to contest imposed ideologies and recover relevant texts and traditions. Under the sign of the Neobaroque, they have engaged the expressive forms of the historical Baroque to create a discourse of "counterconquest" (José Lezama Lima's term) that operates widely in contemporary Latin America. With its decentering strategies and ironic perspectives, the Neobaroque has been considered by some critics as a Latin American postmodernism, but the resemblance is misleading.[3] Unlike the poststructuralist categories regularly imposed by, or imported from the United States and Europe, the Neobaroque is deeply rooted in Latin America's histories and cultures. Baroque forms flourished in Catholic New Spain as they never did in Protestant New England; we have only to think of the blank walls of colonial churches in New England, the nationalist Neoclassicism in Washington, D.C., and the sleek modernism of twentieth-century Internationalism, to recognize that the Baroque is foreign to U.S. cultural history. Nor did indigenous traditions interact with imported European forms in

Anglo America as they did in Latin America, where they created transculturated modes of expression that encode the particularities of New World cultural contexts. Baroque ideas and images are everywhere embedded in the colonial and postcolonial histories of Latin America, and they are indispensable to our reading of contemporary fiction.

In chapter 1, then, I move back and forth between prehispanic American and seventeenth-century European Baroque modes of visual imagining in New Spain and elsewhere in Latin America. My aim is to recover these visual ontologies as they existed independently, and then show how they have evolved during their cohabitation in the New World. I will refer to two related myths, one Mexica, the other Mexican: the narratives of Quetzalcóatl's mirror and Guadalupe's eye will allow us to consider the different relations of visual images to the realities they (re)present. An indigenous god and a Baroque virgin: these may seem far-flung sources for our reading of contemporary Latin American fiction, but they are not. Along with other images and texts, they allow us to consider the different ways of seeing that have converged over centuries in Latin America. So this first chapter provides the "historical background" upon which the "foreground" of my subsequent readings of literary texts depends.

The following chapters offer examples of the cultural encounters that constitute the New World Baroque. In chapter 2, I concentrate on the visual structures of the prehispanic codices in Mesoamerica, and trace their engagement in two modern media—murals and literary narrative. My primary focus is on Diego Rivera's murals in the National Palace in Mexico City, Elena Garro's novel *Los recuerdos del porvenir* (*Recollections of Things to Come*), and Eduardo Galeano's poetic encyclopedia of American history, his trilogy entitled *Memoria del fuego* (*Memory of Fire*). These artists create visual and verbal structures that correspond to those of precontact codices, and they dramatize how indigenous forms confronted and modified European colonizing systems, and continue to do so.

Chapter 3 surveys theories of cultural hybridity now generally grouped under the rubric of the Neobaroque, developed beginning in the nineteen-forties by Cuban writers Alejo Carpentier and José Lezama Lima, and subsequently by Severo Sarduy. This middle chapter is the fulcrum of my argument because Alejo Carpentier is pivotal to any discussion of the Neobaroque as a postcolonial ideology. Carpentier recognizes the Baroque in its historical, colonizing function, but he also insists that the Baroque cannot be limited to a single historical period or place; rather, it is a collective spirit, a culture's way of being, which is characterized by dynamic structures and polycentric perspectives capable of recognizing and including difference. For Carpentier, the kinetic energy of Baroque space accommodates the interactions of American histories and cultures, as does its dynamic impulse to expand and displace. So he recodifies the *function* of the Baroque, making it an instrument by which Latin American writers may subvert colonizing institutions and modern constructions of race and rationalism. For Carpentier, the

Baroque has flourished in the New World precisely because cultures have collided and converged here: "The American Baroque develops along with . . . the awareness of being Other, of being new, of being symbiotic, of being a *criollo;* and the *criollo* spirit is itself a baroque spirit."[4] I will explore this possibility in Carpentier's fiction, particularly *El siglo de las luces* (translated as *Explosion in a Cathedral*) and *Concierto barroco,* as well as in his essay "The Baroque and the Marvelous Real," where he presents his most compelling statement of the New World Baroque as a mode of postcolonial critique.

Chapter 4 addresses the conventions of Baroque hagiography and related modes of character portrayal in visual and verbal media. Here, I pair Frida Kahlo and Gabriel García Márquez. Both are influenced by Baroque portraits of suffering virgins and ecstatic saints, and both project a Baroque dynamic of pain and pleasure, torture and transcendence. In all discussions of the New World Baroque and Neobaroque, an understanding of the nature of Catholic modes of visual expression is essential, even if the artists and writers in question are not religious. The Marxist commitment of both Kahlo and García Márquez might seem to make the depiction of Catholic saints and martyrs irrelevant, but we will find that the kind of self-consciousness depicted in Baroque portraiture can tell us a great deal about Kahlo's self-portraits and García Márquez's characters. In their different ways, they confirm the flexibility (and ongoing utility) of Baroque modes of self-representation in recent Latin American art and literature.

My final chapter is on the Borgesian Baroque. Despite Borges's early disavowal of the Baroque, and despite his limpid style, his work has important affinities to Baroque iconographic and rhetorical strategies. It is Neobaroque in its self-conscious engagement of Baroque structures of visual perception and spatial extension; the mirror, the labyrinth, the dream, the trompe l'oeil, and the mise en abîme serve his greatest theme, the illusory nature of all knowledge. The Baroque trope *la vida es sueño* (life is dream) is as fundamental to Borges's metaphysics as it was to the writers of the historical Baroque—Calderón de la Barca, Quevedo, Sor Juana Inés de la Cruz, Cervantes, Sir Thomas Browne. Furthermore, his devotion to artifice and allegory is Baroque in nature, as is his emblematic strategy of encoding the whole universe in a few of its parts. Though Baroque art and architecture were not produced in the Southern Cone as elsewhere in Latin America, the conventions of Baroque illusionism nonetheless operate in Borges's *ficciones.* His urbane universalism, his recuperation of apparently endless texts and traditions, and his constant contemplation of infinity and eternity reflect the impulse to overarch and include that beats at the heart of all Baroque forms of expression. His work suggests how Baroque attitudes and expressive forms may animate recent fiction, even when they are not immediately recognizable as such.

Here and throughout, I establish aesthetic and historical links between the European Baroque and Latin American forms of expression, the better to distinguish what is new about the New World Baroque, and what is not. Contempo-

rary Latin American writers manipulate Baroque forms for postcolonial purposes, rejecting colonizing structures and at the same time recuperating collective cultural forms that have been eclipsed by modernity's rationalisms and realisms. The term "Neobaroque" points to this self-conscious combination of resistance and recuperation; Baroque forms are ironically reconfigured and thus recover continuities buried beneath a ruptured history. The term "New World Baroque" is less explicit in this regard, referring more generally to the long transcultural process of adapting European Baroque forms to American cultural circumstances. Thus, the Neobaroque depends upon the New World Baroque and includes it, even as Neobaroque writers self-consciously recodify its forms. Baroque, New World Baroque, Neobaroque: these categories grow out of each other historically and overlap aesthetically and ideologically. The fiction we will discuss exploits the tensions between old worlds and new, between the structures of modernity and their Neobaroque subversions. As in Pierre Menard's version of the *Quixote,* the New World Baroque reflects its European models and transforms them utterly.

INTERARTISTIC INTENTIONS

Why, in the following chapters, do I attempt to hold visual and verbal structures in a single, sustained thought? For one thing, the arts are not separate in Latin America. Rare is the Latin American novelist or poet who does not write passionately about art, artists, and visual aesthetics; furthermore, painters are often poets, and poets painters. This mobility among media is a matter of historical tradition: visual and verbal modes of communication have played complementary roles since the earliest establishment of empire in the Spanish New World. In the viceroyalties of New Spain, New Granada, New Castille (Peru and Bolivia), and later Río de la Plata, artists and writers collaborated to project a Catholic vision of reality; after independence, their images and words served to establish nations; and more recently, they have acted as the democratic conscience of oligarchic governments. The Romantic conflict between artist and society, between individual inspiration and collective imperatives, never took hold in Latin America. Artists and intellectuals are public figures and political forces; they advocate, illustrate, educate; they accept political positions, write political journalism, paint murals on public walls. These communal functions and intentions over centuries have resulted in close contact among artists, writers, and their respective media.

This public role reflects and extends the role of artists in prehispanic Mesoamerica, though the word "artist" is inadequate in this context. The *tlacuilo* and *ah ts'ib* (painter/priests), in central Mexican and Maya cultures respectively, served as scribes for the gods, painting their dispositions in iconographic languages and interpreting their meanings in oral performance. The visual grammar of the codices contained and communicated the theological, astronomical, calendrical, and di-

vinatory wisdom of the community, historical and genealogical records, and, in the case of the Mayas, the history of their dynasties as well. The pictorial writing of these "painted books" makes no distinction between "text" and "image." Painting and writing combine in colorful pictographic and ideographic structures, as do theological, astronomical, and aesthetic wisdom. In chapter 1, we will see examples of this iconographic language and consider its complex conjunctions; in chapter 2, we will discover its presence in recent works of literature and art.

The long history of intertwining visual and verbal idioms in Latin America means that to be "cultured" is not necessarily synonymous with being "literate." Notwithstanding Angel Rama's study of *la cuidad letrada* (the literate city) in colonial Spanish America, or Ernesto de la Torre Villar's equally important history of the book and printing in New Spain, or Roberto González Echevarría's discussion of more recent literary culture,[5] the Latin American "archive" is not necessarily in printed form. There were, and are, vast regions, including urban areas, where print culture is not deeply rooted—a fact that does not necessarily imply that people do not know how to read. Think of García Márquez's insistence on the source of his fiction in his grandparents' storytelling (a point made again in his recent autobiography) and his narrative engagement of Baroque images of saints, monsters, and miracles, which we will discuss in chapter 4. These oral and visual sources reflect his experience of growing up in a small town on the coast of Colombia, *not* his level of literacy or his access to books. Obviously, texts and images circulate in different measures and relations according to place, period, person, and political intention, but in all cases an integrated understanding of visual and verbal modes of perception and expression is indispensable to our understanding of contemporary Latin American literature. We will be closer to our purpose, then, if we speak of forms of cultural *legibility,* rather than literacy. In Latin America, there can be no question of the superiority of print culture over visual understanding. Rather, it is the relations among these different modes of imagining that I aim to reconstruct, along with the cultural mechanisms that make them available (however unevenly) to one another, and to their users.

I offer this interartistic approach not so much to make specific comparisons as to provide a historical and cultural context in which to place the contemporary practice of literary fiction in Latin America. Countries share visual traditions across national borders, traditions that constitute cultural identities and reflect shared historical experiences of colonization, appropriation, and transculturation. What more compelling sources of self and society are there than the Virgin of Guadalupe and the *Cristos sangrantes* in Mexico, Santa Rosa of Lima in Peru, the Black Christ of Esquipulas in Guatemala, the Virgin of Monserrat in Colombia, the Virgin of Charity of El Cobre in Cuba? These cultural icons transcend specific religious content; their origins and aesthetics integrate competing cultural traditions, ontologies, and ideologies. Furthermore, the image-laden surfaces of Baroque architecture connect the histories of Mesoamerica, the Andes, Brazil, and

the Caribbean. And mural painting has been practiced across times and territories throughout pre- and postconquest America. These visual media developed over centuries to narrate a variety of ideas; all carried (and some still carry) metaphysical content; all were (and some still are) ideological instruments aimed at enforcing collective imperatives, whether theological, imperial, national, postcolonial, or a combination of the above. In all cases, the affective requirement remains: the painter or sculptor creates visual images that narrate (prophesy, pontificate, polemicize) and the viewer is asked to envision (embody, enter into, act upon) the narrative. Such discursive energy is as basic to prehispanic artifacts as it is to Baroque portraits of saints and demons, or to twentieth-century murals that assert a postcolonial, collective identity. How images consolidated and confirmed ideologies, how syncretic cultural forms were generated by the collision and convergence of different cultures, and how this process continues in contemporary Latin American fiction are the questions that impel my study.

THE INORDINATE EYE

It will be clear by now that my approach is designed to avoid (to the extent possible) privileging Eurocentric and logocentric models of literary analysis. Instead, I foreground cultural narratives that have been, and continue to be, encoded in visual forms. The interartistic study of Latin American literature enables readers to place literary texts in cultural contexts that would otherwise be occluded or invisible in the verbal text alone. My focus, then, is both extratextual and textual, both art historical and literary critical, and I spend as much time (or more) discussing visual structures as literary ones. By referring to Latin American visual media in their historical context and then placing contemporary novels alongside them, I hope to elucidate the authors' fictional engagement of these media and at the same time establish a critical perspective external to their fiction.[6] This method reflects the procedures of the authors themselves, who use visualizing strategies to displace the boundaries delimiting cultural and expressive fields. Because visual media are "other" to the verbal economy of modern fiction, they serve authors (and critics) as oblique instruments by which to position works of literature culturally and politically, and assess their expressive capacities. The juxtaposition of different signifying systems—visual and verbal—allows these authors (and us) to consider how meaning is conveyed in different media, and to what ends. As in most comparative literary studies, I will work toward an understanding of specific works by weighing their similarities and differences, but my interartistic comparison will also ask how different media communicate their meaning, to whom, and why. For this reason, the images that I include in the following chapters are not simply illustrations of my argument, but integral to it.

The title of my book is a metaphor for these interartistic relations, and for the

expansive literary structures that are their product. In its literal sense, "inordinate" defines spatial relations, the negative particle designating what those relations are *not*. Inordinate relations are *not co*-ordinate relations; inordinate points are *not* deployed in ordered relation, as are coordinate points, but in irregular, decentered, asymmetrical relation.[7] A Spanish dictionary provides the definition of "inordinate" closest to my own intention, and to that of the writers whose work I will discuss: *una energía de signos que no siempre depende de la razón organizadora/ coordinadora*—an energy of signs that does not always depend upon organizing/ coordinating reason.

The figurative meaning of "inordinate" parallels its literal sense: "inordinate" structures are *not* normative, *not* predictable, but eccentric, disparate, uneven. The Baroque passion to increase and include characterizes much contemporary Latin American fiction, and this passion frequently follows from (and may result in) disproportion, disjunction, and their accompanying narrative energies. In his Nobel speech, García Márquez speaks of Latin American realities as "boundless," "outsized," "unbridled" (*inmensa, descomunal, desaforada*); this territory, he suggests, is unchartable, unsearchable, immeasurable, and presumably its literature equally so.[8] His insistence on the inordinate nature of Latin American reality may be exoticizing and aggrandizing in ways that the Canadian critic Amaryll Chanady has labeled "territorializing the imaginary," but García Márquez shares with his Latin American contemporaries the impulse to create discourses of difference that distinguish them from Europe and the United States, an impulse amply noted by Latin American cultural critics.[9]

García Márquez begins his Nobel speech "The Solitude of Latin America" with a relevant anecdote. He refers to the Florentine navigator Antonio Pigafetta's account of his voyage around the world with Magellan, and retells Pigafetta's description of "how the first native encountered in Patagonia was confronted with a mirror, whereupon that impassioned giant lost his senses to the terror of his own image" (230). This parable is not about the destruction wrought by European colonizers but rather the inadequacy of European forms to contain the "impassioned giants" of Latin America. The colonizer's mirror cannot encompass the Latin American other, and it is the artist's task, the parable implies, to amplify and enrich (or subvert and supplant) imported modes of expression. So García Márquez offers a retrospective prediction of the power of the Latin American image to incorporate heterogeneous traditions, a capacity we will contemplate further when we come to Quetzalcóatl's mirror and Guadalupe's eye.

My metaphor of the inordinate eye is intended as an alternative to the "gaze" so widely invoked in both feminist and postcolonial criticism to signal the appropriation of the other by visual means. For example, the cultural critic Homi Bhabha writes of "the structured gaze of power whose objectivity is authority": the colonized subject, according to Bhabha, returns this structured gaze through mimicry, thus effecting a "strategic reversal of the process of domination . . . that turns the

gaze of the discriminated back upon the eye of power."[10] Bhabha's model is attractive because it points to the resistance of colonized subjects, but he does not concern himself with cultural specifics. Nor does he allow for a reciprocal relation in which the colonized does *not* mimic the colonizer. The resistance that Bhabha envisions is binary and closed, moving between oppressor and oppressed without the transformative tensions or syncretic energies that characterize the New World Baroque, and without recognizing that both cultures are inevitably affected by the exchange. Furthermore, he ignores modes of seeing that are not organized by Western notions of perception or grounded in a classical hegemonikon—soul, reason, ego, subjective consciousness. Bhabha's statement inverts my definition above; he describes relations of power that *do* depend upon organizing/coordinating reason. The idea of "returning Europe's gaze" is radically insufficient to encompass the inordinate transcultural processes that continue to operate in Latin American art and literature.

My aim, then, is to subvert the binaries of domination and subordination, European subject and colonial object, that impel postcolonial theory and criticism, even as I attend to colonial and postcolonial expressive forms. More amenable to my intention is Christine Buci-Glucksmann's discussion of the eccentric dynamics of seeing. In her 1986 study *La Folie du voir: De l'esthétique baroque* (The folly of seeing: On baroque aesthetics) she tracks representations of sight and insight, calling attention to the distortions and dissimulations by means of which Baroque artists challenged classical canons of perspective and spatial order.[11] She does not mention the New World Baroque, however, and our concern here is with Latin American modes of seeing and being, and their modes of (re)presentation across media and cultures. My discussion throughout is motivated by the following questions. What forms of attention does a particular image or text require of its viewer or reader? What is its social and political function, and how does function affect attention? What is the aesthetic experience of viewers and readers, and how has that experience changed over time, as they attend to the same artifact in different cultural contexts? In all cases we will take into account their historical experience in order to make sense of our own.

Acknowledgments

There are many people to thank. My greatest debt, as always, is to my friends who have read my drafts and given me their insights and encouragement: Wendy B. Faris, Evelyn Fishburn, Kathleen Haney, Monika Kaup, Michael Schuessler, and Silvia Spitta. Eduardo González, Margaret Rich Greer, and Ellen T. Baird read the manuscript for the University of Chicago Press and offered me the wisdom of their experience. José Pascual Buxó, Myrna Soto de Pascual, Elena Estrada de Gerlero, Rosa Beltrán, Héctor Barraza, David Lazar, and Stephen Zamora have enlivened my understanding of the New World Baroque in many ways, as has Djelal Kadir my vision of comparative American studies.

In 1991, Paul Winkler, then director of the Menil Collection in Houston, invited me to give a talk in connection with an exhibition of François de Nomé's fabulous paintings of imaginary architecture. Bainard Cowan encouraged me to turn that talk—on Alejo Carpentier's narrative use of a painting by de Nomé—into an essay, which he and Jefferson Humphries included in their volume *Poetics of the Americas: Race, Founding and Textuality,* published by Louisiana State University Press in 1997. Parts of that essay recur in chapter 3.

If Paul Winkler and Bainard Cowan set this book in motion, Randolph Petilos, my editor at the University of Chicago Press, has helped me to detain it. Randy commands a seemingly endless supply of patience, tact, and humor to accompany his intelligence and good judgment. Mara Naselli, also at the University of Chicago Press, has been unfailingly acute on textual and substantial matters. I am very grateful to both of you.

There are also institutions to thank: the National Endowment for the Humanities for a research fellowship in 2001, the University of Houston and the Martha Gano Houstoun Endowment for supporting production costs and otherwise encouraging this project, the Museo Soumaya in Mexico City for providing me with reproductions of the works from their collection. I have also benefitted from the public museums in Mexico that I acknowledge in the captions to my images, especially the National Museum of Art (MUNAL), whose beautifully conceived exhibitions have been a great source of information and enjoyment. FOTOFEST is another point of origin. In 1992, FOTOFEST sponsored the exhibition in Houston that inspired *Image and Memory: Photography from Latin America 1886–1994* (University of Texas Press, 1998), where I broached some of the ideas that inspire this study. I am grateful to my coeditor of *Image and Memory,* Wendy Watriss, artistic director and cofounder of FOTOFEST, and to Susan Bielstein, who understood the value of our project and saw to its publication.

Quetzalcóatl's Mirror and Guadalupe's Eye

SYNCRETISM AND SEEING

Las culturas van hacia su ruina, pero después de la ruina vuelven a vivir por la imagen. . . . La imagen se entrelaza con el mito que está en el umbral de las culturas, las precede y sigue su cortejo fúnebre. Favorece su iniciación y su resurrección.

Cultures fall into ruin, but after their ruin they live again through the image. . . . The image intertwines with myth, which exists at the threshold of cultures; it precedes and follows their funeral procession. It favors their initiation and their resurrection.

JOSÉ LEZAMA LIMA[1]

Oyeme con los ojos . . . Hear me with your eyes . . .

SOR JUANA INÉS DE LA CRUZ[2]

Quetzalcóatl and Guadalupe—foundational images of ancient Mesoamerica and modern Mexico—frame my first chapter. Jacques Lafaye's seminal study of these mythic protagonists, *Quetzalcóatl and Guadalupe: The Formation of Mexican National Consciousness 1531–1813*, published in French in 1974, describes their cultural and political contexts: Quetzalcóatl, plumed serpent, god of wind, air, earth, progenitor of human beings, embodied in countless images throughout the long histories of the ancient cultures of Mesoamerica; Guadalupe, dark virgin, always represented by the same image that was supposed to have appeared to the indigenous convert (and now Catholic saint) Juan Diego in 1531 at Tepeyac, near Tenochtitlán/

Mexico City.[3] Lafaye shows how both figures are joined over time to an opposite other, and how this cultural syncretism empowers both: the indigenous god Quetzalcóatl merges with St. Thomas the Apostle, and the Virgin of Guadalupe with the indigenous goddess Tonantzín. Carolyn Dean also stresses the power of syncretic images in her book *Inka Bodies and the Body of Christ*, published in 1999.[4] Tracing the interaction of Inka and European visual structures in colonial Peru, she focuses upon a series of seventeenth-century representations of the Corpus Christi procession in Cuzco. In these paintings, as well as in portraits of the Inka elite, she finds evidence of transcultural processes that are uniquely recorded and transmitted in the visual syntax of bodily ornamentation.

Lafaye and Dean are two among a group of distinguished scholars writing about the interactions of indigenous cultures and European colonizing systems in the Americas, and I mention them in particular because they emphasize the role of visual images in this ongoing process.[5] Their interest is in the political function of transcultural images rather than their mythic or psychic content, but their work nonetheless signals my own approach. Consider, for example, the goddess Coatlicue (fig. 0.1). Her image required reverence from her Nahua viewers, elicited horror from her European viewers, and today asks for aesthetic and intellectual discrimination as we stand in front of her towering figure in the National Museum of Anthropology in Mexico City.[6] In yet another transformation, as the symbol of Gloria Anzaldúa's "border consciousness" and the "new mestiza," Coatlicue encodes an awareness of U.S. cultural politics.[7] And, as I suggested in my introduction, she has also entered metaphorically into the house of Latin American fiction. In making her way from temple to museum to university, and now into our literary consciousness, Coatlicue both reflects and embodies distinct episodes in the history of human belief and cultural self-understanding. So we approach her and all prehispanic images with a clear sense of the gulf between modern Western systems of representation and those of the creators of these visual structures.

Production, consumption, medium, message, function: in every area, we are keenly aware of the incommensurability of cultures in indigenous America and Baroque Europe, not to mention our own contemporary culture of electronic media and global communication systems. Nonetheless, by engaging visual artifacts over time and across cultures, we may recognize what has been obscured or eclipsed by dominant (European) literary and linguistic categories, and establish a critical context in which cultures are not so much objects of knowledge as subjects of speculation. I will begin to explore this possibility by considering a number of visual images and the mythic narratives that accompany them, starting with the precontact Mesoamerican myth of Quetzalcóatl's mirror, written down in alphabetic script thirty-seven years after the Spanish invasion according to accounts of informants who remembered its prehispanic performance. I will then proceed to mythic mirrors in the European Baroque iconographic tradition, eventually to

arrive at the sculpted images of the *Cristos sangrantes* (bleeding Christs) and the painted image of the Virgin of Guadalupe. These images, like our mythic mirrors, depend upon the reciprocity of seer and seen, image and world; in fact, the Virgin's eye will eventually *become* a mirror that is said to trace the lines of the world. Throughout our discussion, we will consider the differences and eventual accommodations among indigenous and European ways of seeing.

QUETZALCÓATL'S MIRROR

The Spanish adventurers whom we now refer to as *conquistadores* sailed from Cuba and landed on the island of Cozumel in March of 1519, where they immediately confronted innumerable images of supernatural creatures. Initially comparing them to the pagan gods of Greece and Rome, the soldier and chronicler Bernal Díaz del Castillo tells of Cortés's approach to these "idols of most hideous shapes": "Cortés ordered us to break up the idols and roll them down the steps, which we did. Next he sent for some lime, of which there was plenty in the town, and for some Indian masons; and he set up a very fair altar, on which we placed the image of Our Lady. He also ordered two of our carpenters . . . to make a cross of some rough timber. . . . Meanwhile, the *cacique* and the *papa* and all the Indians stood watching us intently."[8] Fortunately, some of the colonizing clergy who followed Cortés had a more ample optic. Conversion justified conquest, so they, like Cortés, were required to substitute Catholic images for indigenous "idols." Nonetheless, a few friars worked to preserve indigenous myths in their verbal and visual forms, and their names are justly celebrated because their records, however tendentious, remain central to our knowledge of Mesoamerican cultures before European contact.[9] We have, then, a significant number of Nahua and Maya myths preserved by the same men who were engaged in banishing them from the collective memory.

Quetzalcóatl is both a deity and a human leader associated with the Toltec ceremonial center of Tula and with the Maya center of Chichen Itza (fig. 1.1).[10] The story of his encounter with a mirror encompasses both his historical and mythic identities, and it dramatizes his protean capacity to move from one condition to the other. The details are recounted in the *Anales de Cuauhtitlán,* a collection of oral narratives from the central highlands of Mexico, written down before 1570 in Roman script in Náhuatl (the language of the ancient indigenous groups of the *altiplano* and still spoken by more than a million Mexicans[11]) and published, probably in the seventeenth century, with two other postconquest texts as the *Códice Chimalpopoca.*[12] The compiler is unknown, as is his informant (or informants); in fact, the whereabouts of the original manuscript is also unknown.[13] The compilation was named *Chimalpopoca* in 1885 for the man who translated a part of it into

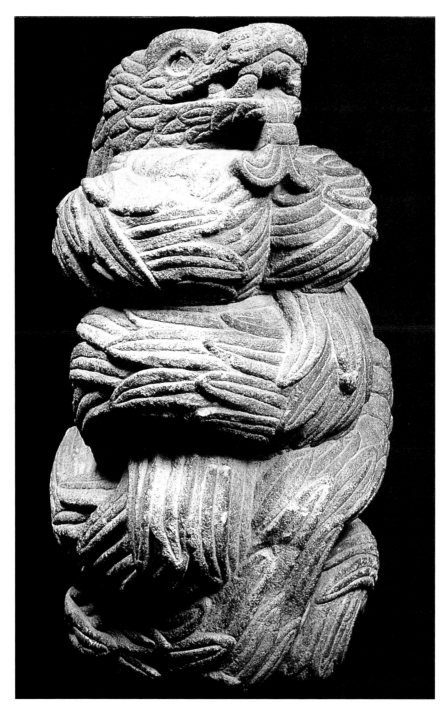

FIGURE 1.1 Quetzalcóatl (sculpted figure), Mexica, central Mexico. Ethnological Missionary Museum, Vatican State.

Spanish; only in 1945 was it translated in its entirety from Náhuatl into Spanish, and into English only in 1992. Here, I cite the Mexican novelist Carlos Fuentes's restatement of this myth. His reference to Quetzalcóatl's "fall," with its Christian resonance, already suggests the process of transculturation that we are tracing here.

Tezcatlipoca, Ilhuimécatl y Toltécatl decidieron expulsar de la ciudad de los dioses a Quetzalcóatl. Pero necesitaban un pretexto: la caída. Pues mientras representase el más alto valor moral del universo indígena, Quetzalcóatl era intocable. Prepararon pulque para emborracharlo, hacerle perder el conocimiento e inducirlo a acostarse con su hermana Quetzaltépatl ¿Bastarían las tentaciones humanas? Para desacreditar al dios ante los hombres, sí. Pero, ¿para desacreditarlo ante los dioses y ante sí mismo? Entonces Tezcatlipoca dijo: "*Propongo que le demos su cuerpo.*" Tomó un espejo, lo envolvió y fue a la morada de Quetzalcóatl. Allí, le dijo al dios que deseaba mostrarle su cuerpo. "¿Qué es mi cuerpo?" preguntó con asombro Quetzalcóatl. Entonces Tezcatlipoca le ofreció el espejo y Quetzalcóatl, *que desconocía la existencia de su apariencia,* se miró y sintió gran miedo y gran vergüenza: "Si mis vasallos me viesen—dijo—huirían lejos de mí." Presa del terror de sí mismo—del terror de su apariencia—Quetzalcóatl bebió y fornicó esa noche. Al día siguiente, hujó. Dijo que el sol lo llamaba. Dijeron que regresaría.[14]

[Tezcatlipoca, Ilhuimécatl and Toltécatl decided to banish Quetzalcóatl from the city of the gods. But they needed a pretext: a fall from grace. Because while he still represented the highest moral values of the Indian universe, Quetzalcóatl was untouchable. They prepared to make him drunk so that he might lose consciousness and be induced to lie with his sister Quetzaltépatl. . . . Would human temptation be enough? To discredit the god before men, yes. But to discredit him before the gods and before himself?

Then Tezcatlipoca said, "*I propose that we give him his body.*"

He took a mirror, wrapped it up and went to Quetzalcóatl's house. There he told the god that he wished to show him his body.

"What is my body?" asked Quetzalcóatl in surprise.

Then Tezcatlipoca offered him the mirror and Quetzalcóatl, *who did not know that he had an appearance,* saw himself and felt great fear and shame.

"If my vassals should see me like this," he said, "they would flee from me."

Full of fear of himself—the fear of his appearance—Quetzalcóatl drank and fornicated that night. The following day he fled. He said that the sun had called him. They said that he would return.][15]

Quetzalcóatl's enemies mean to undo him. Their strategy is to give him an image, that is, to embody him and thus to make him visible, vulnerable, vain. Tezcatlipoca is an adversary worthy of Quetzalcóatl; he is the god of the "smoking mirror" (in Náhuatl *tezcatl,* mirror, and *tlepuca,* a combination of *tletl,* spark, and *puctli,*

smoke) and is frequently shown to have a circular mirror in place of one foot, from which issue two plumes of smoke or, in other representations, a stream of water or flames or a serpent.[16] The Codex Borgia, housed in the Apostolic Library of the Vatican since the late nineteenth century, shows the four red and black embodiments of Tezcatlipoca, their relative sizes reversed from the upper to lower registers, each with his foot of polished obsidian (color plate 2). In fact, art historian Mary Ellen Miller states that in late postclassic central Mexica culture, Tezcatlipoca also appears to have been embodied as the obsidian mirror itself.[17] He is as protean as Quetzalcóatl and, in fact, mirrors Quetzalcóatl: in one of his forms, he *becomes* Quetzalcóatl, his opposite other, a kind of evil twin.[18] John Bierhorst's translation of the *Chimalpopoca* gives to Quetzalcóatl's enemy an even more sinister aspect than Fuentes's version. The smoking mirror/Tezcatlipoca approaches Quetzalcóatl with his *tezcatl*, his obsidian mirror, and speaks to him not of his "body" but his "flesh": "I've come to show you your flesh." Quetzalcóatl responds, "Where have you come from? What is this 'flesh' of mine? Let me see it."[19]

Quetzalcóatl immediately understands the power, and the danger, of this flesh. He realizes that his image endows him with the status of a sentient being in a physical world, and also with a communal role and responsibility; he accepts his "appearance"—his image—as his destiny. The Nahua storyteller tells us that that he looks in the obsidian mirror and sees "verrugas de sus párpados, las cuencas hundidas de los ojos y toda muy hinchada su cara . . . deforme" ("his eyelids were bulging, his eye sockets deeply sunken, his face pouchy all over—he was monstrous").[20] It seems that the reflection he sees is merely a snake. What, Quetzalcóatl asks himself, will my vassals think? Here, by vassals, we must understand believers, those who over centuries created and venerated his countless images. Quetzalcóatl sees himself through others' seeing him; his image contains and reflects himself to himself through the perception of others.

Oddly, Fuentes does not finish retelling the story but stops before the most interesting, and surely the most important part: Quetzalcóatl's transformation into the plumed serpent. Quetzalcóatl's enemies have thought to disempower him by imaging/embodying him. But like so many plots against so many gods in diverse world mythologies, this one also backfires. Tezcatlipoca has forced Quetzalcóatl to recognize his appearance (his image) and the latter leaves, but not in shame (Fuentes's Christian interpretive adduction) and not without a plan to reestablish himself. He will fight image with image. The myth continues as Quetzalcóatl goes to Coyotlinahual, a "featherworker" who fashions him a mask.

> En seguida le hizo su máscara verde; tomó color rojo, con que le puso bermejos los labios; tomó amarillo, para hacerle la portada; y le hizo los colmillos; a continuación le hizo su barba de plumas, de *xiuhtótol* y de *tlauhquéchol*, que apretó hacia atrás. (*Códice Chimalpopoca*, 9)

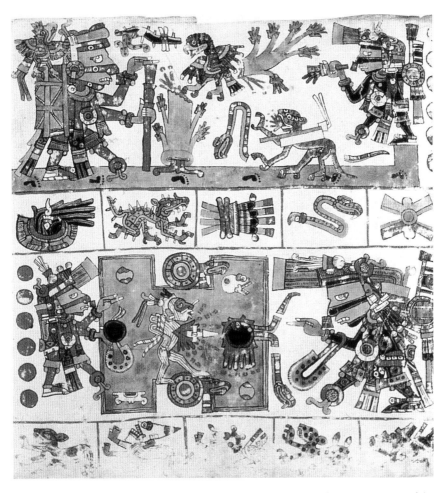

PLATE 2 Codex Borgia, plate 21, Mixteca-Puebla, central Mexico. Apostolic Library of the Vatican. Photograph: Archivo Fotográfico Manuel Toussaint / Instituto de Investigaciones Estéticas / Universidad Nacional Autónoma de México.

> [Then he fashioned his turquoise mask, taking yellow to make the front, red to color the bill. Then he gave him his serpent teeth and made him his beard, covering him below with cotinga and roseate spoonbill feathers.] (Bierhorst, 33)

Again, Quetzalcóatl is brought a mirror. Again he sees his image, which is now an elaborate mask—an image that conveys both the storyteller's and the listener's amplified experience of the god. Such specific physical description expresses the culture's investment in the power of the image to *become* the body of a god.

Consider the Mesoamerican belief that a divine essence will recognize an im-

age appropriate to itself. By virtue of what we might call a visual sympathy between a god and his/her/its image, the god will inhabit and possess the sculpted or painted or carved material. This understanding of visual sympathy implies a reciprocity between image and object that goes beyond verisimilitude to what Inga Clendinnen calls "significant appearance," and Serge Gruzinski calls "an extension of essence."[21] The spirit recognizes its physical and moral correspondences because the sculptor or painter has properly conceived and executed the image; the image-maker has penetrated the essence of that spirit and incorporated it in paint or wood or stone. This reciprocal relation of spirit and image is dramatized in the myth we have just considered. Quetzalcóatl recognizes himself in the reflected gaze of his believers. His mask now embodies his appropriate role and responsibilities; he is not simply a serpent with feathers and human characteristics but a metamorphic presence that is simultaneously and variously a sacred quetzal bird, a serpent and a human being. That the Mesoamerican gods were often shown as priests wearing masks confirms the power of the image and echoes Quetzalcóatl's historical, human identity as priest/prophet of Tula. This time, when Quetzalcóatl sees his image, we are told that "quedó muy contento de sí" (9) ("Seeing himself, Quetzalcóatl was well pleased" [33]).

Scholarly commentary on the iconography of Quetzalcóatl is extensive. Román Piña Chan follows the archeological evidence of this figure from its earliest appearances in Olmec culture (1500–900 BC) through numerous transformations, up to its encounter with European culture. He shows how

> an aquatic serpent or spirit of terrestrial waters becomes the magic concept of a dragon in the forms of a serpent-jaguar; how this dragon gave way to bird-serpents or winged dragons whose domain was the sky; how, in turn, they were transformed into the beautiful plumed serpent, in the cloud of rain that accompanied the serpent of fire; how these serpents or celestial dragons became the animals who announced the god of rain; and how the plumed serpent, with spirals engraved on his body, became Quetzalcóatl, the god man-bird-serpent.[22]

This passage underscores the permanent dynamism of the mythic image; feathered serpents appear, then disappear, the better to appear again, and again, as Quetzalcóatl.[23] His image/mask appears hundreds of time in sites throughout Mesoamerica, carved on columns and friezes and monoliths, painted on walls and in codices, incised in ceramics, and composed of fitted stones to adorn the façades of ceremonial structures.

The temples dedicated to Quetzalcóatl—at Teotihuacán (see fig. 3.9), Uxmal, Xochicalco (fig. 1.2)—capture this sense of perennial becoming in the rhythmic repetition of varied forms of the image over the stone surfaces of their façades.[24] So, too, the painted and sculpted images of the plumed serpent express the dy-

FIGURE 1.2 Quetzalcóatl (stone relief on face of pyramid at Xochicalco), state of Morelos, Mexico. Photograph: Archivo Fotográfico Manuel Toussaint/Instituto de Investigaciones Estéticas/Universidad Nacional Autónoma de México, Maricela González.

namism of the Mesoamerican worldview, with its reigning principles of *nahualli* and *ollin* (complementarity and movement), and its conception of calendrical cycles that allow for the reappearance of the gods in altered forms.[25] Octavio Paz finds metamorphosis to be *the* essential characteristic of the Mesoamerican pantheon. In his essay on Mesoamerican visual culture, published in English as the introduction to the exhibition catalogue *Mexico: Splendors of Thirty Centuries*, Paz refers to a Maya creation narrative, an analogue to the Nahua narrative of Quetzalcóatl's mirror:

> The Plumed Serpent: Quetzalcóatl on the highlands and Kukulcan in the Yucatan, the god who emerged from the Gulf and who blows a conch shell and is named Night and Wind (*Yohualli Ehecatl*), god of vital breath and the destroyer god of the second era of the world, Evening and Morning Star, god 1 Reed, who disappeared in the place where "the water of the sky joins the water of the sea" (the horizon) and who will return in the same place and on the day to reclaim his inheritance—Quetzalcóatl, the sinner and penitent god, the painter of words and sculptor of discourse.[26]

Like Quetzalcóatl, the more than two hundred deities of the Mesoamerican pantheon constantly change names, places, roles, and appearances; they are spirit

forces rather than individualized gods. Their images shift according to situation, teller, and cultural context, and this metamorphic capacity necessarily defers definition; the avatars are not innumerable, but neither is there is any Bullfinch-type catalogue of who's who, because the Mesoamerican gods are multiple and volatile.[27] The boundaries between human, animal and natural forms are permeable; the plenitude of being, not idiosyncratic identity, is their referent.

THE INDIGENOUS IMAGE AS PRESENCE

The intertwining of visual forms and narrative identities depends upon a conception of the human body that precedes (and still today evades) the modern Western separations of mind from body and self from world. In Mesoamerican myth cultures, the body is coextensive with the world, an expressive space that contains— rather than filters or fixes—the world. Here, we may usefully speak of an embodied culture, a culture of embodiment. In Náhuatl poetry, the image for "human being" is *in ixtli, in yollotl—rostro y corazón,* face and heart. The great scholar and translator of Náhuatl literature Miguel Leon-Portilla writes that for the ancient Mexicans *in ixtli, in yollotl* was "la fisonomía moral y principio dinámico de un ser humano" (the moral physiognomy and dynamic principle of the human being).[28] Similarly, in Maya hieroglyphics, the glyph for "self" has cognate meanings of "face," "head," "image," and "portrait." According to archeologists Stephen Houston and David Stuart, "The self extends visibly to other representations, yet essence transfers along with resemblance; the surface, the 'face,' does not so much mimic aspects of identity as realize them. In terms of being, an image embodies more than a clever artifice that simulates identity; it both resembles and *is* the entity it reproduces."[29] Houston and Stuart further chart the permeable boundaries of self and world in the use of bodily metaphors to describe buildings (the door is the "mouth of a house," the post its "foot," the ridgepole its "head"). On the façades of the Maya "masked temples," faces were painted and/or carved around the door, transforming the entrance of the building into the jaws of a terrestrial monster who "devours" those who enter and "vomits" those who exit.[30] Clearly, significant information resides in the mythic penetration and transformations of human bodies and the natural world.

It will be clear by now that Mesoamerican cultures were (and are) based on belief systems that posit the sacred significance of the physical universe. In their discussion of Mesoamerican cultures and peoples, Roberta and Peter Markman refer to a "shamanistically conceived world [that] was not a world of animals and plants, of killing and harvesting so that they might survive, but a world of the spirit made manifest in these material things."[31] The visual image was not a question of mimetic resemblance, and certainly not of individual artistic expression in any

modern sense. Rather, it contained the spirit world in material form. Whether sculpted in stone, painted, or molded from clay, images were conceived and executed to fulfill cosmic functions—calendrical, ritual, prophetic, propitiatory—and they were believed to bring into presence the represented god. While some Mesoamerican images may be said to be "secular"—historical record-keeping, genealogical charts of rulers—they share with "sacred" images the purpose of participation in natural and cosmic processes.

In *The Blood of Kings,* a magisterial study of the visual codes of the Mayas, Linda Schele and Mary Ellen Miller show how the secular and sacred converged in the Maya king's presumptive capacity "to host the supernatural":

> Ritual was conceived as the bridge between the supernatural and the mundane worlds, and the king was the agent of power who made the transition from the sacred to the mundane. Thus, Maya art depicts the historical action of civil kings, but those kings acted with sacred authority and supernatural power. The imagery of art was a symbolic language that depicted both the historical actions of kings and the supernatural framework of the cosmos that gave those actions sacred purpose.[32]

The king "when dressed in the costumes of different gods, was more than just their symbolic stand-in. He was a sacred conduit, a vessel that gave flesh to the god by ritual action" (302). The power of the image in such ritual transactions was considered so dangerous that "the Maya regularly 'killed' buildings by removing faces of sculptures depicting both humans and zoomorphs and drilling holes in pottery. Much of the deliberate damage done to the faces of kingly portraits and other sculpture was the result of these killing rituals" (43–44). A carved relief featuring the Maya king Shield Jaguar and his wife Lady Xoc depicts a bloodletting ceremony that makes explicit the identity between the ruler's body and the cosmic order (fig. 1.3). Her blood drops from the rope that pierces her tongue onto pieces of *amate* paper in the basket below; the paper will be burned during the ritual so that its smoke may nourish the gods. Cosmic survival was believed to depend upon the ruler's ritual practice and physical participation, and the visual image was believed to bring this symbiosis into presence.

Carolyn Dean affirms a similar ontology of the image in Inka culture. She discusses portraits of Inka rulers, differentiating between their postcontact representation and their precontact *embodiment*. In prehispanic Peru there were no portraits in the Western sense, no representations of an absent person or thing:

> in the Andean tradition, the powerful essences of rulers (rather than their superficial form) were housed in (rather than recorded on) rocks and/or bundles of their bodily excrescences (e.g., hair and nails); these were referred to as their *wawkis* (*huaques*), or "brothers." In part because *wawkis* and mummies of the royal deceased

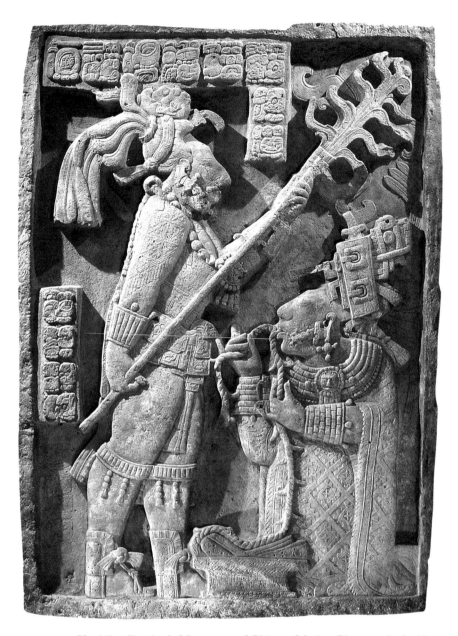

FIGURE 1.3 Yaxchilan (lintel 24), Maya, state of Chiapas, Mexico. Photograph: Archivo Fotográfico Manuel Toussaint/Instituto de Investigaciones Estéticas/Universidad Nacional Autónoma de México, Maricela González.

were revered, kept, and treated as though they were still animate or capable of im-
minent animation, there was no Andean tradition of sublimational image-making
because there was no absence to disavow.[33]

Prehispanic images did not *resemble* the royal deceased but rather embodied
them—they *were* the rulers. Dean shows how postcontact Inkas appropriated the
canons of Western portraiture to encode their precontact traditions and articulate
a transculturated native identity.[34]

Despite the diversity of indigenous groups in precontact America, then, a
shared cultural substratum emerges that allows us to generalize an indigenous
image-as-presence. Indigenous American cultures privileged the capacity of the
visual image *to be,* or *become,* its object or figure. The image *contained* its referent,
embodied it, made it present physically and experientially to the beholder. There
was no dichotomy between presence and absence, no assumed separation between
image and object. The image was not distinct from its referent but integral to it ac-
cording to culturally determined systems of analogy. Still today, in ritual dances
performed in festivals throughout Mesoamerica and the Andes, the spirit of the
animal carved on a mask recognizes and inhabits its wearer; in what is called the
wearer's *nagual,* the image and its meaning are one. A spirit may also abandon its
image for a variety of reasons—anger, boredom, a fickle nature. An image contains
the special history of the spirits that have inhabited it; in rural Mexico, Catholic
images of the same saint may contain very different histories and attributes from
village to village. The *image-as-presence* thus constitutes a fundamental integrity of
spirit and object—an integrity easily (mis)taken for magic by modern Western cul-
ture, which, of course, maintains the separation between images and their objects.

Consider a recent example. Reports in Mexico's newspapers in the fall of 2000
on the activity of the volcano Popocatépetl, east of Mexico City, included scien-
tific information, but most accounts focused on the ways in which local popula-
tions personified the volcano and understood its activity as coded information from
ancient gods. In Náhuatl, Popocatépetl means "Smoking Mountain" or "Lord of
the Lighted Torch"; the volcano, which has been sending up smoke and ash for
millennia, has long been a site of religious devotion. Early Spanish chroniclers de-
scribed the religious practices associated with the site, and contemporary residents
still refer to the volcano as "Don Goyo." The name is a term of endearment for
Gregorio Chino Popocatépetl, a combination of St. Gregory the Great, for whom
a neighboring village is named, and an old man associated with the prehispanic de-
ity Tlaloc, lord of rain. An article in a magazine devoted to Mexican culture reports
that for contemporary residents of the villages on the skirts of the volcano,

> Gregorio Popocatépetl is as much volcano-nature as man-god. As mountain, it is
> the water that runs from springs, the fertilizing ash and powerful landscape; as
> human being, he is the old man known to many who suddenly appears and disap-

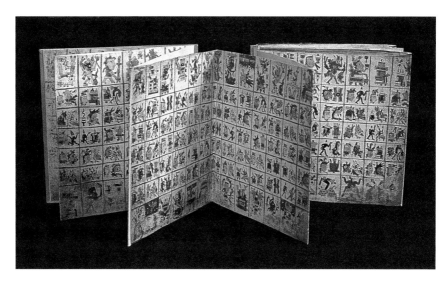

FIGURE 1.4 Codex Cospi, Mixteca-Puebla (Borgia group), central Mexico. University Library of Bologna.

pears, the one who asks for food and gifts but only accepts them if they are placed in the sacred sites on the heights of the volcano.[35]

So a Catholic saint merges with the Nahua god of rain in the form of an old man who regularly appears to the residents of the villages on the slopes of the volcano. Don Goyo's cave is the navel of the volcano and his feast day is March 12. Spirit forces simultaneously occupy natural forms and Catholic figures, combining topographic attributes and diverse theological systems in culturally significant ways.

My discussion of Don Goyo is intended to suggest that mythic understanding continues to operate in Mexico, but I would also suggest that most image-consumers no longer consciously ascribe to such an understanding. The *Anales de Cuauhtitlán*, the 1570 compilation in which the story of Quetzalcóatl's mirror appears, is at the beginning of this long process of loss. The myth was written down in European alphabetic script, a mode that favors discursive narration, whereas before the arrival of Europeans, it would have been recorded in elaborate visual structures comprised of nonalphabetic systems—glyphs, pictographs, ideographs—painted on the folded texts we now call codices (fig. 1.4) and then performed by a *tlacuilo* before an audience. John Bierhorst speculates that the postconquest "informant" still had access to preconquest visual sources. In certain passages, Bierhorst notes that the teller "speaks to us as though we were looking over his shoulder, while he points to the painted figures. . . . In places the text reads like a sequence of captions, as though the unseen pictures could carry the burden of the tale."[36] In

the written transcription of this oral account, Bierhorst identifies the transcultural operations whereby the teller moves between his traditional visual, performative mode and his new discursive medium in order to remember and record the story of his (former) culture's mythic origins.[37]

So we recognize that visual embodiment and oral performance were integral to the metamorphic identities and shifting powers of the Mesoamerican gods. The visual and performative media that embodied them were fluid enough to encompass a cosmogony based upon principles of complementarity, movement, and metamorphosis, a cosmogony that the alphabetic medium cannot adequately represent.[38] On the contrary, alphabetic documents tend to fix the universe, to record and preserve knowledge, and thus ensure stability. While we celebrate the preservation of indigenous American myths in whatever modified form they have come to us, we must also understand how far we are from their original participatory visual/oral medium. As we read the story of Quetzalcóatl's mirror, whether in Náhuatl, Spanish, or English, we recognize that it is *about* a mythic image, but no longer *is* a mythic image. Its figural text and communal performance have been supplanted by the silent abstraction and discursive logic of European alphabetic form.

EUROPEAN MIRRORS: THE IMAGE AS RE-PRESENTATION

Consider, then, the essential cultural distinction between the indigenous *image-as-presence* and the European image imported into the Americas. The latter conveys a likeness of its object but remains distinct from it. The Western conception of re-presentation, beginning with the Greeks, is based in belief systems that hold the world to be separated from, and controlled by the observing I/eye. This separation encodes an understanding of the observer's detachment from phenomena and thus accommodates (and also fosters) modern Western conceptions of empiricism, objectivity, and individuality. Alice Jardine summarizes the ontology of this image: "Representation is the condition that confirms the possibility of an imitation (mimesis) based on the dichotomy of presence and absence and, more generally, on the dichotomies of dialectical thinking (negativity). Representation, mimesis, and the dialectic are inseparable; they designate together a way of thinking as old as the West."[39] This "dichotomy of presence and absence" is maintained through the conventions of Western perspective, which remind viewers of the image's *likeness to* nature and, hence, our *separation from* nature. Western perspective frames what is seen from outside the framed scene, thus encoding the seer's detachment from the visible world.[40]

Contrast this conception of mimesis to what we have just seen of the precontact image in Mesoamerica, which does not separate subject and object, perceiver and perceived, but rather assumes that the world is around and in the self, not

merely in front of it. We may begin to test this difference by juxtaposing the myth of Quetzalcóatl's mirror to the Greek myth of Narcissus. Both envision mirror images of mythic figures (Narcissus is the mortal son of a river god and a nymph); both recount the reactions of these figures to their unexpected images and their unsuspected bodies; both have enemies who set the creation of their image in motion; both are subject to metamorphosis.

The story is well known. Narcissus rejects the love of Echo and all other suitors, men and women. He retreats from them and rests beside of pool of still water, a scene endlessly rendered by Renaissance and Baroque artists. He finds his reflected image beautiful, but does not realize that it is he himself whom he sees. Bending to kiss the image, he falls into the water and drowns or, in an alternate version, pines to death for his nonexistent lover. His identity is reflected in the pool of water, as is Quetzalcóatl's in Tezcatlipoca's obsidian mirror, but the difference is that the Nahua deity recognizes himself and does *not* like what he sees, whereas Narcissus doesn't recognize himself and *does* like what he sees. The Greek myth is cautionary; we are meant to understand Narcissus's mistake. He should have recognized the image in the pool as a (mere) likeness of himself—as (mere) representation. Instead, he mistakenly assumes that the image *is* his beloved. In his longing for an animate image, we glimpse an analogue to the Mesoamerican image-as-presence, but his desire remains unsatisfied; the possibility of ritual participation fails Narcissus, for unlike Quetzalcóatl, he is without "vassals" to clarify his image by reflecting it back to him. His image is iterative rather than transformative. Narcissus's story is a demonstration of the *failure* of re-presentation; subject and object collapse, the self cannot distinguish itself from its reflection, cannot individuate, cannot continue to exist. In dramatizing the error of adoring an image, the myth of Narcissus presages the Christian injunction against idolatry and affirms the Western conception of the eye as intellectual instrument rather than primal participant.

Christian doctrine has long questioned the relation of seeing and believing. According to the influential metaphor of St. Paul, Christians can expect to see no more than "through a glass darkly" in this life; visual images may confuse, deceive, seduce.[41] Nonetheless (or perhaps therefore), mirrors figure prominently in Catholic iconography where, beginning in the Middle Ages, they are almost always associated with women. The mirror was related to moon symbolism, with its phasing/female cycles and reflective (i.e., passive) nature; as the moon receives reflected light from the sun, so the mirror receives reflected images.[42] These characteristics came to be associated with the virginity of Mary; by means of the virgin birth God is reflected in the person of Christ. In Renaissance and Baroque iconography, the Virgin is often surrounded by cherubs or clouds that support different objects, one of which is a mirror. The virtues emblematically encoded in these objects are enumerated in the litany of Loreto (*la letanía lauretana*), codified in the sixteenth cen-

tury but widely circulated in varying versions long before.[43] In this Marian prayer, the Virgin is a vessel of honor, a mystical rose, the morning star, the throne of wisdom, the ark of the covenant, the gate of heaven, and the mirror of divine justice. Here again, the mirror is metaphorical rather than causal: it "reflects" an idea, a concept, a doctrine (the Virgin birth; God's justice) but does not impel narrative events, as it does in the myths of Quetzalcóatl and Narcissus. Nor is the Virgin's mirror the illusionistic surface that it will become for secular Baroque artists and writers. In chapter 5, we will consider how Jorge Luis Borges engages the mirror and other Baroque metaphors of visual illusion to explore (and ironize) the possibility of seeing anything for certain.

In fact, during the Baroque period the mirror acquires a negative charge. There are exceptions, of course; one thinks of Calderon's *La púrpura de la rosa,* but in painting, the mirror is often a moralizing emblem, an emblem of *vanitas*—wrong-headed worldliness, undue investment in one's own youth and beauty. These scenes, too, are almost always gendered. The mirror is held by a young woman or stands on a table beside her, and we are asked to bear witness to her folly as she appreciates her own reflection. Mary Magdalene is a prime example of this admonitory iconography in Catholic art. She is often represented in her prepenitential state with a mirror, as on the left hand side of the allegorical painting entitled *The Conversion of St. Mary Magdalene* by the eighteenth-century Mexican painter Juan Correa (fig. 1.5). To the mirror on her table, Correa adds a portrait of an elegant suitor wedged into the frame, thus heightening the visual allusion to her life as a prostitute before her conversion. On the other side of the canvas, she weeps in penance, foreshadowing the revised self whom she will become and who is pictured in the background on the right. This world and the next are as sharply divided in Correa's composition as the Magdalene's roles of prostitute and penitent, oppositions that engage the Western duality between image and object, and the Catholic divide between flesh and spirit.

Over time, the iconography of *vanitas* blurs into *memento mori;* the beauty reflected in the mirror depends upon youth, and youth will fade. Skulls begin to provide regular company to the mirror, reminding the viewer of the speciousness of pleasure and the falsity of appearance. Mirrors reflect only what is visible, whereas only what is *in*visible is lasting and true. My discussion of the mirrors in Catholic iconography, like my discussion of the mirror images of Quetzalcóatl and Narcissus, presupposes that the most telling function of the image in any culture is the (re)presentation of its gods, or God; the interdiction against "graven images" in some cultures only affirms this point.[44] How divinity is imaged (or not) is basic, and the difference between the indigenous American image as a *repository* of spirit and the Western image as a *reflection* of spirit caused wholesale destruction in America. Nowhere do the transcultural dynamics of collision and accommodation in the New World unfold more starkly than under the sign of "idolatry."

FIGURE 1.5 Juan Correa, *The Conversion of St. Mary Magdalene* (eighteenth century), Mexico. National Museum of Art. Instituto Nacional de Antropología e Historia / Consejo Nacional para la Cultura y las Artes.

IDEOLOGY AND IDOLATRY IN NEW SPAIN

Returning to Cortés in the Yucatan in 1519, destroying indigenous "idols," we now understand his actions in terms of the confrontation of distinct ontologies of seeing, and his iconoclasm as a confirmation of the ideological importance of visualizing activities in the colonizing agenda. For the *conquistadores,* and then for the clergy, images were theological and political matters, and the mass conversion of the conquered was inextricably tied to them.[47] Tzvetan Todorov, in *The Conquest of America: The Question of the Other,* argues that the conquest was a "hermeneutic conquest," and that Cortés's "semiotic conduct"—his assimilation and manipulation of indigenous sign systems—was key to his victory over the Mexicas in 1521.[45] Perhaps, but Todorov fails to acknowledge that semiotic conquest was countered by semiotic seduction.[46] Cortés can hardly contain his amazement at the artistic wonders of Tenochtitlán, and even the sober, sensible Bernal Díaz del Castillo praises three indigenous artisans (*imagineros*) as "equal to Michelangelo," naming them one by one. Indeed, no sixteenth-century Spanish chronicler is silent on the subject. Where they begin by describing "hideous idols," they soon shift their gaze to the Christian images and artifacts created by indigenous artisans, and their adjectives abruptly change from excoriation to exaltation. The fact that image-making enters so prominently into their accounts—whether to condemn or even-

tually to congratulate—attests to the centrality of visual images in "correct" spiritual practice.

The Spaniards' iconoclasm, then, can be understood as a perverse projection of their own investment in image-making. Cortés's destruction of indigenous images reflects his clear understanding of their power, and Bernal Díaz recognizes this ambiguity as he repeatedly describes Cortés's relation to idols and images. Here we read an instance among many when Cortés showed the Mayas

> a most sacred image of Our Lady with Her precious Son in her arms, and declared to them that we worshipped it because it was the image of the Mother of our Lord God, who was in heaven. The *caciques* (chiefs) answered that they liked this great *tececiguata*—which is the name they give to great ladies in their country—and asked that it [she] be given them to keep in their town.[48]

For Cortés, the image *re-presents* what is absent ("in heaven"); for the Mayas, the image *is* the spirit ("this great *tececiguata*").

In Cortés's second letter there is one moment when this confrontation of ontologies becomes almost unbearably ironic. All are gathered in Moctezuma's royal palace. Cortés quotes Moctezuma's formal speech, addressed to the assembled Spaniards, which is concerned solely with the politics of visual knowing:

> "Do not believe more than you see with your own eyes, especially from those who are my enemies, and were my vassals, yet rebelled against me on your coming (as they say), in order to help you. I know they have told you also that I have houses with walls of gold, and that the furniture of my halls, and other things of my service, were also of gold, and that I am, or make myself, a god, and many other things. The houses you have seen are of lime and stone and earth." And then he held up his robes, and showing me his body he said to me, "Look at me, and see that I am flesh and bones, the same as you, and everybody, and that I am mortal, and tangible."[49]

Here, Moctezuma projects his own cultural understanding, assuming that the Spaniards will see him as an idol, as a god inhabiting material form. He pleads for a realistic understanding of his appearance ("flesh and bones"), not realizing that his human status is never in question, and that he will soon die at the hands of men whom he mistakenly imagines to have taken his body for that of a god.

The Spaniards took to their work of conquest and conversion with iconoclastic fury. Every soldier and missionary was, by definition, an iconoclast, a fact infamously documented by the Franciscan Diego de Landa, whose *Relación de las cosas de Yucatán* (translated as *Yucatan Before and After the Conquest*) describes indigenous iconographic practices and his efforts to obliterate them. De Landa arrived in the Yucatan in 1549, during the first years of colonizing activity in the area; in 1562 he

was recalled to Spain to defend himself against charges of overstepping his ecclesiastical authority.⁵⁰ His stay in Spain spanned more than ten years, during which time he wrote his *Relación* as a legal argument on his own behalf, assiduously documenting his knowledge of Maya hieroglyphic forms and his iconoclastic activities in this regard. De Landa was charged and judged by various church and political bodies and eventually exonerated; he returned to the Yucatan as its second bishop in 1573, and remained there until his death at age fifty-five, in 1579.

Beyond de Landa's theological understanding of the "idols" of the Mayas as instruments of the devil, he also addresses their function as repositories of spirit:

> So many idols did they have that their gods did not suffice them, there being no animal or reptile of which they did not make images, and these in the form of the gods and goddesses. They had idols of stone (though few in numbers), others more numerous of wood, but the greatest number of terra cotta. The idols of wood were especially esteemed and reckoned among their inheritances as objects of great value. They had no metal statues, there being no metals in the country. As regards the images, they knew perfectly that they were made by human hands, perishable, and not divine; but they honored them because of what they represented and the ceremonies that had been performed during their fabrication, especially the wooden ones.⁵¹

De Landa is right that the Mayas "knew perfectly" that their images were made by "human hands," but he is mistaken that they honor them for what they *represent*. For the Mayas, "representation" does not mean *resemblance*, as de Landa imagines, but rather *embodiment*. There follows his description of the infamous auto-da-fé in 1562 at Maní, where he orders the burning of five thousand Maya "idols" and twenty-seven painted codices.

> These people also used certain characters or letters, with which they wrote in their books about the antiquities and their sciences; and these, and with figures, and certain signs in the figures, they understood their matters, made them known, and taught them. We found a great number of books in these letters, and since they contained nothing but superstitions and falsehoods of the devil we burned them all, which they took most grievously, and which gave them great pain. (82)

It was for this abuse of his authority that he was recalled to Spain, but even as he awaited judgment in Spain, he offered his iconoclasm as proof of his good faith. His fixation on idols and idolatry betrays what he and other colonizers feared: the image-as-presence is too powerful to be annihilated by fire or decree.

Unlike the indigenous image, the Catholic image is *not* to be a repository of spirit; it exists *not* to embody God but rather to facilitate the believer's call upon God. It is an *index* pointing to truth, not a vessel containing truth. The vivid particularities of Catholic paintings and statues, pageants and processions, are in-

tended to conduct the believer elsewhere, not to bring spirit into actual physical contact with the beholder; so St. Paul exhorts early Christians to intuit God with "the eyes of your understanding" (Ephesians 1:18). Centuries of commentary by Catholic scholastics, based on classical Greek texts, had determined that physical beauty was desirable because it could serve as a vehicle to metaphysical truth.[52] Precisely because the visual image remains separate from the transcendental truths it re-presents, it must strive to make those truths available to the intellect and the senses by means of line, color, dramatic narrative scenes, and so on. Beyond pedagogical and proselytizing purposes, an empathic reaction to visual images may transport the believer to divine mysteries. By the time de Landa was burning idols at Maní, European painting had begun to project a new interiority, an intense emotional understanding of religious experience, even while insisting that the artifact itself remain a mere intermediary between the subjectivity of the believer and the object of belief. The Council of Trent, which met in three sessions between 1545 and 1563, encouraged the use of images in spiritual practice, but the Tridentine decrees were clear, as the Roman Church had been since the Second Council of Nicaea in the eighth century: the image itself was *not* to be worshipped.[53]

The distinction between *latria* (worship) and *idolatria* (idol worship) was a fine one for recently converted indigenous populations.[54] Documents throughout the colonial period attest to incessant vigilance against idolatrous worship of Catholic images on the one hand, and unauthorized invasion of indigenous images into Catholic iconic practice on the other. In New Spain, Church officials felt increasingly compelled to insist upon the separation of the image from its (invisible, spiritual) object. Measures were taken to ensure that the image not be mistaken for the spiritual event or personage it re-presented. For example, sixteenth-century atrial crosses in New Spain, elaborately carved in stone, are unique in depicting only the thorn-crowned head of Christ, rather than the entire body (fig. 1.6). This revision of European iconography was made so that indigenous converts would not take literally the image of human sacrifice, a Mesoamerican ritual practice that the colonizing clergy were working to extirpate. The instruments of Christ's passion— nails, hammer, ladder, whip, lance—were carved on the cross, for if the tortured body was not to be seen, its suffering could be symbolically suggested in the instruments of bodily torture.[55] These atrial crosses make visible the collision of the Mesoamerican and Catholic conceptions of the image, the former supposing (heretically, of course) that images are identical to their object, the latter insisting upon their absolute separation.

The metamorphic nature of the Mesoamerican gods further complicated the Catholic clergy's problem in drawing strict lines between "pagan" and Christian images. Indigenous images embodied unstable, combinatory entities subject to constant transformation, so they could be (and often were) reconfigured according to aspects of Christian saints and virgins. Church and government archives are full of records documenting Catholic efforts to oppose such unauthorized syncretism.

FIGURE 1.6 Atrial cross, San Agustín Acolman (sixteenth century), state of Mexico, Mexico.

Over three centuries of colonial rule we finds innumerable petitions by indigenous converts asking that worship be allowed in caves or mountain retreats. (*Adoratorio* is the term used to describe these illicit places of worship, as *ídolo* describes the illicit images found there.) Because indigenous images were worshipped in natural surroundings, the Church understood these petitions to reflect a heretical combination of religious forms (recall the cave of the volcano spirit Don Goyo Popocatépetl). The petitioners were usually discredited and punished, as were those who reported apparitions of Catholic figures in such sites.[56] Petitions were denied, but syncretic practice could not be stopped.

Official worry about idolatry continues to this day where Catholic images exert powerful popular attraction. A booklet still sold at Chalma, an important pilgrimage site in Mexico, explains the apparition of the Christ of Chalma, who appeared to indigenous converts (in a cave, in fact) and is the object of veneration by thousands of pilgrims every year. The booklet reproduces in its entirety a text written in 1810 by an Augustinian friar named Joaquín Sardo, who displays the Catholic vehemence against indigenous images even as he recognizes their latent force in Catholic iconic practice:

> During the centuries of the gentiles, unhappy age, when our America lay buried in the darkness of idolatry, the natives of Ocuila and its surroundings [the area of Chalma] were miserably shrouded in shadows, blindly adoring and worshipping an idol whose name, because of the total change in religion and customs, has been erased even from their memory; I cite only the most probable name of this false deity, who was venerated as Ostotoctheotl, the translation of which is God of the Caves, although this too is uncertain.[57]

The mention of the name of the indigenous god supposedly "erased from memory" confirms the syncretic practices that the text discredits, and the continuing play of visual ontologies.

In spite of "idolatrous" tendencies, indigenous artisans were obliged to construct, decorate, and furnish ecclesiastical structures throughout colonized Latin America. In New Spain, the same *tlacuilos* who had depicted their own cosmological and historical narratives in codices now began to copy European engravings, and idiosyncratic admixtures of indigenous and European visual forms began to appear on walls and sculpted façades.[58] Along with the hybrid postconquest codices that we will see in the next chapter, the murals in sixteenth-century churches and cloisters provide fascinating transcultural documents of the vast encounter of images in America. The earliest of these constructions, Franciscan and Augustinian monasteries in central Mexico, are exemplary (fig. 1.7). In the Augustinian monastery of San Miguel Arcángel Itzmiquilpan, in the state of Hidalgo, the hand of the *tlacuilo* is clearly visible in the inordinate details—horses with sandals, native warriors, now Europeanized, with volutes coming out of their mouths to sig-

FIGURE 1.7 San Miguel Arcángel Itzmiquilpan (fresco, sixteenth century), state of Hidalgo, Mexico. Instituto Nacional de Antropología e Historia, Mexico. Photograph: Dolores Dahlhaus.

nify speech.[59] Once again, then, the familiar irony: the friars acknowledged and extended the artistic traditions of the *tlacuilos* while working to erase their cultural memory. And the second irony: indigenous cultures refused erasure.

While these statements are accurate, they do not, perhaps, do justice to the complexity of the cultural negotiations among colonizing clergy, indigenous artists, and cultural informants. I have already acknowledged several of the friars to whom we owe some of our knowledge of prehispanic cultures, and we should also recognize unofficial Catholic practices of cultural inclusion. The early eighteenth-century chapel in Santa María Tonantzintla, in the state of Puebla, demonstrates the Church's tacit sanction of syncretic ideologies of visual knowing.[60] A profusion of leaves, flowers, and tropical fruit weave a cosmic space for winged cherubs and wide-eyed Indian boys (fig. 1.8). These "folk Baroque" walls of sculpted polychrome and gilded stucco are dynamic pentimentos of transcultural processes. Robert Harbison, in his study *Reflections on Baroque,* speculates that Mexican artisans could not have been much moved by the prescribed biblical narratives, and so diverted their energies into nonnarrative decoration: "The feeling is seen in the redressing of balances and reassigning of importance. The little saints can look particularly puny perched in the marvelous gold forest of a retable, as if they have

FIGURE 1.8 Santa María Tonantzintla (detail, mural reliefs, seventeenth century), state of Puebla, Mexico.

climbed up for the view. . . . Sometimes while examining these staggering products of enthusiasm the feeling comes over one that Christian imagery has been swamped by something else."[61] Whether swamped or heightened, the "something else" that animates the folk Baroque of Santa María Tonantzintla also animates the high Baroque in much of Latin America.

The stucco façade of the Sanctuary of the Virgin of Ocotlán is an example of

the Mexican Churrigueresque (color plate 3). This most elaborate of New World Baroque styles is named for the Spanish architect José Benito Churriguera (1665–1735), who never worked in Mexico but whose name now describes the highly ornamented surfaces of seventeenth and eighteenth-century Mexican façades and *retablos* (altarpieces).[62] The exchange between "inside" and "outside" in the echoing forms of façades and altarpieces reflects the evangelizing function of their images; the theological discourse of the interior *retablos* moves out onto the façade in order to reach the largest audience possible. And vice versa: the monumental structure surrounding the wrought iron entrance to a chapel in the Church of the Carmelites in San Luis Potosí (color plate 4) is carved in stone and overlaid with stucco, as if the façade had followed the worshipper into the sanctuary. The Mexican Churrigueresque engages Classical elements (columns, cornices, caryatids) in order to challenge Classical order, calling upon an array of illusionist resources in the process. Layers of angular cornices are sharply stacked and foreshortened to create the illusion of even greater height than the immense retablo actually commands. The trapezoidal *estípite* columns narrow at the base, their soaring verticality seeming to affirm the weightlessness of the animated surfaces they pretend to support. These trompe l'oeil techniques challenge the physical confines of the retablo to create the illusion of infinite space, making the *retablo* itself a trompe l'oeil —an image that pretends to contain the universe.

So we approach the complex interactions among cultures that produced the visual forms of the New World Baroque—this first instance of planetary globalization in which radically different cultures met and mixed as never before in human history. Despite the vastly different ontological and ideological assumptions of Catholic and indigenous cultures, their expressive forms also proved congruent in a number of ways, including the profusion of geometric and organic elements, the refusal of a single unifying perspective, the ritual performances surrounding their visual images, and their cosmogonies comprised of legions of personages and plots. These aesthetic and cultural overlaps begin to explain why the Baroque continued to flourish in Latin America until the end of the eighteenth century, long after its energies were exhausted in Europe, and why it continues to enliven contemporary forms of expression, including the literary works to be discussed in the following chapters.

THE COUNTER-REFORMATION AND BAROQUE FORMS OF EXPRESSION

The Counter-Reformation was Thomistic and Aristotelian. Aristotle's aesthetic and scientific writings were recovered for the Christian West in the twelfth and thirteenth centuries, and they inspired aspects of St. Thomas Aquinas's theology. Along with his contemporary St. Bonaventure (c. 1218–74), St. Thomas (1225–74)

PLATE 3 Sanctuary of the Virgin of Ocotlán (façade, eighteenth century), Tlaxcala, Mexico. Photograph: Archivo Fotográfico Manuel Toussaint / Instituto de Investigaciones Estéticas / Universidad Nacional Autónoma de México, Pedro Angeles Jiménez.

invested Aristotle's conception of nature with spiritual significance, arguing that the Christian could discover God in the body, the senses, and the physical world. In *Image as Insight: Visual Understanding in Western Christianity and Secular Culture,* Margaret R. Miles elaborates St. Thomas's Aristotelian conception of the visual image:

> Soon after Aristotle became known in the medieval West, his idea that images formed by perception are an irreducible part of all thought was applied to theological knowledge. Thomas Aquinas said that theology requires the continuous use of images. Aquinas, like Aristotle, corrected the tendency of popular Platonism to

PLATE 4 Church of the Carmelites, Portal of the Archangels (eighteenth century), San Luis Potosí, Mexico. Instituto Nacional de Antropología e Historia.

regard sensible objects as the first step toward knowledge, but a first step to be left behind as quickly as possible, by insisting on the permanent mediating function of images.[63]

Miles then quotes Aquinas on this "permanent mediating function":

> The image is the principle of our knowledge. It is that from which our intellectual activity begins, not as a passing stimulus, but as an enduring foundation. When the imagination is choked, so also is our theological knowledge. (143)

Aquinas uses the word "imagination" in its etymological (and Aristotelian) sense to mean the capacity to create mental images. The cultivation of the visual imagination becomes necessary to theological understanding, for re-presentation may deduce (or produce) spiritual meaning from the physical world. This Thomistic attitude became Counter-Reformation doctrine during the sessions of the Council of Trent in the mid-sixteenth century, and the naturalism of subsequent Baroque representation reflects this attitude: transcendental meanings lie beyond color composition and texture, and they are also potential in them.[64]

The Council of Trent was convened by Pope Paul III in 1545 in response to the Protestant challenge to Catholic institutions and dogmas. The Catholic Church recognized the need to reform its own internal practices in order to shore up existing spheres of influence and also extend them, not least in those lands recently claimed by Spain in America. The decrees of the Council of Trent responded to Protestant attacks on a number of doctrinal fronts, including their practice of iconoclasm. One of the many ironies of this period is that while Catholic clergy were destroying "idols" in New Spain, Protestant reformers in northern Europe were destroying Catholic paintings, altars, and entire churches. The council answered "the opponents of images" by reaffirming the legitimacy of images in Catholic practice and reiterating their correct use. The twenty-fifth and final session of the Council of Trent, on December 3–4, 1563, issued its decree "On the Invocation, Veneration, and Relics, of Saints, and on Sacred Images," which addresses the nature and function of visual images. Images are *not* spirit but rather recall the invisibility of spirit: "the people shall be taught that not thereby is the Divinity represented, as though [Divinity] could be seen by the eyes of the body, or be portrayed by colors or figures."[65] This restatement of the Catholic ontology of re-presentation also addresses the nature of relics in order to counter Protestant charges that the veneration of relics is idolatrous. Relics are, of course, often parts of saints' bodies, but according to this decree they are nonetheless re-presentational, that is, not to be taken as parts of the body per se but rather as symbolic of the body. The invocation and intercession of the saints in "the honor paid to relics" is supposed to bring to the believer's mind the *image* of "the holy bodies of holy martyrs . . . through which many benefits are bestowed by God on men," but they do not make the body present. Hav-

ing thus established images and relics as *other* than what they re-present, the decree moves on to other matters.

Divinity is not, then, visible "to the eyes of the body," as the council's twenty-fifth decree puts it, but the activity of *visualizing* divinity is nonetheless central to Counter-Reformation policy. Images exist for the purpose of inspiring devotion, and to do so, they must provoke a combination of empathy and imagination in the worshipper. Scenes are to be painted as realistically as possible in order to appeal to the senses and emotions of the viewer, and thus to his or her visual imagination. If this aesthetic was proselytizing in intent, it was popularizing in effect. Art was to instruct not so much by exemplifying doctrine as by evoking an internal, personal response.

Privileged visual subject matter corresponded to matters under siege by Protestants: the role of the Virgin and saints as intercessors between believers and God; the necessity of suffering and martyrdom as sanctifying activities; the status of particular sacraments (the Eucharist, the priesthood, penance). Figures in ecstasy, figures *in extremis*: these embattled areas of theology lend themselves naturally to arresting artistic depiction—naturally, we think, till we realize that explicit physical depiction is, in many ways, a Baroque invention. Christ's passion, Mary's mourning, the martyrdom of saints, penitential castigations, purgatory: such scenes were designed to encourage the beholder to experience empathically the suffering of these figures, and thus share in their transcendence. We will return to the Baroque portrayal of sanctified suffering in our discussion of Frida Kahlo and Gabriel García Márquez in chapter 4. Here, it is enough to say that Counter-Reformation representation is designed to encourage the imaginative practice of envisioning spirit, as the Eucharist encourages believers to imagine the body and spirit of Christ in the sacramentally changed bread.

It was, in fact, the Protestant challenge to the doctrine of transubstantiation that impelled the Council of Trent to address the symbolic nature of the mass, with its re-presentation of Christ's body and blood. The decree from the twenty-second session of the council, September 17, 1562, "Doctrine on the Sacrifice of the Mass," goes out of its way to distinguish the image from its object. The first section of the decree describes Christ's last supper and death as leaving

> a visible sacrifice, such as the nature of man requires, whereby that bloody sacrifice, once to be accomplished on the cross, might be *represented,* and the memory thereof remain. . . . [Christ] offered up to God the Father His own body and blood under the *species* of bread and wine; and, under the *symbols* of those same things, He delivered His own body and blood to be received by His apostles. (my emphasis)

The "great mystery" of the Eucharist is transubstantiation, and also substitution: the bread and wine are the body and blood of Christ, and also their symbols. This decree stresses the separation of the symbols from Christ's "bloody sacrifice" in

PLATE 5 Miguel Cabrera, *Allegory of the Precious Blood of Christ* (eighteenth century), Mexico. National Museum of the Viceroyalty. Instituto Nacional de Antropología e Historia. Photograph: Dolores Dahlhaus.

order to subvert the worship of the body itself, at the same time that the Church encouraged the detailed depiction of the crucifixion. Christ's blood flows freely in Baroque re-presentation, as does the blood of saints and martyrs, as shown in this mid-eighteenth-century painting by Miguel Cabrera, the artist who may be said to represent the culmination of Baroque painting in New Spain (color plate 5).

The fifth section of this same decree is entitled "On the Solemn Ceremonies of the Sacrifice of the Mass," and it again recognizes the "nature of man" and the consequent importance of appealing to the senses:

> whereas such is the nature of man, that, without external help, he cannot easily be raised in the meditation of divine things; therefore has holy Mother Church insti-

tuted certain rites, to wit that certain things be pronounced in the mass in a low, and others in a louder, tone. She has likewise employed ceremonies, such as mystic benedictions, lights, incense, vestments, and many other things of this kind, derived from an apostolical discipline and tradition, *whereby both the majesty of so great a sacrifice might be recommended, and the minds of the faithful be excited, by those visible signs of religion and piety, to the contemplation of those most sublime things which are hidden in this sacrifice.* (my emphasis)

Sensory engagement (sound, smell, touch, as well as sight) is prescribed, and attention is called to the "hidden" meanings made available through sensory experience. Ecclesiastical performance becomes a means of enlivening the senses of believers for the twin purposes of devotion and instruction.

In fact, dramatic visualization characterizes virtually every aspect of religious practice in the Spanish New World, and the drama is often made explicit by the inclusion of theatre curtains. Draped gracefully to the side of a painted scene or framing the windows of a façade, sometimes held by angels, the curtains point to the role of re-presentation—staging, spectacle—in Catholic Counter-Reformation practice, and to the nature of the image as artifice. Curtains remind viewers that they are once-removed from the real, even as they are allowed to visualize the scene along with the painter or sculptor, and that they are twice-removed from the transcendental truths latent in the scene, for curtains also suggest the revelation of invisible mysteries about to be unveiled.[66] Sculpted plaster curtains adorn the folk Baroque façade of Nuestro Señor de Santiago de Jalpan, one of five missions built by the Franciscan friar Junípero Serra in the Sierra Gorda of Mexico, before he proceeded to build his chain of sober presidio/missions along the coast of California (fig. 1.9).

The Churrigueresque matches the folk Baroque in its passion for curtains. The Sagrario Metropolitano, the parish church adjoining the cathedral in Mexico City, epitomizes the ultrabaroque in Mexico, and it adopts the curtain as a metaphor for its entire façade. *Sagrario* means "tabernacle," a reference to the bejeweled cabinet that holds the consecrated Host on the altar, and whose doors or curtains, when drawn back, reveal the miracle of the Eucharist. The façade of the Sagrario, rippling with sculpted *estípite* columns and foreshortened cornices, becomes a metaphoric curtain, protecting and also promising the mystery of salvation that awaits those who enter.

Beyond aesthetic prescriptions, the decrees of the Council of Trent also specify the institutional means by which to control visual production and consumption. Bishops would now approve all images used in churches and/or associated with liturgy, a regulation that was almost immediately applied in the New World (as in the case of Diego de Landa in the Yucatan, for one; see n. 50). It might seem that this centralized control would generate standardized artistic production, and to some extent it did. Conventions were established for the representation of biblical scenes

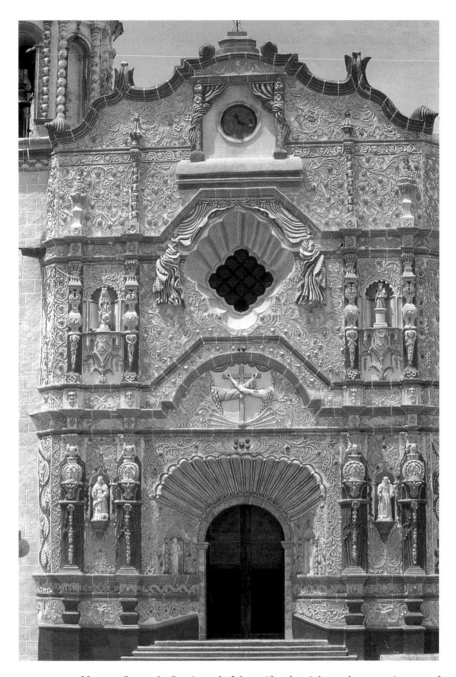

FIGURE 1.9 Nuestro Señor de Santiago de Jalpan (façade, eighteenth century), state of Querétaro, Mexico. Photograph: Archivo Fotográfico Manuel Toussaint / Institutode Investigaciones Estéticas / Universidad Nacional Autónoma de México, Eumelia Hernández Vásquez.

and saints' lives, but the vast demand for Catholic images in America, the majority of which, from the sixteenth to the eighteenth centuries, were made by native or *mestizo* artisans, assured a wealth of inordinate interpretations of European models. We have already seen several examples of syncretic iconography—atrial crosses without bodies, fantastical murals on monastery walls—and we will see more in subsequent chapters.

Recall that the Aristotelianism of St. Thomas Aquinas and St. Bonaventure underpins Counter-Reformation attitudes toward the image, and became church doctrine in the decrees of the Council of Trent. St. Thomas was Dominican, and St. Bonaventure, Franciscan. These orders were central in carrying out the spiritual conquest in New Spain in the sixteenth and seventeenth centuries. The Franciscans arrived in 1524, and the Dominicans followed in 1526.[67] These were mendicant rather than monastic orders, friars rather than monks, whose discipline it was to go into the world and spread the word, rather than remain in monasteries and contemplate it. Other orders followed the Franciscans and Dominicans, as did the secular clergy, which eventually replaced the mendicant orders as ministers to the converted. No group was more important in consolidating the power of the Catholic Reformation in New Spain than the Jesuits, who arrived in 1572, nine years after the concluding session of the Council of Trent. And no group was more energetic in their obedience to the Tridentine injunction that piety be cultivated through visual images.

Ignatius de Loyola, founder of the Jesuits, understood perfectly the form of attention required by the Counter-Reformation image. In his *Spiritual Exercises,* published in Latin in 1548, he prescribes a series of meditations on sin, and on the life, passion, resurrection, and ascension of Christ. He does not speak explicitly of the relationship of visual images to these themes, but he constantly calls upon the experience of the senses—and especially the eyes—to give reality to the contemplated scene. Here is the spiritual exercise of "seeing the place," which he describes with great specificity:

> when the meditation or contemplation is on a visible object, for example, contemplating Christ our Lord during His life on earth, for He is visible, the composition will consist of seeing with the imagination's eye the physical place where the object that we wish to contemplate is present. By the physical place I mean, for instance, a temple or mountain where Jesus or Our Lady is, depending on the subject of the contemplation.[68]

John Rupert Martin, in his study of European Baroque art, shows that St. Ignatius's *Spiritual Exercises,* coupled with the aesthetic ideology enunciated by the Council of Trent, inspired a new naturalism in religious art, which manifested itself most forcefully in Spain.[69] The example Martin gives is the *Christ of Clemency* (1603–6), a polychrome crucifix sculpted and painted by Juan Martínez Montañés

for the Cathedral of Seville, where it still hangs. The sculpted figure bows his head in such a way that the worshipper kneeling below may look up and see that Christ's eyes are open and looking down upon him or her, a drama of reciprocal seeing that Martin links to St. Ignatius's advice to the worshipper to "imagine Christ our Lord before you, hanging upon the cross. Speak with Him of how from being the Creator He became man, and how, possessing eternal life, He submitted to temporal death to die for our sins. . . . And as I see Him in this condition, hanging upon the cross, I shall meditate on the thoughts that come to my mind" (117, paragraph 53). So the imaginative making of images becomes a spiritual discipline during the Counter-Reformation.

This act of envisioning is constantly represented in Baroque painting and sculpture.[70] The eighteenth-century Mexican painter Carlos Clemente López depicts St. John Nepomuk visualizing Christ on the cross, exactly as St. Ignatius recommends (color plate 6).[71] The Jesuit call to visualize the invisible, and to visualize oneself doing so, led viewers to an increasingly self-conscious relationship with the physical bodies of Christ, the Virgin, and the martyred saints, and with their own sensory experience.[72] Naturalistic representation becomes a conduit to the supernatural, and flesh and blood the means of bringing the beholder into mystical communion with disembodied divinity.

Nothing could be further from Protestant Reformation practice, which serves, by way of contrast, to underscore the Counter-Reformation's embrace of visual images. The Puritans arrived in the New World in 1620, a century and a year after Cortés disembarked on the gulf coast of Mexico. The absence of visual images and decoration in Puritan churches reflects the privileging of intellectual apprehension over the physical experience of the senses, and written texts over visual images. If, for the Catholic Reformation, the senses could lead to spiritual knowledge, for the Protestant reformers, the opposite was true: sensory experience, including the perception of visual images, impeded spiritual knowledge because it distracted the believer from the mental apprehension of metaphysical truth. Whereas the Catholic Reformation found metaphysical truth to be commensurable with physical beauty, the Puritan's eye was disciplined inward and upward, not outward toward physical phenomena, however beautiful. The world was to be shunned rather than engaged in the pursuit of God.

These different Reformation attitudes toward visual images are attributable to different theological and philosophical sources. Whereas the Catholic Reformation was Thomistic and Aristotelian, the Protestant Reformation was Augustinian and Platonic. Long preceding Aquinas's recovery of Aristotle in the thirteenth century is St. Augustine's interpretation of Plato. In the fourth century, Augustine synthesized available Platonic texts and Christian theology, finding the Platonic dialectic between physical and ideal forms amenable to his own understanding of carnal and spiritual realms—his City of God and City of Man. More than a millennium later, Protestant Reformers adopted this Augustinian dualism; indeed,

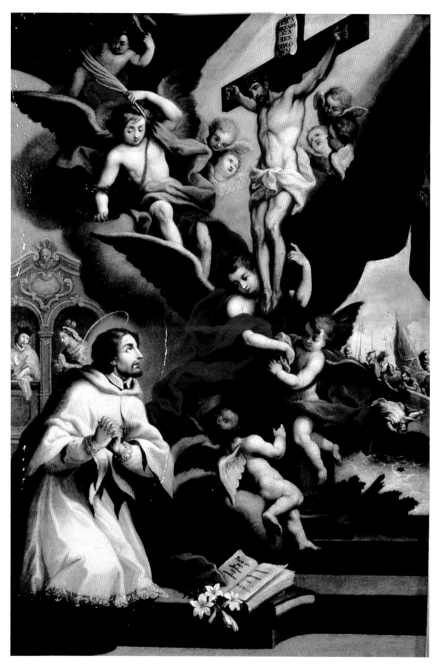

PLATE 6 Carlos Clemente López, *Vision of St. John Nepomuk* (eighteenth century), Mexico. Ficke Collection, Davenport Museum of Art, Iowa.

Calvin heightened Augustine's distinctions with his emphasis on fallen human nature, the presence of evil in this world, life as a journey, the world as an abyss, and so on. For Calvinists, progress in wisdom is the movement of the mind *away from* the world toward God, and this progress is achieved by the study of the Bible and other accepted written texts. The availability of printed theological literature was crucial to the Protestant reform, which dismissed the imaging eye of Aquinas and Loyola in favor of the reading eye of Luther and Calvin.[73] Protestant texts might be accompanied by visual images to the extent that they aided intellectual (verbal) understanding, but unlike Catholic images, they were not aimed at encouraging sensuous or emotional experience of the divine. The negative relation of the image to spiritual insight in Protestant practice reflects the dawning Protestant ideology of spiritual autonomy, that is, the individualized, vertical relation to God that does not countenance the communal participation required by visual forms of attention. Jacques Barzun provides a useful summary of these two reform movements: "the Catholic effort to regain ground produced new works of architecture and the fine arts; the Protestant effort produced literature and large works of doctrine."[74]

Related to these philosophical and expressive distinctions are political ones. The Protestant Reformation was suspicious of displays of wealth and power, and Catholic paintings, altars and edifices represented the same ecclesiastical hierarchies and heavenly hosts that Protestants wished to banish. Iconoclasm was inevitable. Margaret R. Miles writes that Protestant attitudes varied in sixteenth-century Europe, but in general,

> concern with images and efforts to remove them from Christian worship are characteristic of the Protestant reform. There was less agreement on how to accomplish it—whether by violent action, by orderly and legalized procedures, or simply by "removing them from the heart," as Luther advocated. (100)

Violent action was not uncommon, despite Luther's recommendation. Miles concludes that Protestants throughout sixteenth-century Europe "sought to harness the didactic and persuasive capacity of images without permitting them to act directly—that is, without adequate linguistic interpretation—on the unconscious minds of believers" (116).

Contrast this attitude to the Latin American images called *Cristos sangrantes* (fig. 1.10). The Counter-Reformation's program to fortify the sacrament of the Eucharist led to much graphic depiction of Christ's blood, and Christ's bodily suffering continues to be foregrounded in Latin American religious practice.[75] During Holy week, the *Cristos sangrantes* are removed from walls and placed in aisles or in front of altars, where their wounds can be touched. Paint is worn off knees, feet, hands, because the image itself is understood to contain spirit. These crucifixes are a far cry from the sixteenth-century atrial stone crosses with only the carved image of Christ's head (figure 1.6, above), where the intention on the part

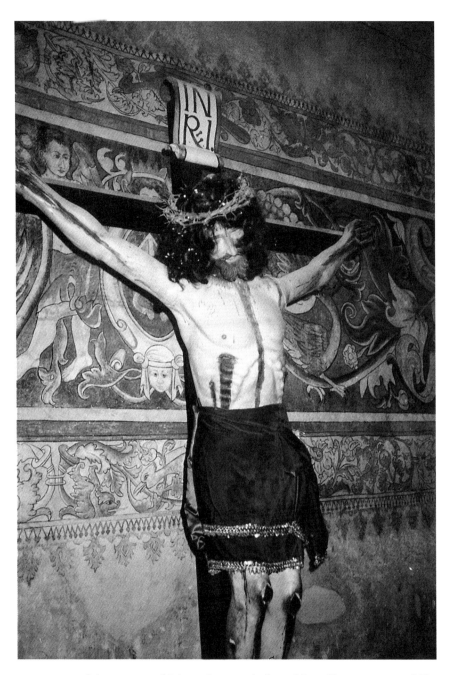

FIGURE 1.10 *Cristo sangrante* (eighteenth century), Santa María Xoxoteca, state of Hidalgo, Mexico.

of the colonizing clergy was to separate the image from the physical reality of Christ's sacrifice. Here the intention is something very nearly its opposite: to insist upon his bodily presence. The *Cristos sangrantes*, like the ancient "idols," are empowered by the unstated assumption that if well and truly made, the image *becomes* the thing it resembles. Official Catholic doctrine notwithstanding, these images are repositories of spirit for those who touch them. They continue to lay claim on the popular imagination because they continue to engage both indigenous and Counter-Reformation traditions of visual representation. The image-as-presence animates them, and the transubstantiation of matter into spirit, strictly reserved by Catholic doctrine for the sacrament of the Mass, also operates in and upon Christ's image.

SYNCRETISM AS CATHOLIC POLICY AND CULTURAL PRACTICE

I have stressed the irony of the Spanish colonizers' destruction of idols while simultaneously engaging the idolaters to create Catholic structures in which idols were (and are) still visible. This irony is not original to New Spain. Church policy had long allowed for the inclusion of images from "pagan" cultures. Figures from Greek and Roman mythology were adopted as precursors to, and prophets of Christ's coming. In *De la idolatría*, Carmen Bernand and Serge Gruzinski cite the sibyls, ancient Roman prophetesses painted on the walls of the Sistine Chapel, as evidence of the Church's willingness to take non-Christian figures into the fold.[76] Sibyls also appear in New Spain in the sixteenth century. A parade of them, dressed as medieval ladies seated sidesaddle on their palfreys, adorns the walls of the sixteenth-century *Casa del Deán* in Puebla,[77] and in the apse of the Franciscan monastery of Acolman, they accompany the Hebrew prophets, all foretelling equally the birth of Christ.[78] Series of sibyls became increasingly popular in New Spain during the seventeenth and eighteenth centuries, a female/protofeminist trope that embodies the iconographic universalism imported into New Spain.[79]

In fact, this Catholic practice was greatly amplified in the New World, because the syncretism that allowed sibyls to sit beside saints also allowed the accommodation of the prehispanic pantheon. Whereas the first colonizing clergy had as their stated project and policy the destruction of indigenous cultures, there eventually arose in *criollo* culture a desire to create a Christian pre-history for New Spain. *Criollos,* persons of European descent born in the New World, comprised the neo-Hispanic oligarchy of colonial America, but an oligarchy fully aware of its own colonized status. To be *criollo* in New Spain was both a circumstance of birth and a cultural condition, an attitude of self-awareness and a search for self-definition. Jorge Alberto Manrique describes the *criollo,* and *criollo* culture, in New Spain: "el criollo va de alguna manera forjando su propio ser" (the *criollo* forges his own being as he goes along).[80] By the late sixteenth century, the *criollo* intelligentsia had

begun to appropriate prehispanic history and myth, exalting the indigenous past even as they often disdained the indigenous present, placing Mexico's mythological (and mythologized) past beside the Classical cultural traditions of Europe. If Spain claimed ancient cultures as their patrimony—Greece and Rome authenticated and ennobled Spanish traditions—New Spain would claim its own indigenous cultural heritage and thus its identity. The seventeenth-century Mexican intellectual Carlos de Sigüenza y Góngora and his contemporary and friend, the poet and playwright Sor Juana Inés de la Cruz, are Manrique's exemplars of syncretic enthusiasm in *criollo* culture, as they are in José Lezama Lima's essential essay on the New World Baroque, "La curiosidad barroca," to which we'll return in chapter 3. The *criollo* elite embraced the Baroque as an instrument of counterconquest, to use Lezama Lima's term, filling Spanish forms with New World content, the better to consolidate their own political and cultural territory.[81]

In the ecclesiastical sphere, the Jesuits were prime purveyors of theories of cultural syncretism, and they employed their universalizing strategies throughout the Spanish and Portuguese territories in the Americas. Consider their construction of Quetzalcóatl's Christian identity in New Spain. The Jesuits advanced the argument that Quetzalcóatl was the first to announce the advent of Christ in America, and their reasoning was this: Quetzalcóatl was the New World personification of St. Thomas, the apostle assigned by Christ to Christianize "the East," now understood to be America.[82] The syncretic association of Quetzalcóatl and St. Thomas was an early official instance of what was to become integral to the New World Baroque: the establishment of cultural continuities with an (imagined) American past.

Why St. Thomas? The Jesuits promoted his identity with Quetzalcóatl on the basis of his missionary assignment, and also on the etymology of his name. Jacques Lafaye explains: "Since the figurative meaning of the name Quetzalcóatl was 'precious twin,' it appeared to be a synonym of the Greek *Thome,* which also meant 'twin,' whence the translation of Quetzalcóatl as *Santo Thome* or *Thomas*" (156). Beyond this coincidence, there were other reasons to recommend St. Thomas to a *criollo* culture searching for ways to represent itself. First, St. Thomas was willing to confront violence and suffer martyrdom, a virtue highly prized by Counter-Reformation culture, and by the Jesuits in particular.[83] When Christ proposed to return to Judea in spite of threats to his life, Thomas said to the other disciples, "Let us also go, that we may die with him" (John 14:4–5). Equally important was his famous tendency to doubt; this is the same doubting Thomas who refused to accept the resurrection of Christ without seeing and touching the wounds. He was not present when Jesus appeared to the rest of the apostles after his resurrection, and Thomas would not believe their account without visual proof: "Unless I shall see in his hands the print of the nails, and put my finger into the print of the nails, and thrust my hand into his side, I will not believe" (John 20:25). Christ appears, satisfies Thomas's requirement, and then encourages the opposite impulse: belief

without seeing: "Thomas, because thou hast seen me, though hast believed; blessed are they that have not seen, and yet have believed" (John 20:29). The seventeenth-century Mexican painting by Sebastian López de Arteaga depicts the moment when the body ceases to be an object in this world and becomes a symbol of spirit (color plate 7). The Western separation of image from object, of material from meaning, is affirmed, even as Thomas refuses the separation, insisting upon the mythic integration of body and belief. *Criollo* culture in New Spain had constantly to negotiate these competing relations between seeing and believing. Sor Juana's poetic line "y solamente lo que toco veo" (and only what I touch I see) recalls Thomas's need for physical confirmation in the face of Christ's call for disembodied belief, and epitomizes the efforts of writers and painters in Baroque New Spain to devise syncretic modes to bridge this divide.[84]

THE VIRGIN OF GUADALUPE

Nowhere is this process as plain as in the history of the image of the Virgin of Guadalupe, and nowhere is the interplay of image and ideology more vertiginous. The Virgin is supposed to have appeared to an indigenous convert and left her image at a site near Tenochtitlán/Mexico City in 1531, a decade after the Spanish invasion had made iconoclasm official policy. Tepeyac was a site sacred to the Mexicas, dedicated to the goddess Cihuacóatl, meaning "woman serpent," also called Tonantzín, "our mother," a name reserved for the consort of Quetzalcóatl and with him, "inventor of men." Juan Diego, whose Náhuatl name was Cuauhtlatohuatzin, or Cuauhtlatohuac, "he who speaks like an eagle," was baptized in 1524, and would have been well aware of the cult of Tonantzín where, seven years later, he is said to have seen the image of the Virgin of Guadalupe.[85] She is always depicted exactly as her dark image is thought—by tradition and deep-seated belief—to have been indelibly imprinted upon Juan Diego's broadcloth garb. The image believed to be the original is on display in the Basilica of Guadalupe; a Mexican flag is sometimes draped to one side of the framed cloth, reminding the viewer that the image is a political emblem as well as an object of religious devotion (fig. 1.11).

The Mexican Virgin of Guadalupe is preceded by the Spanish Virgin of Guadalupe, who was accorded particular devotion by the conquerors from Estremadura and whose image (which does not resemble the Mexican image) accompanied them on their voyages of exploration. In Spain, the monastery of Guadalupe was an important pilgrimage site from the mid-fourteenth century to the beginning of the sixteenth because it was the center of the political and religious enterprise of the *reconquista*—the crusade against the Muslim presence in Spain and, by extension, against the heresy of indigenous populations in America. Hence the immediate association of the Spanish Virgin of Guadalupe with the New World project. Jonathan Brown, in *Images and Ideas in Seventeenth-Century Spanish Painting*,

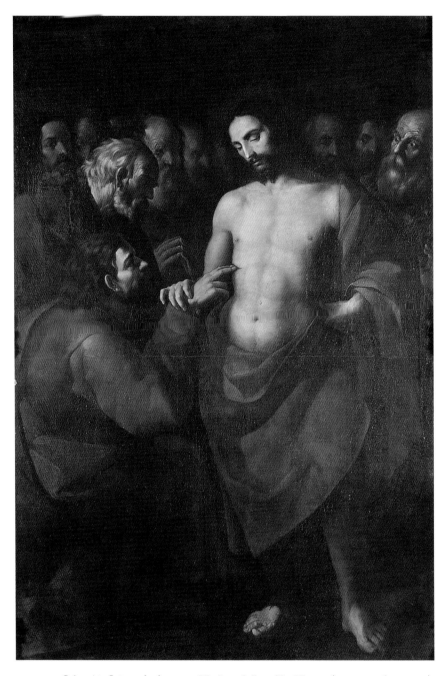

PLATE 7 Sebastián López de Arteaga, *The Incredulity of St. Thomas* (seventeenth century), Mexico. National Museum of Art. Instituto Nacional de Antropología e Historia/Consejo Nacional para la Cultura y las Artes. Photograph: Archivo Fotográfico Manuel Toussaint/Instituto de Investigaciones Estéticas/Universidad Nacional Autónoma de México.

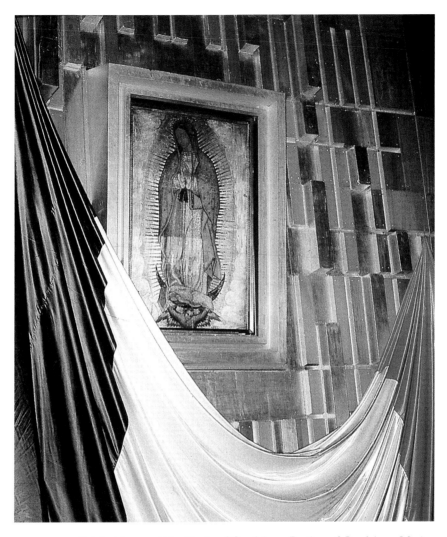

FIGURE I.II Original image of the Virgin of Guadalupe, Basilica of Guadalupe, Mexico City.

writes about the Spanish Virgin that among her supplicants "were the explorers of the New World, who had prayed to the Virgin of Guadalupe to deliver them from danger, and who conquered and colonized America in her name. Columbus and Cortés both came to Guadalupe and gave their thanks."[86] That this preferred Spanish Virgin should make an appearance in Mexico is not surprising, but that her image and identity should be so completely revised—as a dark virgin who appeared to an Indian, and whose image was almost certainly painted by a *tlacuilo*—is nothing short of astonishing. The revision proves fundamental. Jacques Lafaye argues that the "change of images was the first forward step of Mexican national con-

ciousness," (234) and Octavio Paz generalizes this assertion: "The history of the nation was one with that of the Catholic religion . . . with its institutions and doctrines but above all else with its *images*—the Savior and his mother, the prophets and martyrs, male and female saints."[87]

A recent cycle of exhibitions at the National Museum of Art in Mexico City makes clear the role of painting in the process of national consolidation. Three exhibitions, called collectively *Los pinceles de la historia* (The paintbrushes of history), demonstrate how visual images in New Spain became a principle means of confirming—indeed, conferring reality upon—historical events, including (and most importantly) "miraculous" events.[88] The example of the Virgin of Guadalupe is central: her apparition is shown to be "true" by visual means, and in the process becomes integral to emergent Mexican nationalism. Paintings of the Virgin with the Mexican eagle and serpent, and with allegorical figures of America and Europe, demonstrate the project of unifying Mexico's cultural histories by visual means, of transforming cultural difference into national identity (fig. 1.12).

Syncretic virgins and saints exist throughout Latin America. An important example is the patroness of Cuba, the *Virgen de la Caridad del Cobre* (the Virgin of Charity of El Cobre), who combines the Spanish Virgin of Illescas (a figure of Byzantine origin), the Amerindian *taino* spirit Atabey or Atabex, and the Yoruba deity derived from Ochún.[89] But there is a visual/narrative aspect to the Virgin of Guadalupe that distinguishes her from other syncretic virgins, and it is this: her image is a meta-image, an image of an image that celebrates seeing. The history of the making of the image is often depicted along with the image itself, in the four corners around the oval image of the Virgin (color plate 8).

The narrative is as follows: the Virgin of Guadalupe appears to the Indian Juan Diego in Tepeyac, instructs him to go to the Catholic hierarchy and convey her request that a "house" be built for her on the spot where she appeared. Bishop Juan de Zumárraga, Franciscan friar and first bishop of Mexico, receives Juan Diego. (It is cynically said that herein lies the miracle: that the bishop would receive an Indian.) He hears Juan Diego but will not believe him; as in the biblical account of Thomas, he requires physical proof, and it is miraculously provided. The Virgin reappears and shows Juan Diego where he will find Castilian roses, instructing him to take them to the bishop.[90] But even this sign is not enough. Only when the Virgin leaves her image imprinted on Juan Diego's *tilma*—only when her physical presence is transferred to the cloth on Juan Diego's body—is the Church hierarchy convinced of her appearance. This miracle of the imprinted image reflects the ontology of the indigenous image-as-presence, which encodes the body's relations with natural and cosmic phenomena, and enables the viewer to participate in both. Juan Diego's *tilma* is just such an arena of mythic transaction, and it is crucial to the narrative that the protagonist is wearing the *tilma*. The materiality of the image and its virtual corporeality are integral to its meaning.

The episodes of this narrative are depicted as often as the Virgin herself, and

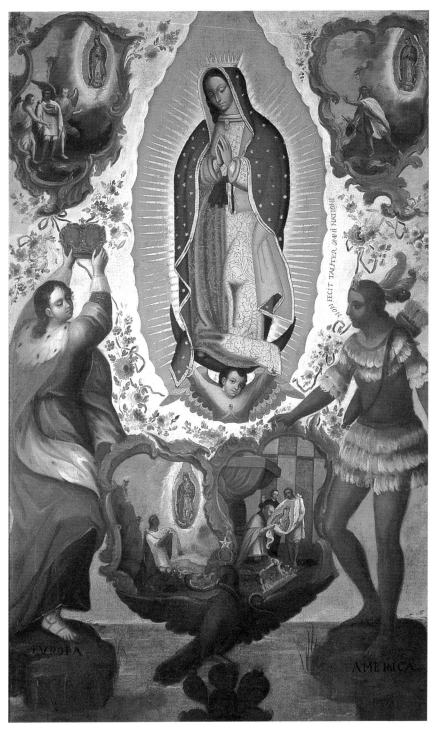

FIGURE 1.12 Anon., *Our Lady of Guadalupe, Patron of New Spain* (eighteenth century), Mexico. Museum of the Basilica of Guadalupe. Photograph: Manuel Zavala Alonso.

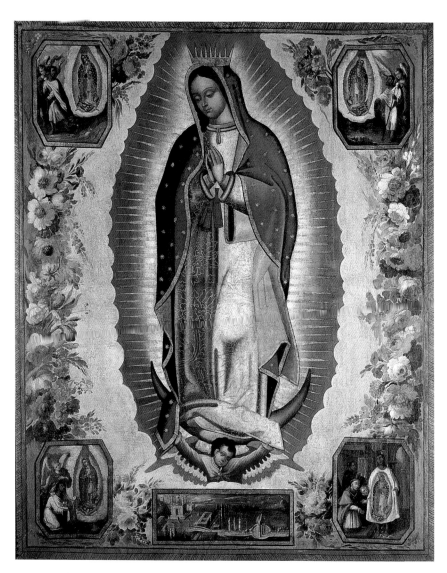

PLATE 8 Anon., *The Virgin of Guadalupe with the Four Apparitions and Vista of Tepeyac* (eighteenth century), Mexico. National Museum of the Viceroyalty. Instituto Nacional de Antropología e Historia. Photograph: Dolores Dahlhaus.

like her image, they have become almost iconic in their changeless formulation. They are in the corners of paintings of the Virgin, as in color plate 8, or deployed around the Virgin as in figure 1.12, and they may also be separate paintings on altarpieces, walls, or ceilings. They show that the miracle is double: the Virgin appears, and she also leaves an image of her appearance as a material presence. Note the image of the image in figure 1.13, a 1779 painting by José de Alcíbar. The folds of Juan Diego's *tilma* are represented around the image, along with the roses, to remind the viewer that the material image is itself miraculous, that it is not separated from what it represents. It is a wonder that this conjunction of material and meaning— of *tilma* and spirit—was accepted in a Catholic context where efforts of inquisitorial magnitude were being made to assure that images *not* be worshipped, and that recent converts *not* see apparitions in sites sacred to their former deities. The spiritual content of this material object was considered, furthermore, to be transferable by physical contact. A venerated image of the Virgin of Guadalupe in the Balvanera chapel of the monastery of San Francisco in Mexico City was painted on the wood of the table where the *tilma* was supposed to have been laid by Bishop Zumárraga himself.

Acceptance of the image of the Virgin of Guadalupe was not immediate, as the narrative of Juan Diego and Bishop Zumárraga pretends. By the mid-sixteenth century, the cult of the Virgin in Tepeyac had become so popular among indigenous converts that there were, in fact, suspicions of idolatry, and the clergy who supported the miracle (apparitionists) vied with those who didn't (iconoclasts) on political, social, and racial grounds, as well as theological ones.[91] Written texts swirled around the image, proposing arguments for and against, and the scientific tests that are now regularly run on the *tilma* suggest the on-going impulse to interrogate the materiality of the image itself. Related to this debate about the veracity of the image is another, and that is the status of Juan Diego. His historical existence is disputed by historians and some members of the clergy, including a recent abbot of the Basilica de Guadalupe, whose opposition delayed the canonization of Juan Diego as further studies were undertaken at the behest of the Vatican. Debate continued, but the canonization took place on July 30, 2002, during Pope John Paul II's fifth visit to Mexico.[92]

An iconographic detail allows us to trace the gradual acceptance of Juan Diego by the colonizing clergy. In the early seventeenth century, representations of the Virgin began to include what are called *vistas*, miniature "views" of the hill at Tepeyac such as the one in color plate 8. *Vistas* were added to the bottom of paintings of the Virgin and they usually included the Basilica of Guadalupe, built between 1695 and 1709 on the (mythical) model of the ancient temple of Solomon in Jerusalem.[93] Thus *vistas* referred not only to the indigenous context of the apparition but also to the metaphoric substitution of Mexico for Jerusalem, and Mexicans for the Israelites as God's chosen people. The presence of these *vistas* affirms the increasing role of Juan Diego in the church's program of evangelization of

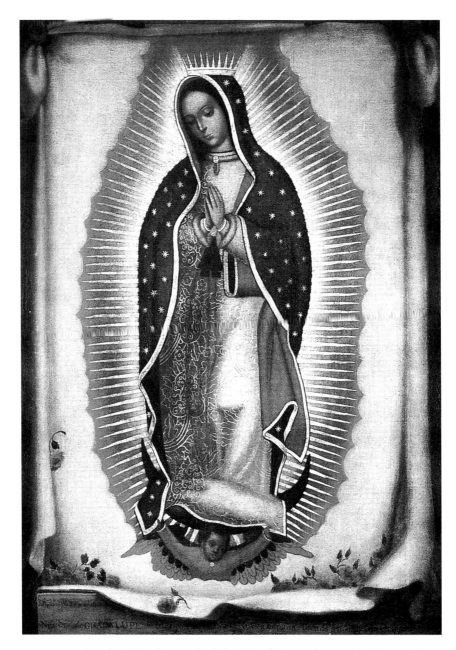

FIGURE 1.13 José de Alcíbar, *The Virgin of Guadalupe* (eighteenth century), Mexico. Private collection. Photograph: Dolores Dahlhaus.

native peoples, and the *criollos'* increasing dependence upon the image of the Virgin for protonationalist purposes.

The story of Juan Diego and the Virgin of Guadalupe is envisioned in countless versions of the same four images, and it is also narrated in the *Nican mopohua,* a text that purports to record verbatim, in Náhuatl, the conversations between the Virgin and Juan Diego. The title consists of the first two words of the Náhuatl account, which mean *aquí se narra* (here it is told), a title that emphasizes the essential orality of this text about a visual image.[94] The Virgin's words in this document are considered by believers to be something close to holy writ; as in the bible, sentences are printed in numbered verses. The visual image on Juan Diego's *tilma* and its narrative embodiment in the *Nican mopohua* are a coherent entity, an image/text, each medium serving the other over centuries as foundation and complement.

Any single account of the textual history of the *Nican mopohua* would be an oversimplification, and the matter of its authorship is unlikely to be determined definitively. One theory proposes that the text was written by a priest, Miguel Sánchez, more than a century after the events it recounts, in 1648. Another proposes that it was written only three decades after those events, in the mid 1550s, by an indigenous intellectual, Antonio Valeriano, a former student of Bernardino de Sahagún and other Franciscans at the Colegio Imperial de Santa Cruz de Tlatelolco. Historians tend to prefer the former theory, whereas cultural and literary critics tend toward the latter.[95] Among the latter is Miguel León-Portilla, who accepts Valeriano's authorship and calls the *Nican mopohua* a "gem of Náhuatl literature." He speculates that the text may have been written at the behest of the second bishop of Mexico, the Dominican Alonso de Montúfar, to be presented as a theatrical production to indigenous audiences.[96] Whatever its immediate cultural uses, we may consider the *Nican mopohua,* like the sixteenth-century cross at Acolman and the murals at Itzmiquilpan, a transcultural artifact par excellence. It both records and embodies the historical encounter of different ontologies of the image at the moment of their meeting.

León-Portilla analyzes the convergence of cultures and media in the text, signaling Valeriano's fluency in preconquest Náhuatl literature and his integration of certain oral poetic conventions into his European medium of alphabetic prose. The *Nican mopohua's* combination of intimacy and solemnity derives from Náhuatl poetic conventions, León-Portilla shows, as does its emphasis on sensory apprehension (in this way coinciding with Counter-Reformation aesthetics). There are repeated references to seeing, gazing, light, sight, radiance, as well as to the Virgin's breath as a metaphor for her words and the bishop's injunction to hear her breath and believe her words. León-Portilla uncovers further indigenous cultural

and literary conventions in the conception of personal merit, the poetic formulas of sleeping and dreaming, and the paratactic emblems and attributes of ancestry and heaven:

Se detuvo a ver Juan Diego. Se dijo: "¿Por ventura soy digno, soy merecedor de lo que oigo? ¿Quizá nomás lo estoy soñando? ¿Quizá solamente lo veo como entre sueños? ¿Dónde estoy? ¿Dónde me veo? ¿Acaso allá donde dejaron dicho los antiguos nuestros antepasados, nuestros abuelos; en la tierra de las flores, en la tierra del maíz, de nuestra carne, de nuestro sustento; acaso en la tierra celestial?"[97]

[Juan Diego stopped to look. He said to himself: "By any chance am I worthy, have I deserved what I hear? Perhaps I am only dreaming it? Perhaps I am only dozing?" "Where am I? Where do I find myself?" Is it possible that I am in the place our ancient ancestors, our grandparents, told about, in the land of the flowers, in the land of corn, of our meat, of our sustenance, possibly in the land of heaven?"][98]

Unlike the bishop, Juan Diego does not hesitate to believe his eyes when the Virgin appears; his uncertainty is not about the veracity of the image but about his own worthiness. The bishop's incredulity and Juan Diego's belief may be understood to reflect their different visual ontologies. For the bishop, image and spirit are separate and distinct, whereas for Juan Diego, image and spirit are one. The power of the image is its visible, tangible immediacy; the object *contains* its meaning.

Both Nahua and European traditions are present in this syncretic text, and its author engages one cultural tradition to promulgate the other. Consider the moment, as recounted in the *Nican mopohua,* when the bishop's incredulity turns to belief, when the image *becomes* the Virgin. Juan Diego arrives with "roses from Castille" in his *tilma.* The roses are obviously a European import, but the image in which they are embedded is not: flowers appearing in the hollow of the *tilma* are conventional in Náhuatl poetry. León-Portilla points to this image in a precontact *cantar* (a poem set to music but not necessarily sung) by the Nahua poet Tochihuitzin Coyolchiuhqui. I cite León-Portilla's Spanish translation of Tochihuitzin's text:

¿Acaso allí veré las flores?
Si me las muestran,
Llenaré con ellas el hueco de mi manto
y así saludaré a los príncipes . . .[99]

[Do I see flowers there?
If they appear to me
I will fill the hollow of my garb
and thus greet the princes . . .]

So the author of the *Nican mopohua* avails himself of Náhuatl poetic conventions, but his crucial departure from tradition—the roses from Castille—prepares the listener/reader for the apparition of a Christian goddess, when Juan Diego's *tilma* will bloom with the image of the Virgin:

> Y así como cayeron al suelo todas las variadas flores preciosas, luego allí se convirtió en señal, se apareció de repente la Amada Imagen de la Perfecta Imagen Santa María, Madre de Dios, en la forma y figura en que ahora está . . . (versículos 183–83)

> [And just as all the different precious flowers fell to the floor, then and there the beloved Image of the Perfect Virgin Holy Mary, Mother of God, became the sign, suddenly appeared in the form and figure in which it is now . . . (verses 181–83)]

I have said that the indigenous gods were metamorphic, that their images shifted according to situation, teller, and cultural necessity. The sudden appearance of the divine image in response to the bishop's disbelief is akin to the mythic metamorphosis of Quetzalcóatl in response to the need to show his vassals that he is the plumed serpent. The metamorphic capacity of the Virgin's image as it miraculously adapts to cultural necessity is encoded in the final sentence of *Nican mopohua*:

> Y el señor obispo trasladó a la Iglesia Mayor la amada Imagen de la Amada Niña Celestial. La vino a sacar de su palacio, de su oratorio en donde estaba, para que todos la vieran y la admiraran, su amada Imagen. Y absolutamente toda esta ciudad, sin faltar nadie, se estremeció cuando vino a ver, a admirar su preciosa Imagen. Venían a reconocer su carácter divino. Venían a presentarle sus plegarias. Muchos admiraron en qué manera se había aparecido, puesto que absolutamente ningún hombre de la tierra pintó su amado Imagen. (versículos 214–20)

> [And the Reverend Bishop moved the beloved Image of the Beloved Heavenly Maiden to the principal church. He took her beloved Image from his residence, from his private chapel where it was, so that all could see it and admire it. And absolutely this entire city, with no exception, was deeply moved as everyone came to see and admire her precious Image. They came to acknowledge its divine character. They came to offer her their prayers. They marveled at the miraculous way it had appeared, since absolutely no one on earth had painted her beloved Image. (verses 212–18)]

The image is understood to be sui generis: like the Mesoamerican gods, the Virgin recognizes her image and inhabits it. The account of the *Nican mopohua* begins with the bishop's doubt and ends with belief that is based in the capacity of the image to contain its object.

This ontology of presence is encoded in every one of the innumerable images

of the Virgin of Guadalupe, Juan Diego, the roses, the *tilma*, the *vistas* of Tepeyac. It is the third of the four scenes, when the kneeling Juan Diego receives the roses, that is the most often reproduced because it epitomizes the Virgin's apparition to indigenous Mexico. The political utility of this dark virgin in converting indigenous peoples is clear enough. After her appearances to Juan Diego, she appears the following day, as recounted in the *Nican mopohua*, to Juan Diego's uncle, an old man named Juan Bernardino, whom she cures of his illness, and then to a wounded Indian, where once again her image is therapeutic. The conversations between the Virgin and Juan Diego emphasize this colonizing agenda:

> yo en verdad soy vuestra madre compasiva, tuya y de todos los hombres que en esta tierra estáis en uno, y de las demás estirpes de hombres, mis amadores, los que a mí clamen, los que me busquen, los que confíen en mí . . . (versículos 29–31)

> [I am truly your compassionate mother, yours and of all the people who live together in this land. And of all the other people of different ancestries, my lovers, those who cry to me, those who seek me, those who trust in me . . . (verses 29–31)]

The image of the Virgin of Guadalupe and the now-saint Juan Diego still serve the ends of cultural appropriation but we might wonder who appropriates whom, because their power clearly inheres in their indigenous content. In the syncretism of Guadalupe-Tonantzín and Juan Diego-Cuauhtlatohuatzin, the mythic image survives and enlivens the re-presented image of the Catholic Counter-Reformation.

GOD THE PAINTER

I have said that the Virgin appeared and left an image of her appearance, but this formulation is doctrinally incorrect. According to official Catholic doctrine, it would be God who brought her into presence by re-presenting her. Indeed, the final line of *Nican mopohua* already points to this doctrinal necessity: "They marveled at the miraculous way [the image] had appeared, since absolutely no one on earth had painted her beloved Image." As if to set the visual record straight, there emerges in the eighteenth-century a conventional scene referred to generically as the *taller* (the artist's workshop).[100] The scene shows God painting the image of the Virgin of Guadalupe on the *tilma* of Juan Diego, which is no longer worn but held up by angels who serve as God's metaphoric easel (figs. 1.14 and 1.15). The single rose held by Christ in figure 1.14 forecasts the subsequent apparition of the image, now being given its final touches by God. Figure 1.15 also foreshadows events to come, adding iconographic emphasis to the Mexican-ness of the miracle by including Juan Diego and a vista of Tepeyac, not to mention the emblematic Mexican

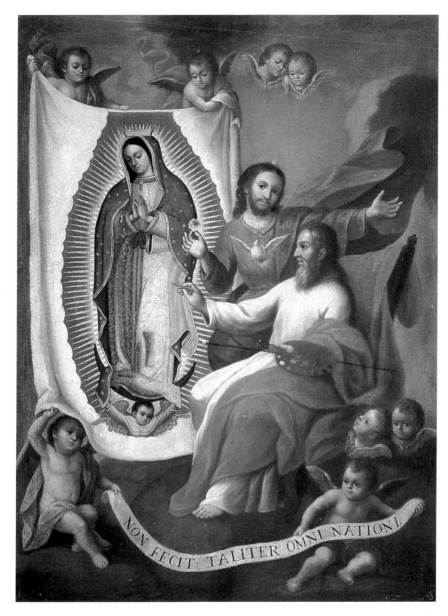

FIGURE 1.14 Anon., *God Eternal Painting the Image of the Virgin of Guadalupe* (c. 1653), Mexico. Museum of the Basilica of Guadalupe. Photograph: Jesús Sánchez Uribe.

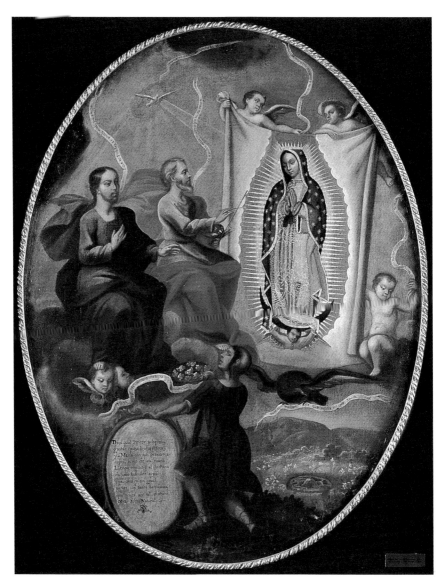

FIGURE 1.15 Joaquín Villegas (attr.), *The Eternal Father Painting the Virgin of Guadalupe* (eighteenth century), Mexico. National Museum of Art. Instituto Nacional de Antropología e Historia/Consejo Nacional para la Cultura y las Artes. Photograph: Arturo Piera.

eagle beneath God's canvas. In these paintings, the Catholic separation between image and object is restored and maintained. In their self-conscious dramatization of layer upon layer of representation, they are Tridentine allegories of the function of painting in religious worship: images are an *index* pointing to invisible truth. Here, the invisible truth is this: the Virgin is God's creation and it is God who is to be worshipped, not the image. By portraying God as Prime Painter, these paintings go beyond the question of authorship to propose something like the divine status of image-making itself.

Textuality underpins iconography, as is typical in Baroque religious art. In both paintings, phylacteries (undulating ribbons) bear spoken dicta that become written emblems floating in compositional space. In figure 1.14, the phrase *Non fecit taliter omni nationi* is taken from Psalms 147:20: "He hath not dealt so with any nation." The passage, which often accompanies the image of Guadalupe, refers to God's special relation to the Israelites, now appropriated to stand for God's blessing upon Mexico in the form of the Virgin of Guadalupe. These words were reportedly spoken by Pope Benedict XIV in 1754 when he issued the apostolic brief declaring the Virgin patroness of New Spain. Long before, however, the passage had been associated with the image of the Virgin of Guadalupe.[101]

In figure 1.15, the ribbon of language that floats from God's mouth is also striking. It bears the inscription of God's voice, as it were, its textual source clearly labeled: *In manibus meis descripsite,* Isaiah 49:16: "I have graven thee upon the palms of my hands." This text places God in his Genesis mode as divine architect, except now as divine painter or rather, in the King James translation, as divine engraver. The corporeal metaphor inverts the image-as-presence in indigenous culture: if indigenous gods were thought to inhabit their image, here the image inhabits God. The painting of the Virgin of Guadalupe is *incorporated* into the hands of God the Maker: "I have graven thee upon the palms of my hands." For its eighteenth-century viewers, this passage would surely have recalled Christ's crucifixion, his wounds also graven upon the palms of his hands. Thus the seemingly changeless image of this Baroque Virgin accrues meaning with every representation.

Such iconographic discourse encodes a form of attention appropriate to a society accustomed to reading meanings in visual structures. The Latin phrases floating on the phylacteries would have been accessible only to the educated few, of course, but the phylacteries exceed the content of their alphabetic inscriptions to become visual emblems of "wisdom," "spoken truth," and "textual tradition." Just as today's viewers with no knowledge of Latin will understand the phylacteries emblematically, so seventeenth- and eighteenth-century viewers saw the written texts as visual allegories, as *iconographic* texts that point to truths beyond the limits of visibility (and readability).

These paintings of the Divine Painter are quintessentially New World Baroque in their adaptation of European iconographic traditions to New World circumstances. Octavio Paz addresses this question with customary insight: "The art of

FIGURE 1.16 Anon., *Christ Painting the Virgin of Guadalupe* (top of retablo, eighteenth century). Church of the Congregation, Querétaro, Mexico.

New Spain, like the very society which created it, did not want to be *new;* it wanted to be *another.* This ambition tied it even more firmly to its peninsular model: the Baroque aesthetic sought to surprise, to dazzle, to go beyond. The art of New Spain is not an art of invention but of free use—more precisely: freer use—of the fundamental elements of imported styles. It is an art that combines and mixes motifs and manners."[102] Figure 1.16 provides evidence of Paz's assertion in its dramatic embellishment of the visual tropes that are already specifically Mexican. Now it is Christ who paints the image of the Virgin while God looks down approvingly and the Holy Spirit illuminates the image. Historical viewers would have seen this imposing variation at the top of a magnificent altarpiece in the church of the Congregation in Querétaro and immediately understood it as an intensification of the Mexican representational miracle.

In 1755 the painter Miguel Cabrera wrote a theological tract entitled *Maravilla americana* to confirm the faithfulness of his own paintings of the Virgin to their miraculous original and, not incidentally, to establish himself and the painters of his time as inheritors of God's paint brushes.[103] Cabrera and his contemporaries considered themselves to be both faithful copyists and designers of cultural difference—a dual role that their viewers expected and understood. Consider, for example, Cabrera's painting of the image of the Virgin with the bishop Juan de Zumárraga, Juan Diego, and John the Baptist (fig. 1.17). The presence of Zumárraga and Juan Diego attest to the Virgin's Mexican-ness, and the presence of John the Baptist to her universality, since John was the first to announce the mystery of the incarnation and thus occupies a privileged position with respect to all visualizations of the Virgin. Cabrera's angels pull back theatrical curtains to reveal the image of the Virgin, now framed, mounted and draped in an elaborately carved *retablo*. The scene dramatizes the painter's role as copyist: there are no roses or folds, which would suggest the *tilma* itself. This image is expressly *not* the original but a copy of the original, a human re-presentation of the divine image. Thus the painter demonstrates (and fulfills) his imperative as God's apprentice.

THE VIRGIN'S EYE

The accumulating layers of representation of the Virgin added another when, in 1929, the official photographer of the Basilica of Guadalupe saw the reflection of a bearded man in the right eye of the image of the Virgin. The advancing technology of photography facilitated his discovery, and in the 1950s, an unusual alliance of other sciences and technologies—ophthalmology, computation, infrared analysis—were also used to examine the *tilma*. The reflection in the Virgin's eye was located, debated, and verified by officially sanctioned Catholic sources.[104] The bearded man is, of course, Juan Diego. (Juan Diego is always represented with a beard, despite the fact that beards are usually a sign of European origin.) Supposedly also reflected is a group of people (thirteen, according to accounts on the internet) who are taken to be a family, including a woman carrying a baby on her back in the style of the sixteenth century in Mexico. This recent accretion of meaning foregrounds yet again the reciprocity of the image, as does the original account of Bishop Zumárraga, when he finally sees and believes. The miracle is not a miracle until the image is seen by others, who constitute it and thus make visual understanding possible. So the miracle triples: the reflections in the Virgin's eye are images within the image of the miraculous Virgin. As we will see, intensification by repetition is basic to the New World Baroque.

I conclude by noting the obvious: scientific verification—whether ophthalmological or testimonial or documentary—is hardly necessary to confirm the power of this image. Today, in Mexico City, virtually every taxi stand burns candles

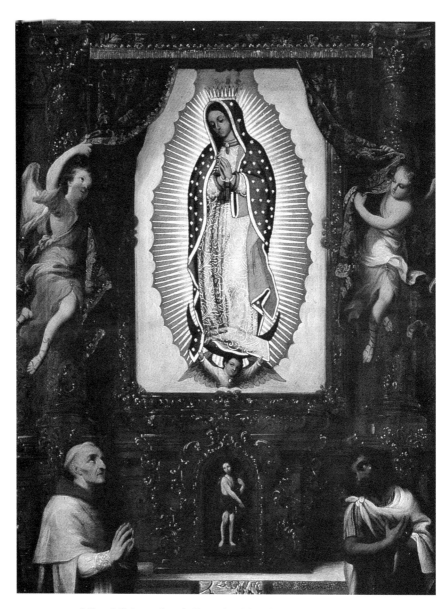

FIGURE 1.17 Miguel Cabrera (attr.), *Portrait of the Virgin of Guadalupe with St. John the Baptist, Fray Juan de Zumárraga, and Juan Diego* (eighteenth century), Mexico. National Museum of Art. Instituto Nacional de Antropología e Historia / Consejo Nacional para la Cultura y las Artes. Photograph: Arturo Piera.

before the image of the Virgin of Guadalupe, not to mention the presence of the image on walls and park benches, in niches and windows and hanging from trees. Throughout Mexico, and increasingly in the United States, the image presides over neighborhoods and entire towns. On December 12, the highways of Mexico fill with pilgrims on foot, bicycles, cars, and trucks, all heading toward to the Basilica of Guadalupe, all adorned with, and empowered by a single image. I think of no analogue in the United States, despite the image-based nature of its media cultures. In the accounts of Quetzalcóatl and Guadalupe, the listener/reader/viewer is asked to follow the process whereby spirit acquires bodily form, and its image acquires the power to contain and communicate spirit. In both accounts, transcendental meanings are played out on the site of the image itself, a drama still enacted in many parts of Latin America, impelled by the unsearchable conjoinings of cultural traditions and human desire.

2

Prehispanic Codices, Murals, and Historical Display

RIVERA, GARRO, GALEANO, AND IBARGÜENGOITIA

. . . any theory of painting is a metaphysics.

MAURICE MERLEAU-PONTY[1]

My discussion in this chapter pursues three expressive forms touched upon in chapter 1: prehispanic codices, mural painting, and contemporary fiction. I will approach what I call the "historical display" of these media, beginning with the codices, whose visualization of time—event, succession, duration—embodies a conception and perception of space/time radically different from those imported by the Spanish. I will then relate the visual and conceptual structures of the codices to painted walls, an important medium of communal self-representation from prehispanic times to the present, and to several works of contemporary Latin American literature. This trajectory will extend our consideration of cultural mechanisms of accumulation and accommodation and their forms of visual knowing. By referring first to the codices, with their complex combination of pictographic and oral performance, I hope to unsettle the boundaries that we now take for granted when we write (or utter) the word "book" in reference to Latin American literature.

In his essay entitled "Scriptural Economies," Michel de Certeau pursues the traces of orality in contemporary print culture, describing his undertaking as "a quest for lost and ghostly voices in our 'scriptural' societies."[2] He tells us that he wishes to hear

the fragile ways in which the body makes itself heard in language, the multiple voices set aside by the triumphal *conquista* of the economy that has, since the beginning of the modern age (i.e., since the seventeenth or eighteenth century), given itself the name of writing. . . . These voices can no longer be heard except within the interior of the scriptural systems where they recur. They move about, like dancers passing lightly through the field of the other. (131)

De Certeau is referring to Europe but his use of the word *conquista* points to the meeting of Spain and indigenous America. At the very moment of the paradigm shift in Europe that de Certeau describes, the *conquista* of oral and iconographic systems was also underway in America. Thus another French observer and grand enthusiast of the recently "discovered" indigenous American cultures, Michel de Montaigne, could write without irony at the end of the sixteenth century: "Our world has lately discovered another [world] . . . no less big, and full and solid than our own . . . ; yet it is so new, such a child, that we are still teaching it its ABC."[3] Montaigne's reference to the alphabet is metaphoric, of course, but de Certeau's is not. Like de Certeau, the novelists whom I discuss in this chapter are listening to the "multiple voices" still heard (and seen) in the codices. This is not mere nostalgia, because ancient voices do exist beneath the surface of the printed page in Latin America, and the expressive structures of the New World Baroque continue to include them, "like dancers passing lightly through the field of the other."

THE SPACE/TIME OF THE CODICES

The Mesoamerican codices are not books in any contemporary sense.[4] Nor are they "codices," a term that, strictly speaking, refers to a bound manuscript. Neither bound nor manuscripts in the usual sense of handwritten, "codex" was first used by nineteenth-century historians to refer to these texts painted according to native canons. The term has stuck, along with the more recent term "screenfold," and I will use them in preference to *libro pintado* (painted book), the label given them by the invading Europeans. Cortés's chronicler Bernal Díaz del Castillo admiringly compares them to "folded cloth from Castille," and describes the many *amoxcalli* or *casas de códices* that they immediately encountered upon their first contact with indigenous populations: "Hallamos las casas de ídolos y sacrificios . . . y muchos libros de su papel, cogidos a dobleces, como a manera de paños de Castilla" (We found houses of idols and sacrifices . . . and many books of their paper, folded like cloth from Castille).[5] Neither books nor codices and certainly not cloth from Castille, these texts were produced by a number of indigenous groups in Mesoamerica. They were made by gluing together strips of bark paper or deer skin painted with intricate figures in elaborate, signifying geometries, and folded in accordion fashion (see fig. 1.4).[6] The visual vocabulary of the codices includes pictographs (iconic

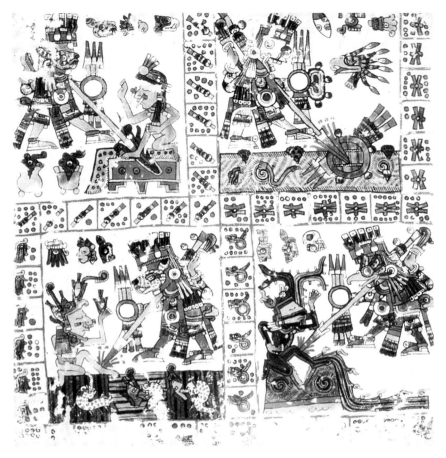

FIGURE 2.1 Codex Borgia, plate 54, Mixteca-Puebla, central Mexico. Vatican Library, Vatican State. Photograph: Archivo Fotográfico Manuel Toussaint/Instituto de Investigaciones Estéticas/Universidad Nacional Autónoma de México.

representations of human and animal figures) and ideographs (symbolic representations of numerical calculations and abstract ideas); there are also hieroglyphs in the Maya codices, that is, phonetic symbols and syllabic inscriptions used for proper names and historical information (dates, genealogies, etc.).[7]

Extant prehispanic codices exhibit a range of styles, but in general they include both glyphic and figural elements deployed in horizontal and vertical registers that sometimes divide the surface of the folds into upper and lower registers and, in the case of the calendrical charts, into grids. The pictographs are two-dimensional, detailed, and often colorful, and on plate 54 from Codex Borgia, bordered by ideographic calendrical notations (fig. 2.1). The Borgia is a divinatory codex produced in the southern central highlands of Mexico, and belongs to the group of codices now known as Mixteca-Puebla.[8] It was probably created shortly before

the Spanish invasion, in the late fifteenth or early sixteenth century, during the cultural period now known, with ironic hindsight, as "late postclassic." The codices have been explicated by a number of contemporary scholars, including Elizabeth Hill Boone, Joyce Marcus, Victoria R. Bricker, Bruce E. Byland, Mary Ellen Miller, Karl Taube, and Serge Gruzinski, among others whom I cite in this chapter. Their work builds on that of scholars who laid the foundations of the discipline and to whom I am also indebted: Eduard Georg Seler, Román Piña Chan, Constantino Reyes-Valerio, Miguel León-Portilla, and Enrique Florescano, to name the most important among them. Each of these scholars presents detailed analyses of the signifying structures of the codices and their modes of interpretation, which allows me to focus on the worldview they embody, and then to speculate on their continuing presence in modern murals and literary fictions.

The codices reflect the similarity among cosmologies and material cultures throughout ancient Mesoamerica, for despite significant differences among groups speaking Náhuatl- and Maya-based languages, there are essential commonalities. Octavio Paz, in his essay "The Art of Mexico: Material and Meaning," begins with their material culture and urban organization—the cultivation of corn, the absence of draft animals and metal working except for "exquisite workmanship in gold and silver," city states, the ritual ball game—and then lists the characteristics that concern us here: the conjoining of cosmological, astrological, and historical phenomena:

> cosmological speculations in which the notion of time played a central role, with striking emphasis on the concepts of movement, change, and catastrophe. . . . a religious pantheon ruled by the principle of metamorphosis: the universe is time, time is movement, and movement is change, *a ballet of masked gods* dancing the terrible pantomime of the creation and destruction of the world and of human beings.[9]

The codices conflate time and space in a structure that privileges movement and mutability, and whose purpose is to understand and predict cosmic and calendrical phenomena. Not all codices are divinatory; there is a large body of recorded knowledge (histories, genealogies) that is not specifically calendrical, but this information, too, depends upon and conveys the understanding of space/time/spirit described by Paz. The written record of ancient Mesoamericans—whether painted, carved, sculpted or molded—reflects the primary cultural importance of permutating temporal cycles, the understanding of which was based on astronomical observation and astrological speculation. But more than any other medium, the codices epitomize the scientific genius of the Nahua and Maya peoples in astronomical observations and calculations, and they embody their mythic investment in their measurements. Miguel León-Portilla, a pioneer in the study of prehispanic "literatures," writes that "to assign a date was to know, perhaps even to identify themselves with the ever changing nature of the universe. Time was not an abstract

concept; it was a living reality, a deity, the cosmic substratum of everything."[10] Astronomical observations illuminated both communal and cosmic history, though neither Mayas nor Nahuas would have separated the two; days, months, years were considered to be the medium and channel for gods and humans; cosmology was a philosophy of history. Constant ritual commemorations and propitiations of the deities who presided over a particular day, as well as the genealogies of princes and rulers, depended upon the knowledge recorded in the codices, and upon its ongoing interpretation. Eduard Georg Seler, one of the early interpreters of the Mesoamerican codices, in his seminal study of the Codex Borgia published in 1904, concludes that the "space of time" of the codices is "the alpha and omega of sacerdotal science of the Mexican and Central American peoples."[11] His inadvertent alphabetic metaphor—like Montaigne's—marks the shift in scriptural economies that would occur soon after the Codex Borgia was created.

To show any fold of a codex apart from the rest belies the ways in which meaning moves across the folds. The screenfold structure allows the interpreter to see several folds at once, to consult folds in clusters rather than consecutively, to flashforward and back and across—that is, to move multidirectionally through the space of astronomical and calendrical signs. (The consecutive numbering of the "plates" [*láminas*] is, of course, a Western imposition, and should not be understood to imply a linear, progressive narrative. Quite the contrary.) Plate 54 of the Borgia (fig. 2.1) presents four embodiments of Venus striking four embodiments of supernatural figures, whose meaning is conditioned by the adjacent fold, which shows another Venus striking another supernatural figure (fig. 2.2). This fold, in turn, dialogues with the three adjacent to it, which together present the interactions of the five world directions and their supernatural patrons. In the upper left quadrant of figure 2.2 is the image of a deer (or deerskin) with the twenty day signs attached to its body (or skin). Such combinations of pictographs and ideographs offered auguries whose interpretation depended, as Bruce E. Byland puts it, "on the priest's reading of the images and his knowledge of the characteristics of the various powerful creatures represented."[12] So we must speak of *functions* rather than selves or subjects or stories; these are not linear narratives but overlapping, repeating sequences of day signs and deities that operate in and on the world according to the *tlacuilo*'s interpretation.

Central to the divinatory codices are calendrical charts called *tonalamatl* in Náhuatl, a compound word meaning "book" that joins the word for day, *tonalli* (literally sun, spirit, part, portion) with the word for the bark paper (*amatl*) made from the native ficus tree; in fact, the Náhuatl root *tonal* also contains the concepts of fate, destiny, and name, as well as a set of meanings associated with spirit, including fire and heat.[13] Eduard Georg Seler translates *tonalamatl* as "the book of days and their influence on destinies."[14] (The Maya word for the calendrical charts is unknown.)[15] The 260-day ritual calendar was termed *tonalpohualli* (count of days),[16] its interpreter a *tlacuilo* or *tonalpouhque* (literally, "one who is consecrated

FIGURE 2.2 Codex Borgia, plate 53, Mixteca-Puebla, central Mexico. Apostolic Library of the Vatican, Vatican State. Photograph: Archivo Fotográfico Manuel Toussaint/Instituto de Investigaciones Estéticas/Universidad Nacional Autónoma de México.

to days"), and in Maya, *ah ts'ib*. The first eight folds of the Codex Borgia present the 260-day ritual calendar; figure 2.3 shows the fifth fold of the Borgia *tonalpohualli*. Other folds, including those shown in figures 2.1 and 2.2, augment the *tonalpohualli* with pictographs and ideographs that carry information about the qualities of the days; yet others relate the *tonalpohualli* to the solar year. Far from our own calendar, with its linear numeration of years and its seven repeating day-names and twelve month-names that represent only themselves (the significance of their Roman referents long since forgotten), a given day in the *tonalpohualli* possesses material and mythic identity. Even the vestigial symbolic content of our watches and clocks, with the circular movement of their "hands" on "faces" that gives rise to the spatial metaphors of clockwise and counterclockwise, has given

FIGURE 2.3 Codex Borgia, plate 5, Mixteca-Puebla, central Mexico. Apostolic Library of the Vatican, Vatican State. Photograph: Archivo Fotográfico Manuel Toussaint/Instituto de Investigaciones Estéticas/Universidad Nacional Autónoma de México.

way to the abstraction and immobility of digital clocks. The *tonalpohualli*, on the contrary, projected metaphorically the movement of the gods in the space of human experience: each day possessed a number, a direction, a hieroglyphic symbol representing an object or animal, and a presiding deity. In the concrete figurations of the codices, time was visualized and spatialized, history materialized, and fate embodied.

The codices are, then, in some primary sense calendars, but I repeat that the modern Western conception of calendar is totally inadequate to describe their content. Duration is conceived not as sequence or cycle or singular event but as all of these things at once; duration is projected as habitable space structured by the

interpenetration of divine, human, animal, and other natural presences. Astronomical cycles were observed and recorded and honored, and "to happen" implied not so much an event as a *disposition*, both in the spatial sense of the word, as a placement or arrangement, and also in the psychological and premonitory sense of the word, as a prevailing tendency or inclination. The spatial and premonitory meanings of *inclination* are also conflated in the codices. Since the gods regulated human activity, it was essential to know the disposition, the inclination, of the day, that is, the position and the mood of the day in its complex phenomenal and noumenal identity.

Given the importance of spatial positioning, it is not surprising that the five "world-directions"—north, south, east, west, and center, the direction of up/down—are elaborately depicted according to reigning gods, natural phenomena, and temporal markers, for the world-directions also served as media and channels for sacred forces. North, south, east, and west are represented on separate folds of the Borgia and the fifth direction, the center or direction of up/down, is represented by the image in the top right corner of figure 2.2, above. This figure descends into the open mouth of the earth—the earth's teeth are bared, the figure's feet are above his head, his arms below and in motion—providing yet another inkling of the complex conception of space encountered by Old World in the New.

Consider one more preconquest visualization of time and space, again from a divinatory codex from the central highlands of Mexico, the Fejérváry-Mayer (fig. 2.4). Here we see a visualization of the four corners of the Mexica universe, the center of which is occupied by the founding deity Ometéotl and its four corners by four incarnations of Tezcatlipoca, god(s) of the smoking mirror whom we encountered in the myth of Quetzalcóatl's mirror. Tezcatlipoca is the metamorphic son of Ometéotl, whose shifting forms are embodied here by color, composition, and direction. Miguel León-Portilla explains:

> The red Tezcatlipoca son identified himself with the East . . . the black Tezcatlipoca with night and the region of the dead, located in the North; Quetzalcóatl, night and wind, with the West, region of fecundity and life [associated with white]; and finally, the blue Tezcatlipoca, personified as Huitzilopochtli in Tenochtitlán, associated himself with the South, the area located to the left of the sun. [17]

In the center, Ometéotl, god of duality, male and female, day and night, is also called Tezcatlanextía, "mirror that illumines things." Given his dual nature as lord of day and night, Ometéotl is both Tezcatlanextía and Tezcatlipoca, and he is, furthermore, aligned with other gods in his male and female aspects. This Nahua creation image/narrative is far more detailed (and fluid) than my account suggests, but my aim is to imagine the *tlacuilo*'s performance of this spatial/temporal image in all of its cosmic and human significance. To this end, Elizabeth Hill Boone's

FIGURE 2.4 Codex Fejérváry-Mayer, plate 1, Mixteca-Puebla, central Mexico. National Museums and Galleries on Merseyside, Liverpool. Photograph: Archivo Fotográfico Manuel Toussaint/Instituto de Investigaciones Estéticas/Universidad Nacional Autónoma de México.

account in "The Structures of the Mexican *Tonalamatl*" is helpful. After a detailed description of the elements of this screenfold, she summarizes:

> In this one complex and masterful presentation the painter uses the regular passage of the *tonalpohualli* to recreate the physical space of the cosmos with its cardinal directions, cosmic trees, birds and the lords who rule those directions. As it passes, time moves from one part of the cosmos to another, absorbing the mantic meaning associated with each direction. Thus, the ribbon of time describes the cosmos as a physical and geographical entity; at the same time the physicality of the cosmos inscribes time with mantic meaning. This single diagram, interpreted as a temporal

and spatial map of the cosmos, shows how inextricably time is linked to space in the central Mexican mind. (397)

In imagining the codices, then, we must conflate modern Western visualizations of spatial and temporal coherence—maps and calendars—and add the idea of dance, whose medium is movement. Furthermore, we must amplify our notions of reading and writing to include public performance. The *tlacuilo*—diviner/painter/priest/performer—would associate the painted images with a mythic incident and then recount it to an audience; orality and image complemented one another, without one being a version of the another. The Náhuatl phrase for the codices is *in tlili in tlapalli,* red ink, black ink, a metaphor that evokes the scribal activity of the *tlacuilo* and his material medium. So we understand that any modern written account of Mesoamerican myth can only be partial, since a glyph-by-glyph translation of a preconquest codex belies the somatic and performative nature of its "writing" and "reading."[18] In his study of postconquest codices, Serge Gruzinski describes the understanding of the figurations of the codices *before* the arrival of the Europeans:

> It seems that they considered images to be more than just a representation or figuration of things existing in another place, another time. Mexican images were designed to render certain aspects of the divine world physically present and palpable; they vaulted a barrier that European senses are normally unable to cross. The thrust of the brush and the coupling of shapes and colors literally brought the universe of the gods to life on agave bark or deer hide. . . . In this respect the techniques practiced by *tlacuilos* were more a path to divinity than a means of expression. Prehispanic canons of selection and arrangement were designed to help grasp and extract the Essential. An image rendered "visible" the very essence of things because it was an extension of that essence.[19]

In Maya ritual practice, blood was dripped onto strips of *amate* and burned so that the essence of the ruler might be breathed by the gods (see fig. 1.3). Body, world, and writing were conceptually and ritually conjoined; the painting and performance of the codices are perceptual and somatic modes of intending and understanding the world.

The metaphor of dance, used by Michel de Certeau to refer to the premodern voices that survive in modern scriptural economies, is repeatedly invoked by Octavio Paz. I have already quoted Paz's phrase describing time as "the ballet of masked gods"; about Tezcatlipoca and the mirrors that are his metamorphic embodiment, he writes: "The gods are time, but not time petrified. Time is perpetual movement, the dance of metamorphoses, the dance that is the 'Flower War,' a cruel and illusory game, a dance of reflections thrown by four facing, antagonist mirrors."[20] Paz, too, struggles to summon metaphorically the codices' integration of space, time,

sentience, and movement in their cosmo-logic of lines, colors, and volumes. By combining conceptually our modern sense of maps, calendars, and the physical movement of dance, we may begin to approach an understanding of this iconographic/performative medium, which precedes the modern divorce of time from space and cosmic movement from human history.

Postconquest codices immediately betray evidence of Europeanization. In fact, their production flourished in the sixteenth century as did no other precontact expressive medium, and in these transcultural documents we may read the overlapping desires of indigenous and European parties. Elizabeth Hill Boone writes eloquently about the dynamics of destruction and cultural memory during this period:

> Although Aztec painted books had early been the focus of destruction by zealous conquistadores and mendicant friars from Europe, this trend reversed around the middle of the sixteenth century when Aztecs and Europeans alike realized the utility of the manuscript tradition.
>
> Aztec elites needed to accommodate the new viceregal order, but they still wanted to guard the ideas and institutions of their past and to protect and bolster their present rights and positions. They had maps and property plans painted to document what land holdings and financial interests they retained or claimed, and they commissioned historical documents to record a distinguished past they wanted to continue under the new viceregal and Christian order.
>
> The Spaniards, for their part, recognized the desirability of understanding the Aztec systems in order to reap the full economic, political, and spiritual benefits of their new land. Secular authorities of the viceregal government, who judged pictorial codices admissible as evidence in court cases, sponsored the painting of maps, tax and tribute assessments, and registers of properties and salaries to improve their knowledge and control of the territory. Once the friars saw that their ignorance of the old religious customs hindered their missionary efforts, they began to seek out existing Aztec books and to create their own records of Aztec religions so that they might more effectively combat its continued practice.[21]

Again we note the function of visual imaging in the constitution of history, but the idea of history contained in the postcontact codices rapidly departs from the conception of space/time/movement contained in the precontact codices.

In only a few decades, then, the visual syntax of the codices adapts itself to vastly different forms of attention. Some codices (the Codex Selden, for example) bridged the conquest, continuing to be performed in their communities of origin. But most did not, and the inclusion of Western canons of re-presentation makes the postconquest codices inordinate documents par excellence in their integration of contradictory ways of seeing. In them, precontact visualizations of dynamic space/time are fit into discrete, successive scenes that reflect the engravings in European books, and they begin to acquire linear narrative structures and centered

visual perspectives that integrate backgrounds, human forms, and spatial settings to depict social and domestic relations. The flat precontact style is retained for rendering iconographic detail, but fixed-point perspective replaces fluid textual spaces. Objects are increasingly arrayed in rows and catalogued with explanatory Náhuatl or Latin captions: textual labels had, by 1570, according to Serge Gruzinski, become "the prime vector of information" and thus "represent the triumph of the 'book.'"[22]

We may assume that these changes reflect necessity: the need of the *tlacuilos* to accommodate their new audience and, at the same time, to preserve the ideas and institutions of their past and protect their position under the new domination. The balance of these necessities shifts from codex to codex, and the Westernization of style varies according to audience and intention. The Codex Mendoza is an example of this scriptural hybridity, and the Codex Telleriano-Remensis (fig. 2.5) is another. The images in these codices preserve the prehispanic stylistic and iconographic structure but bear informative Spanish glosses at the bottom of their pages. With respect to these codices, I can accurately say "pages," because instead of folded strips of bark paper they are composed of individual sheets of imported paper and bound as European-style books. Here, the postconquest codices shift definitively from mythic concerns to political and material ones, and their documentary function becomes primary. Another postconquest example is the Lienzo de Tlaxcala (literally, canvas of Tlaxcala), a single strip showing eighty-seven framed, labeled scenes of successive historical events; figure 2.6 shows the Spanish victory as the battle of Cholua, with Cortés and La Malinche on the lower right. The Tlaxcaltecas allied with the Spaniards to defeat their Mexica enemies, so these scenes present the events leading to the fall of Tenochtitlán as a victory from the indigenous point of view—an irony engaged by Elena Garro in her short story "La culpa es de los Tlaxcaltecas" (It's the Tlaxcaltecans' fault).[23] Again, the political aim of this codex explains the extraordinary Westernization of its visual forms: the Tlaxcaltecans wished to remind the Spaniards of how much was owed to them, so they created visual structures that encode the Spaniards as the primary "readers" of their text. To add to the historical layers of this document, the original, painted in 1550 for the accession of the viceroy Velasco in 1552, has been lost, and what we have are copies, the earliest dating from 1773.[24]

We have seen that postconquest codices were quickly modified to suit European forms of attention, but the processes of transculturation also worked in the other direction. As Elizabeth Hill Boone notes in the passage I cited, the colonizing clergy engaged indigenous visual structures in their efforts to document precontact culture, the greatest example being the Florentine Codex. The Franciscan Bernardino de Sahagún arrived in New Spain eight years after the conquest, in 1529, with twenty friars and several Nahua nobles whom Cortés had taken to Europe the year before and who were now returning to Mexico. In 1536, the Franciscans established the Colegio Imperial de Santa Cruz de Tlatelolco for the purpose

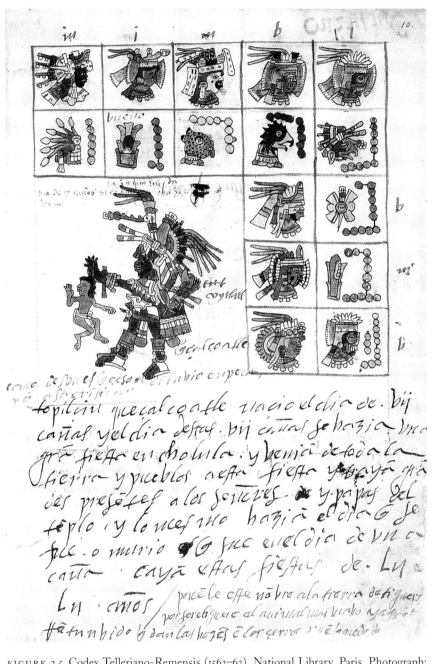

FIGURE 2.5 Codex Telleriano-Remensis (1562–63). National Library, Paris. Photograph: Archivo Fotográfico Manuel Toussaint/Instituto de Investigaciones Estéticas/Universidad Nacional Autónoma de México.

FIGURE 2.6 Lienzo de Tlaxcala (c. 1550, copy 1773). National Museum of Anthropology, Mexico City. Photograph: Archivo Fotográfico Manuel Toussaint/Instituto de Investigaciones Estéticas/Universidad Nacional Autónoma de México.

of educating the sons of the indigenous elite in Latin and Spanish grammar, music, sacred and universal history, classical literature, and philosophy. Sahagún was assigned to the Colegio Imperial, but it was not until 1558 that he received permission to pursue the anthropological work for which he is justly renowned. And none too soon, for the time to locate informants who had experienced precontact culture was growing short; these informants described to Sahagún what they had learned as young men in their institutions of higher learning, as well as social, political, and religious practices. Sahagún is not, then, the "author" of the Florentine Codex in any usual sense. Rather, he oversaw the encoding of precontact cultural memories in Náhuatl in alphabetic script and also (recognizing the importance of pictographic representation in the precontact codices and wishing to accommodate his informants' customary use of visual syntax) in a fascinating compendium of visual images (fig. 2.7).

FIGURE 2.7 Florentine Codex (c. 1579). Library Medicea Laurenziana, Florence. Photograph: Archivo Fotográfico Manuel Toussaint / Instituto de Investigaciones Estéticas / Universidad Nacional Autónoma de México.

Below I will discuss in more detail Eduardo Galeano's epic trilogy of American culture, *Memory of Fire,* but here, I want to quote his homage to Bernadino de Sahagún:[25]

> En los doce libros de la *Historia general de las cosas de la Nueva España,* Sahagún y sus jóvenes ayudantes han salvado y reunido las voces antiguas, las fiestas de los indios, sus ritos, sus dioses, su modo de contar el paso de los años y de los astros, sus mitos, sus poemas, su medicina, sus relatos de épocas remotas y de la reciente invasión europea . . . La historia canta en esta primera gran obra de la antropología americana.

> [In the twelve books of the *General History of New Spain,* Sahagún and his young assistants have saved and assembled ancient voices, the fiestas of the Indians, their rites, their gods, their way of counting the passage of years and stars, their myths, their poems, their medicines, their tales of remote ages and the recent European invasions . . . History sings in this first great work of American anthropology.][26]

As Galeano's lyrical celebration of these "ancient voices" suggests, this is an indispensable document in approaching the precontact world of the Mexican highlands. The cultural rupture was irrevocable, but Sahagún's work predicts the continuing power of visual images in the hybrid forms that European conquest would engender in Latin America.

In another transcultural modification, painted books called Testerian codices were used from the sixteenth through the eighteenth centuries to teach Catholic ritual, prayers, and dogma to indigenous converts, and they deployed visual images as well as alphabetic writing to do so.[27] These visual catechisms were usually in the form of tiny books to be carried by the believer and consulted when necessary. Their name comes from the Franciscan Jacobo de Testera, whose use of visual devices is documented by Gerónimo de Mendieta in his sixteenth-century chronicle *Historia ecclesiástica indiana.*[28] This syncretic artifact—a miniature bound codex containing Christian images—reflects the intention of prehispanic codices to communicate metaphysical content, but the medium is now directed to colonizing purposes.

Today, yet other cultural imperatives condition the production of texts on bark paper. *Amate* is still produced by the Otomí people in central Mexico, and a small part of their production still serves ritual purposes within the indigenous community—anthropomorphic figures cut from *amate* call upon (or drive away) the countless spirits that still inhabit the world.[29] But most *amate* is now produced for sale outside the community; it is sent to other pueblos to be painted with colorful birds, flowers, and landscapes, a medium and style developed relatively recently for commercial markets. So the function of painted bark paper has become artisanal and economic rather than ritual or documentary—a change that marks yet

another step in the transculturation of indigenous cultural practice and Western modes of production and consumption.

DIEGO RIVERA AS TLACUILO

The Mexican muralist movement also engaged and transformed the visual languages of the codices. Muralists working in postrevolutionary Mexico during the 1920s, '30s, and '40s sought to politicize the language of modern art by engaging the visual media of prehispanic cultures. In my preface, I made the distinction between literacy and legibility: the muralists' intended audience was not educated but was cultured in a long tradition of reading communal iconographic languages. This was a distinction about which the muralists were clear as they self-consciously set about extending indigenous and colonial modes of communal self-representation. José Vasconcelos, secretary of education in Mexico from 1921 to 1924 and the founder of the muralist movement, also understood the continuity of cultural traditions he was engaging when he commissioned artists to paint on public walls. Images were to be made available to whole communities and to become the center of communal life, as they had been centuries earlier on the façades of the pyramids at Teotihuacán and Monte Albán, and later on Baroque façades, cloisters, and church interiors. These twentieth-century murals, like their precursors, were intended to create a shared visual language, and they have become standard decor in countless patios and rooms of government buildings on central plazas, not only in Mexico but throughout Latin America. In the 1920s Vasconcelos aimed to create cultural spaces in which all of citizens would fit, and he understood the role of images in doing so: "No hago historia; intento crear un mito" (I don't write history; I attempt to create a myth).[30]

This self-conscious mixture of history and myth impels modern Mexican muralism.[31] The muralists created icons of national consciousness, and their project was specifically tied to the *indigenista* movement.[32] This pan-American movement generalized the awareness of indigenous cultures during the first decades of the twentieth century, valorizing indigenous traditions and practices and reconstituting the question of cultural inclusiveness. (The self-awareness of Native American and Chicano groups in the United States, beginning in the 1960s and sometimes expressed in murals, is a manifestation of this movement.) No longer was the inclusion of indigenous cultures limited to areas where the indigenous heritage was a defining cultural characteristic; rather, it had become (and remains) an essential element of regional and national self-definition throughout the hemisphere. Virtually all contemporary postcolonial discourse in/about Latin America includes elements engendered by *indigenista* imperatives.

The muralist movement was, then, part of a larger effort to recognize indige-

nous cultural histories and visual traditions. In Mexico after 1848, images of indigenous heroes had symbolized resistance to foreign invaders, but this nineteenth-century iconography of Romantic (and doomed) heroism had now run its course. Postrevolutionary muralists were commissioned to represent the resurgent ideology of cultural *mestizaje*, and they recurred to indigenous visual forms, including the codices, to elaborate their version of national history. Any discussion of this point must center upon Diego Rivera, whose murals in the National Palace in Mexico City alone provide sufficient evidence of my assertions. In these murals, Rivera paints the codices and the *tlacuilos* as necessary precursors to his own twentieth-century visualizations of history.

The story of Rivera's return to Mexico in 1921 after fourteen years in Europe is well known. Summoned by Vasconcelos, Rivera was commissioned to paint the history of the Mexican Revolution and project its proletarian future on public walls. In fact, Rivera had already been subsidized indirectly by Vasconcelos, who had seen to it that he visit Italy before returning to Mexico; there Rivera understood the didactic power of murals, learned the craft of fresco, and studied the relation of fresco to architecture.[33] Under Vasconcelos's influence, murals were to become *the* medium in Mexico to embody the new national consciousness, an agenda that required the muralists to break with the fundamentally elitist program of European modernism.[34] Rivera rapidly developed his muralist style—both intimate and epic, realistic and yet integrating the compressed planes and geometric forms of Cubism in the service of his mythologizing ends.

The three vast walls of the principal stairwell in the National Palace, on the central plaza of Mexico City, were painted between 1929 and 1935. As the visitor climbs the great flight of stairs, he or she is surrounded by the circulating space of Mexican time: to the right, the North wall depicts "The Aztec World," the wall in front of the viewer depicts "The Conquest to 1930," and the South wall depicts "Mexico Today and Tomorrow." In these murals, Rivera visualizes historical events and cultural traditions as coexisting and interacting in his spatial composition. On the second floor of the National Palace an open balcony runs along the four sides of the enormous interior patio, where a series of panels covers one entire wall and turns the corner to cover part of another. These panels were originally intended to cover all four sides of the patio and thus envelop the viewer, as does Mexico's spatialized history in the stairwell. They were painted between 1942 and 1951 and include five large panels depicting specific indigenous regional cultures, a sixth celebrating the making of *amate* paper, and a seventh showing the abuses of the colonizing Spaniards—the end of the prehispanic idyll depicted in the previous panels. Six smaller panels are set around carved door frames and ornamented pilasters.

Rivera's engagement of the indigenous past has been much noted, and my particular interest here is his use of the codices.[35] As idealized as his (re)vision of Mexican indigenous history is, he was realistic in his recognition of the continuum that

connected him to indigenous visual traditions and his *tlacuilo* forebears. Like the Neobaroque writers whom we'll discuss in the following chapters, his impulse to recuperate and revise are one, and his radical revisions are aimed at constructing continuity despite rupture. In his panel on the Tarascan culture, Rivera foregrounds the production of the codices and the work of the *tlacuilo,* who stands in the center of the mural holding a screenfold (color plate 9). The *tlacuilo,* as we have seen, was scribe and painter, diviner and recorder of the mythic space of history, performer of communal values—roles Rivera aspired to play in modern Mexico.[36] It is as *tlacuilo,* I would argue, that he understood his own work from the moment he returned from Europe in 1921. In this panel, he celebrates the Mesoamerican tradition that gave to the artist social and political importance, implicitly rejecting the post-Romantic tradition that posits something like its opposite: the inevitable conflict between artist and society, between individual inspiration and collective forms of expression. The presence of the *tlacuilo* and the iconography of the codices in this panel and others of the National Palace make these murals metatexts: they are murals about muralism, and about the communal and cosmic function of the prehispanic image as Rivera (re)conceived it.

The *tlacuilo* combined the functions of artist and conveyor of communal wisdom, and Rivera and the other muralists engaged by Vasconcelos were enjoined to do so as well. As José Joaquín Blanco puts it in his study of Vasconcelos, the "*triples misioneros*" of the postrevolutionary period were the teacher, the artist, and the book, and each was to incorporate the functions of the other two. The painting was to be a text, and the painter a teacher: "The artist was not only the voice of the people but also their guide; with Vasconcelos, the Mexican school of painting became a messianic art."[37] The murals, like the codices, were to embody a social organization and a metaphysics, the two coinciding in Vasconcelos's phrase *la raza cósmica* (the cosmic race). Beyond the visual narratives of *indigenista* ideology, the murals created during this period were characteristically textual in their presentation of history as allegory (as Manichaean struggles of Indian versus Spaniard, capitalist versus worker) and their use of mythic and historical narratives from every period of Mexican historical culture. As so often in Latin American cultural expression, texts generated images and images confirmed texts in their own dance of cultural semiosis.

Rivera's panel of the Mixtec culture in his National Palace series shows pictographs being set in mosaic and recreated on headdresses, banners and shields; here again, his celebration of the indigenous past focuses on symbolic systems of visual expression and their artistic techniques. His panel of the Huastec culture copies from the Codex Borbonicus the pictograph of the corn goddess Chicomecóatl on the viewer's left, and seemingly a banner, also taken from the Borbonicus, on the right (figs. 2.8 and 2.9). What Rivera represents as a banner is, in fact, a ceremonial platform where a captive dressed as the corn goddess is about to be sacrificed; the grisaille below this panel also echoes figures in the Borbonicus.[38] The

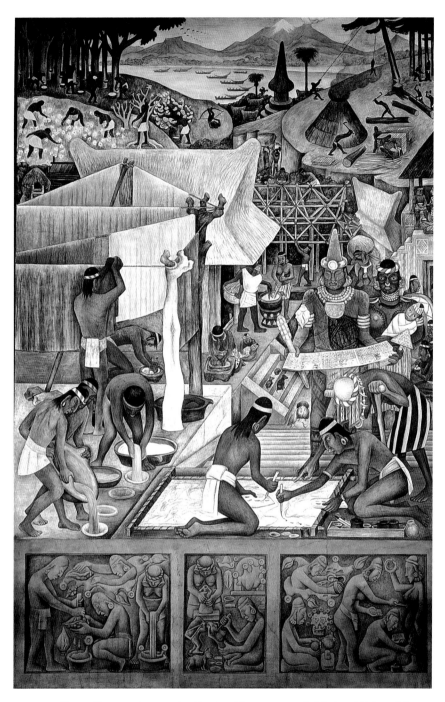

PLATE 9 Diego Rivera, *Tarascan Civilization* (fresco, 1942–51), National Palace, Mexico City. Instituto Nacional de Bellas Artes / Banco de México. Photograph: Bob Schalkwijk.

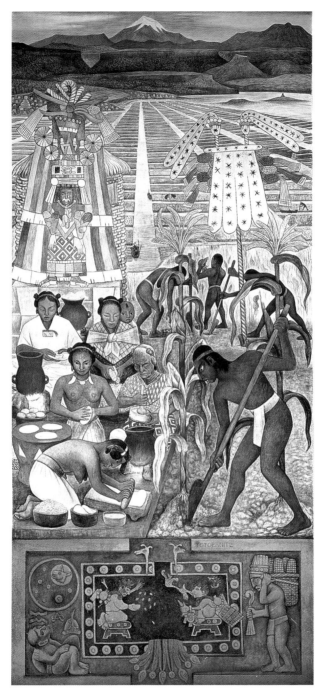

FIGURE 2.8 Diego Rivera, *Huastec Civilization* (fresco, 1942–51), National Palace, Mexico City. Instituto Nacional de Bellas Artes / Banco de México. Photograph: Bob Schalkwijk.

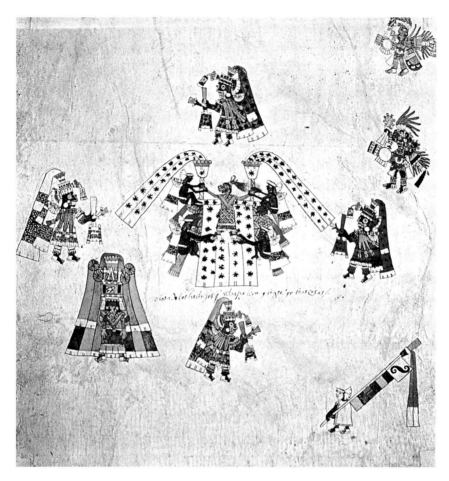

FIGURE 2.9 Codex Borbonicus, plate 31 (detail), Mixteca-Puebla, central Mexico. Photograph: Archivo Fotográfico Manuel Toussaint / Instituto de Investigaciones Estéticas / Universidad Nacional Autónoma de México.

origin of this codex is debated; it may have been painted after the arrival of the Spaniards, but it maintains its preconquest visual format. In two panels framing an ornamental pilaster, Rivera shows the production of the bark paper and beneath it, in a grisaille border that runs beneath all the panels, a codex imagined by the modern artist that recounts the Spanish invasion and enslavement of his indigenous counterparts (fig. 2.10). Rivera's celebration of the indigenous past was also a celebration of the *mestizo* present, but in this grisaille and in the last of the series of the murals in the National Palace, he shows the grotesque abuses set in motion by the European invasion (fig. 2.11). In *The Disembarkation of the Spanish at Veracruz*, Rivera places a green-eyed *mestizo* child in the middle of his painting, an icon of the racial ideology of "the cosmic race." Yet given the horrors surrounding the child,

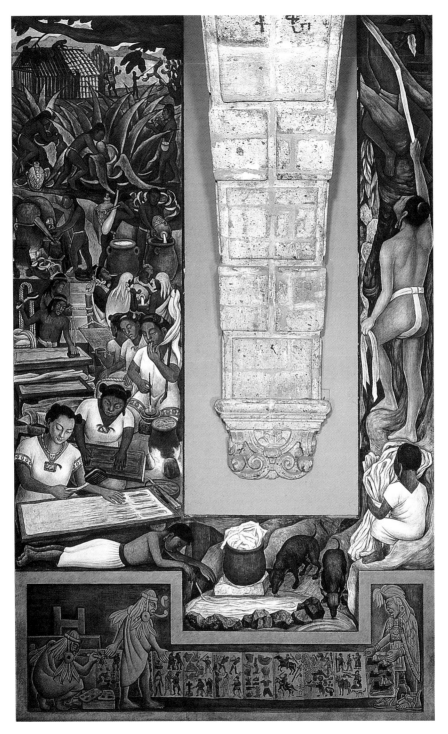

FIGURE 2.10 Diego Rivera, *Maguey Industry* (fresco, 1942–51), National Palace, Mexico City. Instituto Nacional de Bellas Artes / Banco de México. Photograph: Bob Schalkwijk.

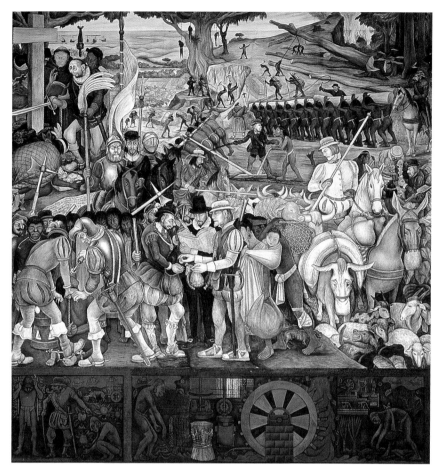

FIGURE 2.11 Diego Rivera, *Disembarkation of the Spanish at Veracruz* (fresco, 1942–51), National Palace, Mexico City. Instituto Nacional de Bellas Artes / Banco de México. Photograph: Bob Schalkwijk.

there is little to suggest the postrevolutionary optimism that it was Rivera's task to convey.

The murals in the National Palace are certainly Rivera's most important thematic treatment of the codices, but another set of images bears mentioning. As Rivera was painting the immense walls of the stairwell there, he executed a related project on quite another scale. In small format watercolor, he "illustrated" the *Popol Vuh* (council book), the sacred book of the Quiché Maya. Like the *Anales de Cuauhtitlán*, the *Popol Vuh* was written down in alphabetic script after the conquest by people who still remembered the preconquest codices.[39] As if to recover the cosmic visualizations no longer available to this postconquest mythography, Rivera painted his own series of images to accompany the text of the *Popol Vuh* (fig. 2.12).

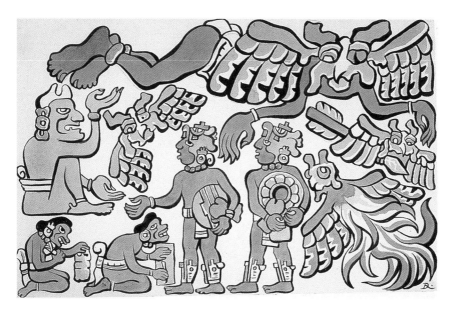

FIGURE 2.12 Diego Rivera, *The Mansions of Xibalba,* plate 15 (1931), from Rivera's illustrated *Popol Vuh.* Museo Casa Diego Rivera, Guanajuato. Instituto Nacional de Bellas Artes / Banco de México.

They are stylized versions of the preconquest codices with certain icono-graphic signs retained, and though they are hardly among the works for which Rivera is celebrated, they, too, constitute a metatextual commentary on the con-tinuing tradition of indigenous images and image-makers to which Rivera felt he belonged.

The prehispanic divinatory codices are not only thematic but also structural in Rivera's work. His murals rarely consist of a single scene but are, rather, series structured to suggest the inordinate relations of events, personages, and cultures across the space of related panels. The monumentality of the murals contrasts with the book-size codices, of course, but we may nonetheless think of the panels of Rivera's murals as modern analogues to the folds of the codices, whose meaning accrues among the panels, each of which is inseparable from the significance of the whole. Beyond the related panels of the National Palace, Rivera's paired murals in the Institute of Cardiology in Mexico City are examples (figs. 2.13 and 2.14). Their history moves horizontally and vertically, backward and forward: horizontally in the paired panels, which are separated by a door but are close enough to require a horizontal reading; and vertically in the figures who spiral from bottom to top—from the foregrounded ancients to the modern figures who recede into the back-ground as they rise in space. This fluid spatial display encompasses time; history is movement in space.

So, too, *Dream of a Sunday Afternoon in the Alameda Park* transforms prehispanic

FIGURE 2.13 Diego Rivera, *History of Cardiology: Anatomists, Physiologists, Clinicians* (fresco, left panel, 1943), Institute of Cardiology, Mexico City. Instituto Nacional de Bellas Artes / Banco de México. Photograph: Bob Schalkwijk.

FIGURE 2.14 Diego Rivera, *History of Cardiology: Researchers Using Instruments and Apparatus* (fresco, right panel, 1943), Institute of Cardiology, Mexico City. Instituto Nacional de Bellas Artes/Banco de México. Photograph: Bob Schalkwijk.

cosmogonic conceptions into visual structures (fig. 2.15). Another presentation of history as dynamic space, this emphatically horizontal work (its width is over four times its height) nonetheless moves vertically in space and back in time. On the bottom are contemporary figures on park benches who dream the historical figures above them: a peasant dreams of Juárez and, on the other side of the mural, a revolutionary dreams of Zapata, both figures seeming to move upward in parallel currents. History circulates in the space of the mural. Presence, rather than progress, is the medium of Rivera's historical display.

I have said that Rivera visited Italy shortly before returning to Mexico, where he absorbed the muralist tradition from Giotto through the Baroque. Immediately upon his return to Mexico and hardly a year after his trip to Italy, he accompanied Vasconcelos to the Yucatan, where he saw another kind of muralism.[40] For the first time he saw the Maya pyramids, and so began what would become a lifelong study of prehispanic architecture, culminating in the design and construction of his own great pyramid, the Anahuacalli museum, which still houses his collection of indigenous artifacts.[41] Rivera recognized that the pyramids did not separate time from space, that they were "time turned into geometry, into space." This is Octavio Paz's phrase, and he gives the following examples as evidence of his assertion: "The pyramid at Tenayuca has fifty-two serpent heads: the fifty-two years of the Aztec century. The pyramid of Kukulkán at Chichén-Itzá has nine double terraces (the eighteen months of the year), while its staircases have 364 steps plus one on the top platform (the 365 days of the solar calendar) . . . the temple of Quetzalcóatl has 364 serpent fangs." The list continues, and concludes: "Marriage of space and time. Movement expressed in the geometry of stone."[42] Rivera combined this American sense of time/space with European expressive forms (Cubism, too, is centrally concerned with the structuring of space) to project a spectacle that is at once mythic and historical.

In Rivera's extensive writings on prehispanic architecture, he returns again and again to its *integration* of painting, sculpture, and architecture, insisting that it is impossible to tell where one medium begins and the other leaves off. He also admires the "integration of form, space, volume, color, in an irreproachable plan based on perfect logic," and concludes that the pyramids are "a harmonious whole completely integrated in their plastic forms."[43] So too, he often stressed the fact that his own frescoes were integral parts of the buildings that housed them: "[fresco] is not a painted wall but a painting that is a wall."[44] As early as 1924, in a stairwell in the Ministry of Public Education, Rivera paints himself as an architect seated in that same stairwell, studying the plans laid before him.

Rivera's chapel at Chapingo is a similarly self-conscious project of structural and cultural synthesis, which in its totality is titled *Canto a la tierra* (Song to the earth). The chapel belonged to a hacienda that had been expropriated during the revolution and turned into an agricultural school, which continues today as the Universidad Autónoma de Chapingo. Its motto was, and is: "Enseñar la explotación de la

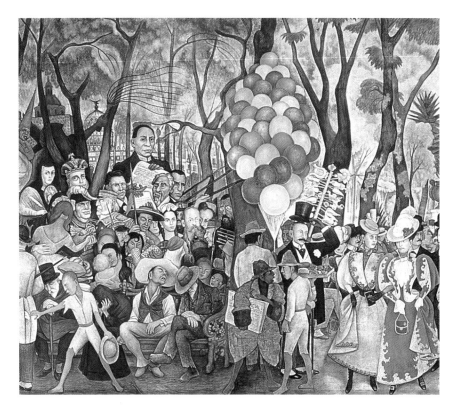

FIGURE 2.15 Diego Rivera, *Dream of a Sunday Afternoon in the Alameda Park* (detail, fresco, 1947–48), Mexico City. Instituto Nacional de Bellas Artes/Banco de México. Photograph: Bob Schalkwijk.

tierra, no la del hombre" (teach the exploitation of the land, not man).[45] The interior of the chapel is entirely covered with allegorical scenes of the revolution and postrevolution, a project commissioned in 1924, three years after Rivera's return from Europe, and accomplished between 1925 and 1927 (color plate 10). No photographic image can convey the sensuous effect of entering the muted, intimate space of the chapel at Chapingo, with its luxuriant earth tones that envelop the viewer. Rivera heightens our sentient experience of space by constituting us as spectator-actors within the chapel; perspective is not determined by angle or distance but by the interaction of seer and seen. Here, I return to the distinction I made in chapter 1 between perspective and participation: Western fixed-point perspective encodes the singularity of the seer and his/her separation from what is seen, whereas the indigenous image generalizes the seer's physical *participation* in natural and cosmic processes. In Rivera's chapel, we may speak of proportion or scale, but not of perspective in any usual sense. The artist's aim is to subvert any single, stationary viewpoint, and he adapts his architectonic medium to this end. Rivera's contemporaries

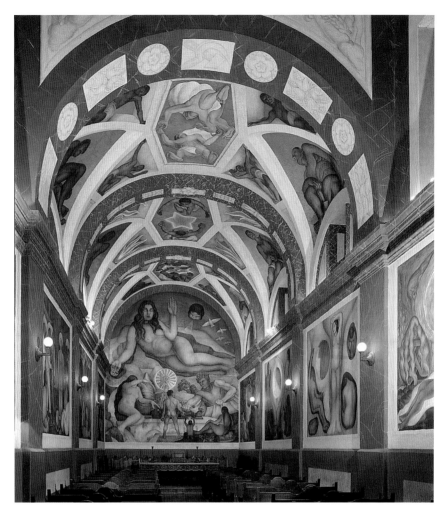

PLATE 10 Diego Rivera, Chapel at Chapingo (full view, 1925–27), state of Mexico, Mexico. Instituto Nacional de Bellas Artes/Banco de México. Photograph: Bob Schalkwijk.

called his murals Baroque and I, too, will consider the continuities of Rivera's work with Baroque forms of attention in the following chapter.[46] Here, though, my concern is Rivera's self-conscious engagement of indigenous modes of imagining.

Rivera's *incorporation* of the viewer—his inclusion of the viewer's body and his own in the spatial field of his murals—implies an aesthetic that corresponds to the indigenous image-as-presence. The image in prehispanic Mesoamerica is not a reflection of the world, but is *in* and *of* the world. Rivera's figures are incorporated into the physical world depicted in the murals, and into the space created by the murals themselves. The painting on the "altar" of Chapingo is titled *The Liberated Earth with Natural Forces Controlled by Man* (fig. 2.16). The monumental nude *is*

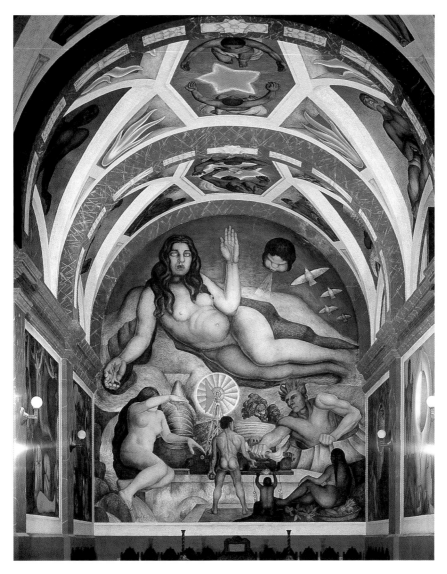

FIGURE 2.16 Diego Rivera, *The Liberated Earth with Natural Forces Controlled by Man* (fresco, 1925–27), Chapel at Chapingo, state of Mexico, Mexico. Instituto Nacional de Bellas Artes/Banco de México. Photograph: Bob Schalkwijk.

the liberated earth, the Mexican land: her figure is arranged in the shape of the Mexican territory, and her upraised hand (the Yucatan peninsula!) blesses the space over which she presides in Christ-like fashion. In fact, the figure is a portrait of Lupe Marín, Diego's first wife, who was pregnant with their second child. Facing her is a male nude who touches two electrical wires together in a gesture that sug-

gests man's technological control over nature. Despite the allegorical title of this "altarpiece," Rivera's most recent biographer Patrick Marnham argues that Chapingo is not about technology or liberation. He notes that the murals depict a total of seventeen female and two male nudes: "some innocent, some erotic and one quite alarming, the vast superhuman figure, like some profane God the Mother, with flowing locks, green eyes, strapping thighs, knotty hands and swelling, pregnant belly, thrusting aside her rib cage and breasts . . . [who] dominates the entire interior from its reclining position." He concludes: "The deeper message of Chapingo is not about politics, it is about sex" (93).

Perhaps, but the telluric charge of this figure is first and foremost political. The panels that line the walls of the nave depict ideological encounters: there are scenes of the Mexican "trinity" (worker, farmer, and soldier), a union organizer preaching to workers, and the dead body of a worker surrounded by mourning women, the composition of which is an explicit echo of Giotto's fresco of the death of Christ in the Scrovegni Chapel in Padua. Throughout, the transformation of Catholic images into Marxist and Mexican ones is striking. Consider the dual portrait of the revolutionary "martyrs" Emiliano Zapata and Otilio Montaño, tucked below an *oeil de boeuf* on the upper register of the east wall (color plate 11). They are wrapped in bloodstained shrouds and rest in niches hollowed out in the land. In death, they at last possess the earth they died to reclaim, and the earth also possesses them. Enacting a kind of revolutionary transubstantiation, their bodies nourish the corn that grows abundantly over their graves. In this intimate muralistic space, as well as in the monumental spaces of the National Palace and the Ministry of Public Education, Rivera listens to "the fragile ways in which the body makes itself heard," to repeat de Certeau's phrase. Incorporation and integration become the reigning structural principles of his mural art.

Rivera is often discussed together with his contemporaries, the muralists David Alfaro Siqueiros and José Clemente Orozco, and later with Rufino Tamayo; certainly they all combined indigenous iconography and European modes of visual expression, but Rivera exceeds the others in his knowledge of prehispanic traditions and in the self-consciousness of his transcultural agenda. I will, therefore, draw attention to only one other muralist who adopted the codices as cultural and cosmic precursor in the same spirit as Rivera: not Siqueiros or Orozco or Tamayo but Desiderio Hernández Xochitiotzin, who, from 1957 to 1968, created a visual epic in the graphic style of the codices in the Municipal Palace in Tlaxacala, an hour and a half east of Mexico City (fig. 2.17). The interior patio of this building is painted on all four sides with dense pictographic and alphabetic texts that encompass the histories and political relations of the prehispanic cultures of the region. These murals are almost fiercely historical, as if the muralist wished to reclaim a usurped history in both visual and verbal media. Here, the interaction of texts and images is explicit: beneath the murals are passages from chronicles by the Spanish colonizers of the region, Motolinía, Durán, Torquemada, and Muñoz Camargo,

PLATE 11 Diego Rivera, *Blood of the Revolutionary Martyrs Fertilizing the Earth* (fresco, 1925–27), Chapel at Chapingo, state of Mexico, Mexico. Instituto Nacional de Bellas Artes/ Banco de México. Photograph: Bob Schalkwijk.

which are accompanied in turn by pictographs from the codices; furthermore, a band of text runs between the murals and the texts, serving both as captions to the murals and headings for the texts. In the space surrounding an arch (fig. 2.18), Hernández Xochitiotzin traces his own artistic lineage back to the *tlacuilo,* his genealogy moving from bottom to top and culminating in the ideograph of abundance from the Codex Borbonicus, a tribute to the art of the codices and also to his more recent precursor, Diego Rivera. In their use of the codices, the intention of these muralists is similar, but their aesthetic approaches differ markedly. Hernández Xochitiotzin's murals are linear in their narrative structures whereas Rivera's structures fracture space and multiply perspectives; Rivera's visual histories don't progress, but circulate. In Cubist and codex fashion, Rivera engages simplified volumes and nonmimetic color to create dynamic spaces, whereas Hernández Xochitiotzin depends entirely upon a multitude of human figures. He fills his frescoes in Baroque fashion, as does Rivera, but where the latter integrates the embodied experience of the viewer into the mythic space of his murals, Xochitiotzin merely instructs the viewer in Mexican history.

Besides murals, visual echoes of the codices have passed into other popular

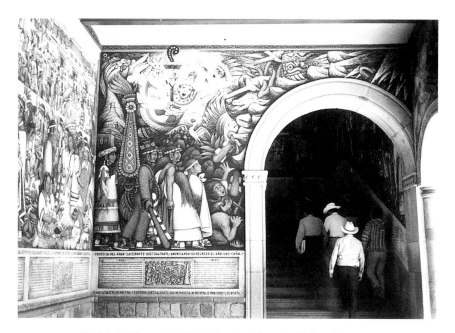

FIGURE 2.17 Desiderio Hernández Xochitiotzin. Municipal Palace (fresco, twentieth century), Tlaxcala, Mexico.

visual vernaculars including embroidery, ceramics and, appropriately, bark paintings. Magazines and books regularly contain motifs from the codices in advertising; an image from the Florentine Codex introduces Diana Kennedy's essential book on Mexican cuisine, and figures from the codices appear in Mexico City's subway stations and on walls along the *periférico* (beltway). Vestiges of the codices also persist in contemporary novelistic form.

FICTION AS FRESCO: ELENA GARRO'S *LOS RECUERDOS DEL PORVENIR* (*RECOLLECTIONS OF THINGS TO COME*) AND *LA SEMANA DE COLORES* (THE WEEK OF COLORS)

The epic mythologizing of Latin American history, so familiar in recent fiction, is conceptually related to modern muralism and also to the Mesoamerican codices. Elena Garro's 1963 novel *Los recuerdos del porvenir* (*Recollections of Things to Come*) and her as-yet-untranslated collection of stories, *La semana de colores* (The week of colors, 1989) reflect and construct an understanding of time and space related to both media, as does Eduardo Galeano's trilogy *Memoria del fuego* (*Memory of Fire*, 1982–86). To propose that these works engage the visual/performative structures and strategies of the codices and modern muralism is to suggest that conventional

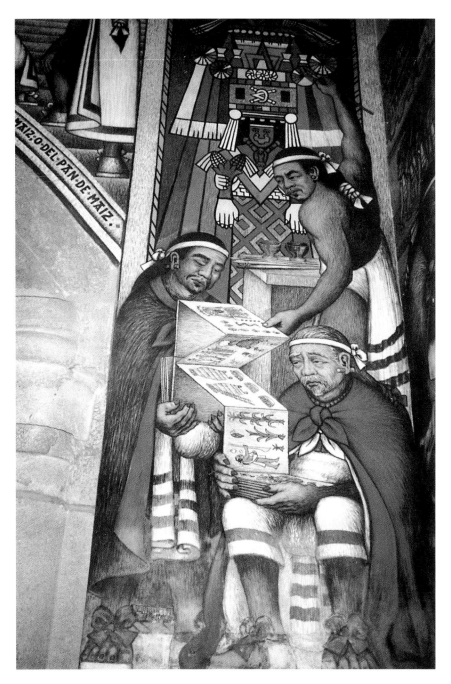

FIGURE 2.18 Desiderio Hernández Xochitiotzin (detail).

novelistic time and space (plot and setting) are subverted, and that individualized selves (characters) are at risk. We will see how this is so in the discussion that follows.

Of my literary examples, *Recollections of Things to Come* and *La semana de colores* are most directly linked to the codices. Garro was well acquainted with Mesoamerican forms of thought. In a 1975 interview, she describes Latin American historical consciousness as based in both Western and indigenous conceptions of time: "Above all, I have been interested in dealing with the theme of time, because I believe that there is a difference between the Western time that the Spaniards brought and the finite time that existed in the ancient Mexican world. I believe that this combination has given a special temporality to our culture and I wanted to recreate that new dimension."[47] The subject of her novel, as its title in Spanish suggests (literally, memories of the future), is the nature of time, a theme that a number of critics have noted. Jean Franco discovers various "temporalities at work in the novel—the disjunctive time of revolutionary change, the nostalgic time of memory, frozen time, festive and ritual time,"[48] and Amy Kaminsky does likewise, using Julia Kristeva's binaries of "monumental" and "historical" time to construct a reading that tests (and contests) Kristeva's ideas.[49] Neither critic considers Garro's own description of the "special temporality" of her novel.

Throughout *Recollections of Things to Come* the reader perceives the "new dimension" of time that Garro wishes to "recreate." Consider this passage, in which time is materialized and visualized:

> ¿De dónde llegan las fechas y a dónde van? Viajan un año entero y con la precisión de una saeta se clavan en el día señalado, *nos muestran un pasado, presente en el espacio,* nos deslumbran y se apagan. Se levantan puntuales de un tiempo invisible y en un instante recuperamos el fragmento de un gesto, la torre de una ciudad olvidada, las frases de los héroes disecadas en los libros o el asombro de la mañana del bautizo cuando nos dieron nombre.
>
> Basta decir la magia de una cifra para entrar en un espacio inmediato que habíamos obvidado. El primero de octubre es para siempre en mi memoria el día que empezó el juicio de los invitados.[50]

> [Where do dates come from, and where do they go? They travel for a whole year and, with the precision of an arrow, pierce the appointed day, *show us a past now present in space,* dazzle us, and burn out. They emerge punctually from an invisible time, and in an instant we recover the fragment of a gesture, the tower of a forgotten city, the words of heroes dissected in books, or the astonishment of the morning of our baptism when they gave us a name.
>
> To enter the nearby space we had forgotten, we merely have to utter the magic of a number. In my memory, October first will be forever the day when the trial of the guests began.][51]

Here, the space of time is not figurative but physical: it may be "entered" by saying the "magic of a number," and the date of one's baptism is an image of one's self.[52] Garro's dates "pierce the appointed day with the precision of an arrow," an image that echoes the Venus tables in the Codex Borgia (figs. 2.1 and 2.2 above) in which a variously personified Venus pierces the foot of a seated figure, who spouts blood. The position of Venus was crucial to the Nahuas, who traced this dangerous and powerful planet with great concern; in fact, Garro's word for the dates' piercing weapon (*saeta,* a word better translated "dart" than "arrow") is often used to describe the weapon carried by the embodiment of Venus in the Codex Borgia. For Garro's narrator, the date is a password into the mythic temporality of ancient Mexico, which was fraught with potential catastrophe and whose gods required constant ritual propitiation. So, too, the dictator of Garro's fictional town of Ixtepec, but unlike the ancient gods, there is no chance that General Rosas will be understood or appeased.

Following the passage I've just cited, Garro's narrative moves to a more conventional retrospective account of the events of that unforgettable October first, and before. But mythic projection and realistic retrospection continue to oscillate throughout *Recollections of Things to Come,* and the reader learns to chart their systole and diastole. It is Garro's tendency to recur to mythic structures the moment she introduces the political abuses that the novel dramatizes. Her story takes place during the Cristero rebellion, a millenarian uprising against government repression of the Catholic Church in the aftermath of the Mexican Revolution, primarily in the Mexican states of Jalisco, Michoacán, and Colima during the second half of the 1920s.[53] The larger-than-life General Rosas enters the village of Ixtepec and holds its population in thrall. Latin American dictator novels often depend upon Baroque iconography of evil, and upon Baroque strategies of self-reflection, multiplication, and exaggeration, as we will see in chapter 4. But Garro's dictator does not. Rather, his evil is made palpable in relation to the mythic space/time of the divinatory codices.

> Seguimos bajo su sombra inmóvil que repetía el mismo crimen una y otra vez con la precisión de un maniático. En su tiempo inmóvil los árboles no cambiaban de hojas, las estrellas estaban fijas, los verbos ir o venir eran el mismo, Francisco Rosas detenía la corriente amorosa que hace y deshace las palabras y los hechos y nos guardaba en su infierno circular. Los Moncada habían querido huir para hallar el ir y venir de las estrellas y de las mareas, el tiempo luminoso que gira alrededor del sol, el espacio donde las distancias están al alcance de la mano; habían querido escapar al día único y sangriento de Ixtepec, pero *Rosas abolió la puerta que nos lleva a la memoria del espacio* y rencoroso los culpó de las sombras inmóviles que él había acumulado sobre nosotros. . . . Su mundo fijo nos lo cobraba en crímenes. (262, my emphasis)

[We remained under his motionless shadow, which repeated the same crime over and over again with the painstaking precision of a maniac. In his immobile time the trees did not change their leaves, the stars were fixed, the verbs "to come" and "to go" were the same; Francisco Rosas stopped the amorous current that makes and unmakes words and deeds and kept us in his circular hell. The Moncadas had wanted to run away to find the coming and going of the stars and the tides, the luminous time that spins around the sun, the space where distances are within the reach of one's hand; they had wanted to escape from the single, bloody day of Ixtepec; but *Rosas abolished the door that leads us to the memory of space,* and rancorously he blamed them for the motionless shadows he had heaped on us. . . . We paid for his fixed world in crimes. (254–55, my emphasis)]

Under the dictatorship of Rosas, time is no longer transformative but "immobile"; spatial movement has been abolished; "the door that leads us to the memory of space" has been sealed. General Rosa's "motionless shadows," an image twice repeated in this passage, erase the "memory of space," without which time can no longer perform its cosmic dance. Rosas cancels the animate space/time in which the "we" of this community lives—or, rather, lived—for the town is gone, destroyed by political and social abuses. The voices we hear are those of the dead.[54]

Garro devises a dual narrator, a "we" who is the collective voice of the dead town and an "I" who is the stone promontory upon which the town once stood. The "I" narrator begins the novel:

Aquí estoy, sentado sobre esta piedra aparente. Sólo mi memoria sabe lo que encierra. La veo y me recuerdo, como el agua va al agua, así yo, melancólico, vengo a encontrarme en su imagen cubierta por el polvo, rodeada por las hierbas, encerrada en sí misma y condenada a la memoria y a su variado espejo. La veo, me veo y me transfiguro en multitudes de colores y tiempos. Estoy y estuve en muchos ojos. Yo sólo soy memoria y la memoria que de mí se tenga. (9)

[Here I sit on what looks like a stone. Only my memory knows what it holds. I see it and I remember, and as water flows into water, so I, melancholically, come to find myself in its image, covered with dust, surrounded by grass, self-contained, and condemned to memory and its variegated mirror. I see it, I see myself, and I am transfigured into a multitude of colors and times. I am and I was in many eyes. I am only memory and the memory that one has of me. (3)]

Vision plus movement equals history: like Quetzalcóatl and Guadalupe, Garro's narrative eye is reflected back by those who see it: "I am and I was in many eyes." The narrator sweeps across time and space, across communities and individual lives, telling stories about societies and selves. This "variegated mirror," like Rivera's murals, refuses a single perspective, and like his murals it recalls the Nahua

and Maya conception of "world-directions": north, south, east, west, and the center, the direction of up and down. So too, Garro's narrator: the earth is above and below and around the narrator, who circulates purposefully in space.

Garro struggles against her novelistic medium to overcome the conventional separation between teller and tale, suggesting instead a sentient continuity between them. The first-person narrator *is* the stone; the stone *contains* and *embodies* the story.[55] We have seen that prehispanic cultures posited the integral relations of human, natural, and cosmic realms; Garro's narrator/stone encodes the somatic reciprocity characteristic of the codices. Sensuous apprehension of form and color regularly defines the temporal experience of the narrator; in the paragraph cited above, the "variegated mirror" of memory suggests the narrator's combination of vision and movement, and his/her/its transformation into a "multitude of colors and times." Garro's characters, too, are described in terms of natural phenomena and communal structures. The eyes of one character, an outsider to the town, are described as "deep and [having] rivers and sheep bleating sadly in their depths." Another is "cut off from my voices, my streets, my people. Her dark eyes showed traces of cities and towers, distant and strange." And others, as we have seen, wish to escape Ixtepec to find "the comings and goings of the stars and the tides, the luminous time that spins around the sun." Topography, natural phenomena and the products of the land are registered in/as the characters' psychic terrain. This fluid movement from human to animal to earth to water and spirit reflects Mesoamerican indigenous ontology, in which humans do not stand apart from the rest of creation, and gods and heroes assume shifting forms and functions. So Garro's narrative voice becomes a kind of spirit-field that penetrates the earth and the people of Ixtepec.

Besides the narrator's, another body in this novel is eventually transformed into stone. Isabel, the novel's principal character, is deeply self-divided, double:

> Había dos Isabeles, una que deambulaba por los patios y las habitaciones y la otra que vivía en una esfera lejana . . . Y la Isabel suspendida podía desprenderse en cualquier instante, cruzar los espacios como un aerolito y caer en un tiempo desconocido. . . . Isabel podía convertirse en una estrella fugaz, huir y caer en el espacio sin dejar huellas visibles de ella misma. (29, 30)

> [There were two Isabels, one who wandered through the rooms and the patios, and the other who lived in a distant sphere. . . . The Isabel who was suspended could detach herself at any moment, traverse space like a meteor, and fall into an unknown time. . . . Isabel was capable of changing into a shooting star, of running away and falling into space without leaving a visible trace. (25, 26)]

Her double identity is, I believe, intended to engage the metamorphic identities of the Mesoamerican gods. The first Isabel becomes a stone that does not partic-

ipate in the world's body as does the stone/narrator. At the end of the novel, she is silenced and her story carved in stone, a fixed re-presentation of her life, a tale forever separated from its teller. But the second Isabel seems to become Garro's narrator, embodying the interpenetration of consciousness and world. The narrator, like an ancient sculpture, is to be understood as a concept in stone, an apotheosis of communal beliefs in material form. On the contrary, the first Isabel is petrified by way of punishment.

Recollections of Things to Come traces what happens when humans subvert the relations of earth and spirit, and no one can redress the violations. On a political level, we may take the novel as a dramatization of the imposition of European spatial perspective (homogenous, uniform, and absolute) upon American territory, with General Rosas playing the role of imperial agent.[56] Or again, we may read the novel in terms of Michel Foucault's parallel argument that time overpowers space in cultures colonized by Europe and the United States.[57] But in fact, New World Baroque forms have largely resisted the imposition of linear time on American time/space; in subsequent chapters, we will see how fragments of the past are integrated into New World Baroque settings, bringing partial histories into inordinate spatial relation. Garro's narrative structure recuperates indigenous time/space and puts it in motion in her twentieth-century setting, affirming the agrarian, communitarian, mythic underpinnings of Mexico's indigenous heritage, even as she describes its disruption and demise.

We are told that the stone/narrator of *Recollections of Things to Come* is transfigured into a "multitude of colors and times," a metaphor that pervades the thirteen short stories in Garro's collection *La semana de colores.* Each of these stories has as its theme the nature of time, and each reflects the author's understanding of the volatile space of indigenous Mesoamerican time. We have seen the Nahuas' and Mayas' conception of days as animate beings or objects or entities that could be divined through ritual calendrical calculations. The twenty named days, with their twenty related dieties, reflected the operations of supernatural forces in the world of human activity and so, too, in the stories of *La semana de colores,* time is given a physical presence and a personality. It has a disposition and inclination in the double sense I described above, and Garro's characters perform accordingly. Every story contains instances of materialized time—indeed, the trope begins to wear thin over the course of the collection. Here I'll discuss three examples: the title story, "La semana de colores," "El día que fuimos perros" (The day we were dogs), and "¿Qué hora es . . . ?" (What time is it . . . ?).

In "La semana de colores," Don Flor is a *curandero* whom the villagers view with suspicion and visit secretly, but the story is narrated from the point of view of two young girls who are neither suspicious nor secretive. They enter Don Flor's ramshackle house and report his activities without skepticism. So the story begins: "Don Flor le pegó al Domingo hasta sacarle sangre y el Viernes también salió morado en la golpiza" (Don Flor hit Sunday until the blood ran and Friday, too,

turned black and blue from the beating).[58] Each Day—the word is capitalized, as are the names of the days, which is not normally the case in Spanish—occupies a room in Don Flor's house that is painted to match the characteristics attributed by Don Flor to that Day—and each is embodied as a woman. The girls and Don Flor work their way backward through the Week: Sunday's room is labeled Lust and Generosity and is painted red; Saturday's room is labeled Laziness and Chastity and is dark pink; Friday's room is purple, and labeled Pride and Diligence; Thursday's orange, Anger and Modesty; Wednesday's green, Envy and Patience; Tuesday's pale yellow, Avarice and Abstinence; Monday's blue, Gluttony and Humility. The assignment of significance to colors and the dual disposition of the Days again reflect Mesoamerican thought, as we have seen in the personification of the god Ometéotl and his metamorphic son Tezcatlipoca. Dualities are complementary rather than oppositional; contradictory forces operate without canceling each other out.[59]

Don Flor leads the girls from room to room, raging against the "mujer perversa," the Day occupying that particular room. After the tour of the house, he urges the girls to choose the Day they wish to see bleed. The girls become frightened for, the narrator tells us:

> Su padre les explicó que los días eran blancos y que la única semana era la Semana Santa: Domingo de Ramos, Lunes Santo, Martes Santo, Miércoles Santo, Jueves Santo, Viernes de Dolores, Sábado de Gloria y Domingo de Resurrección. . . . Ya se quedaron como pájaros, brincando de la Semana Santa a la Semana de Colores encerrada en la casa de don Flor. (71–72)

> [Their father had told them that the days were colorless and that the only week was Holy Week: Palm Sunday, Holy Monday, Holy Tuesday, Ash Wednesday, Maundy Thursday, Good Friday, Holy Saturday, Easter Sunday. . . . Now they were like birds, jumping from Holy Week to the Week of Colors enclosed in the house of Don Flor.]

The girls are caught between two mythic systems, and it seems that a madman is their mediator. If we were to ignore the indigenous conceptions of spatialized time and personified destiny that operate in this story (not only does Don Flor rage against the Days, but the Days are said to take their revenge by killing him and then escaping) we might conclude that this unexplained violence is the result of Don Flor's madness and misogyny, or perhaps the girls' gullibility. Indeed, *not* to take account of the cultural specificity of Garro's Days is to read the story as nothing more than a regionalist narrative about local superstitions, or a failed allegory of domestic abuse.[60] Without knowing of Garro's interest in the nature of ancient Mesoamerican space/time, we would miss the fact that Don Flor's behavior, however mad and *machista*, is designed to represent the *tonalamatl*'s "count of days and

their influence on destinies." His actions embody his understanding of their operations in his life, and his agency in those operations.

It is tempting to impose a Western understanding of "fate" or "destiny" upon Garro's story. Indeed, the Mesoamerican conception of time/space encodes the terrible power of the gods over human affairs in ways that recall Greek tragedy. But we would limit our reading if we were to do so, for the Greek construction of reality as external to human intention differs significantly from the Mesoamerican conception of human agency. Don Flor is active in the space of time (however futile his activity may seem to the contemporary reader); he is influential, propitiatory, and even nourishing, as Nahua and Maya priests sacrificed human beings to nourish the sun and thus assure cosmic continuance. Don Flor dies, but the Days do not; in this story, the ancient space/time survives. *their dogs came with them?*

Garro's story "El día que fuimos perros" (The day we were dogs) is about two young girls who are indistinguishable from those in "La semana de colores" (The week of colors). They appear in others of the stories as well, and seem somehow to be twin alter egos of the author's younger self. In this story, Eva and her playmate metamorphose into dogs, a transformation that we understand at first to be part of a children's game of make-believe. But the metamorphosis is more portentous than ordinary make-believe:

> Despertamos a las seis de la mañana y supimos que era un día con dos días adentro. Echada boca arriba, Eva abrió los ojos y, sin cambiar de postura, miró a un día y miró al otro. . . . el nuevo día brillaba doble e intacto. Eva miró los dos días. (73)

> [We woke at six in the morning and we knew that it was a day with two days inside it. Sprawled on her back, Eva opened her eyes and without changing position looked at one day and then the other . . . the new day shone double and intact. Eva looked at the two days.]

The narrator, whose point of view is that of the girls, repeatedly emphasizes the spatial character of the temporal medium. The day we were dogs is situated outside the house, has a floor and walls, and the girls exist inside it: "El día se volvió sólido, el cielo violeta se cargó de papelones oscuros y el miedo se instaló en los pilares y las plantas" (73) (The day became solid, the violet sky filled with dark streamers, and fear inhabited the pillars and plants). The solid space of the dog-day seems like a kennel, but without the sense of incarceration that a kennel suggests. On the contrary, the dog-day is a liberation from the time of the house, but the story ends as the girls fall asleep, aware that they have lost the day they were dogs.

"¿Qué hora es . . . ?" (What time is it?) also proposes an alternative temporality. A South American woman of a certain age checks into a European hotel (seemingly in Paris) and begins to ask obsessively what time it is. Worse, she asks obses-

sively whether it is 9:47, the moment when a plane is supposed to arrive from London with her lover. The lover fails to arrive, and day after day the woman asks if it is 9:47; the days pass into months and still the lover doesn't arrive. Again Garro makes time spatial and material; it assumes weight, bulk, burden: "el tiempo se ha vuelto de piedra . . . ese amontonamiento de minutos y de rocas . . ." (50–51) (time has become stone . . . this pile of minutes and rocks). Like the time of the dictatorship in *Recollections of Things to Come,* time in this story is "immobile"; the lover appears too late, and "the door that leads us to the memory of space" is once again sealed. Only in "La semana de colores" is mythic time projected beyond the end of Garro's narration, but Mesoamerican time/space is nonetheless privileged throughout. Cultures are cumulative, and Garro self-consciously includes voices silenced by the "triumphal *conquista*" of writing, as de Certeau puts it, and sets them in motion, "like dancers passing through the field of the other."

How else might the codices and murals shed light on contemporary Latin American literary practice? To approach *Memory of Fire,* the trilogy by the Uruguayan writer Eduardo Galeano, I cite a description of the characters in Carlos Fuentes's first novel, *La región más transparente* (*Where the Air is Clear*). The description was written by the Mexican historian Enrique Krauze in an article entitled "Guerrilla Dandy," which was first published in English in the *New Republic,* and then in Spanish in Octavio Paz's magazine *Vuelta.* The article precipitated the permanent rupture between Fuentes and Paz; Krauze, serving as henchman, denigrated Fuentes's fiction by comparing it to a mural by Diego Rivera:

> Fuentes's first novel does not recall Balzac so much as the great actor of painting, Diego Rivera: *immense texts and murals that proceed more by accumulation and schematic juxtaposition* than by imaginative connection. Both are painfully rigid in suggesting the inner lives of their themes and characters, both treat them as theses or burden them with a didacticism that grows tedious; both have recourse to allegory. Texts that are murals, murals that are texts. The best of Rivera is the flowering of his forms and colors. The best of Fuentes is the verbal avalanche of his prose.[61]

Krauze is wrong about the novel's lack of "imaginative connection," but I find his description of Fuentes's structural procedures to be accurate and insightful (rather than insulting, as he intends): accumulation and juxtaposition, allegory, forms and colors, an avalanche of prose. In any case, Krauze's evaluation is absurd because he erroneously assumes that Rivera and Fuentes wished to portray "inner lives." Rivera never intended to create psychological art (far from it) nor did Fuentes aim to focus on individual relationships in *La región más transparente.* Communal

history, not individuals, is their protagonist. Rivera and Fuentes project the broad outlines of social and political relations; they are artists of the collective. I will consider allegory—Krauze's supposed abomination—in my discussion of García Márquez and Borges in chapters 4 and 5, but here let's address his other abominations, "accumulation and schematic juxtaposition."

These are precisely the devices that structure Eduardo Galeano's brilliant trilogy *Memory of Fire*. If Elena Garro engages metaphoric narrative strategies to encompass Mexico's multiple histories, Galeano's strategies are architectonic; and if Garro recuperates the codices from her position within a culture of transculturated indigenous forms and beliefs, the Uruguayan writer Galeano mobilizes indigenous histories from elsewhere in the hemisphere. Despite their very different cultural positioning with respect to the Mesoamerican codices, Galeano shares with Garro the epic impulse to incorporate the space/time of their historical display. Galeano's work, like Garro's, is inordinate in its temporal and spatial ambitions.

The volumes that comprise *Memory of Fire, Los nacimientos* (*Genesis*, 1982), *Las caras y las máscaras* (*Faces and Masks*, 1984), and *Siglo del viento* (*Century of the Wind*, 1986), together accumulate and juxtapose fragments taken from a millennium of histories and cultures throughout the Americas. Each volume contains hundreds of narrative fragments—entries or scenes that are connected to one another and also complete in themselves. The entries are models of condensation—short short stories that depend upon irony to compress historical and human contradictions into miniature narrative structures. Most are dated and arranged in chronological order; only those from prehispanic sources and other mythic texts are without date. Each entry is also located by city or region (again, with the exception of the mythic narratives) and based on a historical source (whether written, oral or visual, primary or secondary) that is identified by a number (or numbers) at the end of the entry. These numbers refer the reader to a bibliography of around five hundred titles at the end of each of the three volumes; when italics are used in the entry, it indicates direct quotation from the historical source. An index rounds off this surprisingly academic apparatus.

Rare is the entry that is more than half a page long; often a page contains two or three entries, so we might say that mosaic, rather than fresco, is Galeano's muralistic medium. In fact, it is both: extending the metaphor, we might think of his trilogy as three large panels that display the history of the Americas in spaces filled with myriad glittering fragments. The first volume, *Genesis*, moves from prehispanic creation narratives through the historical events of conquest and colonization; the last three fragments are dated 1700. The second volume, *Faces and Masks*, begins in 1701 in the Salinas Valley and ends in 1900 with six scenes located in Mexico City, Mérida, and Tabi, Yucatan. The third volume, *Century of the Wind*, continues in 1901 with three fragments located in San José de Gracia, West Orange, New Jersey, and Montevideo, and ends in 1984 with sixteen fragments from fourteen different places. There follows one final fragment in italics, a letter dated 1986

from Galeano in Montevideo to Cedric Belfrage, his translator in Mexico; the latter pretends to accompany the manuscript of this third and last volume of the trilogy. So Galeano puts himself into his own mosaic of history: "y ahora yo me siento más que nunca orgulloso de haber nacido en América, en esta mierda, en esta maravilla, durante el siglo del viento" ("and now I feel prouder than ever of having been born in America, in this shit, in this marvel, during the century of wind").[62]

Recalling Krauze's phrase, Galeano's "accumulation and schematic juxtaposition" resembles Rivera's serial structures more closely than it does the progressive movement of conventional prose fiction. The reader may enter the trilogy at any point and pursue the text in any direction because the fragments are not explicitly connected by plot or setting except as the whole history and geography of the Americas are its plot and setting. They are not placed in fixed syntagmatic relation, as prose narration requires, though occasional clusters of contiguous fragments crystallize into volatile configurations within the trilogy's larger historical display. The space/time of Galeano's texts depends upon the mobility of its parts: we skip from entry to entry, and from entries to bibliography, as we also jump from Mexico City to Managua to Hollywood to Havana to Escuinapa, from myth to historical event, from archetype to irony, without concern for causal connection. What we experience is the movement of events and persons in phenomenological space, and the accumulation of energies that operate (often catastrophically) in the lives of communities and nations.

Despite the chronological organization of the narrative fragments, then, the relations of the entries are less temporal than spatial; their relations are experienced not as succession but as circulation. In an essay entitled "Space as an Image of Time," the psychologist of art Rudolph Arnheim describes this form of attention: "The task of the recipient is the reverse of that of the creator of the work. He must integrate the temporal succession and translate it into a spatial image. . . . the peephole vistas, the point-sized observations must be gathered into a surveyable whole. The instrument by which the mind accomplishes this translation of time into space is what psychologists call memory."[63] Arnheim's description suggests that all historical narratives must be translated into spatial images if they are to be remembered, but Galeano's structure is explicit about this process in ways that less fragmentary narratives are not. *Memory of Fire* foregrounds the textual translation of history into a structure whereby the reader surveys events as if they were coexistent, present, and visible. Carlos Fuentes uses an analogous trope, the Renaissance theatre of memory, in *Terra nostra;*[64] Galeano's entries, like Fuentes's short chapters in *Terra nostra,* become images in themselves, visualized scenes within a larger presentation of American history. And like Rivera's murals, participation rather than singular perspective is encoded in the structure of *Memory of Fire;* Galeano places his readers in the midst of signifying space and asks us to envision mobile constellations of meaning.

The capacity of this trilogy to mythologize realistic description depends upon

these architectonic strategies, which refract and multiply narrative perspectives. Galeano's entries on Mexican muralism suggest his awareness of the analogy between his structure and theirs. Consecutive entries are labeled with the year 1924 and located in Mexico City: the first is titled "Diego Rivera," the second "Orozco," the third "Siqueiros." These entries are miniature texts on the "big three," and they weave an intertwining triple portrait: in "Diego Rivera," we are told that Diego "paints the people, all the peoples of Mexico, united in an epic of work and war and fiesta." "Orozco" compares Rivera to Orozco: "Diego Rivera rounds out, José Clemente Orozco sharpens. Rivera paints sensualities: bodies of corn flesh, voluptuous fruits. Orozco paints desperations: skin-and-bone bodies, a maguey mutilated and bleeding" (60). Gaining momentum with each scene, "Siqueiros" adds the third part of the triumvirate: Siqueiros is "spectacular, bombastic, turbulent [whereas] Orozco practices painting as a ceremony of solitude. For Siqueiros painting is an act of militant solidarity" (60–61).

This three-point constellation is framed by two entries that refer to the audience of the Mexican murals. The first, "Nationalizing the Walls," begins: "Easel art invites confinement. The mural, on the other hand, offers itself to the passing multitude. People may be illiterate but they are not blind" (59). Galeano's narrator generalizes the muralists's aesthetic: their viewers have become the *subjects* of history rather than its *objects*, actors rather than pawns. The other entry is entitled "The People Are the Hero of Mexican Mural Painting, Says Diego Rivera," and is undated (i.e., mythic); in it, Galeano quotes verbatim a statement by Rivera about the communal function of art and the Mexican muralist movement:

> *Hasta entonces los héroes de la pintura mural habían sido los dioses, los ángeles, los arcángeles, los santos, los héroes de la guerra, los reyes y emperadores y prelados, los grandes jefes militares y políticos, apareciendo el pueblo como el coro alrededor de los personajes estelares de la tragedia . . .* (74)

> [*Until then, the heroes of mural painting had been gods, angels, archangels, saints, war heroes, kings and emperors, prelates, and great military and political chiefs, the people appearing as the chorus around the star personalities of the tragedy . . .* (61)]

Rivera's reconstitution of the protagonists of mural painting is not lost on Galeano, whose literary project coincides with Rivera's artistic agenda. Galeano's heroes include hundreds of figures known and unknown, including Rivera, of course, and many other politically committed artists: García Márquez, for example, whose Nobel Prize speech is partially quoted under the heading "1982: Stockholm." That Galeano selects García Márquez's statement about the difficulty of expressing Latin American realities is hardly surprising: "La interpretación de nuestra realidad con esquemas ajenos sólo contribuye a hacernos cada vez menos libres, cada

vez más solitarios" (318); ("The interpretation of our reality through patterns not our own serves only to make us ever more unknown, ever less free, ever more solitary" [262]). Galeano's endeavor, like García Márquez's and Rivera's, is to engage patterns that *are* his own, to include *all* Latin American expressive forms in his *Memory of Fire.*

Several entries in *Faces and Masks* engage visual forms that are uniquely Latin American in their transcultural recodings. In "1716: Potosí, Holguín" and "1716 Cuzco, Los imagineros" ("The Image Makers"), Galeano describes painters upon whose canvases parrots soar with Baroque angels, and whose bowls of avocados and chilies grace the table of the Last Supper. Melchor Pérez Holguín, who worked in Potosí, Alto Perú (now Bolivia), depicts religious scenes in Andean settings, with saints and virgins in local garb doing everyday things in everyday ways (fig. 2.19). About Pérez Holguín, Galeano's narrator speculates: "[he] doesn't know that the marvel is the thing he is creating, believing he is just copying; nor does he know that his work will remain alive when the pomp of Potosí has been blotted from the face of the earth and no one can remember any viceroy."[65]

Following these dated entries, three undated ones narrate transculturated Andean myths; I cite in its entirety the first of these "point-sized observations," to repeat Arnheim's term:

María, Madre Tierra

En las iglesias de estas comarcas suele verse a la Virgen coronada de plumas o protegida por parasoles, como princesa inca, y a Dios Padre en forma de sol, entre monos que sostienen columnas y molduras que ofrecen frutas y peces y aves del trópico.

Un lienzo sin firma muestra a la Virgen María en el cerro de plata de Potosí, entre el sol y la luna. A un costado tiene al papa de Roma y al otro al rey de España. Pero María no está sobre el cerro sino *dentro* de él, *es* el cerro, un cerro con cara de mujer y manos de ofrenda, María-cerro, María-piedra, fecundada por Dios como fecunda el sol a la tierra.

[Mary, Mother Earth

In churches hereabouts it is common to see the Virgin crowned with feathers or protected by parasols, like an Inca princess, and God the Father in the shape of a sun amid monkeys holding up columns and moldings adorned with tropical fruits, fish, and birds.

An unsigned canvas shows the Virgin Mary in the silver mountain of Potosí, between the sun and moon. On one side is the pope of Rome, on the other the king of Spain. Mary, however, is not on the mountain by *inside* it; she *is* the mountain, a mountain with woman's face and outstretched hands, Mary-mountain, Mary-stone, fertilized by God as the sun fertilizes the land.][66]

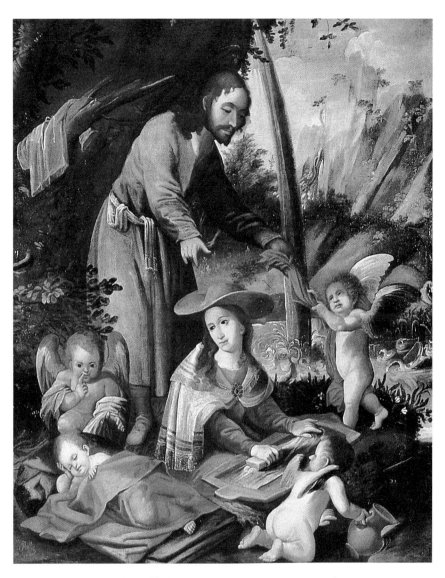

FIGURE 2.19 Melchor Pérez Holguín, *Rest on the Flight into Egypt* (*The Laundering Virgin*) (eighteenth century), Bolivia. National Museum of Art, La Paz. Photograph: Pedro Querejazu.

In Peru, as in Mexico, the reciprocity of human and natural forms characterizes the indigenous image-as-presence (fig. 2.20): the anonymous painter's (and Galeano's) "Mary-mountain, Mary-stone" recalls Garro's narrator-stone and Rivera's underground heroes. The earth is animate, and its subterranean forms are visible.

I take as my concluding textual example the most affecting of Galeano's treatments of the Mesoamerican codices. Titled "1562: Maní, Se equivoca el fuego" ("1562: Maní, The Fire Blunders"), it envisions the infamous bonfire of Maya codices set by the Franciscan Diego de Landa, whom we encountered in chapter 1. Galeano's narrator describes the scene:

> Esta noche se convierten en cenizas ocho siglos de literatura maya. En estos largos pliegos de papel de corteza, hablaban los signos y las imágenes: contaban los trabajos y los días, los sueños y las guerras de un pueblo nacido antes que Cristo. Con pinceles de cerdas de jabalí, los sabedores de cosas habían pintado estos libros alumbrados, alumbradores, para que los nietos de los nietos no fueran ciegos y supieran verse y ver la historia de los suyos, para que conocieran el movimiento de las estrellas, la frecuencia de los eclipses y las profecías de los dioses, y para que pudieran llamar a las lluvias y a las buenas cosechas de maíz.

> [Tonight, eight centuries of Mayan literature turn to ashes. On these long sheets of bark paper, signs and images spoke: they told of work done and days spent, of the dreams and the wars of a people born before Christ. With hog-bristle brushes, the knowers of things had painted these illuminated, illuminating books so that the grandchildren's grandchildren should not be blind, should know how to see themselves and see the history of their folk, so they should know the movements of the stars, the frequency of eclipses and the prophecies of the gods and so they could call for rains and good corn harvests.][67]

Galeano's narrator laments the loss of virtually the entire written record of the Mayas, but the narrator also knows that memory does not depend upon documents alone:

> Cuando le queman sus casitas de papel, la memoria encuentra refugio en las bocas que cantan las glorias de los hombres y los dioses, *cantares que de gente en gente quedan,* y en los cuerpos que danzan al son de los troncos huecos, los caparazones de tortuga y las flautas de caña. (158; Galeano's emphasis)

> [When its little paper houses are burned, memory finds refuge in mouths that sing the glories of men and of gods, *songs that stay on from people to people* and in bodies that dance to the sound of hollow trunks, tortoise shells, and reed flutes. (137, Galeano's italics)]

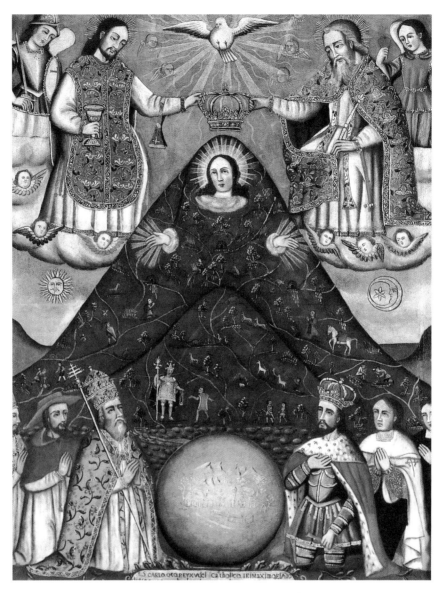

FIGURE 2.20 Anon., *Virgen-Cerro* (Virgin of the mountain) (eighteenth century), Bolivia. Casa de la Moneda de Potosí. Fundación Cultural Banco Central de Bolivia. Photograph: Pedro Querejazu.

Galeano's *tlacuilos* are *sabedores de cosas* (knowers of things), and what they know has survived by corporeal means: "eyes to see themselves and their history," "memory finds refuge in mouths," "bodies that dance." Like the knowers of things, Galeano creates a structure designed to approximate *in tlili in tlapalli*, red ink, black ink, in modern form. Time and space are inscribed in the body's memory, as the epigraph to his *Book of Embraces* (1989) affirms: "*Recordar:* To remember; from the Latin *re-cordis*, to pass back through the heart."[68]

JORGE IBARGÜENGOITIA'S *ESTAS RUINAS QUE VES (THESE RUINS YOU SEE)*

Possible connections between muralism, the codices, and contemporary Latin American literature abound. Carlos Fuentes's *Terra nostra* (1975) and Reinaldo Arenas's *El mundo alucinante* (translated as *The Ill-Fated Peregrinations of Fray Servando,* 1969) move between history and myth by means of metaphoric and narrative procedures that work to displace linear temporal progression in favor of a medium that is synchronic and spatially organized. Alejo Carpentier's *Los pasos perdidos* (*The Lost Steps,* 1953) and Rosario Castellanos's *Balún canán* (1957) take as their subject the mythic temporality of indigenous cultures, weighing modern notions of time-as-progression against indigenous conceptions of time-as-presence. Juan Rulfo's *Pedro Páramo* (1955) and Mario Vargas Llosa's *El hablador* (*The Story-teller,* 1987) also unsettle conventional novelistic structure by proposing a performative space in which voices echo from other worlds and times.[69] In each of these novels the separation between past and present, life and death, individuals and communities, is undone. Cultures and families do not die; they cohabit.

It is not my aim to multiply examples but to offer one more, and then draw some conclusions about the nature of the New World Baroque that operates in these texts. The Mexican author Jorge Ibargüengoitia has an acute eye for bombast and polemical pretension, so it is not surprising that he finds a perfect target in the heroic hermeneutics of Mexican muralism. The polemical art of the Mexican Revolution had no time for irony or ambiguity, nor did Rivera's Marxism encourage him to question his love for industrial technology, all in the name of the advancement and celebration of the worker. It is precisely Rivera's muralistic combination of indigenous myth and Western technology that Ibargüengoitia parodies to perfection in his untranslated novel *Estas ruinas que ves* (These ruins you see, 1975).

This novel, like several of Ibargüengoitia's, is set in a provincial Mexican state called Plan de Abajo (literally "map of below" or "lowlands"). The narrative involves a group of middle-class men who decide one fine day to paint a mural in a local *pulquería* (cantina). *Pulquerías* take their name from *pulque,* the least distilled of the spirits taken from the agave cactus, the most distilled being *tequila. Pulquerías* were (and are) often painted with murals of questionable aesthetic value but fas-

cinating cultural significance, including the one painted by Frida Kahlo on the outside wall of a *pulquería* near her home in Coyoacán, then on the outskirts of Mexico City. Ibargüengoitia's characters call their mural *The Mechanical Eve,* a parody of Rivera's mythologized female body and its filiation with machines. We have glimpsed the connection between mother earth and father technology in Rivera's altarpiece at Chapingo (fig. 2.16, above); here, Ibargüengoitia refers implicitly to Rivera's mechanized figure of the Mexica goddess Coatlicue in his Detroit Industry murals (figs. 3.11 and 3.12). So Ibargüengoitia's characters set to work:

> Después de este comentario nos dedicamos a la creación. Los medidores de la luz eléctrica se convirtieron en los pechos de la Eva Mecánica—título de nuestro mural—que aparecía a la derecha de la composición, recostada sobre un verde prado—la pintura que ya estaba sobre el muro, a la que agregamos unas florecitas—y cubierta con hilos de perlas—que tuvimos que agregar a fuerzas, porque don Leandro consideró que los pechos de fuera, aunque fueran dos medidores, eran desnudez suficiente—; la puerta condenada se convirtió en un torreón, entre cuyas almenas asomaba una misteriosa figura de negro que aparentemente dirigía los movimientos de la Eva Mecánica por medio de los alambres—los cables de la luz—. Por último, para justificar un cable vertical que estaba en la parte izquierda del muro, Malagón pintó en el extremo inferior, la figura de un ahorcado, y en el superior, la rama de un flamboyán—el toque de color. La parte superior del muro la pintamos azul claro: era el cielo.[70]

> [After that comment, we set to the work of creation. The electricity meters became the breasts of Mechanical Eve—as we called our mural—who appeared on the right side of our composition, lying in a green meadow—the color that was already on the wall, to which we added some little flowers. She was covered with strings of pearls, which we were obliged to add because Don Leandro considered that the bare breasts, even though they were electricity meters, were more than enough nudity; the door that had been bricked up was made into a tower, and between the turrets appeared a mysterious black figure who seemed to control the movements of Mechanical Eve by means of wires—the electrical cables. Then, to justify a vertical cable on the left side of the wall, Malagón painted a hanged figure on the bottom end of it, and on the top, a branch of a flame tree—for a touch of color. The upper part of the mural we painted light blue: that was the sky.]

Incorporation is no longer a mythic strategy but a satiric one; content is no longer political but parodic.[71] This passage would seem to conform to Borges's famous definition of the Baroque as "a style which deliberately exhausts (or tries to exhaust) all its possibilities and which borders on its own parody."[72]

In the following chapters, we will elaborate the parodic self-reflexiveness of Baroque forms, as well as other characteristics of the New World Baroque that have

been touched upon here: structures of movement and mutability; blurred boundaries between image and object; paradox and other balanced contrasts; history and memory represented as spatial setting; archetype and allegory designed to generalize (and sometimes mythologize) postcolonial positions; structures of exuberant inclusion as a response to the *horror vacui* of political and social abuse. The monumental production of Rivera, the mythic dimensions of Garro and the textual abundance of Galeano are designed to fill the vacuum of Latin American historical and cultural identity, just as the European Baroque reacted to the newly voided universe of the seventeenth century by filling its artistic spaces with intricate designs of infinite aspiration. If, according to Michel Foucault in *Les mots et les choses* (*The Order of Things*), the Baroque inaugurates the modern separation of words from things, then the New World Baroque contests that separation even as it engages Baroque forms of expression. Words and images are not cordoned off from their objects by a discourse of re-presentation, and selves still circulate in dynamic structures of relation. We will return to Foucault's assertion in chapter 5, but now I want to follow this thread of our discussion: the New World Baroque as an instrument of Latin American cultural autonomy.

3

The New World Baroque and the Dynamics of Displacement

CARPENTIER, DE NOMÉ, LEZAMA LIMA, AND SARDUY

> . . . la novela es un medio de conocimiento, de investigación que llega más allá de la arquitectura, de la pintura.

> . . . the novel is a medium of knowledge, of research that goes beyond architecture and painting.

ALEJO CARPENTIER[1]

The New World Baroque was first theorized as a postcolonial poetics by the Cuban writer Alejo Carpentier. As early as the 1920s, he intuited the inadequacy of formalist interpretations of art and, more precisely, the impossibility of formalist efforts to maintain the separateness of art from its cultural circumstances. Such exclusionary efforts were especially inappropriate in Latin American cultures, whose major challenges were *in*clusionary: what was required, Carpentier felt, was a theory that could overarch the interactions of artistic forms and historical forces, and a literature that could encompass the historical processes whereby cultural forms had been uprooted, transplanted, and reconstituted in New World contexts. Under the sign of the Baroque, Carpentier undertook this challenge. He rejected the idea that the Baroque style flourished only during the seventeenth century, the period designated by historians of European art, and proposed instead a "constant of the human spirit" that " can reappear at any moment and does . . . because it is a *spirit* and not a *historical style*."[2] This amplified Baroque served Carpentier's project of

cultural self-definition, allowing him to develop a theory of transculturation appropriate to Latin American historical experience. From his first novel in 1933 until his last one in 1979, he dramatized this theory, invariably setting in motion fictional interactions among European, American, and African characters and expressive forms. The narrative tension generated by inordinate cultural perspectives provides his most basic plot device, as we will see in *El siglo de las luces* (1962, translated as *Explosion in a Cathedral*) and *Concierto barroco* (1974, published in English under the Spanish title). During the course of my discussion, I will also refer to other writers, principal among them José Lezama Lima and Severo Sarduy, who, along with Carpentier, removed the New World Baroque from its art historical niche and transformed it into an ideology and aesthetics of cultural difference.[3]

Carpentier was born in 1904 and died in 1980; his parents immigrated to Cuba in 1902, his mother of Russian origin, his father French and an architect, a point of interest given Carpentier's predilection for Baroque architectural spaces. He spent more than thirty years of his adult life in France—he spoke Spanish with a French accent, his father's tongue competing with his mother tongue, as Roberto González Echevarría puts it in his biography of the writer.[4] Carpentier lived the entire decade of the 1930s in Paris, where he was in close contact with Surrealist writers and painters. Returning to Cuba in 1939, he felt, and forcefully expressed the need for Latin American artists to examine the discontinuities—and the continuities—of Old and New World cultures and histories. As he formulated the question of the relation of European cultural forms to New World modes of expression, he made "a conscious and concerted attempt to encompass the Latin American experience as a whole, without undue concern for regional or national boundaries," as Carlos Fuentes would say of Carpentier early in his own career.[5] These transcultural concerns were to make Carpentier the progenitor of the subsequent generation of novelists in Latin America, a precursor without whom the work of Garro, Galeano, García Márquez, Fuentes, and many others would not have been possible. After returning from France in 1939, Carpentier stayed in Cuba for six years, until 1945, moving that year to Caracas and returning to Havana only after the conclusion of the Cuban Revolution in 1959. Again he stayed in Havana for six years, then in 1966 proceeded one more time to Paris where, as Cuban cultural attaché, he remained until his death in 1980. Besides being a great literary intellectual, Carpentier was a lifelong student of the plastic arts (among which he included music), and he regularly engaged these media to structure his narrative accounts of the Baroque New World.

THE RECOVERY OF THE BAROQUE FOR NEW WORLD PURPOSES

Carpentier's evolving theory of the New World Baroque moves from Cuba to Mexico to France, Belgium and Spain, and then back again to "toda Latino-

américa," the last a conceptual space as well as a geographical territory.[6] An indispensable collection of Carpentier's interviews, published in Cuba in 1985 and spanning almost fifty years, allows us to trace this trajectory in some detail. In numerous interviews, Carpentier mentions his first visit to Mexico in 1926 and, in particular, his awakening to the political, cultural, and aesthetic project of Mexican muralism. In a 1975 interview entitled "Reyes, Orozco y Rivera fueron mis maestros" (Reyes, Orozco and Rivera were my teachers), Carpentier states:

> Vine por primera vez a México en 1926, había cumplido veintiún años. . . . Ese viaje fue mi iniciación. . . . tuve la inmensa suerte de hacerme amigo, de conocer, de vivir y de ver trabajar a esos gigantes de la pintura universal: Diego Rivera y Clemente Orozco me enseñaron a conocer el mundo, a valorizar los valores autóctonos, nacionales y auténticos de México. . . . Entonces viví los días más importantes para mi formación intelectual. Aprendí que el movimiento iniciado por los grandes mexicanos en la cultura universal era digno de tomarse en ejemplo en toda Latinoamérica.[7]

> [I came for the first time to Mexico in 1926. I had turned twenty-one years old. . . . That trip was my initiation. . . . I had the great luck to become a friend, to know, to live with and watch these giants of universal painting work: Diego Rivera and Clemente Orozco taught me to know the world, to value the autochthonous, national, and authentic values of Mexico. . . . There I lived the most important days of my intellectual education. I learned that the movement in universal culture initiated by these great Mexicans was worthy of being taken as an example in all of Latin America.]

Rivera, rather than Orozco, would prove to be the enduring influence and friend: Carpentier recalls that even before meeting Rivera, he had received in Cuba a periodical entitled *El machete* that published Diego's texts on art and revolution, and he cites a line from one of those texts: "Cada pared conquistada para los pintores revolucionarios es una posición conquistada a la burguesía" (Every wall conquered by revolutionary painters is territory taken from the bourgeoisie).[8] This phrase must have acquired immediacy as he watched the muralists at work in 1926.

Carpentier's Mexican "initiation" was not only political but also cultural. He was introduced to indigenous American cultures, and he contrasts Cuba to Mexico in this respect:

> Los pueblos nacen, por su propia idiosincrasia, con una particular propensión a que la sensibilidad se les manifieste en un sentido o en otro. México, por ejemplo, o Perú, contaban, a la llegada de los conquistadores, con una gran tradición plástica. Y fue de su fusión con lo que de España les vino, de donde había de surgir ese tercer estilo

que llamamos *barroco americano*. En Cuba, por el contrario, no había rastro de una tradición semejante.[9]

[Communities are born, because of their own idiosyncrasies, with a particular propensity or sensibility that manifests itself in one way or another. Mexico, for example, or Peru possessed a great artistic tradition when the conquistadors arrived. It was the fusion of this tradition with what came from Spain that produced the third style we call the *American Baroque*. In Cuba, on the contrary, there was no trace of such a tradition.]

The "fusion" of indigenous traditions and European forms that Carpentier observed in Mexico would become the basis for his transcultural theory of the New World Baroque, which he extended to Cuba and the rest of Latin America despite their different histories and traditions.

A third facet of his initiation in Mexico was aesthetic. He recalls his amazement at seeing the realism of Rivera's murals, at a time when abstraction still held sway in Europe and was taking hold in the United States and parts of Latin America. (Fully fifty years later, Carpentier will have one of his characters in *La consagración de la primavera* [Rite of spring] register the same amazement when he, too, travels to Mexico and stands before a Mexican mural.) The muralists' program to record their own history and cultural practices was eye-opening because even at this early stage Carpentier was aware that his greatest challenge would be to describe Latin American realities, and he saw Rivera and Orozco brilliantly meeting this challenge. Again, I cite his description of their influence on his younger self:

de ese contacto surgió en mí una tremenda duda: yo acababa de ser iniciado en la pintura no figurativa, en las maneras de pintar de un Picasso, de un Gris, en el cubismo, en una pintura que cada vez más iba hacia lo abstracto, y de repente, he ahí que me encontraba en México con un tipo de pintura profundamente afincada en lo real circundante, en lo contingente, en lo vivo, y que estaba plasmando *una serie de realidades nuevas de América* y de una manera completamente inesperada e imprevista.[10]

[from this contact a tremendous doubt arose in me: I had just been initiated into nonfigurative painting such as that of a Picasso, a Gris, in Cubism, painting that moved increasingly toward abstraction, when suddenly in Mexico I encountered a kind of painting profoundly rooted in the reality around it, in contingency, in lived experience, which was giving form to *a series of new American realities* in completely unexpected and unforeseen ways.]

In the phrase I have emphasized, Carpentier refers to the muralists' deployment of panels and perspectives to dramatize the converging cultures of postrevolutionary

Mexico. In their handling of space, Carpentier intuited an American version of the Baroque *horror vacui*.

This term describes the Baroque impulse to leave no space unfilled, and reflects the conceptual void created in seventeenth-century Europe by the new sciences. The scientific discoveries referred to collectively as the Copernican Revolution challenged religious certainties and unsettled the everyday experience of space.[11] The secularization of the world had begun, despite the Church's best efforts to keep God in his biblical heaven. Erwin Panofsky puts it succinctly: "No period has been so obsessed with the depth and width, the horror and the sublimity [of space] as the Baroque, the period in which man found himself confronted with the infinite as a quality of the universe instead of as a prerogative of God."[12] To this secular understanding of infinite space, with its attendant fear of emptiness and absence, Baroque artists reacted with visions of kinetic space: proliferating figures and motifs in dilating spaces, theatrical spaces opening onto the illusion of infinity, multiple pictorial planes and breached boundaries between real and pictorial spaces. These strategies favor inclusion and accumulation rather than selection, and polycentric perspectives rather than the single vanishing point of Renaissance perspective. Robert S. Huddleston, in his essay "Baroque Space and the Art of the Infinite," asserts:

> The effect of movement and action was now more important than the effect of symmetry and balance that had dominated the art of the Renaissance. Baroque artists aimed to undo the Classical unity of form and function, to unbalance the composition and achieve the impression of movement and space that the new age demanded.[13]

The New World Baroque responded to this imperative, but unlike its European models, it was less concerned with the new science than with local necessities, and the expansive spaces of Baroque forms were apt for the accommodation of America's plural histories and cultures.

Clearly Carpentier understood the Mexican murals in these terms, as an attempt to fill the void created by America's lack of autonomous identity, that is, as an enactment of a dynamic spatial drama between abundance and absence. José Lezama Lima and Severo Sarduy also recognize this drama. Lezama Lima argues that the Baroque offers "una nueva integración surgiendo de la *imago* de la ausencia" ("a new integration emerging from the *imago* of absence").[14] His construction parallels Carpentier's in his reaction to the vacuum created by three centuries of imperial occupation. To the "absence" of colonized American space, he opposes a "gnostic space" to be filled with visual images that revivify the indigenous American past: "tal como en el mundo antiguo el destierro, el cautiverio y la liberación empiezan a poblar lo estelar y a reactuar sobre la historia" ("as in the ancient world, exile, captivity and liberation begin to populate the stellar and re-act upon his-

tory").[15] For Lezama Lima, the European Baroque is dead but its forms were reborn in America, where they have reclaimed the "amplitude of its lands" and its "ancestral world."[16]

Severo Sarduy, too, focuses on the nature of Baroque space in his book *Barroco* (1974). He traces the undoing of Renaissance geocentrism in the seventeenth century by the German astronomer Johann Kepler, whose theory of the elliptical movement of the solar system supplanted the conception of circular movement around the sun and with it, according to Sarduy, the balanced structures of Classicism: "El paso de Galileo a Kepler es el del círculo a la elipse, el de *lo que será trazado alrededor del Uno a lo que está trazado alrededor de lo plural, paso de lo clásico a lo barroco*" (The step from Galileo to Kepler is from the circle to the ellipse, *from the form inscribed around the One to the form inscribed around the many, the step from Classicism to the Baroque*).[17] Sarduy's version of the Baroque dialectic between abundance and absence is set in astronomical space, but its filiation with Carpentier's geographical imperative is clear enough. Sarduy, Lezama Lima, and Carpentier are aligned in their use of Baroque space to constitute Latin America as a mobile complex of cultural and historical constellations. Though they vary markedly in their assessment of the nature and feasibility of the enterprise, each recognizes the Baroque impulse to displace and decenter, amplify and include.[18]

Carpentier, Lezama Lima, and Sarduy were not insensitive to the irony of reviving colonial forms to construct a postcolonial identity, but they came increasingly to understand the Baroque as a postcolonial strategy, as an instrument of *contraconquista* (counterconquest), to use Lezama Lima's term, by means of which Latin American artists might define themselves *against* colonizing structures. As different as these writers are, they are alike in transforming the Baroque into a process of cultural recuperation and revitalization. If Sarduy was to emphasize the artifice of Baroque narrative devices and their capacity to subvert hegemonic perspectives, Carpentier and Lezama Lima would engage its formal tensions and descriptive strategies as the means to embrace the diversity of "American contexts."[19] Each in his own way set out to conquer the conquerors by appropriating Baroque strategies to express his vision of Indo-Afro-Ibero-America, but their common purpose was to "Recomponer, reincorporar, lo roto" (Repair, reincorporate what is broken), as Carlos Fuentes puts it in his essay on Lezama Lima.[20]

The project is utopian, of course, and in its service Carpentier invokes the Mexican muralists' handling of "a new American reality," which he links to the Baroque. In a 1967 interview entitled "We All Have a Baroque Style," he compares the muralists to Mario Vargas Llosa, Carlos Fuentes, Miguel Angel Asturias, Julio Cortázar, and himself.[21] In another interview, published a year earlier, Carpentier had already proposed this analogy; these writers, like the muralists, respond to the American tension between abundance and insufficiency with characteristic *horror vacui:*

Quizás, al pertenecer a un universo relativamente ignorado, el escritor latino-
americano se siente obligado a darles un nombre a las cosas, a darles una textura;
eso explica la multiplicidad de los signos, que constituye la característica del estilo
barroco.[22]

[Perhaps since he belongs to a relatively unknown universe, the Latin American
writer feels obliged to give a name to things and give them a texture; this explains
the multiplicity of signs that constitutes the Baroque style.]

The impulse to name Latin American realities is as old as the Spanish invaders, but
Carpentier's "textural" impulse is his own. No doubt writers everywhere feel that
they confront "a relatively unknown universe," but the writers of the New World
Baroque make this confrontation their aesthetic and ideological priority. By
"texture," Carpentier suggests the aura and intensity of centuries of cultural syn-
cretism in Latin America. In his statement we recognize the outlines of what will
become his most persistent theme: the meaning and necessity of the Baroque in
the New World.

Back to Mexico in 1926: which of Rivera's murals would Carpentier have seen?
The chapel at Chapingo was largely completed, and the murals at the Ministry of
Public Education were underway. Here Rivera created some of the most memo-
rable images of his long career. Its 128 panels celebrate Mexican folk rituals and
indigenous modes of production; they cover three walls and three stories of the
Ministry's two arcaded interior courtyards, and are known collectively as the Court
of Fiestas and the Court of Labor.[23] They were partially completed in 1926—
enough so the young Carpentier could have appreciated their grand conception
and design. In an article in *Revista de avance,* published shortly after his return to
Cuba, he raved about Rivera's integration of architectural and pictorial space.
Two of the series in the Court of Fiestas—the Proletarian Revolution and the
Agrarian Revolution—Rivera himself called *corridos* (traditional narratives in
song) but Carpentier, in his article, refers to them as a symphony: "¡esa sinfonía
pictórica—¡sinfonía pastoral, sinfonía heroica, sinfonía de las mil voces!" (this pic-
torial symphony—pastoral symphony, heroic symphony, symphony of a thousand
voices!) Of the triptych at the end of the Court of Fiestas, he writes that "se alzan
los rojos pendones del primero de Mayo, cuyo simbolismo es *leit motiv* que Diego
hace sentir de cien maneras en el mundo plástico de sus frescos" (the red banners
for the first of May are raised, whose symbolism is the leit motif that Diego makes
felt in a hundred ways in the artistic work of his frescoes").[24] The undulating in-
terconnectedness of *Ribbon Dance* (fig. 3.1) recalls the Baroque phylacteries that
we saw in chapter 1 (figs. 1.14 and 1.15) and will see again in chapter 4 (figs. 4.13,
4.15, and color plate 16); Diego's ribbons also predict the Baroque folds that will
appear in chapter 5.

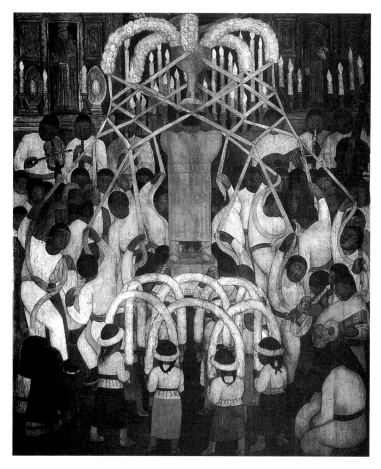

FIGURE 3.1 Diego Rivera, *Ribbon Dance* (fresco, 1923–28), Court of Fiestas, Ministry of Public Education, Mexico City. Instituto Nacional de Bellas Artes/Banco de México. Photograph: Bob Schalkwijk.

Carpentier covers an entire page with a bedazzled account of the scenes in the Court of Fiestas, and then turns to the Court of Labor. The scenes that fill its three levels depict intellectual, industrial, and agricultural work—a "whitmaniano salmo al trabajo" (Whitmanian psalm to work) according to Carpentier, who notes in particular the panel showing miners *Leaving the Mine,* which he describes as "un laico descendimiento de la cruz" (a secular descent from the cross) (fig. 3.2).[25] Rivera's imagery encompasses and recodifies America's iconographic heritage in multiple panels and perspectives, and Carpentier will eventually urge writers to do the same: "detallar, pintar, darle a uno la sensación del peso, consistencia, color de los objetos y cubrir enormes superficies" (describe, paint, give the sensation of weight, consistency and the color of objects, cover enormous surfaces).[26] His early

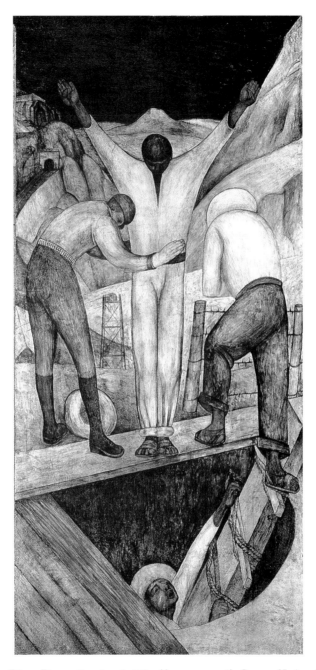

FIGURE 3.2 Diego Rivera, *Leaving the Mine* (fresco, 1923–28), Court of Labor, Ministry of Public Education, Mexico City. Instituto Nacional de Bellas Artes / Banco de México. Photograph: Bob Schalkwijk.

attention to the texture of space in Rivera's murals predicts his own narrative strategies.

In this same 1927 essay, Carpentier also praises the murals at Chapingo (color plate 10). In the previous chapter, I said that integration and incorporation were Diego Rivera's reigning principles, and Carpentier would have seen them in operation at Chapingo, where Rivera's architectural genius fills the intimate space of the former hacienda's chapel. The hacienda was built in the eighteenth century and its chapel is Baroque, with a continuous barrel vault ceiling, side walls divided by columns supporting side arches, and *oeil de boeuf* windows above. Pete Hamill quotes a critic of the time that "the lines of the composition are Baroque, as befits the architecture,"[27] and so, too, does the *horror vacui*. Rivera covers every surface with colors, forms, and figures. Bodies—those of viewers and the painted figures alike—are incorporated into the chapel's space, which is at once intimate and hyperbolic, its dynamism enveloping the viewer and at the same moving centrifugally upward and outward. We sense Carpentier's response to Chapingo twenty-three years later in his 1949 preface to *El reino de este mundo* (*The Kingdom of this World*), where he proposes an attitude he calls *un estado límite* (extreme state) in which *lo maravilloso* is experienced within the real. I will quote his statement below, but here it is sufficient to propose that Carpentier's *estado límite* is the psychological analogue to the spatial dynamism of Chapingo: the real is present and palpable but expanded, decentered, explosive.

I began by referring to the interview titled by Carpendier's statement, "Reyes, Orozco and Rivera were my teachers." We have seen Orozco and Rivera, but what about Reyes? Carpentier met the Mexican intellectual Alfonso Reyes in Havana in 1927 and established a friendship that extended the "initiation" begun in Mexico the year before. Carpentier had been arrested and imprisoned for four months upon his return from Mexico by the Cuban dictatorship of the time, which had intensified its repression of students and intellectuals.[28] Carpentier left Havana the following year for Paris, where he continued his friendship with Reyes:

> Recuerdo que fue en 1927, acababa de salir de prisión y el maestro Reyes se encontraba de paso en un viaje a París. Iniciamos una gran amistad que continuó en 1928–1929 en París. Leí a Reyes, hablé con él, me enseñó a conocer el mundo a través del conocimiento de lo auténticamente nuestro, de lo autóctono, de lo americano. Por ello fue que mi incursión en el surrealismo europeo no me hizo olvidar mi preocupación por lo americano: lo autóctono, la fuerza vivificante de la tierra, la magia del paisaje, *las mutaciones históricas, los sincretismos culturales . . .* (302, my emphasis)

> [I remember that it was in 1927; I had just gotten out of prison and *maestro* Reyes was passing through Havana on his way to Paris. We began a great friendship that continued in 1928–1929 in Paris. I read Reyes and talked to him; he taught me to know the world through the knowledge of what is authentically ours, the autoch-

thonous, the American. For that reason my incursion into European Surrealism
didn't make me forget my concern with things American: the autochthonous, the
vivifying force of the earth, the magic of the landscape, *historical mutations, cultural
syncretisms . . .* (my emphasis)]

One of the things that Carpentier would surely have discussed with Reyes was
Spanish Baroque literature, for during this period Reyes was himself reconsidering
Latin America's literary heritage, and reading Luis de Góngora intensively. And
they would surely have discussed the Mexican muralist movement that Carpentier
had discovered the previous year.

Carpentier was twenty-three when he met Reyes. Reyes was thirty-seven and
had already published a scholarly edition of Góngora's *Fábula de Polifemo y Galatea*
and a critical consideration of Góngora's life and work, *Cuestiones gongorinas.*[29] 1927
was the tercentenary year of the death of Góngora, and it proved to be a significant
moment of reevaluation, thanks to the work of Reyes and also to the outspoken ap-
preciation of García Lorca and other influential Spanish poets of the Generation
of '27, whose group name honors Góngora's legacy.[30] Alfonso Reyes was appointed
Mexican ambassador to Argentina in 1927, a post he held till 1930, during which
time he traveled between Paris and Buenos Aires. In Buenos Aires, Jorge Luis
Borges would also benefit from Reyes's mentorship, as Carpentier had in Paris, but
Borges would react in quite another way to their tutor's enthusiasm for the Span-
ish Baroque. If Reyes's revalorization of the Baroque was to amplify Carpentier's
understanding of the forms (and metaphor) he needed to pursue his inclusive cul-
tural agenda, Borges was soon to reject the Baroque for reasons that we will con-
sider in chapter 5. Carpentier, from the time of his trip to Mexico in 1926, intuited
the need for a cultural ideology appropriate to express New World realities, and he
began even then to reconceive the history of the Baroque in America. It was in
France during the thirties, and then in the Caribbean, that he would discover the
means to theorize that history.

THE TRANSHISTORICAL "BAROQUE SPIRIT": CARPENTIER AND D'ORS

Carpentier has been accused of "essentializing" the diverse cultures and topogra-
phies of Latin America by arguing that the Baroque is an autochthonous and au-
thentic American form, to repeat two of his adjectives cited above, and certainly
his inclusion of prehispanic artifacts in his definition of the Baroque is question-
able by any standard account of art history. His aim was precisely to disrupt stan-
dard accounts in order to include the "historical mutations" and "cultural syn-
cretisms" of Latin America, to use two more of his phrases, and the Baroque
provided him the way to do so. But before Carpentier could make the Baroque an
"essentially" American mode, he had to universalize it; before the Baroque could

serve as a postcolonial American aesthetic, it had to be liberated from its narrow berth on the ships of the Spanish colonizers. Carpentier's conception of the Baroque as a "constant of the human spirit" reflects cultural theorists current in Europe in the twenties and thirties, most especially Eugenio d'Ors and later, the Venezuelan philologist Arturo Uslar Pietri. Carpentier was in Paris during the thirties when d'Ors, a Catalan art historian and philosopher, was elaborating his transhistorical conception of recurring cultural "eons," and then in Caracas during the late 1940s when Uslar Pietri published his famous survey of Venezuelan literature. In *Letras y hombres de Venezuela,* Uslar Pietri writes about the seventeenth-century Venezuelan historian José de Oviedo y Baños: "the Baroque for him was more than a luxury of forms, it was a *disposition of spirit,*" and he adds that the Baroque is "almost a condition of being Hispanic."[31] Surely Carpentier would have read both d'Ors and Uslar Pietri at the time of their publication. Then there was the important work of the Argentine art historian Angel Guido, who proposed in *Redescubrimiento de América en el arte* in 1944 not just a history of New World Baroque art and architecture but also a theory of Latin American culture based on its recurring engagement of Baroque forms of expression. It is likely that Carpentier read Guido, and almost certain that Lezama Lima did.[32] In short, the Baroque was being reconceived during this period in ways that would contribute to Carpentier's conception of Baroque spirit and its particular American embodiments.

These theorists predict subsequent formulations whereby the meaning of the Baroque has been amplified historically and culturally: Lezama Lima's "*contraconquista*" and his "*eras imaginarias,*" Edouard Glissant's "rerouting," Bolívar Echeverría's Baroque "ethos."[33] These writers and critics, like Carpentier, start with the historical Baroque, engage it on European grounds, and then depart from those grounds—not to *dehistoricize* the Baroque but to *transhistoricize* it and thus reclaim its relevance in Latin America.[34] For Carpentier, the Baroque is *at once uniquely American and also universalizing,* a "human constant" that appears in cultures across time and territories. In Latin America, the operations of Baroque "spirit" allow for the possibility of cultural continuity—*una solución de continuidades* (a solution of continuities) as Fuentes puts it—despite the ruptures of conquest and colonization.[35]

Among these transhistoricizing formulations, I prefer Uslar Pietri and Carpentier's "spirit" because the word is itself Baroque; its multiple meanings developed during the seventeenth century, most particularly in the work of Blaise Pascal. In his *Pensées,* Pascal elaborates two intellectual types, *l'esprit géometrique* and *l'esprit de finesse* (geometrical and intuitive temperaments). Pascal's *esprit* combines intellectual and spiritual capacities (as it still does in French usage), and importantly for Carpentier, it also suggests a tendency or prevailing sensibility.[36] Carpentier would have been aware of Pascal's conception of "spirit," with its etymological origin of "breath" and its filiation to "inspire" and "aspire"; this French usage

assisted him, I believe, in translating the historical European Baroque into his conception of New World identity. We have discussed the time/space of precontact Mesoamerican cosmology and the ways in which Elena Garro and Eduardo Galeano engage this experiential field to their narrative medium. Carpentier's *espíritu barroco* is also an experiential field that facilitates the interactions of cultural spaces belonging to different orders of time. So chronological periodization is supplanted by conceptual and actual spaces, and temporal sequence with multidirectional movement.

As I have suggested, Carpentier's liberation of the Baroque from its European historical moorings had its most significant precursor in Eugenio d'Ors. D'Ors developed his transhistorical system of cultural resemblance during the late '20s and '30s in France (and in French); in *Du Baroque* (1935), d'Ors discusses periods and cultures other than seventeenth-century Europe, and in *Cupole et monarchie* (1928), he ties architectural styles to modes of government, and modes of being.[37] I have mentioned Alfonso Reyes's role in directing Carpentier's attention to the literature of the Baroque period, as well as Uslar Pietri's, but d'Ors addressed the relations of *all* areas of cultural expression, for example, in his memorable formulation that "in epochs with Baroque tendencies, the architect becomes a sculptor, sculpture paints, painting and poetry take on music's dynamic tones."[38] Though none of his multitude of examples is Latin American, his argument immediately proved useful to Carpentier as he searched for ways of representing Latin America's collective cultural experience. So he repeatedly refers to d'Ors in his interviews and in his 1975 essay "The Baroque and the Marvelous Real": "According to Eugenio d'Ors—and it seems to me that his theory is irrefutable in this respect—the Baroque must be seen as *a human constant*."[39]

A detailed comparative study of d'Ors and Carpentier remains to be undertaken and when it is, it will illuminate Carpentier's conception of the New World Baroque. First, one would want to recognize d'Ors's own influences, especially his dependence upon Oswald Spengler's historiographic theory of recurring cultural patterns. Carpentier, too, had read Spengler, and in my discussion of *Concierto barroco* I will return to the question of Spengler's influence. But it is d'Ors whom Carpentier quotes in his essays, and whose examples he adopts.[40] D'Ors offered Carpentier his conception of Baroque morphology, with its "proliferating elements" that grow out of each other, its "proliferating cells" that decenter the structure, that create inordinate relations among expressive elements, whether formal or thematic.[41] In d'Ors's discussion, mathematics, music, painting, architecture, sculpture, and literature themselves become morphological elements that generate and extend the signifying capacities of one another. Carpentier would adapt this morphological method to his own theory of the New World Baroque.

There are also distinctions to be made between the two. D'Ors's concept is *not* tied to a particular geographical location or cultural configuration, as is Car-

pentier's, but rather to a conception of "eons" in which cultural characteristics recur. D'Ors traces Baroque *themes,* which he relates to Romantic tropes, whereas Carpentier is interested in the *function* of the Baroque in Latin America. And if d'Ors finds that the Baroque manifests itself during the decline of a given civilization, Carpentier insists that the Baroque signals cultural fulfillment. Referring to d'Ors' argument in "The Baroque and the Marvelous Real," Carpentier acknowledges this last difference:

> Eugenio d'Ors, que no siempre me convence enteramente con sus teorias artísticas, pero que indudablemente en algunos ensayos es de una penetración extraordinaria, nos dice . . . [que] hay un eterno retorno del barroquismo a través de los tiempos en las manifestaciones del arte; y ese barroquismo, lejos de significar decadencia, ha marcado a veces la culminación, la máxima expresión, el momento de mayor riqueza, de una civilización determinada.

> [Eugenio d'Ors, who doesn't always completely convince me of his artistic theories but who is certainly extraordinarily insightful in some of his essays, tells us . . . [that] there is an eternal return of the Baroque in art through the ages, and this Baroque, far from signifying decadence, has at times represented the culmination, the maximum expression and the richest moment of a given civilization.][42]

Carpentier's New World Baroque is neither teleological nor eschatological, nor does it foresee progressive movement toward cultural culmination. Rather, it is revolutionary in the original sense of the word, returning, remembering, and recovering cultural formations that have been suppressed over time. When Carpentier speaks of the Baroque as "the richest moment of a given civilization," he refers to an ongoing, cumulative, cultural present.

Based on Carpentier's experience of Mexican muralism in 1926, his conversations with Alfonso Reyes from 1927 to 1930, his reading of Eugenio d'Ors during the 1930s and of Guido and Uslar Pietri during the 1940s, he universalizes the Baroque as a state of mind (*un espíritu*), in order to particularize it as a *Latin American* state of mind:

> ¿Y por qué es América Latina la tierra de elección del barroco? Porque toda simbiosis, todo mestizaje, engendra un barroquismo. El barroquismo americano se acrece con . . . la conciencia de ser otra cosa, de ser una cosa nueva, de ser una simbiosis, de ser un criollo; y el espíritu criollo de por sí, es un espíritu barroco. (126)

> [And why is Latin America the chosen territory of the baroque? Because all symbiosis, all *mestizaje,* engenders the Baroque. The American Baroque develops along with . . . the awareness of being Other, of being new, of being symbiotic, of being a *criollo;* and the *criollo* spirit is itself a Baroque spirit. (100)]

The Baroque flourishes in America because its cultures are hybrid, eccentric, inordinate. So Carpentier works to restore to the present the fullness of Latin America's accumulated imaginaries, an effort that begins to explain the presence of a seventeenth-century European Baroque painting in Carpentier's *El siglo de las luces.*

EXPLOSION IN A CATHEDRAL: BAROQUE SPACE IN DE NOMÉ'S PAINTING AND CARPENTIER'S NOVEL

Carpentier's novel *El siglo de las luces* (literally, "the century of lights," and figuratively, "the Age of Enlightenment") is a novel about the manifestations of the French Revolution in the Caribbean during the very unreasonable end of the "Age of Reason." The novel was published in Spanish in 1962, and translated a year later into English by John Sturrock with the title *Explosion in a Cathedral,* a mistake, in my view, but one that points directly to our concern with the nature of Baroque space: the presence in Carpentier's novel of a painting by François de Nomé, also known as Monsù Desiderio (fig. 3.3).[43] This painting isn't dated but is thought to have been painted in the early 1620s, and it is repeatedly described

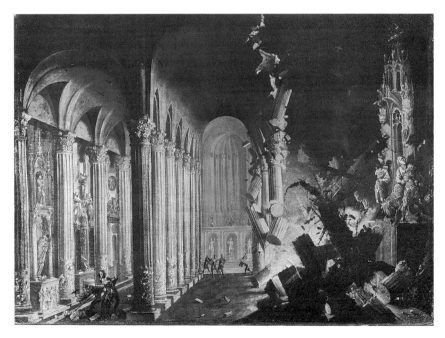

FIGURE 3.3 François de Nomé (Monsù Desiderio), *Explosion in a Cathedral,* alternately titled *King Asa of Judah Destroying the Idols* and *King Asa of Judah Destroying the Statue of Priapus* (c. 1620). Reproduction by permission of the Syndics of the Fitzwilliam Museum, Cambridge.

in Carpentier's novel; the narrator tells us that it is by "an anonymous Neapolitan master" and that its title is "Explosion in a Cathedral." In fact, this title is not the one given by the Fitzwilliam Museum in Cambridge, England, which owns the painting. There it is known as *King Asa of Judah Destroying the Idols* or *King Asa of Judah Destroying the Statue of Priapus.* Roman numerals and the letters REX appear in the upper left hand corner of the canvas, referring to the biblical text from First Kings, chapter 15, which tells of the Judaic king Asa's destruction of pagan idols. The letters and numerals are invisible in every reproduction I have seen, and can be made out only when looking at the original. In any case, the seventeenth-century viewer of de Nomé's canvas would surely have understood the scene to be emblematic of some larger human drama, even if he or she couldn't read the biblical text; allegorical forms of attention are embedded in this painting, as in much Baroque representation.

Modern viewers are also likely to assume an allegorical intent and wonder what symbolic situation is unfolding here. The figures in the lower left-hand corner of the painting are busy with hammer and lever, destroying a fallen statue. They seem decidedly unlike the avenging King Asa, and the visual reference is probably more topical. The historical moment of the painting, the early seventeenth-century, points to the Reformation and the destructive work of Protestant iconoclasts in northern Europe.[44] Catholic painters were well aware of Protestant iconoclasm, of course, and they knew themselves to be beneficiaries of the Tridentine counter-offensive that involved the vast production (and patronage) of visual images. Though de Nomé's canvas is far from the naturalistic representation of biblical subjects encouraged by the Council of Trent, it nonetheless depicts a Counter-Reformation drama, and would certainly have directed its (Catholic) viewers to prescribed modes of representing and seeing (and to Protestant transgressions of those prescriptions). Church interiors were an increasingly common subject of paintings during the Counter-Reformation, in part because of the religious controversy of the time and in part because they provided the dynamic play of light, space, and sensuous surface so basic to Baroque taste. However, they usually depict a moment when the church is deserted and one can almost hear the silence and feel the cool damp air; indeed, de Nomé painted such calm interiors himself.[45] *Explosion in a Cathedral* is obviously another matter, and his small figures may seem less a critique of Protestant iconoclasts than a parody of them, so exacting is their attention to this statue even as the whole church is falling down around them.

The second title attributed to this painting by the Fitzwilliam would seem to be a historical accretion: the biblical passage cited by de Nomé makes no reference to a statue of Priapus, Classical god of male procreation, son of Dionysus and Aphrodite. Nonetheless, the broken masonry by the statue is intriguing: its gray color, different from the yellow of the exploding columns, suggests that it may be a piece of the statue itself—possibly the penis, which in antique representations was modeled in column-like proportions. Also note the surface of the column be-

hind the iconoclasts, where the markings on the masonry appear in the shape of a winged figure. On the right of the canvas, there are more statues, which look less as if they are exploding than crumbling with age, ghosts as irreal as the winged figure on the column. In François de Nomé's paintings, architectural details contain a teeming, fantastic world.

And another art historical puzzle: the identifying tag beside the painting in the Fitzwilliam credits Monsù Desiderio, a name that has been, and continues to be used interchangeably with what recent research has affirmed as the artist's name, François de Nomé.[46] This confusion of names accurately suggests the obscurity of the artist's life. What little is known about him is that he was born in the last decade of the sixteenth century—a marriage document points to his birth year as 1593 in the city of Metz, in the area of the Lorraine, France. De Nomé was sent to Rome at the age of nine or ten as an apprentice to a Flemish painter there, and after some years, proceeded to Naples, where it seems that he established himself permanently. No work of his is dated with certainty after 1634.

It is not known whether de Nomé painted murals, but if he didn't, he was an exception among his contemporaries. Throughout Europe and especially in Italy during the Baroque period, artists painted walls, galleries, ceilings and cupolas with scenes of cosmic scope, and their experience in this architectural medium explains in part their technical mastery of perspective construction. Through the handling of light and shadow, they created the illusion of great heights, depths, and distances on plaster surfaces. Whether de Nomé worked in fresco or not, he creates a similar illusion on his small canvases; *Explosion in a Cathedral* measures only twenty-nine by thirty-nine inches but projects space on a huge scale while also managing to attend to minute pictorial detail. The disproportion between the size of de Nomé's canvas and the immensity of its perspectives may also seem parodic, but it is not; the rendering of minutely observed details in seemingly infinite spaces is characteristically Baroque.

If the absence of attributable murals is exceptional, de Nomé's geographical trajectory was not. By the beginning of the seventeenth century, northern European artists were flocking to Italy, and to Rome in particular, which had become the artistic center of Europe. The recuperation of Classical culture began in the Renaissance continued uninterrupted; only in Rome could Greek and Roman sculpture be studied in depth. De Nomé arrived at a time when ancient artifacts were being unearthed daily; J. Patrice Marandel, in his biographical essay on the painter, notes that "the visual and emotional power of freshly excavated monuments, indeed of an entire antique city coming back to life—as a ruin—must be taken into account to understand the general climate in which de Nomé's work developed" (23).

The same can surely be said about many other artists. Take the Flemish painter Peter Paul Rubens who, along with Caravaggio, may be said to be *the* quintessential Counter-Reformation Baroque painter.[47] Rubens arrived in Rome at the same

time as François de Nomé, making two trips early in his career, in 1601–2 and again in 1605, to study Roman sculpture.[48] Rubens's muscular saints and martyrs are based on Classical representations of pagan gods, and are at the same time embodiments of the affective intention of Tridentine aesthetics. Jacques Barzun describes the Baroque combination of Classicism and emotionalism in the section of *From Dawn to Decadence* that he titles "The Opulent Eye": "Exuberance by design and not from wildness—the spirit of Rubens—is the dominant trait of the Baroque."[49] There are many examples of Rubens's exuberance by design, and none is more affecting than the central panel of his triptych, *The Descent from the Cross,* in the Cathedral in Antwerp (fig. 3.4). The physical weight of Christ's inert body is dramatized by a male figure above the cross who holds a corner of the shroud in his teeth, and the Virgin, her face desperate, reaches out to assist in the onerous task. Rubens's "exuberance" may seem far removed from the irrealism of his contemporary François de Nomé, as does the monumentality of his murals and canvases, but both painters engage Baroque aesthetic attitudes in their different ways.

We can use these differences to consider an art historical debate about the Baroque, which on one hand views the Baroque as the culmination of Renaissance Classicism and on the other, as its subversion. This debate presupposes the periodization of styles, which in turn presupposes a conception of culture as action and reaction, as a pendulum constantly swinging between extremes. In this periodic pendulum model, Mannerism separates the Baroque by a century or so from Classical Renaissance forms, which the Baroque either recuperates or derails, according to the perspective of the art historian. Erwin Panofsky takes the former position, arguing that the Baroque represents the second life of the Renaissance after the "exaggeration and overcomplication" of Mannerism, whereas Robert Harbison sees the Baroque as subverting the rationalism of Renaissance structures with its own exaggerations and complications.[50] Both are right, of course, depending upon the artist or architect whom they choose to illustrate their position. Rubens will serve to illustrate Panofsky's theory, and de Nomé (and much New World Baroque art, architecture, and literature) will illustrate Harbison's. Either way (and both), the Baroque overarches and includes what would seem to be the contradictory impulses of formalism and theatricality, naturalism and artifice, sensuousness and spirit.

I call attention to this inclusiveness because Carpentier will embrace it, whereas most art historians have preferred to construct a dichotomy between Classicism and the Baroque, between continuity and rupture. Beginning with Heinrich Wölfflin in the late nineteenth century and including Carpentier's precursors, Eugenio d'Ors and Oswald Spengler, not to mention Lezama Lima and Sarduy: all have defined the Baroque *against* Classicism. Lezama Lima, recognizing this tendency and parodying it, quotes an unnamed critic as saying that "The earth is Classical,

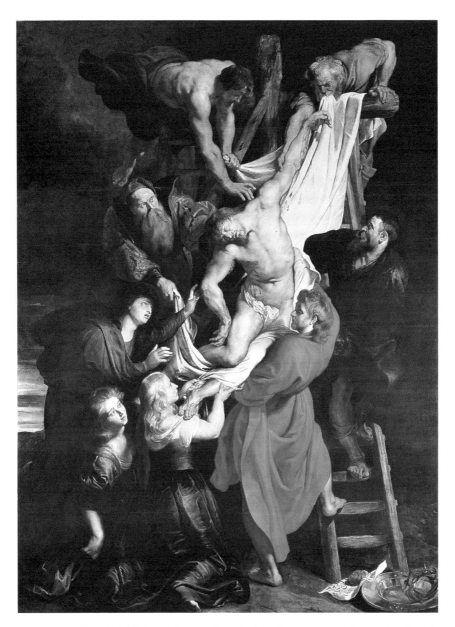

FIGURE 3.4 Peter Paul Rubens, *Descent from the Cross* (center panel of triptych, 1611–14), Cathedral, Antwerp. Photograph: Scala/Art Resource, NY.

the sea Baroque."[51] The Baroque *does* depart from Classicism in ways that Latin American writers and critics have exploited for the purpose of establishing their distance and difference from Europe, and I, too, will underscore the differences in my discussion of Baroque space. Clearly the Baroque is subversive of Classical forms; clearly it does encode the profound transformation in human understanding that Umberto Eco describes in his influential essay on the poetics of the open work. Referring to the seventeenth century, Eco asserts: "For the first time, man opts out of the canon of authorized responses and finds that he is faced (both in art and in science) by a world in a fluid state that requires corresponding creativity on his part."[52] The Baroque *does* mark a turning point in the history of critical response, but Eco's claim of historical rupture is overstated. I prefer the more measured account of Mexican essayist and writer Gonzalo Celorio, who argues that the Baroque both disrupts *and* extends Renaissance structures. For Celorio, it is not so much a question of radical rupture as a reordering of priorities and intentions: the Baroque adopts Classical models but for different purposes and in different proportions. Ornamentation, which is secondary in Classical expression, becomes primary in the Baroque. Narrative is still central, but digression is privileged over linearity, and decorated surfaces become repositories of meaning. Celorio summarizes these Baroque adjustments by proposing a metaphor: the branches have become more important than the trunk.[53]

It is true that the relation between parts and wholes is radically restructured in Baroque forms of expression. Previous conceptions of wholeness, whether Eurocentrism, geocentrism, Catholicism, scholasticism, or humanism, were assaulted during the seventeenth century, and their parts shaken loose. The constant addition of new parts to world maps was more than enough to undermine existing relations of geographical parts to the global whole, not to mention the astronomical discoveries that undermined the existing conception of the cosmic whole, and the Protestant Reformation that undermined the theological whole. Parts, suddenly separated from their systems, become visible and problematic; fragmentation threatens to overwhelm integration, and artifice is privileged because nature, it seems, needs help. So Baroque artists engage strategies of illusionism and indirection (allegory, emblematic and iconographic systems) to reconstruct meaningful relations among the parts. If the artist is Rubens, he will rely on Classical naturalism and Counter-Reformation theology to give coherence to his representations of the world; if he is François de Nomé, he will emphasize the fragments, the ruins, the exploded structures of institutions and ideas. We will look further into the Baroque relations of parts and wholes, but here it is enough to conclude that François de Nomé's chiaroscuro accumulations of Classical fragments in dynamic Baroque spaces will appeal two hundred years later to the French Surrealists, among whom we find the young Cuban writer Alejo Carpentier.

When and where would Carpentier have seen de Nomé's *Explosion in a Cathedral?* I would very much like to know. The Fitzwilliam Museum acquired the

painting in 1962 from a British collector who bought it in 1940 from a gallery in London; in fact, the painting seems to have been in private British hands since 1778. It was not exhibited before 1950, when it was part of the first exhibition of de Nomé's work, at the Ringling Museum of Art in Sarasota, Florida. French museums have a significant number of de Nomé's paintings, so Carpentier might have seen others of his flickering scenes hanging in the Musée des Arts Décoratifs in Paris, or his masterpiece entitled *Hell* in Besançon. Most likely, though, it would have been through his Surrealist connections. André Breton was an enthusiastic appreciator of de Nomé, and the Menil Collection in Houston, Texas, includes three de Només. Jean and Dominique de Menil were in close contact with Surrealist circles in the thirties and afterward, so the presence of these paintings in their collection would seem to affirm the Surrealists' familiarity with de Nomé's work. Carpentier's enthusiasm for Surrealist aesthetics eventually waned, but his fascination for de Nomé's architectural fantasies did not.[54]

De Nomé's "anonymous" painting is described at the outset of Carpentier's historical novel, which begins in 1790 in Cuba and ends in 1808 in Madrid. The painting is hung by the author, so to speak, on a fictional wall in a mansion in Havana, then moved during the tumultuous course of the novel to Madrid, where the reader last glimpses it on May 2, 1808, the night of the uprising in the streets of Madrid against the Napoleonic invasion. By my count, de Nomé's painting appears six times in the novel.[55] On the most obvious level, it is a visual analogue for the upheavals that the novel recounts; revolution is often imaged as explosion. The French Revolution was, furthermore, violently anticlerical, so for Carpentier's purposes, the fact that de Nomé's explosion is visualized in a church is appropriate. The irony of Carpentier's title in Spanish is clear: *El siglo de las luces* chronicles the benighted end of the Age of Enlightenment, an irony also depicted in de Nomé's painting, where we see Classical columns, the very symbol of rationalism, order, balance, and proportion, explode before our eyes.

In none of de Nomé's paintings are his figures presented as individuals; his saints, martyrs, and mythological heroes are not portraits in any usual sense. In fact, they often seem interchangeable with his statues, which themselves look more like ghosts or skeletons than statues. De Nomé's figures are dwarfed by the larger sweep of a history gone haywire; they are overwhelmed by forces they neither created nor control. The architectural fragments that surround and engulf the figures in almost all of his paintings show a social order *in extremis*. In figure 3.5, titled *Burning of Troy with the Flight of Aeneas and Anchises,* the figures are recognizable but their function is allegorical: they are ciphers for the ravages of war. De Nomé's investment is in dynamic space and exploding structures, not in individual agency.

De Nomé's paintings project an architectural allegory of decay and death, their tone combining the apocalyptic and the elegiac. In Counter-Reformation Baroque iconography, mutability is the dark side of transcendence; life is a dream or stage or labyrinth, tropes that regularly encode the Baroque preoccupation with the illu-

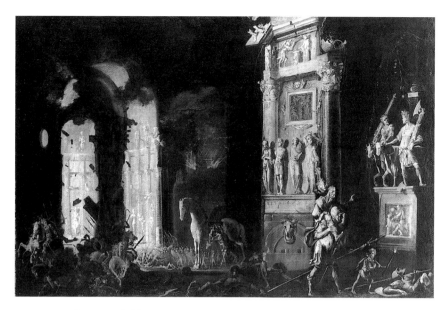

FIGURE 3.5 François de Nomé, *The Burning of Troy with the Flight of Aeneas and Anchises* (1624). Reproduced by permission, Statens Konstmuseer, Stockholm.

sory and ephemeral nature of experience. The Mexican art historian Guillermo Tovar de Teresa notes: "Awareness of the ephemeral is one of the constant preoccupations of the Baroque man. All is relative, all is mutable, all is fleeting save the certainly that one must die."[56] But how seriously are we to take de Nomé's vision of ruin? His landscapes are littered with the remnants of Classical civilizations, but we see them from unreal perspectives and understand them as products of impossible engineering, the ruins of buildings that could never have been built in the first place—indeed, seem not even to *claim* having been built.[57] In fact, they appear to be primarily the ruins not of buildings but of architectural ornaments—arcades, towers, pediments, kiosks, turrets, free-standing façades—with scant evidence of the edifices to which they were presumably once attached. His compositions energetically exaggerate the Baroque triumph of ornament over structure; structural features are divorced from their function and absorbed into the ornamental intricacy of the whole. What better example of Gonzalo Celorio's assertion that in Baroque art, the branches are more important than the trees? De Nomé includes Classical culture, but he reorders and up-ends it.

Whether we understand de Nomé's ruins as elegiac or ironic or both, we may agree that his genius is at once architectural and archeological, and his strength a combination of meticulousness and anarchy. So hyperbolic is his vision of ruins that the modern viewer again suspects parody: parody of the Baroque trope of mutability for which Classical ruins were emblematic; parody of Baroque ornamenta-

tion; even self-parody, because de Nomé clearly revels in the multiplying oddities of his architectural landscapes. In any case, his ruins pit exuberance against foreboding, continuity against fragmentation, Classical containment against Baroque proliferation. The tension produced by complementary oppositions is typical of the Baroque, but de Nomé's architectural fantasies are nonetheless idiosyncratic. Clearly his aim was not to produce a meditation on mutability, and even less a reflection of reality, but rather to inspire in the viewer an emotional response, a set of sensations. But sensations of what? Of historical grandeur, perhaps, and at the same time, nostalgic regret for a history long since exhausted? In the seventeenth century, there was a genre of landscape paintings with ruins, the conventions of which were designed to evoke the heroic past, and with it, the exotic other. Or perhaps de Nomé's eccentricity is explained by his own transcultural trajectory.

Born in northern Europe and working in southern Europe, de Nomé negotiates this cultural crossing most obviously in his combination of northern Gothic architecture with Italianate depictions of Roman ruins.[58] Many French, Dutch, and Flemish artists went to Rome, but most did not stay; the religious conflict was resolving itself in the north, and the art market was flourishing. De Nomé did not stay either, but instead went further south, to Naples, around 1610. His biographer J. Patrice Marandel asserts that Naples "always retained in its popular culture (which permeated the upper classes) a substratum of paganism. This took the form of superstitions, fascination with esoterica and the practice of witchcraft" (25–26). The fantastical nature of de Nomé's work is surely in some part the result of his movement from north to south, from Metz to the Roman center of orthodoxy, and then to the Neapolitan periphery. He produced his paintings on the edge the mainstream, between cultures, and he is among those few artists, like Piranesi, Fuseli, and Blake, of whom it can be said that they have no followers. His eccentric positioning would not have been lost on Alejo Carpentier as he himself looked for ways to express Latin American realities that were both continuous and discontinuous with Europe. De Nomé was an insider and an outsider, and his painting must have seemed to Carpentier appropriate to his own narrative requirements as he worked to represent a New World on the Western margins of European culture.

It may be de Nomé's peripheral positioning that makes his aversion to empty space—his *horror vacui*—so dramatic. In his paintings, as I have noted, individual experience is subsumed by the sheer expanse of space, by the seeming weight of space as such, even as space is depicted as open, dynamic, potential. This Baroque obsession with space is epitomized by de Nomé's contemporary, Blaise Pascal, but in a very different register. Pascal writes in anguish and amazement:

> The whole visible world is only an imperceptible atom in the ample bosom of nature. No idea approaches it. We may enlarge our conceptions beyond all imaginable space; we only produce atoms in comparison with the reality of things. It is an infinite sphere, the center of which is everywhere, the circumference nowhere.[59]

If Pascal is anguished by the explosion of space, de Nomé seems to be exhilarated by it. Pascal's metaphor will become the subject of one of Jorge Luis Borges's best known *ficciones*, as we will see in chapter 5.

Art historian Christopher Wright writes about de Nomé that "No other painter of the period managed to depict events with such a sense of theatre while at the same time removing all sense of moral seriousness from the occasion."[60] Indeed, biblical enormities often provide the pretext for his visual fantasies: besides King Asa's destruction of the idols in "Explosion in a Cathedral," de Nomé painted a number of saints' lives and martyrdoms in which he sets miniscule figures against vast, irreal, lurid architectural and topographical backdrops. In *Martyrdom of a Saint* (color plate 12), a female is about to be beheaded by a hardy executioner, while an infidel (viz. the turban) prances on a white horse downstage left and the saint's companions flee downstage right. Emotional identification was the supposed aim of Baroque depictions of martyrdom, which were considered "devotional art" for their power to move the viewer to worship, but in this instance the viewer is hardly likely to identify with the martyr's suffering. Again, the affective quotient of de Nomé's painting inheres not in the religious or personal drama but in the spatial one. Background overwhelms foreground, and architectural ruins threaten to fall upon the martyr before executioner's sword. Kinetic space engulfs all figures, executioner and saint alike.

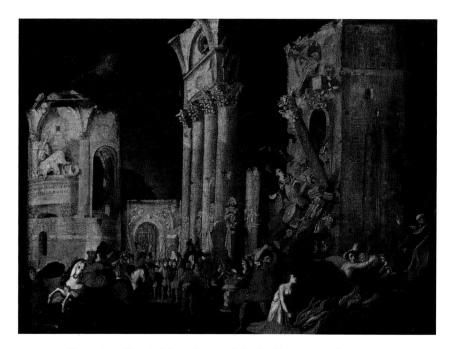

PLATE 12 François de Nomé, *Martyrdom of a Saint* (n.d.). Private collection, Rome.

Such a spatial drama also unfolds in the novel *Explosion in a Cathedral,* where Carpentier engages the theatricality of the French Revolution in the Caribbean both thematically and structurally. To speak of the "theatre" of war is common enough, of course, but Carpentier literalizes the metaphor, engaging the Baroque trope of *teatrum mundi*—the world as a stage—to encode the period's illusions and self-deception.[61] In his novel, as in de Nomé's canvases, scenes often occur in chiaroscuro, in eerie light flickering against a backdrop of darkness. During the French Revolution, a commonplace set of associations revolved around this contrast of light-enlightenment-freedom and darkness-ignorance-imprisonment—associations that Carpentier engages ironically in the title of his novel as well as in particular scenes. Historians have traced the ways in which this imagery of enlightenment shifted as the abuses of the French Revolution increased, to images of blinding light, and then to images of conflagration.[62] De Nomé's work is apposite, of course, in its juxtaposition of Classicism and conflagration, which his *Burning of Troy* makes explicit (fig. 3.5 above). Carpentier, too, plays with this contrast. His novel describes leaders of the French Revolution who conceived of themselves in terms of Greek and Roman models and who, with the aid of the artists of the time, assumed a Neoclassical style to confirm their chosen identity. It was Jacques-Louis David who produced the archetypal Neoclassical portrayal of the French Revolution's version of itself, yet it is not David's Classicism but de Nomé's Baroque manipulation of Classicism that allow Carpentier his critical perspective on the abuses of the French Revolution in the Caribbean.

Revolutionary events as they are recounted in the novel reflect a chaos of dynamic forces and vectors but no direction, no coherence, certainly no conclusion. Carpentier portrays a time "in between," an interstice between "before" and "after" that contains both past and future, a suspended moment in which old forms have ceased to operate and new ones have not yet come into being. The history of the word "revolution" is instructive in this regard; it originally implied a cyclical process, a revolving historical movement of regular and recurring change—historical renewal through revitalization rather than rupture. If this original sense of "revolution" privileges the past, modern usage privileges an unknown future. The French Revolution was the first revolution to fully engage this modern sense of revolution as historical rupture, as suspension on the brink of the future. It is just such a moment that de Nomé's painting also conveys, a suspended history that must have seemed to resemble Carpentier's own, writing his novel, as he was, during and shortly after the Cuban Revolution.[63]

Consider de Nomé's canvas titled *Hell* (fig. 3.6). This painting is structured according to dynamic centers ("proliferating nuclei," as Carpentier will call them in "The Baroque and the Marvelous Real") that diffuse point of view and require the spectator to shift his or her position to see the work. Space dilates and circulates rather than directs or encloses; the several virtually autonomous "nuclei" of this canvas are structured by light, line, and mass, and each seems independently

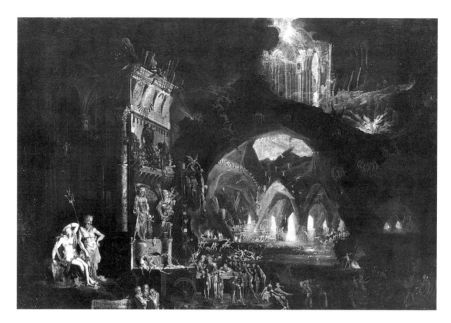

FIGURE 3.6 François de Nomé, *Hell* (1622). Reproduced by permission of Museé de Beaux-Arts et d'Archéologie, Besançon, France. Photograph: Charles Choffet.

to flicker, fade, move in and out of focus. Composition, perspective, the effects of light and shadow replace moral content; hell is a spectacle to behold rather than a moral environment to be feared, or endured. Reward and punishment, power and fear and obedience: none of the usual moral categories are relevant, for the theme of the painting is not morality but movement in space. Carpentier's description of the Baroque is applicable to de Nomé's painting: "es un arte en movimiento, un arte de pulsión, un arte que va de un centro hacia afuera y va rompiendo, en cierto modo, sus propios márgenes" (117) ("It is art in motion, a pulsating art, an art that moves outward and away from the center, that somehow breaks though its own boundaries" [93]).

Countervailing kinetic pressures and colliding spatial energies give to de Nomé's painted scenes a sense of suspended time, and Carpentier does something similar in his description of chaotic events. I have said that the French Revolution was the first revolution to understand itself as historical rupture and renewal, but it stalled in the Caribbean; rupture had occurred, but renewal had not. Carpentier's novel provides an ironic image of modern revolutionary values; despite the frantic activities of the revolutionaries, history is arrested, suspended, on hold. Theatricality overwhelms moral or political content in Carpentier's novel, as it does in de Nomé's painting. The novel ends with one final description of de Nomé's painting. We see it (or, rather, read it) in the last pages of the

novel, hanging on another fictional wall, this time in an abandoned house in Madrid—having moved from west to east, across the Atlantic one more time. The painting by the "unknown Neapolitan master" is stained, the narrator observes, with a streak that looks like blood. The Napoleonic invasion of 1808 has begun, and revolutionary chaos again engulfs the painting. There the novel ends.

METONYMIC DISPLACEMENT AND THE BAROQUE CONCEIT

> Luego hice *El siglo de las luces,* que es una sinfonía del Caribe, una visión total de todo aquello, de las islas, del mar, de los caracoles, de las palmas.

> Then I wrote *Explosion in a Cathedral,* which is a symphony of the Caribbean, a total vision of everything, the islands, the sea, the conch shells, the palms.

ALEJO CARPENTIER[64]

By integrating François de Nomé's painting into the Caribbean landscape of *Explosion in a Cathedral,* Carpentier makes Baroque dynamism emblematic of American spaces. Literary critic Raúl Silva Cáceres analyzes the painting's repeated appearances in the novel in terms of the Baroque device of metonymic displacement: repetition, extension, elaboration, and transformation of visual and/or narrative elements in "un proceso expansivo de las significaciones" (an expansive process of meanings).[65] Metonymic displacement impels the movement of Baroque narratives in the same way that it impels the eye over the animated surfaces of Baroque façades and frescoes: compositional elements permutate as they move through fictive space (whether the space is painted or printed); elements grow out of one another or dissolve into one another; ideas and images associate and accumulate in patterns that become the basis for the structure as a whole.

Silva Cáceres's analysis follows Severo Sarduy's description of Baroque "mechanisms" in his 1972 essay "The Baroque and the Neobaroque," among which Sarduy lists "proliferation":

> Otro mecanismo de artificialización del barroco es el que consiste en obliterar el significante de un significado dado pero no reemplazándolo por otro, por distante que éste se encuentre del primero, sino por una cadena de significantes que progresa metonímicamente y que termina circunscribiendo al significante ausente, trazando una órbita alrededor de él, órbita de cuya lectura—que llamaríamos lectura radial— podemos inferirlo.[66]

> [Another Baroque mechanism of artificialization consists in obliterating the signifier of a given signified without replacing it with another, however distant the latter might be from the former, but rather by a chain of signifiers that progresses met-

onymically and that ends by circumscribing the absent signifier, tracing an orbit around it, an orbit whose reading—which we could call a radial reading—enables us to infer it.][67]

Here, as in *Barroco,* his booklength study published two years later, Sarduy links astronomy to metaphysics, and metaphysics to metonymy: the "orbit" that he reads "radially" traces the interaction of constituent parts in a perpetual dynamic of displacement, or "syntagmatic enchainment," as he also calls this process. Similarly, Octavio Paz writes of José Lezama Lima's novel *Paradiso* as "a world of architectures in continual metamorphosis,"[68] and the French philosopher Gilles Deleuze describes this dynamic of permanent permutation in terms of the fold. Referring to the "interindividual, interactive clustering" typical of the Baroque structures, Deleuze writes: "The Baroque fold unfurls all the way to infinity."[69]

Whatever our metaphor, this process creates intertwining forms that are more sinuous than staccato. Recall Carpentier's admiration for Diego Rivera's frescoes in the Ministry of Public Education, with their interrelated panels and serpentine ribbons ("the leit motif that Diego makes felt in a hundred ways . . .") or his description at the beginning of his novel *Concierto barroco* of an eighteenth-century Mexican portrait of the Viceroy, Count of Galves (color plate 13). The narrator of the novel describes "un retrato del dueño de la casa, ejecutado con tan magistral dibujo caligráfico que parecía que el artista lo hubiese logrado de un solo trazo—enredado en sí mismo, cerrado en volutas, desenrollado luego para enrollarse otra vez—sin alzar una ancha pluma del lienzo" ("a portrait of the Master, drawn with such calligraphic perfection that it seemed as though the artist had executed it in a single tracing—entwining upon itself and bordered with scrollwork that unrolled to enroll again—without having lifted quill from canvas").[70] The exaggerated artificiality of this painting is appropriate for the Master's portrait; he is a rich *criollo* and is himself hyperbolic, egocentric, self-involved. The painting is, in fact, an unintended parody of metonymic displacement; its tracery sketches a dizzying labyrinth of loops and swirls, but we cannot accurately speak of the displacement of compositional elements because, as the narrator observes, there is only one element—the single line that folds again and again upon itself. Ornamentation is the subject of this work. The triumph of form over content is so extreme that Carpentier's choice of painting can only be understood as a critique of the colonizing structure to which the master belongs—a structure, Carpentier proposes, that privileges surface over significance. The master will soon leave this structure and find himself in a very different sort of Baroque space, to which I will return at the end of this chapter.

In "The Baroque and the Marvelous Real," Carpentier waxes enthusiastic about the fluidity of Baroque structures, which include indigenous American pyramids, Baroque chapels, and temples in India. On the bas-reliefs of Hindu temples, he tells us, there are

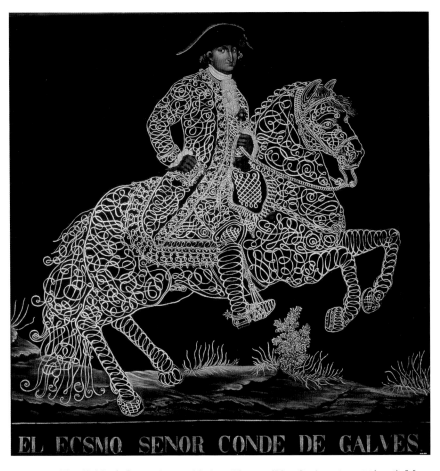

PLATE 13 Fray Pablo de Jesús, *Count of Galves, Viceroy of New Spain, 1785–1786* (1796), Mexico. National Museum of History. Instituto Nacional de Antropología e Historia/Consejo Nacional para la Cultura y las Artes.

metros y metros, por no decir kilómetros, de bajos relieves, más or menos eróticos, que son barrocos en la forma y barrocos en el erotismo por la imbricación de figuras, por el arabesco constante, por la presencia de . . . una serie de focos proliferantes que se prolongan al infinito; llega el momento en que se detiene el bajo relieve, pero podría seguir con el impulso adquirido, si hubiese una mayor superficie que esculpir, hasta una distancia increíble. (118)

[meters and meters, if not kilometers, of more or less erotic bas-reliefs that are formally baroque and erotically baroque because of the imbrication of figures, the constant arabesques, the presence of . . . a series of proliferating foci—in groups and individually, dancing and always united, interlocked like plants—foci that extend to

infinity. There comes a moment when the bas-relief ends, but it could easily continue to cover incredible distances with its accumulated energy, if only there were more surface to sculpt. (94)]

About indigenous American structures, so crucial to his theory of the New World Baroque, Carpentier writes: "There is almost never even a meter of empty surface in an Aztec temple" (98). Space expands until the Baroque composition seems to include the universe.

The generative capacity of interrelating signifiers is also emphasized by Umberto Eco in his discussion of Baroque space. For Eco, the dynamism of "component parts" is essential to the Baroque reordering of Renaissance perspective:

> . . . by giving up the essential focusing center of the composition and the prescribed point of view for its viewer, aesthetic innovations were in fact mirroring the Copernican vision of the universe. [The Copernican vision] definitively eliminated the notion of geocentricity and its allied metaphysical constructs . . . the various component parts are all endowed with equal value and dignity, and the whole construct expands towards a totality that is near to the infinite. It refuses to be hemmed in by any ideal normative conception of the world. It shares in a general urge toward discovery and constantly renewed contact with reality.[71]

Whether we conceive of the narrative structure of *Explosion in a Cathedral* in terms of Silva Cáceres's metonymic displacement, Sarduy's chain of signifiers, Carpentier's proliferating foci, or Eco's component parts, the repetitions and relocations in the novel serve to create multiple, decentered perspectives that overarch heterogeneity. The repeated appearances of de Nomé's painting, the characters' frenetic geographical displacements, the seemingly interchangeable epigraphs from Goya's *Disasters of War,* the profusion of objects and attributes, the mutable oppositions of past and present, light and dark, movement and stasis: all of these narrative elements are animate and unstable, and intended to comprise *una visión total de todo aquello* (a total vision of everything), as Carpentier describes his novel in the epigraph to this section.

The passage from *Explosion in a Cathedral* most often cited as an example of Carpentier's *barroquismo* is one in which a *caracol* (conch shell) is taken as an emblem of Baroque space.[72] I agree that this image begs to be read emblematically, and certainly spiraling forms are common Baroque decorative designs. But the self-enclosure of the conch is less representative of Carpentier's conception of the New World Baroque than the open-ended proliferation of elements that he describes on Hindu temples and indigenous American pyramids. In this novel, too, things constantly cascade over one another, amplifying and confusing space itself.[73] Consider the description of Havana that is offered to the reader in the very first paragraph of *Explosion in a Cathedral* (a single paragraph several pages long in Spanish,

of which I cite only a part, and which is, unfortunately, divided into thirteen paragraphs in the English translation):

la ciudad, extrañamente parecida, a esta hora de reverberaciones y sombras largas, a un gigantesco lampadario barroco, cuyas cristalerías verdes, rojas, anaranjadas, coloreaban una confusa rocalla de balcones, arcadas, cimborrios, belvederes y galerías de persianas—siempre erizada de andamios, maderas aspadas, horcas y cucañas de albañilería, desde que la fiebre de la construcción se había apoderado de sus habitantes enriquecidos por la última guerra de Europa. Era una población eternamente entregada al aire que la penetraba, sedienta de brisas y terrales, abierta de postigos, de celosías, de batientes, de regazos, al primer aliento fresco que pasara. Sonaban entonces las arañas y girándulas, las lámparas de flecos, las cortinas de abalorios, las veletas alborotosas, pregonando el suceso. Quedaban en suspenso los abanicos de penca, de seda china, de papel pintado. Pero al cabo del fugaz alivio, volvían las gentes a su tarea de remover un aire inerte, nuevamente detenido entre las altísimas paredes de los aposentos. (29–30)

[At this hour of shimmer and long shadows, [the city] looked strangely like a gigantic baroque chandelier, whose green, red and orange glass lent colour to a jumbled rocaille of balconies, arcades, domes, belvederes and lattice-covered galleries, bristling all over with scaffolding, timber, cross-beams, forked props and builder's poles now that the inhabitants (enriched by the last war in Europe) had been gripped by the building fever.

It was a town constantly exposed to the invading air, thirsty for land and sea breezes, with its shutters, lattices, doors and flaps all open to the first cool breath. Then the tinkling of lustres, chandeliers, beaded lampshades and curtains, and the whirling of weathercocks would announce its arrival. Fans of palm fronds, Chinese silk, or painted paper, would be motionless. But when this transient relief was over, people would return to their task of setting in motion the still air, once more trapped between the high walls of the rooms. (11–12)]

The Baroque, says Umberto Eco, tends toward dynamism and indeterminacy of effect: Carpentier's architectural elements in this passage and throughout the novel do indeed "set in motion the still air." Like the peripetia of his revolutionaries, Carpentier's objects create the illusion of dilating space—a sense of expansion without direction or destination. They constitute a *conjunto* (literally *with/together*, usually translated by the French word *ensemble*) that continually accumulates moving parts: the paragraph goes on to describe palaces with "splendid columns and coats of arms carved in stone" and manorial houses with "precious marble and fine paneling, with rose windows and mosaics, and with slim volute grilles so unlike iron bars that they looked more like iron vegetation" (12). In some of his novels (for example, *The Kingdom of this World* and *Lost Steps*), Carpentier "territorializes" the

New World Baroque with descriptions of lush topographies and exotic flora and fauna, but here his vegetation is wrought iron.[74] Artifice rather than nature—artifice *as* nature—constitutes Carpentier's Baroque metonymy in this novel; as in de Nomé's paintings, his architectural ornaments and furnishings move and multiply and melt into one another. The parts shift and circulate, together signifying the "pulsating" *conjunto* that is Havana and by extension, the Caribbean and *toda Latinoamérica*.

Octavio Paz writes that the great literary invention of the Baroque period was the Baroque conceit, the *coincidentia oppositorum*, the yoking of opposites in aesthetic structures that neither homogenize nor destroy difference, but rather hold oppositions open in order to generate expressive energy.[75] Baroque writers adapted earlier traditions of conjoining opposites[76] to the contradictory character of seventeenth century Europe—its sensualism and spirituality, intellectual innovation and theological dogmatism, empiricism and scholasticism—and in Latin America, to myriad cultural contradictions. Robert Harbison, in *Reflections on Baroque*, comments on the capacity of Baroque structures to accommodate inconsistency:

> Perhaps this offers a clue to why the Baroque was so successful in Latin America. . . . Even before it attempts to accommodate exotic cultural material, it seems that the Baroque thrives on contradictions and flowers in those perverse enterprises which try to insert contrary motives into a prescribed format, prefiguring European genres as the medium for rambunctious native imagination. . . . The formal principles on which [the Baroque] is built more easily lend themselves to stimulating intimations of primeval chaos than the establishment of classical order.[77]

The complementarity of opposites in Baroque aesthetics has been indispensable to three centuries of Latin American expression and, more specifically, to the formulation of Carpentier's own Baroque conceit, *lo real maravilloso americano*.

It has been argued that the Baroque eventually supplants the marvelous real in Carpentier's thinking, but I disagree.[78] Carpentier balanced the claims of the two throughout his career, and in some ways superimposed them.[79] "The marvelous real" is itself a Baroque *coincidentia oppositorum:* the marvelous opposes the real and also resides within it.[80] The very different nature of the Surrealist juxtaposition, when compared to Carpentier's *real maravilloso*, begins to explain his rejection of Surrealist aesthetics, despite their importance in his early artistic formation. The Surrealist juxtaposition (umbrella/sewing machine) requires a relation of radical disparity that is meaningless *except* as the elements remain disparate, random, mutually exclusive. On the contrary, the Baroque conceit proposes oppositions that continue to oppose while at the same time being displaced and reordered in dynamic spatial and conceptual relations. Their meaning depends upon contact, not upon separation or isolation. This distinction is made explicit in an interview with José Lezama Lima, who, like Carpentier, constructed his New World Baroque

aesthetics upon Surrealist foundations. When asked to differentiate between the poetics of Surrealism and the Baroque, he responded with a comment about his own poetic process: "no es surrealismo, porque hay una metáfora que se desplaza, no conseguida directamente por el choque fulminante de dos metáforas" (it's not Surrealism, because there is a metaphor that is displaced rather than generated by the explosive shock of two metaphors).[81] Coexisting, complementary oppositions, not mutual exclusion, are the structural bases of Baroque expression.

Recall the Thomistic/Aristotelian sources of Baroque naturalism, and the Counter-Reformation program of naturalism as a means to express the supernatural. Carpentier understood this Baroque program very well, for while his project was not religious, it *was* metaphysical—or marvelous, as he preferred to call the mysteries that inhere in the visible world. In his 1964 essay "On the Marvelous Real in America," Carpentier distinguishes the "marvelous real" from the "manufactured mysteries" of the Surrealists:

> . . . lo maravilloso comienza a serlo de manera inequívoca cuando surge de una inesperada alteración de la realidad (el milagro), de *una revelación privilegiada* de la realidad, de una iluminación inhabitual o singularmente favorecedora de las inadvertidas riquezas de la realidad, de una ampliación de las escalas y categorías de la realidad, percibidas con particular intensidad en virtud de una exaltación del espíritu que lo conduce a un modo de "estado límite." Para empezar, la sensación de lo maravilloso presupone un fe.

> [. . . the marvelous begins to be unmistakably marvelous when it arises from an unexpected alteration of reality (the miracle), from *a privileged revelation* of reality, an unaccustomed insight that is singularly favored by the unexpected richness of reality or an amplification of the scale and categories of reality, perceived with particular intensity by virtue of an exaltation of the spirit that leads it to a kind of extreme state [*estado límite*]. To begin with, the phenomenon of the marvelous presupposes faith.][82]

I have already suggested that Carpentier's *estado límite* is analogous to the expansive, volatile spaces of the Baroque, and I would add that the "privileged revelation" to which he refers describes the experience of the marvelous within the real. The converging ontologies of Guadalupe and Quetzalcóatl are engaged in Carpentier's conception of *lo real maravilloso americano:* the forms of the New World Baroque are capable of transmitting forces that are sacred, mythic, *other;* the visible refers to the invisible and also contains it. Carpentier's passage concludes: "Those who do not believe in saints cannot cure themselves with the miracles of saints, nor can those who are not Don Quixotes enter, body, soul, and possessions, into the world of Amadís of Gaul or Tirant le Blanc" (86). The recognition of absence is central to this formulation: plenitude ("body, soul, possessions") depends upon imagina-

tive projection, upon vision as a physical *and* metaphysical matter. This, I think, is what Carpentier means when he speaks of faith.[83]

The Baroque artist, then, whether reacting to Copernicus or colonization, struggles to fill the canvas, the façade, the score, the page with moving parts that, in their energy and instability, exist in signifying relation. For Carpentier, this signifying relation encompasses not just Havana and the Caribbean but Latin America in all its dynamic indeterminacy. In response to an interviewer's question, "What does the expression 'Nuestra América' suggest to you?" Carpentier responds emphatically:

> La de una *totalidad*—como en función de *totalidad* la veía José Martí. Aunque sus regiones, sus países, tengan características propias ¡y cuán propias! su historia es regida por denominadores comunes. Sus enemigos son los mismos. Sus males son comunes. Sus virtudes, muy semejantes. Los mismos peligros (otra vez habría que citar a José Martí) se ciernen sobre el destino de todas las naciones del Continente.[84]

> [A *totality*—José Martí saw it in terms of *totality*. Although its regions and countries have their own characteristics (and how!) their history has common denominators. Their enemies are the same. Their problems are shared. Their strengths are similar. The same dangers (to quote José Martí once again) hover over the destiny of all the nations of the continent.]

In Baroque fashion, Carpentier acknowledges the diverse parts that make up Latin America's histories and cultures, and then projects a structure in which they constitute an inclusive *conjunto*. His *universalismo americano* is not an ambition to harmonize the parts into some sort of essential unicity but rather an aspiration to encompass their interactions, however inconclusive the effort. Carpentier's reference to José Martí suggests that this aspiration is inherent in Latin American literature; certainly it persists among contemporary writers and critics.[85] John Rupert Martin, referring to the seventeenth-century Baroque, describes the "sense of the totality and continuity of space—of plurality in unity."[86] Though Carpentier would have preferred "heterogeneity" and "inclusiveness" to Martin's "plurality" and "unity," he too celebrates the capacity of the Baroque to embrace fragmentation and eccentricity. We turn now to Carpentier's most explicit defense of this proposition.

"THE BAROQUE AND THE MARVELOUS REAL"

"The Baroque and the Marvelous Real" is the second of a pair of essays in which Carpentier formulates his ideology of American identity. This essay builds upon an earlier one, "On the Marvelous Real in America," which served as prologue to

The Kingdom of this World (1949) and was later expanded and collected in *Tientos y diferencias* (1964). In his 1975 essay, "The Baroque and the Marvelous Real," Carpentier continues to engage *lo real maravilloso americano,* and as his two-part title suggests, he now finds this American ontology to be an inherently Baroque mode of being.

A number of examples of Baroque art and architecture ground his argument. Considering Carpentier's "initiation" in Mexico fifty years earlier, it is not surprising that most of his examples are Mexican. He mentions the Baroque façade and carved *retablos* of San Francisco Javier Tepotzotlán, the Jesuit church and seminary north of Mexico City, begun in 1670 and completed in middle of the eighteenth century, now the site of Mexico's National Museum of the Viceroyalty (fig. 3.7). The façade is monumental; inside, space opens up into the cupola of a diminutive side chapel called *el camarín,* the room where the statue of the Virgin was dressed for processions and other ceremonial occasions. Angels seem to take flight even as they are placed almost horizontally inside the tightly arched enclosure (fig. 3.8). The sky is filled—it is all hours of the day and night. The sun and moon appear on either side of the angels; stars are everywhere, and it is all weathers at once, with clouds and clear sky. And yet, though it is filled, the space surrounding the angels remains open, dilating, expansive.

The façade of Tepotzotlán represents the apogee of eighteenth-century Mexican Baroque, its style Churrigueresque, after the Spanish architect José Benito Churriguera, whom Carpentier mentions at the outset of his essay. Whereas the European Baroque was emphasizing grandeur and virtuosity of architectural structure, the Churrigueresque in New Spain embellished relatively simple buildings; what lacked in structural sophistication was made up for by profuse ornamentation. The Churrigueresque succeeds an earlier style called Plateresque, whose simple structures also contrast with (and heighten) the intricacy of their decorated façades. This earlier colonial style retains vestiges of Arabic influence in its twining vines and floral motifs, its arabesques and arches, its occasional niches and fretted woodwork (color plate 14). San Pablo Yuriria fills its façade with human figures and foliation; on either side of the window strapwork radiates out from an angel who carries and bow and arrow, and above the door are three "jaunty musicians."[87] The Plateresque may seem sober next to the Churrigueresque, but its decorative impulse is anything but understated in intent: the style derives its name from *platero,* meaning silversmith, suggesting a comparison between the sculpted stone of the façade and the finely carved ornamental motifs and traceries of worked silver.

Carpentier argues that these imported Baroque forms interact with indigenous forms, also Baroque, in a transcultural process that produced an intensified Baroque.[88] In the same breath that he mentions the Jesuit seminary at Tepotzotlán, he also mentions the pyramid of the Feathered Serpent at Teotihuacán, with its protruding sculptures of Quetzalcóatl and the storm god (Tlaloc), god of rain and

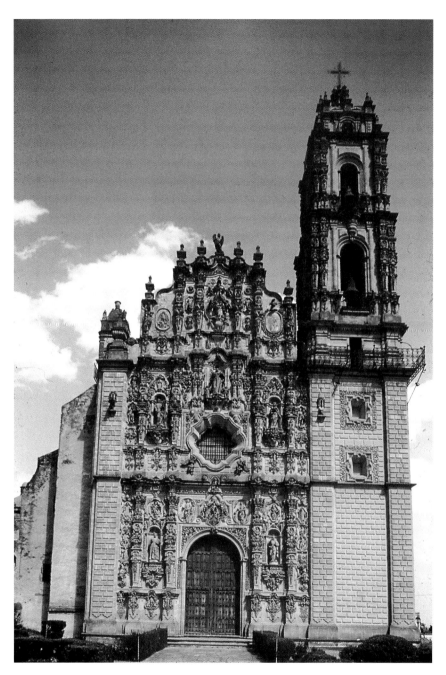

FIGURE 3.7 San Francisco Javier Tepotzotlán (façade, eighteenth century), Mexico. Now the National Museum of the Viceroyalty. Instituto Nacional de Antropología e Historia. Photograph: Dolores Dahlhaus.

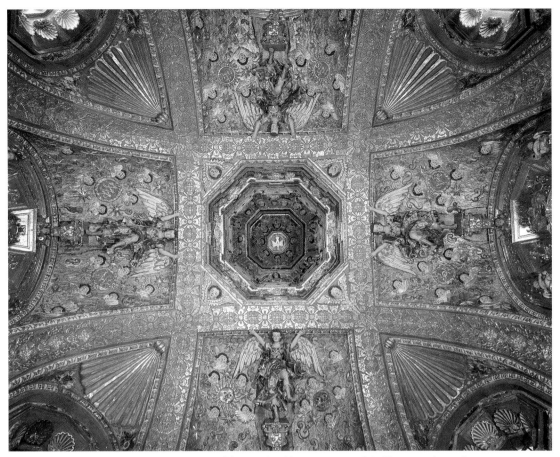

FIGURE 3.8 San Francisco Javier Tepotzotlán (dressing room of the Virgin, eighteenth century), Mexico. Now the National Museum of the Viceroyalty. Instituto Nacional de Antropología e Historia. Photograph: Dolores Dahlhaus.

water (fig. 3.9).[89] "Think," says Carpentier, "of the great heads of Quetzalcóatl at Teotihuacán, think of the ornamentation of the temples. It's Baroque; of course it's Baroque, with its geometries of both straight and curved lines, its particular fear of empty surfaces" (98). Carpentier's choice of this pyramid is telling, for its high relief sculptures are exceptional, as is the fretwork at Mitla in Oaxaca, also mentioned in his essay, along with the pyramid of Quetzalcóatl in Xochicalco, a Mexican site outside of Cuernavaca, where a low relief feathered serpent undulates along the entire length of its south face (fig. 1.2) There is no central focus here—and I refer equally to the Baroque façade and cupola, and to the surface of the pyramids; rather, there are proliferating foci (*focos proliferantes*), as Carpentier calls them: "decorative elements that completely fill the space of the construction . . . motifs that contain their own expansive energy, that launch or project forms centrifugally"

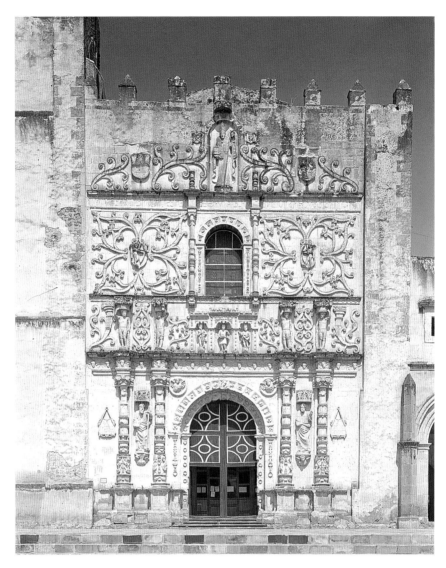

PLATE 14 San Pablo Yuriria (façade, sixteenth century), state of Guanajuato, Mexico. Photograph: Archivo Fotográfico Manuel Toussaint / Instituto de Investigaciones Estéticas / Universidad Nacional Autónoma de México, Pedro Cuevas.

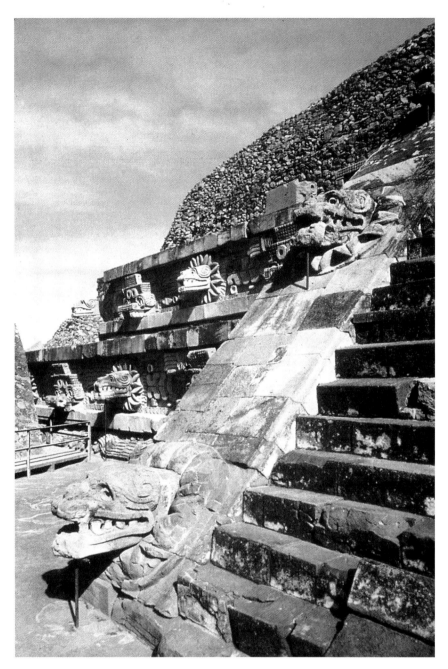

FIGURE 3.9 Sculpted heads of Quetzalcóatl and the storm god (Tlaloc). Pyramid of the Feathered Serpent at the ceremonial site of Teotihuacán, Mexico.

(93). For Carpentier, the Baroque no longer refers to an imported style but to a dynamic process of displacement and exchange, which he takes to be the common denominator of American cultures.

In his own Baroque style, Carpentier multiplies examples, mentioning the *Popol Vuh* and Nahua poetry and, by implication, the Mesoamerican codices that we saw in the previous chapter. And in the city of Puebla, Mexico, Carpentier focuses on the images in the Chapel of the Virgin of the Rosary in the Church of Santo Domingo. Here, New World fauna, flora, and physiognomies join the densities of the Spanish Baroque on the white and gold sculpted reliefs that loop and curve off the walls of the Rosary Chapel; there is no dividing line between sculpture, painting, and architecture, and the fanciful figures that appear on the walls are born of the conjunction of European engravings and American eyes and hands (fig. 3.10).[90] Bands of plaster grow out from the surface of the wall to envelop human and mythological figures, intertwine with other bands and move back to the wall—strapwork that predicts the interwoven ribbons in Rivera's murals that so fascinated Carpentier.

Eugenio d'Ors argues that the Baroque, in its devotion to nature and naturalism, has pantheistic tendencies: "El barroco contiene siempre en su esencia algo de rural, de *pagano,* de campesino. Pan, dios de los campos, dios de la natura, preside cualquier creación barroca auténtica" (82); ("The Baroque tends intrinsically toward the rural, the *pagan,* the peasant. Pan, the god of the fields, the god of nature, rules over all authentic Baroque works" [d'Ors's emphasis]). Whether one agrees with d'Ors's conflation of pantheism and paganism, it is easy to distinguish his European perspective from Carpentier's Latin American one. Carpentier's appreciation of the New World Baroque does not stem from the irruption of untamed nature into elite cultural forms, but from the fabulous refractions of European forms produced by indigenous artisans working in America.

These transcultural products have been labeled *tequitqui* by José Moreno Villa, who adopts the Náhuatl word meaning *tributario,* an artist or artisan living under imperial domination from whom tribute is exacted, the tribute here being images and artifacts.[91] Moreno Villa applies his term to America's *productos mestizos* (mestizo products), as he puts it—artifacts made by indigenous and mestizo artisans according to European models, which necessarily blur the boundaries between orthodoxy and heterodoxy, between official and popular forms of expression. Elizabeth Wilder Weismann also discusses the cultural "ecumenism" of *tequitqui* on Baroque façades and *retablos:* "All Baroque decoration in Mexico partakes of a popular quality, inasmuch as it seems to rely on the rendering of traditional detail by experienced craftsmen, rather than on the execution of specific designs supplied from outside the craft. So in the later seventeenth and in the eighteenth century, art in New Spain became truly Mexican, as the greatest decorative projects were taken over by folk artists."[92] *Tequitqui* is folk art in this sense, not in the European sense that Eugenio d'Ors intends when he speaks of "the rural, the *pagan,* the peasant."

FIGURE 3.10 Rosary Chapel, Church of Santo Domingo (strapwork with figures, seventeenth century), Puebla, Mexico.

For Carpentier, as for Moreno Villa and Weismann, the presence of *tequitqui* evidences the energy and originality of Latin American forms of transculturation, and is specific to the New World Baroque.

The term is often used to describe sixteenth-century architecture and artifacts in rural settings such as Santa María Tonantzintla (fig. 1.8) and San Miguel Arcángel Itzmiquilpan (fig. 1.7), but it is the syncretic images of the Rosary Chapel that Carpentier vividly remembers. He was a musicologist as well as a novelist, so he notes in particular the celestial choir, molded in plaster on the wall above the entrance, playing instruments from the European Renaissance modified by New World materials and musical practice (fig. 3.10). In fact, in 1964 Carpentier had already described the Rosary Chapel to illustrate his developing theory of the New World Baroque:

> No temamos, pues, el barroquismo en el estilo, en la visión de los contextos, en la visión de la figura humana enlazada por las enredaderas del verbo y de lo ctónico, metida en el increíble concierto angélico de cierta capilla (blanco, oro, vegetación, revesados, contrapuntos inauditos, derrota de lo pitagórico) que puede verse en Puebla de México.[93]

> [Let us not fear the Baroque in our style, in our vision of contexts, in our vision of the human figure entwined in the word and world, placed in the incredible angelic concert of a certain chapel (white, gold, vegetation, convolutions, unheard counterpoints, defeat of Pythagoras) that may be seen in Puebla, Mexico.]

In his injunction that the reader not *fear* the Baroque, we intuit centuries of depreciation of Baroque forms, as well as the prevailing attitude of Latin American cultural historians who were Carpentier's contemporaries. Most colonialists writing in the forties and fifties stressed the repressive politics of the Baroque in Latin America without regard to the transcultural energies that Carpentier was engaged in defining. I will return to these cultural historians in my conclusion, but here let's follow Carpentier's argument to its end.

His culminating example of the New World Baroque is the sculpted stone statue of Coatlicue (preface, fig. 0.1). Coatlicue, whom Carpentier identifies as the "goddess of death," is, in fact, the Mexica goddess of death *and* life, mother of gods and humans, carved, archeologists agree, shortly before the fall of the Mexica empire. She is a late expression—one might say a late accumulation—of the iconographies of various indigenous groups over several centuries. For Carpentier, Coatlicue is herself a Baroque conceit, the conjoining poles of life and death suggested iconographically by the twin serpents that face each other where her head should be. The Nahua myth tells of her decapitation and the genesis of the god Huitzilopochtli, who sprang fully armed from her decapitated trunk, like Athena from the brow of Zeus. She is over eight feet tall and carved from a single stone—mono-

lithic and also eclectic, carved on every inch of surface, including the bottom of her feet. As Octavio Paz puts it succinctly: "Coatlicue attempts to say everything."[94]

This figure combines several animals, including woman, and for Carpentier she epitomizes the impulse of the New World Baroque to accumulate, accommodate, include. Paz, too, sees her as a cultural *coincidentia oppositorum*, encompassing opposites without destroying difference: *lo real* and *lo maravilloso*, material and myth. In his essay on prehispanic art, he writes:

> The Coatlicue is, at one and the same time, a charade, a syllogism, and a presence that is the condensation of a *mysterium tremendum*. The realistic attributes are combined in accordance with a sacred syntax, and the resulting phrase is a metaphor that conjoins the three times—past, present, future—and the four directions. A cube of stone that is also a metaphysic.[95]

This "discourse in stone" recalls the narrative voice in Elena Garro's *Los recuerdos del porvenir*, the personified promontory upon which the Mexican village of Ixtepec and the entire culture once stood. But Garro's tone is elegiac, whereas Paz and Carpentier are celebratory; the New World Baroque does not signify decadence but rather, to repeat Carpentier's assertion, "the richest moment of a given civilization," because its dynamic structures are open to cultural memory, recuperation, inclusion. Its artifacts exist in a cumulative present tense.

Coatlicue is an emblem for this process in several works of modern art. As we saw in our preface, the Mexican painter Saturnino Herrán's 1918 painting *Coatlicue Transformed* (color plate 1) places a crucifix on the body of the Mexica goddess, making literal the superimposition of Spanish religious culture on indigenous Mexico. And Diego Rivera, in his 1933 mural in the Detroit Institute of Arts, recreates Coatlicue as a goddess of twentieth-century technology—another Coatlicue transformed (figs. 3.11 and 3.12). I doubt that Carpentier saw Rivera's Detroit murals—there is no mention of them in the many interviews where he invokes Rivera's work—but he would certainly have applauded the depiction of Coatlicue as an American admixture of ancient and modern, technological and telluric.

Carpentier's emphasis on Mexican art and architecture in "The Baroque and the Marvelous Real" does not obscure his devotion to the Cuban Baroque. In an interview published in 1974, a year before "The Baroque and the Marvelous Real," Carpentier describes the "Baroque ecology" of Cuba:

> Le diré, lo del barroquismo cubano . . . responde a una ecología. La época colonial nuestra no nos ha dejado grandes muestras de arquitectura barroca—comparables a los de México, Perú o Ecuador. Y sin embargo, Cuba es barroca en sus rejas, sus cristalerías, sus muebles, la vegetación tradicional de sus patios. Y en cosas menos tangibles y sin embargo presentes, cotidianas, familiares: las ocurrencias del lenguaje, la proliferación de la música, la omnipresencia del mar, el color de las

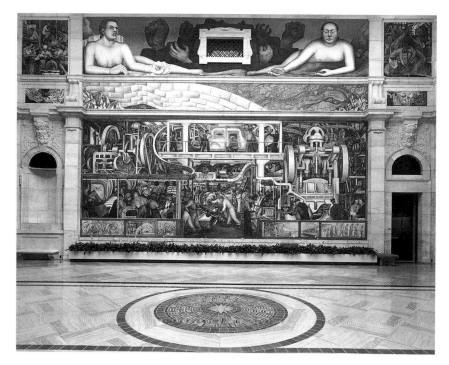

FIGURE 3.11 Diego Rivera, *Detroit Industry, South Wall* (1932–33), Detroit. Photograph: copyright Detroit Institute of Arts. Reproduced with permission.

cosas, cierta frondosidad del ambiente, cierto ritmo de danza que surge donde menos se espera. No sé. El barroquismo cubano es difícil de definir: está en el aire que se respira. Se siente.[96]

[I would say that the Cuban Baroque . . . corresponds to an ecology. Our colonial period has not left us many examples of Baroque architecture comparable to those of Mexico, Peru, or Ecuador. And yet, Cuba is Baroque in its grille work, its glasswork, its furniture, the traditional vegetation of its patios. And in things intangible and yet present, quotidian, familiar: the use of language, the omnipresence of music and the sea, the color of things, a certain luxuriant atmosphere, a certain dance rhythm that arises when least expected. I don't know. The Cuban Baroque is difficult to define: it is in the air one breathes. One feels it.]

There is an irony in Carpentier's catalogue of *things* to illustrate the "intangible" nature of the Cuban Baroque, but it is precisely the Baroque style that allows the writer to capture Latin American realities. In his 1964 essay, Carpentier cites Léon-Paul Fargue ("the most Baroque of the French poets of this century") as saying,

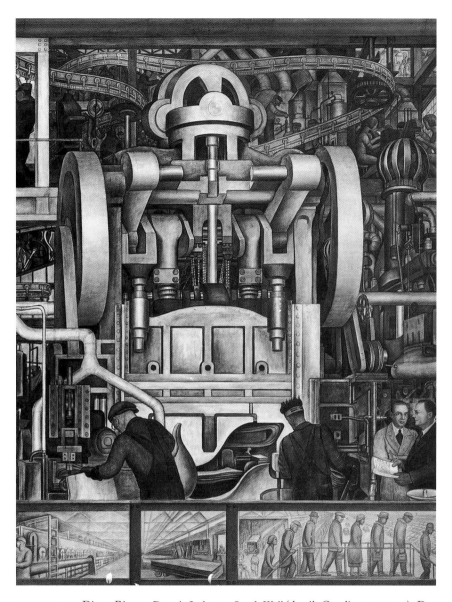

FIGURE 3.12 Diego Rivera, *Detroit Industry, South Wall* (detail, Coatlicue, 1932–33), Detroit. Photograph: copyright Detroit Institute of Arts. Reproduced with permission.

"*Show* me the object; make it with your words so that I can *touch it, value it, feel its weight*," to which Carpentier adds: "The object lives, is seen, lets its weight be felt. The prose that gives it life and substance, weight and measure, is a Baroque prose, a forcefully Baroque prose."[97] The tangible and intangible are continuous: a Baroque *spirit* ("the air one breathes") impels the material particularities of Latin American cultural formations and links them to the universe.

COLUMNS AND COLONNADES

For Carpentier, the columns of Havana epitomize the Cuban Baroque. His essay "La ciudad de las columnas" ("The City of Columns") was published in his 1964 collection *Tientos y diferencias* and six years later, in a separate edition with photos of Havana's architectural profusions by Paolo Gasparini, and again in 1982 with photographs by Fotografías/Grandal.[98] In both illustrated editions, there are photographs of grille work, stained glass, façades, but most of all, there are columns. According to Carpentier, Cuba's Baroque spirit is shown in its penchant to "acumular, coleccionar, multiplicar columnas y columnatas" ("accumulate, collect, multiply columns and colonnades"); in Havana, "todos los estilos de la columna aparecen representados, conjugados o mestizados hasta el infinito" ("all styles of columns are represented, conjoined or hybrid ad infinitum"), together creating what Carpentier calls "un irreverente y desacompasado rejuego" ("an irreverent and off-beat replay") of European forms. In fact, the photos show mainly Classical columns and colonnades, which multiply in a *rejuego* that comes to stand for Carpentier's cultural argument: the New World Baroque is unfinished, diverse, inclusive; its component parts exist in nonhierarchical relations that constitute a dynamic, indeterminate *conjunto*.

The Mexican historian Jorge Alberto Manrique describes the Baroque "attack" on the Classical column, by which he means the transformation of the column's function from a structural to a decorative one.[99] Classical columns are weight-bearing, whereas the columns on Baroque façades and *retablos* are not. The latter necessarily refer to the former, but they do so ironically, eschewing (or parodying) the verticality, stability and immobility of Classical columns.[100] The evolution of Baroque columns begins with modest undulating striations that produce a visual tension between horizontal and vertical movement; the spiraling rotations of the *salomonic* column further complicate its upward movement; the Churrigueresque *estípite* column narrows at the base to produce the illusion of floating in space even as its wider top suggests the weight it (no longer) bears. So removed does the Baroque column eventually become from its Classical function of structural support that it sometimes pretends to disappear altogether: its core is hollowed out and garlands twist around a column of air, a metaphoric column like Sarduy's "chain of signifiers" orbiting around an absent center. In fact, most Baroque columns

aren't really columns at all, but pilasters whose only function is to create the paradoxical impression of great mass and great movement.

Eugenio d'Ors precedes Carpentier in focusing on Baroque columns, with their parody of Classical solidity and solemnity, and their coexisting intentions of falling and flying (*gravitar y volar*) that "laugh at the principle of contradiction."[101] Once again, a Baroque conceit: opposing intentions may be true at once, and Baroque columns reflect this energy of opposition. The photographs of Havana by Gasparini and Grandal that accompany Carpentier's essay record columns, both flying and falling, that could be details from a François de Nomé painting. Along with the columns that cover the façades of Tepotzotlán and Ocotlán (fig. 3.7 above and color plate 3) and the portal of Church of the Carmelites in San Luis Potosí (color plate 4), we have ample evidence of the Baroque's "irreverent and off-beat replay" of Classical forms.

Carpentier indulges his love of Baroque columns and colonnades in the final scene of his final novel, *El harpa y la sombra* (*The Harp and the Shadow*, 1979). The ghost of Christopher Columbus haunts St. Peter's square after the failure of his beatification, initiated by Pope Pius IX in the mid-nineteenth-century. Columbus, the "Invisible One," stands in

> el lugar preciso de la plaza donde, cuando se mira hacia las columnatas de Bernini, la columnata frontal oculta tan perfectamente las otras tres, que cuatro parece una sola. "Juego de apariencias"—pensó: "Juegos de apariencias, como fueron, para mí, las Indias Occidentales.". . . Y, en el preciso lugar de la plaza desde donde, mirándose hacia los peristilos circulares cuatro columnas parecen una sola, el Invisible se diluyó en el aire que lo envolvía y traspasaba, haciéndose uno con la transparencia del éter. [102]

> [the exact spot in the plaza where, when you looked at Bernini's columns, the one in front hid the other three perfectly, so that all four appeared to be one. "An optical illusion," he thought. "An optical illusion like the West Indies were for me.". . . And in the precise spot in the plaza where the four columns of the circular colonnades merged into one, the Invisible One evaporated into the air that enveloped and passed through him, and he became one with the transparent ether.][103]

So the novel ends, with an almost mystical reference to the illusory quality of *las Indias Occidentales,* and with a play of perspectives appropriate to Baroque spaces and cultures.

CONCIERTO BARROCO AND SPENGLER'S ART OF FORM

Any discussion of Carpentier's Baroque practice requires reference to *Concierto barroco.* Set in the mid-eighteenth century, it describes a performance of Vivaldi's

opera *Moctezuma* as well as an imaginary meeting of a triumvirate of Baroque composers, Vivaldi, Handel, and Scarlatti ("the Venetian, the Saxon, and the Neapolitan"). This short novel covers remarkable ground—from Mexico City to Havana to Madrid to Venice, with a trip to Paris projected after the novel ends—and as in *Explosion in a Cathedral,* Carpentier uses geographic mobility to release the Baroque from its European moorings. When asked in interviews to comment on *Concierto barroco,* Carpentier invariably pointed to its transatlantic context: Vivaldi's 1733 opera about the conquest of America; the librettist Alvise Giusti's source in Antonio de Solís's enormously popular chronicle of the conquest, published in 1684; the subsequent proliferation of operas on that theme.[104] He also mentions the "rebirth" of Vivaldi's music in the 1930s and 1940s, which echoes the recovery of Baroque literature in the 1920s and after.[105]

Music is usually considered a temporal medium rather than a spatial one, but not by Carpentier, who refuses to separate music from the plastic arts, or eliminate space from his consideration of sound. For him, optics and acoustics are interrelated, a conception that coincides with Oswald Spengler's discussion of the Baroque in *The Decline of the West* (1918). Spengler was translated into Spanish in 1923, and that Carpentier read him is unquestioned. Critics have recognized Spengler's appeal to Latin American intellectuals; Roberto González Echevarría notes that in Spengler's universal history "there is no fixed center, and Europe is simply one more culture," and he also points to Spengler's refutation of Hegel's dialectical historicism in favor of a dialogic system of styles and structures across historical periods.[106] These ideas would have appealed to Carpentier, and though we may take him at his word in crediting Eugenio d'Ors as his source for his transhistorical conception of the Baroque, Spengler is far more important to Carpentier when it comes to music.[107] Spengler's treatment of the relations of music to the spatial structures of painting, architecture and mathematics is essential to our understanding of *Concierto barroco.*

For Spengler, music is an "art of form" that exists in space like painting or architecture,[108] and to separate it from the visual arts according to mere physiology— eye versus ear—is a fundamental error. Spengler addresses the overlapping structures of Baroque media in ways that Carpentier surely found suggestive: "If an art has boundaries at all—boundaries of its soul-become-form—they are historical and not technical or physiological boundaries."[109] By calling into question the "boundaries" of art forms, Spengler calls attention to his own method, which he describes as a "comparative morphology in world-history" (50):

> We *read* "Othello" and "Faust" and we study orchestral scores—that is, we change
> one sense-agency for another in order to let the undiluted spirit of these works take
> effect upon us. Here there is always an appeal from the outer senses to the "inner,"
> to the truly Faustian and wholly un-Classical power of imagination. . . . It is not an

accident that Beethoven wrote his last works when he was deaf—deafness merely released him from the last fetters. (219–20, Spengler's emphasis)

Spengler cultivates an astonishing historical and aesthetic range, always claiming his right (and duty, he would say) to abolish boundaries, not just between "sense organs" and expressive media, but also between Romanticism and the Baroque. His discussion of Baroque music includes Beethoven as well as Monteverde and Bach.

> The music of the Gothic is architectural and vocal, that of the Baroque pictorial and instrumental. The one builds, the other operates by means of motifs. For all the arts have become urban and therefore secular. We pass from superpersonal Form to the personal expression of the Master, and shortly before 1600 Italy produces the *basso continuo*, which requires *virtuosi* and not pious participants. (230)

Baroque music requires "virtuosi" because the development of symphonic instruments removes the limitations of the human voice or, rather, the human voice is now one instrument among others; even when the music is opera, the structure is orchestral, polyphonic. Spengler's emphasis on the moving parts of Baroque music—its operation "by means of motifs"—highlights the metonymic and mobile nature of Baroque expression that we have already seen in a variety of media: Carpentier's novels, Diego Rivera's murals, François de Nomé's paintings, New World façades and *retablos*.

In the central scene of *Concierto barroco,* the "jam session" in chapter 5, Carpentier incorporates precisely the characteristics of Baroque music that Spengler describes. His narrator refers to the new instruments of the time, to Scarlatti's "devilish virtuosity" and Handel's "dazzling variations . . . in the figured bass," as well as to the "pictorial" nature of music. In one scene, music shades into painting when a canvas is suddenly illuminated to reveal a scene of Eve and the serpent, a visual image that shades back again into music—into Filomeno's folksong about a snake, with its repeating African refrain of Ca-la-ba-són, and Vivaldi's hilarious displacement of the phrase with his own chant of "Kábala-sum-sum-sum" (79–81). Permutation isn't just from medium to medium but also from culture to culture, and Louis Armstrong's appearance at the end of the novel offers yet another permutation: jazz, the most culturally hybrid of U.S. musical forms and arguably the most Baroque in its dynamic structures of improvization. The plot of *Concierto Barroco* reflects Carpentier's conception of the Baroque as a *conjunto* of asymmetrical signifiers generating one another, converging, diverging, moving on.

Spengler's discussion of the "mathematical instinct" of the period, and his connection of this instinct to the *space* of Baroque musical form are also relevant to Carpentier's novel. About mathematics, Spengler writes: "the Baroque, differing

sharply from the Classical, presents us with a mathematic of spatial analysis. . . . It is the style of a Soul that comes out in the world of numbers, and the world of numbers includes something more than the science thereof" (58). The "style" of the Baroque "Soul" inheres, for Spengler, in Descartes's mathematics, which progress from the idea of magnitude (i.e., perceivable dimensions) to variable relations between points in space; length is replaced by position, and finite geometry by a "tendency toward the infinite" (75).[110] Whereas Classicism requires "visible limits," the Baroque no longer does: rather it is "an actualizing of an infinite space in which things visible appear . . . limited in the presence of the illimitable" (75). Descartes's triumph over the "visible limits" of Classical mathematics underpins the doubleness of Baroque representation: the "limited" signals the "illimitable," the part signals the whole, the near signals the far.[111] The "illimitable" extension of the new mathematics has its analogue in music where, Spengler writes, "the great task [of the composer] was to extend the tone-corpus into infinity, or rather to *resolve it into an infinite space of tone*" (230, Spengler's emphasis). The "space-straining music" of the Baroque—the fugue, the sonata forms of the suite, the concerto grosso, the variations and ornamentations of musical motifs—are no longer measured in terms of magnitude but as "vehicles of pure and unlimited motion" (231).

Structural analogues to Spengler's "illimitable" extension in *Concierto barroco* might include the magnificent trumpeting of Handel's oratorio and Armstrong's jazz improvisations, the intertextual references to Shakespeare and Stravinsky, the discordant variations on the historical theme of Moctezuma. In fact, Carpentier comments on the musical "variation" in a 1978 interview, echoing Spengler in his assertion that its function is to reveal to the listener "all possible implications of a given theme." In this interview, besides music he mentions Goya, Picasso, and Cervantes ("What are the adventures and tribulations of Don Quixote if not a series of variations on a single theme?") and concludes that "the principle of variation is a constant in Spanish art." [112] Indeed, the title of Carpentier's essential, untranslated collection of essays *Tientos y diferencias* is a musical metaphor best translated as "Toccata and variations."

For Spengler, it is chamber music, with its intertwining themes and variations, that provides "our prime symbol of endless space":

> *Here, in chamber music, Western art as a whole reaches its highest point*. . . . When one of those ineffably yearning violin melodies wanders through the spaces expanded around it by the orchestration of Tartini or Nardini, Haydn, Mozart or Beethoven, we know ourselves in the presence of an art beside which that of the Acropolis is alone worthy to be set. (231; Spengler's emphasis)

Spengler's assertion is itself Baroque in its hyperbole and its reach: his embrace of Classical architecture and Baroque music in a single celebratory phrase comes as a

surprise after his repeated contrasts between Classicism and the Baroque. But his *coincidentia oppositorum* is as appropriate to his theory of Baroque Soul as Carpentier's Classical columns are to his theory of Baroque Spirit. In *Concierto barroco*, the jam session of "the Venetian, the Saxon and the Neapolitan," joined by Satchmo and Stravinsky, signals the "unlimited space-universe" of the Baroque, a universe that Carpentier makes America's own.

4

The Baroque Self

KAHLO AND GARCÍA MÁRQUEZ

... la pintura está más cerca del jeroglífco que del lenguaje. Es apasionado afán de comunicación, pero con procedimientos mudos. ... Toda la gracia de la pintura se concentra en esta dual condición: su ansia de expresar y su resolución de callar.

... painting is closer to hieroglyphics than language. It wants passionately to communicate but is mute. ... The wonder of painting lies in this double condition: its longing to speak and its resolve to remain silent.

JOSÉ ORTEGA Y GASSET
"Velázquez"[1]

Painting myself for others, I have painted my inward self with colors clearer than my original ones. I have no more made my book than my book has made me—a book consubstantial with its author, concerned with my own self, an integral part of my life. ... Have I wasted my time by taking stock of myself so continually, so carefully?

MICHEL DE MONTAIGNE
"On Giving the Lie"[2]

In this chapter, we shift our focus from the nature of Baroque space to the related matter of Baroque subjectivity. So far, we have concentrated on artists and writers who create inordinate spatial structures to encompass the dynamics of American cultural identities. Elena Garro's space/time in Ixtepec, Eduardo Galeano's hemi-

spheric mosaic, Alejo Carpentier's Caribbean displacements, José Lezama Lima's gnostic space, Severo Sarduy's chain of signifiers orbiting around an absent center: these are recognizably New World Baroque metaphors and methods that conform to Walter Benjamin's observation about the Baroque: "History merges into setting."[3] This phrase, from Benjamin's 1928 study of German Baroque drama, refers to European manifestations of the Baroque, but his insight is applicable to the syncretic American images I have just enumerated. I expect that Benjamin would also have recognized Jorge Luis Borges's garden of forking paths as a Baroque "setting" in its conceptual conflation of time and space: a labyrinthine space that contains a vast chronological network encompassing all possible histories. I will return to Borges's Baroque structures in my final chapter, but here my subject is the Baroque self, and my aim is to locate certain continuities between European Baroque modes of rendering subjectivity on the one hand, and Latin American modes of self-representation on the other. In the process, we will identify substantial discontinuities as well.

The life and work of the Mexican painter Frida Kahlo have been discussed (and filmed and photographed) to such an extent that further exposure would seem to be superfluous. What has not been appreciated, however, is Kahlo's essential relation to Baroque forms of visual expression. The indigenous references in her work have been amply noted, but the Baroque iconography that meshes seamlessly with those references has not, for Kahlo engages Baroque *and* indigenous iconographies, metropolitan *and* popular forms, in ways that we have seen to be typical of the New World Baroque.[4] Amply noted, too, is Kahlo's rather superficial relation to European Surrealism; the index to Hayden Herrera's biography of Kahlo cites nineteen separate references to Surrealism but not a single one to the Baroque.[5] This virtual silence on Kahlo's engagement of Baroque modes of self-representation is, in my view, a mistaken imposition of recent European and U.S. categories on Kahlo's work, an imposition that has played a central part in the astonishing process whereby her work and her very self have been turned into objects of consumer culture. What I intend to consider here is how Kahlo recuperates and revises the structures of Baroque portraiture in order to dramatize modern female subjectivity.

To place Kahlo's self-portraits in their proper cultural context will require that we consider conventions of self-representation in seventeenth-century Europe, and then trace their transculturation in Mexico, a back and forth movement designed to detect the foreshadowings of Kahlo in her Baroque precursors, and also to suggest (in Borgesian fashion) her influence upon them. This strategy reflects Carpentier's insight that the Baroque is not just a historical period but also a spirit, a way of knowing and being in the world that recuperates dormant cultural energies, and sometimes entire cultures. Having approached Kahlo in this fashion, I will extend our understanding of her self-portraiture to the characters in Gabriel García Márquez's fiction.

In the course of my discussion, I address the overlapping categories of Baroque, New World Baroque, and Neobaroque. Both Kahlo and García Márquez are New World Baroque artists, by which I mean that they self-consciously engage Baroque conventions for New World purposes. Like the artists and writers we have seen in preceding chapters, and recalling Lezama Lima's term *contraconquista*, Kahlo and García Márquez are *contraconquistadores;* they adapt Baroque structures to their syncretic cultural contexts, and in the process appropriate and assimilate the hegemonic other. But García Márquez's work is also Neobaroque in ways that Kahlo's is not. Whereas Kahlo's multiple self-portraits are designed to *intensify* interiority, García Márquez's repeating characters *ironize* interiority; if Kahlo strives to unify the self (as did Pascal and Sor Juana Inés de la Cruz) even as it doubles and divides under her brush, García Márquez regales in a proliferating, segmented, composite self. Both artists move from individuals to archetypes, but Kahlo's New World Baroque universalizes, whereas García Márquez's Neobaroque abstracts—the former to *construct* the self, the latter to *deconstruct* it. García Márquez's much discussed magical realism is surely as rooted in his ironic use of Baroque caricature as it is in his flying carpets and biblical hurricanes.

THE PASSIONS OF THE SOUL

Seventeenth-century Baroque portraiture depicts the birth of the modern self. "The passions of the soul" is Descartes's phrase, and it is cited by John Rupert Martin to suggest the growing investment of Baroque art in the representation of interiority. Martin points to the paradoxical use of flesh-and-blood realism to suggest the internal instability of the self, an instability recognizably modern in its doubts and indeterminacies: "The resurgence of the passions in the artistic domain may be regarded as one of the consequences of Baroque naturalism, which at the same time that it gave closer scrutiny to human actions and physiognomy, led to a deeper interest in the emotional life."[6] The creative tension between Baroque naturalism and this new interiority reflects the dawning awareness of the ambiguous relations of mind and body, self and world, and with them, the dawning dislocations of *ser* and *parecer* (being and seeming). This transitional moment is famously discussed by Michel Foucault in *Les mots et les choses* (*The Order of Things*, 1966), but here I want to consider Erwin Panofsky's observation about this new self-consciousness.

In his 1934 essay "What Is Baroque?" the art historian and iconographer addresses the nature of European Baroque self-representation in terms of seventeenth-century theories of knowledge and cultural change. He points to the new science and philosophy of sensation and impression, and cites Descartes's phrase *cogito ergo sum* as confirmation that by the mid-seventeenth century, the mind was newly conscious of its own activity and its problematic relation to the world.[7] The separation of mind and body that devolves from Cartesian thought and becomes a

hallmark of Western modernity had not yet been fully established, but the integration of mind and matter could no longer be assumed. Panofsky writes that "Baroque people" were "haunted (and enlivened) by the intense consciousness of an underlying dualism":

> They not only feel, but are also aware of their own feelings. While their hearts are quivering with emotion, their consciousness stands aloof and 'knows.' . . . The experience of so many conflicts and dualisms between emotion and reflection, lust and pain, devoutness and voluptuousness had led to a kind of awakening and thus endowed the European mind with a new consciousness.[8]

We are still a long way from our own post-Romantic, psychologized conception of the unique individual, but Panofsky is accurate in his description of the emotional self-awareness, born of conflicting possibilities, that characterizes the Baroque self. In the visual arts, perspectival play encodes these conflicting possibilities by complicating, multiplying, and ironizing Renaissance perspective, and writers, along with painters, dramatize the ways in which mind and matter must be mediated—their relations adjudicated—through representation, whether verbal or visual.

These generalizations are epitomized in the anxious thoughts of Blaise Pascal. His fragmentary musings were written during the middle decades of the seventeenth century and collected posthumously in 1670 under the title *Pensées;* these fragments, as Jorge Luis Borges puts it, are "predicates of the subject Pascal . . . traits or epithets of Pascal."[9] Their theme is the self, and the self's consciousness of itself; Pascal's point of view constantly oscillates between subject and object, between what he can know and what can be known.

> To know man, then, it is necessary to know how it happens that he needs air to live, and to know the air, we must know how it is thus related to the life of man, etc. Flame cannot exist without air; therefore to understand the one, we must understand the other. . . .

> And what completes our incapability of knowing things is the fact that they are simple, and that we are composed of two opposite natures, different in kind, soul and body. For it is impossible that our rational part should be other than spiritual; and if any one maintain that we are simply corporeal, this would far more exclude us from knowledge of things, there being nothing so inconceivable as to say that matter knows itself.[10]

In these metonymic constructions, Pascal contemplates the interconnectedness of everything, whether the connections are complementary or contradictory or both at once. Pascal was trained as a mathematician but he would eventually assert that "the heart has reasons of which reason itself knows nothing." So he expresses (and

embodies) the doublings and divisions of the self that Martin and Panofsky find in Baroque painting, and which characterize Baroque art in all media: Montaigne's essays, Calderón's plays, Velázquez's paintings, and Cervantes's novel, where the tension that torments Pascal is incorporated in the fictional selves of Sancho Panza and Don Quixote.

Pascal's beloved precursor Michel de Montaigne published his *Essais* between 1580 and 1588, and they, too, present an extended contemplation of the Baroque self: its instability, its fickleness, and the unreliability of its modes of expression. In his essay entitled "On Experience," Montaigne writes, "I study myself more than any other subject. That is my metaphysics; that is my physics." (C'est ma metaphisique, c'est ma phisique).[11] Montaigne's encounters with the self are never methodical, always tenuous, ever circumstantial. In another essay, "Of Prompt or Slow Speech," he writes, "I do not find myself in the place where I look; and I find myself more by chance encounter than by searching my judgment."[12] Montaigne searches for himself and observes the search: playing with his cat, he wonders whether his cat is playing with him, and writing his book, he finds that his book no less writes him. World and self are mutually constitutive, and Montaigne constantly reminds himself and his reader that whatever self-knowledge he achieves will be achieved by self-representation, by the self representing itself to itself in an ongoing, unstable, and often frustrating process. The naturalistic specificity of Montaigne's descriptions (his long disquisition on his kidney stones, his detailed descriptions of vehicles, "cannibals," physiognomy, his forms of work and leisure) does not mitigate the instability of the self. On the contrary, the concretions of the world only heighten his sense of the massy, messy multiplicity of the single self whom he endlessly explores and revises. Montaigne's efforts to visualize the self—a process equally sensory and conceptual—often engage the metaphor of painting, as the epigraph to this chapter attests.

It is just such con/fusion of subject and object, even as the self is presented utterly naturalistically, that has made Velázquez's *Las Meninas* (Ladies in waiting) the defining example of Spanish Baroque painting (fig. 4.1). Here, Velázquez paints himself painting himself, a circle of self-representation that includes the monarchs whom he ostensibly paints but whom we see only as reflected mirror images at the back of the salon.[13] This oscillation between the interior and exterior of the canvas doubles the oscillation between subject and object, painter and painted; the Baroque self is both surveyor and seen. Velázquez's elusive play of reflections is as Borgesian as it is Baroque, but unlike the insubstantial wraiths that people Borges's fiction, Velázquez's figures are densely physical. In his portraits of the historical personages that surrounded him in the Hapsburg court—kings and courtiers and priests, dwarfs and *meninas*—as well as in his imaginary portraits of Aesop and Menippus and other legendary figures in contemporary dress, Velázquez established what was to become the model for the relations of psychology and setting in modern portraiture.[14]

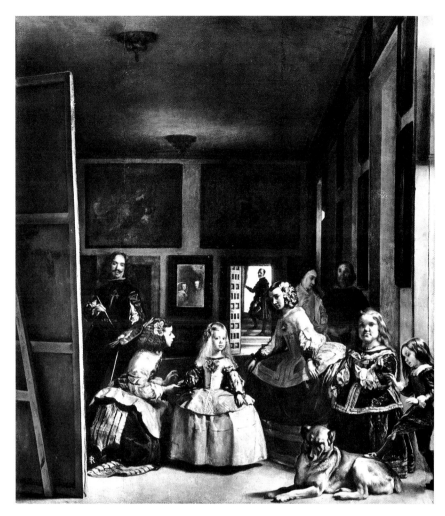

FIGURE 4.1 Diego Velázquez, *Las Meninas* (1656). Prado Museum, Madrid. Photograph: Alinari/Art Resource, NY.

The Baroque self-consciousness that Velázquez dramatizes is fully exploited in Baroque religious art. The cast of religious personages is enormous, and when angels and archangels are added in, the representation of selves is virtually endless. The innumerable portraits of Christ and the holy family, the apostles and saints and martyrs, the clergy and selected believers (usually those who commissioned the painting) embody an emotional landscape as surely as they also portray physical events and metaphysical meanings. We have discussed the Counter-Reformation insistence upon the separation of the image from what it represents; the visual image was to point to invisible realities but was not to be mistaken for those realities. This had long been Church policy, and the separation of image and object was

reiterated and reinforced by the Council of Trent. This renewed emphasis on *re*-presentation increased the need for visual techniques that could depict invisible truths, and Baroque artists developed strategies to do so. The desire to communicate the ineffable in visible form impels what I will call the transcendental naturalism of Baroque portraiture. This mode strives to fuse the physical and the metaphysical in visual metaphors that inevitably veer toward allegory. Religious portraits depict selves who are at once individuals and archetypes, selves whose specific emotional interiority is designed to project an allegory of interiority as such.

Caravaggio's portrait of Mary Magdalene responds to this dual imperative, and also to the demotic agenda of Baroque religious art (fig. 4.2). Though Caravaggio was hardly a Catholic propagandist, his art nonetheless follows the Counter-Reformation prescription that its viewers should identify with the saints and learn from their sanctity. The informality of Caravaggio's Magdalene makes her as accessible to viewers as their own sister or daughter; she is vulnerable, simple, asleep. Along with St. Sebastian, the archetypal Baroque martyr whose languid body pierced with arrows provided the pretext for countless sensuous representations of the male nude, the Magdalene epitomizes the Baroque combination of eroticism and other-worldliness, and she likewise provided the pretext for painting radiant female flesh.[15] In fact, she was portrayed with a sensuousness reserved for her alone among female saints; she was a prostitute (though "courtesan" might better communicate her status—rich brocades and satins often complement her female flesh), and the life of erotic pleasure that preceded her conversion is inevitably the subtext for the scenes of penance (also erotic) that so often serve as the setting for her portraits. (Figure 1.5, Juan Correa's *The Conversion of Mary Magdalene,* explicitly depicts both the "before" and the "after" of this celebrated conversion narrative.) In Baroque art, conversion was a favored topic, given the recent loss of one-third of European Catholics to Protestantism and so, too, was the sacrament of penance, which had been challenged and discarded by Protestant reformers. What better way to emphasize the importance of these interconnected agendas than by portraying a converted sinner and her penitential suffering? Unlike most artists of the time, however, Caravaggio does not depict the ecstatic moment of Mary Magdalene's conversion, or her lifetime of penance in the wilderness following Christ's death. Rather, he makes her an emblem of the peace that follows confession, repentance, and absolution.

This issue of penance was a crucial dividing line between Protestants and Catholics. The Protestant doctrine of grace dispensed with the need for penance; baptism and faith were considered to be sufficient for the absolution of sins, and in any case, the believer's salvation depended wholly upon God's grace. Catholics, on the contrary, continued to believe that salvation could (and must) be earned. The self-examination required by confession was essential to this end, and the Counter-Reformation emphasis on the penitential process helped foster the Baroque self-

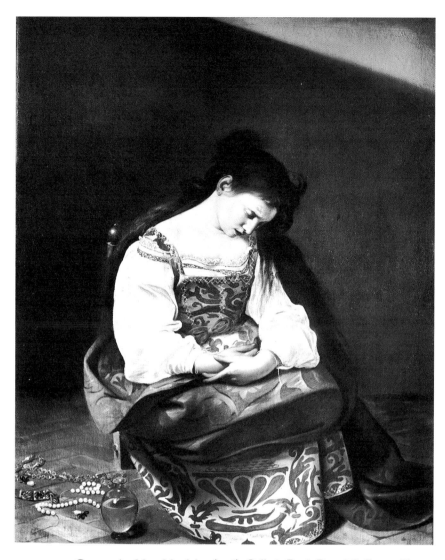

FIGURE 4.2 Caravaggio, *Mary Magdalene* (1596). Galleria Doria Pamphili, Rome. Photograph: Alinari/Art Resource, NY.

awareness (and self-dividedness) that Panofsky describes and Pascal embodies. Jacques Barzun writes that "from the Reformation onward a new intensity of religious feeling imposed the question: 'is my soul destined for salvation?'"[16] Confession was viewed by the Catholic Church as a way to self-knowledge and illumination, and in this sense, it runs parallel to Montaigne's secular self-examination, though Montaigne's intention was not to discover salvation but to know the self for its own sake.

How can we tell that Caravaggio's sleeping figure is Mary Magdalene? Beside her, scattered on the floor, are pearls. These irregular pearls recall one of the possible etymologies of the word Baroque, as I will explain in the following chapter, but more to the point here, they are "attributes" of Mary Magdalene, that is, the prescribed visual detail that identifies a saint in a work of visual art and refers to his or her special virtues and intercessory capacities. These iconographic elements, as well as the particulars of the saint's expression, stance, clothing, and surroundings, were laid out in manuals such as Cesare Ripa's *Iconologia*, first published in Rome in 1593 and reprinted dozens, perhaps hundreds of times over the following two centuries.[17] Contemporary viewers were well accustomed to "reading" this visual lexicon: strands of pearls would immediately have recalled the Magdalene's former life of luxury, and when the strands are broken and the pearls scattered, they become symbols of her tears and her liberation. One might think that any strand of precious stones would suffice to communicate these narrative details, but the symbolic charge of pearls is richer yet: pearls originate in imperfection, in the transfiguration of an infirmity or abnormality—a bit of grit—inside the oyster.[18] Thus conversion and penance are joined in this scene of a sleeping girl, an example that illustrates the allegorical intention of virtually all Baroque religious portraiture.

Other visual attributes of Mary Magdalene are the vessel containing the perfumed oil with which she washed Christ's feet, and her hair—long, loose, blonde or copper or auburn—with which she dried them.[19] The shimmering, unstable reflection of Caravaggio's pearls in the oil of the vessel—a dynamic interplay of attributes—points to yet another allegorical message: the volatility of self and substance.

Caravaggio's group portrait, *The Entombment of Christ*, is also concerned with these volatile relations (fig. 4.3). Baroque religious art searches for ways to bring the supernatural into the realm of human experience, a goal that inevitably focuses upon the quintessential Christian intersection of humanity and divinity in Christ's passion. The spiritualization of sense impels all Baroque religious portraiture, a conjunction of physics and metaphysics, to recall Montaigne's phrase, that is most often accomplished in portraits of martyrdom and ecstasy, both of which combine pain and pleasure in a mystical mode. It is a commonplace that the Counter-Reformation valorized suffering as a mode of social control; certainly suffering was portrayed with an altogether original energy by Baroque artists. Caravaggio's depiction in this painting of the Virgin—the suffering mother, *la Dolorosa*—is representative of spiritualized suffering, and of the transcendental naturalism characteristic of Baroque religious portraiture. Note Mary Magdalene at the back of the group, her arms raised, her hair down, her expression extravagant, ecstatic, possessed. Note as well the figure in the foreground, possibly a likeness of the painter himself: in fact, Caravaggio often included self-portraits in his religious paintings, a practice that reflects the growing awareness of the self and its manifold re-presentations.[20]

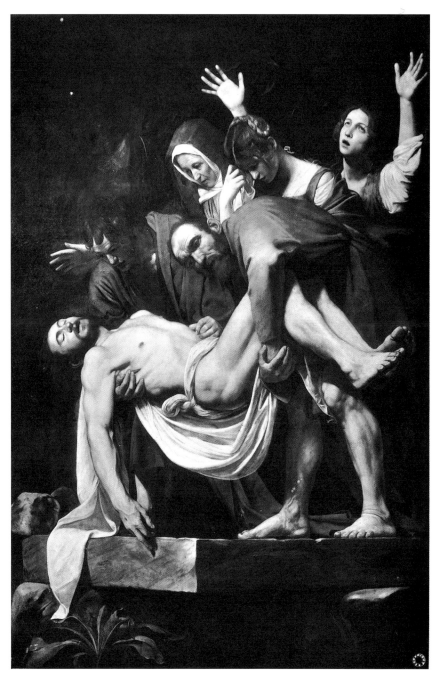

FIGURE 4.3 Caravaggio, *The Entombment of Christ* (1602–4). Pinacoteca Vaticana, Rome. Photograph: Alinari/Art Resource, NY.

Lives of saints are, by definition, extreme, and the metaphysics of the Baroque body cannot be understood without reference to these heroic figures in transcendental garb. Mystical incorporation received unprecedented emphasis during the Counter-Reformation in response to the Protestant rejection of the transubstantiation of the Eucharist (hence the Counter-Reformation emphasis on Christ's bodily suffering) and the related rejection of the intercessory role of the saints (hence the insistence on the efficacy of their suffering). The Council of Trent addressed the status of saints' bodily relics in Catholic worship, and no wonder; saints increasingly cultivated the habit of dying grisly deaths in the line of duty, and their pain was increasingly depicted as indistinguishable from ecstasy.[21] Nor does their rapture mask physical deformity, injury, deprivation and death: the Baroque glorifies the body in all its visceral aberrations. We recognize St. Lucy by her eyes, which she carries on a platter, St. Agatha by her breasts, similarly detached and displayed, and St. Apollonia by her teeth, extracted by the Romans who tortured and martyred her and thus created the patron saint of dentists and those suffering from toothache.

Stories of suffering saints long precede the seventeenth century, but the widespread depiction of their suffering does not. Francisco Zurbarán's series of saints, including Lucy and Agatha, painted in the 1620s and '30s, may be said to epitomize this fascination with the body as a fragile composite of parts, a fascination that reflects Baroque science as well as theology. We have only to remember Rembrandt's *Anatomy Lesson,* painted in 1632, to see how the new physical sciences informed the increasingly clinical depiction of human bodies. Baroque theatre (and theatricality) assisted in this purpose, presenting live bodies upon which tragic conflicts could be played out; the unremitting scenes of physical cruelty in Calderón's plays will serve as example. Seventeenth-century picaresque narratives are equally invested in the description of inflicted suffering; here, *Don Quixote* (1605, 1615) is exemplary. Jorge Luis Borges long ago recognized Cervantes's masterpiece as an ironic hagiography, comparing the tortures visited upon the innocent hidalgo to "la aventura contemplativa y extática de los santos" (the contemplative and ecstatic adventure of the saints).[22] Walter Benjamin, in *The Origins of German Tragic Drama,* reaffirms this connection between belief and bodies, noting that in Baroque drama torture "was a more immediate basis of violent emotions than so-called tragic conflicts" and "martyrdom prepared the body of the living person for emblematic purposes."[23] I cite Benjamin's statement to predict the emblematic physicality of Kahlo's self-portraits and García Márquez's fictional personages.

The etymological source of the word martyr is witness—someone who sees—and whether a saint was believed to have been martyred or not, his or her physical vicissitudes were considered to be vehicles of spiritual transcendence. By the seventeenth century, saints' lives had become dual narratives of sentience and spirit,

and they provided material that permanently expanded the emotional range of Western painting. In what is itself a wonderfully Baroque phrase, Arnold Hauser contrasts the popularizing, propagandistic Baroque to the Mannerism that preceded it: "This emotionalism and sentimentalism, this wallowing in pain and suffering, wounds and tears, is Baroque, and has nothing to do with the intellectualism, spiritual aloofness, and emotional remoteness of Mannerism."[24] Hauser is right, of course. Baroque religious portraiture is affective and hyperbolic, and from his rationalist perspective, inordinate beyond tolerating. What he doesn't remark upon is the fact that the wounds and tears are always accompanied by an allegorical distillation of passions in the form of ideas, a combination of sensuousness and sobriety that becomes clear when we compare the Baroque, as Hauser suggests, to the "intellectualism" of Mannerist painting, or the exteriority of Renaissance sculpture. It is enough to contrast the self-contained surfaces of Michelangelo's David (1506) to Bernini's centrifugal St. Teresa, sculpted 140 years later, to envision the different sensibilities that Hauser describes (fig. 4.4).

The Counter-Reformation Church sought to revive the direct and popular appeal of saints' lives as recounted in *The Golden Legend,* a compendium of legends collected by the Dominican friar Jacobus de Voragine in the thirteenth century, and portraiture was essential to this project.[25] Writing of devotional images during the Baroque period, the Peruvian iconographer Teresa Gisbert asserts that believers were encouraged "to establish an intimate and personal relationship with the object of devotion by means of a representational image. . . . This emotional union between the sacred—personified by God, Christ, the Virgin, and the saints—and the person who aspires to communicate with them . . . [is considered] to be inherently Baroque."[26] Not all saints are biblical or legendary, of course. Many lived and died and were canonized during the sixteenth and seventeenth centuries; most were either founders or members of reformed orders, and many wrote about their mystical experiences, whether in poetry or prose or in handbooks on meditative practice.[27] They would have been part of a living, collective memory in both Europe and New Spain. Image makers and image consumers might have known the saints whose portraits they fashioned or beheld, or at least known someone who did, up to several degrees of separation; such connections were remembered, recounted and mythologized. So these portraits would have been actual physical likenesses, as well as visual allegories of a given form of sanctity.

The epitome of Baroque saints is Saint Teresa of Avila, founder of the reformed order of the Carmelites, indefatigable administrator and exemplary ecstatic. Gian Lorenzo Bernini's visualization of Saint Teresa's own metaphor for her ecstasy—the dart of God's word piercing her heart—is sculpted in marble, a medium that heightens the Baroque conjoining of solid sensuousness and transported spirit. The combination of eroticism and otherworldliness in Bernini's masterpiece is quintessentially Baroque,[28] as is its plastic capacity to project its competing intentions from a distance and at the same time draw the viewer into the intimacy of the

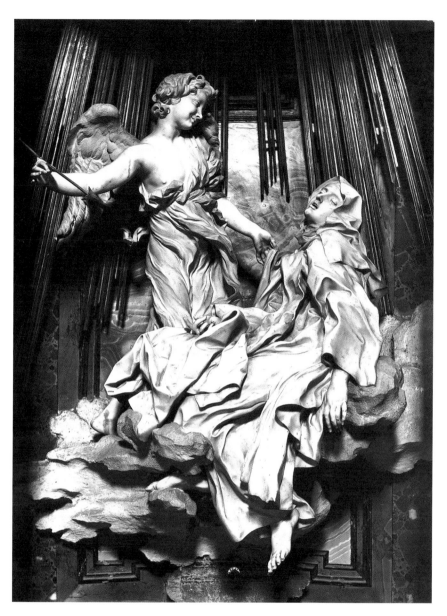

FIGURE 4.4 Gian Lorenzo Bernini, *The Ecstasy of St. Teresa* (marble, 1645–52). Coronaro Chapel, Santa Maria della Vittoria, Rome. Photograph: Alinari/Art Resource, NY.

event. Frank J. Warnke notes that the Baroque understanding of ecstatic transcendence included a conception of intense intellectual activity; to transcend individual identity required "the precise and self-aware definition of that identity," not just "lax emotional surrender."[29] For a miraculous moment, the singular self expands to incorporate the universe.

Ecstasy, then, may be considered a Baroque *coincidentia oppositorum,* or a *coincidentia variorum,* to coin a phrase, because Bernini strives to collapse erotic experience, intellectual self-awareness and spiritual transcendence in a single image, thereby empowering (and obliging) the viewer to inhabit a new realm of subjectivity. Saint Teresa's writings conclude Walter Benjamin's discussion of Baroque interiority:

> the subjective perspective is entirely absorbed in the economy of the whole. . . . thus it is that the fire of ecstasy is preserved, without a single spark being lost, secularized in the prosaic, as is necessary. In a hallucination, St. Teresa sees the Virgin strewing roses on her bed, and she tells her confessor, [who] replies, "I see none." "Our Lady brought them to *me,*" answers the Saint. In this way the display of manifest subjectivity becomes a formal guarantee of the miracle, because it proclaims the divine action itself.[30]

The saint's "manifest subjectivity" is based in the "fire of ecstasy" and underwrites the real. Pain and profit are linked as never before: the body facilitates the experience of spirit, its entrance into "the economy of the whole."

Secular portraiture followed religious portraiture in encoding the transcendent dimension of the sitter (fig. 4.5). This portrait of an aristocratic woman from the early seventeenth century was painted in New Spain by the second of three generations of Echaves. The first, Baltasar de Echave Orio, the son of a Sevillian painter, arrived in the 1560s, following the market, as it were, painting religious scenes and personages for the churches that were, by this time, being constructed in astonishing numbers. His son, Baltasar de Echave Ibía, and grandson, Baltasar de Echave y Rioja, followed in his footsteps. By the seventeenth century, painters were increasingly commissioned to paint secular portraits, which served both social and political purposes. The long tradition in Spain of intermarriage among Christians, Muslims, and Jews before the expulsion of the latter groups in the late fifteenth and sixteenth centuries made family lineage an obsession in Spanish culture worldwide. At the time it became common practice to join several names with "y" ("and") and "de" ("from") in order to demonstrate paternity, maternity, and place of origin. The word *hidalgo* (lower nobility) derives from *hijo de algo* (son of something), an etymological reminder of the importance of the formalities of descent and the fictions that supported them. In New Spain, portraiture became a way of affirming social status and lineage, as Echave Ibía's portrait of this woman suggests; her names have not come down to us, but we can be sure that she had several. Our interest

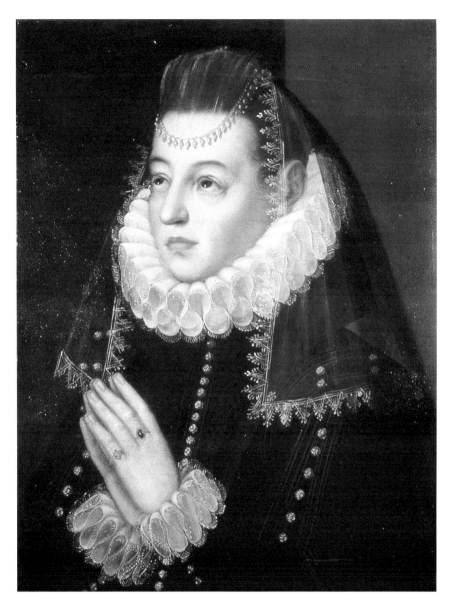

FIGURE 4.5 Baltasar de Echave Ibía, *Portrait of a Woman* (seventeenth century), Mexico. National Museum of Art. Instituto Nacional de Antropología e Historia/ Consejo Nacional para la Cultura y las Artes. Photograph: Archivo Fotográfico Manuel Toussaint/ Instituto de Investigaciones Estéticas/Universidad Nacional Autónoma de México, Pedro Angeles Jiménez.

here is in the transcendental naturalism of this secular portrait, a tradition that Frida Kahlo engages and adapts to her purposes. This dialectic between self and other, between corporality and disembodied spirit, is so engrained in Mexico, and in Frida's work, that Diego Rivera could write without hesitation after her death in 1954 that "she painted at the same time the outside and the inside, the depths of herself and the world."[31] Emblematic status is conferred upon the secular subject; thus, the visible self is invested with metaphysical mystery.

FRIDA KAHLO'S NEW WORLD HAGIOGRAPHY

The Baroque emphasis on the bodily expression of spiritual torment is indispensable to any discussion of Frida Kahlo's self-portraits. Kahlo was not religious, but she routinely engaged the Baroque iconography of sanctified suffering; her work often alludes to martyrdom, and her self-portraits function as ceremonial retellings by means of which both her body and her paintings are imbued with ritual significance. This is partially the effect of so many similar self-portraits. We look at one self-portrait at a time, of course, but any viewer knows that there are many more—a proliferating self, as it were; the meaning of her portraits resides as much in their repetition as in the content of any single one of them. In the vast production of visual hagiographies in New Spain, a high degree of stylization inevitably resulted from the sheer numbers of portraits of saints, with their prescribed attributes endlessly repeated along with scenes of their life and death. The repeating selves of Frida are congruent with Baroque hagiography in this regard, and most especially with folk Baroque representations of saints, where artisans were limited (by ability and resources, perhaps, but also by popular demand) to reproducing the same images that everyone already knew by heart.

Beyond the repetitive nature of Baroque religious portraiture, there is a central iconographic tradition of repeating selves that flowered in New Spain as nowhere else. In what are called anthropomorphic Trinities, the Trinity is visualized as three identical selves rather than the individualized triad of Father, Son, and Holy Spirit as dove or emanating rays of celestial light. In Andrés Lopez's image, Christ proliferates from three in one to six in one—two holy families, as it were, with a single face (fig. 4.6). This iconic tradition recovers the etymological connection between "identical" and "identity" and suggests, by extension, the universality of all single selves.

Our sense of Kahlo's repeating self-portraits as heir to this mystical iconography is confirmed when we think about the multiple self-portraits painted by another Baroque artist. In Rembrandt's many self-portraits, we see the passage of time, we see the painter changing, getting older, wearing different costumes in different settings and poses.[32] This is also true of Montaigne's multiple self-portraits, which are prey to history and change over time, however unpredictably. On the

FIGURE 4.6 Andrés López, *Trinity in Heaven, Trinity on Earth* (seventeenth century), Mexico. National Museum of Art. Instituto Nacional de Antropología e Historia/Consejo Nacional para la Cultura y las Artes.

contrary, Kahlo's self-repetitions, her variations on the theme of the single self, have the effect of suggesting a hallucinatory multiplicity of timeless selves. Or is it an obsessive reduction of multiplicity to the claustrophobic shell of a single self? Her double self-portraits make explicit this ambiguous instability of the self: its doublings (*The Two Fridas*), its divisions (*Tree of Hope*), its disjunctions (*My Doll and I*), and its diffusion into some cosmic whole (*The Love Embrace of the Universe*). Double portraits became fairly common during the Baroque period and continued through the nineteenth century. Several portraits of seated sisters, closely resembling each other, might seem to be precursors to *The Two Fridas,* the irony being, of course, that Kahlo's double portrait is of a single self.

Other New World Baroque traditions of multiple selves also resonate in Kahlo's work. Portraits were often painted in series, with each portrait independent and yet also a part of the larger work that is the series as a whole. Such series might be the twelve Roman sibyls who were said to have predicted the events of

Christ's life, the twelve apostles, the twelve sons of Jacob, the four evangelists, the seven archangels, the seven deadly sins, the seven sacraments represented allegorically, or the seven figures representing the liberal arts. In these composite portraits, formal sequence (linear order) is not prescribed; rather, the parts comprise a *conjunto* whose internal relations are dynamic and multidirectional. Group portraits of nuns, priests and friars were also common; no religious order failed to portray its collective self, often gathered under the cloak of its founder or the Virgin, or sprouting from a living family tree. Such plural portraits are the genealogical tree of the Franciscan order in Zinacantepec, Mexico (color plate 15), and an early nineteenth-century family tree (fig. 4.7). Selves are individualized and yet their identity is conferred by the group to which they belong. In all cases, these portraits are designed to suggest a multiple, interconnected, corporate self. (See also figs. 4.19 and 4.20.) Though Kahlo's family tree in *My Grandparents, My Parents and I* differs in obvious ways from these precursors, the question she embeds in her image does

PLATE 15 *Spiritual Genealogy of the Franciscan Order* (detail, sixteenth century), San Miguel Zinacantepec, state of Mexico, Mexico. Instituto Nacional de Antropología e Historia. Photograph: Bob Schalkwijk.

not: what is the relation of the self to others, and to its own multiple parts (fig. 4.8)? García Márquez's Buendías and his autumnal Patriarch will also pose this question, but in an ironic register.

I take this visual structure—multiple portraits meant to depict a collective entity—to be one more manifestation of the Baroque interrogation of the relation of parts to wholes. During the sixteenth and seventeenth centuries every conception of wholeness was shattered, whether geographical, astronomical, anatomical or theological, and the parts of those systems were set adrift. Furthermore, the emerging sciences required analysis of physical realities, which meant breaking things into their constituent parts, such that fragmentation must have come to seem the very purpose of the new empiricism. The instability we have identified

FIGURE 4.7 Anon., *Portrait of the Captain of the Grenadiers Don Manuel Solar and His Family* (1806), Mexico. Museo Soumaya/Instituto Nacional de Antropología e Historia. Photograph: Javier Hinojosa.

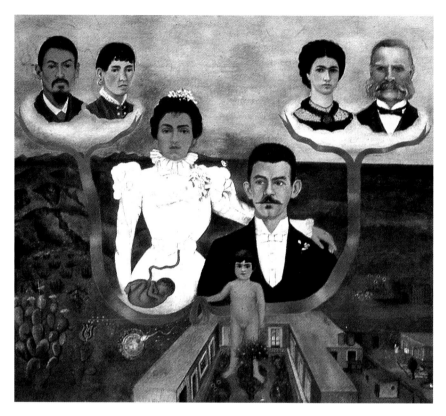

FIGURE 4.8 Frida Kahlo, *My Grandparents, My Parents and I* (1936), Mexico. Instituto Nacional de Bellas Artes / Banco de México. Photograph: Archivo Fotográfico Manuel Toussaint / Instituto de Investigaciones Estéticas / Universidad Nacional Autónoma de México.

in the Baroque self and its representations may be understood as a struggle with unanchored parts: the autobiographical writings of Montaigne and Pascal are mediations between fragmentation and tentative integration. That Montaigne rejoiced in the fragments and Pascal was tortured by them them does not alter this fact. Their irregular expressive forms—Pascal's posthumously published "thoughts," Montaigne's "attempts" (*essais*) to follow the vagaries of the self—are typical Baroque structures, in which parts circulate and wholes are never fully defined.

So, too, Kahlo's many self-portraits are the mobile parts of a whole that eludes definition. If we consider Kahlo's self-portraits in this way—as fragments of an indeterminate or absent whole—we immediately perceive the process of metonymic displacement typical of Baroque structures. Their dynamism depends upon the permutation of compositional elements that grow out of one another and dissolve into one another, whether the elements are ideas or images or volumes or voids; the as-

sociation, accumulation, and diffusion of elements become the basis for Baroque structures as a whole. Immobile and isolated as any single instance of a Kahlo self-portrait might appear to be, it does not signify singly but rather as a set or series. Each self-portrait differs from the others, but each one also reflects all of the others. This interaction refuses closure and partially explains how Kahlo's naturalism can depict interiority so effectively to a worldwide audience.

In fact, Kahlo takes several of her characteristic "attributes" directly from Baroque portraiture of women. One is the nun's medallion, worn to signify belonging. In the seventeenth century and into the eighteenth, a medallion displaying a painted or embroidered image was worn by members of certain orders on formal occasions.[33] The famous portrait of Sor Juana Inés de la Cruz—an eighteenth-century copy by Miguel Cabrera of a lost portrait painted during her lifetime—foregrounds the medallion at her throat, which in its image of the Annunciation signals the Marian devotion of Sor Juana and the Jeronomite order (fig. 4.9).

Sor Juana lived two and a half centuries before Kahlo, and yet in many ways she is Frida's closest Mexican contemporary. Like Frida's painting, her writing is inseparable from her life. As a child, she was identified for her brilliance and beauty, and despite her humble origins and illegitimate birth, she was brought as a lady-in-waiting to the viceregal court. At the age of eighteen, she chose to enter the convent and for nearly two decades managed to balance religious service with vast intellectual engagement, but there came the inevitable point when the balance could no longer be maintained. She was ordered to give up her library and her writing, and died three years later in an epidemic of an unknown disease, attending to others in her convent. Mariano Picón-Salas's groundbreaking study in 1944, in which he coins the term *barroco de indias* and appreciates Sor Juana in ways that were still uncommon, contains the following assertion: "Her personal life was a drama of repression and disillusionment that . . . found no outlet or escape valve in bitter mockery and grim realism. Rather, she seemed to armor herself with a proud shield of logic and metaphysics. . . . By arguments arranged like syllogisms she tries to convey to us the anguish of her heart."[34] This statement echoes Pascal's description of his own self-division ("the heart's reason"), and Picon-Salas's metaphor of a "proud shield" recalls the medallion in Sor Juana's portrait. Knowing her circumstances, we now see her medallion less as a badge of belonging than as its opposite—as a symbol of the irreconcilable differences between her world and her self: scholasticism and science, obedience and innovation, nun and poet. Octavio Paz summarizes her self-division: "Despite the brilliance of her career, the pathos of her death, and the admirable geometry that shapes her best poetic creations, there is something unrealized and fragmentary in the life and work of Sor Juana. We can sense the melancholy of a spirit who never succeeded in forgiving herself for her boldness and her condition as a woman."[35]

Frida Kahlo's sense of her status as a woman is as central to her work as it was to Sor Juana's, and her repeated self-portraits echo Sor Juana's awareness of the

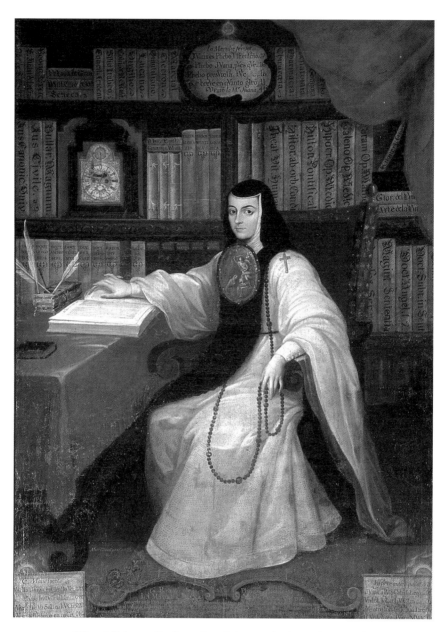

FIGURE 4.9 Miguel Cabrera, *Sor Juana Inés de la Cruz* (eighteenth century), Mexico. National Museum of History. Instituto Nacional de Antropología e Historia. Photograph: Archivo Fotográfico Manuel Toussaint/Instituto de Investigaciones Estéticas/Universidad Nacional Autónoma de México, Ricardo Markel.

ambiguity of all attempts to portray the (female) self. In fact, Sor Juana frequently used portraits as a metaphor for the difficulties of self-representation; she refers to a portrait of herself as *diversa de mí misma* (different from myself) and in Sonnet 145, she calls her portrait a "painted deceit":

> Este que ves, engaño colorido
> que del arte ostentando los primores,
> con falsos silogismos de colores
> es cauteloso engaño del sentido. . .[36]

> [These lying pigments facing you,
> with every charm brush can supply
> Set up false premises of color
> to lead astray the unwary eye . . .][37]

If the medallion at Sor Juana's throat is the sign and symbol of these contradictions, so too are the medallions embedded in Frida's forehead, in such self-portraits as *Thinking about Death* and *Self-Portrait as a Tehuana*. Frida's images represent the obsessive presence of two alter egos within herself: death and Diego (fig. 4.10). Her devotion is also her penance; her headdress in *Self-Portrait as a Tehuana* looks strangely like a nun's habit, and her tears are a standard accoutrement of Baroque female saints.[38]

To the characteristic Baroque tension between self and other, substance and spirit, Kahlo's multiple self-portraits add the tension between copy and original. The effect of their repetition is like a *regressus ad infinitum* in which facing mirrors endlessly reflect their own reflections. In fact, the mirror and the portrait are intimately related in Baroque iconography; I would propose that for Frida Kahlo, as for Sor Juana, these related emblems epitomize their thinking about self-representation. Octavio Paz elaborates the case of Sor Juana:

> In Juana Inés the function of mirrors and portraits is both rhetorical and symbolic. For her, the mirror is the agent for the transmutation of infantile narcissism into self-contemplation; through a process analogous to reading, which converts reality into signs, *the mirror turns the body into an image made of reflections. In the mirror, the body becomes simultaneously visible and untouchable. It is the triumph of eyes over touch.* Subsequently, the image of the mirror is transformed into an object of knowledge. From eroticism to contemplation and from contemplation to criticism: the mirror and its double, the portrait, are a theatre where seeing is metaphorphosed into learning. A learning that to the Baroque sensibility is disillusioned learning.[39]

Kahlo, like Sor Juana, uses the mirror image to envision the relations of self and world, and to situate her body beyond the reach of doctors and Diego, in the realm

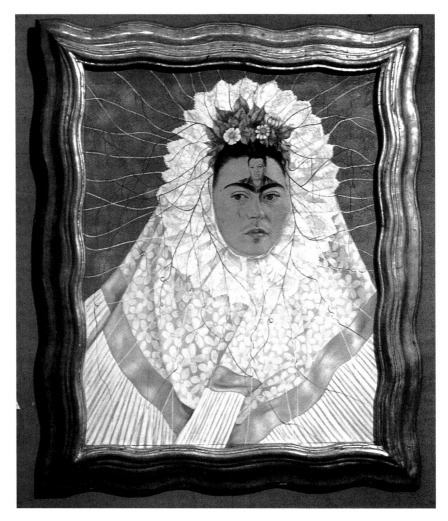

FIGURE 4.10 Frida Kahlo, *Self-Portrait as a Tehuana* (1943), Mexico. Gelman Collection, Banco de México. Instituto Nacional de Bellas Artes. Photograph: Archivo Fotográfico Manuel Toussaint/Instituto de Investigaciones Estéticas/Universidad Nacional Autónoma de México, Pedro Cuevas.

that Paz calls "visible and untouchable." Kahlo's *Framed Self-Portrait* is presented as if it *were* a mirror image: her face is painted on glass and framed by painted *ho-jalata*, the hammered tin that often frames mirrors in Mexico. As in all of her self-portraits, Kahlo is both subject and object of her own discourse; original and copy are presented as indistinguishable.

In chapter 1, we contrasted the function of the mirror image in the myths of Quetzalcóatl and Narcissus, the former an empowering agent, the latter an agent

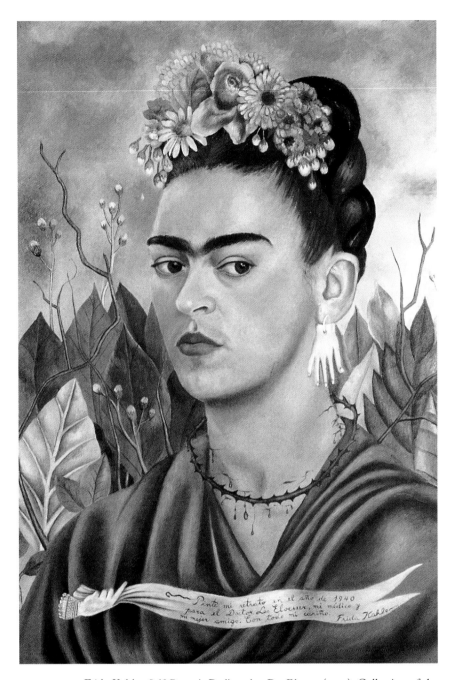

FIGURE 4.11 Frida Kahlo, *Self-Portrait Dedicated to Dr. Eloesser* (1940). Collection of the Estate of Dr. Leo Eloesser, Hoover Gallery, San Francisco. Banco de México / Instituto Nacional de Bellas Artes. Photograph: Archivo Fotográfico Manuel Toussaint / Instituto de Investigaciones Estéticas / Universidad Nacional Autónoma de México, Pedro Cueras.

of deception and self-distancing. Sor Juana and Kahlo combine these attitudes in different measures because Sor Juana, no less than Kahlo, acknowledges the living presence of indigenous culture in her own history and psyche. In the *loa,* or preface, to Sor Juana's theatrical work *Divine Narcissus,* the author refers explicitly to indigenous modes of seeing, and her treatment of the visual image in this poetic drama differs sharply from the secular poetry to which I have just referred. Her Narcissus is Christ, in love with his own image, Human Nature, for whom he dies. Like the reflection in Quetzalcóatl's mirror, Sor Juana's divine Narcissus integrates self and world; image and spirit are not self-divided but integral, identical, one.

Do Kahlo's self-portraits imply such a possibility? Their obsessive repetition would seem to imply the contrary: that self-knowledge is fragmentary, fleeting, even futile, no matter how many attempts one makes to represent the self to the self. Not to mention the repetitions within the repetitions: Kahlo's many surgeries and miscarriages, repeated long after her doctors and common sense dictated otherwise, and her two marriages to Diego, a double disaster. These repetitions in Frida's life, as in her art, seem more like Narcissus, who drowns in his own reflection, than the Mesoamerican figure of Quetzalcóatl, who is empowered by his. But in fact, her self-portraits transcend narcissism because the body itself communicates with the viewer, conveying the psychic life of the painter as she repeatedly expresses her self in color and form. The body expresses what cannot be seen: her own pain and her proximity to human suffering as such. Experience and expression are united in Kahlo's images.

Nuns' portraits furnish yet another iconographic detail to Kahlo's Baroque supply. Well-to-do families commemorated their daughters' taking of vows with a portrait that showed them with a crown of flowers, holding a taper or a sacred image. The conventions of these nineteenth-century portraits of *monjas coronadas* (literally, crowned nuns[40]) are echoed in Kahlo's self-portrait titled *Self-Portrait Dedicated to Dr. Eloesser,* in which she wears an elaborate floral headdress (fig. 4.11). Her necklace of thorns is coincident with this version of herself as a *monja coronada;* her crown, like Christ's, is ironic, signaling her entry into the kingdom of the cloister. The portraits of *monjas coronadas* are often labeled with the name and parentage of the novice, and the date of her entry into the convent. Kahlo also labels many of her self-portraits, a practice that critics have linked to the narrative descriptions on the painted ex-votos that depict scenes of miraculous interventions by a saint or virgin in the lives of the persons who commissioned the painting.[41] The labels of this folk medium echo the Baroque impulse to annotate and record, and they extend this didactic tradition of visual representation.

In fact, Baroque religious painting often included writing, not only on framed spaces beside or beneath the image but also on phylacteries, the ribbons of language that wind through space. In an anonymous Mexican painting of *La Benedicta de Acto-*

pan (Tota Pulchra) from the last third of the sixteenth-century, phylacteries surround and connect the Virgin of Actopan, and they prefigure those that surround (and strangle) Frida (color plate 16 and fig. 4.12). The anonymous eighteenth-century Mexican painting entitled *Christ Carrying the Cross* (fig. 4.13) is an allegory of the difficulty of being a good Christian; notice the virtues and vicissitudes labeled on ribbons and attached to crosses, referring to Christ's injunction, "Take up your cross and follow me." There are fully forty-six labeled ribbons that describe such "crosses": *Tristezas, Aflicciones, Tormentos, Dolores* (Sadness, Afflictions, Torments, Pains). We see echoes of this visual trope in Kahlo's *Roots,* where her body is her cross, the roots emblematic of her own *tristezas, aflicciones, tormentos, dolores* (fig. 4.14).

The motif of Christ's purposeful blood became conventional during the Baroque period. Here, *Allegory of the Blood of Christ, Christ Enclosed in the Garden,* an anonymous nineteenth-century work, traces the fruitful issue of Christ's body in the allegory of the Eucharist (fig. 4.15; see also color plate 5). Such celestial tracery is echoed ironically in the industrial wasteland of *Henry Ford Hospital,* in which Kahlo traces the *fruitlessness* of *her* issue (fig. 4.16). In both contexts, the body works allegorically and emblematically to define and reinforce systems of belief and social practice, but where Christ's body refers to the cosmos—heaven and earth and all creation—Kahlo's is hers alone.

This array of visual echoes from Mexican Baroque religious painting enriches Kahlo's work, but there is one reference to which I attribute the particular pathos (and power) of her self-portraits. This is Kahlo's engagement of Marian iconography. *My Nurse and I,* in which a telluric figure gives her veined breast to a miniature Frida, is an allegory of cosmic maternity in a Marian mode. It is *not,* however, the Virgin *with* child, but the Virgin *without* child, that subtends Kahlo's self-portraiture. The suffering Virgin (*la Dolorosa*) is portrayed by seventeenth-century Mexican painter Baltasar de Echave y Rioja, the third generation of the Echaves in New Spain (fig. 4.17). The dagger of pain that invariably pierces the heart of *la Dolorosa* is implicit in many of Kahlo's self-portraits, and explicit in *The Little Deer,* with its head of Frida and its body pierced with arrows (fig. 4.18).[42]

In *My Birth* too, the image of *la Dolorosa* is key (color plate 17). This painting has been discussed in terms of the Aztec goddess Tlazoltéotl, who is also depicted at the moment of childbirth,[43] but much more to the point is the portrait of the Dolorosa that hangs above the bed. Here, Frida gives birth to herself—another double portrait of sorts, which then itself redoubles: the suffering mother, her head covered on the bloody bed, doubles *la Dolorosa* in the portrait above her bed (her head also covered), as she herself is doubled by her dead child. This painting within the painting encodes the double pain of Frida, the pain of birth and also the pain of loss. The work is Baroque in its engagement of these internal self-reflections, as well as in its use of Christian iconography.

PLATE 16 Anon., *La Benedicta de Actopan (Tota Pulchra)* (sixteenth century), Mexico. National Museum of the Viceroyalty/Instituto Nacional de Antropología e Historia. Photograph: Dolores Dahlhaus.

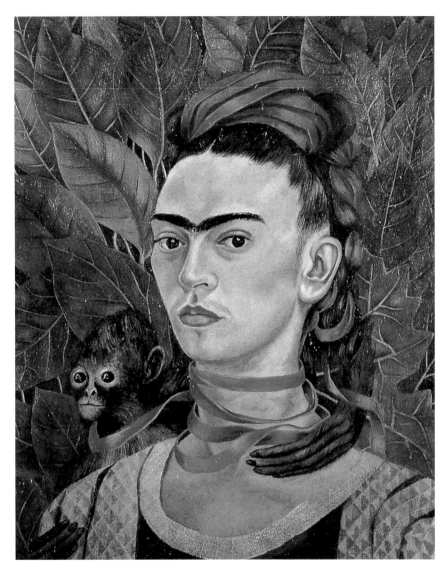

FIGURE 4.12 Frida Kahlo, *Self-Portrait with Monkey* (1940), Mexico. Gelman Collection, Banco de México. Instituto de Bellas Artes. Photograph: Archivo Fotográfico Manuel Toussaint/Instituto de Investigaciones Estéticas/Universidad Nacional Autónoma de México, Pedro Cuevas.

FIGURE 4.13 Manuel Villavicencio, *Christ Carrying the Cross* (eighteenth century), Mexico. Museo de Arte Religioso Santa Mónica de Puebla. Instituto Nacional de Antropología e Historia.

FIGURE 4.14 Frida Kahlo, *Roots* (1943), Mexico. Fundación Dolores Olmedo, Banco de México. Instituto Nacional de Bellas Arte. Photograph: Archivo Fotográfico Manuel Toussaint / Instituto de Investigaciones Estéticas / Universidad Nacional Autónoma de México.

The Virgin's suffering is paramount in Mexican Baroque portraiture because Christ's passion is paramount. The sacred heart of Christ—emblem of the passion—is doubled in Mexican Baroque iconography by the sacred heart of Mary (figs. 4.19 and 4.20). In these twin paintings by the eighteenth-century Mexican artist Juan Patricio Morlete Ruiz, the iconography is conventional: thorns and a cross identify Christ's heart above the grieving Virgin; a lily and a dagger identify the Virgin's heart above the grieving Christ. Morlete Ruiz's paintings prefigure Kahlo's self-portrait called *Memory,* which cannot possibly be understood except in terms of Marian emblems (color plate 18). The sacred heart gushes with blood at her feet, and the dagger that symbolizes the Virgin's suffering is rendered in the form of the pole upon which Frida was impaled in the tram accident that caused her life-long suffering. Kahlo's Baroque dagger—an ironic angel astride its far end—pierces her heart, her Tehuana outfit hanging beside her, its arm linked in hers. So we discover another Coatlicue Transformed, a syncretic image of ritual suffering and sacrifice, a transcultural reference to the mythic function of injury in both indigenous and Christian cultures. In Mexico City during the first half of the twentieth-century, this iconography of embodiment would have been as available to Kahlo as the air she breathed, and as recognizable to her Mexican audience as her own face is to us now as an emblem of female suffering—and female self-awareness.

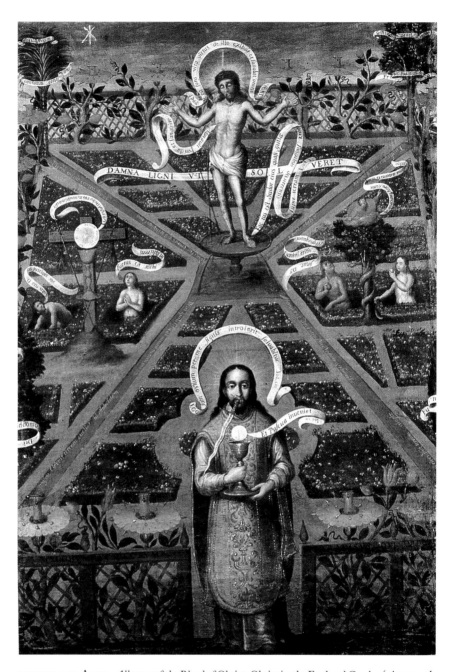

FIGURE 4.15 Anon., *Allegory of the Blood of Christ, Christ in the Enclosed Garden* (nineteenth century), Mexico. Museo de Arte Religioso Santa Mónica de Puebla. Instituto Nacional de Antropología e Historia.

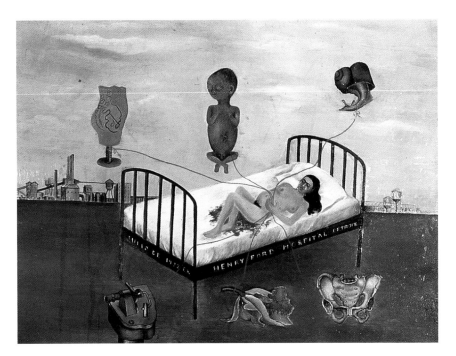

FIGURE 4.16 Frida Kahlo, *Henry Ford Hospital* (1932), Detroit. Fundación Dolores Ol-
medo, Banco de México. Instituto Nacional de Bellas Artes, Mexico. Photograph: Archivo
Fotográfico Manuel Toussaint/Instituto de Investigaciones Estéticas/Universidad Nacional
Autónoma de México.

FOLK BAROQUE

I have quoted Arnold Hauser's characterization of the Baroque as "wallowing in
pain and suffering, wounds and tears," and indeed, such hyperbolic emotionalism
is palpable beneath the surface of Kahlo's impassive self-portraits. This tension
arises in part from Kahlo's combination of the Baroque religious portraiture and its
nineteenth-century extension in popular portraiture. Here I use the word "popu-
lar" in its Spanish sense, "of the people," a style or medium that is *not* elite, *not* ac-
ademic, *not* official. All Baroque visual forms, whether carved, painted, sculpted or
embroidered, had (and still have) their popular versions, and any attempt to draw
boundaries between them will be imprecise and artificial. As we have seen, the
New World Baroque is a hybrid mode, and the art historian Pál Keleman is correct
in asserting that whether officially sanctioned or not, its forms were inspired by a
"folkloristic imagination."[44] Robert Harbison makes this point in another way:

> if Baroque was learnèd, it was at the same time deliberately incorrect and aberrant,
> which helps make it a harder mode to define satisfactorily than its predecessors.

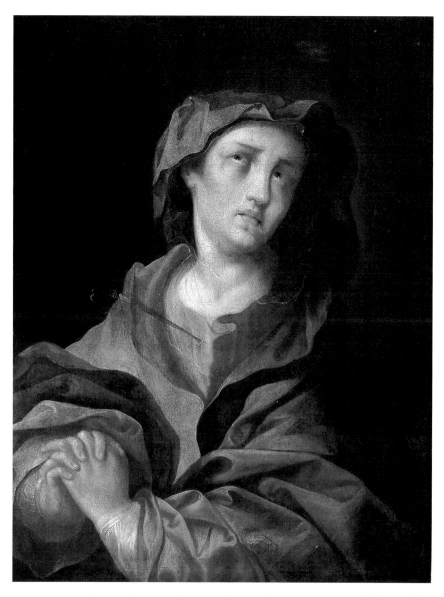

FIGURE 4.17 Baltasar de Echave y Rioja, *La Dolorosa* (seventeenth century), Mexico. National Museum of Art. Instituto Nacional de Antropología e Historia / Consejo Nacional para la Cultura y las Artes, Mexico.

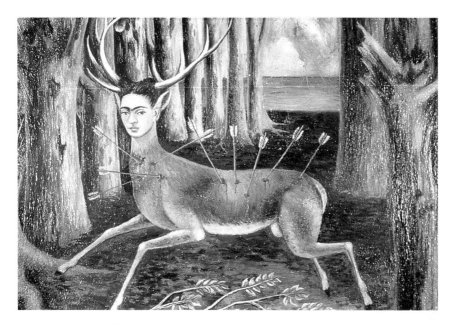

FIGURE 4.18 Frida Kahlo, *The Little Deer* (1946), Mexico. Collection of Jorge Espinoza, Banco de México / Instituto Nacional de Bellas Artes. Photograph: Archivo Fotográfico Manuel Toussaint / Instituto de Investigaciones Estéticas / Universidad Nacional Autónoma de México.

> Mexican craftsmen caught the exuberance and excess of Baroque even if the fine points of its commentary on Renaissance forms, in-jokes intensely enjoyable to those who notice them, were lost or misunderstood. By this route and using this conception of the style's essence, *emphasizing its exuberance and incorrectness, one can say that Mexican Baroque is the most complete fulfillment of the potential of Baroque perception.* The strengths and weaknesses of this European style are more richly present in the New World than anywhere in Europe.[45]

The New World Baroque always includes "incorrectness" to a greater or lesser degree, that is, the creative *divergence* from metropolitan norms occasioned by the creative *convergence* of indigenous and mestizo image-makers with those norms. Kahlo's self-portraits are obviously convergences in this syncretic sense, as are her mural paintings in a local *pulquería,* the miniature Mexica pyramid in her garden, and her self-adornment as a Tehuana.[46]

That the "folk Baroque" has flourished alongside the institutionally supported Baroque is logical: the Counter-Reformation was a proselytizing movement and its art forms were conceived to appeal to the masses, in part by reflecting back to them their own passions and concerns. Popular renditions will differ from official

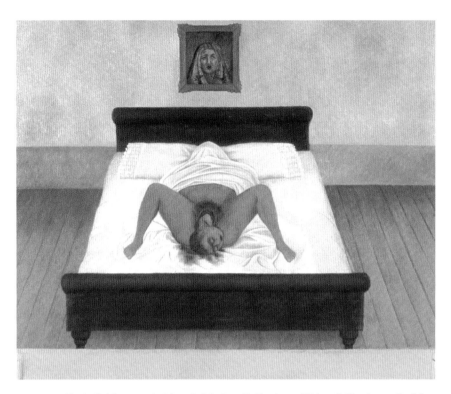

PLATE 17 Frida Kahlo, *My Birth* (1932), Mexico. Collection of Edgar J. Kaufmann Jr., New York. Banco de México / Instituto Nacional de Bellas Artes, Mexico.

forms in their tendency to disguise or integrate what the high form exaggerates, given the didactic project of the latter to make its ideology visible; thus in popular portraiture, the hyperbolic emotion of the Baroque saints is often subsumed in an impassive gaze. Such popular portraiture persisted longer than its "official" counterpart, though again the boundaries blur, since religious portraiture also continued, though in less hyperbolic registers, throughout the nineteenth century. The work of Hermenegildo Bustos is the best known of these popular portraitists—in fact, one of the few known by name, for most worked anonymously (fig. 4.21).[47] Bustos's portraits, like Kahlo's self-portraits, have something of the still life about them, the immobility of the sitter seeming to objectify the self, even as the viewer senses the tensions behind the masklike face. These faces certainly do not "wallow" in emotion, but they *are* theatrical in seeming to gesture beyond the image toward the viewer, asking us to wonder how (and whether) to reconcile the contradictions behind the sitter's unflinching regard. Bustos's portraits do not offer themselves as an open series, however, but as individual instances, whereas Kahlo's impassive face repeatedly masks the same interior drama. Her self-portraits are parts of a single visual allegory whose invisible meaning is pain.

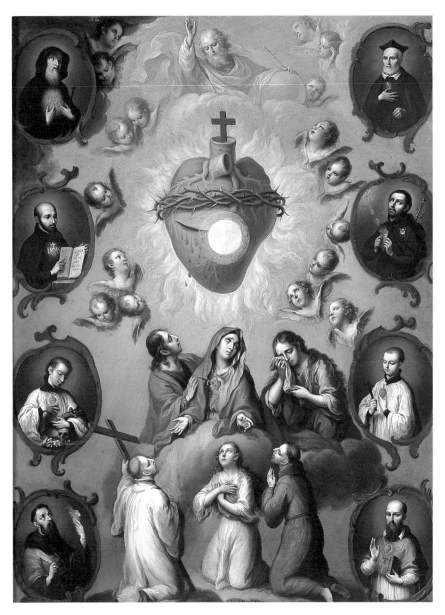

FIGURE 4.19 Juan Patricio Morlete Ruiz, *The Sacred Heart of Jesus* (eighteenth century), Mexico. National Museum of Art. Instituto Nacional de Antropología e Historia/Consejo Nacional para la Cultura y las Artes.

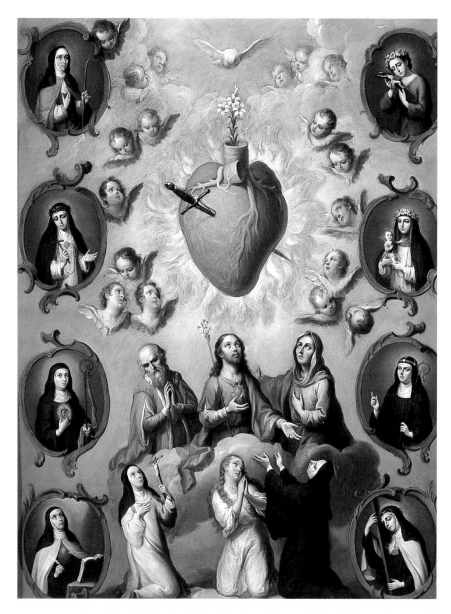

FIGURE 4.20 Juan Patricio Morlete Ruiz, *The Sacred Heart of Mary* (eighteenth century), Mexico. National Museum of Art. Instituto Nacional de Antropología e Historia/Consejo Nacional para la Cultura y las Artes.

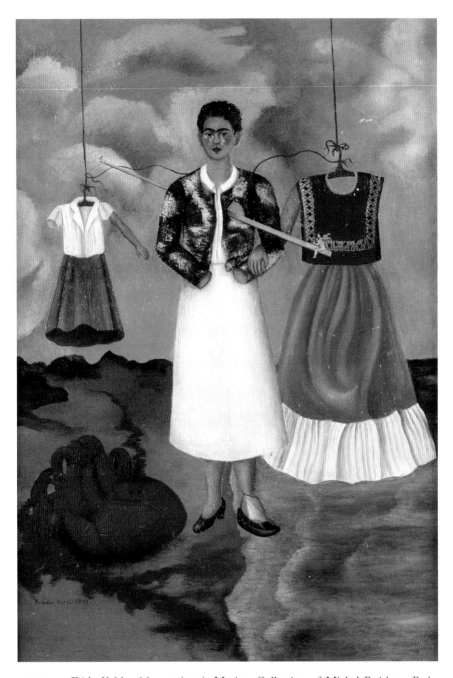

PLATE 18 Frida Kahlo, *Memory* (1937), Mexico. Collection of Michel Petitjean, Paris. Banco de México. Instituto Nacional de Bellas Artes. Photograph: Archivo Fotográfico Manuel Toussaint/Instituto de Investigaciones Estéticas/Universidad Nacional Autónoma de México.

FIGURE 4.21 Hermenegildo Bustos, *Portrait of a Priest* (nineteenth century), Mexico. Museo Soumaya. Instituto Nacional de Antropología e Historia. Photograph: Javier Hinojosa.

To study Kahlo is to discover an artist who internalized an entire iconographic tradition—the Mexican Baroque in its academic and popular forms—and who summarized them in her slender production. That her work conjoins this tradition of re-presentation to the indigenous metaphysics of presence accounts for the immediacy of her appeal; her self-portraits seem infused with spirit as were indigenous images for their beholders, or as the image of the Virgin of Guadalupe is for contemporary believers. In chapter 1 we noted that the mental visualization of biblical events became a spiritual discipline during the Baroque period, and that in the New World this mystical conception of the image combined with the capacity of indigenous images to contain spirit. In Kahlo's self-portraits, this syncretic tradition is fully operative; we see the painter painted, as in Velázquez, and we also sense the unmistakable urge of the painter to *become* the painting, to occupy the thing itself. Her self-portraits are offered as talismans, relics, holy images into which she herself may enter and escape; they do not mediate between self and world so much as integrate the two. This complex negotiation between self and non-self goes well beyond the usual signifying systems of Western re-presentation; Kahlo's affective power is, I believe, rooted in this transcultural imaginary.

GARCÍA MÁRQUEZ'S BAROQUE ICONOGRAPHY

Like Kahlo, García Márquez has been little discussed as a New World Baroque artist, an oversight the more surprising because his luxuriant syntax and intricate narrative structures are Baroque in the common sense of the word: hyperbolic, exuberant, sinuous, sometimes self-reflexive. Furthermore, he has regularly reminded us of his relation to the Spanish Baroque tradition. In a 1969 interview, he pays homage to the "marvelous origins" of the Spanish Baroque, mentioning the novels of chivalry, *Don Quixote,* the theatre and poetry of the Golden Age: "Style, elegance, luxury, total excess have not been given their due. Young Latin American novelists have known how to be inventive in the best tradition of the Spanish Baroque and, at the same time, to engage in social criticism that is no less telling for being colorful."[48] In 1969, García Márquez would surely have included himself among these "young Latin American novelists," and in 2002 he does so explicitly as he looks back upon this younger self in his autobiography, *Vivir para contarla* (*Living to Tell the Tale*). He writes that during his six semesters as a university student in the late 1940s, when he was supposed to be studying law, he was, in fact, dedicating himself "a leer lo que me cayera en las manos y recitar de memoria la poesía irrepetible del Siglo de Oro español" ("to reading whatever I could get my hands on, and reciting from memory the unrepeatable poetry of the Spanish Golden Age").[49] His early fascination for the Spanish Baroque tradition predicts his narrative negotiations between European Baroque structures and New World

modes of imagining. My discussion here will focus on his representation of the Baroque self.

Consider García Márquez's characters in relation to what we've just seen of Kahlo's self-portraits. Are not many of them also types, archetypes, repeating selves recognizable by their distinguishing embellishments rather than by differences in personality or positioning such as narrative realism normally requires? In *Cien años de soledad* (*One Hundred Years of Solitude*), aren't the series of José Arcadios variations of male erotic energy, and aren't all of the Aurelianos variations of *dis*embodied mind? The twins who appear to reverse this archetypal dualism are generally supposed by the residents of Macondo to have been switched at birth. In *El otoño del patriarca* (*The Autumn of the Patriarch*), the Patriarch is an archetype of evil with a series of doubles who make possible his reappearance every time his death is wrongly reported, as it is at the beginning of each chapter. And the six hundred and twenty-one women with whom Florentino Ariza sleeps in *El amor en los tiempos del cólera* (*Love in the Time of Cholera*) are, despite their variations, a single surrogate—and scapegoat—for Fermina Daza, who is herself the archetypal Beloved, just as Florentino is the archetypal Lover. In Florentino's fanaticism, in the repeating generations of Arcadios and Aurelianos and the surreal cruelties of the Patriarch, García Márquez ironizes the affective strategies of Baroque self-representation.

García Márquez's characters are prodigious in a Baroque mode, whether prodigies of beauty or sex or evil or patience or some other fabulous obsession (little gold fishes, magnets, ice). Baroque religious portraiture is their cultural precursor in its theatricality and hyperbole, a precursor that provides García Márquez with a sustained opportunity for irony. Take Florentino's amorous excesses (and symbolic abstinence), which are offered as examples of suffering in a saintly mode. In fact, martyrdom is repeatedly invoked to describe Florentino's state. After seeing Fermina for the first time, he falls violently ill, but his godfather, a homeopathic practitioner, needs only one glance at him to announce that the symptoms of love and cholera are the same; he prescribes an infusion of linden blossoms to calm Florentino's nerves, but Florentino wishes only "to enjoy his martyrdom."[50] We are not surprised to find that this obsession is generational and that Florentino is one in a series; he discovers in his father's notebook a sentence that he thought he had written himself: "Lo único que me duele de morir es que no sea de amor" ("The only regret I will have in dying is if it is not for love").[51] The echoes of hagiographic hyperbole are unmistakable, but García Márquez transforms their pathos into parody, simultaneously adhering to, and breaking from Baroque convention.

In fact, García Márquez's portrait of Florentino engages an array of Baroque conventions, beginning with the descriptions of extreme physicality. Recall Florentino's life-long constipation—reminiscent of Montaigne's kidney stones and Rabelais's fascination with bodily functions. Recall, too, Florentino's "fragrant vomit" (in which, indeed, he "wallows," to repeat Arnold Hauser's word), an indis-

position that results from drinking cologne in order to sample the taste of his beloved. His physicality is not grotesque, like that of the Patriarch and some of the Buendías; his bodily parts are not exaggerated, as the grotesque requires, but rather put under a microscope and examined in enlarged, minute detail, as it were. So Florentino echoes ironically the symbolic corporeality of saints and martyrs. His every gesture is theatrical, his performance and persona obsessively displayed and directed toward a single object (Fermina) at the same time that they are endlessly self-reflexive. All of this, even as we are also treated to detailed descriptions of his aging body and, for that matter, the aging bodies of everyone else in the novel.

Human and divine love are often isomorphic in Baroque iconography—our defining example is the coincident eroticism and ecstasy of Bernini's St. Teresa—and these loves are portrayed as equally torturous. In Florentino, García Márquez uses this tradition to comic effect. Consider his suffering in terms of José de Alcíbar's eighteenth-century Mexican painting of the Jesuit missionary St. Francis Xavier (fig. 4.22). Called the Apostle of the Indies and Japan, St. Francis Xavier, was represented in countless New World versions, often in what Mexican iconographer Jaime Cuadriello calls the "prodigious rhetoric" of ecstasy, the flame on his chest signaling his special relation to the divine word, as the flame on the heads of the apostles gathered at Pentacost signals theirs.[52]

Florentino's love letters are the most obvious of the Baroque flames that burn in his head and heart. His letters oscillate between appearance and reality, between Fermina and his illusory projections of her. In the Arcade of the Scribes, Florentino is hired by a lover to write letters to his beloved at the same time that the beloved also hires Florentino; thus Florentino becomes involved "in a feverish correspondence with himself" (172). Then he doubles this already self-reflexive structure by imagining what Fermina Daza might have wanted to write to him, had she been his client, and he begins to compile a *Lover's Companion* such as those sold in doorways for twenty *centavos:* "Puso en orden las situaciones imaginables en que pudieran encontrarse Fermina Daza y él, y para todas escribió tantos modelos cuantas alternativas de ida y vuelta le parecieron posibles" (253); ("He categorized all the imaginable situations in which he and Fermina Daza might find themselves, and for all of them he wrote as many models and alternatives as he could think of" [172]). The Baroque practice of collecting and cataloguing, and the related impulse to multiply variations in an open series, are enacted here. We are told that Florentino's compendium eventually contains a thousand letters in three volumes, and that no printer will take the risk of publishing them. The multiplying layers of illusion engulf the medium itself.

I have proposed José de Alcíbar's portrait of Saint Francis Xavier as a visual analogue to Florentino, but Alcíbar's portrait is in no way ironic, whereas García Márquez's "Saint" Florentino most certainly is. Consider instead William Hogarth's parodic portrait of Sir Francis Dashwood, dressed in a Franciscan habit and positioned in the "wilderness" setting typical of penitents (fig. 4.23). Baroque

FIGURE 4.22 José de Alcíbar, *Saint Francis Xavier* (eighteenth century), Mexico. National Museum of Art. Instituto Nacional de Antropología e Historia/Consejo Nacional para la Cultura y las Artes.

FIGURE 4.23 William Hogarth, *Sir Francis Dashwood, Bt., at His Devotions* (detail, eighteenth century), England. Museum of Birmingham.

paintings often show the saint in a meditative posture, envisioning Christ's body on the cross as a vicarious means of experiencing his suffering (see color plate 6). Hogarth's pseudo-saint Sir Francis visualizes a body of quite another sort, and a theatrical mask replaces the conventional skull that accompanies penitents to remind them of the vanity of earthly things. Where Sir Francis's halo should be, a leering face smiles down, a visual "attribute" that is at once an alter ego, a demon, and a pagan spirit. This Hogarthian parody is caricature in our contemporary sense, that is, an amusing mockery of saintliness that corresponds to Florentino's "virtue" as he suffers his martyrdom of love.

And the six-hundred and twenty-one women who serve as Fermina's surrogates? Are they not ironic reflections of Frida Kahlo's serial selves, objectified by male desire, their identity also endlessly, fruitlessly, deferred? The humor on the surface of Neobaroque caricature easily turns dark, distressing, even demonic, as Hogarth's painting begins to suggest.

Remedios the Beauty, who ascends to heaven with Fernanda's sheets in *One Hundred Years of Solitude* is another ironic embodiment of a Baroque archetype, in her case the levitating Virgin. Remedios's "assumption" is a political and social matter, not a religious one, but García Márquez's emphasis on the billowing sheets confirms my visual analogy, for no Baroque Virgin has ever risen to heaven without luxuriant drapery unfurling around her. Recall that Ursula, almost blind, rec-

ognizes the nature of the wind as it begins to blow, and she senses, more than sees, "Remedios, la bella, que le decía adiós con la mano, entre el deslumbrante aleteo de las sábanas que subían con ella . . . y se perdieron con ella para siempre en los altos aires donde no podían alcanzar ni los más altos pájaros de la memoria" ("Remedios the Beauty waving good-bye in the midst of the flapping sheets that rose up with her . . . and they were lost forever with her in the upper atmosphere where not even the highest-flying birds of memory could reach her").[53] When flowing robes are not available, flapping sheets will do.

And when humans and birds aren't flying, angels are. The Virgin always levitates with the help of angels, as do the martyred saints, and García Márquez's very old man with enormous wings (in the story of that title), corresponds ironically to any and all of a vast flock of Baroque angels. In color plate 19, an old man with enormous wings is being skewered by a young man with enormous wings. This canvas by the Mexican painter Luis Juárez is dated around 1620 and is still in a Mannerist style, but its theatricality and naturalism predict the droves of Baroque angels and demons that would soon light on Latin American shores. The trope of flying in García Márquez's story has also been linked to the African mythology that circulates orally in Caribbean Colombia.[54] In *Of Love and Other Demons*, García Márquez will explicitly dramatize the interpenetration of African and Spanish Catholic cultures, whereas in "The Old Man with Enormous Wings" the syncretism is implicit. Nonetheless, the reader intuits the simultaneous operation of disparate cultural modes. So far removed is García Márquez's old man from the winged creatures in Juárez's painting, and so far removed as well from traditional African escape narratives—and yet seemingly related to both—that we sense the creative disruption of one mythology by the other. This tension explains in part the carnivalesque energy of the story, and its sustained ambiguity with respect to the old man's identity. Is he a bird, an angel, a man, a monster, or perhaps a hawk or an airplane, as the hapless priest in the story suggests? García Márquez's narrative allows all of these options to operate simultaneously, without resolving into one or another. His composite character eventually rouses himself, gains altitude and fades slowly into "an imaginary dot on the horizon of the sea."[55]

García Márquez provides interesting indications about his own relation to saints' lives in his autobiography *Living to Tell the Tale*. He tells us that "sacred history" figured prominently in the storytelling world of his childhood in Aracataca: "La voracidad con que oía los cuentos me dejaba siempre esperando uno mejor al día siguiente, sobre todo los que tenían que ver con los misterios de la historia sagrada" (107); ("The voracity with which I listened to stories left me always hoping for a better one the next day, above all those that had to do with the mysteries of sacred history") (90–91). The room in which he is born and where he sleeps till he leaves his grandparents' house at the age of eight is filled with images of saints.

PLATE 19 Luis Juárez, *St. Michael Archangel* (seventeenth century), Mexico. National Museum of Art. Instituto Nacional de Antropología e Historia / Consejo Nacional para la Cultura y las Artes.

En aquel dormitorio había también un altar con santos de tamaño humano, más realistas y tenebrosos que los de la Iglesia. Allí durmió la tía Francisca Simodosea Mejía, una prima hermana de mi abuelo a quien llamábamos la tía Mama Yo dormí en la hamaca de al lado, aterrado con el parpadeo de los santos por la lámpara del Santísimo que no fue apagada hasta la muerte de todos, y también allí durmió mi madre de soltera, atormentada por el pavor de los santos. (41)

[In that bedroom there was also an altar with life-size saints, more realistic and gloomy than those of the Church. Aunt Francisca Simodosea Mejía always slept there, a first cousin of my grandfather's whom we called Aunt Mama. . . . I slept in a hammock off to the side, terrified by the blinking of the saints in the light of the perpetual lamp that was not extinguished until everyone had died, and my mother slept there, too, when she was single, tormented by her terror of the saints. (35)]

García Márquez recalls anecdotes involving particular saints. For instance, Saint Rita de Casia was known for her patience with her wayward husband and was, for this reason, the object of his mother's "inexhaustible devotion" (132), and the fierce Catholicism of his paternal grandmother involved daily conversations with select saints and martyrs. In short, this special population with their extraordinary capacities was an integral part of the author's childhood. So, in *One Hundred Years of Solitude,* when we are told that the zealous outsider Fernanda has replaced the aloe branch and loaf of bread that have always hung over the door of the Buendía house with a niche for the sacred heart of Jesus, we recognize the arrival in Macondo of what one critic refers to as "la sonrisa dulzona de la iconografía tridentina" (the sickly sweet smile of Tridentine iconography).[56] Fernanda's redecoration signals the advent of repressive times in Macondo, and it is precisely this ironic relation between Baroque iconography and political critique that will be fully developed in *The Autumn of the Patriarch.*

NEOBAROQUE CARICATURE IN *THE AUTUMN OF THE PATRIARCH* AND *ONE HUNDRED YEARS OF SOLITUDE*

Saints are at once human and holy, complex selves and also archetypes that slip easily into stereotype, and from stereotype to caricature, and García Márquez takes full advantage of these fluid lines in his portrayal of the Patriarch and the Buendías. After all, saints are often converted sinners, outlaws so perfect that they become saints, their vices and virtues combining in a single image, as we have seen with Mary Magdalene, whose sins and sanctity are equally apparent to viewers in command of the requisite visual vocabulary. Baroque emotion encompasses moral and psychological extremes, and evil was typed iconographically for the same didactic reasons that saints were typed according to their virtues. In fact, taxonomies of emotional, psychological, and moral types flourished during the seventeenth century, and caricature develops alongside realistic portraiture. Let's begin in Europe.

Erwin Panofsky locates the origins of Baroque caricature in the drawings of Leonardo da Vinci, and he is quick to distinguish the term from current usage. Baroque caricatures are "by no means meant to be funny. They register extremes, outstanding natural phenomena, and are far too dispassionate and too little individualized to make us laugh." Panofsky mentions the caricatures of Bernini and

Shakespeare (particularly Falstaff), noting that they are aimed not at revealing the individual but rather "the limits of human nature as such" (84). John Rupert Martin also refers to the Baroque interest in the systematic study of human expression, and finds in the caricatures of Rembrandt and Bernini "the indispensable first steps leading to a more searching exploration of the emotional life" in their painting and sculpture.[57] Though caricature did not yet carry the modern connotation of satire, it sometimes worked to that effect, since (stereo)typing may function as critique. Nonetheless, both Panofsky and Martin focus on Baroque caricature as a tool of psychological investigation with a universalizing intent. Montaigne's search for himself in all his particularity is marked by countless references to Classical writers and traditions, one indication among many that he was concerned with what united him to all mankind as well as what set him apart. When Montaigne was asked the reasons for his close friendship with La Boetie, he responds with a list of abstract traits, concluding that it was "because he was he, because I was I."[58]

This summation is echoed in the characters of Spanish Baroque theatre, who also grope toward some mysterious core of the self in a theological register. In literature, of course, the conception of character-as-type goes back to Aristotle, and the *dramatis personae* of Lope de Vega and Calderón de la Barca extend and intensify this moralizing tradition.[59] The characters created by Lope and Calderón embody an array of extreme emotions and moral attitudes that in their totality are meant to reveal "the limits of human nature as such," to repeat Panofsky's phrase. Lucian Paul Thomas writes about Calderón's characters that they "bring together an aggregate of general traits [that] disregard irregularities, peculiarities, and anomalies so as to rise to the common convergence point of human impulses and conceptions."[60] This is an overstatement, because characters in Spanish Baroque drama are rarely so unitary, but neither do they conform to our contemporary sense of autonomous individuality. Margaret Rich Greer observes that psychological meaning in Baroque drama is "not located within an 'inner' self but between the individual and other members of the social group. . . . identity is shown as constituted by social process."[61] The pressures of gender, social position, and moral obligation motivate human behavior, not the idiosyncrasies of personality; when placed in contact with others during the course of the play, the characters' moral and social attitudes unfold and they become, in varying degrees, allegorical selves. Jacques Barzun states about Baroque theatre generally: "What the playwright offered was his poetry and his analysis of the human emotions . . . human types deeply studied."[62] This Baroque procedure finds its tragicomic mode in picaresque fiction, in which behaviors represent human types in their social and economic contexts. Indeed, in its parodic treatment of Baroque types, we may think of the picaresque tradition as predicting the literary strategies under consideration here.

There is a great deal more to be said about character in Baroque drama, but others have done so admirably,[63] so I return to García Márquez and his relation to this tradition. I propose that this twenty-first-century author recovers the conven-

tions of seventeenth-century Baroque character construction in order to challenge the modern conception of the autonomous, independent self. In Montaigne, Pascal, Velázquez, Cervantes, as in Lope and Calderón, subjectivity is not yet conceived as idiosyncratic interiority; rather, the self is integral to larger systems (family, community, church, cosmos) that confer identity, however elusive and unstable. The singular, psychologized self will come later, and it is this modern self—the naturalized denizen of narrative realism—that García Márquez challenges with his Neobaroque engagement of Baroque character.

His 1975 novel, *The Autumn of the Patriarch*, is a primary example of my contention. Structurally, the Patriarch is an instance in a series—a series not only of his own repeating selves (his disappearances and reappearances and stand-in doubles) but also of fictional dictators. The so-called dictator novel has become a Latin American genre with conventions of its own; beginning with Miguel Angel Asturias's *El señor presidente* in 1949, virtually every writer of the boom has enriched this tradition of ironic, inverted hagiography.[64] Each of their fictional dictators is an archetype (of corruption, sexual appetite, cruelty, greed, pride, paranoia, etc.), and when the archetype/allegory reaches fantastic dimensions (usually involving an exaggerated physical function), it becomes grotesque.[65] In Baroque representations of the self, whether in the plays of Calderón or the portraits of saints, the grotesque is given a moral charge and thus shades into monstrosity—a slippage that the dictator novel almost invariably engages. Robert Harbison observes that the

> human monstrosities which interest the Baroque tend first of all to more lavish scales than the nearest Mannerist equivalents and therefore act differently on the spectator. Even in their most conventionalized form they incorporate more direct observation and are, therefore, more disconcerting in their effect. Here in the realm of the grotesque the Baroque dissolves old categories and crosses long-established boundaries so aggressively that finally in an artist like Hogarth the grotesque is no longer kept in its place but practically identified with the truth.[66]

In *The Autumn of the Patriarch*, the grotesque shades into monstrosity for the purpose of political critique (presented, indeed, as a kind of "truth"). Baroque art and literature used allegory not only for religious purposes but also to glorify monarchy; John Rupert Martin notes that of all the uses of Baroque allegory, "the most spectacular was the glorification of the earthly ruler. If the Baroque was the age in which divinity was brought down to earth, it was also a time when men sought to become divine" (104). Martin cites Bernini's bust of Louis XIV as "the supreme Baroque image of princely apotheosis," and we may think of García Márquez's Patriarch as its ironic inversion.

Baroque political allegory in its visual forms has interesting points in common with contemporary Latin American dictator novels. Take Peter Paul Rubens's

Medici cycle (1621–25) in the Luxembourg Palace in Paris, which celebrates Marie de' Medici's reign as regent for her son Louis XIII, and later as his counselor and friend (never mind that she was banished from France on several occasions, and eventually died in exile in Cologne.)[67] Rubens's monumental series presents his patron in an episodic allegory amidst Roman gods and goddesses, that is, among archetypes of virtues and vices, capacities and characteristics. In one panel, Marie is accompanied by Minerva, goddess of wisdom who, in turn, is assisted by Prudence and Abundance; in another, Truth and Time attend upon Marie and her son. Rubens uses these archetypes not to explore interiority but to glorify his subject, and equally important, to generalize his material. Political winds shifted quickly in Europe during the seventeenth century, and his allegorical images allowed him to avoid evoking specific (and potentially contentious) events, while nonetheless presenting recognizable political scenarios.[68] Contemporary dictator novels engage allegory to similar effect: to heighten their critique of dictatorship to a level that addresses human depravity as a universal matter while at the same time indicting political injustices at home. Their allegories facilitate a flexible relation between the narrative and its symbolic levels according to the political positioning and interpretive acuity of the reader. Baroque artists enlist allegory to archetypalize their subject, and thus generalize (and amplify) their political reach. So, too, García Márquez creates a mythic spectacle by rarifying his dictator's ignominy to the level of a cosmic abstraction. The patriarch is a force, not a face.

Such archetypalizing strategies, paired with hyperbolic physicality, are basic to García Márquez's political critique.[69] The patriarch's identifying symbols—his "attributes"—are a series of metonyms: the gloved hands, the huge "graveyard feet," the buzzing ears, the herniated testicle, the sound of the single gold spur. The people recognize him by his parts, which circulate in the lunar landscape of the novel but never coalesce or conjoin to constitute a self. The patriarch is all dynamic surface, and the novel all exuberant texture, with its sentences that continue for pages, its chapters of one paragraph, its theatrical settings bristling with lurid detail. Scenes flicker in atemporal stasis (history again merges into setting) and the patriarch appears to exist outside of time. There is no development or change; in fact, we never see the patriarch acting, but only the products of his actions: for instance, an enemy roasted like a suckling pig and served to his generals for dinner— one detail among many that heighten the grotesque dimensions of the caricature.

The mingled horror and relish that impel *The Autumn of the Patriarch* are consonant with an important facet of the historical Baroque sensibility, and that is its unflinching depiction of extreme physical cruelty. The patriarch is heir to the composite tyrant/martyr archetype of Baroque drama discussed by Walter Benjamin, whose observation on the formulaic apotheosis of torture I have already cited.[70] We will encounter this Baroque "cult of cruelty" again in *Of Love and Other Demons*,[71]

but my point here is that García Márquez engages Baroque caricature not to explore the self as as a universal matter, the purpose of Baroque drama, nor to satirize the self, the purpose of picaresque narrative, but rather to subvert subjectivity altogether in the service of political critique, much as Rubens does in his allegorical supernaturalism. But whereas Rubens fills his historical personages with supernatural archetypes and mythic qualities, García Márquez inverts that process. In an ironic *horror vacui*, he empties his historical personage of human content, offering instead a composite of parts that equals the negation of the human. Hence the inverted hagiography of which I have spoken.

It is precisely this inversion that makes *The Autumn of the Patriarch* an impassioned political statement, and a clear example of the Neobaroque. The patriarch is an abstract principle; he stands for absolute will, and is also its victim; he is archetype and allegory of political repression and, inversely and ironically, of human suffering as well. As the traditional saints' lives embody the dialectic between theological and emotional poles (sin and sanctity, pain and pleasure, fear and wonder), so the patriarch's allegorical meanings include the possibility of his own undoing. For he *does* finally die: the "stagnant time" and "lethargy of the universe" are overcome, and the novel concludes with ". . . la buena nueva de que el tiempo incontable de la eternidad había por fin terminado" ("the good news that the uncountable time of eternity has come to an end").[72] This resolute, even optimistic conclusion suggests how García Márquez's Neobaroque differs from Postmodernist critique as it is generally practiced in the United States and Europe; the modern self is deconstructed in the caricature of the patriarch, but the possibility of meaning is not. The Neobaroque interacts ironically with Baroque "stylemes," and thus with the continuing possibility of moral and aesthetic value.

"Stylemes" is Irlemar Chiampi's word, and I cite a passage from her book *Barroco y modernidad* in which she uses this term and distinguishes between the Neobaroque and postmodernism in ways that support the distinction I have just made. Chiampi writes:

> It is improbable that Latin American Neobaroque texts would constitute a spatial logic identical to the dominant feature of the cultural logic of late capitalism. It is true that these texts are shot through and crammed to the bursting point with every sort of reference and allusion. Yet if they are spaces of euphoric intensity, they are also *the coming-together of heterogeneities*, brilliant surfaces where *Baroque stylemes* shine in an inflated swirl of strata and layers, simultaneities and synchronies that do not achieve unification. . . . we can confirm that the potential meaning and pathos of the ludic/euphoric manipulation of textures remains, and *specifiable residues of the historical Baroque have not yet been exhausted. Unlike the postmodern as criticized by [Fredric] Jameson, this manipulation does not simply array its fragments as so many commodities,* but rather unleashes the figures of a new form of tension, albeit within the same flattening of history and decentering of the authorial function.[73]

The "coming-together of heterogeneities" in *The Autumn of the Patriarch* does, in fact, "unleash the figures of a new form of tension." The immobility of evil contains the possibility of renovation; the patriarch's power contains the seeds of its own subversion. In its "flattening of history"—its generalized landscape of oppression—García Márquez intensifies the novel's political impact; his procedures could not be further from the postmodernist tendency, described by Chiampi, to "array fragments as so many commodities." To quote her once again, the "specifiable residues of the historical Baroque have not yet been exhausted."

Let's pursue Garcia Márquez's patriarch a bit further. He is a Neobaroque parody of a Baroque archetype in his status as a political abstraction, devoid of interiority. If we turn to García Márquez's Nobel Prize speech, we encounter an extended catalogue of historical Latin American dictators, any and all of whom are versions of the patriarch, and he of them.[74] He is a composite entity, distilled from the particular perversions of an array of historical Latin American dictators; he is a cipher that contains multitudes, to paraphrase Whitman ironically, a thwarted archetype, an abstraction that does not nullify but *recodifies* the universalizing intent of Baroque caricature. The extent to which García Márquez engages the universalizing strategies of Baroque caricature in a deconstructive mode is apparent in a 1990 interview, published at the time of the English translation of his other dictator novel, *The General in his Labyrinth*. García Márquez was asked whether the last days of Simón Bolívar described in that novel were intended as a metaphor for the decline of Fidel Castro: "The author dismissed this idea with a wave of his hand. What's interesting, he says, is not what Castro and Bolívar have in common but the qualities that all men of power share."[75] In this interview, García Márquez mentions a plan to travel to Japan to work with director Akira Kurasawa on a film of *The Autumn of the Patriarch*, to be set in medieval Japan.

Neobaroque abstraction is García Márquez's method to a lesser degree in *One Hundred Years of Solitude*, in his series of Aurelianos and José Arcadios and his monumental women, Ursula, Amaranta Ursula, Petra Cotes, Fernanda. These characters are more individualized and psychologized than the patriarch, but they, too, are marked by Baroque conventions. Here, too, the author uses archetypalizing strategies, including hyperbolic physicality, to undermine the singular, stable self of conventional narrative realism. Oversized physical "attributes" are everywhere (breasts, hips, penises of epic proportion) as are monstrous combinations of body parts, both human and animal: the final Buendía, born with a pig's tale, only punctuates a long history of unruly parts which, like those of the patriarch, seem to transgress bodily confines and move fitfully through eccentric fictional spaces.[76] Alejo Carpentier remarks that the "proliferating nuclei" of Baroque structures operate so that the center "somehow breaks through its own borders,"[77] and we sense this kind of energy throughout *One Hundred Years of Solitude*. José Arcadio Segundo's blood wends its way through the streets of Macondo to the astonished feet of Ursula, and the generations of Aurelianos and José Arcadios, permeable and

permutating, grow out of another like variations on a theme in a Baroque fugue—the theme here being the contrasting poles of sentience (the José Arcadios) and cerebration (the Aurelianos). In *One Hundred Years of Solitude*, the proliferating nuclei are not decorative elements, as is often the case in Baroque compositions, but aspects of human selves that orbit around an absent center, to use Severo Sarduy's image once again.

This Neobaroque recodification of Baroque conventions mirrors the seventeenth-century Baroque recodification of Renaissance Classicism. As the seventeenth-century Baroque displaced Classical canons of order and reason, so the Neobaroque displaces empiricism and individualism. Heinrich Wölfflin, who first articulated the Baroque as a term of art history, considers how and why the historical Baroque supplanted Classical canons, and he does so by contrasting the relations of parts to wholes in Renaissance and Baroque architectural structures:

> The idea of beautiful proportion vanishes, *interest concentrates not on being, but on happening.* . . . Architecture ceases to be what it was in the Renaissance, an art of articulation, and the composition of the building, which once raised the impression of freedom to its highest pitch, yields to *an ensemble of parts without true independence.*[78]

Applying Wölfflin's description of the Baroque to García Márquez's Neobaroque, we see that the Buendías are an ensemble of parts without true independence; no genealogy appears in the original Spanish edition of the novel because García Márquez did not intend that the reader differentiate among his characters as individuals. And certainly the novel concentrates "not on being, but on happening." The metonymic mobility of García Márquez's characters is Baroque, but his subversion of sensibility, his emptying out of the self, is recognizably Neobaroque. So he challenges the novel's dependence upon Western notions of individuality and conjures instead a fluid collective self that exists across generations and cultures. Such de-psychologized entities as the Buendías and the patriarch have plenty of company in contemporary Latin American fiction. They inhabit José Donoso's *Casa de campo* (*A House in the Country*), Carlos Fuentes's *Terra nostra*, Reinaldo Arenas's *El mundo alucinante* (translated as *The Ill-Fated Peregrinations of Fray Servando*), Jorge Luis Borges's "Circular Ruins" and his "Library of Babel," to name only a few brilliant examples of this mode. In these works too, the Neobaroque self offers a mode of resistance to constraining conceptions of the singular self. Their revisioning opens the self and society to possibilities beyond the limitations of rationalism and realism.

Del amor y otros demonios (*Of Love and Other Demons,* 1994) is García Márquez's most historically "set" novel. Unlike the allegorical territory of *The Autumn of the Patriarch* and *One Hundred Years of Solitude,* this novel is specifically located in the Colombian city of Cartagena, "pearl of the Indies," during the late-eighteenth century—allusions to Voltaire and Domenico Scarlatti confirm the time frame. The city hangs suspended somewhere between decay and ruin, still an imperial center but one that reflects the decadence of the Spanish empire, embattled from without, enclosed from within. This novel, too, has Neobaroque characteristics but not those we have seen so far; its characters are not archetypes or circulating series or ensembles of parts. Rather, they are creatures of literary realism, and their collective purpose is to dramatize the intersecting cultures of the Caribbean coast during the late viceregal period. Nor is this novel an inverted hagiography in the same sense as *The Autumn of the Patriarch,* where hagiographic hyperbole breeds its monstrous other. The conventions of hagiography pervade this novel, but instead of serving to abstract and archetypalize they serve to specify the complex interactions between personal deviation (Sierva María's) and hierarchical structures (the Church's and society's). Only in this novel does García Márquez address the African presence in the Caribbean in such sustained fashion. In fact, his fictional Cartagena dramatizes the spectrum of racial categories and social classes that Irving Leonard described as "pigmentocracy" in his study of the Baroque period in New Spain.[79] Sierva María is the daughter of a *criollo* and a *mestiza;* she speaks Yoruban, Congolese, and Mandingo; is given the attributes of Mary Magdalene; and is martyred *by* the Church, not *for* it.

From the novel's tongue-in-cheek dedication to García Márquez's literary agent, "For Carmen Balcells, bathed in tears," to the theatrical martyrdom of his principal character Sierva María de Todos los Angeles, the author engages the Baroque themes of sanctity and suffering, repression and liberation, to which he adds the Baroque themes of betrayal and thwarted love. Sierva María suffers, it seems, the twin tortures of spiritual possession and erotic passion, but unlike Saint Teresa, her ecstasy is not inspired by her union with God, but by a man of flesh and blood. She eventually dies from the combined effects of possession and passion, or perhaps from something else altogether: the bite of a rabid dog. The Bishop who oversees the terrible physical tortures prescribed for her exorcism insists that the devil may easily disguise himself as a case of rabies, so there can be no separation of causes. The illusory nature of appearance is never more real than when demons (and witches) are concerned: the Abbess of the Convent of Santa Clara quotes St. Thomas Aquinas as saying: "A los demonios no hay que creerles ni cuando dicen la verdad" ("One must not believe demons even when they speak the truth").[80] The priest, Cayetano Delaura, who is designated to perform the exorcism, falls madly in love with Sierva María and she with him, whereupon he fails

to return to her cell, prompting the narrator to conclude in the last two sentences of the novel that she dies of love:

> La guardiana que entró para prepararla para la sexta sesión de exorcismos la encontró muerta de amor en la cama con los ojos radiantes y la piel de recién nacida. Los troncos de los cabellos le brotaban como burbujas en el cráneo rapado, y se les veía crecer. (198)

> [The warder who came in to prepare her for the sixth session of exorcism found her dead of love in her bed, her eyes radiant and her skin like that of a new-born baby. Strands of hair gushed like bubbles as they grew back on her shaved head. (147)]

This final image reflects the first; the epigraph of the novel also quotes St. Thomas: "'For the hair, it seems, is less concerned in the resurrection than other parts of the body.' Thomas Aquinas, *On the Integrity of Resurrected Bodies,* question 80, chapter 5."

An introductory author's note, signed by "Gabriel García Márquez, Cartagena de Indias, 1994," implies that his character Sierva María is based upon a legendary figure whom his grandmother told him about when he was a boy:

> . . . una marquesita de doce años cuya cabellera le arrastraba como una cola de novia, que había muerto del mal de rabia por el mordisco de un perro, y era venerada en los pueblos del Caribe por sus muchos milagros. (11)

> [. . . a little twelve-year-old marquise with hair that trailed behind her like a bridal train, who had died of rabies caused by a dog bite and was venerated in the towns along the Caribbean coast for the many miracles she had performed. (5)]

The novel that follows is her imagined hagiography.

García Márquez has said that the ideas for his novels come to him in a striking visual image, and the bridal train of hair is surely the point of departure for *Of Love and Other Demons*.[81] The introductory author's note describes a journalistic assignment thirty-five years earlier that takes him to the convent of Santa Clara in Cartagena, which is being torn down to make way for a five-star hotel. Workmen are removing the bones of three generations of bishops, abbesses, and priests from the ruins of the chapel:

> En la tercera hornacina del altar mayor, del lado del Evangelio, allí estaba la noticia. La lápida saltó en pedazos al primer golpe de la piocha, y una cabellera viva de un color de cobre intenso se derramó fuera de la cripta. El maestro de obra quiso sacarla completa con la ayuda de sus obreros, y cuanto más tiraban de ella más larga y abundante parecía, hasta que salieron las últimas hebras todavía prendidas a un cráneo de niña. . . . Extendida en el suelo, la cabellera espléndida medía veintidós metros con

once centímetros. . . . El maestro de obra me explicó sin asombro que el cabello hu-
mano crecía un centímetro por mes hasta después de la muerte, y veintidós metros
le parecieron un buen promedio para doscientos años. A mí, en cambio, no me pare-
ció tan trivial. (11)

[The surprise lay in the third niche of the high altar, on the side where the Gospels
were kept. The stone shattered at the first blow of the pickax, and a stream of living
hair the intense color of copper spilled out of the crypt. The foreman, with the help
of the laborers, attempted to uncover all the hair, and the more of it they brought
out, the longer and more abundant it seemed, until at last the final strands appeared
still attached to the skull of a young girl. . . Spread out on the floor, the splendid hair
measured twenty-two meters, eleven centimeters. . . . The impassive foreman ex-
plained that human hair grew a centimeter a month after death, and twenty-two
meters seems a good average for two hundred years. I, on the other hand, did not
think it so trivial a matter. (4)]

At this point, the author recalls the legend recounted to him by his grandmother,
and the novel begins.

Like the transgressive physicality in *One Hundred Years of Solitude,* where body
parts break loose and fill the space of Macondo, so, too, Sierva María's "torrent" of
hair. This "stream of living hair the intense color of copper" links her iconograph-
ically to Baroque representations of Mary Magdalene, in which blond or auburn
hair is an identifying attribute; like Sierva María, Mary Magdalene is said to have
been possessed by demons—seven of them, which Christ "cast out."[82] Mary Mag-
dalene is a composite self, as Sierva María is a composite of cultures. The woman
"sinner" who is reported to have dried Christ's feet is not, in fact, named in the
biblical account, but has come to be identified with Mary Magdalene, as have a
number of other women associated with Christ.[83] Indeed, this process of accumu-
lation continues: a new role as Christ's consort has recently been assigned to Mary
Magdalene by several feminist biblical scholars, and popularized by Dan Brown's
thriller *The Da Vinci Code.*[84] This figure of legend is believed to have gone to south-
ern France after Christ's death to spend the rest of her days in penance,[85] a detail
that explains her particular popularity with French Baroque artists. In her peni-
tential portraits, her hair is her distinguishing attribute. Figure 4.24 is a work from
seventeenth-century New Spain attributed to Baltasar de Echave Ibía, the same
artist who painted *Portrait of a Woman* (fig. 4.5, above). Echave Ibía's suffering is
less formal, more deeply felt, than contemporaneous European paintings of the
Magdalene; the figure is not coquettish but gaunt, haggard, and yet ecstatic, her
pain and pleasure a single sensation. This ambiguity suits García Márquez's char-
acter, for Sierva María's hair does not signal penance (she is never penitent) but
rather her freedom. She transgresses every boundary of race, class, and gender in
her hierarchical society, and her hair, and life, are cut short as a result.

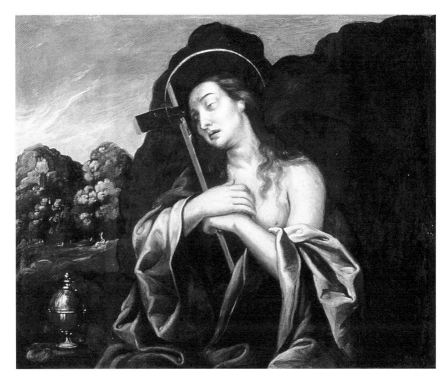

FIGURE 4.24 Baltasar de Echave Ibía (attr.), *The Magdalene* (seventeenth century), Mexico. National Museum of Art. Instituto Nacional de Antropología e Historia/Consejo Nacional para la Cultura y las Artes.

From the moment of this character's birth, the association between hair, demonic possession and sainthood is established. Dominga de Adviento, the African slave who will raise Sierva María in her Yoruban culture and customs,

> le prometió a sus santos que si le concedían la gracia de vivir, la niña no se cortaría el cabello hasta su noche de bodas. No bien lo había prometido cuando la niña rompió a llorar. Dominga de Adviento, jubilosa, cantó: "¡Será santa!" (59)

> [promised her saints that if they granted the girl the grace of life, her hair would not be cut until her wedding night. No sooner has she made the promise than the girl began to cry. Dominga de Adviento sang out in jubilation: "She will be a saint!" (42)]

The narrator subsequently describes the girl's "fiery hair spilling over her shoulders" and her "torrent of hair, which fell to her waist by the time she was five, as if it were a rosebush" (88, 43). Despite Dominga de Adviento's vow, her hair will be

cut before her wedding night by those who believe her to be possessed; indeed, her wedding night will never occur. As she lies in prison bruised and beaten, it is her shaven head that most upsets her exorcist and lover. And it is her hair that we see in the final sentence of the novel; she is dead but her hair *brotaban como burbujas* (gushed like bubbles) from her head.

Necklaces, too, serve as iconographic links between Sierva María and Mary Magdalene. I have mentioned the Magdalene's pearls, which are variously emblematic of her worldliness, her conversion, her tears, and her liberation. Sierva María is raised in the slaves' courtyard behind her family's decaying mansion, where the women hang "los collares de distintos dioses, hasta el número de dieciséis" (60); ("the beads of various gods around her neck, until she was wearing sixteen necklaces" [43]). Her education reflects the traditions of her African caretakers:

> Sierva María aprendió a bailar desde antes de hablar, aprendió tres lenguas africanas al mismo tiempo, a beber sangre de gallos en ayunas y a deslizarse por entre los cristianos sin ser vista ni sentada, como un ser inmaterial. (60)

> [Sierva María learned to dance before she could speak, learned three African languages at the same time, learned to drink rooster's blood before breakfast and to glide past Christians unseen and unheard, like an incorporeal being. (43)]

But not for long. The Christians put an emphatic end to her "incorporeality," and her body becomes center stage for the cultural drama. Like Frida Kahlo's indigenous iconography in her self-portraits, Sierva María's necklaces make visible the syncretic sources of her self.

These necklaces are taken when she is incarcerated, and then returned to her by another priest and exorcist, Father Tomás de Aquino de Narváez. This character is based on the Colombian saint Pedro Claver (1580–1654), a Spanish-born Jesuit who was ordained in Cartagena in 1616 and worked among the African slaves in the city.[86] This saint is still widely represented and revered in the region, and though he lived before the time period of the novel, García Márquez puts him into the story of his own imaginary saint. Father Tomás de Aquino is a former prosecutor of the Holy Office in Seville who now lives in Cartagena's slave district and speaks the African languages of his parishioners. In the following passage, he returns Sierva María's necklaces:

> A medida que se los colgaba en el cuello a Sierva María los iba enumerando y definiendo en lenguas africanas; el rojo y blanco del amor y la sangre de Changó, el rojo y negro de la vida y la muerte de Elegguá, las siete cuentas de agua y azul pálido de Yemayá. El se paseaba con tacto sutil del yoruba al congo y del congo al mandinga, y ella lo seguía con gracia y fluidez. (178)

[As he hung them around Sierva María's neck, he named and defined each one in African languages: the red and white of the love and blood of Changó, the red and black of the life and death of Elegguá, the seven aqua and pale blue beads of Yemayá. He moved with subtle tact from Yoruban to Congolese and from Congolese to Mandingo, and she followed suit with grace and fluency. (131–32)]

We are told that at this moment, Sierva María feels as if the soul of Dominga de Adviento has filled her cell, but her relief is temporary. Father Tomás de Aquino dies mysteriously and the signs of demonic possession are understood to intensify. Sierva María's desperation mirrors Mary Magdalene's, who, in the Spanish painter Alonso del Arco's rendition, rips off her pearls, attributes of her former life, as Sierva María's beads are the attributes of hers (fig. 4.25). It may be that the grapes about which Sierva María dreams repeatedly, and which she envisions (and eats) at the moment of her death, are also attributes, iconographically and symbolically related the Magdalene's scattered pearls.

Sierva María's "possession" is, of course, a political and social matter; she calls into question the social hierarchy by refusing to belong to any single category or class. She is a martyr in the traditional sense, in that she dies without acknowledging the authority of her persecutors or the veracity of their claims against her; certainly she does not "recant" her eccentric cultural positioning. This is no tale of simple victimization. By the time of her death, Sierva María has already attracted a following—Delaura is not her only *devoto*—and the author's note indicates that her cult of resistance is still celebrated in popular practice. The novel, in keeping with the conventions of Baroque hagiography, tends toward allegory, whose meaning is this: the attempt to impose ideological homogeneity upon cultural heterogeneity must fail, for the colonized are also colonizers, and it is the Catholics who will be converted in the end. That Sierva María's hair continues to grow for two centuries after her death suggests the value and vitality of New World Baroque heterogeneity, of which she is herself emblematic.

The conventions of Baroque hagiography require the physical inscription of metaphysical meanings. Sierva María's exorcist and lover Cayetano Delaura visits her in her cell, noting her amazing tolerance for pain and, in particular, the wound on her ankle, "ardiente y supurada por la chapucería de los curanderos" (112); ("inflamed and festering as a result of the healers' ineptitude" [83]). Delaura tells her that together they will defeat the demons that possess her, and he adds a sandalwood rosary to the Santería beads around her neck. We may think of Delaura as an ideological version of Florentino Ariza, a suitor who suffers passionately and would gladly die a martyr's death for love's sake.[87] Delaura believes Sierva María to be possessed by the devil as he himself is possessed by love: he weeps "lágrimas de aceite ardiente que le abrasaron las entrañas" ("tears of burning oil that seared him deep inside") and he writhes "en un lodazal de sangre y de lágrimas" (159) ("in a mire of blood and tears") (118). The lovers recite (and rewrite) the poetry of Garcilaso de

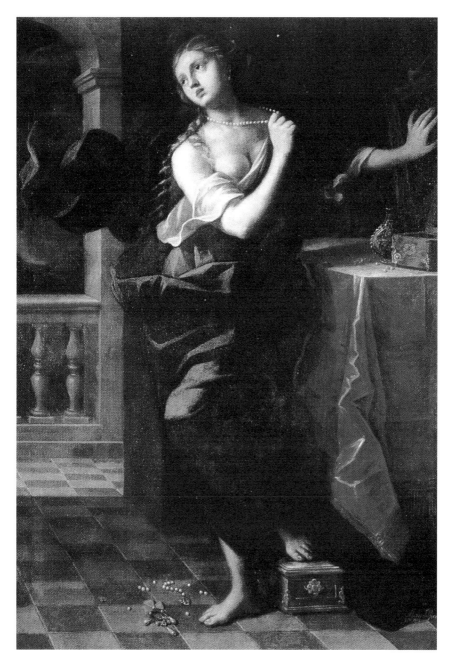

FIGURE 4.25 Alonso del Arco, *Mary Magdalene Removing Her Jewelry* (seventeenth century), Spain. Museo de Bellas Artes, Asturias.

la Vega, the Renaissance lyricist who precedes and predicts the heightened lyricism of the Spanish Golden Age, with its conjoining languages of divine possession and erotic passion.

During the Baroque period, a revivification of the practice (and persecution) of magic accompanied the development of the empirical sciences, a contradiction that continued well into the eighteenth-century in the Americas. Jacques Barzun writes that "the age of the new method and the new revelations (in the plural and without capital letter) saw a resurgence of superstition, most violently expressed in the persecution of witches."[88] In García Márquez's novel, this mix of science and superstition is embodied in his character Abrenuncio de Sa Pereira Cao. Abrenuncio is a Portuguese Jew who has fled the Inquisition and operates according to various cultural systems. He is a medical doctor and a philosopher; his library contains Voltaire, Leibniz, the *Amadís de Gaula,* and *Don Quixote*—all forbidden by the Inquisition, as he knows. In an odd vignette, this character insists upon burying his one-hundred-year-old horse in Catholic holy ground, and he convinces a priest to let him do so. He is knowledgeable about rabies, and is consulted on that subject, but his somewhat mystical science is no match for the Holy Office.

As a woman accused of demonic possession, Sierva María is considered a witch by the Church, whose institutional shadow falls upon everyone in the novel. In 1610, Cartagena became a seat of the Inquisition, with jurisdiction over what is present-day Colombia and the island of Santo Domingo; the palace of the Inquisition, built in the early seventeenth century, remains to this day one of Cartagena's most imposing Baroque structures. Sierva María's exorcism takes place elsewhere, in a solitary pavilion attached to the convent of the Clarissans that had been "used as a prison by the Inquisition for sixty-eight years and still served the same purpose for Clarissans gone astray" (63). In fact, the novel abounds in confining structures (prisons, asylums, hospitals, convents) that are made to order for analysis in terms proposed by Michel Foucault's *Discipline and Punish,* René Girard's *Violence and the Sacred,* Elaine Scarry's *The Body in Pain,* and Hélène Cixous and Katherine Clément's *The Newly Born Woman.* I leave the application of these theories of the social body to others, but I want to signal one passage as a possible point of departure.

In *The Newly Born Woman,* Cixous and Clément discuss the dialectic between imprisonment and liberation, which we have just seen playing itself out on Sierva María's body, as a condition common to all women, and they use metaphors coincident with those of García Márquez to make their argument:

> Women's bodies must be bound so that the constraints will make the demons come out; then, when the spectators have gathered in a circle, when the lions have come into the ring, they are let go—the pleasure of danger, the raging beauty of wild beasts in constrained freedom, of the violent demoniacal forces gripping the women; but no, they are no longer women, no longer girls. The female body served only as

intermediary, prop, passage. Passage accomplished, that which is no longer a woman, but beast, devil, symptom is set free. The girls are not released, the demons are: the girls are *bound*.[89]

I have said that Sierva María is an emblem of the New World's cultural heterogeneity, but is she also an emblem of Woman/Girl? Future studies, if they engage Cixous and Clément, may want to universalize Sierva María's experience on the basis of gender, even as they recognize the cultural specificity of García Márquez's character. The fiction of several Latin American women writers would also lend itself to such a challenge: I think immediately of Elena Poniatowska's *Hasta no verte Jesús mío* (*Here's to you, Jesusa!* 1969) and *Querido Diego te abraza Quiela* (*Dear Diego,* 1976), Angeles Mastretta's *Arráncame la vida* (*Tear this Heart Out,* 1988), Rosario Castellanos's *Oficio de tinieblas* (translated as *The Book of Lamentations,* 1967) and *Balún canán* (1957), and Rosa Beltrán's as yet untranslated *El paraíso que fuimos* (The paradise we were, 2002). Because these writers work in, and write about cultures in which women have been excluded from dominant modes of discourse, their use of visual forms of self-representation becomes an essential means of unsettling patriarchal projections of female identity. Whether they engage such forms thematically, structurally, or metaphorically, they do so at least in part to counterbalance linguistic abstraction and encourage the placement of phenomenal bodies in physical spaces, in material cultures and communities. The following statement is by Rosario Castellanos, from her essay "Si 'poesía no eres tú' entonces ¿qué?" ("If Not Poetry, Then What?") collected in *Mujer que sabe latín* (Woman who knows Latin, 1973):

> El sufrimiento es tan grande que desborda el vaso de nuestro cuerpo y va a la búsqueda de recipientes más capaces. Encuentra las figuras paradigmáticas de la tradición. Dido, que eleva la trivialidad de la anécdota (¿hay algo más trivial que una mujer burlada y que un hombre inconstante?) al majestuoso ámbito en que resuena la sabiduría de los siglos. . . . Entre tantos ecos empiezo a reconocer el de mi propia voz.

> [Suffering is so enormous that it spills over the vessel of our bodies and goes in search of more capable vessels. It finds the paradigmatic figures of a tradition. Dido, who raises the triviality of an anecdote (is there anything more trivial than a scorned woman and an unfaithful man?) to majestic heights, where the wisdom of centuries resounds. . . . Among so many echoes I began to recognize my own voice.][90]

In this essay, Castellanos mentions Ortega y Gasset's definition of culture as a sense of hierarchies. It is as if García Márquez, in *Of Love and Other Demons,* had set out to illustrate Castellanos's insight and Ortega's idea, focusing on gender hierarchies, and on racial and institutional ones as well.

Of Love and Other Demons is, then, singular in García Márquez's canon in its realistic engagement of the social structures and expressive forms of colonial Colombia. In his manipulation of Baroque "stylemes"—his ironic engagement of hagiographic history and its conventions of ecstatic subjectivity—we recognize the Neobaroque, and in his specific dramatization of the historical Baroque—the heterogeneous cultures and belief systems in colonial Cartagena—we see the New World Baroque. Nearly every character struggles (some consciously, most not) to create an identity from a contradictory array of cultural possibilities; institutions, too, struggle to accommodate their volatile cultural components. Fear, confusion, misunderstanding, and intolerance appear to be the primary result of these cultural crossings, and yet García Márquez also celebrates their particular energies. Consider Dominga de Adviento, Sierva María's surrogate mother:

> Se había hecho católica sin renunciar a su fe yoruba, y practicaba ambas a la vez, sin orden ni concierto. Su alma estaba en sana paz, decía, porque lo que le faltaba en una lo encontraba en la otra. (18–19)

> [(She) became a Catholic without renouncing her Yoruban beliefs, and she practiced both religions at the same time, and at random. Her soul was healthy and at peace, she said, because what she did not find in one faith was there in another. (11)]

Such comprehensiveness is allowed in the slave quarters, but not among the *criollo* class to which Sierva María belongs by birth. Nevertheless, it is Dominga de Adviento who serves as García Márquez's prophet of the future and who, along with Sierva María, embodies the repressed energy and dangerous beauty of New World ways of being.

EL BARROCO GABRIELINO

El barroco gabrielino far exceeds the characters and themes I have discussed here, and by way of concluding this chapter, I want to generalize the Baroque dimensions of García Márquez's fiction. First, the conjoining traditions of representation: the cohabitation of sensuousness and spirit in Baroque representation is consonant with the cohabitation of "real" and "magic" in much of García Márquez's fiction, and is amplified and enriched by another sort of cohabitation—the parallel African traditions dramatized in *Of Love and Other Demons* and the indigenous traditions mentioned in *One Hundred Years of Solitude* and *Living to Tell the Tale*.[91] *El barroco gabrielino* is a transculturated Baroque, a New World Baroque that includes these traditions, whether implicitly or explicitly, and it serves as a mode of historical recovery and cultural remembering such as Alejo Carpentier both predicted and prescribed. That García Márquez engages Neobaroque techniques of

intensification and irony only enhances his transcultural, postcolonial project. That magical realism recuperates and manipulates Baroque techniques and modes of cultural understanding is nowhere clearer than in García Márquez's fiction.

Second, the instability of the Baroque self allows García Márquez to modulate the relations of "magic" and "real" in his characters and his contexts. Such "hallucinatory" scenes as the banana company massacre or the serial murder of the seventeen Aurelianos in *One Hundred Years of Solitude* are contemporary stagings of the Baroque slippage between subject and object, self and world. So, too, the objects in this novel are hallucinatory. The ice and magnets that announce the world of Macondo are endowed with an energy altogether uncommon for novelistic furnishings; the ice mentioned in the justly famous first sentence of the novel is later described as "un enorme bloque transparente, con infinitas agujas internas en las cuales se despedazaba en estrellas de colores la claridad de crepúsculo" (22–23); ("an enormous, transparent block with infinite internal needles in which the light of the sunset was broken up into colored stars" [25–26]). And when José Arcadio becomes overly enthusiastic about the magical capacity of Melquíades's magnets, with which he hopes "to extract gold from the bowels of the earth," Melquíades calms him down by assuring him that "Las cosas tienen vida propia. . . . Todo es cuestión de despertarles el ánima" (9); ("Things have a life of their own. . . . It's simply a matter of waking up their souls" [11]). In these animate objects we sense the American-ness of García Márquez's Baroque. As in Frida Kahlo's paintings, the New World Baroque image *contains* spirit; Macondo is filled with wonderment that often inhabits particular, material objects.

A third and related element of *el barroco gabrielino* is his practice of *horror vacui*. García Márquez's fills his novels to overflowing with descriptions of things, the exuberant enumeration of which gives to his fictional worlds a Baroque texture that is sensuous, ornate, dynamic, theatrical. Richness of narrative detail on an immense scale characterizes *One Hundred Years of Solitude, The Autumn of the Patriarch, Love in the Time of Cholera,* as it does a Baroque *retablo* or mural or façade, and countless examples could be offered. Here I cite a scene from *Love in the Time of Cholera,* where Fermina Daza finds herself at the Arcade of the Scribes: "un lugar de perdición, vedado, por supuesto, a las señoritas decentes" (153); ("a place of perdition that was forbidden to decent young ladies" [100]). Fermina nonetheless directs her steps into the Arcade: "Se sumergió en la algarabía caliente de los limpiabotas y los vendedores de pájaros, de los libreros de lance y los curanderos y las pregoneras de dulces" (154); ("She sank into the hot clamor of the shoeshine boys and the bird sellers, the hawkers of cheap books and the witch doctors and the sellers of sweets" [101]). Her attention is drawn by a paper seller hawking "magic ink," and after considering a rainbow of colors she decides on a bottle of gold ink to write her love letters to Florentino. Whereupon she proceeds to the stalls of the candy sellers and chooses six of every kind—"seis cabellitos de ángel, seis conservitas de leche, seis ladrillos de ajonjolí, seis alfajores de yuca, seis diabolines, seis

piononos, seis bocaditos de la reina, seis de esto y seis de lo otro, seis de todo" (155); ("six angel hair, six tinned milk, six sesame seed bars, six cassava pastries, six chocolate bars, six blancmanges, six tidbits of the queen, six of this and six of that, six of everything" [101])—until the colors and smells and tastes and sheer variety of the confections are said to cast a spell upon her. This piling up of instances is intended to suggest abundance ("six of everything") and also to compensate for insufficiency, or the fear of it. In García Márquez's rich attention to the material world, he awakens the transcendental dimension of the real—"the secret life of the insatiable world" (302), as Fermina puts it later in the novel. This affirmation of the senses, combined with a perception of dynamic, expansive spaces of infinite depth and dimension, is characteristic of the New World Baroque, and is epitomized in García Márquez's fiction.

5

Borges's Neobaroque Illusionism

... the rhythm of the whole still speaks an audible language, and it requires no special persuasion to see in the equipoise of the parts an art inwardly related to the *like codex* drawing of the folds.

HEINRICH WÖLFFLIN
Principles of Art History[1]

... the Baroque differentiates its folds in two ways, by moving along two infinities, as if infinity were composed of two states or floors: the pleats of matter, and the folds in the soul.

GILLES DELEUZE
The Fold: Leibniz and the Baroque[2]

The Cuban writer Severo Sarduy begins his book *Barroco* with the etymology of the word "Baroque," and then observes that most books on the Baroque begin the same way.[3] Perhaps, but remembering Jorge Luis Borges's passion for etymology, I have waited till now to survey the etymological roots and branches. There are several competing theories on the matter, and we will look briefly at two. The first traces the word back to the Latin *veruca,* meaning wart, which becomes *barróco* in Portuguese, *barrueco* or *berrueco* in Spanish, and over time and by metaphorical

extension, the descriptive term for pearls of irregular shape.[4] This metaphor seems wonderfully appropriate for the Baroque refusal of Renaissance symmetry and centeredness, and certainly there are plenty of irregular pearls in Baroque paintings, as we have had occasion to notice. But warts are warts, and the term was initially used to suggest "deformed," "grotesque," "ugly," and thus to deprecate the asymmetry of the Baroque, rather than celebrate it. (When Alejo Carpentier specifically allows for "ugliness" in his essay on the New World Baroque, he is responding to this history,[5] though "baroque" is not the only art historical period label that begins as a term of opprobrium: so, too, gothic, rococo, cubism, kitsch . . .) In any case, Erwin Panofsky is not persuaded by this etymological hypothesis, and he dismisses the history of *veruca/barrôco/berrueco/*baroque as "most improbable."[6]

Instead, Panofsky locates the origins of the term in medieval scholasticism, and George Kubler, the estimable Latin American art historian, concurs: "The term itself is in no way descriptive of form or period: it was originally *baroco:* a thirteenth-century mnemonic term describing the fourth mode of the second syllogism coined for the use of students of logic by Petrus Hispanus, who later became Pope John XXI."[7] Panofsky explains what Kubler asserts. Words of three syllables were used by students of the time as mnemonic devices to recall the structure of a syllogism; the letter *a* in a syllable meant an affirmative universal proposition, the letter *o* an affirmative particular proposition. Panofsky gives as examples the mnemonic devices "barbara" and "baroco": "barbara" stands for a syllogism with three affirmative universals (All men are mortal; all mortals need food; therefore, all men must eat) and "baroco" for a syllogism beginning with an affirmative universal followed by two affirmative particulars (All cats have whiskers; some animals have no whiskers; therefore, not all animals are cats). This mnemonic system is far more complicated than I have indicated,[8] but my description is sufficient to suggest that this second etymology associates the Baroque with the cerebral, logical, academic intellectualism of medieval scholasticism. By the late sixteenth century, the term was invoked in popular parlance to deprecate an excess of these characteristics; Panofsky reminds us that "when humanistic writers, including Montaigne, wished to ridicule an unworldly and sterile pedant, they reproached him with having his head full of 'Barbara and Baroco'" (19). Ironically, Montaigne's *Essais* now stand at the beginning of the historical period named for the tendencies he depreciated, and are considered an early and brilliant example of Baroque self-consciousness and sensibility.

Panofsky does not proceed to wonder why *baroco*—and not *barbara* or any of the other scholastic mnemonic devices—evolves into a term of art historical description. Consider again the structure of *baroco.* Its propositions lead us to partial truth claims: not all animals have whiskers, but some do; not all animals are cats, but some are. Whereas *barbara* universalizes its truth claims with propositions that are *always* valid, *baroco* offers contingent truths dependent upon the particularity of the propositions. *Baroco* is, then, qualitative rather than quantitative, its parts

existing in dynamic relation, each interacting with the others in ways that open up alternatives and raise questions about where to stop. Not all animals have whiskers and not all animals are cats, but *some* animals *do* have whiskers: besides cats, what about mice and moles and moose and men? The meaning of the *baroco* syllogism will always exceed the affirmations of its propositions because they necessarily include elements that are *not* affirmed, that are absent but included. So, this second etymological hypothesis suggests the mobility and inclusiveness of Baroque structures, as the first hypothesis suggests their extravagance and eccentricity.

If Carpentier and Kahlo and García Márquez are part of the irregular pearl lineage of the Baroque (sensuous, emotional, theatrical), Jorge Luis Borges is of the syllogistic branch, the cerebral, logical side of the Baroque. The second (and apparently more reliable) etymology reminds us that the Baroque can be sober and restrained in style and structure. I have, until this point, stressed the expansive, effusive, theatrical Baroque, which reaches its apogee in eighteenth-century Latin America and constitutes the distinguishing historical style throughout much of the region. But it is also true that a complementary impulse begins to operate in Europe during the mid-seventeenth century that acquires the name of classical.[9] The eastern façade of the Louvre is an example of this other Baroque, this "classical Baroque," as are the writings of several seventeenth-century writers to whom Borges regularly refers. Sir Thomas Browne, Blaise Pascal, and Francisco de Quevedo tend toward sobriety while also engaging the volatile relations of self and world that we have seen in previous chapters.[10]

Borges was well aware of the entire spectrum of Baroque writing, not just its syllogistic branch, and he acknowledged such irregular pearls as Baltasar Gracián, Diego de Saavedra Fajardo, Luis de Góngora and, of course, Miguel de Cervantes.[11] To some, he conceded only an ironic nod but to others he accorded extravagant praise—most particularly to Cervantes and Quevedo, one from either branch of the Baroque. Writing about Quevedo in his 1952 collection *Otras inquisiciones* (*Other Inquisitions*) he asserts about Quevedo's poems: "Son (para de alguna manera decirlo) objetos verbales, puros e independientes como una espada o como un anillo de plata" ("Quevedo's works are [to find some way to express it] verbal objects, pure and independent like a sword or a silver ring").[12] He cites several texts, including Quevedo's sonnet "Hasta la toga del veneno tirio," and then concludes his essay:

> Trecientos años ha cumplido la muerte corporal de Quevedo, pero éste sigue siendo el primer artífice de las letras hispánicas. Como Joyce, como Goethe, como Shakespeare, como Dante, como ningún otro escritor, Francisco de Quevedo es menos un hombre que una dilatada y compleja literatura. (44)

> [Three hundred years have passed since the corporal death of Quevedo, but he still continues to be the leading artisan of Hispanic letters. Like Joyce, like Goethe, like

Shakespeare, like Dante—like no other writer—Francisco de Quevedo is less a man than a vast and complex literature. (42)]

Borges understood his own work to be part of this "vast and complex literature," and I believe that his capacity to crystallize abstract ideas and unarticulated emotions in luminous "verbal objects" such as those he praises in Quevedo draws upon the emblematic and illusionist strategies of Baroque poetics and pictorial artifice.

I will elaborate this claim below, but first we should note that two years after Borges's extravagant praise of Quevedo's "lapidary" verse, he published his preface to the 1954 edition of *Historia universal de la infamia* (*A Universal History of Infamy*), a second edition of his first book of fiction (originally published in 1935) in which he condemns the Baroque with faint praise, wryly depreciating his early stories as "Baroque," beginning with the "excessive title" of the collection itself. Critics have generally accepted Borges's dismissal because his spare style does not coincide with usual notions of Baroque diction and syntax, and also because he is a miniaturist, a characteristic that contradicts conventional notions of the Baroque as monumental, grandiose.[13] Nor is Borges's work sensuous or emotional in the same way as the authors and artists whom we have seen so far. But works *not* characterized by spatial extension or stylistic ornamentation or exaggerated emotionalism may also be Baroque, as José Antonio Maravall observes in his magisterial study of the Spanish Baroque:

El autor barroco puede dejarse llevar de la exuberancia o puede atenerse a una severa sencillez. Lo mismo puede servirle a sus fines una cosa que otra. En general el empleo de una u otra, para aparecer como barroco, no requiere más que una condición: que en ambos casos se produzcan la abundancia o la simplicidad, extremadamente. *La extremosidad,* ése sí sería un recurso de acción psicológica sobre las gentes, ligado estrechamente a los supuestos y fines del barroco. . . . Gracián, al hacer el elogio del Escorial, lo que admira en él es su condición de extremosidad.

[Baroque authors could allow themselves to be carried away by exuberance or could hold to a severe simplicity. Either served their ends equally. To appear baroque, the use of one or the other required the fulfillment of no more than one condition: that in both cases, abundance or simplicity take place in the extreme. *In the extreme:* this was one means of psychological action on people, one that was closely bound to the assumptions and goals of the baroque. . . . When Gracián praised the Escorial, what he admired was its extremeness.][14]

Maravall's "condition of extremity" recalls Jacques Barzun's definition of the Baroque, quoted in chapter 3: "exuberance by design." Both phrases accommodate the miniature as well as the monumental, the centripetal as well as the centrifugal—seeming oppositions that, in fact, often operate conjointly in Baroque structures.

We have seen that García Márquez's Baroque is characterized by richness of narrative detail *and* immensity of scale, and *el barroco borgesiano* also contains (as Borges's narrator says in "The God's Script") the intimate designs of the universe and the universe itself. Intricacy is the other face of extension, and compression can be inordinate, too.

Borges's miniature narratives accommodate vast thematic concerns, and they also cover immense textual territory. The New World Baroque is accustomed to including foreign materials and alternative traditions, and surely Borges's texts are Baroque in this sense, though they depart distinctly in the cultures they seek to include. Borges's literary project is not "Indo-Afro-Ibero-American," to use Carlos Fuentes's phrase, as are Garro's, Galeano's, Carpentier's, and García Márquez's; rather, his is a de-bordering, de-nationalizing project that refuses American parameters. He reaches back before the Spanish invasion of America to medieval Spain and its three-part flowering of Judaism, Islam, and Christianity, which lasted for seven hundred years on the Iberian peninsula—a literary project that Carlos Fuentes recognizes as Borges's "supreme narrative synthesis": "I certainly would not have had this early, fraternal revelation of my own Arab and Jewish heritage without such stories as 'Averröes' Search,' 'The Zahir' and 'The Approach to al-Mu'tasim.'"[15] Borges also recuperates Classical philosophy and literature, not to mention Anglo-Saxon poetry, Norse sagas, Eastern religious texts and the tales of Scheherazade. His reading reflects no unity of theme or singularity of message but rather innumerable points of entry, but entry into what? Like Sarduy's chain of signifiers, his proliferating references to texts real and imaginary seem to orbit around an absent (or infinite) center. Indeed, Borges's inclusiveness often borders on self-parody—a strategy of the Baroque, according to Borges himself.

Am I arguing that Baroque writers and philosophers, and even painters, influenced Borges's work? Certainly some did, but my interest is in their aesthetic affinities rather than influence per se. Am I arguing that Borges is above all (or only) Baroque? Borges always includes the means to deconstruct any single reading of his work, so to insist upon a homogenized "Borges barroco" would be folly. What I *am* proposing is that our reading of Borges will be enriched by an understanding of Baroque modes of expression, and vice versa: that Borges's work will enrich our appreciation of the Baroque and the variety of its forms and purposes in Latin America. Before going further, however, we must wonder why this writer, who seemed ready to embrace every imaginable literary tradition, felt compelled to distance himself from his Baroque precursors.

BORGES'S ANTI-BAROQUE

Recall that both Borges and Alejo Carpentier met the Mexican literary intellectual Alfonso Reyes in the late 1920s, when Reyes was engaged in resuscitating Spanish

Baroque literature from two centuries of oblivion. Carpentier had established his friendship with Reyes in Paris in 1927, the year that Reyes was named Mexican ambassador to Argentina, a post that took him to Buenos Aires for three years. There, it was Borges who would begin to learn from Reyes, as Carpentier had in Paris, and like Carpentier, Borges would surely have discussed Baroque literature with Reyes.[16] Borges, too, was engaged in a reconsideration of the Baroque, and had already published essays on Quevedo and Góngora.[17] Both of these early essays reflect the aesthetics of *ultraísmo,* the avant garde movement that Borges had almost single-handedly transplanted from Spain to Argentina in 1921, after five years of residence in Europe. The *ultraístas* were concerned to create a poetics that would avoid worn-out metaphors while still foregrounding metaphor as such, and it is predictable that Borges would look for models in Quevedo and Góngora.[18] In his *ultraísta* manifestoes during the early twenties, he repeatedly admires Quevedo but when he comes to Góngora, he tempers his praise. Beatriz Sarlo points out that beyond poetry per se, Borges was seeking "to construct a literary language for Buenos Aires and also give to the city a mythic dimension," a project that did not fit easily into the extravagant wing of the Spanish Baroque.[19] In a 1926 essay Borges considers Góngora's imagery and concludes with a comment directed to his fellow *ultraístas:* in spite of their Gongorine heritage, some "honorable pages" may yet be written in Argentina.[20] Although Borges and Alfonso Reyes would remain lifelong friends, Borges was never persuaded by Reyes's passion for Góngora, and he reacted with suspicion to the enthusiasm surrounding Góngora's tercentenary in 1927.[21]

Unlike Carpentier, then, for whom the Baroque provided the vehicle he needed to pursue the question of Latin American identity, Borges found it inadequate for the same purpose. Borges, too, was struggling to define a local, national, and continental aesthetic, but unlike Carpentier, he felt the need to divest himself of overbearing European influences. In Argentina, there was little Baroque art and architecture because the region had not been intensively colonized during the Baroque period. There was a belated vogue in "neocolonial" architecture at the beginning of the twentieth century, but it reflected a rear guard action of longtime residents of Buenos Aires who wished to emphasize their ties to Spain in the face of large numbers of immigrants from elsewhere. Nor did Argentina have an indigenous cultural heritage analogous to those areas in Latin America where the Baroque had flourished; Carlos Fuentes has quipped that the Mexicans descended from the Aztecs and the Argentines descended from ships. By the mid- to late-nineteenth century, the indigenous peoples who remained in Argentina were subject to policies of removal and genocide such as those in the United States during the same period. Whereas Carpentier adopted indigenous forms as part of his own constructed cultural heritage, Borges would not, despite his strategic use of indigenous cultural settings in two stories that we will discuss below.[22] If Carpentier insisted upon the

American-ness of his transculturated Baroque, with its postcolonial potential of *contraconquista,* Borges addressed the question in quite another way. Always aware of his peripheral position as an Argentine writer—a writer "on the edge," as Beatriz Sarlo puts it nicely—Borges reacted by amplifying "America" to include cultural and historical materials everywhere, real and imaginary. So the nature of his inclusionary impulse differs from that of his Cuban contemporary, as did his Argentina from Carpentier's Cuba. For Borges in the 1920s, to define his American-ness (his *criollo*-ness[23]) was to reject traditions that were specifically Spanish and/or American in favor of "universal" ones. The Baroque does not figure in the conception of the Argentine writer and tradition described in Borges's 1932 essay by that name.

Then, too, there was the matter of style. By the time Borges made Reyes's acquaintance in 1927 in Buenos Aires, the young writer was trying to shake off his youthful tendency to overwrite. His first three volumes of prose betray the ornate style current in Argentine letters at the time: *Inquisiciones* (Inquisitions, 1925), *El tamaño de mi esperanza* (The measure of my hope, 1926), and *El idioma de los argentinos* (The language of Argentines, 1928) are filled with the elaborations of a writer who had not yet established his own style. Borges opposed their republication for fully sixty years,[24] though shortly before his death he gave permission to the editors of the Pléiade edition of his complete works to add a selection from these early works. In 1994, eight years after his death, Seix Barral reprinted all three volumes, for which we can be guiltily grateful because they provide the opportunity to contrast his early work to the spare style that we have long considered "Borgesian." Much later, Borges would say about his prose style during this period: "I was Baroque when I was a young man. I did my best to be Sir Thomas Browne, to be Lugones, to be Quevedo, to be somebody else."[25] Ironically, Emir Rodríguez Monegal credits Alfonso Reyes with *liberating* Borges from the Baroque. Referring to Reyes's limpid style, Rodríguez Monegal asserts that "subtly, ironically, through his example, Reyes would lead Georgie away from the Baroque and teach him how to write the best Spanish prose of the century."[26] Borges rejected the ornate style of his youth, but his narrative structures remain Baroque exercises in balance, counterbalance, contradiction, compensation, and sustained ambiguity.[27]

In his preface to the 1954 edition of *Historia universal de la infamia,* Borges nevertheless reduces the Baroque to a single form and function: the Baroque is self-reflexive to the point of self-parody.

> Yo diría que barroco es aquel estilo que deliberadamente agota (o quiere agotar) sus posibilidades y que linda con su propia caricatura. . . . *Barroco (Baroco)* es el nombre de uno de los modos del silogismo; el siglo XVIII lo aplicó a determinados abusos de la arquitectura y de la pintura del XVII. Yo diría que es barroca la etapa final de todo arte, cuando éste exhibe y dilapida sus medios.[28]

[I should define as baroque that style which deliberately exhausts (or tries to ex-
haust) all its possibilities and which borders on its own parody. . . ."Baroque" is the
name of one of the forms of the syllogism; the eighteenth century applied it to cer-
tain excesses in the architecture and painting of the century before. I would say that
the final stage of all styles is baroque when that style only too obviously exhibits or
overdoes its own tricks.][29]

With this formulation—"a style which deliberately exhausts (or tries to exhaust)
all its possibilities and which borders on its own parody"—Borges confines the Ba-
roque to a metahistorical category akin to Mannerism or postmodernism—that is,
to the late, "exhausted" stage of any style or period, a bag of tired tricks.[30]

Borges continues his preface, referring to several more constituents of the "vast
and complex literature" for which, in his earlier essay, he had named Quevedo as
standard bearer. He notes that the nature of the Baroque is "intellectual" and that,
according to Bernard Shaw, all intellectual work is "essentially humorous," but
Gracián's humor, he says, is involuntary, whereas John Donne's is voluntary, culti-
vated. Directing his attention to his own stories, written twenty years earlier, he
links them to the Baroque and depreciates them with—what else?—a parody of
Baroque metaphysics and metaphors:

> Los doctores del Gran Vehículo enseñan que lo esencial del universo es la vacuidad.
> Tienen plena razón en lo referente a esa mínima parte del universo que es este libro.
> Patíbulos y piratas lo pueblan y la palabra *infamia* aturde en el título, pero bajo los
> tumultos no hay nada. (291)

> [The theologians of the Great Vehicle point out that the essence of the universe is
> emptiness. Insofar as they refer to that particle of the universe which is this book,
> they are entirely right. Scaffolds and pirates populate it, and the word "infamy" in
> the title is thunderous, but behind the sound and fury there is nothing. (12)]

According to Borges, these early "Baroque" stories are empty; they offer sound and
fury in response to a vacuum. In short, they already demonstrate the *horror vacui* of
the Borgesian Baroque.

It is easy to agree with Borges that the (frustrated) impulse to embrace the
universe is characteristically Baroque, as are its self-reflexive, parodic strategies.
And doesn't this also describe Borges's own work? Parody is rarely absent from
Borges's *ficciones,* and a universalizing impulse runs throughout them. The differ-
ence is that Borges engages Baroque self-consciousness self-consciously. The Mex-
ican theorist Gonzalo Celorio distinguishes between Baroque writers of the sev-
enteenth century and Neobaroque writers of today by saying that the former didn't
realize they were Baroque, whereas the latter do.[31] This deceptively simply formu-
lation is useful, given Borges's complex relation to his Baroque precursors. Self-

referential strategies abound in the historical Baroque, and these strategies are self-consciously manipulated by Neobaroque writers, among whom I count Borges. It is precisely this self-reflexiveness that distinguished the Baroque from Classicism in the seventeenth century, and now distinguishes the Neobaroque from Modernist forms of realism. Celorio asserts that the Baroque is art about art, whereas Classicism is art about nature; the Baroque and Neobaroque display their artifice, whereas Classicism and modernism hide theirs in the service of realism. This is an oversimplification, as Celorio acknowledges, but his emphasis on "*el doble discurso, la doble textualidad*" (the double discourse, the double textuality) of the Baroque, with its impulse to recuperate and revise texts and traditions, is appropriate to our discussion.[32] Borges's work is double in the sense that we have seen Montaigne's and Velázquez's and Pascal's to be; his stories and essays constitute a sustained contemplation of the act that engenders them, a serial reflection upon the (im)possibility of representation. But to this doubleness Borges adds irony. He self-consciously doubles the "double discourse" of the historical Baroque in order to ironize systems of knowledge and power such as those that the Baroque historically served, and to mediate among disparate systems of meaning.

The Brazilian theorist Irlemar Chiampi describes the Neobaroque as "the intensification and expansion of the experimental potential of the [historical] Baroque . . . now accompanied by a powerfully revisionist inflexion of the ideological values of modernity."[33] We have already seen this "revisionist inflexion" in García Márquez's use of Baroque hagiography to construct an alternative conception of the self. In similar fashion, Borges's anti-Baroque is also a form of Neobaroque, an ironic engagement of Baroque devices for the purpose of subverting modern hierarchies that privilege reason and empiricism, and thus limit our vision of the real. In particular, I will pursue Borges's Neobaroque "intensification and expansion" of Baroque metaphors of seeing and not-seeing.

Optical illusion fascinated Borges, and his favorite devices are intended to call into question visual perception—the mirror, the labyrinth, the dream, the trompe l'oeil, the embedded structures of mise en abîme and regressus ad infinitum. His illusionism is occasioned not by the cosmic anxieties of the seventeenth century, of course, but by his own skepticism about knowing and representing. And also, perhaps, by his encroaching blindness. As a young man, he knew that blindness was his fate; he had been diagnosed early on with the same progressive loss of sight that his father had suffered.[34] Vision and its related modes of verbal description are often the subject of Borges's essays and stories, as is the capacity of language to create visual images ("verbal objects") in the mind's eye.[35] His images are far less flamboyant than the swooning saints and suffering martyrs to whom we have referred in our discussion of Kahlo and García Márquez, less theatrical than the architectural images of François de Nomé and Alejo Carpentier, and certainly less polemical than the ideological epics of the Mexican muralists. Nonetheless, to the extent that Borges's miniature narratives engage illusionist strategies to amplify

the canons of realistic representation, they are as extravagant as any Rubens ceiling or Rivera wall. At the end of chapter 3, I cited Spengler's observation that Beethoven's deafness "merely released him from his last fetters." Without presumption or insensitivity, I would propose that Borges's blindness released him from his.

TROMPE L'OEIL TRICKS

An author's fondest dream is to turn the reader into a spectator; is this ever attained?

VLADIMIR NABOKOV, *Despair*[36]

Artistic devices of spatial illusion were developed during the Baroque period in response to the cultural anxieties mentioned in previous chapters, and also in response to the new taste for virtuosic visual display. Scientific discoveries and religious revolt were toppling venerated systems of belief; the authority of perception had been undermined, and despite the sensuous naturalism of much Baroque painting, the senses were increasingly understood to be a source of deception and disillusionment. Michel Foucault's discussion of this epistemological crisis is well known, as is his reference to Borges in his introduction to his book on this subject, *Les mots et les choses* (*The Order of Things*, 1966). Foucault writes about this epistemic break:

> At the beginning of the seventeenth century, during the period that has been termed, rightly or wrongly, the Baroque, thought ceases to move in the element of resemblance. Similitude is no longer the form of knowledge but rather the occasion of error. . . . The age of resemblance is drawing to a close. It is leaving nothing behind it but games. Games whose powers of enchantment grow out of a new kinship between resemblance and illusion; *the chimeras of similitude loom up on all sides, but they are recognized as chimeras;* it is the privileged age of trompe-l'oeil painting, of the comic illusion, of the play that duplicates itself by representing another play, of the *quid pro quo,* of dreams and visions; it is the age of the deceiving senses; it is the age in which the poetic dimension of language is defined by metaphor, simile, and allegory.[37]

Epistemological certainty was eroding and Baroque artists responded ironically, fantastically, with the visual "games" to which Foucault refers. Though he overstates the presence of an animistic episteme in Europe before the seventeenth century—Western mimesis has, since the Greeks, separated images from objects in order to re-present them—he is right to emphasize the sea change taking place during the Baroque period. The Baroque rupture with Classical canons of reason and representation would have been as compelling to Foucault in the 1960s as it

had been to Latin American writers who, beginning in the 1920s, were looking for ways to challenge inherited systems of knowing. I will return to Foucault's reference to Borges's 1941 story, "The Analytical Language of John Wilkins," but first let's consider his "chimeras of similitude."

Examples come in all sizes, shapes and media, but in every instance, whether monumental ceilings or modest still lifes, these chimeras share an affective intention: to make their viewers wonder "Is this real? What is real?" and, furthermore, to make us wonder (in the sense of "marvel") at the artist's virtuosity in provoking such questions in the first place.[38] Think about the difference between this double wonderment of Baroque illusionism and the flesh-and-blood naturalism of Baroque representation that we saw in the previous chapter. Baroque naturalism continued the Renaissance program of representing the real by offering viewers a "transparent window" through which to view its scenes and personages, even as it multiplied and mobilized the "windows." This metaphor describes the fixed-point perspective of Renaissance realism formulated by Leon Battista Alberti in the fifteenth century.[39] Albertian perspective also creates an illusion, of course—of three dimensional space on a two-dimensional surface—but by the seventeenth century, this illusion was accepted as the pictorial artifice most closely resembling the experience of the human eye. Baroque painters combined Albertian perspective with new techniques of light and shading to create greater depth and spatial dynamism, but even when their scenes included the Holy Spirit or angels or divine miracles, they were not intended to call into question the status of the real. Their work is presented to viewers as a re-presentation of the real, not as reality itself; viewers of, say, López de Arteaga's doubting Thomas (color plate 7) or Echave Ibía's penitent Magdalene (fig. 4.24) are invited to identify emotionally with their subject matter, but not to question their verisimilitude, and certainly not to confuse them with their own reality.

To the contrary, Baroque illusionism subverts this kind of re-presentation by calling attention to its artifice, to its perspectival manipulations, and thus to the problematic nature of referentiality as such. Trompe l'oeil (literally, "deceive the eye") paintings challenge the conventions of Albertian perspective by deploying Albertian conventions to their extreme; their creators manipulated the mimetic techniques of fixed-point perspective so that their painted images would not merely re-present the real, but be (mis)taken for it. As we will see, they sometimes added idiosyncratic pictorial and perspectival devices to heighten the deception, but central to all trompe l'oeil images is this debate of art with itself—this spectacle of realism engaged in an assault on its own realistic claims. Jean Baudrillard, theorist of simulacra, describes this irony:

> In trompe l'oeil it is never a matter of confusion with the real: what is important is the production of a simulacrum in full consciousness of the game and of the artifice by miming the third dimension, throwing doubt on the reality of that third dimen-

sion by miming and outdoing the effect of the real, throwing radical doubt on the principle of reality.[40]

Doubt is also cast upon the existence of the viewing subject. Trompe l'oeil paintings transgress the separation between subject and object, between pictorial and real space, that defines Western re-presentation—a transgression of conventional binaries and boundaries that explains why illusionism remains a peripheral branch of Western art. The objects and spaces in trompe l'oeil painting are no longer determined by the viewer's controlling gaze; rather, the viewer enters into dynamic relation with illusionary objects and spaces because the autonomy of the single self has been breached. No wonder that Baudrillard finds trompe l'oeil less a branch of painting than of metaphysics.

In these ways trompe l'oeil recalls the indigenous image-as-presence, where image and object are conflated because self and world are intertwined. Illusionist painters such as the Jesuit Andrea Pozzo, in his ceiling fresco for the Church of St. Ignatius in Rome, strove to create an image that contains the universe and the self, and is coextensive with the divine (color plate 20). Borges, too, creates trompe l'oeil images in "The Aleph," "The Library of Babel," and "Pascal's Sphere" that refuse the self-containment of the re-presented world of literary realism. But the aim of trompe l'oeil fictions, whether painted or printed, is more than to simply undermine realistic representation; it is also to amplify the viewer's or reader's experience of the real by pointing to orders of being that are impossible to represent realistically. So though we may agree with Baudrillard about the assault of trompe l'oeil devices on realism and reality, we also recognize his disregard for the transcendental motivation of much Baroque illusionism, which aspires to bring mystery into presence. Borges's illusionism engages this aspiration, though not in any conventional way; his subject is not what is real and unreal, but the paradoxical possibilities of the real. His ontological explorations makes his work Neobaroque rather than Postmodernist, a claim that I will argue in my conclusion.

Art historian John Rupert Martin says that "a sense of the infinite pervaded the entire Baroque age and coloured all its products."[41] Consider the Baroque artists who painted frescoes on church cupolas, ceilings, and walls. Their subject was often infinite (transcendental) space, and their large-scale deceptions depended upon making Alberti's transparent window disappear into thin air. Put another way, they removed the perceptual frame of Renaissance perspective so that viewers might step from their own finite space into the vast illusory space projected *behind* the picture plane. In color plate 20, Andrea Pozzo's *Allegory of the Missionary Work of the Jesuit Order*, architectonic and plastic elements pretend to collide on the painted ceiling of the nave of St. Ignatius. In this stunning example of perspectival manipulation known as *quadratura*, the distinction between interior and exterior space is erased; the enclosed space of Renaissance realism opens out upon (the illusion of) light and air and bodies swirling in space. The theatricality of Pozzo's ceiling—its

PLATE 20 Andrea Pozzo, *Allegory of the Missionary Work of the Jesuit Order (The Glorification of St. Ignatius)* (1691–94), Church of St. Ignatius, Rome.

effect upon the viewer—proceeds from the disjunction between the illusion of infinite space and our awareness of our own physical finitude. Pozzo exploits this tension between artifice and nature—between the dilation of represented space on the one hand, and the located position of the viewer on the other. In an equally spectacular trompe l'oeil ceiling by Giovanni Battista Gaulli, known as Baciccio, in the Jesuit Church of the Gesú in Rome, a slanting mirror has been placed on the floor of the nave; the earthling looks down to see the celestial ceiling reflected in the mirror below, further reminding us of our limited location in finite space. Our double wonderment depends upon this tension between fixity and infinity, and in this sense we may say that the fixed-point perspective of Renaissance art has not disappeared from these ceilings but has been ironically included.

Such architectural illusionism was known in antiquity and revived in the early fourteenth century, but the great vogue of *quadratura* begins later, in the sixteenth century in Italy, and continues in the seventeenth throughout Europe, when interior walls and ceilings were regularly frescoed with grand vistas of exterior spaces (fig. 5.1). Art historian Sybille Ebert-Schifferer writes about this kind of architectural illusionism: "The mathematical basis of perspective construction developed

FIGURE 5.1 Baldassare Peruzzi, *Sala delle Prospettive* (fresco, c. 1515). Villa Farnesina, Rome.

in the seventeenth century into a genre of its own. . . . Eventually, in the Baroque era, painters would conjure up visions of boundless space on two-dimensional ceilings, and use painted architectural illusions in stage decorations and on building façades."[42] Julie Stone Peters, in her book on theatre and print culture in Europe, provides examples of sixteenth and seventeenth engravings of "perspective construction" in stage sets, offering them as "expressions of the general cultural impulse to match stories, representations of knowledge, and renderings of history to a set of visual and spatial coordinates."[43] Such perspectival manipulations were inspired in part by the telescopes, microscopes, and personal optical lenses coming into use at the time, and in part by the desire to bring the newly limitless and incomprehensible space of seventeenth-century science into the realm of the visible and tangible. (Recall Pascal's thought, cited in chapter 3, that places the self between the incommensurable poles of the infinite and the infinitesimal.) And in religious contexts, as I have said, pictorial illusionism was engaged to bring the viewer into the presence of the divine.

Any current use of Baroque illusionist strategies is necessarily self-conscious, and often ironic. Take an example from a recent film. An Italian villa covered with *quadratura* decoration is a primary setting for *Ripley's Game*, the second installment of the quirky criminal activities of Patricia Highsmith's fictional character Tom Ripley, played this time by John Malkovich. The exaggerated trompe l'oeil murals and illusory architectural ornamentation in Ripley's villa, far from suggesting a Baroque longing for the infinite, provide the visual and spatial coordinates, as Peters puts it, by which to measure the protagonist's monumental capacity for falsehood and self-deception. In the film, a neighbor depreciates Ripley's *quadratura* (and his pretensions) in his hearing, a faux pas that sets Ripley's revenge (and the plot) in motion. Closer to home, trompe l'oeil murals appear in U.S. cities in the form of windows, doors, cornices, and other architectural ornaments painted on the blind walls of warehouses, department stores, apartment buildings. In *The Production of Space*, Henri Lefebvre notes that in Greek architecture and continuing through Palladio and Bernini, "façade and perspective went hand in hand," and recent urban architectural illusionism enacts Lefebvre's assertion in the extreme.[44] As we drive by, we may first think that a new building has been built, but on second glance, we wonder at our "mistaken" understanding of the real, and at the artist's technical capacity to deceive us. Ebert-Schifferer summarizes this double wonder: every trompe l'oeil painting compels the viewer "to contemplate its object-ness, the conditions of its making, and the mechanics of human perception as such" (18).

Baroque sculptors, like architectural illusionists, ironized the Albertian perspectival frame, creating figures in marble and masonry that refuse their enclosed representational space and reach out beyond their designated frame. This rupture of the picture plane again calls into question the distinction between the viewer's

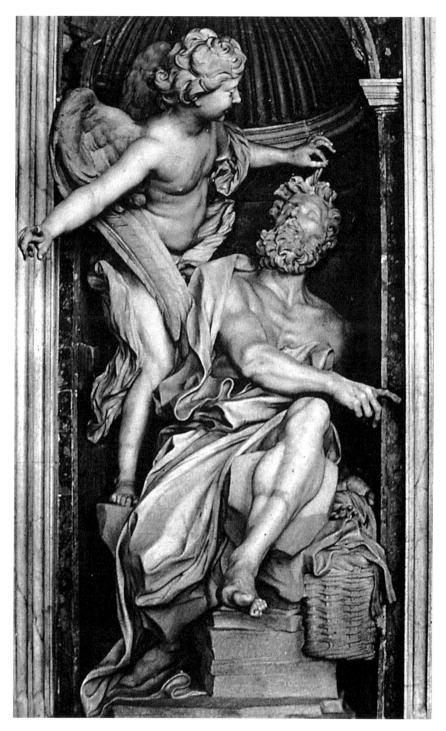

FIGURE 5.2 Gian Lorenzo Bernini, *Habakkuk and the Angel* (1655–61). Chigi Chapel, Santa Maria del Popolo, Rome.

space and pictorial space, between represented and real. In figure 5.2, *Habakkuk and the Angel* in the Church of Santa Maria del Popolo in Rome, Bernini's figures transgress their spatial enclosure as if they belonged equally to the world of the viewer and to the created world of art. This work is not a trompe l'oeil—there are no structural devices designed to make the viewer think that this marble figure is a "real" human being or, for that matter, that the sculpted angel is a "real" angel. But the breaching of spatial planes is nonetheless similar in intent to that of trompe l'oeil painting in that it simultaneously calls attention to, and dispels the distinction between artifice and nature. In fact, Bernini's Habakkuk is placed diagonally across from another niche in the side chapel, where another of Bernini's sculpted figures (Daniel) also strains forward and upward. The dynamic relationship between Habakkuk and Daniel doubles the viewer's sense of displacement and imbues the space with an energy unmistakably Baroque in its will to transgress boundaries and explode enclosure.

Perhaps for this reason, small spaces are also common in Baroque illusionary art. Cupboards, cabinets and niches filled with a welter of things are often the setting for trompe l'oeil painting because they allow the artist to manipulate (and disrupt) the Albertian depiction of spatial planes. In color plate 21, in his painting entitled *Quince, Cabbage, Melon and Cucumber*, the Spanish painter Juan Sánchez Cotán uses dramatic light and shading to define the picture plane, which is delimited by the wall that frames the recessed larder. He creates the illusion of recessional movement away from the viewer into the depths of the larder at the same time that he also projects a slice of melon and the end of a cucumber into the viewer's space.[45] Gilles Deleuze, in his book on Baroque philosophy and aesthetics, argues that this transgressive movement is basic to Baroque thought and expression, and he uses the example of trompe l'oeil to exemplify this penchant for dynamism and disruption: "Matter tends to flow out of the frame, as it often does in trompe l'oeil compositions, where it extends forward horizontally."[46]

In fact, the matter is more complicated than Deleuze suggests, because Sánchez Cotán's painting moves both forward and backward, both inward and outward with respect to the picture plane, drawing emphatic attention to both surface and depth. There are no visible brushstrokes or layering of paint or any other surface disturbance that would betray the artifice, even as the rough texture of the quince and cabbage are perfectly rendered, as is the twisted fiber of the strings from which they hang (and which highlight, by contrast, the dark depths of the niche behind). Again the division between nature and artifice is undone; the tactile and the visual collude to confirm the painter's deception—his vegetables and fruit are not painted images at all but objects in the viewer's world.

Whence the second stage of wonderment to which I have referred: the more successful the artist is at hiding himself, the more we are compelled to admire his dexterity. In this respect, the illusionist bears an uncanny resemblance to the forger and to God, whose miracles are often presented in Baroque painting as embedded

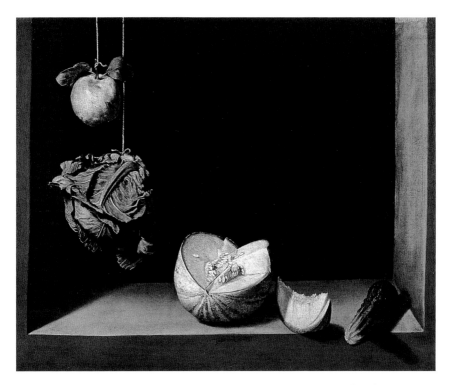

PLATE 21 Juan Sánchez Cotán, *Quince, Cabbage, Melon and Cucumber* (1602), Spain. San Diego Museum of Art.

trompe l'oeil scenes in otherwise realistic contexts. It is precisely this structure that Borges ironizes so brilliantly in "The Secret Miracle."

Borges's character stands before a firing squad in Nazi Germany but is granted a year's reprieve to finish his life's work, a long drama in verse. At the end of Borges's story, we learn that this reprieve is an illusion, and that the year (fully experienced and realistically described) has miraculously transpired in the instant that it took the firing squad's bullets to reach Hladik's body. Here, Borges engages not only the embedded trompe l'oeil structure of Baroque painting, but also the conventions of ecstatic experience discussed in the previous chapter. His character has undertaken the intellectual activity upon which his experience of transcendence depends, and has been granted the miracle through his faith in that activity.[47] Hladik prays for time to finish his work, and is given as much as he needs; his reprieve constitutes a kind of temporal *quadratura* in which time, rather than space, opens onto infinity. But in Neobaroque fashion, Borges also parodies these conventions. Hladik's text is described as "incoherent," "a circular delirium," and "a tragicomedy of errors," even as it is also the *raison d'être* of the miracle. Fur-

thermore, the miracle is *secret.* In saints' lives, the two planes—sacred and profane—must eventually intersect, the former radically altering the latter. Hladik's miracle effects no revision of the horrific reality in which it is embedded; there are no consequences, no witnesses, no followers, indeed, no completed drama in verse. Reality is ruthlessly triumphant, as it is for martyred saints, of course, but their deaths are understood by believers to be significant, as Hladik's is not. So Borges mocks the conventions of Baroque representation at the same time that he achieves this stunning reversal: Hladik's miracle is no less a miracle for being secret, no less an imaginative transcendence of evil for having had no effect at all on the exercise of evil.

Like trompe l'oeil paintings, Borges's story both undermines and amplifies the real; the reader enters the illusory time of Hladik's miracle as the viewer enters the illusory space of Pozzo's ceiling or Sánchez Cotán's larder. Whether visual or verbal, these structures depend upon the disjunction between orders of reality, between the reader's or viewer's location in space and time and the artist's or writer's imagined *dis*locations. Only after Hladik's miracle is accomplished does the reader readjust his or her eyes to the light of day and find that the ironclad limits of our reality have been reestablished. Or have they? It may be that the reader's vicarious experience of Hladik's miracle has displaced those limits forever.

Trompe l'oeil painting flourished in the Protestant Netherlands as well as in Catholic Europe, with differences in emphasis. The trompe l'oeil letter rack became an established genre in the Dutch Republic during the seventeenth century in accordance with the regional enthusiasm for intimate interiors. Letter racks are a kind of still life, a domestic furnishing consisting of strips of ribbon or leather tacked to a wall to hold letters, documents and small objects that often refer to the individual who commissioned the work (color plate 22). The writing on the painted documents is meant to be read for personal and political information as are the objects, which may also contain allegorical meanings. The magnifying glass in Edward Collyer's painting *Trompe l'oeil* may signify the importance of looking closely and seeing well, or conversely, the futility of looking closely: no matter how carefully you look at this letter rack, you will discover only fragmentary information. In these small paintings, as in the immense architectural frescoes, illusion depends upon the manipulation of perspective and proportion, but now, instead of foreshortening objects to create the illusion of enormity, the artist aims to replicate the dimensions of the objects he depicts. Instead of disrupting Albertian perspective by extending the vanishing point out of sight, or by moving simultaneously backward and forward in representational space like cupboard trompe l'oeil paintings, letter racks truncate Albertian perspective with the flat surface to which the objects are affixed; the painted plane of the wall coincides with the surface of the canvas itself. Pictorial space exists only *in front of* the flat surface upon which the objects are pinned (and painted). The challenge to the painter's skill is to make something as

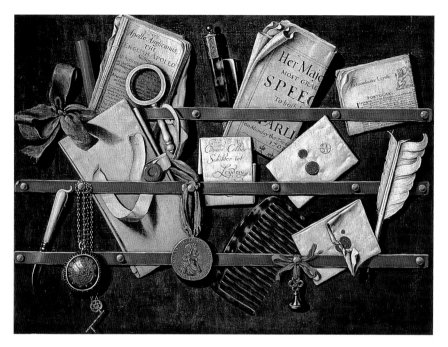

PLATE 22 Edward Collyer, *Trompe l'Oeil* (1703), Dutch Republic. Stedelijk Museum de Lakenhal, Leiden, The Netherlands.

flat as paper appear to protrude into the viewer's space; the folds and creases in the paper present a further challenge to the painter's technical prowess, and further possibilities for perspectival play.

Cornelius Gijsbrechts's painting *Letter Rack with Christian V's Proclamation* multiplies perspectival planes by including paintings within the painting (fig. 5.3).[48] Furthermore, the artist paints a frame around the letter rack and a curtain in front of it, making the entire painting a painting within a painting. In chapter 1, we noted the significance of curtains in Baroque religious representation, and they are also a favored device in trompe l'oeil paintings. They pretend to hang in front of the painting, in the space of the viewer, supposedly waiting to be pulled across the painting to protect it from undue exposure or intrusive eyes. With the addition of the curtain, Gijsbrechts's painting becomes a trompe l'oeil painting of a trompe l'oeil painting. So this artist heightens the already dizzying play of refracted "realities."

Given Borges's penchant for fragmentary texts, these letter racks would seem to predict (and also reflect) his literary techniques of derealization. But we need to look at one more visual device before we discuss further narrative structures. This device also disrupts the realistic claims of the work, but instead of presenting the painted objects as real, like Sánchez Cotán or Collyer or Gijsbrechts, it does some-

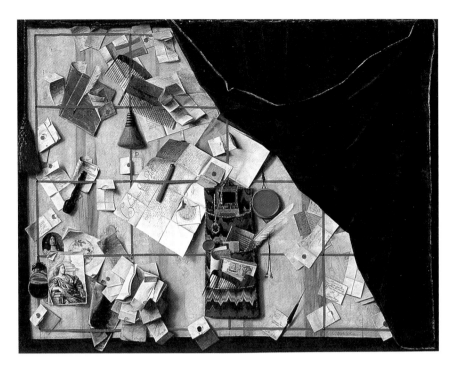

FIGURE 5.3 Cornelius Gijsbrechts, *Letter Rack with Christian V's Proclamation* (1668), Spanish Netherlands. Statens Museum for Kunst, Copenhagen.

thing conceptually its opposite. It calls attention to the painting *as painting,* as a two-dimensional artifact, by adding a pictorial detail, supposedly on the surface of the painting and outside of the represented scene, that is so realistically placed that *it,* not the objects in the painting, is to be (mis)taken for real. Such "outside" details became conventional in Baroque trompe l'oeil painting: the curtains we just mentioned, which apparently hang in front of the painting; a nail that apparently affixes objects to a wall; a cracked or broken glass that apparently covers the painting; a *cartellino* or small piece of paper, apparently tacked onto the surface of the canvas; a fly, apparently sitting on the surface of the painting (fig. 5.4). These "intrusions" from outside the pictorial space of the painted scene are designed to contradict its mimetic claims by reminding the viewer that the painting is merely a flat surface covered with a layer of pigment. It is the intrusion that is presented as real.

Borges creates an analogous play of layered realities in his postscript to "Tlön, Uqbar, Orbis Tertius," when two objects from the "ideal" world of Tlön intrude into the "real" world of the narrator. These objects, a compass and heavy metal cone, are described in his postscript as "intrusions from this fantastic world into the world of reality."[49] Borges inverts the usual trompe l'oeil procedure by having a fantastic object intrude into the "reality" of the narrative space, but by the time the

FIGURE 5.4 Jacobus Biltius, *A Trompe l'Oeil* (1678), Dutch Republic. Johnny Van Haeften, Ltd., London.

reader reaches the postscript, the layers of irreality have already been stacked: Tlön is itself part of an embedded structure, an imaginary region *within* the literature of the imaginary region of Uqbar, which is (or was) contained in yet another literary text, an encyclopedia in the narrator's "real" world. The compass and metal cone are like a fly or nail in a trompe l'oeil painting; they penetrate the normally sealed "picture plane" of narrative realism, confusing "inside" and "outside," causing Borges's "real" and "ideal" worlds to intermingle.

This confusion of "realities" exists within the story, but Borges isn't yet satisfied. The postscript in which these intrusive objects are described is postdated; it begins with the parenthetical date 1947, seven years after the story was published in 1940.[50] So the postscript further disrupts the realistic frame of the story, projecting events into the reader's future. Postscripts, like footnotes, necessarily oscillate between the interior and exterior of the text, between representation and reader, which is why writers of fiction rarely use them. (There are a few instances, of course, including Manuel Puig's *The Kiss of the Spiderwoman* and Vladimir Nabokov's *Pale Fire*, a text about an embedded text that epitomizes the Neobaroque fracturing of representational planes. Similar effects are achieved by first-person narrators who address the reader directly—José Donoso's *A House in the Country* is a stunning example—and by photographs or paintings inserted into the text, such as those in W. G. Sebald's *Austerlitz* or Allan Gurganus's *The Practical Heart.*) But my point here is to call attention to the postscript in "Tlön, Uqbar, Orbis Tertius," and to suggest how Borges worked to multiply (and merge) planes and perspectives.

In Baroque art, such techniques are sometimes attributed to the Baroque impulse to connect pictorial and experiential planes. Gilles Deleuze, for example, uses the metaphor of the fold to signal the interconnectedness of Baroque structures, in which "inside" and "outside" are continuous rather than oppositional, and matter is porous and permeable.[51] In chapter 3, we discussed the related mechanism of metonymic displacement, by which elements (object, motifs, characters) exceed their own boundaries and connect to other, related forms in an unfolding fresco of difference. This dynamism depends upon *contact*, not upon separation or isolation. Like Bernini's *Habukkuk and the Angel*, the theatrical personages in Baroque painting and sculpture often reach out toward the viewer with gestures that seem to represent the desire for connection and continuity.

But doesn't this desire also speak to the underlying sense of rupture that Foucault describes? The Baroque tropes of the world-as-a-stage and life-as-a-dream would surely suggest as much. Space may be "co-extensive,"[52] but the subject of Baroque illusionism is always, to a greater or lesser degree, discontinuity. The incommensurability of ontological realms and, by extension, the incapacity of epistemological systems to distinguish, or mediate, among them, is a Baroque obsession. In Bernini's sculpture, Pozzi's ceiling, and our various examples of trompe l'oeil paintings, the message is explicitly designed to contradict the realistic medium; the connection between representation and the real is intentionally disrupted. Borges's

lifelong exploration of the relations of thought to its narrative forms corresponds to this sense of incommensurability. In "Pascal's Sphere," we are told that "[Pascal] Sintió el peso incesante del mundo físico, sintió vértigo, miedo y soledad" ("He felt the incessant weight of the physical world; he felt confusion, fear, and solitude").[53] The burden of the real also weighs upon Borges and his phantasmagoric narrators.

Consider the "perspective construction" of "The Library of Babel," with its minute description of the vast geometry of the Library, its mathematically measured distances and identical corridors, staircases and towers, each with its exactly numbered shelves, books, pages, lines, and letters—even as we are also told that the Library is infinite, immeasurable, unknowable.[54] Borges dispenses with the Albertian frame that fixes the distance between viewer and represented space, projecting instead the illusion of infinite space behind the "picture plane" of his realistic description. His narrator offers a risible survey of spatial "intuitions":

> Los idealistas arguyen que las salas hexagonales son una forma necesaria del espacio absoluto o, por lo menos, de nuestra intuición del espacio. Razonan que es inconcebible una sala triangular o pentagonal. (Los místicos pretenden que el éxtasis les revela una cámara circular con un gran libro circular de lomo continuo . . .)[55]

> [The idealists argue that hexagonal rooms are a necessary form of absolute space or, at least, of our intuition of space. They reason that a triangular or pentagonal room is inconceivable. (The mystics claim that their ecstasy reveals to them a circular chamber containing a great circular book whose spine is continuous . . .)][56]

Despite the abstract enormity of such potential spaces, Borges's narrator also pays assiduous attention to material detail, not failing to notice "two very small closets": "In the first, one may sleep standing up; in the other, satisfy one's fecal necessities" (51). Later, he juxtaposes the "inexhaustible stairways for the traveler and latrines for the seated librarian" (52). This hilarious negotiation between infinite space and the functional constraints of real human bodies gives to the narrator the quality of a Don Quixote, whose vast illusions are constantly being interrupted by "real" physical facts: thrashings, stampeding pigs, amorous stirrings, hunger, and so on. In the juxtaposition of "fecal necessities" *and* "inexhaustible stairways," Borges parodies both the mimetic assiduousness and the metaphysical aspiration that underpin Baroque architectural illusionism, while at the same time adopting the paradox upon which their effects depend: the disjunction between the limited space of artistic media and human selves on the one hand, and the disembodied illusion of infinite extension on the other.

If Borges's narrator recalls the tragicomic hero Don Quixote, he also echoes Blaise Pascal as this seventeenth-century cleric and sceptic confronted the quantifiable and yet immeasurable space proposed by the new science and mathematics. Borges's story may be read on one level as an allegory (and parody) of the newly quantifiable space in Pascal's "dejected century," as Borges puts it in "Pascal's Sphere."[57] A second essay on Pascal is included in the same collection, *Otras inquisiciones* (1952), which pursues the same theme: the unfathomable relations between the solitary self and infinite space. Borges writes: "Pascal, nos dicen, halló a Dios, pero su manifestación de esa dicha es menos elocuente que su manifestación de la soldedad. Fue incomparable en ésta" ("Pascal, they tell us, found God, but his manifestation of that joy is less eloquent than his manifestation of solitude, in which he had no equal").[58] For Pascal, the "when" and "where" of the single self are no longer knowable because infinite time and space have engulfed both.[59] The comparison of Borges's narrator to Pascal's persona allows us to weigh the Baroque against the Neobaroque, and the seventeenth century against the twentieth. Pascal's nostalgia for a comprehensible order of infinite magnitude is both ironized and intensified in Borges's Neobaroque Library of Babel.

Borges sets his multiperspectival system in motion by redoubling the doubleness of Baroque illusionism. Besides his parody of the devices of architectural illusionism, we note that the text we are reading exists *outside* of the Library. The first-person narrator appears to move in and out of the Library at will, but his implied readers do not. Rather, he writes to readers who stand outside the Library and inhabit a world something like our own; in fact, the narrator explicitly recognizes the distance of his own representational plane from that of his readers ("the human species—the unique species—is about to be extinguished, but the Library will endure" [57]). He fails to note another significant disjunction between "inside" and "outside": his text is legible beyond the confines of the Library as it would not be within, where, we are told, alphabetic order has not yet been established. Nor is his text four hundred and ten pages long, as are all the books inside the Library. In short, it seems to have escaped from the suffocating symmetry of the Library and entered the plane of the reader.

My use of spatial terms—"plane," "inside," "outside"—to describe the shifting perspectives of a literary text is necessarily metaphoric, as are these terms when applied to painting, for that matter. Nonetheless, Borges considered the graphic potential of textual space in ways that are not at all metaphoric. He often expressed his interest in the Kabbalistic idea that letters and words are pictures of the universe, and his use of the Aleph as an emblem containing the world has its source here. In the postscript to "The Aleph," the narrator refers to the shape of "la primera letra del alfabeto de la lengua sagrada" ("the first letter of the sacred alphabet"): "It is also said that it takes the shape of a man pointing to both heaven and earth, in order to show that the lower world is the map and mirror of the higher."[60] In "Los teólogos" ("The Theologians") and "Del culto de los libros" ("On

the Cult of Books"), Borges further investigates the formal sympathy between signifier and signified, alphabet and universe. In both texts, he refers to religious and philosophical traditions in which the visible structures of letters, words, and texts have metaphysical significance. In these traditions, as in Borges's *ficciones,* such structures are not mere metaphors for textual space but implicated in it. Literary space, in being conceptual, cannot be measured, but it can be *experienced* as measurable; in Borges's stories, multiple textual planes function together with his verbal emblems—Aleph, labyrinths, mirrors, Library—to generate the reader's experience of space as such.

As we have seen, Borges multiplies perspectives with footnotes. If the illusory infinity of the Library of Babel is projected behind the picture plane of mimetic description, as in Baroque architectural illusionism, the footnotes to this story—in small print, specific, matter of fact—are projected in front of the narrative frame into the finite space of the reader, like the flies in trompe l'oeil paintings. One of the footnotes is labeled "editor's note," adding yet another perspective to the text—another fly, as it were—onto the "picture plane" of the story. The final footnote is appended to the final word of the final sentence ("hope"), and it offers the reader alternative emblems of infinity. In the middle of this final footnote, in parentheses, we read: "In the early seventeenth century, Cavalieri said that all solid bodies are the superimposition of an infinite number of planes" (58). So Borges winks at yet another Baroque structure of infinity (rather like his own) thus, extending the oscillation between ontological planes beyond the end of his story and adding fuel to my reading of this story as a parodic allegory of the newly empirical space that weighed so heavily upon Pascal, and also, it seems, upon his Argentine heir.

We read of "fathomless air" and "inexhaustible stairways" that "sink abysmally and soar upwards to remote distances" at the same time that we read fussy little footnotes that "extend forward horizontally" into our own space, to repeat Deleuze's phrase. Architectural illusionism of this sort is everywhere in Borges's work. In another of his architectural fantasies, "Parábola del palacio" ("Parable of the Palace"), collected in *El hacedor* (*Dreamtigers,* 1960), Borges's narrator again shuttles between immensity and intricacy, this time by means of the subtlest shadings of color: "Cada cien pasos una torre cortaba el aire; para los ojos el color era idéntico, pero la primera de todas era amarilla y la última escarlata, tan delicadas eran las gradaciones y tan larga la serie" ("Every hundred paces a tower cleft the air; to the eye their color was identical, yet the first of all was yellow, and the last, scarlet, so delicate were the gradations and long the series").[61] The minute chromatic gradations of the towers can be appreciated, apparently, only from a great distance by the narrator with his bird's eye view; to those on the ground, the towers appear identical in color. Here, as in "The Library of Babel," the narrative oscillation between recession and projection creates an effect similar to that of Pozzo's ceiling and Gijsbrechts's paper rack combined; we must step from our own spatial field

into the infinite space of the architectural illusion, and then back again into our fragmentary, phenomenal, human position.

Borges exploits this sensation of moving in and out of perceptual planes—this sensation of dizzying heights and abysmal depths, vast distances and sudden proximities—in order to create the illusion of illusion itself. Deleuze describes the metaphysics of Baroque illusionism in terms that may clarify this purpose:

> The essence of the Baroque entails neither falling into nor emerging from illusion but rather *realizing* something in illusion itself, or tying it to a spiritual *presence* that endows its spaces and fragments with a collective unity. . . . The Baroque arts know well that hallucination does not feign presence, but that presence is hallucinatory. . . . Prey to the giddiness of minute perceptions, [Baroque fictional characters] endlessly reach presence in illusion, in vanishment, in swooning, or by converting illusion into presence. (125, Deleuze's emphasis)

I have implied that the theme of "The Library of Babel" is the Pascalian disillusionment of a self caught between his own finitude and his fearsome intuition of infinity, but Borges also touches tentatively upon the *power* of illusion and the possibility, in Deleuze's phrase, of "realizing something in illusion itself." The final "hope" of the narrator that some "eternal traveler" will eventually decipher the infinite Library suggests that illusionary devices may yet breach the binaries of real and ideal, reason and mystery, sight and insight. In his final sentence, Borges asks his readers to entertain the aspiration to plenitude that inheres in all Baroque illusionism.

This aspiration is given to other Borgesian narrators as well. The narrator/priest of the "The God's Script" may be said to behold divinity in a Deleuzian "giddiness of minute perceptions." He is incarcerated in a tiny cell, which, in turn, is embedded in a vast prison of admirable imaginary architecture. Eventually he is able to describe his long awaited vision: "Vi el universo y vi los íntimos designios del universo" ("I saw the universe and I saw the intimate designs of the universe").[62] This play between entirety and intricacy is perfectly Baroque and perfectly Borgesian. The priest's vision removes him from the real, and also amplifies the real; he does not act upon his vision, but this does not diminish his achievement. Here, as at the end of "The Library of Babel," Borges both emulates and parodies the metaphysical vertigo of Baroque illusionism.

I have said that the devices of Baroque illusionism aim to provoke a double wonderment in the viewer and so, too, Borges's techniques of derealization impel the particular doubleness that pervades so much of his work: the illusion of infinity in a tightly contained narrative space. His architectonic emblems facilitate this irony, allowing him to condense vast philosophical speculations in sharply visualized symbolic structures. To Borges's Library, we may add his garden of forking

paths and labyrinths, his Aleph and sphere of Pascal, his circular ruins and jaguar's spots: like the Library, they ask the reader to entertain infinity in their "intimate designs." These emblems may be compared to the "lapidary" formalism of Quevedo's "verbal objects," which Borges so admired, at the same time that they are multiple, polysemic, interconnected by function and repetition. Vast and virtuosic and yet also somehow vacant, these verbal emblems impel the dialectic in Borges's work between abundance and absence, between the longing for plenitude and the experience of emptiness—the dialectic that operates in all forms of Baroque expression to a greater or lesser degree. I leave it to my reader to survey the imaginary architecture of others of Borges's miniature tales of infinity: "The Garden of Forking Paths," "The Two Kings in Their Two Labyrinths," "The Aleph," "Pascal's Sphere," "The Circular Ruins." In each of these texts, Borges constructs illusionary spaces that resist the conventions of realism even as they continue to operate within them. As in Pozzo's ceiling, Florentine *quadratura* and Dutch trompe l'oeil, the framed space of realistic perspective has not disappeared but been ironically included. So the Borgesian real routinely opens out upon vistas of infinity and eternity.

NEOBAROQUE ORIGINALITY

Despite the seeming simplicity of his style, Borges's narrative structures depend upon the repetition, displacement, and relocation of visual emblems and textual fragments from an enormous assortment of cultures, disciplines, media, and genres. This work of recuperation reflects the Baroque conception of originality: not innovation but the brilliant reworking of previous texts and traditions. Mariano Picón-Salas observes that "no words in seventeenth-century Spanish thought were so disdained as 'novelty' and 'innovation.'"[63] And Octavio Paz, writing about Sor Juana's *Allegorical Neptune*, comments on "the abundance of quotations, references, and literary allusions—four or five to a page."[64] Nothing, compared to Borges. So the Neobaroque upstages the Baroque by using Baroque devices to magnify those same devices.

Baroque originality consists of "influencing one's precursors," and this art of recuperation and inclusion is as fundamental to Borges's work as it was to the poetry of Quevedo or Sor Juana. Indeed, more so, because he must resist the modernist priority of the individual writer's uniqueness over the tradition as a whole. Borges's repeated use of a "handful of metaphors" is a Baroque strategy, as is his insistence that his essays and stories are merely commentaries on earlier texts, or annotations to earlier traditions. This expression of "belatedness" has been taken as a postmodernist position *avant la lettre*, but it was Baroque before it was postmodernist, and when it was Baroque it was not a statement of belatedness but of participation. In his desire to "universalize" his work, Borges began early on to fill what he per-

ceived as the vacuum of Argentine realism with a wealth of alternative texts and traditions. His recourse to a common storehouse of images is self-consciously Baroque, hence, Neobaroque.

This conception of originality precedes "the Western cult of personality" and the "romantic discovery of the personality," to use two of Borges's phrases.[65] The historical Baroque writer's contribution had its source not in *genio* but *ingenio*, not in innovation but in the poetics of *imitatio*—the erudite, elegant, and often veiled incorporation of works of "authority," whether in philosophy, literature or the sciences. In the visual arts, we have seen the use of prescribed "attributes," colors, and compositions to depict a given saint or biblical scene. Rubens's biographer observes that "the process of appropriation, assimilation and transformation of older forms and images was the mainspring of Rubens's creative genius."[66] It is not that Baroque artists lacked individualized ways of seeing or idiosyncratic modes of self-expression, but "creativity" was differently conceived. Octavio Paz says of Sor Juana's love poems:

> Like all poets of her time, Sor Juana does not attempt to express herself; she constructs *verbal objects* that are emblems or monuments that illustrate a vision of love transmitted by poetic tradition. Those verbal objects are unique—or aspire to be—not as expressions of an experience or a personality, both unrepeatable, but as unusual combinations of elements composing the poetic archetype of amorous sentiments. . . . In the most intensely personal poems of the Golden Age—those of a Garcilaso or a Lope de Vega—we find no confession or confidence, in the modern meaning of those words. . . . those experiences are presented in canonical forms and take on a representative quality. Poets and their readers sought not a lived reality but the perfection of art that transfigures what has been lived and gives it an *ideal reality*. (279, my emphasis)

Paz's praise of Sor Juana's "verbal objects" recalls Borges's praise of Quevedo, and it also points to Borges's verbal emblems. The creative engagement of earlier poetic traditions and images gives to individual works a "representative quality" and an "ideal reality"—qualities that Borges dramatizes and also achieves in his stories and essays.

Borges explicitly recognizes the idealizing function of Baroque originality in a reference to Góngora in "La postulación de la realidad" ("The Postulation of Reality").

> Para el concepto clásico, la pluralidad de los hombres y de los tiempos es accesoria, la literatura es siempre una sola. Los sorprendentes defensores de Góngora lo vindicaban de la imputación de innovar—mediante la prueba documental de la buena ascendencia erudita de sus metáforas. El hallazgo romántico de la personalidad no era ni presentido por ellos.[67]

[To the classical mind, the plurality of men and of eras is incidental; literature is always one and the same. The surprising defenders of Góngora exonerated him of the charge of innovation—by documenting the fine erudite lineage of his metaphors. They had not the slightest premonition of the romantic discovery of the personality.][68]

Borges labels Góngora's use of metaphors "classical," but his point is clear: he was critical of Góngora's ornate style, but he celebrated his techniques of recuperation and renovation—"the fine erudite lineage of his metaphors"—which enable literature to transcend the individual poet and become part of the poetic tradition. The Baroque "verbal object" is an instantiation of a larger idea, a single dimension of the universal whole. In another essay, attributing his insight to the medieval Spanish/Arab philosopher Averroës, Borges writes:

> si el fin del poema fuera el asombro, su tiempo no se mediría por siglos, sino por días y por horas y tal vez por minutos. . . . La imagen que un solo hombre puede formar es la que no toca a ninguno.

> [if the purpose of the poem were to astound, its life would be not measured in centuries but in days, or hours, or perhaps even minutes. . . . The image that only a single man can shape is an image that interests no man.][69]

The poet, Borges insists, is not an inventor but a discoverer.

There are times, though, when discovery *is* invention. The nature of Neobaroque originality differs from the Baroque precisely because it *does* comes after the Romantic constructions of individuality and originality. To abjure originality, as Borges does, is to offer an ironic reflection on the primary literary value of our time—idiosyncratic genius—and to be original for that reason. Borges has, of course, provided the avatar of this double bind in "Pierre Menard, Author of the Quixote," where Pierre Menard quotes his Baroque precursor verbatim, and is celebrated for his originality by virtue of his modern historical positioning. Pierre Menard is Borges's alter ego; both participate in a cultural history that moves backward and forward in time; each new "imitator" alters the tradition and is thus the more embedded in it.

Borges's texts are often presented as parts of, or appendages to a larger text or context: a summary, review, annotation, footnote, a suspended series or erudite commentary on ideas and texts drawn from "universal" history. In the prologue to his 1944 collection, *Ficciones,* he makes explicit this structure of imaginative recuperation:

Desvarío laborioso y empobrecedor el de componer vastos libros. . . . Mejor proced-
imiento es simular que esos libros ya existen y ofrecer un resumen, un comen-
tario. . . . he preferido la escritura de notas sobre libros imaginarios.[70]

[It is a laborious madness and an impoverishing one, the madness of composing vast
books. . . . The better way to go about it is to pretend that those books already exist,
and offer a summary, a commentary to them. . . . I have chosen to write notes to
imaginary books.][71]

For Baroque writers, this relation to textual tradition would have gone without
saying, though the books to which they referred were not imaginary. For the Neo-
baroque writer, however, this statement is a manifesto, a call to reconsider the
artifacts of one's own cultural past. The repeating ideas, images, and phrases of
Borges's *ficciones* enhance our sense that they are the parts of a single, circulating
whole, and vice versa: that each contains the "total library" of which it is a part.

So I would propose that Borges is original in ways that derive from the Ba-
roque, and are Neobaroque in intention. Theorists of the Neobaroque attend
closely to the use of received cultural and textual materials. Irlemar Chiampi writes
about the "reciclaje de formas, la energización de materiales desechos" (the recy-
cling of forms, the energizing of discarded materials), and Severo Sarduy, taking a
related tack, asserts the impossibility of apprehending the whole because the per-
ceiving subject is always partial, unstable.[72] Neobaroque reality is, in Sarduy's def-
inition, artifice artfully engaged, simulation with parodic intent. The subtlety and
variety of Borges's use of quotations and allusions, including his Menardian "tech-
nique of deliberate anachronism and erroneous attribution," is kaleidoscopic, to
use a metaphor suggested by Evelyn Fishburn in her essay on this subject.[73] It is
also self-consciously hyperbolic. Gilles Deleuze's description of the Baroque reac-
tion to the seventeenth-century crisis of systems of knowledge and belief again il-
luminates Borges's work:

> The Baroque solution is the following: we shall multiply principles—we can always
> slip a new one from out under our cuffs and in this way we will change their use. We
> will not have to ask what available object corresponds to a given luminous principle,
> but what hidden principle responds to whatever object is given, that is to say, to this
> or that "perplexing case." (67)

Deleuze's formulation—"slip a new one from out under our cuffs"—resonates with
Borges's textual sleights of hand, as does his reference to the fluid relations of
"available objects" and "luminous principles." The Baroque response to emptiness
is to "multiply principles": proliferation, rather than the selection of one path or an-
other, is its necessary mode. The Neobaroque idea is to include everything and then

construct an intellectual or artistic edifice that will accommodate (however ironically) the contradictions—an Aleph, a garden of forking paths, a Library of Babel.

Borges was especially fond of the mise en abîme (literally, set in the abyss). Like trompe l'oeil, its primary subject is its own referential status. It, too, invokes infinity, but not through perspectival play or emblematic strategies; rather, it proposes an infinite series of identical, embedded images or texts, one producing the next and nesting within it, *ad infinitum.* We may think of mise en abîme as an abstract trompe l'oeil, because endless self-repetition can only be imagined, never depicted or described. *Regressus ad infinitum* is closely related to mise en abîme in that it, too, proposes an abstract structure of endless self-reflection; the most obvious example is an image reflected in facing mirrors, the multiplication of which appears to regress endlessly into the distance. Mise en abîme also implies spatial displacement, but of the embedded Chinese box or Russian doll variety: the repeating images or texts do not so much regress into the distance as successively inhabit one another.

Borges considers the mise en abîme and its narrative analogues in two separate essays, one published in 1939 in *El hogar,* and the other in 1952 in *Otras inquisiciones.* The first essay, entitled "Cuando la ficción vive en la ficción" ("When Fiction Lives in Fiction"), begins with a childhood intuition:

> Debo mi primera noción del problema del infinito a una gran lata de bizcochos que dio misterio y vértigo a mi niñez. En el costado de ese objeto anormal había una escena japonesa; no recuerdo los niños o guerreros que la formaban, pero sí que en un ángulo de esa imagen la misma lata de bizcochos reaparecía con la misma figura y en ella la misma figura, y así (a lo menos, en potencia) infinitamente. . . .

> [I owe my first inkling of the problem of infinity to a large biscuit tin that was a source of vertiginous mystery during my childhood. On one side of this exceptional object was a Japanese scene; I do not recall the children or warriors who configured it, but I do remember that in a corner of the image the same biscuit tin reappeared with the same picture, and in it the same picture again, and so on (at least by implication) infinitely. . . .][74]

Another example that will appear again in his second essay on mise en abîme is Josiah Royce's map of England, which is so exact that it "must contain a map of the map, which must contain a map of the map of the map, and so on to infinity" (160). Then, in one of his rare references to a particular painter, Borges invokes Veláz-quez's *Las Meninas* (fig. 4.1):

Antes [del 1921], en el Museo del Prado, vi el conocido cuadro velazqueño de *Las meninas:* en el fondo aparece el propio Velázquez, ejecutando los retratos unidos de Felipe IV y de su mujer, que están fuera del lienzo pero a quienes repite un espejo. . . . Recuerdo que las autoridades del Prado habían instalado enfrente un espejo, para continuar esas magias. (325)

[Earlier [than 1921] in the Prado Museum, I had seen Velázquez's famous painting *Las Meninas.* In the background is Velázquez himself, working on a double portrait of Philip IV and his consort, who are outside the frame but reflected in a mirror. . . . I remember that the Prado's administrators had installed a mirror in front of the painting to perpetuate these enchantments. (160)]

We are not surprised that Borges recalls the administrators' mirror, which doubles the already-double structure of Velázquez's painting. This play of opposing mirrors, whose images move back and forth between the "inside" and "outside" of the painting, is a *regressus ad infinitum,* not a mise en abîme, which would require that a copy of Velázquez's *Las Meninas* appear somewhere in *Las Meninas*—perhaps on the back wall of the painted salon where, indeed, Velázquez painted several copies of his own paintings. But no: it seems that Borges's Baroque precursor (though not the museum administrators) were satisfied with a single circle of self-reflections.

What is interesting for our purposes is Borges's analogy between visual and verbal illusionism. After recalling the play of mirrors in the Prado, he writes: "Al procedimiento pictórico de insertar un cuadro en un cuadro, corresponde en las letras el de interpolar una ficción en otra ficción" (325); ("The pictorial technique of inserting a painting within a painting corresponds, in the world of letters, to the interpolation of a fiction within another fiction") (160). He first mentions texts that include allusions to other texts (not replicas of themselves), but in these cases "the two planes—the actual and ideal—do not intermingle" (160). It is in texts that contain replicas of themselves that the two planes *do* intermingle. Borges's first example is the six-hundred and second night of *The Thousand and One Nights,* where Scheherazade is said to tell the king his own story, which must necessarily include hers, and thus all of her stories. Borges writes: "In *The Thousand and One Nights,* Scheherazade tells many stories; one of them is, almost, the story of *The Thousand and One Nights*" (161). His subsequent examples are drawn from Baroque literature and art: the play within the play in *Hamlet,* a similar instance of theatrical doubling in Corneille's *L'Illusion comique* and, of course, Cervantes's interpolations of *The Quixote* in *The Quixote.*

Had *One Hundred Years of Solitude* been written when this essay was published, Borges might have included it in his list examples. The last Buendía reads about himself reading about himself, and reads about the end of his world as he lives it. Here, the phrase *mise en abîme* seems less figurative than actual as we imagine

Aureliano Babilonia reading about, and at the same time sucked into the abyss of Macondo's apocalyptic ending.

And yet another figure is imagined in the vortex of a mise en abîme that is also a *regressus ad infinitum.* Borges asserts that Pascal probably believed in identical worlds, some of which contained other worlds within them. "It is logical to think (although he did not say it) that he saw himself multiplied in them, endlessly."[75]

In Borges's second essay on the mise en abîme, "Magias parciales del *Quijote*" ("Partial Magic in the *Quixote*"), he contemplates at greater length the mirroring devices in the *Quixote,* and then asks:

> ¿Por qué nos inquieta que Don Quijote sea lector del *Quijote,* y Hamlet, especta-dor de *Hamlet?* Creo haber dado con la causa: tales inversiones sugieren que si los caracteres de una ficción pueden ser lectores o espectadores, nosotros, sus lectores o espectadores, podemos ser ficticios.

> [Why does it disturb us that Don Quixote be a reader of the *Quixote* and Hamlet a spectator of *Hamlet?* I believe I have found the reason: these inversions suggest that if the characters of a fictional work can be readers or spectators, we, its readers or spectators, can be fictitious.][76]

The mise en abîme of the book within the book expands as Borges proposes that the reader him/herself may be "textualized"—one more link in an endless series of readers and texts.

Borges's question ("Why does it disturb us . . .") is raised in similar fashion by the art historian Norman Bryson: "The veiled threat of trompe l'oeil is always the annihilation of the individual viewing subject as universal center."[77] Mise en abîme breaches the boundary between reader and text as trompe l'oeil painting breaches the boundary between viewer and painted scene; both defy the separation between "inside" and "outside" required by narrative and pictorial realism. Then Borges raises the stakes to a cosmic plane:

> En 1833, Carlyle observó que la historia universal es un infinito libro sagrado que todos los hombres escriben y leen y tratan de entender, y en el que también los escriben. (47)

> [In 1833, Carlyle observed that the history of the universe is an infinite sacred book that all men write and read and try to understand, and in which they are also written. (196)]

In this mise en abîme, not just the reader but the whole world is "textualized," that is, embedded in a text, or understood *as* text. Orders of reality intermingle, as they

do in the postscript to "Tlön, Uqbar, Orbis Tertius," but here, the tension between real instances and ideal categories is conceptually overcome.

In this regard, the structure of the fold is relevant. Heinrich Wölfflin, in his defining discussion of Baroque form in 1915, insists upon the "psychological significance" of the fold: "The psychologist of style finds a particularly rich booty in the stylized drapery of this epoch. With relatively few elements, an enormous variety of widely differing individual expressions has here come to birth."[78] Individual expression consists in the mastery of convention: we have seen several examples of such Baroque "originality"—in the marble robes of Bernini's Santa Teresa (fig. 4.4), the painted fabric of Caravaggio's Magdalene (fig. 4.2), and the plaster façade of the Nuestro Señor de Santiago in Jalpan, Mexico (fig. 1.9). We have already discussed the metaphoric value of curtains in Baroque art and architecture, but folds encompass a larger field. They were considered a measure of technical virtuosity in the artist's handling of depth, movement, and light; painted drapery was constructed fold by fold, with variations of shading, color and texture creating the illusion of the rise and fall of cloth in a sinuous dynamism of representational surface. The mastery of drapery was a necessary stage in the artist's apprenticeship; like the obligatory study of Roman sculpture and architectural ruins, drapery was allied to the study of nature, but a composed nature, an artificial nature, as it were. Folds become a kind of signature in Baroque art, and both Deleuze and Wölfflin treat them as symbolic of Baroque modes of conceiving and expressing the world. We may think of Borges's mise en abîme structures, in which actual and ideal are no longer oppositional, as the continuous undulations of a Baroque fold.

Jon Thiem's term "textualization fable" nicely describes such narrative folds. Thiem discusses the "interpenetration of irreconcilable worlds" in recent works of magical realist fiction, and gives examples from several writers (including Borges) where the (fictional) reader's world collapses into the world of the fiction that the (fictional) reader happens to be reading (within the fiction that I happen to be reading, and that I too risk collapsing into). About this dizzying structure, Thiem states: "Texts may encompass worlds and worlds may be texts, but the way they come together, clash, and fuse in a textualization fable violates our usual sense of what is possible."[79] The "violation" in Borges's mise en abîme structures reflects his refusal of the boundaries between worlds required by the conventions of literary realism; instead he proposes structures of difference without discontinuity. Wölfflin's insight, quoted as the epigraph to this chapter, applies to Borges's textualization fables: "it requires no special persuasion to see in the equipoise of the parts an art inwardly related to the drawing of the folds." Borges's embedded structures and forking fictions follow the physics and metaphysics of the Baroque fold.

Literary critics have effectively linked Borges's textualization fables to Kabbalistic thought, but they have tended to disregard the relation of these "folded" texts to the Baroque.[80] Borges himself, however, did not. In his 1951 essay "Del culto de

los libros" ("On the Cult of Books"), he traces the figure of the universe-as-text from Plato to Pythagoras to Clement of Alexandria to St. Ambrose and St. Augustine; he proceeds to the *Sepher Yetzirah* and the Koranic concept of the "Absolute Book," and then remarks, "Más lejos fueron los cristianos" ("The Christians went even further").[81] He locates this Christian "exaggeration" in the seventeenth century, citing Francis Bacon's *Advancement of Learning*, Sir Thomas Browne's *Religio Medici*, and Galileo, whose works "abound with the concept of the universe as a book" (361), and implies that these intellectuals refined and intensified the trope, as in fact they did. Frances Yates affirms that conceptions of the isomorphism of language and world permeated seventeenth-century science,[82] and Octavio Paz, in his study of Sor Juana, argues that all of her work is imbued with a Neoplatonic understanding of the world as hieroglyphic.[83] In New Spain during the eighteenth century, certain Christian mystics intensified this symbolic literalism in their veneration of "monograms" comprised of intertwining letters believed to contain divinity.[84]

LA VIDA ES SUEÑO (LIFE IS A DREAM)

Borges's fascination with the mise en abîme is at its most intense in the embedded structure of waking/dreaming. In this version of the Baroque fold, it is the dreamer who is "textualized" (or "visualized") in his or her own trompe l'oeil dream. The conjunction of dream and waking is similar to that of text and reader (or text and world). In his essay "When Fiction Lives in Fiction," Borges proposes that dream and waking are two different ways of reading the same pages of the same book, and again he makes one of his rare references to painting:

> Arturo Schopenhauer escribió que los sueños y la vigilia eran hojas de un mismo libro y que leerlas en orden era vivir, y hojearlas, soñar. Cuadros dentro de cuadros, *libros que se desdoblan en otros libros,* nos ayudan a intuir esa identidad. (327, my emphasis)

> [Arthur Schopenhauer wrote that dreaming and wakefulness are the pages of a single book, and that to read them in order is to live, and to leaf through them at random, to dream. Paintings within paintings and *books that branch into other books* help us sense this oneness. (162, my emphasis)]

Borges connects the "identidad" (the oneness) of waking and dreaming to the structure of the mise en abîme: waking and dreaming are like paintings within paintings and "libros que se desdoblan en otros libros." (The English translation misses the spatial metaphor of *desdoblar,* to unfold, and also, inevitably, the double

meaning of *sueño* in Spanish—"sleep" and "dream.") Instead of provoking in Borges the "disturbing" intuition that readers may be fictional, this mise en abîme leads to an intuition of "oneness" in which supposed oppositions (waking and dreaming) coexist without contradiction.

Borges famously dramatizes this relation in "The Circular Ruins," which is a perfect mise en abîme. A man dreams a son who becomes "real"; at length this man, who has believed himself to be "real," discovers that he has been dreamt by another. These two dreamers/dreamt are enough to project the possibility of an infinite series of dreamers/dreamt, including the reader. This structure breaches the frame of narrative realism even more effectively than that of reader/text, because the dreamer is not oppositional to his/her waking self. Dreamer and dreamt may generate each other endlessly; there *is* no waking frame. In this story, Borges's celebration of illusion is clear, as we have seen it to be in its companion story "The God's Script," which also includes a dream within a dream. Both stories are set in an imaginary architecture of ruins, pyramids, and amphitheatres—a symbolic Mesoamerican setting that suggests an indigenous ontology of presence. In these stories, as in the indigenous artifacts discussed in earlier chapters, the gods are not separate from their visible images; spirit inheres in the jaguar's spots in "The God's Script," and in the "vehement creatures" dreamed by Borges's character in his circular ruin, who sees a statue that is a god:

> La soñó viva, trémula: no era un atroz bastardo de tigre y potro, sino a la vez esas dos criaturas vehementes y también un toro, una rosa, una tempestad.[85]

> [He dreamt of it as a living, tremulous thing: it was not an atrocious mongrel of tiger and horse, but both these vehement creatures at once and also a bull, a rose, a tempest.][86]

The character dreams of the "oneness" of signified and sign, and though his god will prove to be a chimera of similitude, his effort of imagination is celebrated nonetheless. Here, as there, we sense the story to be an allegory of Borges's own art—another level of mise en abîme.

The metaphor of dream goes back to Plato and before, and it is implied in all philosophies based on universals. In Borges's most concentrated discussion of idealist metaphysics, "A New Refutation of Time," he again engages the mise en abîme of dreamer/dreamt, and again in a non-Western setting (an anthropomorphic dream in ancient China), this time to "confirm" the idealist hypothesis of atemporality. Borges imagines "a moment of the utmost simplicity":

> Hará unos veinticuatro siglos, [Chuang Tzu] soñó que era una mariposa y no sabía al despertar si era un hombre que había soñado ser una mariposa o una mariposa que ahora soñaba ser un hombre.[87]

[Some twenty-four centuries ago, Chuang Tzu dreamed he was a butterfly, and when he awoke he was not sure whether he was a man who had dreamed he was a butterfly or a butterfly who dreamed he was a man.][88]

Borges's narrator ponders this structure for the space of a long paragraph and then (of course) adds another level: that of the "almost infinite readers" of the parable:

> . . . imaginemos que de sus casi infinitos lectores, uno sueña que es una mariposa y luego que es Chuang Tzu. Imaginemos que, por un azar no imposible, este sueño repite puntualmente el que soñó el maestro. Postulada esa igualdad, cabe preguntar: Esos instantes que coinciden ¿no son el mismo? ¿No basta *un solo término repetido* para desbaratar y confundir la historia del mundo, para denunciar que no hay tal historia? (147, Borges's emphasis)

> [. . . let us imagine that one of its almost infinite readers dreams he is a butterfly and then that he is Chuang Tzu. Let us image that, by a not impossible chance, this dream repeats exactly the dream of the master. Having postulated such an identity, we may well ask: Are not those coinciding moments identical? Is not *one single repeated term* enough to disrupt and confound the history of the world, to reveal that there is no such history? (330, Borges's emphasis)]

With this hypothetical reader who also dreams that he is a butterfly, Borges adds a textualization fable to his mise en abîme dream structure. This reader dreams the very same dream as Chuang Tzu ("por un azar no imposible") and thus *becomes* Chuang Tzu. The fold doubles upon itself and the dream is redreamt, a double dream that Borges's narrator offers as (tongue-in-cheek) "proof" of the principle of identity and the nonexistence of time. Then he ironizes his (already ironic) assertion, capitulating to progressive time, individual personality and mortality: "*And yet, and yet,*" his narrator laments, "the world, unfortunately, is real; I, unfortunately, am Borges" (332). Once again the Neobaroque writer parodies Baroque aspiration and also exemplifies it.

Borges's investigation of idiosyncratic personality reaches a "condition of extremity," to repeat Antonio Maravall's definition of the Baroque, in "Funes the Memorious," where mise en abîme merges conceptually with Borges's labyrinth of forking paths; Funes cannot remember an event, a person, a word without falling into the abyss of endless embedded meanings and forking associations. He is the terrible inversion of the dreamers in "The Circular Ruins" and "The God's Script"; his dreams are nightmares of specificity rather than illusions of identity; the "intimate designs" of the universe do not illuminate the universe but blind him to it. A related nightmare occurs in "The Zahir," where, as in "Tlön, Uqbar, Orbis Tertius," an object from an unknown realm intrudes into the "real" world of the narrator. The zahir, a coin that the narrator no longer possesses but cannot forget, is an ideal

object gone haywire, a mental image that eliminates all others. This character, like Funes, suffers from a visual dysfunction: his mind's eye is blinded by a single object, as Funes is blinded by an infinite proliferation of objects.

Life as a dream (or nightmare), life as a stage and the self as actor in someone else's play are Baroque chimeras of similitude *par excellence,* and they served an array of seventeenth-century writers to address the epistemological uncertainties of their time. As different as they are in other respects, Quevedo's *Sueños,* Calderón's *La vida es sueño,* Shakespeare's *A Midsummer Night's Dream,* and Sor Juana's *Primero sueño* foreground the special "seeing" of dream and its relations to waking consciousness, the physical body, the autonomy of the self. Octavio Paz notes that an important source for Sor Juana's *Primero sueño,* Macrobius's commentary on the dream of Scipio, lists five kinds of dreams, only two of which—nightmare and apparition—correspond to our modern understanding of dream. Paz is careful to specify that Sor Juana's dream envisions "the soaring of the soul freed from its bodily chains, not the delirium of the body liberated from the censorship of reason. Thus it differs radically from Freud's—and our—view of dream. For Freud, *sueño* liberates desire, instinct, the body; for Sor Juana, *sueño* liberates the soul."[89] I take Borges's dreams to encompass both sets of meanings. They include both "the pleats of matter and the folds of the soul," to repeat Deleuze's phrase from the epigraph to this chapter, and are offered as a corrective to the dualisms of Western representation, an effort to maintain the multiplicity and indeterminacy of the real that can now, it seems, only be dreamed.

"ALLEGORICAL SCRIPT": BORGES AND BENJAMIN

> Allegories are, in the realm of thoughts, what ruins are in the realm of things.
>
> WALTER BENJAMIN, *The Origins of German Tragic Drama*[90]

Borges uses the illusionary devices we have just surveyed to amplify narrative referentiality, and he also engages allegory to this end. Allegory flourished during the seventeenth century, and like the perspective constructions of trompe l'oeil and the vortices of mise en abîme, it both resisted and accommodated the ideological revolutions of the time—another chimera of similitude that knew itself to be one. Despite the dawn of empiricism, John Rupert Martin states that "The allegorical habit of mind was too deeply ingrained in the intellectual life of the seventeenth century to be quickly dislodged by the rigorous objectivity of science" (121). Octavio Paz concurs: "The culture of the seventeenth century was symbolic and emblematic. . . . In poetry, the fusion of the allegorical, the symbolic and the mythological was constant: myths, and their heroes, were first of all examples, emblems."[91] As we saw in the previous chapter, even the flesh-and-blood naturalism of Baroque por-

traiture is not about individuals but archetypes, a circumstance that confers upon the work of both Kahlo and García Márquez an unmistakable allegorical tint. Borges, too, eschews individualized characters in favor of plotted ideas, and his unnamed narrators often seem to project the condition of being as such. If the idealizing impulse of Baroque allegory was theological and imperial in nature, Borges's allegories are Neobaroque in their embrace of multiple signifiers and their subversion of homogenizing systems. But in both cases, allegory is engaged to mediate the relations of reality and its metaphysical meanings.

Allegory depends upon the dialectic between absence and presence, between represented objects/places/persons and their unstated referents. Metaphor and symbol also depend upon this dialectic, but unlike allegory, their missing term must eventually emerge in order that they *be* metaphors or symbols, whereas allegory, because of its greater length and complexity, may sustain absence without resolving its own inherent dualism. Like the syllogism termed *baroco,* allegory's signification exceeds its signifiers because it necessarily includes that which is *not* present, as well as that which is.[92] And like trompe l'oeil, it depends upon the capacity of the text to make the reader attend not only to what is depicted, but also to what is not; allegory makes present that which would otherwise be inaccessible: divinity, infinity, eternity. Borges acknowledges this capacity in an early essay on *Don Quixote* in *El idioma de los Argentinos* (1928), and in his 1949 essay "From Allegories to Novels," he insists upon it.[93]

Walter Benjamin elaborates a similar understanding in his study of German Baroque drama (*Trauerspiel*). He collected Baroque poetry and emblem books, and when in 1923 he decided to make an academic career, he chose to write his *Habilitationsschrift* on Baroque drama of the Protestant Reformation, which he compares to Spanish Baroque theatre and especially to the plays of Calderón de la Barca. George Steiner, in his introduction to the English translation of Benjamin's study, writes that Benjamin "made some six-hundred excerpts from long-dormant Baroque plays, from theological tracts of that tormented period, and from secondary sources."[94] He also drew upon the work of his German contemporary, Erwin Panofsky, who was at that time beginning to elaborate his iconographical approach to Renaissance and Baroque art. Typically brilliant and idiosyncratic, his *Origin of German Tragic Drama* is the only full-length book he ever wrote, and it was rejected by his professors at the University of Frankfurt; when he attempted to contact Panofsky and the Warburg group, he was rebuffed—tragically, in the opinion of Steiner.[95] In fact, Benjamin's book was published in 1928, but Steiner states that after 1931, it was "literally an extinct work—one of a fascinating group of writings and works of art consigned to oblivion by the rise of National Socialism and the consequent dispersal or destruction of the German-Jewish community" (7). I draw attention to this historical context because Benjamin was writing at the same time that Reyes and García Lorca were recovering the Spanish Baroque tradition, and at the same time, too, that Borges was attempting to establish his distance from it.

It seems unlikely that Borges would have read Benjamin during this period, and less likely that Benjamin would have read Borges. But it is affinity, not influence, that concerns me here, and what is interesting for our purposes is that these writers—both of whom have played a central role, ex post facto, in theoretical discussions of postmodernism—filtered their work through their understanding of Baroque forms of representation. If Borges officially rejected the Baroque for the reasons we have touched upon, Benjamin embraced it because in the fragmentary nature of the *Trauerspiel,* he saw a corrective to modernity's claim of uninterrupted historical progress, and realism's claim of transparent verisimilitude. In the devices of the *Trauerspiel*—in the "ruins" of its allegorical structures—he discovered an aesthetic counterposition to the "transparent window" of pictorial realism, and an allegory for art in general: "That which lies here in ruins, the highly significant fragment, the remnant, is, in fact, the finest material in baroque creation."[96]

In *The Origin of German Tragic Drama,* Benjamin analyzes the capacity of Baroque allegory to create illusion and sustain ambiguity. Like other Baroque illusionist structures, it challenges the fixed perspective of Albertian realism, emphasizing instead the fragmentary, hence fluid nature of history and things.[97] It is the power of allegory to entertain (and sustain) fragmentation while operating within an overarching framework that attracts Benjamin and, I believe, Borges; Benjamin describes "the will to symbolic totality" of Baroque allegory at the same time that he finds objects "staring out from the allegorical structure . . . incomplete and imperfect" (186). The "significant fragments" move in fluid relation; Benjamin writes that they "fill out and deny the void in which they are represented" (233). This phrase perfectly encapsulates the tension between abundance and absence that impels Baroque *horror vacui.* For Benjamin, allegory negotiates these extremes, offering a compromise between (or perhaps a fusion of) chaos and system.

Thus Benjamin struggles to rescue allegory (as Borges does in the essays I have mentioned) from its nineteenth- and twentieth-century devolution into petrified dualisms, false one-to-one correspondences between texts and meanings. Against modern allegory as a closed system, Benjamin counterposes Baroque allegory, which moves among different representational planes:

> Even great artists and exceptional theoreticians, such as Yeats, still assume that allegory is a conventional relationship between an illustrative image and its abstract meaning. Generally authors have only a vague knowledge of the authentic documents of the modern allegorical way of looking at things, the literary and visual emblem-books of the baroque. . . . Allegory—as the following pages will serve to show—is not a playful illustrative technique, but a form of expression, just as speech is expression, and, indeed, just as writing is. (162)

He notes, further, that the transindividual status of Baroque allegory is not based in psychology but in "politico-religious" systems of power and belief:

the baroque apotheosis is a dialectical one. It is accomplished in the movement between extremes. In this eccentric and dialectic process the harmonious inwardness of classicism plays no role, for the reason that the immediate problems of the baroque, being politico-religious problems, did not so much affect the individual and his ethics as his religious community. . . . [T]he new concept of the allegorical . . . was in fact adapted so as to provide the dark background against which the bright world of the symbol might stand out. (160)

It is "the dark background" of allegory that Benjamin celebrates, and also its "baroque apotheosis," whose meaning is ambiguity and whose motive is desire.

Borges, too, understands allegory in these terms, an understanding epitomized at the end of Borges's story "Pedro Salvadores": "Como todas las cosas, el destino de Pedro Salvadores nos parece un símbolo de algo que estamos a punto de comprender" ("As with so many things, the fate of Pedro Salvadores strikes us a symbol of something we are about to understand, but never quite do").[98] A similar formulation—"the immensity of a revelation which does not occur"—had already appeared at the end of "La muralla y los libros" ("The Wall and the Books"),[99] and the intuition is embodied at the end of "The Library of Babel" by the nameless narrator, whose hope exists against the "dark background" of infinite, uncharted space.

The allegorical tendency of much contemporary Latin American fiction has been amply noticed, and perhaps most emphatically by Fredric Jameson, who has argued that "third world" texts inevitably stage "national allegories."[100] Against Jameson's generalization, Benjamin revivifies our awareness of the particular history of allegorical representation. In *Reinventing Allegory,* Theresa Kelley points to Benjamin's historicism, arguing that his "tragic understanding of allegory initiates the modern reinvention of allegory—a reinvention whose historical trajectory begins in the seventeenth century."[101] Gilles Deleuze also acknowledges Benjamin's "reinvention":

Walter Benjamin made a decisive step forward in our understanding of the Baroque when he showed that allegory was not a failed symbol, or an abstract personification, but a power of figuration entirely different from that of the symbol. . . . The world of allegory is especially projected in devices and emblems. (125)

Deleuze's reference to "devices and emblems" must be understood in both literal and figurative terms because Benjamin shifts back and forth between literary strategies and visual structures, between allegories and emblems. Theresa Kelley describes these hybrid structures:

As seventeenth-century writers and artists adapted Renaissance emblems, and as editors of emblem books and books on iconography deployed new typographical

methods to complicate the simpler images in Renaissance emblem books, the Baroque emblem became more clearly marked as an elaborate visual and verbal fiction. Its components demanded a reader ready to supply the interpretive links to make those parts (texts, inscription, motto, or even the iconographic visual "bits" that increasingly cluttered the visual image) cohere. For this reason, the Baroque emblem and the emblematic and allegorical set pieces of the *Trauerspiel* offer ample evidence of how images might also be ruins, montage-like assemblages of material from the past. (254–55)

Kelley's final sentence alludes to Benjamin's work and to the statement that serves as epigraph to this section: "Allegories are, in the realm of thoughts, what ruins are in the realm of things."

For Benjamin, Baroque allegories resemble ruins in this way: they contain fragments of an absent past brought into the present, which survive in dynamic, non-hierarchical relations: "In the field of allegorical intuition the image is a fragment, a rune." And again: "What has survived is the extraordinary detail of the allegorical references: an object of knowledge which has settled in the consciously constructed ruins" (176, 182). Baroque ruins are the result of accumulation and a conscious display of craftsmanship (178). In the previous chapter, I quoted Benjamin's assertion that in Baroque structures, "history merges into setting." This is so, according to Benjamin, because in the fragments, time is converted into a spatial image; ruins are a visible emblem of the historical process of accommodation and inclusion.

I have several times referred to Borges's "emblematic" images, which serve a structural purpose that goes beyond the usual function of figurative language. According to Benjamin:

> This is what happens in the baroque. Both externally and stylistically—in the extreme character of the typographical arrangement and the use of highly charged metaphors—*the written word tends toward the visual.* It is not possible to conceive of a starker opposite to the artistic symbol, the plastic symbol, the image of organic totality, than *this amorphous fragment which is seen in the form of allegorical script.* (175–56, my emphasis)

This understanding of "allegorical script" as an accumulation of fragments that "tends toward the visual" is basic to Baroque poetry—Quevedo's "verbal objects" and Sor Juana's—and also to Borges's emblematic fictions, which strive to create the illusion of structures to be seen. His Aleph, his Library, and his labyrinths are allegorical ruins in the emblematic sense that Benjamin intends, their perspectival manipulations designed to heighten the illusion of visible, habitable structures at the same time that they create the illusion of infinite (invisible) extension. That

these Borgesian emblems were elaborated in stories published during the 1940s and early 1950s, as Borges's eyesight was failing, makes their uncanny illusionism the more remarkable and, perhaps, the more understandable.[102]

EMBLEMATIC *FICCIONES*

The relationship of seeing and reading, vision and interpretation is the subject of all Baroque emblems, whatever their specific content; their wit (*ingenio, agudeza*) depends upon the interaction of texts and images to generate the allegory that the reader/viewer is asked to decipher. The veiled significance of emblems was part of their attraction because they responded to a deeply-rooted conception of the world as a meaningful complex of signs, despite the crisis of referentiality that characterized the seventeenth century. John Rupert Martin remarks that "The inveterate disposition to look for symbolic meanings in nature and art goes far to explain the vogue of the emblem book and the iconological handbook" (121). Mariano Picón-Salas also connects the vogue in emblem books to this allegorical disposition: "In the new art of allegory, Spanish literature revived the emblem. . . . Symbols and metaphors became so indispensable that Juan de Horozco y Covarrubias published his *New Art of Propagating Ideas and Images* to meet the great demand."[103] The most widely circulated emblem books in Europe were Andrea Alciato's *Emblematum liber* (1531) and Cesare Ripa's *Iconologia* (1593), texts that became enormously influential as source material for visual and architectural media in the New World. Alciato's "From War, Peace," offers an allegorical emblem: a warrior's helmet that has been converted into a peacetime bee hive (fig. 5.5). The final lines of the epigram admonish readers to stay far from arms except when they cannot have peace in any other way. Because the texts were in Latin and the visual images widely known, these icono-verbal constructions provided a kind of universal language in both religious and secular arenas.[104]

Alciato and Ripa were not the only compilers of emblem books, nor was theirs the only style or level of sophistication. Gerhart Hoffmeister notes that Alciato had "approximately six hundred followers who produced over two thousand emblem books."[105] About the astonishing popularity of emblem books, Martin observes that "they obviously satisfied a deeply felt need for an allegorical mode of communication" (121). I would propose that Borges's emblematic structures also respond to this need, for there is something of the emblem book or iconographical handbook in his perpetual recourse to a finite set of visual images. His essay "La esfera de Pascal" ("Pascal's Sphere") begins and ends with this phrase: "Quizá la historia universal es la historia de unas cuantas metáforas" (14); ("Perhaps universal history is the history of the various intonations of a few metaphors" [353]). Given the repetition of his own metaphors and emblems, we have reason to accept the premise. At the end of this essay, Borges echoes Martin's intuition of "a deeply

EMBLEMA CLXXVII.

En galea, intrepidus quam miles gesserat, & quæ
 Sæpius hostili sparsa cruore fuit:
Parta pace apibus tenuis concessit in usum
 Alueoli, atque fauos grataque mella gerit.
Arma procul iaceant: fas sit tunc sumere bellum,
 Quando aliter pacis non potes arte frui.

FIGURE 5.5 Andrea Alciato, emblem 177, "Ex bello pax," *Emblematum liber* (1531).

felt need for an allegorical mode of communication." His narrator notes that the recurring image of the infinite sphere has become "a mental necessity."

The variety of subjects engaged in emblematic discourse was vast and varied. Besides engravings of intellectual riddles, emblem books included information on the prescribed "attributes" of religious figures and allegorical personifications. Engraved compositions addressed matters of collective concern, whether moral or political, theological or institutional, and they also depicted archetypes of human behavior. The complexity of iconographic languages is such that the Dominican order can encode its doctrinal origins and entire institutional structure (fig. 5.6). And a secular emblem by a Dutch engraver cites a line from Petrarch's sonnet "I dolci colli" around its circumference, and illustrates the sentiment that when one is wounded by love, fleeing only exacerbates one's suffering (fig. 5.7). This emblem recalls our discussion of the visual trope of arrows/daggers in Frida Kahlo's painting *The Little Deer*. I argued that Kahlo's painting foregrounds the iconography of *la Dolorosa*, but the iconography of the wounded lover also applies.

Because emblems were printed, they were usually in black and white, in small format, and far more intricately designed than if they had been executed in paint or fresco. In New Spain, they nonetheless provided visual models for other media, among them oil paintings and images sculpted on façades and painted on interior walls. Emblems were also the basis for another Baroque iconographic medium referred to as "ephemeral architecture."[106] Triumphal arches, funerary monuments, and other temporary structures were constructed and decorated to celebrate important occasions of church and state, and then destroyed, but not before many of them were depicted in engravings and described in texts. (Indeed, some were never constructed, but pretend to have been by virtue of their existence in print.) These ephemeral edifices—at once literal and figurative, literary and graphic, ruins before they are built—reached levels of architectural fantasy altogether worthy of François de Nomé and Jorge Luis Borges.[107]

Borges's story "The Aleph" centers upon an allegorical emblem in this Baroque tradition—"written words that tend toward the visual," in Benjamin's phrase, the Aleph is a verbal object that aspires "to become one single and inalterable complex" (again, Benjamin's phrase), even as it also ironizes such desire. Borges's "limitless Aleph" may be understood as a Benjaminian "hieroglyphic" in its impulse to mediate between "sacred standing and profane comprehensibility."[108] A sphere appears to the narrator that contains all objects and places and people, all spaces and times:

¿Cómo trasmitir a los otros el infinito Aleph, que mi temerosa memoria apenas abarca? Los místicos, en análogo trance, *prodigan los emblemas.*

How can I translate into words the limitless Aleph, which my floundering mind can scarcely encompass? Mystics, faced with the same problem, *fall back on symbols.*[109]

FIGURE 5.6 Anon., "Iurris fortitudinis nostrae Sion fundata in lucernis ad docendum" (The tower of our fortress is built upon the lights of teaching), engraving from Francisco de Burgoa, *Geográfica descripción de la parte septrional del polo artístico de la América, y nueva iglesia de las Indias Occidentales, y sitio astronómico de esta provincia de predicadores de Antequera del valle de Oaxaca,* printed by Juan Ruiz (1674), Oaxaca, Mexico. National Library of Anthropology. Instituto Nacional de Antropología e Historia, Mexico.

FIGURE 5.7 Daniel Heins (Heinsius), emblem 15, "Et più dolsi," from *De emblemata amatoria* (1616), printed by Willem Janssen, Amsterdam.

The narrator lists some of the "emblems" (mistakenly translated into English as "symbols") that mystics "lavish" or "squander" (*prodigan*) upon their efforts to express their visions. (The English translation also mistakes the mystics' "trance" for "problem.") Similarly, Borges's narrator struggles to create an emblem, an illusory ideal, a structure that will contain the universe. He offers a partial list of what he has seen in the Aleph; the list *is* his emblem, a synecdoche whose parts stand for the absent whole, for the unrepresentable cosmos. This back-and-forth movement between fragment and fold, between ruptured similitude and "co-extensive" space, is both thematic and structural in this story. The narrator's list momentarily becomes a Benjaminian "complex," a "hieroglyphic" composed of fragments from the past. But the narrator's trance soon ends, and is replaced by malice and derision; he takes "revenge" on his friend Carlos Argentino by not revealing his vision, and later he demeans Argentino's poetry prize, sniveling that he himself should have won it: "Once more, incomprehension and envy triumphed!" (28). Neobaroque Borges parodies the conflict between "sacred standing and profane comprehensibility" that Benjamin observes in Baroque emblematic objects. In his own emblematic Aleph, significant fragments circulate in unfathomable relation.

In "Pascal's Sphere," Borges again offers a "hieroglyphic" accumulation of fragments, a list that includes dozens of variations of a single image, a sphere that stands variously for God, nature, the universe, and infinity. His enumeration culminates in Pascal's version of this image: "La naturaleza es una esfera infinita, cuyo centro

está en todas partes y la circunferencia en ninguna" (16); ("Nature is an infinite sphere, the center of which is everywhere, and the circumference nowhere" [353]). According to the narrator, this emblem epitomizes the seventeenth-century pre-occupation with space, recently emptied of its former significance; in fact, Borges adds his own twentieth-century version to this "universal" list in "The Library of Babel," where the Library is described as "a sphere whose exact center is any one of its hexagons and whose circumference is inaccessible" (52). The list of spheres in "Pascal's Sphere," like the list of fragments in the spherical Aleph, is an emblem of allegory as such, that is, an emblem that points to the human desire to create sig-nifying systems, even at the moment of their dawning impossibility. So Borges constructs emblems from Benjaminian ruins, calling attention to the fragmentary nature of the emblem and also to its persistent aspiration to plenitude. I have al-ready quoted the narrator's summary of this process: over the centuries, the image of the infinite circle has become "a mental necessity."

We can now return to Michel Foucault's engagement of Borges's 1941 story, "The Analytical Language of John Wilkins." Foucault does not name this story, but credits it with providing the inspiration for *The Order of Things,* his study of seventeenth-century epistemology. In a preface, Foucault cites a list from this story, which Borges's narrator says he recalls because of its "ambiguities, redundancies, and deficiencies." The narrator attributes the list to a certain Dr. Franz Kuhn, who in turn cites an "unknown (or apocryphal) Chinese encyclopedist." The list enu-merates all possible categories to which animals can belong in a certain Chinese system:

> (a) pertenecientes al Emperador, (b) embalsamados, (c) amaestrados, (d) lechones, (e) sirenas, (f) fabulosos, (g) perros sueltos, (h) incluidos en esta clasificación, (i) que se agitan como locos, (j) innumerables, (k) dibujados con un pincel finísimo de pelo de camello, (l) etcétera, (m) que acaban de romper el jarrón, (n) que de lejos parecen moscas.

> [(a) those that belong to the Emperor, (b) embalmed ones, (c) those that are trained, (d) suckling pigs, (e) mermaids, (f) fabulous ones, (g) stray dogs, (h) those that are included in this classification, (i) those that tremble as if they were mad, (j) innumer-able ones, (k) those drawn with a very fine camel's hair brush, (l) others, (m) those that have just broken a flower vase, (n) those that resemble flies from a distance.][110]

Foucault states that "and" has been rendered impossible by Borges's taxonomy, that "fragments of a large number of possible orders glitter separately."[111] For Foucault, no universal order is implied, nor is any possible.

Borges, of course, is parodying the very notion of universal order at the same time that he entertains one, and he may also have had in mind the seventeenth-century *Wunderkammer.*[112] These cabinets held a wealth of objects (products of

both nature and artifice) collected for their exoticism and beauty, not for any conceptual or physical kinship. The aesthetics of wonder of these cabinets did not require logical or linear sequence, but simply the visual relations and associations created within the space of the cabinet itself—an order that Foucault does not recognize, but one that is thoroughly Baroque (and a favorite subjects of trompe l'oeil paintings, as we have noted). Rather, Foucault offers Borges's list as an emblem of the crisis of referentiality that characterizes Western modernity, but he stops there, without attending to the rest of Borges's story. The narrator, after offering his list, muses that

> no hay clasificación del universo que no sea arbitraria y conjetural. . . . La impossibilidad de penetrar el esquema divino del universo no puede, sin embargo, disuadirnos de planear esquemas humanos, aunque nos conste que éstos son provisorios. (86)

> [there is no classification of the universe that is not arbitrary and conjectural. . . . But the impossibility of penetrating the divine scheme of the universe cannot dissuade us from outlining human schemes, even though we are aware that they are provisional. (104)]

For Borges, the fragments lead to a consideration of human aspiration; his narrator here, like the narrator of "Pascal's Sphere," acknowledges the "mental necessity" of such structures, however "arbitrary," "provisional," and open to "conjecture." That Foucault reads this story to suit his own purposes (as do I) reinforces the point: Borges's emblems, with their archetypal personages and disjunctive parts, their trompe l'oeil devices and illusionary architecture, require an interpretive response of the sort that Walter Benjamin attributes to "allegorical script." The reader must supply his or her own "human scheme" and then recognize it as an addition to the ruins, as one more emblem of desire.

The will to place minutely rendered particulars in larger, idealizing structures is characteristically Baroque, and the dynamism of Baroque expression depends upon it: richness of detail filling structures of cosmic ambition. Our examples of illusionary architecture demonstrate the unstable relations among constituent elements, as do the fugues of Bach, the sculpted ensembles of Bernini, Baroque altarpieces, and the *ficciones* of Borges. Nowhere does the tension between parts and wholes produce a more virtuosic structure than the Baroque altarpiece *retablo*, itself a trompe l'oeil, an emblem of heaven and earth in their inconceivable entirety.[113] I offer one final visual analogue to Borges's narrative structures, the *retablo* in the domestic chapel in the Jesuit seminary of San Francisco Javier in Tepotzotlán, just outside Mexico City (color plate 23).

I select this example from a wealth of possibilities because of its relatively small size, which produces an irony of proportion similar to that of Borges's

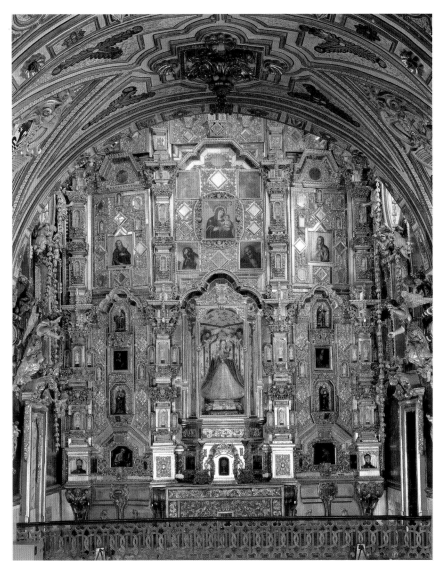

PLATE 23 San Francisco Javier Tepotzotlán (retablo, domestic chapel, 1670–82), now part of the National Museum of the Viceroyalty, Mexico. Instituto Nacional de Antropología e Historia. Photograph: Dolores Dahlhaus.

universalizing *ficciones,* and also because it includes mirrors among its decorative elements. The mirrors, like the semidetached columns and protruding statues on larger *retablos,* give to its two dimensional "picture plane" the same illusory oscillation between depth and foreground that we have seen in trompe l'oeil paintings and in Borges's stories. The mirrors would have multiplied the flickering candles that originally lit the *retablo,* thus intensifying, with their play of light and shadow, the illusion of depth and dynamism. The saints' portraits embedded among the mirrors seem less like paintings than additional mirrors reflecting the viewers who stand before the *retablo.* In this way they recall Velázquez's reflection of the monarchs in *Las Meninas,* serving the same purpose of blurring the boundaries between subject and object, real and represented. Walter Benjamin, writing about such reflexive structures in the dramas of Calderón de la Barca, observes the Baroque dialectic between "the playful miniaturization of reality and the introduction of a reflective infinity of thought" (83). So, too, Baroque *retablos* and Borges's *ficciones* insist that proliferating parts may point to absent wholes. If, suddenly, we see the *retablos* of Tepotzotlán and San Luis Potosí as Borgesian Alephs, as parts of Borges's "unimaginable universe," then we have amplified our understanding of both Borges and the Baroque. This double discourse of Baroque and Neobaroque, grounded in the cultural awareness of the New World Baroque, is essential to the ongoing process of self-reflection and self-construction in Latin America.

Conclusion

NEOBAROQUE PROVOCATIONS

And each day that passes it seems more logical and necessary to approach litera-
ture—whether we are writers or readers—as one approaches the most basic en-
counters of our existence such as love or death, knowing that they form an insepa-
rable part of the whole, and that a book begins and ends much before and much after
its first and last word.

JULIO CORTÁZAR
Reality and Literature in Latin America[1]

We have traced a genealogy of expressive forms—Baroque, New World Baroque,
Neobaroque—that grow out of, and blur into each other metonymically, like
Carpentier's proliferating architectural details, García Márquez's generations of
Buendías, and Borges's limited catalogues of endless things. In weighing these
overlapping categories we have sometimes emphasized rupture, sometimes conti-
nuity, but what is certain is that their products cannot be considered in isolation
and that they interact with structures of power in revisionary ways. The European
Baroque disrupts the symmetries and certainties of Renaissance Classicism; the
New World Baroque ironizes European hegemony by including alterity and cele-
brating hybridity; the Neobaroque subverts the foundations of Western moder-
nity—realism, rationalism, individualism, originality, homogeneous history.

Historical distinctions among these terms are useful, but they may also be

misleading because, as we have seen, the categories are permeable. Carpentier recognized the Baroque of seventeenth-century Europe, only to insist that its ideological and aesthetic structures be expanded to include cultural and historical formations that are neither seventeenth century nor European; Borges rejected the European Baroque, only to employ its counterrealistic strategies in his own trompe l'oeil fictions. Carpentier used the Baroque to inscribe American contexts into universal culture; Borges used the Baroque to inscribe the universe into Buenos Aires. Not to mention Garro, Galeano, and García Márquez, who engage Baroque strategies and structures for their own aesthetic and political purposes. In order to encompass this variety, it is important to allow for play among terms, techniques and intentions. By doing so, we will be able to entertain some generalizations about this alternative form of modernity.

In chapter 5, I cited Irlemar Chiampi's description of the Neobaroque as an "intensification and expansion of the experimental potential of the [historical] Baroque . . . now accompanied by a powerfully revisionist inflexion of the ideological values of modernity."[2] Chiampi elaborates Lezama Lima's term "counterconquest" in her assertion that the Neobaroque is both modern and "countermodern," the art of "*contramodernidad*" (37). Severo Sarduy agrees: "el barroco actual, el neobarroco, refleja estructuralmente la inarmonía, la ruptura de la homogeneidad, del logos en tanto que absoluto . . . Arte del destronamiento y la discusión" ("the contemporary Baroque, the Neobaroque, reflects structurally the disharmony, the rupture of homogeneity, of the logos as an absolute. . . . Art of dethronement and dispute").[3] Enrico Mario Santí observes that the Baroque arises whenever "a paradigm, some version of symbolic practice (writing, painting, dress), is displaced by another version of the same symbolic practice."[4] What is it about the contemporary Baroque—the Neobaroque—that facilitates "displacement," "dethronement," "dispute"?

These questions imply a prior one. Why was the Baroque recognized and reclaimed during the first decades of the twentieth century? Why was T. S. Eliot revisiting the poetry of John Donne at the same time that Reyes, García Lorca, Borges, Dámaso Alonso, and others were recovering Góngora and Quevedo, and Walter Benjamin was turning to German Baroque drama? Why, at more or less the same time, were Oswald Spengler and Eugenio d'Ors constructing transhistorical conceptions of the Baroque that would be used by Latin American writers to recover (and construct) their own New World Baroque? For two hundred years the Baroque had been considered irrational and reactionary when compared to the "Enlightenment" that followed it, but by the 1920s, Enlightenment rationalism had itself become oppressive and, in some cases, totalitarian. The seventeenth-century Baroque had subverted Classical norms of reason and order, and now again, in the early twentieth century, it seemed possible that the Baroque might counter the sterile structures of Hegelian historicism and instrumental reason. In Latin America, the Baroque again seemed to offer structures large enough to en-

compass its multiple histories, cultures, and discourses, including those of the *indigenista* movements developing throughout the continent at the time. I want to (re)trace this twentieth-century recovery of the Baroque in Spain and the Spanish New World, and then summarize the ways in which Neobaroque writers have reinterpreted their Baroque legacy for contemporary use.

MEMORY RECOVERED

Evolving Neoclassical tastes during the eighteenth century were antithetical to Baroque aesthetics, and the artistic products of the previous century were superseded by the more sober style of the Enlightenment. In Europe, innumerable Baroque church interiors were destroyed and replaced by Neoclassical altars and accoutrements; in Latin America, the destruction was lesser and later, but widespread nonetheless.[5] In Spain, the change of royal families in 1700 from the Austrian Hapsburgs to the French Bourbons had much to do with the anti-Baroque fervor, as it eventually did in Latin America as well. The French were never fully persuaded by the Baroque style, Versailles notwithstanding, nor by aspects of Counter-Reformation theology that fueled the Baroque in Italy, Spain, and the Spanish New World. In 1767, the Bourbon king Charles III expelled the Jesuits, foremost patrons of Baroque aesthetics and Counter-Reformation theology worldwide, from Spain and its American territories. The Jesuits had already been expelled from Portuguese and French territories, and Pope Clement XIV, under pressure from the Bourbons and some of his own cardinals, dissolved the order in 1773.[6] The suppression of the Jesuits reflects in part the historical momentum to embrace the secular values that would shortly be promoted by the French Revolution, especially those identified with civil liberties, and the growing preference for empirical observation and intellection over emotion and sensuous apprehension. The emergence of capitalism and rise of Protestantism also fueled anti-Baroque activity. The different Protestant and Catholic policies of visual representation, discussed in chapter 1, predict this eighteenth-century paradigm shift in Europe. And in Latin America, the embrace of French positivism in the nineteenth century arrested official expressions of the Baroque, though the "folk Baroque" has continued uninterrupted throughout the region.

The fate of Baroque literature paralleled that of Baroque art and architecture, and it was not till the 1920s, as we have seen, that readers were encouraged to turn their attention once again to Spain's Baroque literature. Borges's early interest in Quevedo corresponds not to his desire to recuperate a marginalized tradition, but to his project of constructing an avant garde poetics that would renovate the use of metaphor and contest post-Romantic models of subjectivity. Before Borges, the Nicaraguan poet Rubén Dario had incorporated Góngora into his poetic practice in *Prosas profanas* (1896) and he, too, did so for reasons of aesthetic renovation

rather than cultural recuperation. In fact, this early stage in the Latin American re-
covery of the Baroque resembles European avant garde movements in several ways:
in its aesthetics of defamiliarization, its artifice and counterrealism, but not in any
"countermodern" political or social agenda.[7]

It would be the Cuban writers Carpentier and Lezama Lima who, in the fol-
lowing two decades, would politicize the Baroque, reconstituting it as an ideology
of counterconquest to accommodate American cultural formations. Both were in-
terested in Baroque aesthetics for this reason, and it took similar conceptual inser-
tions of American history into European Baroque structures for the recovery of
American Baroque literature to begin elsewhere, and in earnest. Between 1942 and
1945, in Mexico, Alfonso Méndez Plancarte's three-volume *Poetas novohispanos* ap-
peared, and in 1948, Alfonso Reyes's *Letras de la Nueva España.* The former made
colonial Baroque texts available to readers, and the latter argued for their impor-
tance. In 1951, the complete works of Sor Juana Inés de la Cruz were edited for the
first time by Méndez Plancarte to honor the three-hundredth anniversary of the
poet's birth. Octavio Paz's 1982 study of Sor Juana internationalized her work at last
(and once again).[8]

As these writers and literary scholars began to recover (and reedit) works of
American Baroque literature, art historians also began to see the New World Ba-
roque with new eyes. In 1944, the Argentine architect and art historian Angel
Guido published a study entitled *Redescubrimiento de América en el arte.* Guido was,
I believe, the first theorist to link the transculturated art forms of the New World
Baroque to the twentieth-century recuperation of the Baroque, and he was also the
first to argue that the New World Baroque was inherently resistant to European
hegemony. According to Guido, there had been two conquests of America by Eu-
rope, and two counterconquests—what he calls "reconquests." The first conquest
was the one we all know about, and the first American reconquest consisted of the
highly elaborated syncretism of the eighteenth-century Churrigueresque style (the
American "ultrabaroque," as Guido calls it), which accomplished "un verdadero
proceso estético rebelde contra el arte de la metrópoli" (a veritable process of aes-
thetic rebellion against the art of the colonizing center).[9] Guido notes in particu-
lar the "spirit of rebellion" of the Andean Baroque, citing "el indio José Kondori,"
who sculpted the sun and moon, elements of indigenous flora, and extraordinary
indiátides (indiatids) on the façade of the church of San Lorenzo Potosí in Bolivia
(figs. 6.1, 6.2, 6.3). Guido coins this term to replace "caryatid," thus pointing em-
phatically to the substitution of indigenous figures for European ones in this first
"reconquest" of American territory.[10] He does not address explicitly the ontology
of the indigenous image, but his appreciation of the hybrid energy of the New
World Baroque is clear enough. By the end of the eighteenth century, he finds that
this energy had been extinguished by the realism and rationalism of the European
Enlightenment. Thus the second conquest of America: European hegemony had
once again been established, and the New World Baroque was banished from sight.

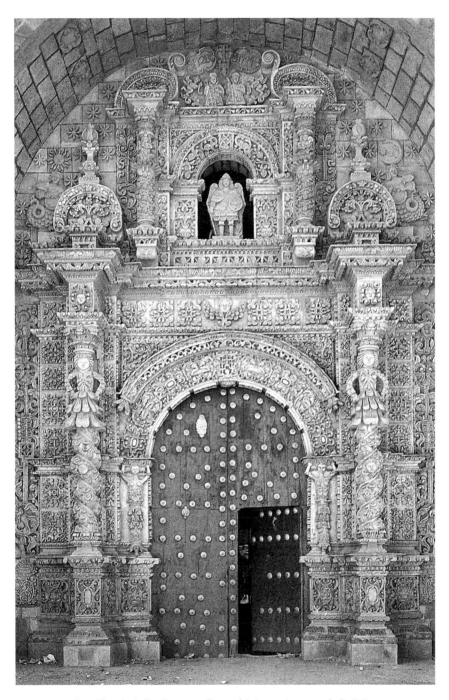

FIGURE 6.1 José Kondori, San Lorenzo Potosí (eighteenth century), Bolivia.

FIGURE 6.2 José Kondori, San Lorenzo Potosí (detail).

FIGURE 6.3 José Kondori, San Lorenzo Potosí (detail).

But now, in the 1940s, Guido perceives a second "reconquest" in the resurgence of Baroque forms of expression, and in the new awareness of Latin American identity and its artistic products. It is not just the renewed interest in the historical Baroque that constitutes this second undoing of European hegemony. Guido writes:

> ¿No son, acaso, jalones—aunque imprecisos aún—de esta segunda reconquista: la moderna pintura popular de los jóvenes fresquistas mexicanos; los rascacielos gigantes de Norte América; *Don Segundo Sombra,* de nuestro Güiraldes; *La vorágine,* del colombiano Rivera; *Doña Barbara,* del venezolano Gallegos; la generalización de la música criolla; la invasión de las grandes metrópolis, por el cancionero vernacular? (41–42)

> [Aren't, perhaps, the landmarks—though still imprecise—of this second reconquest the modern populist painting of the young Mexican muralists; the gigantic skyscrapers of North America; *Don Segundo Sombra,* by our Güiraldes; *La vorágine,* by the Colombian Rivera; *Doña Barbara,* by the Venezuelan Gallegos; the spread of popular music; the invasion of the big cities with folk songs?]

Here, Guido refers to North America, but with this exception his focus is entirely upon Latin America, where he observes a new affirmation of American "authenticity" and thus predicts the cultural discourse of Carpentier and Lezama Lima, Paz and Fuentes, Garro and Galeano, to name only a few of his offspring, direct and indirect.[11] For Guido, the Baroque both precedes and succeeds the *grands récits* of the Enlightenment, and is fully capable of expressing postcolonial positions.

But Guido's view was still the exception among scholars in the 1940s. Historians remained largely dismissive of the "irrational" and "excessive" products of the New World Baroque, which is to say, of the entire colonial period. These anticolonialists include the Venezuelan scholar Mariano Picón-Salas, who in 1944 coined the term *barroco de indias* (Baroque of the Indies) and observed the particularities of the New World Baroque in ways that no historian had yet done.[12] Nonetheless, his *barroco de indias* remains a historical description of colonizing institutions rather than a theory of culture. He understood Baroque art, architecture, and literature to be impelled solely by the need to fortify existing power structures: Spanish monarchy, Counter-Reformation, *criollo* aristocracy and its attendant social and racial hierarchies. There is no trace of *contraconquista* here; what Lezama Lima would shortly call "Baroque curiosity," Picón-Salas called "intellectual confusion" and "aesthetic degeneration." Though Picón-Salas intuited the "extraordinary vitality" of the Baroque period in New Spain, he generalized its structures as "repressive," and found them "decadent" in relation to earlier Classical forms.

Irving A. Leonard, in his 1959 study *Baroque Times in Old Mexico,* also focused on the imperialist purposes of the New World Baroque. His work, too, was groundbreaking, but like Picón-Salas, he lacked an eye for artifacts other than the

official, and even if he had had one, he would certainly have taken the *tequitqui* (mestizo products) of indigenous artisans as signs of submission to colonizing structures, rather than indices of the rich syncretic culture developing beside (and beneath) those structures.[13] And as recently as 1984, Leonardo Acosta, in his otherwise thoughtful approach to the colonial Baroque, writes:

> el barroco se introduce en América una vez terminada la etapa aventurera de la conquista, el "período heroico." Su finalidad será, precisamente, mitificar y eternizar esa conquista, darle validez, no ya legal, lo cual había sido labor de los teólogos y juristas, sino artística, cultural.[14]

> [the Baroque is brought to America when the adventure stage of the conquest, the "heroic period," is over. Its purpose will be precisely to mythologize the conquest and make it eternal, give it validity—not legal validity, which was the job of theologians and jurists, but artistic and cultural validity.]

Acosta is right about the intentions of the Spanish colonizers, but he does not acknowledge the subversive ways in which those intentions were absorbed and reconstituted in New World contexts.

Here, then, we see in sharp outline the contrast between anticolonialist historians and postcolonialist writers. All deplore the injustices of the period, but for Neobaroque writers like Carpentier and Lezama Lima, the forms associated with the repressive Spanish colonization also provide the means by which to subvert that repression. It is perhaps inevitable that historians will describe events, whereas writers will detect the subversive undercurrents impelling them. Thus the latter began to displace the New World Baroque from its assigned historical role as monologic agent of colonial oppression, and to focus instead on its mobile, inclusive structures and its consequent capacity to express American cultural contexts. This is not some nostalgic return to a familiar tradition; on the contrary, writers have converted Baroque forms into instruments of cultural introspection, a coming-to-consciousness of Latin America's cultural past for the purpose of liberating its cultural present. Thus they construct a communal identity rooted in their own history, and recognizable to themselves.

The decade of the forties was an opportune time for Latin American writers to distinguish between the Counter-Reformation Baroque imposed by the European colonizers and their own *contraconquista* Baroque. If, during the twenties and thirties, the recovery of Spanish Baroque literature in Latin America had been impelled by an intense transatlantic exchange under the various flags of Borges's avant garde, Reyes's gongorism, and Carpentier's Surrealist reading of Eugenio d'Ors, the Neobaroque from the forties through the seventies was impelled by quite another motive—the desire to transmogrify the Baroque into a *sui generis* American "spirit." As we have seen, Carpentier and Lezama Lima initiated and shaped this

movement. Europe was no longer invited into the discussion, besides which it was involved in its own conquests and reconquests. When the war ended in Europe, the severity and solidity of Bauhaus in architecture, minimalism in art, and existentialism in literature presided over the ruins . . . not the Baroque ruins that had, in the late twenties, signaled for Walter Benjamin a release from the freight train of Hegelian history, but rather the ruins caused by the freight train itself.[15]

During the 1970s, Severo Sarduy reconstituted yet again the Latin American Baroque, shifting his focus from the thematics of cultural nationalism to the subversive strategies of Neobaroque artifice. In chapter 3, we noted Sarduy's 1974 book *Barroco,* in which he engages seventeenth-century science to elaborate his theory of spatial and textual displacement. In his essay "The Baroque and the Neobaroque," published two years earlier, he specified a number of Neobaroque strategies of displacement, but it is parody that he considers its privileged instrument. Parody recuperates previous models and subverts them in one way or another, thus enabling (and empowering) the writer to select, reject, adapt, ironize, and otherwise ponder (and construct) cultural values.[16] Neobaroque parody revivifies the canon debate and makes literature the site of "dethronement and dispute," to repeat Sarduy's phrase. In previous chapters, we have seen examples of this process in the work of Ibargüengoitia, García Márquez, and Borges, among others. In their own essays on the subject, Sarduy and Irlemar Chiampi choose Latin American writers who flaunt their artifice in even greater measure: Reinaldo Arenas, Luis Rafael Sánchez, the poets Haroldo de Campos, Carlos Germán Belli, and in the case of Chiampi, the work of Sarduy himself.

THE NEOBAROQUE AND POSTMODERNISM

This historical trajectory has appeared in the preceding chapters in less diachronic form, but I lay it out here because I want to emphasize this essential point: the contemporary Latin American Baroque—the Neobaroque—is always aware of the cultural past and its products, and always engaged in a project of recuperation and revision. This does not mean that the effort is conservative or closed; on the contrary, it is subversive in ways we have seen, and others that we haven't. Neobaroque writers in Latin America depict cultures with overlapping histories and shared institutional structures, and they understand their cultures to be cumulative, despite conquest, colonization, globalization and other forms of suppression and appropriation. This position stands in sharp contrast to the modern (and postmodernist) tendency to value cultural products in terms of their originality, that is, as fundamentally discontinuous with their own past.

Hence "neo" rather than "post": the Neobaroque is countermodern, not postmodern, in its critical reception and reinterpretation of Western modernity. It violates aesthetic and ideological norms in ways that revitalize them; this is the

meaning of "counterconquest"—revitalization by means of revision. In their self-conscious recovery of depreciated cultural materials, Neobaroque writers challenge the ahistoricism and elitism of European modernism, and in their critical re-assessment of those materials, they challenge postmodernism's pessimism about the possibility of meaning. Although the postmodernist dismissal of Western "metanarratives" is sometimes presented as political engagement, the mechanisms that might create alternative structures are largely absent, so political critique is effectively obviated. Postmodernist pastiche has also been confused with Neo-baroque parody, but again, the difference is clear. The former juxtaposes cultural fragments without respect to their historical or cultural status, whereas the latter places cultural fragments (texts, traditions, objects, historical figures) in dynamic relation in order to reimagine histories and cultures.[17] The parts exist in "dishar-mony" but their configurations are meaningful, however tentatively and temporar-ily: think of Borges's Aleph, Galeano's hemispheric mosaic, Garro's week of col-ors. Sarduy's image of the Neobaroque as a chain of signifiers circling around an absent center also suggests this possibility: meanings are multiple and elusive, but not impossible. Signifiers are in motion and the motion itself is meaningful.

This is why, in each of the previous chapters, I have paid close attention to the dynamism of constructed spaces in both visual and verbal structures, and to the decentering (or polycentering) perspectives that this dynamism allows. In the Neobaroque, seeing is foregrounded and perspective is disrupted; sight may be-come insight, an explosion in a cathedral. Carlos Fuentes puts it this way: "The language of abundance is also the language of insufficiency . . . the Baroque *hor-ror vacui* is not accidental."[18] Neobaroque meanings are relational and volatile, and they depend upon contact; the labyrinth extends in space, and its forking paths will eventually intersect at inordinate points. Recall Gonzalo Celorio's metaphoric tree to distinguish the Baroque from Classicism. Celorio proposes that Baroque artists are more interested in the branches than the trunk. This metaphor may also be applied to the postcolonial positioning of Latin American writers, who wish to dis-tinguish their own branches from the European trunk. In their Alephian, Buen-dían constellations, in their memories of fire and the future, they negotiate between branches and trunks, parts and wholes. One senses in all of their work the impetus to balance fragmentation against totality, to construct inclusive structures that nonetheless subvert any single, unifying system. This contradictory process of vi-sion, revision and reconnection is both countermodern and modern, aspiring at once to rupture and renovate. For this reason, the Neobaroque is pertinent as an at-titude rather than a style.

Serge Gruzinski writes that the Neobaroque takes into account "the prodi-gious inventiveness of Baroque culture" that created in Latin America a world "without precedent that has continued to evolve within the confines of moder-nity."[19] The Neobaroque also challenges those confines by means superficially sim-ilar to those of postmodernism—fragmentation, incompletion, ironic quotation,

unstable selves, the thematics of disillusionment—but the Neobaroque is less postmodern than premodern (pre-Romantic, pre-Enlightenment, pre-Positivist). Neobaroque writers work to recuperate syncretic cultural models and eccentric expressive structures that have continued to exist in Latin America beneath the surface of homogenous histories and coordinate reason. In this way, the recovery of the Baroque for contemporary use in Latin America has its parallels not only in the poetics of the avant garde movements to which I have referred, but also in the Celtic revival in Ireland, the Harlem Renaissance in the United States, the integration of folk traditions in the music of Bartok and Copeland—other artistic movements that have revived occluded cultural traditions in order to contest the "confines" of modernist forms of expression. And if the Neobaroque is not "post," neither is it "re": the authors whom we have discussed are not motivated by a nostalgia for origins but by their self-conscious participation in an inclusive historical process.

AN ALTERNATIVE MODERNITY

What, then, are the shared strategies of subversion and inclusion in contemporary Baroque literature in Latin America? I will summarize those that we have discussed in the preceding chapters. Each is related to the others and, together, they move beyond modernity.

1) BAROQUE REASON

The resuscitation of Baroque forms in Europe beginning in the 1920s was, in part, a response to the bankruptcy of Enlightenment rationalism. As for Latin America, Octavio Paz argues that it "remained on the fringe of capitalist development and did not share in the Enlightenment," but in fact, Positivism was the Enlightenment's ubiquitous nineteenth-century export to the region.[20] Under the aegis of Positivism, the values of the European Enlightenment were widely disseminated in Latin America. In 1949 Leopoldo Zea provided the definitive account of Positivism's stranglehold throughout Latin America, with its reigning principles and practices of scientific empiricism, technological progress, and its privileging of European cultural values.[21] Zea also traced modes of resistance to these principles, one of which was the recuperation of non-European, premodern aesthetics and ideologies. He mentions the *indigenista* movements that were recovering autochthonous sources of Latin American culture, but he does not notice the parallel reevaluation of Baroque forms of expression.

Gilles Deleuze does, of course, and though his focus is on Europe, he illuminates this process of recovery in Latin America by stressing the capacity of the historical Baroque to integrate oppositions without resolving contradictions.

That is where the Baroque assumes its position: Is there some way of saving the old theological ideal at a moment when it is being contested on all sides, and when the world cannot stop accumulating its "proofs" against it The Baroque is just that, at a time just before the world loses its principles. *It is the splendid moment when Some Thing is kept rather than nothing,* and where response to the world's misery is made through an excess of principles, a hubris of principles, and a hubris inherent to principles.[22]

The Baroque allows contraries to coexist; elements supposed since the Enlightenment to be mutually exclusive are, in Baroque structures, complementary. The "splendid" contradictions of the seventeenth century would have been familiar (and attractive) to Latin American writers confronting the monolithic modernity of the early twentieth century. The recovery of the New World Baroque offered the possibility of reestablishing a tension between science and intuition, reason and the senses, closed systems and creative "disharmonies," to use Sarduy's term once again.

This is not un-reason but another kind of reason, an alternative epistemology that accommodates antinomies, including the magic and the real. I have argued elsewhere that the trend referred to as magical realism represents a strong current in the contemporary Latin American Baroque.[23] What they share most fundamentally is the imperative to contest modern systems that have separated spirit and matter, mind and body, time and space, ideal and real, reason and un-reason. Magical realism, like the Neobaroque, reaches back before modernism and Romanticism to recover "nonrational and intuitive forms of knowing."

This phrase is Carlos Fuentes's, and he uses it in his essay titled "José Lezama Lima: Cuerpo y palabra del barroco" (José Lezama Lima: body and word of the Baroque), to describe Lezama's Neobaroque aesthetic:

> La apuesta de Lezama, claramente, es a favor del hermano pobre de la historia, la Cenicienta de la voluntad racional y fáustica del Occidente: las formas no-racionales e intuitivas del conocimiento. En efecto, el poeta venezolano Guillermo Sucre ha llamado a la de Lezama "estética de la intuición" que descarta lo causal para intentar la síntesis creadora. [24]

> [Lezama's wager is clearly in favor of the poor brother of history, the Cinderella of Western, rational, Faustian will: nonrational and intuitive forms of knowing. In fact, the Venezuelan poet Guillermo Sucre has called Lezama's aesthetic "an aesthetic of intuition," one that dispenses with causality so as to attempt a creative synthesis.]

Neobaroque writers revivify the alternative rationality of the Baroque and take it as an invitation to include what has been excluded, to engage a complex of inordinate

texts and contexts. The process is dialogic and open-ended; its forms of stylistic rupture speak against the modern monologic of *either/or*, and in favor of an alternative *both/and.*

2) FOLK BAROQUE

This refusal of homogeneity and linearity makes possible the interactions of the indigenous and European conceptions of representation that we have traced in chapters 1 and 2, and thus the syncretic ontology of the image that enlivens the Latin American Baroque, both historical and contemporary. The dynamic of loss and reconstitution that marks colonial Latin America unfolds before our eyes on the façade of Nuestro Señor de Santiago de Jalpan (fig. 1.9) and the walls of Santa María Tonantzintla (fig. 1.8). Alejo Carpentier's precursor, Eugenio d'Ors, attributes the "Baroque spirit" to its adoption of "multipolar schemas instead of unipolar ones; merging and continuous, not discontinuous or separate."[25] "Multipolar schemas" are suited to colonial and postcolonial contexts because they blur the divide between "high" and "low" cultures, and between between modern and premodern ways of seeing and being.

Angel Guido celebrates just such a schema in his focus on José Kondori's *indiátides* (figs. 6.1, 6.2, 6.3 above), as do Carpentier, Lezama Lima, Garro, and García Márquez in their different ways. We have seen Carpentier's and Lezama Lima's celebration of the popular (syncretic) Baroque, Garro's engagement of indigenous modes of thought and expression, and García Márquez's use of popular traditions of Baroque portraiture. And in the work of Jorge Luis Borges, the social fluidity of Spanish Baroque forms is crucial, as witness his simultaneous devotion to Cervantes and Quevedo. Alfonso Reyes, in his 1928 essay "Sabor de Góngora" ("Savoring Góngora"), insists upon the demotic character of Baroque artifice in Spain. He notes that alongside the erudite poetic tradition there existed the *juglares o poetas transhumantes* (minstrels or wandering poets) who recited their poetry to the sound of "simple music" at fairs and along pilgrimage routes; he also cites the immense popularity of theatrical productions in verse.[26] In short, the folk Baroque has always existed alongside (and amplified) official expressions, and in Latin America there is no historical Baroque form, sacred or secular, that does not continue to enliven popular forms today, including the novel and short story.[27]

3) PARTS AND WHOLES

Integral to Baroque reason is its impulse to include and its openness to heterogeneity; the Baroque is attentive to strategies whereby fragments may suggest coherence amidst multiplicity. Walter Benjamin recognized this form of attention in his metaphor of Baroque ruins, asserting that significant fragments are "the finest

material in baroque creation": "For it is common practice in the literature of the baroque to pile up fragments ceaselessly, without any strict idea of a goal, and in the unremitting expectation of a miracle, to take the repetition of stereotypes for a process of intensification."[28] We have seen this process of repetition and intensification in Carpentier's "irreverent and offbeat replay" of Havana's proliferating columns, in García Márquez's proliferating Buendías, and in Borges's "handful of metaphors." José Lezama Lima offers an image for this dynamic relation between disparate parts and indeterminate wholes:

> Plutonismo: fuego originario que rompe los fragmentos y los unifica. . . . [que] quema los fragmentos y los empuja, y metamorfoseándolos hacia su final. . . . una tensión, un impulso si no de la verticalidad como en el gótico, sí un impulso volcado hacia la forma en busca de la finalidad de su símbolo. . . [29]

> [Plutonism: originary fire that breaks the fragments and unifies them. . . . that burns the fragments, metamorphosing them and impelling them toward their end. . . . a tension, an impulse if not toward verticality like the Gothic, then an impulse that lurches toward form in search of its symbolic purpose.]

"History merges into setting," to repeat Benjamin: the Neobaroque subverts the linear, causal temporality of realistic plot by envisioning an open-ended process whose *finalidad* is dynamic form. I have proposed that the Baroque *retablo* epitomizes this impulse.

4) SPACE AND TIME

Benjamin's phrase, quoted above, refers to the Baroque habit of deploying fragments of the past in visualized space.[30] This strategy of "historical display," as I have called it in chapter 2, precedes the nineteenth-century overpowering of space by homogenous, progressive time. The privileging of history over geography is characteristically modern; in Mexican muralism, we saw how Baroque structures of historicized space challenge this modern hierarchy, and how Elena Garro does so to accommodate Mesoamerican conceptions of self and world. Eduardo Galeano, too, deploys hemispheric memory in his narrative structure of historical episodes, but it is Garro who makes explicit the difference between Mexico's syncretic sense of circulating history and the gridded spaces of urbanism and ownership imposed by European colonization. Borges's emblematic strategies and architectural illusionism also project human time (and timelessness) in space. So, Neobaroque literature typically uses Baroque pictorial devices to amplify (and explode) uniform temporality; the expressive devices of pictoral and literary texts differ, of course, but their expressive aims do not.

In our discussion of Jorge Luis Borges, we explored the Baroque conception of originality as a collective, cumulative wisdom, rather than an attribute of individual genius. Borges's ironic appropriation of previous texts has been called "belatedness" by theorists of postmodernism, and his work has been offered as a primary example of this "nothing-new-under-the-sun" attitude.[31] But Borges's insistence that his work is a mere footnote or annotation to existing literature is not, as we have seen, motivated by a sense of futility but by an impulse to recuperate and reinvent. Unlike the "recycling" of postmodernist production, or the "simulation" of Baudrillardian deconstructionism, Borges's ironic intertextuality aspires to revivify occluded texts and traditions. Postmodernism has done nothing to displace the modern idea of the artist as creator and originator, whereas the Neobaroque creator self-consciously shapes what has been received. In this activity of transforming the tradition, the Neobaroque, like the Baroque, is indeed art about art, and it necessarily involves questions about how expressive forms cross boundaries between generations and cultures. The Brazilian Neobaroque poet and theorist Haroldo de Campos approaches this matter with the metaphor of "anthropophagy": the Neobaroque writer devours traditions, incorporating them figuratively in "an impetuous and unrestrainable metabolism of difference."[32]

The Neobaroque challenge to the idea of originality contains a critique of modern ideologies of individualism and, by extension, modernist forms of psychological realism. The self does not construct the world but is constructed by it, as in Borges's beautiful epilogue to *El hacedor* (translated as *Dreamtigers*).

> Un hombre se propone la tarea de dibujar el mundo. A lo largo de los años puebla un espacio con imágenes de provincias, de reinos, de montañas, de bahías, de naves, de islas, de peces, de habitaciones, de instrumentos, de astros, de caballos y de personas. Poco antes de morir, descubre que ese paciente laberinto de líneas traza la imagen de su cara.[33]

> [A man sets himself the task of portraying the world. Through the years he peoples a space with images of provinces, kingdoms, mountains, bays, ships, islands, fishes, rooms, instruments, stars, horses, and people. Shortly before his death, he discovers that the patient labyrinth of lines traces the image of his face.][34]

Borges persistently dramatizes his characters' embeddedness in the world—its places, histories, ideas, things—replacing idiosyncratic personality with transindividual tradition. Borges's metaphor of the artist is instructive: the painter and writer (his persona is both) eventually sees the image of his face not by gazing at the world, but by becoming it.

García Márquez, too, subverts the singular self in his use of the conventions of Baroque character, and Garro in her engagement of prehispanic conceptions of being. García Márquez and Garro portray communal archetypes and social selves—the dictator, the clan, the town, the animate landscape—whereas Borges portrays ideas of selfhood as such. If García Márquez's ebullient characters and Garro's *pueblerinos* seem to come from another planet when compared to Borges's reticent wraiths, they are nonetheless kinfolk, descended from two related modes of Baroque self-construction. These authors downplay (or dismiss) psychological background and description, foregrounding their characters' intellectual, political, and phenomenological embeddedness instead. Put another way, they reorder the priorities of the novel by creating characters who reach out from singularity toward some sort of symbolic status, whether for themselves or their community. This doubleness—this interplay between interiority and archetype—subtends the allegorical impulse of much contemporary Latin American fiction, including José Donoso's *Casa de campo* (*A House in the Country*, 1978), Manuel Puig's *El beso de la mujer araña* (*The Kiss of the Spider Woman*, 1976), and Angeles Mastretta's mosaic of miniatures, *Mujeres de ojos grandes* (*Women with Big Eyes*, 1990), to name a few additional examples of this Neobaroque mode.

6) ARTIFICE AND EMOTION

But what about the passion and emotion, and the extreme physicality that also characterize Baroque self-representation? We have seen that the Baroque self, however hyperbolic, contains a transcendental core that connects the individual self to human types and archetypes. The ecstatic and the erotic coexist in dynamic relation, as do artifice and emotion, erudition and sensuality.

In his 1928 essay, Alfonso Reyes argued that the reason for the twentieth-century recovery of Spanish Baroque poetry was that writers again dared to embrace artifice, *la virtud estética* (aesthetic virtue), after two centuries of realism.[35] By "aesthetic virtue," Reyes means more than artifice because he intends the word "aesthetic" in its etymological significance of "appealing to the senses." If Borges celebrates Quevedo's verbal objects for their sensuous artifice ("pure and independent like a sword or silver ring"), Reyes celebrates Góngora's for the same tension: Góngora is a poet of the senses whose images, according to Reyes, embody "un anhelo de cristalización" (a longing for crystalization) (196). During the 1920s, Borges was suspicious of Reyes's gongorism, but he, too, appreciated Baroque poetry for its sensuous surface: first the world's surface, then the surface of the "crystalline" artifact itself. As Bernini turns Saint Teresa's sensuality into sumptuous stone, so García Márquez turns Florentino's renegade body into a parodic portrait of Saintly Love, and the Arcade of the Scribes into Candy itself. Richness of descriptive detail serves archetype and allegory, whether the subject is Love or Candy, commu-

nity or cosmos. Neobaroque writers undermine modern ideologies of individualism, even as they heighten our experience of the human capacity for sensuous apprehension and corporeal participation.

I began my study with a metaphor of seeing—da Vinci's "rounder" vision when one looks with both eyes. I offered this metaphor at the outset in order to forecast the dynamic doubleness of Baroque, New World Baroque and Neobaroque vision, and their capacity to include contradictions without suppressing difference. Carlos Fuentes echoes da Vinci's metaphor in *The Buried Mirror:*

> The roundness of the Baroque, its refusal to grant anyone or anything a privileged point of view, its assertion of perpetual change, its conflict between the ordered world of the few and the disordered world of the many. . . . our vision is reunited, we see with both eyes, and our bodies are whole again.[36]

Round but not closed; whole and in motion. A new world.

Notes

1. This term has a long and distinguished history in Latin American cultural discourse; for a useful account, see Silvia Spitta, *Between Two Waters: Narratives of Transculturation in Latin America* (Houston: Rice University Press, 1994), ch. 1, "Transculturation and the Ambiguity of Signs in Latin America," pp. 1–28.

2. The last three terms are developed by Edouard Glissant, Walter Mignolo, and Serge Gruzinski respectively. See Edouard Glissant, "Concerning a Baroque Abroad in the World," in *Poetics of Relation*, trans. Betsy Wing (Ann Arbor, University of Michigan Press, 1997), pp. 77–79; Walter Mignolo, "The Movable Center: Geographical Discourses and Territoriality During the Expansion of the Spanish Empire," in *Coded Encounters: Writing, Gender and Ethnicity in Colonial Latin America*, ed. Francisco Javier Cevallos-Candau et al. (Amherst: University of Massachusetts Press, 1994), pp. 15–45; and Serge Gruzinski, *La colonización de lo imaginario: Sociedades indígenas y occidentalización en México, Siglos XVI–XVIII* (1988; Mexico City: Fondo de Cultura Económica, 1991).

 Gauvin Alexander Bailey stresses transcultural formations throughout Latin America in his admirable survey, *Art of Colonial Latin America* (London: Phaidon Press, 2005). See also essays by Teresa Gisbert, Rolena Adorno, and Amaryll Chanady in *Amerindian Images and the Legacy of Columbus*, ed. René Jara, and Nicholas Spadaccini (Minneapolis: University of Minnesota Press, 1992).

 The following exhibition catalogues deal explicitly with syncretic forms of attention: *Converging Cultures: Art and Identity in Spanish America*, ed. Diane Fane (New York: The Brooklyn Museum and Abrams, 1996); *Cambios: The Spirit of Transfor-*

mation in Spanish Colonial Art (Santa Barbara: The Santa Barbara Museum of Art/University of New Mexico Press, 1992); *Iberoamérica mestiza: Encuentro de pueblos y culturas* (Madrid and Mexico City: Centro Cultural de la Villa/Instituto Nacional de Antropología e Historia, 2003), with essays by Elisa García-Barragán, Eduardo Matos Moctezuma, and Mario Vargas Llosa, among others; and *Painting the New World: Mexican Art and Life 1521–1821,* ed. Donna Pierce, Rogelio Ruiz Gomar, and Clara Bargellini (Denver and Austin: The Denver Art Museum/University of Texas Press, 2004).

3. See, for example, Pedro Lange-Churión, "Neobaroque: Latin America's Postmodernity?" in *Latin America and Postmodernity: A Contemporary Reader,* ed. Pedro Lange-Churión and Eduardo Mendieta (Amherst: Humanity Books, 2001), pp. 253–73; and Horst Kurnitzky, "Barroco y postmodernismo: Una confrontación postergada," in *Modernidad, mestizaje cultural, ethos barroco,* ed. Bolívar Echeverría (Mexico City: Universidad Nacional Autónoma de México, 1994), pp. 73–92.

4. Alejo Carpentier, "The Baroque and the Marvelous Real," trans. Tanya Huntington and Lois Parkinson Zamora, in *Magical Realism: Theory, History, Community,* ed. Lois Parkinson Zamora and Wendy B. Faris (Durham, NC: Duke University Press, 1995), p. 100.

5. Angel Rama, *La ciudad letrada* (Hanover, NH: Ediciones de Norte, 1984); in English, *The Lettered City,* ed. and trans. John Charles Chasteen (Durham: Duke University Press, 1996); Ernesto de la Torre Villar, *Breve historia del libro en México* (Mexico City: Universidad Nacional Autónoma de México, 1987); Roberto González Echevarría, *Myth and Archive: A Theory of Latin American Narrative* (Cambridge: Cambridge University Press, 1990).

6. It is difficult, if not impossible, to critique the European scriptural economy without contrasting it to other signifying systems. Angel Rama makes this point in *La ciudad letrada,* referring to the imperial function of European literary modes in colonial Latin America:

> Todo intento de rebatir, desafiar o vencer la imposición de la escritura, pasa obligadamente por ella. Podría decirse que la escritura concluye absorbiendo toda la libertad humana, porque sólo en su campo se tiende la batalla de nuevos sectores que disputan posiciones de poder. (52)

> [All attempts to deter, defy, or negate the imposition of these functions of writing must, inescapably, also be formulated in writing. One might go so far as to assert that writing eventually looms over all human liberty, because new emerging groups can effectively assail positions of social power only on a two-dimensional battlefield of line and space. (37)]

It is ironic, then, that Rama's own focus never leaves the printed page. He does not explore the relations of expressive media or the production of cultural texts other than the alphabetic, nor does he examine the radical differences in expressive media that operated in colonial cities and rural villages (*ciudades de españoles* and *pueblos de indios*). For a discussion of this essential distinction, see Silvia Spitta's preface to *Más allá de la ciu-*

dad letrada: crónicas y espacios urbanos, ed. Boris Muñoz y Silvia Spitta (Pittsburgh: Biblioteca de América, 2003), pp. 7–23.

7. "Inordinate" is always a relational term, a term of relative positioning: *ordinal* numbers describe relations of degree, quality, or position (first, second, third), as opposed to *cardinal* numbers (one, two, three).

8. Gabriel García Márquez, "The Solitude of Latin America," trans. Marina Castañeda, in *Lives on the Line: The Testimony of Contemporary Latin American Authors,* ed. Doris Meyer (Berkeley: University of California Press, 1988), pp. 230–34.

9. Amaryll Chanady, "The Territorialization of the Imaginary: Self-Affirmation and Resistance to Metropolitan Paradigms," in *Magical Realism: Theory, History, Community,* pp. 125–44. When García Márquez was asked in a 1983 interview whether the "exaggerated proportions" of his novels are a matter of literary license, he replied: "No, disproportion is part of our reality too. Our reality is in itself out of all proportion." The examples he gives—the Danube versus the Amazon, European rain versus Latin American hurricanes—confirm his reference (and resistance) to European measures. See Plinio Apuleyo Mendoza, *The Fragrance of the Guayaba,* trans. Ann Wright (London: Verso, 1983), p. 60.

10. Homi K. Bhabha, *The Location of Culture* (London: Routledge, 1994), p. 112. Peter Beardsell engages Bhabha's model, as well as those of other postcolonial theorists (Todorov, Foucault, Said) in his study *Europe and Latin America: Returning the Gaze* (Manchester and New York: Manchester University Press, 2000).

11. Christine Buci-Glucksmann, *La Folie du voir: De l'esthétique baroque* (Paris: Editions Galilée, 1986).

CHAPTER ONE

1. José Lezama Lima, "Imagen de América latina," in *América latina en su literatura,* ed. César Fernández Moreno (Mexico City: Siglo XXI, 1972), p. 462, my translation.

2. Sor Juana Inés de la Cruz, Lira 211, "Amado dueño mío," *Obras completas* (Mexico City: Editorial Porrúa, 1989), p. 167. Lira 211 is translated as "Belovèd of My Life" by Alan Trueblood, in *Sor Juana Anthology* (Cambridge: Harvard University Press, 1988), p. 71.

3. Jacques Lafaye, *Quetzalcóatl and Guadalupe: The Formation of Mexican National Consciousness 1531–1813* (1974), trans. Benjamin Keen (Chicago: University of Chicago, 1976).

4. Carolyn Dean, *Inka Bodies and the Body of Christ: Corpus Christi in Colonia Cuzco, Peru* (Durham, NC: Duke University Press, 1999).

5. Among scholars focusing in particular on the mechanisms of transculturation in colonized American cultures, see James Lockhart, *The Nahuas After the Conquest: A Social and Cultural History of the Indians of Central Mexico, Sixteenth through Eighteenth Centuries* (Stanford: Stanford University Press, 1992); Louise Burkhart, *The Slippery Earth:*

Nahua-Christian Moral Dialogue in the Sixteenth Century (Tucson: University of Arizona Press, 1989); Steve Stern, *Peru's Indian Peoples and the Challenge of Conquest: Huamanga to 1640* (Madison: University of Wisconsin Press, 1982); Nancy Farriss, *Maya Society under Colonial Rule: The Collective Enterprise of Survival* (Princeton: Princeton University Press, 1984); and Charles Gibson, *The Aztecs under Spanish Rule: The History of the Indians of the Valley of Mexico 1519–1810* (Stanford: Stanford University Press, 1964).

6. See Octavio Paz's discussion of these evolving forms of attention, in "The Art of Mexico: Material and Meaning," in *Essays on Mexican Art,* trans. Helen Lane (New York: Harcourt Brace & Co., 1993), pp. 31–43. For a fascinating discussion of the "discovery" of Coatlicue in 1790, along with the so-called Aztec calendar stone and other archeological treasures during excavations for public works projects in Mexico City, and the intellectual and theological debates they triggered, see Jorge Cañizares-Esguerra, *How to Write the History of the New World: Histories, Epistemologies and Identities in the Eighteenth-Century Atlantic World* (Stanford: Stanford University Press, 2001), pp. 266–91.

7. I refer to Gloria Anzaldúa's influential study *Borderlands/La frontera: The New Mestiza* (San Francisco: Spinsters/Aunt Lute, 1987). See also Norma Alarcón, "Gloria Anzaldúa's *Borderlands/La Fontera:* Cultural Studies, 'Difference,' and the Non-Unitary Subject," in *Contemporary American Women Writers: Gender, Class, Ethnicity,* ed. Lois Parkinson Zamora (London: Addison Wesley Longman, 1998), pp. 11–31.

8. Bernal Díaz del Castillo, *The Conquest of New Spain,* trans. J. M. Cohen (New York: Penguin, 1963), pp. 61–62. This text was completed in 1568. The English translation comprises only about three-fourths of the original Spanish; below, I cite passages not included in the English translation, and provide translations of my own.

9. Among them are Bernardino de Sahagún, Jerónimo de Mendieta, Diego Durán, Juan de Torquemada, and Juan de Acosta, to name only a few. In this regard, see George Kubler, *Esthetic Recognition of Ancient Amerindian Art* (New Haven: Yale University Press, 1991).

10. The ubiquity of this mythic figure in central Mexican and Maya cultures is linked to his historical identity as a priest who left the sacred site of Tula and traveled to Chichén Itzá, disappearing to the East with the promise to return. For an account of Quetzalcóatl's historical and mythic displacements, see William Ringle, Tomás Gallareta Negrón, and George J. Bey III, "The Return of Quetzalcóatl: Evidence for the Spread of a World Religion during the Epiclassic Period," *Ancient Mesoamerica* 9 (1998): 183–232; and Enrique Florescano, *The Myth of Quetzalcóatl* (1995), trans. Lylsa Hochroth (Baltimore: Johns Hopkins University Press, 1999).

11. According to the 2000 Mexican census, Náhuatl is spoken by 1,448,936 speakers. Twenty-eight indigenous languages are counted, with "other languages" also a category, for a total of 6,044,547 speakers of indigenous languages, or approximately 5 percent of the Mexican population. See the website of Mexico's Instituto Nacional de Estadística, Geografía e Informática: http://www.inegi.gob.mx/inegi/default.asp.

12. *Códice Chimalpopoca; Anales de Cuauhtitlán; Leyendas de los soles* (1945), trans. Primo Feliciano Velásquez (3rd ed; Mexico City: UNAM, 1992). The three manuscripts listed above comprise the *Códice Chimalpopoca*, the first and third in Náhuatl, dated 1558 and 1570, by anonymous authors, the second in Spanish by Pedro Ponce. They are written on European paper rather than *amate* (bark paper), and first appear in a bibliographic catalogue in Mexico in 1736. A close reading of the Chimalpopoca's transcultural context is by Willard Gingerich, "Quetzalcóatl and the Agon of Time: A Literary Reading of the *Anales de Cuauhtitlán*," *The New Scholar* 10, 1–2 (1986): 41–60.

Miguel León-Portilla discusses this text and weighs the validity of postconquest alphabetic texts as reliable sources of Nahua thought, given the fact that they were collected by Spanish missionaries and written by their catechized native assistants. *Aztec Thought and Culture*, trans. Jack Emory Davis (Norman: University of Oklahoma Press, 1963), pp. vii–xiv, 193–94.

13. The manuscript has been missing from the archives of Mexico City's National Museum of Anthropology since 1949. This fact is noted in the introduction to John Bierhorst's complete English translation of the Codex Chimalpopoca, *History and Mythology of the Aztecs: The Codex Chimalpopoca* (Tucson: University of Arizona Press, 1992), p. 10.

14. Carlos Fuentes, "La violenta identidad de José Luis Cuevas," in *Casa con dos puertas* (Mexico City: Joaquín Mortiz, 1970), pp. 259–60, my emphasis.

15. Fuentes's retelling of this myth is translated under its Spanish title: *El mundo de José Luis Cuevas*, trans. Consuelo de Aerenlund (New York: Tudor Publishing Co., 1969), pp. 24–25, my emphasis.

16. See Silvia Trejo, "Tezcatlipoca: 'Espejo humeante,'" in *Dioses, mitos y ritos del México antiguo* (Mexico City: Miguel Angel Porrúa, 2000), pp. 59–81.

17. Mary Ellen Miller and Karl Taube, *The Gods and Symbols of Ancient Mexico and the Maya: An Illustrated Dictionary of Mesoamerican Religion* (London: Thames & Hudson, 1993), p. 114. See also Karl Taube, "The Iconography of Mirrors at Teotihuacán," in *Art, Ideology, and the City of Teotihuacán*, ed. Janet Catherine Berlo (Washington, D.C.: Dumbarton Oaks, 1992), pp. 169–204. The reflecting surfaces of stone and water played important roles in divinatory rites from the earliest evidence of Mesoamerican cultures.

For a study of the thematics of mirrors and reflections in Latin American literature, including a discussion of Narcissus-Huitzilopochtil, see Marta Gallo, *Reflexiones sobre espejos: la imagen especular: cuatro siglos en su trayectoria literaria hispanoamericana* (Guadalajara: Universidad de Guadalajara, 1993).

18. The metamorphoses of Tezcatlipoca according to colors are well known. Octavio Paz writes: "Which Tezcatlipoca? There are four. The black Tezcatlipoca, Smoking Mirror, is the jaguar god who in his mirror sees into the depths of men; he is converted into his opposite and double, the young Huitzilopochtli, the hummingbird, who is the blue Tezcatlipoca. At another point in space appears the white Tezcatlipoca, who is Quetzalcóatl. And at the fourth point, between the green maize and ocher earth,

appears the red Tezcatlipoca, who is Xipe Totec." "Will for Form," in *Mexico: Splendors of Thirty Centuries* (New York: The Metropolitan Museum of Art/Little Brown and Company, 1990), p. 19.

19. John Bierhorst, *History and Mythology of the Aztecs,* p. 32.

20. *Códice Chimalpopoca,* p. 9; John Bierhorst, *History and Mythology of the Aztecs,* p. 32.

21. In *Aztecs: An Interpretation* (Cambridge: Cambridge University Press, 1991), Inga Clendinnen refers to a text that exhorts the Mexica sculptor to unravel the implications of appearance, to penetrate the object and incorporate his findings in the image. Clendinnen imagines the aesthetic and cultural charge of the indigenous image-maker:

> Vegetable beings offer only their appearance as clues, so appearance must be immaculately reproduced. Creatures which move and act betray their sacred affiliations by behaviour as much as by appearance: both must be studied, and the representation made to incorporate the findings. And animate and inanimate things alike reveal significant relationships by context, and by (not necessarily obvious) resemblance in some detail of appearance. (226)

See Clendinnen's chapter 9, "Aesthetics," pp. 213–35. See also Serge Gruzinski's description of the image-maker's cultural function, in *Painting the Conquest: The Mexican Indians and the European Renaissance,* trans. Deke Dusinberre (Paris: Unesco/Flammarion, 1992), p. 16.

22. Román Piña Chan, *Quetzalcóatl: Serpiente emplumada* (Mexico City: Fondo de Cultura Económica, 1977), p. 67, my translation.

23. See William Ringle, Tomás Gallareta Negrón, and George J. Bey III, "The Return of Quetzalcóatl: Evidence for the Spread of a World Religion during the Epiclassic Period," cited above.

24. Xochicalco is interesting in this regard, for it was a crossroads of cultures; the presence of Maya, Teotihacan, Totnac, Zaptec, and Nahua cultures are found there, and it is known to have been a center for astronomical and calendrical research. See Leonardo López Luján, Robert H. Cobean T., and Alba Guadalupe Mastache R., *Xochicalco y Tula* (Mexico City: Consejo Nacional para la Cultura y las Artes, 2001).

25. The narrative of Quetzalcóatl's mirror explicitly details the operative calendrical principles: see Bierhorst, *History and Mythology of the Aztecs,* p. 4.

26. Octavio Paz, "Will for Form," in *Mexico: Splendors of Thirty Centuries,* p. 19.

27. This volatility of forms and functions is well conveyed in the admirable overview of the Mesoamerican pantheon by Mary Ellen Miller and Karl Taube, *God and Symbols of Ancient Mexico and the Maya: An Illustrated Dictionary of Mesoamerican Religion,* cited above.

28. Miguel León-Portilla, *Los antiguos mexicanos a través de sus crónicas y cantares* (Mexico City: Fondo de Cultura Económica, 1961), p. 149. See also Alfredo López Austin, *Cuerpo humano e ideología: Las concepciones de los antiguos nahuas,* 2 vols. (Mexico City: Universidad Nacional Autónoma de México, 1980), and by the same author, *Hombre-Dios: Religión y política en el mundo náhuatl* (Mexico City: Universidad Nacional Autónoma de México, 1973).

29. Stephen Houston and David Stuart, "The Ancient Maya Self," *RES* 33 (Spring 1998): 77, Houston and Stuart's emphasis. This entire issue of *RES* is devoted to "Pre-Columbian states of being."

30. Claude-François Baudez, "Los templos enmascarados de Yucatán," *Arqueología mexicana* VII, 37 (May–June 1999): 54–59.

31. Roberta H. Markman and Peter T. Markman, *The Flayed God: The Mesoamerican Mythological Tradition* (New York: HarperCollins Publishers, 1992), p. 5

32. Linda Schele and Mary Ellen Miller, *The Blood of Kings: Dynasty and Ritual in Maya Art* (New York: George Braziller, 1986), p. 42.

33. Carolyn Dean, *Inka Bodies and the Body of Christ,* p. 114, my emphasis.

34. The exhibition catalogue *The Colonial Andes: Tapestries and Silverwork, 1530–1830,* ed. Elena Phipps, Johanna Hecht, and Cristina Esteras Martín (New York: Yale University Press/The Metropolitan Museum of Art, 2004) includes several useful essays on the transculturation of self-representation in viceregal Peru.

35. Edgar Anaya Rodríguez, "¡Feliz cumpleaños, Don Gregorio!" *México desconocido,* March 2001, p. 31; my translation.

36. John Bierhorst, *History and Mythology of the Aztecs,* p. 7.

37. Useful discussions of how the prehispanic codices were performed are by Mark King, "Hearing the Echoes of the Verbal Art in Mixtec Writing," and Peter L. van der Loo, "Voicing the Painted Image: A Suggestion for Reading the Reverse of the Codex Cospi," in *Writing without Words: Alternative Literacies in Mesoamerica and the Andes,* ed. Elizabeth Hill Boone and Walter D. Mignolo (Durham: Duke University Press, 1994), pp. 102–36, 77–86.

38. León-Portilla writes about this translation from an oral medium to an alphabetic one. Referring to a number of contemporary Mesoamericanists, he writes:

> They affirm that the simple fact of transforming indigenous orality into fixed, established texts radically changes what was recited or sung. Orality, always open to enrichments and adaptations in diverse circumstances, cannot be encapsulated or confined in alphabetic writing or converted into something totally outside the original culture. Such a transformation does not reflect the mental procedures associated with the indigenous vision of the world.

El destino de la palabra: De la oralidad y los códices mesoamericanos a la escritura alfabética (The destiny of the word: from the orality of the Mesoamerican codices to alphabetic writing) (Mexico City: El Colegio Nacional y Fondo de Cultura Económica, 1996), pp. 22–23, my translation.

39. Alice Jardine, *Gynesis: Configurations of Woman and Modernity* (Ithaca: Cornell University Press, 1985), p. 119. See, in general, chapter 6, "Thinking the Unrepresentable: The Displacement of Difference," pp. 118–44. On the Western ontology of the image, see W. J. T. Mitchell, "What Is an Image?" *Iconology: Image, Text, Ideology* (Chicago: University of Chicago, 1986), pp. 7–46; and Roland Barthes, "The Rhetoric of the Image," in *Image Music, Text,* trans. Stephen Heath (New York: Hill and Wang, 1977), pp. 32–51

40. Erwin Panofsky notes that "perspective" means "seeing through," and that post-Renaissance perspective is aimed at dematerializing the expressive medium: "[W]e are meant to believe we are looking through a window into a space. The material surface upon which the individual figures or objects are drawn or painted or carved is thus negated, and instead reinterpreted as a mere 'picture plane.'" *Perspective as Symbolic Form* (1927; New York: Zone Books, 1991), p. 27.

41. See Christopher Braider, "The Fountain of Narcissus: The Invention of Subjectivity and the Pauline Ontology of Art in Caravaggio and Rembrandt," *Comparative Literature* 50, 4 (1998): 286–315. This essay became chapter 2 in the author's interartistic study of the Baroque period, *Baroque Self-Invention and Historical Truth: Hercules at the Crossroads* (Aldershot, England: Ashgate, 2004).

42. J. E. Cirlot, *A Dictionary of Symbols,* trans. Jack Sage (London: Routledge and Kegan Paul, 1962), p. 201.

43. The litany of Loreto, approved by the Church in 1587, was composed according to the conventions of Marian litanies already in existence that praised the Virgin by associating objects with her virtues. Such litanies began to appear in the twelfth century, proliferated in the thirteenth and fourteenth centuries, and have their origins in popular Latin poetry.

44. Alain Besançon focuses upon the destruction of religious images as a means of tracing the history of representation in the West. See *The Forbidden Image: An Intellectual History of Iconoclasm* (1994), trans. Jane Marie Todd (Chicago: University of Chicago Press, 2000).

45. Tzvetan Todorov, *The Conquest of America: The Question of the Other,* trans. Richard Howard (New York: Harper Torchbooks, 1984). See especially in part 2 the sections entitled "Moctezuma and Signs" and "Cortés and Signs," pp. 63–124.

 Despite conflicting visual ontologies, images were privileged in the sixteenth century as vehicles by which to communicate truths across the cultural divide between European and indigenous subjects. In this regard, see the fascinating essay by Thomas Cummins, "From Lies to Truth: Colonial Ekphrasis and the Act of Crosscultural Translation," in *Reframing the Renaissance: Visual Culture in Europe and Latin America 1450–1650,* ed. Claire Farago (New Haven: Yale University Press, 1995), pp. 152–74.

46. For a fascinating study by scholars who *do* understand this process as reciprocal and inordinate, see Carmen Bernand and Serge Gruzinski, *De la idolatría: Una arqueología de las ciencias religiosas,* trans. Diana Sánchez F. (Mexico City: Fondo de Cultura Económica, 1993).

47. Bernal Díaz del Castillo, *Historia verdadera de la conquista de la Nueva España* (Mexico City: Editorial Porrúa, 1986), ch. 209, p. 581. I refer to one of these painters, who is thought by some historians to have painted the image of the Virgin of Guadalupe, in a subsequent footnote. *Imaginero* refers to a wood-carver, and by extension to indigenous image-makers generally. See María del Consuelo Maquívar, *El imaginero novohispano y su obra* (Mexico City: Instituto Nacional de Antropología e Historia, 1995). Maquívar is particularly interested in the guilds that were established in New Spain for indigenous sculptors and painters, and the ways in which these guilds regulated artistic production.

48. Bernal Díaz, *The Conquest of New Spain,* p. 81.

49. *Fernando Cortés: His Five Letters of Relation to the Emperor Charles V,* trans. F.A. MacNutt (New York: G. P. Putnam's Sons, 1908; rpt. Glorieta, NM: The Rio Grande Press, 1977), Second Letter, p. 235. I prefer this translation to the more recent one by Anthony Pagden (Yale, 1986) because it is more literal, and thus conveys more clearly the cultural disjunctions opening up before the eyes of the narrator. For example, in the passage I cite and discuss below, when Cortés writes *mezquita,* Pagden translates the word as "temple" rather than "mosque."

50. De Landa was removed from the Yucatan and tried in Spain by the Church for his destruction of idols and his punishment of idolaters. His indictment was not an attempt to halt his cruelty to his indigenous congregation, but an application of the ruling of the Council of Trent that only bishops could judge idolatry and idolaters. De Landa was not a bishop at the time, but as we know, he was exonerated and returned to the Yucatan as bishop in 1573.

51. Diego de Landa, *Yucatan Before and After the Conquest,* trans. William Gates (New York: Dover Publications, 1978), p. 47.

52. Studies of this tradition are Hans Belting, *Likeness and Presence: A History of the Image Before the Era of Art,* trans. Edmund Jephcott (Chicago: University of Chicago Press, 1994); Margaret R. Miles, *Image as Insight: Visual Understanding in Western Christianity and Secular Culture* (Boston: Beacon Press, 1985); Aiden Nichols, *The Art of God Incarnate: Theology and Image in Christian Tradition* (London: Darton, Longman, and Todd, 1981); Umberto Eco, *Art and Beauty in the Middle Ages* (1959), trans. Hugh Bredin (New Haven: Yale University Press, 1986).

53. The Council of Trent was not the first ecumenical council forced by iconoclastic reformers to address the status of the Catholic image. The legitimacy of visual images in religious worship had been affirmed in the Second Council of Nicaea in 787, but the nature of the icon in Eastern practice was under debate. An icon differs from the Western devotional image in being itself regarded as holy, and venerated as a prototype of the saint it represents. "Veneration" is distinguished from "worship" in Eastern practice—

worship (*latria*) is restricted to divinity, whereas veneration (*dulia*) may be accorded to its re-presentations, with an intermediate category reserved for the Virgin (*hyperdulia*). By the time of the Second Council of Nicaea in 787, the Church found veneration to verge on idolatry, and icons were banned.

In the East, the so-called iconoclastic controversy was not resolved until 843, when those who favored icons prevailed over those who did not. An enormous production of icons ensued from the ninth century to 1453, when Constantinople was taken by the Turks, after which time icons were produced largely in Crete and Russia. Because icons are venerated, their Byzantine style has remained unchanged over centuries, whereas Roman Catholic representations have, of course, developed according to evolving canons of realism. See Alain Besançon, *The Forbidden Image*, especially chapter 3, "The Image in Dispute" (109–46), and "Around Trent" (172–74). See also Kay F. Turner, "The Cultural Semiosis of Religious Icons: La Virgen de San Juan de los Lagos," *Semiotica* 47, 1–4 (1983): 317–61.

54. Alain Besançon notes that "idolatry"—a combination of the words *latreia* (worship) and *eidolon* (idol)—is found only in the New Testament: "the word 'idol' acquired a stable and precise meaning through usage: it is the image, statue, or symbol of a false god. . . . Properly speaking, 'idol' implies the representation of a false god whom one worships as only the true God should be worshipped." *The Forbidden Image,* pp. 65–66.

55. John McAndrew discusses in detail the syncretic iconographies of atrial crosses in his essential study, *The Open-Air Churches of Sixteenth-Century Mexico* (Cambridge: Harvard University Press, 1965), pp. 247–54. Several included obsidian discs in the intersection of the cross, surely evidence of persisting indigenous conceptions of the identity of mirrors and divinity.

56. See Juan Pedro Viqueira Albán's fascinating account of the uprising of indigenous groups in Chiapas in 1712 resulting from an apparition of the Virgin and the consequent repudiation and repression by the Church. *María de la Candelaria: India natural de Cancuc* (Mexico City: Fondo de Cultura Económica, 1993). The account revolves around a "stone idol" and a "hermitage." In this context, see also Guillermo Floris Margadant's commentary on the facsimile edition of legal documents filed by members of the Chamula Indians in the late eighteenth century against their iconoclastic priest: *Autos seguidos por algunos de los naturales del pueblo de Chamula en contra de su cura don José Ordóñez y Aguiar por varios excesos que le suponían, 1779* (Mexico City: Universidad Autónoma de Chiapas/Miguel Angel Porrúa, 1992).

57. *Relación histórica y moral de la portentosa imagen de N. Sr. Jesucristo crucificado aparecida en una de las cuevas de S. Miguel de Chalma* [The Historical and Moral Account of the Marvelous Image of Our Lord Jesus Christ, Who Appeared in the Caves of St. Michael of Chalma] (1810; reprint, Mexico City: Impresos Olalde, 1984), p. 11, my translation.

58. See Michael Schuessler, "Iconografía y evangelización: Observaciones sobre la pintura mural en la Nueva España," in *La literatura novohispana: Revisión crítica y propuestas metodológicas,* ed. José Pascual Buxó and Arnulfo Herrera (Mexico City: Universidad Nacional Autónoma de México, 1994), pp. 255–76.

59. Serge Gruzinski provides excellent reproductions and discussion of the murals in Itzmiquilpan, in *El águila y la sibila: Frescos indios de México* (Barcelona: M. Moleiro Editor, 1994), pp. 52–89. For a close iconographic study of the murals, see Elena Isabel Estrada de Gerlero, "El friso monumental de Itzmiquilpan," *Actes du XLVII Congrès International des Americanistes* (1976), pp. 9–19, and Olivier Debroise Curare, "Imaginario fronterizo/Identidades en tránsito: El caso de los murales de San Miguel Itzmiquilpan," in *Arte, historia e identidad en América: Visiones comparativas,* vol. 1 (Mexico City: Universidad Nacional Autónoma de México, 1994), pp. 155–69.

60. See Antonio Rubial García, *Santa María Tonantzintla: Un pueblo, un templo* (Mexico City: Universidad Iberoamericana, 1991), and Robert Mullen, *Architecture and Its Sculpture in Viceregal Mexico* (Austin: University of Texas Press, 1994), pp. 143–48.

61. Robert Harbison, *Reflections on Baroque* (Chicago: University of Chicago, 2000), p. 172.

62. Elizabeth Wilder Weismann writes: "The Ultra-Baroque, which the Mexicans call Churrigueresque, was brought in by an extremely gifted designer from Seville, Jerónimo de Balbás . . ." *Art and Time in Mexico: From the Conquest to the Revolution* (New York: Harper and Row, 1985), p. 49. Born in Spain at the end of the seventeenth century, Balbás worked in Madrid and later in Seville, traveling to New Spain in 1718, where he accomplished his masterpiece, the *retablo de los reyes* (altar of the kings) in the Mexico City cathedral. He died in 1748, though Churrigueresque structures continued to be built into the last quarter of the eighteenth century in some places, even as Neoclassical styles were replacing Baroque structures in others.

 The work of another Andalusian, Lorenzo Rodríguez, was also crucial in establishing the Churrigueresque style in Mexico. Robert Mullen writes that on the façade of the Sagrario Metropolitano (1749–68), the parish church adjoining the Cathedral in Mexico City, Rodríguez set out "to accomplish in stone what Balbás had created in wood—and succeeded." *Architecture and its Sculpture in Viceregal Mexico,* p. 168.

63. Margaret R. Miles, *Image as Insight,* pp. 142–43.

64. Given the codification of the forms and functions of painting during this period, it is not surprising that there were many instructional manuals for painters and viewers. Francisco Pacheco's *El arte de la pintura,* published in Seville in 1649, invokes Aristotle's theory of imitation as a means of arriving at paintings that inspire "the contemplation of eternal glory" and "the edification of our fellow man." See appendix D, "Francisco Pacheco, On the Aim of Painting," in John Rupert Martin's *Baroque* (New York: Harper and Row, 1977), pp. 288–89.

65. Twenty-fifth decree of the Council of Trent, my emphasis. The English text of the decrees are available at http://history.hanover.edu/texts/trent.html.

66. Theatrical performance was particularly apt for propagating the faith among indigenous populations, and curtains on rural façades refer implicitly to the work of evangelization, that is, to the lifting of the metaphorical curtains that had hidden Christianity from the New World's inhabitants. See the collection of essays on missionary theatre edited by María Sten, Oscar Armando García, and Alejandro Ortiz Bullé-

Goyri, *El teatro franciscano en la Nueva España: Fuentes y ensayos para el estudio del teatro de evangelización en el siglo 16* (Mexico City: Universidad Nacional Autónoma de México, 2000); see also Michael Schuessler, "Géneros re-nacientes de la Nueva España: Teatro misionero y pintura mural," in *La cultura literaria de la América virreinal: Concurrencias y diferencias,* ed. José Pascual Buxó (Mexico City: Universidad Nacional Autónoma de México, 1996), pp. 269–77.

67. Santiago Sebastián distinguishes among the visual strategies developed by the Augustinians, Franciscans, and Dominicans in their churches and cloisters in New Spain during the sixteenth century, and by the Carmelites, Jesuits, and Hospitalarios in the seventeeth and eighteenth centuries. *Iconografía e iconología del arte novohispano,* (Mexico City: Grupo Azabache, 1992), pp. 61–77.

68. *Powers of Imagining: Ignatius de Loyola: A Philosophical Hermeneutic of Imagining through the Collected Works of Ignatius de Loyola, with a Translation of These Works,* trans. Antonio T. de Nicolas; foreword by Patrick Heelan, S.J. (Albany, NY: SUNY Press, 1986), p. 116, paragraph 47.

69. John Rupert Martin, *Baroque,* pp. 55–57.

70. This aspect of Baroque thematics and aesthetics is addressed in detail by Christine Buci-Glucksmann in *La folie du voir: De l'esthétique baroque* (Paris: Editions Galilée, 1986).

71. See Marcus B. Burke's discussion of this painting in *Treasures of Mexican Colonial Painting* (Museum of New Mexico Press/Davenport Museum of Art, 1998), pp. 93–95. Burke explains the seemingly odd popularity of this Czech saint among Jesuits in Mexico, as well as the scenes behind the kneeling figure.

72. The allegory of the five senses is one of the most characteristic of Baroque themes. See Santiago Sebastián, *Contrarreforma y barroco* (Madrid: Editorial Alianza, 1985).

73. Margaret R. Miles, *Image as Insight,* p. 100. See chapter 5, "Vision and Sixteenth-Century Protestant and Roman Catholic Reforms," pp. 95–125. See also J. Phillips, *The Reformation of Images: Destruction in Art in England, 1535–1660* (Berkeley: University of California Press, 1973).

74. Jacques Barzun, *From Dawn to Decadence: 500 Years of Western Cultural Life: 1500 to the Present* (New York: HarperCollins, 2000), p. 39.

75. In Catholic Europe, depiction of extreme corporeal suffering has long since ceased to be central to religious expression. See Leo Steinberg's magisterial study of this matter in *The Sexuality of Christ in Renaissance Art and in Modern Oblivion* (New York: Pantheon, 1983); James Clifton, *The Body of Christ in the Art of Europe and New Spain, 1150–1800* (Munich and New York: Prestel, 1997); and Elisa Vargaslugo, ". . . El más hermoso de los hijos de los hombres . . .," in *Parábola novohispana: Cristo en el arte virreinal,* ed. Elisa Vargaslugo (Mexico City: Fomento Cutural Banamex, 2000), pp. 75–117.

Indigenous rituals of blood letting and human sacrifice would surely have added unconscious impetus to images of Christ's blood in New Spain. Octavio Paz, basing his comments upon Linda Schele and Mary Ellen Miller's *Blood of Kings,* emphasizes the ritual importance of blood in Maya culture in language that echoes Catholic doctrine: "Among the Mayas, the blood of the monarch was the blood of the gods; therefore he was obliged to shed it. . . . The Mayan kings, their wives, and their courtiers perforated and lacerated their bodies with the sacred lancets. The blood was collected in vessels that were also sacred and that contained bits of paper that were burned during the sacrifice. Union of blood and fire." "Reflections of an Intruder," in *Essays on Mexican Art,* p. 73.

76. See Alain Besançon's discussion of this syncretic policy in *The Forbidden Image,* "The Support of Ancient Gods," pp. 168–72.

77. Serge Gruzinski provides excellent reproductions and discussion of these sibyls in *El águila y la sibila,* pp. 133–69.

78. In *Iconografía e iconología del arte novohispano,* Santiago Sebastián writes:

> In the series of sibyls in sixteenth-century Mexico, it is necessary to mention those that decorate the apse of the magnificent Augustinian church of Acolman. There are the Persian and Cumaen sibyls situated in relation to the prophets Samuel and Daniel; the relation of the Cumaen sibyl to Daniel is prescribed in the book by Filippo-Barbieri, published in 1481. (pp. 121–22; my translation)

> Constantino Reyes-Valerio provides a photo of the interior of the church at Acolman in *Arte indocristiano* (1978; Mexico City: Instituto Nacional de Antropología e Historia, 2000), plate 164.

79. Sebastián, *Iconografía e iconología del arte novohispano,* ch. 5, "Las imágenes del humanismo," pp. 105–33.

80. Jorge Alberto Manrique, "Del barroco a la ilustración," in Ignacio Bernal et al., *Historia general de México* (Mexico City: El Colegio de México, 2000), p. 433.

81. For discussions of how the Baroque was used to create and maintain the political power by the *criollo* elite, see John Beverley, "Barroco de estado: Góngora y el Gongorismo," *Del Lazarillo al Sandinismo: Estudios sobre la función ideológica de la literatura española e hispanoamericana* (Minneapolis: The Prisma Institute, 1987), pp. 77–97, and Mabel Moraña, "Barroco y conciencia criolla en hispanoamérica," *Revista de crítical literaria latinoamericana* XIV, 28 (1988): 229–51. Ralph Bauer discusses Sigüenza y Góngora in these terms in *The Cultural Geography of Colonial American Literatures: Empire, Travel, Modernity* (Cambridge: Cambridge University Press, 2003), "Sigüenza y Góngora: Creole Cosmographer of the Baroque," pp. 160–69. In this regard, see also Kathleen Ross, *The Baroque Narrative of Carlos de Sigüenza y Góngora: A New World Paradise* (Cambridge: Cambridge University Press, 1993), especially ch. 1, "Culture of the Spanish American Baroque," pp. 17–39.

82. See Jacques Lafaye, *Quetzalcóatl and Guadalupe,* ch. 10, "Saint Thomas-Quetzalcóatl, Apostle of Mexico," pp. 177–208; Lafaye traces the early Spanish chroniclers whose statements about Quetzalcóatl (both human priest and plumed serpent) lead the Jesuits to conflate St. Thomas and Quetzalcóatl.

83. Margaret R. Miles writes of the Jesuits that they were trained for "lives of sacrificial service, often to the point of martyrdom," which was "one of the highest priorities of the order." *Image as Insight,* p. 121.

84. Sor Juana Inés de la Cruz, Soneto 152, "Verde embeleso de la vida humana," *Obras completas,* p. 137. Sonnet 152 is translated as "Green Allurement of Our Human Life" by Alan Trueblood, in *A Sor Juana Anthology,* p. 101.

85. A wealth of historical scholarship has been lavished upon the circumstances surrounding the apparition. Most important among the studies are Edmundo O'Gorman, *Destierro de sombras: Luz en el origen de la imagen y culto de Nuestra Señora de Guadalupe del Tepeyac* (Mexico City: Universidad Nacional Autónoma de México, 1986); Stafford Poole, *Our Lady of Guadalupe: The Origins and Sources of a Mexican National Symbol, 1531–1797* (Tucson: University of Arizona Press, 1995), David Brading, *Mexican Phoenix: Our Lady of Guadalupe: Image and Tradition Across Five Centuries* (Cambridge: Cambridge University Press, 2001); and Richard Nebel, *Santa María Tonantzín Virgen de Guadalupe: Continuidad y transformación religiosa en México,* trans. Carlos Warnholtz Bustillos (1992; Mexico City: Fondo de Cultura Económica, 1995). I cite other relevant studies in footnotes below.

86. Jonathan Brown, *Images and Ideas in Seventeenth-Century Spanish Painting* (Princeton: Princeton University Press, 1978), p. 113. See chapter 5, "Zurbarán's Paintings in the Sacristy of the Monastery of Guadalupe," pp. 111–27. Bernal Díaz del Castillo mentions Cortés's pilgrimage to the monastery of Guadalupe after his return to Spain, in chapter 145 of *Historia de la Conquista de Nueva España,* pp. 523–24.

87. Octavio Paz, "I, a Painter, an Indian from this Village," in *Essays on Mexican Art,* pp. 88–89, my emphasis.

88. How painting became a political instrument, first of empire and then of nation, is the subject of the three exhibitions of *Los pinceles de la historia.* Rafael Tovar, et al., *Los pinceles de la historia I: El origen del reino de la Nueva España, 1680–1750; Los pinceles de la historia II: De la patria criolla a la nación mexicana, 1750–1860; Los pinceles de la historia III: La fabricación del estado, 1864–1910* (Mexico City: Instituto Nacional de Bellas Artes, 1999, 2000, 2003).

89. See Maria Elena Díaz, "Rethinking Tradition and Identity: The Virgin of Charity of El Cobre," in *Cuba: The Elusive Nation,* ed. Damian Fernández and Madeline Camara Betancourt (Gainesville: University of Florida Press, 2000), pp. 43–59.

90. Miguel León Portilla translates the miracle of the roses as follows:

Y luego Juan Diego subió al cerrito y cuando llegó a su cumbre, mucho se maravilló de cuántas flores allí se extendían, tenían abiertas sus corolas, variadas flores preciosas, como las de Castilla, no siendo aún su tiempo de darse.

[And then Juan Diego went up the hill and when he arrived at the top, he was amazed by the array of flowers, with their buds open, varied precious flowers such as those from Castille, nor was it their season to bloom.]

Tonantzin Guadalupe: Pensamiento náhuatl y mensaje cristiano en el Nican mopohua (Mexico City: Fondo de Cultura Económica, 2000), pp. 135–36, my translation.

91. For fascinating accounts of the apparitionist debate and the political issues bearing upon the status of the image of the Virgin during the sixteenth and seventeenth centuries, see Joaquín García Icazbalceta, *Carta acerca del origen de la imagen de Nuestra Señora de Guadalup*e (1896) (Mexico City: Miguel Angel Porrúa, 1982); Francisco de la Maza, *Guadalupanismo mexicano* (Mexico City: Fondo de Cultura Económica, 1953); and Robert Ricard, *The Spiritual Conquest of Mexico: An essay on the Apostolic and the Evangelizing Methods of the Mendicant Orders in New Spain, 1523–1572* (Berkeley: University of California Press, 1974).

Enrique Florescano notes that the apparition of the Virgin of Guadalupe inspired other, similar apparitions, confirming the centrality of this figure to indigenous populations and fueling official concern about idolatry, particularly on the part of the Franciscans: "Protected by the miraculous apparition of the Virgin of Guadalupe, indigenous groups invented other apparitions in which they invested their longing for identity, communal affirmation and justice." Florescano, *Memoria indígena* (Mexico City: Taurus, 1999), p. 266, my translation.

92. Juan Diego is Mexico's first indigenous saint, and there are now two more. Pope John Paul II canonized four-hundred and seventy saints world-wide, more than all previous popes combined.

93. The temple of Solomon was destroyed before the birth of Christ, but it became a significant topic in seventeenth-century theological and archeological debates. The symbolic source of much of the ecclesiastical architecture (monastic and parochial) in New Spain is the description in chapter 7 of the first book of Kings of the temple of Solomon in Jerusalem, and also in chapter 41 of Ezekiel. The four towers of the Basilica and other architectural details would have been recognized as referring to the temple of Solomon, and thus to Mexicans as the most recent of God's chosen people. In an odd combination of realism and convention, then, the *vistas* in paintings of the Virgin of Guadalupe reflect both actual and symbolic structures.

For a discussion of various sites in New Spain that refer literally and figuratively to the temple of Solomon, see Miguel Angel Fernández, *La Jerusalén indiana: Los conventos-fortaleza mexicanos del siglo XVI* (Mexico City: Smurfit Cartón y Papel de México, 1992). Fernández links the frequent representation of the Temple of Solomon to the early theory that indigenous peoples were the progeny of the lost tribes of Israel and were thought to have come from Jerusalem to Tenochtitlán/Mexico City, mentioning the Franciscan friar Gerónimo de Mendieta's argument in particular. He also notes that the Carmelite friar and architect, Andrés de San Miguel, who built several Carmelite monasteries, wrote a treatise entitled *The Description of the Temple of Solomon*

(116). In fact, the temple of Solomon was the subject of several contemporaneous treatises. For example, *In Ezechielem explanationes et apparatus urbis ac templi Hierosolymitani* was published in Rome in 1596 and contains a commentary on the book of Ezekiel, with plans and elevations after designs by Juan Bautista Villalpando, a Spanish Jesuit architect and scholar. Imaginary architecture became a Baroque commonplace, and views of Jerusalem that included the artist's rendition of the temple of Solomon often served as background for paintings of the crucifixion.

This architectural trope is found throughout colonial Spanish America. See Teresa Gisbert, "Potosí: Urbanism, Architecture, and the Sacred Image of the Environment," in *Potosí: Colonial Treasures and the Bolivian City of Silver*, ed. Pedro Querejazu and Elizabeth Ferrer (New York: Americas Society, 1997), pp. 36–37. Gisbert refers specifically to San Francisco in Lima, the Santuario de Copacabana on Lake Titicaca and the Santuario de Manquiri.

94. For the original Nahua text and four translations into Spanish over three-hundred and fifty years, see Jesús Galera Lamadrid, *Nican mopohua: Breve análisis literario e histórico* (Mexico City: Editorial Jus, 1991). The translations are from 1666, 1926, and two from 1978; Miguel León-Portilla gives a new verse translation in *Tonantzín Guadalupe*, cited above. The text in various languages is available on the internet.

95. Foremost among those who present arguments in favor of the former theory are Francisco de la Maza, *Guadalupanismo mexicano* and David Brading, *Mexican Phoenix*, cited above, and Lisa Sousa, Stafford Poole, and James Lockhart, *The Story of Guadalupe: Luis Laso de la Vega's 'Huei tlamahuiçoltica' of 1649* (Stanford: Stanford University Press, 1998). Jorge Cañizares-Esguerra separates the question of authorship from the question of promulgation, and convincingly gives to Sánchez the credit for institutional acceptance of the miracle. See *How to Write the History of the New World*, pp. 314–17. In referring to the authorship of Valeriano, I follow Edmundo O'Gorman in *Destierro de sombras*, as does Miguel León-Portilla in *Tonantzín Guadalupe*. In O'Gorman, see pp. 298–99 for bibliographic data on the Valeriano text and its subsequent editions. I accept this hypothesis on its linguistic and literary evidence, as well as on the history of the text itself.

96. Miguel León-Portilla discusses the historical and cultural context in which Valeriano lived and wrote in *Tonantzín Guadalupe*, pp. 34–47, 69. León-Portilla coincides with O'Gorman in proposing 1556 as the date of composition.

97. Verses 11–12. Spanish translation by Mario Rojas Sánchez, in Jesús Galera Lamadrid, *Nican mopohua*, p. 137.

98. Verses 11–12. Several English translations of *Nican mopohua* are available on the internet. Verse numbers in English vary slightly from the Spanish text cited above.

99. Léon-Portilla, *Tonantzin Guadalupe*, p. 163; my translation follows. On the work of this Nahua poet, see also León-Portilla, *Quince poetas del mundo náhuatl* (Mexico City: Editorial Diana, 1993), pp. 232–33.

100. See the discussion of *taller* paintings in Jaime Genaro Cuadriello, "Los pinceles de Dios Padre," in *Maravilla americana: Variantes de la iconografía guadalupana, Siglos*

XVII-XIX (Guadalajara: Patrimonio Cultural del Occidente, A.C., 1989), pp. 82–83. In this essay on the historical and theological evolution of the representation of the Virgin of Guadalupe, Cuadriello states that Mexico witnessed "the most audacious Mariological inventions in the history of religious art," despite Inquisitorial attention to doctrinal correctness.

101. Cuadriello notes that this passage was first associated with the image of the Virgin of Guadalupe in 1686, when the phrase was placed beneath a relief of the image on the door of the church of San Agustín in Mexico City. "Los pinceles de Dios Padre," p. 71.

102. Octavio Paz, "The Flight of Quetzalcóatl and the Quest for Legitimacy," foreword to Jacques Lafaye's *Quetzalcóatl and Guadalupe,* p. xiv.

103. "La verdadera imagen" is the central theme of this text, as it is over the centuries in one way or another in virtually all texts dealing with the image of the Virgin of Guadalupe. The phrase is best translated as "the divine image," that is, the one believed to be painted by God and imprinted miraculously on the *tilma* of Juan Diego by the Virgin. The full title of Cabrera's text is *Maravilla americana, o conjunto de raras maravillas, Observadas con la dirección de las reglas de el arte de la pintura en la prodigiosa imagen de Nuestra Señora de Guadalupe de México* [American marvel, or group of strange marvels, Observed according to the rules of the art of painting of the prodigious image of Our Lady of Guadalupe in Mexico]. Cuadriello, "Los pinceles de dios padre," in *Maravilla americana,* pp. 81–83. See also Jorge Cañizares-Esguerra, *How to Write the History of the New World,* pp. 314–18.

104. This matter is detailed by José Aste Tönsmann, *Los ojos de la Virgen de Guadalupe, un estudio por computadora* (Mexico City: Editorial Diana, 1981), and by the same author, *El secreto de sus ojos* (Lima: Tercer Milenio, 1998).

CHAPTER TWO

1. Maurice Merleau-Ponty, "Eye and Mind," in *The Essential Writings of Merleau-Ponty,* ed. Alden L. Fisher (New York: Harcourt, Brace and World, 1969), p. 265.

2. Michel de Certeau, *The Practice of Everyday Life,* trans. Steven Rendall (Berkeley: University of California Press, 1984), p. 131.

3. Michel de Montaigne, "On Coaches," in *The Complete Essays,* trans. M. A. Screech (New York: Penguin Books, 1987), p. 1029. Praising the "astonishing magnificence" of Cuzco and Mexico, Montaigne continues:

> we whipped it and subjected it to our teaching, but not from any superior worth of ours or our natural energy. . . . And as for their piety, observance of the laws, goodness, liberality, loyalty and frankness: well, it served us well that we had less of them than they did; their superiority in that ruined them, sold them and betrayed them. (1029–30)

4. On the "book" and "writing" in Mesoamerica, see Walter D. Mignolo, "Signs and their Transmission: The Question of the Book in the New World," and Elizabeth Hill

Boone, "Introduction: Writing and Recording Knowledge," in *Writing Without Words: Alternative Literacies in Mesoamerica and the Andes,* ed. Elizabeth Hill Boone and Walter D. Mignolo (Durham: Duke University Press, 1994), pp. 220–70, 3–26.

5. Bernal Díaz del Castillo, *Historia verdadera de la conquista de la Nueva España* (Mexico City: Editorial Porrúa, 1986), p. 75.

6. See the comprehensive catalogue of prehispanic Mesoamerican codices and some colonial ones, in José Alcina Franch, *Códices mexicanos* (Madrid: Editorial Mapfre, 1992). Essential discussions of the interpretive structures and cultural functions of the codices include Joyce Marcus, *Mesoamerican Writing Systems: Propaganda, Myth, and History in Four Ancient Civilizations* [Zapotec, Maya, Mixtec, and Teotihuacano] (Princeton: Princeton University Press, 1992), and Enrique Florescano, *Memory, Myth, and Time in Mexico: From the Aztecs to Independence,* trans. Albert G. Bork (Austin: University of Texas Press, 1994), ch. 1, "The Nahua Concept of Time and Space," and ch. 2, "Representation and the Uses of the Past," pp. 1–64. Other important studies are cited below.

 Many facsimile editions of the codices now exist. To recognize the quincentenary in 1992, Mexico's foremost publishing house, the Fondo de Cultura Económica, issued facsimile editions of sixteen Mesoamerican codices. A number of others have also been made available, including a four volume facsimile edition of the Codex Mendoza from the University of California Press.

7. A general introduction to pictographic systems of notation is Miguel León-Portilla, *Codices: Los antiguos libros del nuevo mundo* (Mexico City: Aguilar, 2003). Also helpful in reading the visual syntax of the codices are the appendices in Gordon Brotherston, *Painted Books from Mexico: Codices in UK Collections and the World They Represent* (London: The British Museum Press, 1995).

8. For a discussion of Mixteca-Puebla codices in general, and the Codex Borgia in particular, see Elizabeth Hill Boone, "The Structures of the Mexican *Tonalamatl,*" in *Acercarse y mirar: Homenaje a Beatriz de la Fuente,* ed. María Meresa Uriarte and Leticia Staines Cicero (Mexico City: Universidad Nacional Autónoma de México, 2004), pp. 377–401. See also John Pohl and Bruce E. Byland, "The Mixteca-Puebla Style and Early Postclassic Socio-Political Interaction," in *Mixteca-Puebla: Discoveries and Research in Mesoamerican Art and Archeology,* ed. H. B. Nicolson and E. Quiñone Keber (Culver City, CA: Labyrinthos Press, 1994), pp. 189–99.

9. Octavio Paz, "The Art of Mexico: Material and Meaning," *Essays on Mexican Art,* trans. Helen Lane (New York; Harcourt Brace & Co., 1993), p. 38, my emphasis.

10. Miguel León-Portilla, *Pre-Columbian Literatures of Mexico* (Norman: University of Oklahoma, 1969), p. 116.

11. Eduard Georg Seler, *Comentarios al Códice Borgia,* 3 vols. (Mexico City: Fondo de Cultura Económica, 1963), vol. 1, p. 11, my translation.

12. Bruce E. Byland provides a clear description of the pictographs and ideographs of the

Codex Borgia, and the ways in which they would have been read/performed by the *tlacuilo*, or priest/painter. Introduction to Gisele Díaz and Alan Rodgers, *The Codex Borgia: A Full-Color Restoration of the Ancient Mexican Manuscript* (New York: Dover Publications, 1993), p. xvi.

13. Jill Leslie McKeever Furst analyzes the etymology and multifaceted cultural usages of the conceptions surrounding the word *tonal* in *The Natural History of the Soul in Ancient Mexico* (New Haven: Yale University Press, 1995), pp. 63–108, 135–37.

14. Eduard Georg Seler, *Comentarios al Códice Borgia,* vol. 1, p. 11.

15. In his detailed study of one of what are generally agreed to be only three extant pre-hispanic Maya codices (the Madrid, the Paris, and the Dresden), Bruce Love speaks of "yearbearer" pages, which have the vertical strips of day signs, "almanac" pages with day signs running along the bottom, and *katun* pages, which document the period of 7200 days and are "loaded with ritual information and ripe for interpretation by the initiated priest." *The Paris Codex: Handbook for a Maya Priest* (Austin: University of Texas Press, 1994), p. 17. See also Victoria R. Bricker, "The Structure of Almanacs in the Madrid Codex," in *Papers on the Madrid Codex,* ed. Victoria R. Bricker and Gabrielle Vail (New Orleans: Tulane University, 1997), pp. 1–25.

16. The 260-day calendar represents the operation of eccentric cyclical sequences—a phrase that sounds oxymoronic, if not nonsensical, to Western ears—of thirteen numbers and twenty day signs. In his introduction to *The Codex Borgia: A Full-Color Restoration of the Ancient Mexican Manuscript,* Bruce E. Byland explains:

> The 260-day ritual calendar was constructed using two continuous sequences, one of 13 numbers and the other of 20 day signs. The 13 numbers run in sequence and then start again. Similarly the 20 day signs run in sequence and then start again. The total number of uniquely identified days using this system, then, is 13 times 20, or 260. (xvi)

Each day had its sign and associated deity; Byland lists them and then provides a grid to show how the unequal sequences of thirteen and twenty correspond over 260 days. Other scholars use two circular gears, one with thirteen teeth and the other with twenty, to show how the days and deities coincide irregularly over the 260-day period.

17. Miguel León-Portilla, *Aztec Thought and Culture* (Norman: University of Oklahoma Press, 1963), pp. 35–36; 86.

18. Modern understanding of the codices depends partly upon metaphor, as I suggest in the paragraph that follows. In the essay from which I have just quoted, Elizabeth Hill Boone uses the metaphors of the double helix of DNA, the benzene molecule, and the intertwining structure of hemoglobin, as well as lists of New Orleans restaurants and their variable rankings to discuss the time/space of the codices.

19. Serge Gruzinski, *Painting the Conquest: The Mexican Indians and the European Renaissance,* trans. Deke Dusinberre (Paris: Unesco/Flammarion, 1992), pp. 15–16.

20. Octavio Paz, "Will for Form," in *Mexico: Splendors of Thirty Centuries* (New York: Metropolitan Museum of Art/Little Brown and Company), 1990, p. 19.

21. Elizabeth Hill Boone, "Painted Manuscripts," in *Mexico: Splendors of Thirty Centuries*, p. 268.

22. Gruzinski, *Painting the Conquest,* p. 161. Gruzinski points out that *tlacuilos* were ingenious in integrating preexisting codes into their graphic representations of Spanish names, offices and other cultural novelties; see *Painting the Conquest*, pp. 150–69.

23. In Elena Garro's *La semana de colores* (Mexico City: Grijalbo, 1989).

24. José Alcina Franch, *Codices mexicanos*, "Lienzo de Tlaxcala," pp. 242–49.

25. Sahagún's *Historia general de las cosas de Nueva España* is basically the Florentine Codex translated into Spanish prose, with profuse illustrations. See Miguel León-Portilla, "Bernardino de Sahagún: pionero de la antropología," *Arqueología mexicana* IV, 36 (March–April 1999): 9. This entire issue of *Arqueología mexicana* is devoted to Sahagún, the Florentine Codex, and the *Historia general.*

26. Eduardo Galeano, "1583 Tlatelolco: Sahagún," *Memoria del fuego I: Los nacimientos* (Mexico City: Siglo XXI Editores, 1982), p. 179; "1583 Tlatelolco: Sahagún," *Memory of Fire: I, Genesis,* trans. Cedric Belfrage (New York: Pantheon, 1985), p. 156, ellipsis the author's.

27. Joaquín Galarza, *Códices Testerianos* (Mexico City: TAVA Editorial, 1992); see also Carolyn S. Dean, "Praying with Pictures: A Reading of the *Libro de Oraciones*," *Journal of Latin American Lore* 15, 2 (1989), 211–73.

28. Constantino Reyes-Valerio discussion the Testerian codices, and cites Mendieta, in *Arte indocristiano* (1978) (Mexico City: Instituto Nacional de Historia e Antropología, 2000), p. 443.

29. A study of the contemporary ritual use of *amate* in the two remaining communities in the states of Puebla and Veracruz, Mexico, where *amate* paper is still produced according to ancient practices, is Bodil Christensen and Samuel Martí, *Witchcraft and Pre-Colombian Paper/Brujerías y papel precolombino* (1971; Mexico City: Ediciones Euroamericans Klaus Thiele, 1988). Several indigenous communities in the state of Guerrero, Mexico, still use codices for communal purposes. Martha García, "Los códices de Guerrero: La historia detrás del glifo," *El Nacional,* 13, 14, 15 February 1993.

30. Quoted in José Joaquín Blanco, *Se llamaba Vasconcelos: Una evocación crítica* (Mexico City: Fondo de Cultura Económica, 1977), p. 97.

31. Hugo Méndez-Ramírez relates the historical and mythic structures of muralism to Pablo Neruda's poetic structures in *Neruda's Ekphrastic Experience: Mural Art and Canto general* (Lewisburg, PA: Bucknell University Press, 1999).

32. For a historical approach to these movements, see the essays contained in *México: Historia y alteridad: Perspectivas multidisciplinarias sobre la cuestión indígena,* ed. Yael Bitrán

(Mexico City: Universidad Iberoamericana, 2001), and especially the essay by Teresa Carbó, "Notas para una historia discursiva del indigenismo mexicano," pp. 265–98. The relation of visual art and artists to *indigenismo* is discussed by Dawn Ades in *Art in Latin America* (New Haven: Yale University Press, 1989), ch. 9, "Indigenism and Social Realism," pp. 195–213.

33. Patrick Marnham, *Dreaming with his Eyes Wide Open: A Life of Diego Rivera* (Berkeley: University of California Press, 1998), pp. 148–67.

34. A number of painters who were already well-known, or were to become so, signed on to accomplish Vasconcelos's agenda; besides Rivera, there were Roberto Montenegro, Adolfo Best Maugard, Carlos Mérida, Jean Charlot, and David Alfaro Siqueiros, among others. Government-commissioned murals continued to support Latin American artists for at least five decades, as they did U.S. artists during the Depression and afterward.

35. Rivera's knowledge of prehispanic visual forms is indisputable, though of course he revised the originals to suit his modern medium and political purposes. An early source was the Mexican painter Adolfo Best Maugard, who conducted research in the Musée de L'Homme in Paris during the teens and twenties, and in 1923, published a manual on artistic methods based on prehispanic art and including images of Mesoamerican artifacts. Karen Cordero Reiman discusses the friendship of Rivera and Best Maugard in Europe, and Best Maugard's ideas about reconnecting to their Mexicanness through art, in "Dos figuraciones de modernidad: Retrato de Adolfo Best Maugard (1913) de Diego Rivera y autoretrato (1923) de Adolfo Best Maugard," *Memoria* (the now-discontinued journal of the Museo Nacional de Arte in Mexico City), no. 6 (1995): 5–21. I am grateful to Mary Coffey for this reference.

 Mexican Folkways magazine, for which Rivera was art editor from 1925 to 1937 (its entire run, except for the first four issues), promoted the continuity between ancient and modern Mexico. This bilingual magazine was influential in making indigenous cultures known to both Spanish and English language readers, regularly featuring pictures of prehispanic artifacts and articles on indigenous belief systems and cultural practices. In early issues (1925 and 1926), Rivera himself wrote articles on painting for the magazine. See Margarito Sandoval Pérez, *Arte y folklore en Mexican Folkways* (Mexico City: Universidad Nacional Autónoma de México, 1998), p. 30, which gives a detailed account of the topics covered in this magazine.

36. In *Painting the Conquest*, Serge Gruzinski stresses the social standing of the *tlacuilo*:

 > At the time of the Spanish conquest, all major cities . . . had their own painters (sometimes widely known for their erudition), as well as a storehouse of 'paintings.' *Tlacuilos* were closely linked to the ruling class, for they not only mastered a sophisticated technique but also had access to knowledge of incalculable value (14).

37. José Joaquín Blanco, *Se llamaba Vasconcelos*, p. 102, my translation.

38. See Betty Ann Brown, "The Past Idealized: Diego Rivera's Use of Pre-Columbian Imagery," in *Diego Rivera: A Retrospective* (New York: Detroit Institute of Arts/ W.W. Norton, 1986), pp. 147–49.

39. *Popol Vuh: The Mayan Book of the Dawn of Life,* ed. and trans. Dennis Tedlock, with a commentary based on the ancient knowledge of the modern Quiché Maya (New York: Simon and Schuster, 1985).

40. Patrick Marnham, *Dreaming with his Eyes Wide Open,* pp. 160–61. Marnham argues (wrongly, as I suggest in note 35) that Rivera had no knowledge of, or interest in indigenous expressive forms until this time.

41. See Barbara Braun, "Diego Rivera's Collection: Pre-Columbian Art as a Political and Artistic Legacy," in *Collecting the Pre-Columbian Past,* ed. Elizabeth Hill Boone (Washington, D.C.: Dumbarton Oaks Research Library and Collection, 1993), pp. 251–70.

42. Paz, "The Art of Mexico: Material and Meaning," in *Essays on Mexican Art,* p. 42. See also Paz's essay "Crítica de la pirámide," in *Posdata* (Mexico City: Siglo XXI, 1970), pp. 103–55; in English: "Critique of the Pyramid," trans. Lysander Kemp, in *The Labyrinth of Solitude,* rev. ed. (New York: Grove Weidenfeld, 1985), pp. 284–326.

43. Diego Rivera, "Un pintor opina," an article published by Rivera in *Guía de arquitectura mexicana contemporánea* in 1952; cited in Rafael López Rangel, *Diego Rivera: Arquitectura mexicana* (Mexico City: Secretaría de Educación Pública, 1986), p. 116, my translation. This volume collects Rivera's texts on architecture and reproduces his drawings of architectural aspects of his murals, as well as his drawings for the buildings he was involved in designing.

44. Rivera, *Textos de arte,* ed. Xavier Moyssén (Mexico City: UNAM, 1986), pp. 209, 206, my translation. The architect and muralist Juan O'Gorman emphasizes Rivera's integration of these media in his essay "Diego Rivera, arquitecto," in Rafael López Rangel, *Diego Rivera: Arquitectura mexicana,* pp. 123–24.

45. Antonio Rodríguez, *Canto a la tierra: Los murales de Diego Rivera en la Capilla de Chapingo* (Mexico City: Universidad Autónoma de Chapingo, 1986), p. 10.

46. In a 1928 an essay, Gabriel García Maroto praises the "barroquismo" and "superabundancia" of Rivera's murals in the Ministry of Public Education; he focuses on the Baroque techniques of proliferating parts, metonymic displacement (one element growing out of the next in the structure of a Baroque fugue), and so on. "La obra de Diego Rivera," *Contemporáneos I* (June, July, August, 1928): 43–75.

47. Interview with Roberto Páramo, *El Heraldo Cultural de México,* 31 December 1975, p. 21; cited in Anita Stoll, introduction to *A Different Reality: Studies on the Work of Elena Garro,* ed. Anita Stoll (Lewisburg: Bucknell University Press, 1990), p. 15, my translation. At the time she was writing *Los recuerdos del porvenir,* in the fifties and early sixties, Garro would have had at her disposal the archeological and art historical material that I mentioned above in relation to Diego Rivera's sources, as well as the translations of Náhuatl poetry by Angel María Garibay, the essays of her former husband Octavio Paz, and the literary scholarship of the young Miguel León-Portilla. Garro's dependence upon Garibay and the early work of León-Portilla remains to be studied in detail; when it is, I believe that further analogies will emerge.

48. Jean Franco, *Plotting Women: Gender and Representation in Mexico* (New York: Columbia University Press, 1989), p. 134.

49. Amy Kaminsky, *Reading the Body Politic: Feminist Criticism and Latin American Women Writers* (Minneapolis: University of Minnesota Press, 1993), ch. 6, "The Uses and Limits of Foreign Feminist Theory: Elena Garro's *Los recuerdos del porvenir*," pp. 77–95.

50. Elena Garro, *Los recuerdos del porvenir* (Mexico City: Joaquín Mortiz, 1963), p. 261, my emphasis.

51. Garro, *Recollections of Things to Come,* trans. Ruth L. C. Simms (1963; Austin: University of Texas Press, 1969), p. 254, my emphasis.

52. Elizabeth Hill Boone writes: "When an Aztec child was born, her parents took her to a calendar priest to have her fate read and her calendar name assigned. The Priest cracked the stiff pages of the *tonalamatl,* consulted many different almanacs contained therein, and pronounced the child's fate. . . . In Mesoamerica everything that happened and everything that mattered was governed by the divinatory forces attached to the calendar." "The Structures of the Mexican *Tonalamatl*," p. 381.

53. This period in Mexican history represents the culmination of two centuries of conflict between church and state. In the Cristero Rebellion, liberal anticlericalism met Guadalupan fanaticism; the status of religious culture was at stake, an appropriate background for Garro's engagement of the sacred books of prehispanic Mexico. The essential text on this subject is Jean A. Meyer, *The Cristero Rebellion: The Mexican People between Church and State, 1926–1929* (Cambridge: Cambridge University Press, 1976); see also Paul J. Vanderwood, *The Power of God against the Guns of Government: Religious Upheaval in Mexico at the Turn of the Nineteenth Century* (Stanford: Stanford University Press, 1998).

54. I discuss what I call the "necrogeographies" of this novel and two others, *Pedro Páramo* by Juan Rulfo and *The House of Breath* by William Goyen, in my essay entitled "Magical Romance/Magical Realism: Ghosts in U.S. and Latin American Fiction," in *Magical Realism: Theory, History, Community,* ed. Lois Parkinson Zamora and Wendy B. Faris (Durham, NC: Duke University Press, 1995), pp. 497–550.

55. In fact, Rosario Castellanos also begins her novel *Oficio de tinieblas* (*The Book of Lamentations*) with the description of a promontory. She evokes the Maya myth of San Juan Chamula, who turned sheep into stone so the faithful would have materials to build a church in his honor: "El promontorio—sin balido, inmóvil—quedó allí como la seña de una voluntad" ("And there the rocky outcrop remained, silent and unmoving, sign of a divine desire"). *Oficio de Tinieblas* (Mexico City: Joaquín Mortíz, 1962), p. 9; *The Book of Lamentations,* trans. Esther Allen (New York: Penguin, 1996), p. 1.

 Both Nahuas and Mayas attributed a complex of meanings to stones. Jill Leslie McKeever Furst writes: "Many New World peoples thought their life forces became solid substances with animating powers, particularly after death." *The Natural History of the Soul in Ancient Mexico,* p. 55. See also a related discussion of stones in Michael Hardin, "Inscribing and Incorporating the Marginal: (P)recreating the Female Artist in Elena Garro's *Recollections of Things to Come,*" *Hispanic Journal* 16, 1 (1995): 147–49.

Hardin cites as his epigraph the following statement of Hunbatz Men, a contemporary Maya informant:

> The Journey has just begun. Seek the meaning of the sacred knowledge. See the meaning of cycles within cycles. The stones know. They are the old ones who show the way. They are the ones that speak.

Hunbatz Men and Charles Bensinger, *Mayan Vision Quest: Mystical Initiations in Meso-america*, trans. Louise Montez (San Francisco: Harper, 1991).
 The Inkas also found significance in stones. See Susan Niles, "Inca Architecture and Sacred Landscape," in *The Ancient Americas*, ed. Richard F. Townsend (Chicago: The Art Institute of Chicago, 1992), pp. 347–57.

56. The parenthetical phrase is Bill Ashcroft's, in *Post-colonial Transformation* (London: Routledge, 2001), p. 137. Ashcroft does not refer to America in particular, but Silvia Spitta applies Ashcroft's ideas to Latin America, describing the imposition of cuadricular European spaces upon indigenous American cities. See Silvia Spitta's preface to *Más allá de la ciudad letrada: Crónicas y espacios urbanos*, ed. Boris Muñoz and Silvia Spitta (Pittsburgh: University of Pittsburgh, Biblioteca de América, 2003), pp. 7–23.

57. Michel Foucault, "Of Other Spaces," *Diacritics*, 16, 1 (Spring 1986): 22–27; and "Questions on Geography," in *Power/Knowledge: Selected Interviews and Other Writings, 1972–1977*, ed. Colin Gordon (New York: Pantheon, 1980), pp. 63–77.

58. Elena Garro, "La semana de colores," in *La semana de colores*, p. 59; my translation.

59. Color symbolism and dual focalizations operate in tandem in prehispanic thought. See, for example, León-Portilla's discussion of the levels of the Nahua afterworld. After listing the colors associated with the levels, he writes: "Most important of the thirteen levels were the last two, which constituted *Omeyocan:* the mansion of duality, the source of generation and life, the ultimate metaphysical region, the primordial dwelling place of Ometéotl." *Aztec Thought and Culture*, p. 52.

60. For such a thematic reading, see Carmen Salazar, "*In illo tempore:* Elena Garro's *La semana de colores*," in *In Retrospect: Essays on Latin American Literature: In Memory of Willis Knapp Jones*, ed. Elizabeth S. Rogers and Timothy J. Rogers (York, South Carolina: Spanish Literature Publications Company, 1987), pp. 121–27.

61. Enrique Krauze, "Guerrilla Dandy," *New Republic*, 27 June 1988, p. 30. Krauze must have enjoyed a moment of satisfaction when Fuentes's novel *Los años de Laura Díaz* (*The Years with Laura Díaz*) was published in 1999 with Diego and Frida as characters. In this novel Fuentes's characters are, indeed, as rigid as Krauze alleges but, again, it seems to me that they are conceived muralistically rather than psychologically; in fact, they are presented as fragments of the vast communal history that the novel surveys.

62. Eduardo Galeano, *Memoria del fuego III: El siglo del viento* (Mexico City: Siglo XXI Editores, 1986), p. 337; *Memory of Fire: III. Century of the Wind*, trans. Cedric Belfrage (New York: Pantheon, 1988), p. 278.

63. Rudolph Arnheim, "Space as an Image of Time," in *Images of Romanticism: Verbal and Visual Affinities,* ed. Karl Kroeber and William Walling (New Haven: Yale University Press, 1978), p. 3.

64. See my discussion of *Terra nostra,* where I argue that Fuentes's engagement of Frances Yates's *The Art of Memory* creates in the novel "a spatial arena in which all of human history is played, where collective cultural memory is made available to the individual." *Writing the Apocalypse: Historical Vision in Contemporary U.S. and Latin American Fiction* (Cambridge: Cambridge University Press, 1989), pp. 172–73.

65. Galeano, *Memory of Fire: II, Faces and Masks,* trans. Cedric Belfrage (New York: Pantheon, 1987), p. 13.

66. Galeano, *Memoria del fuego II: Las caras y las máscaras,* (Mexico City: Siglo XXI Editores, 1984), p. 17; *Memory of Fire II: Faces and Masks,* p. 14, Galeano's italics.

67. Galeano, *Memoria del fuego I: Los nacimientos* (Mexico City: Siglo XXI Editores, 1982), p. 158; *Memory of Fire: I, Genesis,* trans. Cedric Belfrage (New York: Pantheon, 1985), p. 137.

68. *El libro de abrazos* (1989); after *Memory of Fire,* Galeano's collections began to incorporate images into their printed text. His collection entitled *Patas arriba: La escuela del mundo al revés* (*Upside Down: A Primer for the Looking-Glass World,* 1998) is illustrated with the engravings of José Guadalupe Posada; the English translation of *The Book of Embraces* is illustrated by Galeano himself.

69. See a discussion of the indigenous content in contemporary Latin American fiction by Gordon Brotherson and Lúcia de Sá, "First Peoples of the Americas and their Literature," in *Comparative Cultural Studies and Latin America,* ed. Sophia A. McClennan and Earl E. Fitz (West Lafayette, IN: Purdue, University Press, 2004), pp. 8–33.

70. Jorge Ibargüengoitia, *Estas ruinas que ves* (Mexico City: Joaquín Mortíz, 1975), pp. 91–2; my translation follows.

71. In Mexican muralism, Ibargüengoitia's analogues are Abel Quezada and Miguel Covarrubias, painters who created comic murals that also parody industrial grandeur and mythologized technology. See Peppi Battaglini Milano, *Abel Quesada: The Muse Hunter* (Mexico City: Joaquín Mortiz, 1989), and Adriana Williams, *Covarrubias,* trans. Julio Colón Gómez (Mexico City: Fondo de Cultura Económica, 1999).

72. Jorge Luis Borges, prologue to the 1954 edition of *A Universal History of Infamy,* trans. Norman Thomas di Giovanni (London: Penguin Books, 1973), p. 11.

CHAPTER THREE

1. Alejo Carpentier and Elena Poniatowska, "Hemos pasado del costumbrismo a la épica latinoamericana" (1963), *Entrevistas: Alejo Carpentier,* ed. Virgilio López Lemus (Havana: Editorial Letras Cubanas, 1985), pp. 116–17. Translations from these interviews are mine.

2. Carpentier, "The Baroque and the Marvelous Real," trans. Tanya Huntington and Lois Parkinson Zamora, in *Magical Realism: Theory, History, Community,* ed. Lois Parkinson Zamora and Wendy B. Faris (Durham, NC: Duke University Press, 1995), p. 95, Carpentier's emphasis.

3. See the discussion of these three writers, with emphasis on Lezama Lima, by César Augusto Salgado, "Hybridity in New World Baroque Theory," *Journal of American Folklore* 112, no. 445 (Summer 1999), 316–31. Salgado connects their theories of the Neo-baroque to art, architecture, and art history in ways that enrich my discussion in this chapter.

4. Roberto González Echevarría, *Alejo Carpentier: The Pilgrim at Home* (Ithaca: Cornell University Press, 1977), p. 30. Guillermo Cabrera Infante begins his biographical sketch of Carpentier with a discussion of the latter's French accent, in "Carpentier, cubano a la cañona," in *Vidas para leerlas* (Madrid: Alfaguara, 1992), p. 134. Cabrera argues that Carpentier was born in Switzerland, not Cuba, and that he dissembled this fact throughout his life—not the only Carpentierian expediency that Cabrera is pleased to uncover.

5. Luis Harss and Barbara Dohmann, *Into the Mainstream: Conversations with Latin American Writers* (New York: Harper and Row, 1966), p. 38.

6. For Carpentier's writings on his travels in these countries during the thirties, where he occasionally focuses on Baroque architecture and aesthetics, see *Obras completas* (Mexico City: Siglo XXI, 1985), vol. 8, "Crónicas I," pp. 23–138. Steve Wakefield's discusses these texts in "Returning Medusa's Gaze: Baroque Intertext in Alejo Carpentier," diss. (University of New South Wales, 2003), pp. 18–42.

7. Alejo Carpentier and Lourdes Galaz, "Reyes, Orozco y Rivera fueron mis maestros" (1975), *Entrevistas,* pp. 301–2.

8. Carpentier and Miguel Osorio Cáceres, "De la soledad a la solidaridad" (1977), *Entrevistas,* p. 359.

9. Carpentier and Santiago Amón, "Sobre arte, con Alejo Carpentier" (1978), *Entrevistas,* p. 425, Carpentier and Amón's italics. Carpentier often emphasized such cultural differences. In a 1975 inteview he contrasts the Mexico of the 1920s to the Havana of the same period: "La Habana era una ciudad muy española, ya que fuimos colonia hasta 1902 en tanto que los países del Continente se emanciparon entre 1810 y 1824. Nuestras costumbres y nuestro ritmo de vida era muy de la Península" (Havana was a very Spanish city, since we were a colony until 1902, whereas the countries on the continent became independent between 1810 and 1824. Our customs and our rhythm of life were very much of the Spanish peninsula). Alejo Carpentier and Magdalena Saldaña, "Opinar sobre la literatura latinoamericana, difícil por la incomunicación: Carpentier" (1975), *Entrevistas,* p. 303.

10. Carpentier and Miguel Osorio Cáceres, "De la soledad a la solidaridad" (1977), *Entrevistas,* p. 361, my emphasis. Carpentier affirms that his opinion of Rivera's contribution has not changed, noting that there has been a tendency to minimize Rivera as an

"anecdotal" painter, but that in the 1920s, "Rivera constituía en América una novedad absolutamente sensacional . . . nos plantea a todos un problema de conciencia: '¿La verdad es esto o la verdad es lo que está *allá*?'" (Rivera constituted in America an absolutely sensational innovation . . . he posed a problem of conscience for everyone: 'Is the truth here, or is the truth *there*?), p. 362, Carpentier's italics.

11. The phrase "Copernican Revolution" refers specifically to the new conception of physical space resulting from the work of four astronomers, Nicolaus Copernicus, Tycho Brahe, Johannes Kepler, and Galileo Galilei. More generally, the scientific revolution of the seventeenth century involves changing conceptions of nature as a whole, based in the dawning disciplines of anatomy, physiology, botany, among others.

12. Erwin Panofsky, *Studies in Iconology: Humanistic Themes in the Art of the Renaissance* (1939; New York: Harper and Row, 1962), p. 93.

13. Robert S. Huddleston, "Baroque Space and the Art of the Infinite," in *The Theatrical Baroque,* catalogue of an exhibition at the David and Alfred Smart Museum of Art (Chicago: University of Chicago Press, 2001), p. 17. In the seventeenth century, motion was considered the basis of all natural philosophy, and the motion of the earth was a particularly charged issue. For a detailed account of the debate surrounding the nature of motion, and hence the dawning modern conceptions of change, development, and progressive relations (degeneration, evolution, disruption, doubt), see Dava Sobel, *Galileo's Daughter: A Historical Memoir of Science, Faith, and Love* (New York: Penguin Books, 1999).

14. José Lezama Lima, "Sumas críticas del americano," in *La expresión americana* (1959), ed. Irlemar Chiampi (Mexico City: Fondo de Cultura Económica, 1993), p. 182; "Summa Critica of American Culture," trans. Mark Schafer, *The Oxford Book of Latin American Essays,* ed. Ilan Stavans (New York: Oxford University Press, 1997), p. 259.

15. Lezama Lima, "Imagen de América latina," in *América latina en su literatura,* p. 466; "Image of Latin America," trans. Mary G. Berg, in *Latin America and its Literature,* ed. César Fernández Moreno, Julio Ortega, Ivan A. Schulman (New York: Holmes and Meier Publishers, 1980), p. 325.

16. In "Sumas críticas del americano," Lezama elaborates upon this American "gnostic space":

> En la influencia americana lo predominante es lo que me atrevería a llamar el espacio gnóstico, abierto, donde la inserción con el espíritu invasor se verifica a través de la inmediata comprensión de la mirada. Las formas congeladas del barroco europeo, y toda proliferación expresa un cuerpo dañado, desaparecen en América por ese espacio gnóstico, que conoce por su misma amplitud de paisaje, por sus dones sobrantes. El *simpathos* de ese espacio gnóstico se debe a su legítimo mundo ancestral, es un primitivo que conoce, que hereda pecados y maldiciones, que se inserta en las formas de un conocimiento que agoniza, teniendo que justificarse, paradojalmente, con un espíritu que comienza. ¿Por qué el espíritu occidental no pudo extenderse por Asia y Africa, y sí en su totalidad en América? Porque ese espacio gnóstico esperaba una manera de fecunda-

ción vegetativa, donde encontramos su delicadeza aliada a la extensión, esperaba que la gracia le apartase una temperatura adecuada, para la recepción de los corpúsculos generatrices. (178–79)

[The predominant element of the American influence is what I might dare call the open, Gnostic space in which the insertion of the invading spirit is verified by the immediate comprehension of the gaze. The frozen forms of the European baroque—and all proliferation is the expression of an injured body—vanish in America on acccount of this Gnostic space, whose knowledge comes from the variety of its landscape, from the excesses of its gifts. The *simpathos* of this Gnostic space is due to its legitimate ancestral world; it is a primitive with knowledge, one who inherits sins and curses, who inserts itself within the forms of dying knowledge, needing to justify itself paradoxically with a spirit in its initial stages. Why was the Western spirit unable to extend itself into Asia and Africa yet able to do so throughout America? Because that Gnostic space was waiting for a kind of vegetal fertilization where we find its delicacy allied with its expanse, was waiting for grace to raise it to an adequate temperature for the reception of the generative corpuscles. (257)]

17. Severo Sarduy, *Barroco* (1974), included in *Ensayos generales sobre el barroco* (Mexico City: Fondo de Cultura Económica, 1987), p. 151–52, n. 5, Sarduy's emphasis; my translation. See especially ch. 3, "La cosmología barroca: Kepler," pp. 177–97, translated by Christopher Leland Winks, in *Baroque New Worlds: Representation, Transculturation, Conterconquest*, ed. Lois Parkinson Zamora and Monika Kaup (Durham: Duke University Press, forthcoming).

18. Irlemar Chiampi contrasts the projects of Carpentier, Lezama, and Sarduy in *Barroco y modernidad* (Mexico City: Fondo de Cultura Económica, 2000), ch. 1, "El barroco en el ocaso de la modernidad," pp. 17–41. For further comparative discussion, see Gustavo Guerrero, *La estrategia neobarroca* (Barcelona: Edicions del Mall, 1987).

19. The quoted phrase is from Carpentier's essay, "Problemática de la novela actual in Latinoamerica," cited below.

20. Carlos Fuentes, "José Lezama Lima: cuerpo y palabra del barroco," in *Valiente mundo nuevo: Epica, utopía y mito en la novela hispanoamericana* (Madrid: Narrativa Mondadori, 1990), p. 225.

21. Carpentier and Nicole Zand, "En América latina tenemos todos un estilo barroco" (1966), *Entrevistas,* p. 145. The passage reads as follows:

Tome a Carlos Fuentes, a Mario Vargas, a Miguel Angel Asturias, a mí mismo. Todos nosotros tenemos un estilo barroco, en el sentido que se le da clásicamente a lo que puede ser un estilo barroco: hablo de los murales mexicanos, por ejemplo. En la actualidad, Julio Cortázar también nos ofrece una prosa barroca, tanto por el tema, como por el ambiente que le es necesario.

[Take Carlos Fuentes, Mario Vargas, Miguel Angel Asturias, myself. We all have a Baroque style in the sense that is classically given to what can be a Ba-

roque style: I am speaking of the Mexican murals, for example. Currently Julio Cortázar is also offering us a Baroque prose in his theme as well as the atmosphere it requires.]

22. Carpentier and Daniel Albo, "El más célebre de los escritores cubanos: Alejo Carpentier: '¡En América latina la literatura es una novedad!'" (1966), *Entrevistas*, p. 144.

23. The conceptual structure of the entire series is discussed and illustrated by Pete Hamill in *Diego Rivera* (New York: Harry N. Abrams, 1999), pp. 98–117.

24. Carpentier, "Diego Rivera" (August 25, 1927), in *Revista de avance,* prologue and selection by Martín Casanovas (Havana: Colección Orbita, 1972), p. 157.

25. Carpentier, "Diego Rivera," 158.

26. Carpentier and Elena Poniatowska, "Hemos pasado del costumbrismo a la épica" (1963), *Entrevistas*, p. 111.

27. Pete Hamill, *Diego Rivera,* p. 123

28. Gonzalez Echevarría, *Alejo Carpentier,* p. 58.

29. *Cuestiones gongorinos* consists of essays written between 1915 and 1923, during which time Reyes was in Madrid; Alfonso Reyes, *Obras completas,* vol. 7 (Mexico City: Fondo de Cultura Económica, 1958), pp. 11–167.

30. See, for example, Federico García Lorca's essay, "La imagen poética de Don Luis de Góngora" (1927), *Obras completas* (Madrid: Aguilar, 1967), pp. 64–88. An abbreviated version of this essay (originally given as a lecture in Grenada in 1927, and published in Madrid in 1932) is translated by Ben Belitt as "The Poetic Image in Don Luis de Góngora," in García Lorca's *Poet in New York* (New York: Grove Press, 1955), pp. 167–77.

31. Uslar Pietri's assertion is indeed "essentializing," but his examples are relevant to our discussion. The passage from which I have excerpted the second phrase reads as follows:

> Lo barroco es casi una condición de lo hispánico. Lo clásico, lo lineal, lo racional, es contrario a las profundas solicitaciones de su sensibilidad y de su emoción. No es un azar que el gran arte hispanoamericano haya sido el barroco. Lo español se ha expresado con grandeza y universalidad avasalladoras en las épocas y en las formas no clásicas. En el gótico florido, en el plateresco, en el churrigueresco. En la *Celestina,* en el *Quijote,* en el *Entierro del Conde de Orgaz,* en las *Meninas,* en los *Fusilamientos de la Moncloa.*

> [The Baroque is almost a Hispanic condition. The Classical, the linear, the rational are contrary to the deep needs of Hispanic sensibility and emotion. It is not a coincidence that the greatest Hispanoamerican art has been Baroque. Spanish culture has expressed itself with overwhelming grandeur and universality in epochs and forms that are not Classical. In the florid Gothic, the

Plateresque, the Churrigueresque. In the *Celestina,* the *Quixote,* "The Burial of the Count of Orgaz," "Las Meninas," and "The Execution of the Moncloa."]

Arturo Urslar Pietri, *Letras y hombres de Venezuela* (Mexico City: Fondo de Cultura Económica, 1948), p. 27, my emphasis, my translation.

32. Angel Guido, "América frente a Europa en el arte," in *Redescubrimiento de América en el arte* (Buenos Aires: F. y M. Mercatali, 1944), pp. 27–42. The inspiration for Lezama's term *contraconquista* is probably Guido, who theorizes a repeating relation between *conquista* and *reconquista*/Baroque and New World Baroque. I will return to Guido in my conclusion. I am indebted to Monika Kaup for this connection, and she, in turn, to Arabella Pauly, "Zur Geschichte des Begriffs neobarroco" (On the history of the concept of neobaroque), introduction to *Neobarroco: Zur Wesensbestimmung Latein-amerikas und seiner Literatur* (Frankfurt: Peter Lang, 1993), pp. 13–36.

33. See José Lezama Lima, *Eras imaginarias* (Caracas and Madrid: Editorial Fundamentos, 1971), Edouard Glissant, "Concerning a Baroque Abroad in the World," in *Poetics of Relation,* trans. Betsy Wing (Ann Arbor: University of Michigan Press, 1997), pp. 77–79, and Bolívar Echeverría, *La modernidad de lo barroco* (Mexico City: Ediciones Era and Universidad Nacional Autónoma de México, 1998).

34. Sarduy, in particular, has been accused of *dehistoricizing* the Baroque, that is, of amplifying its applications to the point where distinctions among periods collapse. See, for example, Marie-Pierrette Malcuzynski, "Le (Neo)Baroque: Enquête critique sûr la transformation et l'application d'un champ notionnel," *Imprévue* 1 (1987): 11–43, translated by Wendy B. Faris in *Baroque New Worlds,* forthcoming.

35. Fuentes, "José Lezama Lima: cuerpo y palabra del barroco," in *Valiente mundo nuevo,* p. 219.

36. Jacques Barzun, *From Dawn to Decadence: 1500 to the Present, 500 Years of Western Cultural Life* (New York: HarperCollins, 2000), pp. 216, 220–21.

37. Eugenio d'Ors, *Du Baroque* (Paris: Gallimard, 1935) and *Cupole et monarchie* (Paris: Librairie de France, 1926). *Du baroque* is based on a seminar that d'Ors gave at the Abby of Pontigny, a Cistercian monastery in Burgundy that had been converted into a meeting place where European intellectuals gathered to discuss selected topics. This explains in part why *Du Baroque* was not published in Spanish until 1944, nor *Cupole et monarchie* until after its publication in French, and under another title: *Las ideas y las formas: estudios sobre la morfología de la cultura* (Madrid: Páez Editores, 1928). D'Ors is sometimes paired with José Ortega y Gasset in histories of Spanish philosophy for his phenomenological existentialism, his interest in expressive forms, and his willingness to hypothesize cultural currents. See A. López Quintas, *El pensamiento filosófico de Ortega y d'Ors* (Madrid: Guadarrama, 1972).

38. Eugenio d'Ors, *Lo barroco* (1935; Madrid: Editorial Tecnos, 2002), p. 85, my translation. D'Ors reverses the relations of media in Classical "eons," arguing that "music becomes poetic, poetry graphic, painting sculptural, and sculpture architectural."

39. Carpentier, "The Baroque and the Marvelous Real," in *Magical Realism*, p. 91, Carpentier's emphasis.

40. Proust, for example. In "The Baroque and the Marvelous Real," Carpentier writes:

 Marcel Proust (Marcel Proust precisamente, y aquí vuelve Eugenio d'Ors, que en su ensayo acertó en muchos puntos), Marcel Proust nos da uno de los momentos de la prosa barroca universal, prosa en la cual—y esto lo observa d'Ors—se intercalan unos "entre paréntesis" que son otras tantas células proliferantes, frases metidas en la frase, que tienen una vida propia y que a veces enlazan con otros "entre paréntesis" que son otros elementos proliferantes. (122)

 [Marcel Proust (especially Marcel Proust, and here again we recall Eugenio d'Ors, who was right on so many points in his essay) Marcel Proust gives us one of the great moments of universal Baroque prose, prose in which are inserted—as d'Ors notes—parenthetical asides, further series of proliferating cells, sentences within sentences that have a life of their own and sometimes connect to other asides that are also proliferating elements. (97)]

41. D'Ors, *Lo barroco,* p. 74; see in particular d'Ors's section entitled "Morfología del barroco. La multipolaridad, la continuidad," pp. 84–91. This section and the one preceding it, "La esencia del barroco. Panteísmo, dinamismo," is translated by Wendy B. Faris in *Baroque New Worlds,* forthcoming.

42. Carpentier, "Lo barroco y lo real maravilloso," in *La novela latinoamericana en vísperas de un nuevo siglo y otros ensayos* (Mexico City: Siglo XXI, 1981), pp. 113–14; "The Baroque and the Marvelous Real," in *Magical Realism,* p. 90–91.

43. The best reproductions of de Nomé's work are found in Pierre Seghers, *Monsù Desiderio ou le théâtre de la fin du monde* (Paris: Robert Laffont, 1981); the most complete selection is found in Felix Sluys, *Didier Barra et François de Nomé dits Monsù Desiderio* (Paris: Editions du Minotaure, 1961).

44. Mariët Westermann's comment is useful in this context: "Although iconoclasts had attacked paintings and sculpture alike, Calvinist agitators complained especially about sculpted images, and prints recording iconoclast attacks emphasize the destruction of sculptures. Apparently, opponents found statues particularly dangerous because their three-dimensionality enhanced the impression that the religious figures might be real." *A Worldly Art: The Dutch Republic 1585–1718* (New Haven: Yale University Press, 1996), p. 48.

45. See the reproductions of de Nomé's "Interior of a Church" and "Interior of a Cathedral," in *François de Nomé: Mysteries of a Seventeenth-Century Neapolitan Painter* (Houston: The Menil Collection, 1991), pp. 51, 53.

46. A useful biographical essay and the most recent bibliography on François de Nomé is by J. Patrice Marandel in *François de Nomé: Mysteries of a Seventeenth-Century Neapolitan Painter,* pp. 13–29, distributed by University of Texas Press.

47. Flanders was ruled by the Spanish Hapsburgs, and Rubens (1577–1640) exerted great influence on Spanish artists, including Velázquez. But to call Rubens a Counter-Reformation painter without qualification would be misleading. In fact, Rubens's family was caught in the middle of the religious wars in the Netherlands in the second half of the sixteenth century. As Protestants, they had to leave Catholic Antwerp for more than a decade, living in exile in Cologne, Germany, also a Catholic city but one that tolerated Protestants. Rubens was born in Germany, where his family eventually converted to Catholicism; his mother, when widowed, returned to Spanish Antwerp in 1589, and there Rubens established himself permanently. The Protestant Dutch Republic had only recently been established, and the lines between Catholics in the Spanish Netherlands and Protestants in the Dutch Republic were at once shifting and sharply drawn. See Kristin Lohse Belkin, *Rubens* (London: Phaidon Press, 1998), pp. 11–20.

48. Kristin Lohse Belkin stresses the importance of Classical sculpture to Baroque painters: "Its impact on Rubens and his immediate predecessors and contemporaries cannot be overestimated. They admired and copied images of the gods and heroes of antiquity, either carved in marble or in the form of plaster casts made from such statues, searching for perfection in the human form." *Rubens,* p. 47. Bruce Boucher comments that for Baroque artists, "nature and the antique were virtually synonymous." *Italian Baroque Sculpture* (London: Thames and Hudson, 1998), p. 16.

49. Jacques Barzun, *From Dawn to Decadence,* p. 336.

50. See Erwin Panofsky, "What is Baroque?" (1934), in *Three Essays on Style,* ed. Irving Levin (Cambridge: MIT Press, 1993); Robert Harbison, *Reflections on Baroque* (Chicago: University of Chicago Press, 2000).

51. José Lezama Lima, "La curiosidad barroca," in *La expresión americana,* p. 79; Lezama Lima uses this statement to imply that the Baroque has come to describe such a vast range of expressive forms as to have reached "el máximo de su arrogancia" (its maximum arrogance).

52. Umberto Eco, "The Poetics of the Open Work" (1962), in *The Role of the Reader: Explorations in the Semiotics of Texts,* trans. Bruce Merry (Bloomington: Indiana University Press, 1979), p. 52.

53. Gonzalo Celorio, "Del barroco al neobarroco," in *Ensayo de contraconquista* (Mexico City: Tusquets, 2001), pp. 78–79. This essay is translated by Maarten van Delden, in *Baroque New Worlds,* forthcoming.
 Bruce Boucher also stresses continuity over rupture: "The Baroque has sometimes been called a reenactment of the High Renaissance, but at a higher pitch. This is a valid way of stressing a continuity between two periods which would at first seem poles apart." *Italian Baroque Sculpture,* p. 14.

54. Carpentier began to distance himself from Surrealist orthodoxies (automatic writing, accidental juxtapositions, etc.) during the thirties in France, and definitively in his 1949 prologue to *The Kingdom of this World,* where he famously offers *lo real maravilloso* as an American alternative, condemning the Surrealists for disguising themselves

"cheaply as magicians." Carpentier, "On the Marvelous Real in America," trans. Tanya Huntington and Lois Parkinson Zamora, in *Magical Realism*, p. 85. For an overview of the interactions of Surrealism and Carpentier's New World Baroque, see Napoleón N. Sánchez, "Lo real maravilloso americano o la americanización del surrealismo," *Cuadernos americanos*, no. 219 (July–August 1978): 69–95.

55. Two critics refer to Carpentier's use of Monsù Desiderio's painting, but neither pursues the implications of its presence in the novel; see Alexis Márquez Rodríguez, *La obra narrativa de Alejo Carpentier* (Caracas: Ediciones de la Biblioteca de la Universidad Central de Venezuela, 1970), p. 128 (illustration n.p.); and Roberto González Echevarría, "Socrates among the Weeds: Blacks and History in Carpentier's *El siglo de las luces*," in *Celestina's Brood: Continuities of the Baroque in Spanish and Latin American Literature* (Durham: Duke University Press, 1993), pp. 186–89.

The 1992 Cuban-French-Spanish film of *El siglo de las luces* (originally a serial on Spanish television) repeatedly shows de Nomé's canvas; its final shot is of Esteban seated in front of the luminous painting, the viewer looking over his shoulder at the scene of suspended destruction. The film was directed by Humberto Solás and stars Jacqueline Arenal (Sophia), François Dunoyer (Víctor Hughes), Rustam Urazaev (Esteban), and Frédéric Pierrot (Carlos).

56. Guillermo Tovar de Teresa, *México barroco* (Mexico City: SAHOP, 1981), p. 59, my translation.

57. See Robert Harbison's *The Built, the Unbuilt and the Unbuildable: In Pursuit of Architectural Meaning* (Cambridge: MIT Press, 1991), especially chs. 4, 5, and 6: "Ruins," "Paintings," and "Unbuildable Buildings." Imaginary ruins becomes a popular Baroque trope, but it reaches back to the late Middle Ages, when vast theological and philosophical speculations were imaged as "cathedrals of thought" by the scholastics.

58. Speaking of de Nomé's work during his years in Rome, J. Patrice Marandel comments: "Separated from the original visual sources of his native Lorraine, it is, however, remarkable to witness how [he] was able to retain, in the middle of Rome, his [northern] cultural identity." *François de Nomé: Mysteries of a Seventeenth-Century Neapolitan Painter*, p. 22.

59. Blaise Pascal, *Thoughts, Letters, Minor Works*, trans. W. F. Trotter (New York: P. F. Collier and Son, 1910), p. 26.

60. Christopher Wright, *The French Painters of the Seventeenth Century* (Boston: Little Brown, 1985), p. 42.

61. This trope is epitomized by Calderón de la Barca's play, *El gran teatro del mundo*. See Anita M. Hagerman-Young and Kerry Wilks, "The Theatre of the World: Staging Baroque Hierarchies," *The Theatrical Baroque*, pp. 36–45.

62. See Ronald Paulson, *Representations of Revolution, 1789–1820* (New Haven: Yale University Press, 1983), p. 174.

63. Guillermo Cabrera Infante asserts that when this novel appeared in Cuba in 1962, it was

"exalted" by Fidel Castro and Raúl Castro, who declared it required reading for military officials. Cabrera quotes Heberto Padilla about the Castros's admiration for the novel: "Ninguno de los dos la leyó. De haberlo hecho se hubieran dado cuenta de que era profundamente contrarrevolucionaria" (Neither one had read it. If they had, they would have realized that it was profoundly counterrevolutionary). *Vidas para leerlas,* p. 143.

64. Carpentier and Magdalena Saldaña, "Opinar sobre la literatura latinoamericana, difícil por la incomunicación: Carpentier" (1975), *Entrevistas,* p. 304.

65. Raúl Silva Cáceres, "Un desplazamiento metonímico como base de la teoría de la visión en *El siglo de las luces,*" *Revista Iberoamericana,* nos. 123–24 (April/September 1983): 495. The phrase that I quote is taken from the following passage; the italicized phrase in the last sentence is Carpentier's:

> . . . el sistema del VER a través de la recolocación de los sistemas referentes de la lengua: la creación de una *perspectiva* como elemento técnico del distanciamiento y la reconstitución ya aludida al principio: la búsqueda de un método de superposición y de contraste que permita iluminar en el espacio de una lengua, de un sistema expresivo, el transcurso de las acciones y del tiempo. La búsqueda de esta perspectiva implica la utilización de elementos heterogéneos que al consolidarse en un sistema expresivo referencial produzcan *un proceso expansivo de las significaciones,* al mismo tiempo que permitan acentuar los contrastes luz/sombra, noche/día, allá/acá, entonces/ahora, casa/época. Es decir, que nos permitan, a través del desplazamiento metonímico que conlleva la expresión [de Carpentier] *tener ojos para pensar,* configurar una VISION profunda de los nuevos objetos literarios. (495, emphasis the author's)

> [. . . the system of SEEING by means of repositioning referential systems of language: the creation of *perspective* as a device for distancing and reconstitution, already alluded to at the outset: the search for a method of superimposition and contrast that allows for the illumination of the space of language, for an expressive system, for the unfolding of actions and time. The search for this perspective implies the use of heterogeneous elements that, when they consolidate in an expressive, referential system, produce *an expansive process of meanings* at the same time that they emphasize contrasts—light/dark, night/day, there/here, then/now, domestic/epic. By means of metonymic displacement, which leads to [Carpentier's] phrase "*to have eyes to think,*" these heterogeneous elements permit us to configure a profound VISION of new literary objects.]

66. Severo Sarduy, "El barroco y el neobarroco," in *América latina en su literatura,* ed. César Fernández Moreno (Mexico City: Siglo XXI, 1972), p. 170, my emphasis.

67. Sarduy, "The Baroque and the Neobaroque," trans. Mary G. Berg, in *Latin American and its Literature,* ed. César Fernández Moreno, Julio Ortega, Ivan A. Schulman (New York: Holmes and Meier Publishers, 1980), p. 118. I have used the new translation by Christopher Leland Winks, forthcoming in *Baroque New Worlds.*

68. This phrase comes from a letter written by Paz to Lezama Lima, as Paz first read *Paradiso* in 1967:

> Leo *Paradiso* poco a poco, con creciente asombro y deslumbramiento. Un edificio verbal de riqueza increíble; mejor dicho, no un edificio sino un mundo de arquitecturas en continua metamorfosis y, también un mundo de signos—rumores que se configuran en significaciones, archipiélagos del sentido que se hace y se deshace . . . es la comprobación de lo que unos pocos advinamos al conocer por primera vez su poesía y su crítica. Una obra en la que Ud. cumple la promesa que le hicieron al español de América Sor Juana, Lugones y otros cuantos más.

> [I read *Paradiso* little by little, with increasing amazement and bedazzlement. A verbal edifice of incredible richness; or rather, not an edifice but a world of architectures in continual metamorphosis and also a world of signs—murmurs that configure in constellations, archipelagos of sense that cohere and disintegrate . . . this is proof of what some few of us guessed upon first reading your poetry and criticism. A work in which you fulfill the promise made to American Spanish by Sor Juana, Lugones, and a few others.]

In Pedro Simón, ed., *Recopilación de textos sobre José Lezama Lima* (Havana: Casa de las Américas, 1970), p. 316, my translation.

69. Gilles Deleuze, *The Fold: Leibnitz and the Baroque,* trans. Tom Conley (1988; Minneapolis: University of Minnesota Press, 1993), pp. 115, 3. Deleuze explains this phenomenon as follows:

> First, *basic images* tend to break their frames, form a continuous fresco, and join broader cycles (either of other aspects of the same animal, or aspects of other animals) because the pictured form—an animal or whatever—is never an essence of an attribute, as in a symbol, but an event, which is thus related to a history or to a series. (125, emphasis the author's)

70. Carpentier, *Concierto barroco* (1974), in *Obras completas* (Mexico City: Siglo XXI, 1983), vol. 4, p. 148; *Concierto Barroco,* trans. Asa Zatz (1974) (Tulsa, OK: Council Oaks Book/University of Tulsa, 1988), p. 35.

71. Umberto Eco, "The Poetics of the Open Work," in *The Role of the Reader,* p. 57.

72. Carpentier, *El siglo de las luces* (1962), in *Obras completas* (Mexico City: Siglo XXI, 1984), vol. 5, p. 219; *Explosion in a Cathedral,* trans. John Sturrock (Boston: Little, Brown and Company, 1963), p. 180. This passage, in part, is as follows. (Sturrock mistakenly translates *caracol* as "snail" rather than "conch," which I have revised below):

> Esteban watched the luminous, motionless clouds, so slow to change their formations that sometimes a whole day was not enough to erase a triumphal arch or the head of a prophet. Total happiness, outside time and space. *Te deum.* Or else, with the point of his chin resting on the cool leaves of an *uvero,* he became

absorbed in the contemplation of a conch shell—a singe conch—which stood like a monument, level with his eyes, blotting out the horizon. This conch was the mediator between evanescent, fugitive, lawless, measureless fluidity, and the land, with its crystallizations, its structures, its morphology, where everything could be grasped and weighed. Out of the sea at the mercy of lunar cycles—fickle, furious or generous, curling and dilating, forever ignorant of modules, theorems and equations—there appeared these surprising shells, symbolizing in number and proportion exactly what the Mother lacked, concrete examples of linear development, of the laws of convolution, of a wonderfully precise conical architecture, of masses in equilibrium, of tangible arabesques which hinted at all the baroquisms to come. (180)

Among the critics who have referred to this passage are Roberto González Echevarría, Raúl Silva Cáceres, Alexis Márquez Rodríguez, Fernando Aínsa, and George Handley.

73. In fact, Severo Sarduy illustrates his argument about Baroque proliferation (the "metonymic operation par excellence") by citing another passage from *El siglo de las luces,* similar to this one, in which Carpentier enumerates a series of architectural objects that migrate metonymically from one to the next, creating a dynamic, volatile, urban space. "El barroco y el neobarroco," in *América latina en su literatura,* p. 171.

74. The quoted verb "territorialize" refers implicitly to Amaryll Chanady's use of the term, mentioned in my introduction, and cited there in note 9. In his oxymoron of wrought iron vegetation, Carpentier brilliantly engages what Gonzalo Celorio describes in "Del barroco al neobarroco," in *Ensayo de contraconquista* (translation by Maarten van Delden, in *Baroque New Worlds,* forthcoming):

. . . el juego de contradicciones que todo mundo acepta como inherente a la estética barroca. La apariencia exterior sería su contenido más profundo: la máscara, su rostro; el engaño, su verdad; la exuberancia, su vacío; el artificio, su naturaleza. (79)

[. . . the play of contradictions that everyone accepts as inherent in Baroque aesthetics. Outward appearance would be its deepest meaning: the mask, its face; deception, its truth; exuberance, its void; artifice, its nature.]

75. Octavio Paz, *Sor Juana, or The Traps of Faith,* trans. Margaret Sayers Peden (Cambridge: Harvard University Press, 1988), p. 70.

76. In the first half of the fifteenth century, Nicholas de Cusa substituted mystic intuition for scholastic rationalism, and made the concept of the unity of opposites central to his widely-read theological treatises. His understanding of the interpenetration of substance and spirit extends St. Thomas's understanding of Aristotle, and informs the "transcendental naturalism" that was made Counter-Reformation policy by the Council of Trent, and which I discuss more fully in the following chapter.

77. Robert Harbison, *Reflections on Baroque,* p. 187.

78. See González Echevarría, *Alejo Carpentier: The Pilgrim at Home,* pp. 223–24; and Djelal

Kadir, *Questing Fictions: Latin America's Family Romance* (Minneapolis: University of Minnesota Press, 1986), ch. 4, "Baroque, or the Untenable Ground: Quest as Self-Reminiscence," pp. 86–104. Kadir argues that Carpentier's Baroque overrules the "programmatics of authenticity" of *lo real maravilloso* at the same time that he (correctly, in my view) reads *lo real maravilloso* as a Baroque conceit: "the baroque discourse sublimates its difficulty of pilgrimage into eccentric figures—asyndeton, enjambment, catachresis, chiasmus, oxymoron—an equivocal language of conceits in which mutually displacing terms insist on being remembered, persist as reminiscence, simply, as paratactic contiguities, and as condensed accretions: 'marvelous reality'"(86).

79. In interviews as late as 1975 and 1976, Carpentier discusses *lo real maravilloso* along with *lo barroco*, giving no indication of disavowing the former term. Alexis Márquez Rodríguez also argues for the commensurability of these concepts in *Lo barroco y lo real-maravilloso en la obra de Alejo Carpentier* (Mexico City: Siglo XXI, 1982), especially in chapter 4, "Lo barroco americano, forma y expresión de lo real-maravilloso," pp. 145–76.

80. Carpentier insists upon this point: "Lo real maravilloso existe en todas partes: en la calle, en la gente, en la naturaleza. Pero uno tiene que saber descubrirlo" (The marvelous real exists everywhere: in the street, in people, in nature. But one has to know how to find it). Carpentier and Darie Novaceanu, "Alejo Carpentier en Rumania" (1976), *Entrevistas*, p. 341.

81. Lezama Lima, interview with T. E. Martínez, cited in Roberto González Echevarría, *Relecturas: Estudios sobre literatura cubana* (Caracas: Monte Avila, 1976); also cited in Néstor Perlongher, "Neobarroco y neobarroso," prologue to *Medusario: Muestra de poesía latinoamericana*, ed. Roberto Echavarren, José Kozer, and Jacobo Sefamí (Mexico City: Fondo de Cultura Económica, 1996), p. 26.

82. Carpentier, "De lo real maravilloso americano," in *Tientos y diferencias* (1964; Montevideo: Editorial Arca, 1967), p. 109, my emphasis. This passage is from the section that was added to the original essay, and published in *Tientos y diferencias* in 1964. "On the Marvelous Real in America," in *Magical Realism*, pp. 85–86, my emphasis.

83. See Erik Camayd-Freixas's discussion of Carpentier's "faith" in *Realismo mágico y primitivismo: Relecturas de Carpentier, Asturias, Rulfo y García Márquez* (Lanham, MD: University Press of America, 1998), pp. 103–10; González Echevarría relates Carpentier's "faith" to Oswald Spengler's *Lebensphilosophie,* in *Alejo Carpentier: The Pilgrim at Home,* pp. 58–60.

84. Carpentier, "Siete preguntas a Alejo Carpentier" (1974), *Entrevistas*, p. 252.

85. See, for example, "Debaten intelectuales sobre la latinidad," *Reforma* (Mexico City), 22 March 2001, p. C4, an article on an international congress in 2001 called "Voces universales de la latinidad," in which writers including Carlos Fuentes and Augusto Roa Bastos participated. See also the commentary surrounding the publication by Alianza Editorial in March 2001 of the four volume "tarea titánica" (titanic task) by the Peruvian literary critic José Miguel Oviedo, *Historia de la literatura hispanoamericana,* which assumes a common Latin American literary tradition; and the discussion surrounding

La biblioteca iberoamericana de ensayo, published by the Universidad Nacional Autónoma de México and Paidós, and edited by scholars in Mexico, Argentina and Spain, where one of the editors, León Olivé, comments: "Lo que sí nos falta en Iberoamérica es consolidar nuestra tradición. Tenemos clásicos, pero no hemos logrado consolidar un flujo continuo de ideas" (What we lack in Iberoamerica is to consolidate our tradition. We have classics, but we haven't managed to consolidate a continous flow of ideas). Quoted by Antimio Cruz, "Alientan debate iberoamericano," *Reforma* (April 15, 2001), p. C 26.

86. John Rupert Martin, *Baroque* (New York: Harper and Row, 1977), p. 175.

87. The quoted phrase, and a wealth of specific historical and iconographic information on Mexican art and architecture, can be found in John Collis and David M. Jones, *Blue Guide Mexico* (New York: W.W. Norton, 1997), pp. 410–11; Collis and Jones refer to the "staggeringly ornate Plateresque" of Yuriria as "tropical Plateresque," noting, on the lower story, on the inner pair of baluster columns reliefs the "sirens with female heads, but the bodies of birds," and above the projecting cornice, four canephorae (canephora is a caryatid with a basket on her head).

88. Carpentier writes about indigenous Mesoamerican art and architecture in the essays collected in *Visión de América* (Mexico City: Editorial Oceano, 1999.) These are largely journalistic pieces from the 1950s, and they include articles on Teotihuacán, Mitla, la Venta, Monte Albán, and Tikal.

89. The identity of this figure is debated; the Náhuatl name for this diety (Tlaloc) is sometimes used.

90. They are also born of different materials: Pál Keleman notes that the elaboration of the Churrigueresque in America was due in part to the abundance of wood for *retablos,* and to an ample supply of accomplished stone carvers and masons for façades and interior stucco work such as that in the Rosary Chapel. *Baroque and Rococo in Latin America* (New Work: McMillan, 1951), p. 256.

91. José Moreno Villa, *Lo mexicano en las artes plásticas* (Mexico City: Fondo de Cultura Económica, 1948), pp. 9, 14. *Tequitqui* parallels the term *mudéjar,* meaning "vassal" in Arabic and referring to art produced by Muslim artists under Spanish domination. Moreno Villa emphasizes the anachronistic character (the "timelessness") of *tequitqui.* See also Constantino Reyes-Valerio, *Arte indocristiano: Escultura del siglo XVI en México* (1978), expanded as *Arte indocristiano* (Mexico City: Institute Nacional de Historia e Antropología, 2000).

92. Elizabeth Wilder Weismann, *Art and Time in Mexico: From the Conquest to the Revolution* (New York: Harper and Row, 1985), pp. 139, 196.

93. Carpentier, "Problemática de la actual novela latinoamericana," in *Tientos y diferencias,* pp. 35–36, my translation.

94. Paz, "Primitives and Barbarians," in *Alternating Current,* trans. Helen R. Lane (New York: Seaver Books, 1967), p. 26.

95. Paz, "The Art of Mexico: Material and Meaning," in *Essays on Mexican Art,* trans. Helen Lane (New York: Harcourt Brace, 1993), p. 41.

96. Carpentier and Ignacio Solares, "Nunca he utilizado la pluma para herir; sólo creo en la literatura que construye, no en la que destruye" (1974), *Entrevistas,* pp. 231–32.

97. Carpentier, "Problemática de la actual novela latinoamericana," in *Tientos y diferencias,* p. 36. George Handley discusses this phenomenological aspect of Carpentier's New World Baroque in *Postslavery Literatures in the Americas: Family Portraits in Black and White* (Charlottesville: University of Virginia, 2001), pp. 122–23

98. Carpentier, *La ciudad de las columnas,* photos by Paolo Gasparini (Barcelona: Editorial Lumen, 1970); *La ciudad de las columnas,* photos by Fotografía/Grandal (Havana: Editorial Letras Cubanas, 1982). The citations below are from the latter edition, pp. 82, 32, and 84. This essay is translated by Michael Schuessler in *Baroque New Worlds,* forthcoming.

99. Jorge Alberto Manrique, "El mundo barroco," in *Historia general de México* (Mexico City: Colegio de México, 2000), p. 471.

100. In *Ensayo de contraconquista,* Gonzalo Celorio recognizes the parentage of the Classical column in the ornamented Baroque column, but he also recognizes the *function* of ornamentation as a part of the Baroque challenge to Classical canons:

> la profusión ornamental, manifiesta por ejemplo en las constantes digresiones que le dan preeminencia a las ramas sobre el tronco, no oculta la procedencia clásica de un texto de Gracián o de Góngora. Sin embargo, es menester preguntarse si la presencia de estos elementos en principio meramente decorativos afecta o no la estructura clásica. Una pilastra estípite, por ejemplo, ¿es realmente una columna clásica ornamentada o más bien su ornamentación constituye un rasgo esencial de su estructura? ¿Por qué no pensar que el barroco asume como esenciales los rasgos que, desde la óptica clásica, serían meros accidentes—superficiales, exteriores, decorativos? (78–79)

> [the profusion of ornamentation evident in the constant digressions that give preeminence to the branches over the trunk do not hide the Classical derivation of a text by Gracián or Góngora. However, it is necessary to ask oneself whether the presence of these elements, at first merely decorative, affects Classical structure. An *estípite* pilaster, for example: is it a Classical column with ornamentation, or does the ornamentation constitute an essential aspect of its structure? Why not say that certain characteristics become essential in the Baroque that, from a Classical view point, were merely accidental—superficial, exterior, decorative? (trans. Maarten van Delden, *Baroque New Worlds,* forthcoming)]

About "The City of Columns," Celorio writes that it is Carpentier's most explicit demonstration of his "architectural vocation." See Celorio's essay "Alejo Carpentier: La Habana, el amor a la ciudad," in *Ensayo de contraconquista,* pp. 31–37.

101. Eugenio d'Ors, *Lo barroco,* p. 37.

102. Carpentier, *El arpa y la sombra* (1979), in *Obras completas* (Mexico City: Siglo XXI, 1983), vol. 4, pp. 377–78.

103. Carpentier, *The Harp and the Shadow,* trans. Thomas Christensen and Carol Christensen (San Francisco: Mercury House, 1990), pp. 158–59.

104. Carpentier mentions in several interviews the process whereby, beginning in the mid-thirties, he began to pursue Vivaldi's opera. In 1937, he heard of its existence but was told that the score had disappeared; then, in the early seventies, he was informed by the French musicologist Roland de Candé that there were two scores extant. In two interviews, he links Vivaldi to Montaigne as early appreciators of the significance of the Americas for Europe. See Carpentier, "Encuentro con Alejo Carpentier" (1978), *Entrevistas,* pp. 385–89; and Carpentier and Ignacio Solares, "Nunca he utilizado la pluma para herir; Sólo creo en la literatura que construye, no en la que destruye" (1974), *Entrevistas,* pp. 230–31. Enrique Ballón Aguirre provides a detailed examination of the use of American material in seventeenth- and eighteenth-century operas, in *Desconcierto barroco* (Mexico City: Universidad Nacional Autónoma de México, 2001).

105. Carpentier and Miguel F. Roa, "Alejo Carpentier: El recurso a Descartes" (1974), *Entrevistas,* p. 214.

106. González Echevarría notes that the translation of Spengler's *Decline of the West,* by Manuel García Morente with the help of Ortega y Gasset, was "an immediate best seller, whose impact on Latin America was instantaneous and pervasive." *Alejo Carpentier: The Pilgrim at Home,* p. 56.

107. D'Ors does discuss Baroque musical form, and his observation about the spatial structure of the Baroque fugue, as distinct from Classical counterpoint, is relevant to our discussion:

> las estructuras clásicas adoptan de preferencia la disposición que se llama en música el *contrapunto;* es decir, aquellas que constituyen un sistema cerrado que gravita en torno de un núcleo situado en el interior, mientras que las estructuras barrocas prefieren la forma de la *fuga,* sistema abierto que señala una impulsión hacia un punto exterior. (*Lo barroco,* p. 89, d'Ors' emphasis)

> [Classical structures prefer what in musical terms is called *counterpoint,* a closed system that gravitates around an internal nucleus, whereas Baroque forms prefer the pattern of the *fugue,* an open system that follows an attraction to an external point. (trans. Wendy B. Faris in *Baroque New Worlds*)]

108. Conversely, architecture as "frozen music" is a familiar trope in Baroque studies. See George L. Hersey's *Architecture and Geometry in the Age of the Baroque* (Chicago: University of Chicago Press, 2000), ch. 2, pp. 23–51. Octavio Paz also insists upon the isomorphism of music and architecture; in the preamble to his *Essays on Mexican Art,* he writes: "There is an unquestionable kinship between [architecture and music], and it is not worth repeating a demonstration that has been performed a number of times, occasionally as unforgettably as the one composed by Valéry in his dialogue *Eupalinos ou l'architecte.* We all know that the two arts are based on number and proportion. Naturally, the other arts also share these properties; otherwise they would not be *arts.*

Nonetheless, in no other do they fuse as completely with their very being as they do in music and architecture: the two *are* proportion and number (4–5; Paz's emphasis).

109. Oswald Spengler, *The Decline of the West,* trans. Charles Francis Atkinson (New York: Alfred A. Knopf, 1980), vol. 1, *Form and Actuality,* p. 221. At the begining of Spengler's monumental work, he writes: "I have not hitherto found one who has carefully considered the *morphological relations* that inwardly bind together the expression-forms of *all* branches of a Culture" (6, Spengler's emphasis). His successors Eugenio d'Ors and Alejo Carpenter would not have disappointed him.

110. In this context, it would be instructive to consider Carpentier's *other* paired presentation of opera and Descartes, his dictator novel *El recurso del método* (translated as *Reasons of State*) published the same year as *Concierto barroco,* in 1974.

111. Fred Kersten, *Galileo and the "Invention" of Opera: A Study in the Phenomenology of Consciousness* (Dordrecht/London: Kluwer Academic Publishers, 1997), p. 95. Kersten contrasts Classicism to the Baroque on this point: Classicism measures the near by the far (the Platonic forms) whereas the Baroque measures the far by the near (the inherent significance of proximate nature, sense perception, the single self).

112. Carpentier and Ramón Chao, "Alejo Carpentier, Premio Cervantes" (1978), *Entrevistas,* p. 431. Carpentier also praises the thirty-three variations of Diabelli's theme by Beethoven and Schoenberg's *Variations* for orchestra, comparing them to the repeated sculpted motifs on the façade of Mitla, a Mixtec site in the state of Oaxaca, Mexico. See "The Baroque and the Marvelous Real," in *Magical Realism,* p. 99.

CHAPTER FOUR

1. José Ortega y Gasset, "Velázquez," in *Papeles sobre Velázquez y Goya* (Madrid: Revista de Occidente, 1950), p. 20, my translation.

2. Michel de Montaigne, "On Giving the Lie," in *The Complete Essays of Montaigne* (1588), trans. Donald M. Frame (Stanford: Stanford University Press, 1943), 2: 18, p. 504.

3. According to Benjamin, it is characteristic of the Baroque that "chronological movement is grasped and analyzed as a spatial image. The image of the setting . . . becomes the key to historical understanding." Walter Benjamin, *The Origin of the German Tragic Drama,* trans. John Osborne (London: Verso, 1977), p. 92; see also pp. 177–82.

4. For a useful discussion of the indigenous sources and iconography in Kahlo's work, see Wendy B. Faris, "Primitivist Construction of Identity in the Work of Frida Kahlo," in *Primitivism and Identity in Latin America,* ed. Erik Camayd-Freixas and José Eduardo González (Tucson: University of Arizona Press, 2000), pp. 221–40. Faris argues that Kahlo's "primitivism" represents a "partial erasure of colonial culture" (234), but she nonetheless refers to Kahlo's syncretic use of indigenous and Catholic imagery. In fact, indigenous and colonial visual traditions operate integrally in Kahlo's work, as is also made explicit in Eli Bartra, *Frida Kahlo: Mujer, ideología, arte* (Barcelona: Icaria, 1994).

5. Hayden Herrera, *Frida: A Biography of Frida Kahlo* (New York: Harper and Row, 1983).

6. John Rupert Martin, *Baroque* (New York: Harper and Row, 1977), p. 73.

7. A trenchant study of Cartesian metaphysics and European Baroque subjectivity is Christopher Braider, *Baroque Self-Invention and Historical Truth: Hercules at the Crossroads* (Aldershot, England: Ashgate, 2004), ch. 4, "Imaginary Selves: The Trial of Identity in Descartes, Pascal and Cyrano," pp. 144–81.

8. Erwin Panofsky, "What is Baroque?" (1934), in *Three Essays on Style*, ed. Irving Levin (Cambridge: MIT Press, 1993), pp. 45, 75.

9. Jorge Luis Borges, "Pascal," in *Other Inquisitions 1937–1952*, trans. Ruth L. C. Sims (Austin: University of Texas Press, 1964), p. 93.

10. Blaise Pascal, *Thoughts, Letters, Minor Works* (1670), trans. W. F. Trotter (New York: P. F. Collier and Son, 1910), p. 30. Pascal died in 1662 at the age of forty; the first edition of his textual fragments was published in 1670.

11. Montaigne, *The Complete Essays of Montaigne*, 3:13, p. 821. Relevant to this discussion is Dalia Ludovitch, *Subjectivity and Representation in Descartes* (Cambridge: Cambridge University Press, 1988), ch. 1, "From Self to Subject: Montaigne to Descartes," pp. 8–38.

12. Montaigne, *The Complete Essays of Montaigne*, 1:10, pp. 26–27. By "judgment," Montaigne means analytical reason.

13. See Joel Snyder's useful discussion of Baroque aesthetics in "*Las meninas* and the Mirror of the Prince," *Critical Inquiry* 11 (June 1985): 539–72. For a discussion of the historical and cultural setting of Velázquez's painting, see José Ortega y Gasset's *Papeles sobre Velázquez y Goya*, cited above.

14. How and why Spanish Baroque portraiture, and particularly that of Velázquez, conditioned nineteenth and twentieth modes of self-representation in France, England, and the United States, was the subject of an excellent exhibition at the Metropolitan Museum of Art. The exhibition catalogue includes a number of interesting comparative essays on the historical and aesthetic interactions of the Spanish Baroque tradition and subsequent modes of self-representation. See Gary Tinterow and Geneviève Wilson-Bareau, *Manet/Velázquez: The French Taste for Spanish Painting* (New York and New Haven: The Metropolitan Museum of Art and Yale University Press, 2002).

15. Two exhibitions are recent reminders of the extensive depiction of this figure during the Baroque period: "In Search of Mary Magdalene: Images and Traditions," at the American Bible Society, New York, 2002; and "María Magdalena: Éxtasis y arrepentimiento," at the Museo de San Carlos in Mexico City, 2001, with an excellent catalogue of the same title (Mexico City: Conaculta/INBA, 2001).

16. Jacques Barzun, *From Dawn to Decadence: 500 Years of Western Cultural Life: 1500 to the Present* (New York: HarperCollins Publishers, 2000), p. 453

17. John Rupert Martin writes of Cesare Ripa's manual: "This great illustrated dictionary of symbols, attributes and personifications, set out in alphabetical order, was consulted

by artists and writers for nearly two hundred years. . . . Even today it remains 'the key to the painted and sculptural allegories of the seventeenth and eighteenth centuries.'" *Baroque*, p. 121. Here Martin quotes Emile Mâle, then proceeds to compare Bernini's statue of "Truth" to Ripa's description of the requisite attributes for such an allegorical figure, and finds that Bernini follows Ripa assiduously. This prescriptive aspect of Baroque representation is foreign to modern viewers, who are likely to project contemporary notions of originality onto Baroque works that are, in fact, conventional to the letter.

18. J. E. Cirlot, *A Dictionary of Symbols*, trans. Jack Sage (London: Routledge and Kegan Paul, 1962), p. 239.

19. In fact, the woman who washed Christ's feet is unnamed (viz. Luke 7:36–50), but as we will see below, Mary Magdalene is a composite of a number of references to women in the Gospels.

20. See Helen Langdon, *Caravaggio: A Life* (London: Chatto and Windus, 1998), pp. 7, 241–45.

21. In his essential study of Baroque religious representation, *L'Art religieux après le Concile de Trente* (Paris: Librarie Armand Colin, 1932), Emile Mâle states that he is unaware of depictions of saints in ecstasy before the seventeenth century. A useful study of the explosion of ecstatic saints is Victor I. Stoichita, *Visionary Experience in the Golden Age of Spanish Art* (London: Reaktion Books, 1995).
 Referring to the Baroque representations of martyrdom, which seem unnecessarily graphic to the modern viewer, Margaret R. Miles writes of seventeenth-century viewers that "What was distinctive and thus would have gripped the emotions was not the grisliness of the painted scenes but the sacrificial heroism of the victims." Martyrdom was understood as an exaltation of the religious life, and for the Jesuits in particular, it was "one of the highest priorities of the order." Margaret R. Miles, *Image as Insight: Visual Understanding in Western Christianity and Secular Culture* (Boston: Beacon Press, 1985), pp. 121, 122. See also Elena Estrada de Gerlero, "Los protomártires del Japón en la hagiografía novohispana," in Rafael Tovar, et al., *Los pinceles de la historia II: De la patria criolla a la nación mexicana: 1750–1860* (Mexico City: Instituto Nacional de Bellas Artes, 2000), pp. 72–89.

22. Jorge Luis Borges, "La conducta novelística de Cervantes" (1928), in *El idioma de los argentinos* (Madrid: Alianza Editorial, 1998), p. 125. Still writing in his early florid prose, Borges elaborates on his description of Don Quixote: "Imperturbable, como quien no quiere la cosa, lo levanta a semidiós en nuestra conciencia, a fuerza de sumarias relaciones de su virtud y de encarnizadas malandanzas, calumnias, omisiones, postergaciones, incapacidades, soledades y cobardías" (123–24); (Imperturble, as if in spite of himself, he is raised to a semigod in our consciousness on the basis of the summary relations of his virtue and his cruel misfortunes, calumnies, omissions, delays, incapacities, solitude, and cowardice [my translation]). Vladimir Nabokov also emphasizes the physical cruelty in Cervantes's novel, in his *Lectures on the Quixote*.

23. Walter Benjamin, "The Corpse as Emblem," in *The Origins of German Tragic Drama*, pp. 215–20. I quote from page 217.

24. Arnold Hauser, *Mannerism: The Crisis of the Renaissance and the Origin of Modern Art* (Cambridge: Harvard University Press, 1986), p. 77

25. Jacobus de Voragine, *The Golden Legend: Readings on the Saints,* trans. William Granger Ryan (Princeton: Princeton University Press, 1993), 2 vols.

26. Teresa Gisbert, prologue to Martha J. Egan, *Relicarios: Devotional Miniatures from the Americas* (Santa Fe, NM: Museum of New Mexico Press, 1993), p. viii.

27. Among "Baroque saints" are Saint Ignatius of Loyola, founder of the Jesuits, and his lieutenant, St. Francis Xavier; Saint Philip Neri, founder of the Oratorian Order; Saint John of the Cross and Saint Teresa, founders of the reformed order of Carmelites; and somewhat later, Saint Alphonsus Liguori, founder of the Congregation of the Redemptionists. Saint Teresa was canonized in 1622; Ignatius Loyola, Francis Xavier, and Philip Neri were all canonized by Pope Urban VIII on August 6, 1623, the day of his election.

28. The Baroque conception of the simultaneity of *agape, caritas,* and *eros* is discussed in detail by James V. Mirollo, "The Death of Venus: Right Reading of Baroque Verbal and Visual Texts," in *The Image of the Baroque,* ed. Ado Scaglione and Gianni Eugenio Viola (New York: Peter Lang, 1995), pp. 203–19.

29. Frank J. Warnke, *Versions of the Baroque* (New Haven: Yale University Press, 1972), p. 52.

30. Walter Benjamin, *The Origin of German Tragic Drama,* p. 234, Benjamin's emphasis.

31. Diego Rivera, "Frida Kahlo y el arte mexicano," in a selection from Rivera's voluminous writings, *Textos de Arte,* ed. Xavier Moyssén (Mexico City: Universidad Nacional Autónoma de México, 1986), p. 292.

32. Ernst van de Wetering points out that the term "self-portrait" did not exist in Rembrandt's time; his self-portraits were referred to as "Rembrandt's likeness done by himself." Van de Wetering takes this difference to specify the different conception of the self at the time, stating that the experience of the individual was "governed first and foremost by categories of Christian and humanistic ethics, and by the doctrine of the temperaments and dispositions, topped off with a liberal dose of astrology." In fact, Rembrandt's self-portraits both challenge and enlarge this conception of the self. See Ernst van de Wetering, "The Multiple Functions of Rembrandt's Self Portraits," in *Rembrandt by Himself,* ed. Christopher White and Quentin Buvelot (London: The Hague and National Gallery Publications, 1999), p. 19.

33. Nuns's medallions are an instance of the widespread use of devotional miniatures with images of the saints, Christ, or Mary, worn during the colonial period in Latin America. These medallions are referred to in Spanish as *relicarios,* though they were not reliquaries in the contemporary English sense of the word. A study of this visual form is by Martha J. Egan, *Relicarios: Devotional Miniatures from the Americas,* cited above.

34. Mariano Picón-Salas, *A Cultural History of Spanish America: From Conquest to Independence* (1944), trans. Irving A. Leonard (Berkeley: University of California Press, 1962), p. 103.

35. Paz, *The Labyrinth of Solitude*, trans. Lysander Kemp et al. (rev. ed. New York: Grove Press, 1985), p. 115.

36. Sor Juana Inés de la Cruz, Soneto 145, "Este que ves," *Obras completas* (Mexico City: Editorial Porrúa, 1989), p. 134. The phrase *diversa de mi misma*" is from Romance 51, p. 73.

37. Sor Juana Inés de la Cruz, Sonnet 145, "These lying pigments," trans. Alan Trueblood, *A Sor Juana Anthology* (Cambridge: Harvard University Press, 1988), p. 95. Trueblood's translation inevitably misses some the *agudeza*, the wit of the repeated play of contraries: *engaño colorido* (painted, brilliant, vibrant, colorful deceit) *falso silogismos de colores* (false syllogisms of color), *cauteloso engaño del sentido* (cunning deceit of the senses).

38. Margaret Rich Greer's study of the Spanish Baroque writer María de Zayas suggests that Kahlo's work might also be usefully compared to this contemporary of Sor Juana's. The depiction of graphic physical suffering, the porosity of the self and its surroundings, multiple repeating images, exaltation through the martyrdom of (female) flesh: these elements are as characteristic of María de Zayas's seventeenth-century prose fiction as they are of Kahlo's twentieth-century self-portraits. See chs. 8, 9, and 10 of Greer's *María de Zayas tells Baroque Tales of Love and the Cruelty of Men* (University Park: Pennsylvania State University Press, 2000), pp. 239–347.

39. Paz, *Sor Juana, or the Traps of Faith*, p. 84, my emphasis.

40. See the discussion of this fascinating subgenre of Mexican female portraiture by Kirsten Hammer, "*Monjas Coronadas:* The Crowned Nuns of Viceregal Mexico," in *Retratos: 2,000 Years of Latin American Portraits* (New Haven: Yale University Press, 2004), pp. 86–101.

41. Ex-votos are also referred to as *retablos*, though they are not to be mistaken for the huge altarpieces that are properly termed as such. See Gloria Fraser Giffords et al., *The Art of Private Devotion: Retablo Painting of Mexico* (Fort Worth: The Meadows Museum/Southern Methodist University, 1991).

42. The iconography of the dagger in the heart *la Dolorosa* derives from the biblical passage describing the presentation of the infant Christ in the temple (Luke 2:22–32); the aged prophet Simeon tells Mary that "a sword will pierce your own soul too." Sor Juana engages the Petrarchan image of a deer pierced with arrows in Lira 211: "Amado dueño mío" ("Belovèd of My Life") to express the suffering caused by separation from one's beloved (see fig. 5.7), a meaning that would apply to Frida's little deer as well. I am indebted to Margaret Rich Greer for this observation.

43. Beneath the reproduction of *My Birth* in Hayden Hererra's biography of Kahlo, the author places the image of a stone carving of Tlazoltéotl at the moment giving birth; she is silent on the painting of *la Dolorosa* within the painting.

44. Pál Keleman, *Baroque and Rococo in Latin America* (New York: McMillan, 1951), p. 221. See also *Baroque to Folk / De lo barroco a lo popular* (Santa Fe: Museum of New Mexico Press, 1980).

45. Robert Harbison, *Reflections on Baroque* (Chicago: University of Chicago, 2000), p. 167, my emphasis.

46. The depiction of Tehuanas was common in the early decades of the twentieth century, and Kahlo's wearing of Tehuana *huipiles* corresponds to this post-Revolutionary practice of celebrating (and appropriating) indigenous cultures. See the exhibition catalogue *Del istmo y sus mujeres: Tehuanas en el arte mexicano* (Mexico City: Museo Nacional de Arte, 1991).

47. For reproductions of the work of this provincial artist, see the exhibition catalogue *Hermengildo Bustos: 1832–1907* (Mexico City: Museo Nacional de Arte, 1993). See also Raquel Tibol, *Hermenegildo Bustos: Pintor de pueblo* (Mexico City: Ediciones Era, 1981), and Octavio Paz, "I, a Painter, an Indian from This Village," in *Essays on Mexican Art*, pp. 85–110. Paz writes that Bustos is unlike Baroque painters in not wishing to paint singular or exceptional portraits; I would argue, on the contrary, that this fact links him to Baroque portraiture, with its tendency toward type and archetype. See Paz's essay online at http://home.earthlink.net/~cheetahead/bustos.html.

48. Miguel Fernández-Braso, *Gabriel García Márquez: Una conversación infinita* (Madrid: Editorial Azur, 1969), p. 75, my translation. Elsewhere, García Márquez again refers to the Baroque tradition engaged by contemporary Latin American novelists: "Nosotros arrancamos, estamos muy fundados en el Siglo de Oro español" (78); (Our point of departure, our roots, are in the Spanish Golden Age).

49. García Márquez, *Vivir para contarla* (New York: Knopf, 2002), p. 4; *Living to Tell the Tale,* trans. Edith Grossman (New York: Knopf, 2003), p. 4.

50. García Márquez, *Love in the Time of Cholera,* trans. Edith Grossman (New York: Alfred A. Knopf, 1988), p. 62.

51. García Márquez, *El amor en los tiempos del cólera* (Barcelona: Bruguera, 1985), p. 249; *Love in the Time of Cholera,* p. 169.

52. Jaime Cuadriello, *Catálogo comentado del acervo del Museo Nacional de Arte: Nueva España,* vol. 1 (Mexico City: Universidad Nacional Autónoma de México/Conaculta-Instituto Nacional de Bellas Artes, 1999), pp. 57–58. See also Marcus B. Burke, *Treasures of Mexican Colonial Painting* (Museum of New Mexico Press/Davenport Museum of Art, 1998), pp. 89–92.

53. García Márquez, *Cien años de soledad* (Buenos Aires: Editorial Sudamericana, 1967), p. 205; *One Hundred Years of Solitude,* trans. Gregory Rabassa (New York: Avon Books, 1970), p. 223.

54. See Vera Kutzinski, "The Logic of Wings: Gabriel García Márquez and Afro-American Literature," in *García Márquez,* ed. Robin Fiddian (London: Longman,

1995), pp. 214–28. Kutzinski depends upon Enrique Pupo-Walker's research in Afro-Caribbean narrative, especially his essay "El carnero y una forma seminal del relato afro-hispánico," in *Homenaje a Lydia Cabrera,* ed. Reinaldo Sánchez and José A. Madrigal (Barcelona: Ediciones Universal, 1977), pp. 251–57. Further literary engagements with this myth of wings, and flying, are found in Alejo Carpentier's *El reino de este mundo* (*The Kingdom of this World*) and Toni Morrison's *The Song of Solomon.*

55. García Márquez, "Un señor muy viejo con unas alas enormes" (1968), in *La increíble y triste historia de la cándida Eréndira y de su abuela desalmada* (Buenos Aires: Editorial Sudamericana, 1973); "The Very Old Man with Enormous Wings," trans. Gregory Rabassa, in *Collected Stories* (New York: Harper and Row, 1984), p. 210.

56. Carmelo Gariano, "La dimensión grotesca del barroco en *Cien años de soledad,*" in *El barroco en América,* XVII Congreso del Instituto Internacional de Literatura Iberoamericana, vol. 1 (Madrid: Universidad Complutense, 1978), p. 699. This collection of essays covers the New World Baroque in literature from colonial to contemporary times, and includes four essays on Baroque aspects of García Márquez's fiction.

57. Martin, *Baroque,* p. 74. Eugenio d'Ors also makes this point in his 1931 seminar on the Baroque at the Abbey of Pontigny in France. Contrasting Classicism to the Baroque, he writes: "By contrast, it seemed fruitful to me to bring up the issue of caricature, always opportune when discussing the Baroque. The taste for caricature (in effect, for character) as opposed to the cult of regular and canonical beauty—Beauty again!—is one of the most authentic signs of the presence of Baroque culture. The modern world has experienced that attraction, and the examples of Bernini, Callot, and Hogarth were very appropriately cited." *Lo barroco* (1935; Madrid: Editorial Tecnos, 2000), p. 90. Excerpts from this work are translated by Wendy B. Faris, in *Baroque New Worlds: Representation, Transculturation, Counterconquest,* ed. Lois Parkinson Zamora and Monika Kaup (Durham, NC: Duke University Press, forthcoming).

58. Quoted in Jacques Barzun, *From Dawn to Decadence,* p. 136.

59. In *Literary Criticism: A Short History,* William Wimsatt and Cleanth Brooks write: "Aristotle treats virtues no less than vices as clearly conceptualized types, but he has a tendency to see the vices more vividly. The tendency is continued and accentuated by his pupil and successor Theophrastus, in whose *Characters* we find such contrasting pairs as the obsequious man (*areskos*) and the surly (*authades*), the boaster (*alazon*) and the mock-modest (*eiron*). . . . Greek ethical theory and comic theory are strongly alike in finding vice, much more than virtue, susceptible of fixed portraiture." In English Baroque drama, the Theophrastan "character" is basic to the work of Ben Jonson; the monstrous cruelties of the powerful are vividly dramatized in the work of John Webster and, of course, in much of Shakespeare, beginning with *Titus Andronicus.* See William K. Wimsatt, Jr., and Cleanth Brooks, *Literary Criticism: A Short History* (New York: Vintage Books, 1957), pp. 49, 174 ff. The Spanish precursors of Lope and Calderón—late Renaissance dramatists such as Juan de la Cueva and Cristobal Virués—drew heavily upon Senecan drama, and specialized in the exaggerated portrayal of monstrous rulers.

60. Quoted in Mariano Picón-Salas, *A Cultural History of Spanish America,* p. 93.

61. Margaret Rich Greer, "Spanish Golden Age Tragedy from Cervantes to Calderón," in *A Companion to Tragedy*, ed. Rebecca Bushnell (Oxford: Blackwell, 2005), pp. 351–69. I am indebted to Professor Greer for her comments on my treatment of Baroque theatre; her insights are reflected throughout.

62. Jacques Barzun, *From Dawn to Decadence*, p. 340, Barzun's emphasis.

63. For studies that address Baroque representations of subjectivity in relation to structures of power, see John Dollimore, *Radical Tragedy: Religion, Ideology and Power in the Drama of Shakespeare and his Contemporaries* (London: Palgrave, 1984) and Melveena McKendrick, *Playing the King: Lope de Vega and the Limits of Conformity* (London: Tamesis, 2000). A complementary study of seventeenth-century French drama is Mitchell Greenberg, *Baroque Bodies: Psycholanalysis and the Culture of French Absolutism* (Ithaca: Cornell University Press, 2001).

64. Other Latin American dictator novels are Alejo Carpentier's *Recurso del método* (translated as *Reasons of State*), Carlos Fuentes's *Terra nostra*, Augusto Roa Bastos's *Yo el supremo* (*I the Supreme*), Mario Vargas Llosa's *Conversación el la Catedral* (*Conversation in the Cathedral*) and *La fiesta del chivo* (*The Feast of the Goat*). In an interview in Houston at the time of the publication in English of *The Feast of the Goat*, I asked Vargas Llosa about the origins of the dictator novel:

 It was in the mid-sixties—I think the idea was Carlos Fuentes's. He said, "Why don't we produce a book of short stories in which each of us writes about our own dictator." Fuentes would write about Santa Anna; García Márquez about . . . about . . . who was García Márquez's dictator? (*Someone from the audience shouts "Rojas Pinilla."*) Yes! Yes! Thank you very much! Rojas Pinilla. (*laughter*) My dictator was Sánchez Cerro or perhaps Odrío, Roa Bastos's dictator was Dr. Francia, Carpentier's was Batista, and so on. I don't know why this project dissolved and disappeared; we were very enthusiastic about it at the beginning. But you are right that slowly, novels about dictators began to appear, and it may have been this project that was their source.

 "Vargas Llosa Speaks about Dictator Novels, Globalization, and Writing as Reverse Strip Tease. . ." *Hotel Amerika*, I, 2 (Spring 2003): 27–37.

65. Mikhail Bakhtin's *Rabelais and His World* is the essential text on Baroque caricature and its cousin, the grotesque. Bakhtin argues against the reduction of the grotesque to mere satire, but he does not contest the link between physical exaggeration and the grotesque. In the case of García Márquez's patriarch, caricature, the grotesque, and political satire are inextricably linked. See *Rabelais and His World* (1965) trans. Hélène Iswolsky (Bloomington: Indiana University Press, 1984), p. 306.

66. Robert Harbison, *Reflections on Baroque*, p. 153.

67. Kristin Lohse Belkin, *Rubens* (London: Phaidon Press, 1998), pp. 173–75.

68. Kristin Lohse Belkin, *Rubens*, especially ch. 6, "Grand Allegories," pp. 173–96. For discussions of the relations of representation and power in the French Baroque, see Louis

Marin, "Classical, Baroque: Versailles, or the Architecture of the Prince," in *Baroque Topographies,* ed. Timothy Hampton (New Haven: Yale University Press, 1991), pp. 167–82; and Orest Ranum, "Encrustation and Power in Early Modern French Baroque Culture," also in *Baroque Topographies,* pp. 202–26.

69. The same pairing underpins the paintings of the Colombian artist Fernando Botero, whose caricatures have been convincingly compared to García Márquez's in terms of "a replenished postmodern Latin American Baroque." See Wendy B. Faris, "Larger than Life: The Hyperbolic Realities of Gabriel García Márquez and Fernando Botero," *Word & Image* 17, 4 (2001): 339–59.

70. Walter Benjamin, *The Origins of German Tragic Drama,* pp. 65–91, especially the section entitled "Tyrant as Martyr, Martyr as Tyrant." Benjamin discusses this archetype in Spanish Baroque drama as well as in German drama.

71. See Guillermo Tovar de Teresa's discussion of *el culto a lo cruel* in *México barroco* (Mexico City: SAHOP, 1981), pp. 30–33.

72. García Márquez, *El otoño del patriarca* (1975) (Mexico City: Editorial Diana, 1986), p. 297; *The Autumn of the Patriarch,* trans. Gregory Rabassa (New York: Harper and Row, 1975), p. 269.

73. Irlemar Chiampi, *Barroco y modernidad* (Mexico City: Fondo de Cultura Económica, 2000), p. 33, my emphasis. The first chapter of this book is translated by William Childers, in *Baroque New Worlds,* forthcoming.

74. Gabriel García Márquez, "The Solitude of Latin America," trans. Marina Castañeda, in *Lives on the Line: The Testimony of Contemporary Latin American Authors,* ed. Doris Meyer (Berkeley: University of California Press, 1988), p. 231. García Márquez begins his catalogue: "Our independence from Spanish domination did not put us beyond the reach of madness."

75. Anthony Day and Marjorie Miller, "Gabo Talks," *Los Angeles Times Magazine,* 2 Sept. 1990, p. 35.

76. Severo Sarduy suggests that Baroque hyperbole is always erotic: "Distancia exagerada, todo el barroco es más que una hipérbole, cuyo 'desperdicio' veremos que no por azar es erótico" ("Exaggerated distance, all Baroque is no more than a hyperbole whose 'prodigality' is erotic, and not by accident, as we will see"). "El barroco y el neobarroco," *América latina en su literatura,* ed. César Fernández Moreno (Mexico City: Siglo XXI, 1972), p. 170. This essay is translated by Christopher Leland Winks in *Baroque New Worlds,* forthcoming. See André Jansen's discussion of García Márquez's Baroque eroticism in "Procesos humorísticos de *Cien años de soledad* y sus relaciones con el barroco," in *El barroco en América,* pp. 681–93.

77. Alejo Carpentier, "The Baroque and the Marvelous Real," trans. Tanya Huntington and Lois Parkinson Zamora, in *Magical Realism: Theory, History, Community,* ed. Lois Parkinson Zamora and Wendy B. Faris (Durham, NC: Duke University Press, 1995), p. 93.

78. Heinrich Wölfflin, *Principles of Art History: The Problem in the Development of Style in Later Art* (1915), trans. M. D. Hottinger (New York: Dover, 1950), p. 10, my emphasis.

79. There is a striking resemblance between Leonard's description of the "American-born aristocracy" and García Márquez's Marquis of Casalduero; furthermore, Leonard's description of the cultural capital to be gained by marrying across social and racial categories is applicable to the marriage of Sierva María's parents. See Irving A. Leonard, *Baroque Time in Old Mexico: Seventeenth-Century Persons, Places, and Practices* (Ann Arbor: University of Michigan Press, 1959), especially ch. 3, "Baroque Society," pp. 37–52.

80. García Márquez, *Del amor y otros demonios* (New York: Penguin Books, 1994), p. 109; *Of Love and Other Demons*, trans. Edith Grossman (New York: Alfred Knopf, 1995), p. 80.

81. García Márquez, interview with Marlise Simmons, "García Márquez on Love, Plagues, and Politics," *New York Times Book Review*, 21 February 1988, p. 23. The interviewer asks García Márquez what happens once he has the image, and he replies: "The image grows in my head until the whole story takes shape as it might in real life. The problem is that life isn't the same as literature, so then I have to ask myself the big question: How do I adapt this, what is the most appropriate structure for this book? I have always aspired to find the perfect structure."

82. Viz. Mark 16:9 and Luke 8:2–3. Cayetano Delaura refers to these and other biblical exorcisms in a conversation with Sierva María's father: "He explained the significance and methodology of exorcism. He spoke of the power given by Jesus to his disciples to expel unclean spirits from bodies and to heal sickness and disease. He recounted the Gospel parable of Legion and the two thousand swine inhabited by demons" (*Of Love and Other Demons*, p. 110).

83. See Peter Murray and Linda Murray, eds. *The Oxford Companion to Christian Art and Architecture.* New York: Oxford University Press, 1996, pp. 291–93.

84. Two far-reaching studies of this figure are Katherine Ludwig Jansen, *The Making of the Magdalen: Preaching and Popular Devotion in the Middle Ages* (New Jersey: Princeton University Press, 2000), and Susan Haskins, *Mary Magdalen: Myth and Metaphor* (New York: Riverhead Books, 1993).

85. Jacobus de Voragine, *The Golden Legend*, vol. 1, pp. 374–83.

86. Pedro Claver is a "Baroque saint," though he was not canonized until 1888. See the article by Miguel Arnulfo Angel that convincingly links a number of settings and characters in *Of Love and Other Demons* to historical places and personages in Cartagena. "Cartagena de Indias en la ficción garciamarquiana: *Del amor y otros demonios*," *Revista casa del tiempo* (March 2001): http://www.uam.mx/difusion/revista/mar2001/arnulfo .html.

87. García Márquez's Cayetano has been linked to the Baroque saint St. Cayetano of Thiene (1480–1547, canonized 1671), in part because of his correspondence with the Augustinian nun Laura Mignani. He founded the Oratory of Divine Love for pious

priests, and the congregation of the Theatines. The son of a count, he made a vow of poverty and practiced extreme self-deprivation; he is, perhaps for this reason, patron saint of the unemployed. See John Cussen, "García Márquez's *Of Love and Other Demons*," http://www.findarticles.com.

88. Jacques Barzun, *From Dawn to Decadence*, p. 212. These seemingly contradictory belief systems operated in tandem: Barzun gives the examples of the English scientists and metaphysicians Joseph Glanvill and Sir Thomas Browne, and he also mentions the execution of nineteen witches in Salem, Massachusetts, in 1692—reminding us that it was not only in Catholic contexts that inquisitorial methods existed alongside the beginnings of modern science.

89. Hélène Cixous and Katherine Clément, *The Newly Born Woman*, trans. Betsy Wing (Minneapolis: University of Minnesota Press, 1986), p. 11, Cixous and Clément's emphasis. I am indebted to Denea Stewart for pointing to this passage and, more generally, for sharing with me her interpretation of *Of Love and Other Demons*.

90. Rosario Castellanos, "Si 'poesía no eres tú' entonces ¿qué?" in *Mujer que sabe latín* (Mexico City: Fondo de Cultura Económica, 1984), pp. 206–7; "If Not Poetry, Then What?" trans. Maureen Ahern, in *A Rosario Castellanos Reader,* ed. Maureen Ahern (Austin: University of Texas Press, 1988), p. 258.

91. In his autobiography, García Márquez writes of the mixture of languages spoken during his childhood in his grandparents' home; the first sentence of this passage refers to the grandparents of his grandparents:

> La lengua doméstica era la que sus abuelos habían traído de España a través de Venezuela en el siglo anterior, revitalizada con localismos caribes, africanismos de esclavos y retazos de la lengua guajira, que iban filtrándose gota a gota en la nuestra. La abuela se servía de ella para despistarme sin saber que yo la entendía mejor por mis tratos directos con la servidumbre. Aún recuerdo muchos: *atunkeshi,* tengo sueño; *jamusaitshi taya,* tengo hambre; *ipuwots,* la mujer encinta; *aríjuna,* el forastero, que mi abuela usaba en cierto modo para referirse al español, al hombre blanco y en fin de cuentas al enemigo. (*Vivir para contarla,* 75–76)
>
> [Their domestic language was the one that their grandparents had brought from Spain across Venezuela in the previous century, revitalized by Caribbean localisms, the Africanisms of slaves, and fragments of the Guajiro language that filtered into ours, drop by drop. My grandmother would use it to conceal things from me, not realizing I understood it better than she because of my direct dealings with the servants. I still remember many terms: *atunkeshi,* I'm sleepy; *jamasaitshi taya,* I'm hungry; *ipuwots,* the pregnant woman; *aríjuna,* the stranger, which my grandmother used in a certain sense to refer to the Spaniard, the white man, in short, the enemy. (*Living to Tell the Tale,* 64)]

CHAPTER FIVE

1. Heinrich Wölfflin, *Principles of Art History: The Problem in the Development of Style in Later Art* (1915), trans. M. D. Hottinger (New York: Dover, 1950), p. 4–6 (page 5 is an

illustration). Wölfflin was the first to define the Baroque as an art historical style in his 1888 monograph, *Renaissance and Baroque,* trans. Kathrin Simon (Ithaca: Cornell University Press, 1965).

2. Gilles Deleuze, *The Fold: Leibniz and the Baroque* (1988), trans. Tom Conley (Minneapolis: University of Minnesota Press, 1993), p. 3.

3. Severo Sarduy, *Barroco* (1974), collected in *Ensayos generales sobre el barroco* (Mexico City: Fondo de Cultura Económica, 1987), p. 149.

4. See Joan Corominas and José A. Pascual, *Diccionario crítico etimológico castellano y hispánico* (Madrid: Editorial Gredos, 1980), who note various meanings of *berrueco,* all of which involve excrescences, lumps, bumps, humps, and so on. The modern word for wart in both Portuguese and Spanish is *verruga.*

5. Beyond Carpentier's desire to contest the modern prejudice against the "ugly" Baroque, it should be noted that a frequent Baroque *coincidentia oppositorum* involved the tension between ugliness and beauty, horror and delight. How Baroque artists could portray mayhem in the service of religious devotion, for example, elicited considerable commentary. See Keith Christiansen, "Going for Baroque: Bringing Seventeenth-Century Masters to the Met," *The Metropolitan Museum of Art Bulletin,* vol. 62, 3 (2005), p. 30.

6. Erwin Panofsky, "What is Baroque?" (1934), in *Three Essays on Style,* ed. Irving Levin (Cambridge: MIT Press, 1993), p. 19

7. The definition is from George Kubler's *The Shape of Time: Remarks on the History of Things* (New Haven: Yale University Press, 1962), p. 128.

8. Marie-Pierrette Malcuzynski notes that not just the vowels but all of the letters of these mnemonic words were significant, and that some had four syllables rather than three, indicating the nature of the propositions and also the relation of the syllogistic structure to others. She cites the *Summulae logicales* by Pietro Ispano (Kubler refers to him as Petrus Hispanus), a scholastic who was born in Lisbon between 1210 and 1220, and died in 1277. His *Summalae logicales* lists a series of mnemonic constructions, including "barbara, celarent, darii, ferion, baralipton, cesare, camestres, festino, baroco, darapti." With regard to *baroco,* Malcuzynski writes: "The letter B demonstrates that it is an irregular syllogism reducible to the first mode of the first figure (Barbara) and the letter C [in *baroco*] indicates the way in which the reduction is effected." Malcuzynski also traces other etymologies of the term, in "Le (Neo)Baroque: Enquête critique sûr la transformation et l'application d'un champ notionnel," *Imprévue* 1 (1987): 28; this essay is translated by Wendy B. Faris, in *Baroque New Worlds: Representation, Transculturation, Counterconquest,* ed. Lois Parkinson Zamora and Monika Kaup (Durham, NC: Duke University Press, forthcoming).

9. This final phrase is Jacques Barzun's: "Often the two styles mingled, as at Versailles, where the façade is flat and calm and the interior exuberant. The artists of the long century seem to divide, some like Vermeer and Claude Lorraine (*le Lorrain*) preferring quiet interiors or landscapes as subjects, and others such as Bernini and Tiepolo choos-

ing intense activity and crowds drawn, more and more accurately, from history and myth." *From Dawn to Decadence* (New York: HarperCollins Publishers, 2000), p. 336.

Frank J. Warnke makes a similar distinction in his comparative discussion of European Baroque literature:

> At least two trends, or, as I have called them, options, are recurrently perceptible amid this variety—the spare, witty, intellectual, paradoxical trend typified by Donne, Herbert, Marvell, Sponde, Quevedo, Huygens, and Fleming; and the ornate, exclamatory, emotional, and extravagant trend typified by Crashaw, Gryphuis, Marino, d'Aubigné, Góngora, and Vondel. The latter option—for many authorities the quintessential Baroque—might for convenience's sake be designated as "High Baroque." The former option—the style of "metaphysical" poetry—might be designated as "Mannerist." The latter term would, so used, have the advantage of including not only the Metaphysical poets but also such figures as Webster, Gracián, Sir Thomas Browne, Pascal, and the early Corneille.

Frank J. Warnke, *Versions of Baroque: European Literature in the Seventeenth Century* (New Haven: Yale University Press, 1972), p. 12.

10. Efraín Kristal discusses Borges's early translation of Sir Thomas Browne, published in *Inquisiciones* (1925), as well as the reference by Borges's narrator at the end of "Tlön, Uqbar, Orbis Tertius" to his "Quevedian translation" of Browne's *Urn Burial.* Kristal stresses Borges's engagement of the "pathos" and "stoicism" of both Browne and Quevedo. See *Invisible Work: Borges and Translation* (Nashville: Vanderbilt University Press, 2002), pp. 91–96.

11. Emir Rodríguez Monegal addresses the centrality of the Spanish Baroque to Borges's work in "Borges, lector del barroco español," in *El barroco en América* (XVII Congreso del Instituto Internacional de Literatura Iberoamericana), vol. 1. (Madrid: Universidad Complutense, 1978), pp. 453–69.

See also David Huerta, "La querella hispánica de Borges," *Letras libres* 1, no. 8 (August 1999): 50–53. Huerta gives Borges's attitude toward Baltasar Gracián as an example of his complex relation to the Spanish Baroque: "The involuted and pompous Baltasar Gracián, pontiff of *conceptismo,* irritated and exasperated [Borges], who made open fun of aspects of [Gracián's] prose, which he considered ridiculous; but Borges was also interested in the geometry of his thinking and in the Baroque nature of his expression" (52, my translation). See also Rosa Pellicer, "Borges, lector de Gracián: Laberintos, retruécanos, emblemas," Borges Studies On Line, http://www.hum.au .dk/romansk/borges/bsol/rp1.htm.

12. Borges, "Quevedo," *Otras inquisiciones* (1952); *Obras completas* (Buenos Aires: Editorial Emecé, 1974), vol. 2, p. 44; "Quevedo," *Other Inquisitions 1937–1952,* trans. Ruth L. C. Sims (Austin: University of Texas Press, 1965), p. 42.

13. Borges's individual works are not monumental, but of course his entire production is. See Eliot Weinberger, "Borges: La biblioteca parcial," *Letras libres* 1, 8 (August 1999), pp. 36–38. Weinberger addresses Borges's huge production, of which fully two-thirds is not collected in the *Collected Works:*

The first three volumes of the *Complete Works* include less than one hundred essays; the fourth adds another three hundred, which still leaves out some two-thirds of the uncollected work. The partial inventory of what is left out of the *Complete Works* includes ultraist articles and manifestos; the three repudiated books of essays; a majority of the articles on Germany, anti-Semitism and the Second World War; almost all the film criticism; a good number of articles on writers and personalities in Argentine culture; the attacks on Perón; countless book reviews and miscellaneous prologues; the thirty prologues he wrote for the Library of Babel collection of fantastic literature; dozens of transcripts of lectures; the articles for Spanish newspapers during his last years; and some of his most important essays, for example: "Our Inabilities" (perhaps the first text that relates machismo and homosexuality), "The Labyrinths of the Detective Story and Chesterton," "The Total Library," "On Literary Description," "The Paradox of Apollinaire," "Personality and the Buddha," "The Innocence of Layamon," "The Scandanavian Destiny," "The Dialogues of Ascetic and King," and "A History of the Echoes of a Name"—to name only a few. (Not to mention countless poems, especially from the ultraist years, and several stories.) (38, my translation)

The essays named are now available in English in Weinberger's collection, *Jorge Luis Borges: Selected Non-Fictions* (New York: Viking, 1999).

14. José Antonio Maravall, *La cultura del barroco: Análisis de una estructura histórica* (Barcelona: Ariel, 1975), pp. 426, 429; *Culture of the Baroque: Analysis of a Historical Structure* (1975), trans. Terry Cochran (Minneapolis: University of Minnesota Press, 1986), pp. 210, 211, Maravall's emphasis.

15. Carlos Fuentes, "The Accidents of Time," in *The Borges Tradition*, ed. Norman Thomas di Giovanni (London: Constable, 1995), p. 53; originally collected in *Geografía de la novela* under the title "Jorge Luis Borges: La herida de Babel" (Mexico City: Fondo de Cultura Económica, 1993), pp. 32–55.

16. In his "Autobiographical Essay" (1970), Borges writes of Reyes that he "used to invite me to dinner every Sunday at the embassy. I think of Reyes as the finest Spanish prose stylist of this century, and in my writing I learned a great deal about simplicity and directness from him." *The Aleph and Other Stories: 1933–1969,* trans. Norman Thomas di Giovanni (New York: E. P. Dutton, 1970), p. 237. See also Borges's review of Reyes's *Reloj de sol* in *El idioma de los argentinos* (1928; Madrid: Alianza Editorial, 1998), pp. 110–16, and Borges's eulogy of Reyes in 1959, in which he acknowledges his debt to Reyes's "example": "La vasta biblioteca que Alfonso Reyes ha legado a su patria no es otra cosa que un símbolo imperfecto y visible" (The vast library that Alfonso Reyes has left to his country is nothing other than an imperfect and visible symbol). He celebrates Reyes's capacity to discover "secretas y remotas afinidades, como si todo lo escuchado o leído estuviera presente, en una suerte de mágica eternidad" (secret and remote affinities, as if everything he heard or read were present in a kind of magic eternity). "Alfonso Reyes," *Borges en Sur (1931–1980)* (Buenos Aires: Emecé, 1999), p. 62.

For a detailed study of this essential friendship, see Amelia Barili, *Jorge Luis Borges y Alfonso Reyes: La cuestión de la identidad del escritor latinoamericano* (Mexico City: Fondo de Cultura Económica, 1999). A useful textual account of Borges's ref-

erences to Reyes, and Reyes's references to Borges, as well a discussion of their literary friendship, is Miguel Capistrán, *Borges y México* (Mexico City: Plaza y Janés, 1999), pp. 61–122.

17. Borges, "Menoscabo y grandeza de Quevedo" in his first volume of prose, *Inquisiciones* (1925; Madrid: Alianza Editores, 1998), pp. 42–49; and "Examen de un soneto de Góngora" in his second volume, *El tamaño de mi esperanza* (1926; Barcelona: Seix Barral, 1994), pp. 111–16. In *Inquisiciones* Borges also wrote on Sir Thomas Browne and translated selected passages of *Religio medici* ("Sir Thomas Browne," *Inquisiciones,* pp. 33–41); there is, furthermore, an essay on John Milton ("Milton y su condenación de la rima," pp. 105–110).

18. See Borges's "manifesto" "Apuntaciones críticas: La metáfora" (1921), in *Las vanguardias literarias en Hispanoamérica (manifiestos, proclamas y otros escritos)*, ed. Hugo Verani (Rome: Bulzoni, 1986), pp. 275–81. Several other texts by Borges from this period are included in this useful anthology.

19. Beatriz Sarlo, "Un ultraísta en Buenos Aires," *Letras libres* 1, 8 (August 1999), p. 42, my translation. In this regard, Jason Wilson asserts that Borges's dismissal of the Baroque during the twenties was tied to his effort to evade the political commitment of the avant garde, and more especially the French avant garde: "However Borges may have felt the thrill of being modern in the 1920s . . . he soon turned his back on the dangers and risks of avant-garde poetry by confusing it with baroque over-writing, with being rhetorical and insincere." "Jorge Luis Borges and the European Avant-Garde," in *Borges and Europe Revisited,* ed. Evelyn Fishburn (London: Institute of Latin American Studies and the University of London, 1998), p. 75. See also the comparative study of *ultraísmo* and other avant garde movements by Beret Strong, *The Poetic Avant-Garde: The Groups of Borges, Auden and Breton* (Evanston: Northwestern University Press, 1997).

20. Borges, "Examen di un soneto de Góngora," in *El tamaño de mi esperanza,* p. 116.

21. In his 1928 collection, *El idioma de los argentinos,* Borges addresses Góngora's tercentenary with a dour little piece of four short paragraphs entitled "Para el centenario de Góngora" in which he affirms his distaste for Góngora and then condemns him with faint praise by expressing the hope that he will be proven wrong. Wrong or no, it is clear that Borges was intensely engaged in assessing his Baroque precursors during this period; of the fifteen essays of *El idioma de los argentinos,* besides the note on Góngora, three are devoted to Baroque writers and subjects: "El culteranismo," "Un soneta de don Francisco de Quevedo," and "La conducta novelística de Cervantes."

22. Borges refused to adopt *indigenista* rhetoric, which must have seemed to him at the time a kind of sentimental revisionism. In his 1959 eulogy for Alfonso Reyes, Borges writes:

> . . . somos herederos de todo el pasado y no de los hábitos o pasiones de tal o cual estirpe. Como el judío de la tesis de Veblen, manejamos la cultura de Europa sin exceso de reverencia. (En cuanto a las culturas indígenas, imaginar que las continuamos es una afectación o un alarde romántico.)

. . . we are heirs to all of the past and not just to the habits or passions of this or that ancestry. Like the Jew in the thesis of Veblen, we handle European culture without excessive reverence. (As for indigenous cultures, to imagine that we continue them is an affectation or a Romantic boast.)]

Borges, "Alfonso Reyes," *Borges en Sur (1931–1980),* pp. 60–61, my translation.

23. Borges's Argentine conception of *criollismo* differs, of course, from that in New Spain discussed in Chapter 1, most obviously in being a product of twentieth-century conditions rather than seventeenth- and eighteenth-century ones. See "Queja de todo criollo" in his first volume of prose, *Inquisiciones,* in which he identifies with the Argentine *criollo*—Spanish in origin, conservative politically, and who, according to Borges, scorns ostentation and prefers silence. Emir Rodríguez Monegal places this early essay in its social and political context in "Borges and Politics," *Diacritics* 8, 4 (Winter 1978), pp. 55–69.

24. In his "Autobiographical Essay," Borges refers to these banned collections:

> Three of the four essay collections—whose names are best forgotten—I have never allowed to be reprinted. When in 1953 my present publisher—Emecé—proposed to bring out my "complete writings," the only reason I accepted was that it would allow me to keep those preposterous volumes suppressed. This reminds me of Mark Twain's suggestion that a fine library could be started by leaving out the works of Jane Austen, and that even if that library contained no other books it would still be a fine library, since her books were left out. . . . Until a few years ago, if the price was not too stiff, I would buy up copies and burn them.

Borges, "Autobiographical Essay" (1970), trans. Norman Thomas di Giovanni, *The Aleph and Other Stories 1933–1969,* pp. 230–31.
 Beret Strong asks interesting questions about Borges's "selective canonical suppressions" and about the complicity of current literary critics in *The Poetic Avant-Garde,* pp. 80 ff.

25. Borges, "I Always Thought of Paradise as a Library," *Borges at Eighty: Conversations,* ed. Willis Barnstone (Bloomington: Indiana University, 1982), p. 123. Borges's simultaneous identification with, and depreciation of the Spanish Baroque is clear in a 1986 interview, where he says of his early poem "Baltasar Gracián" that it "makes fun of me. I am the Gracián of that poem." Carlos Cortinez, ed. *Borges the Poet* (Fayetteville: University of Arkansas Press, 1986), p. 43. Borges's poem reads in part:

> Laberintos, retruécanos, emblemas
> Helada y laboriosa nadería,
> Fue para este jesuita la poesía,
> Reducida por él a estratagemas.
>
> No hubo música en su alma, sólo un vano
> Herbario de metáforas y argucias.

[Labyrinths, puns, emblems
Frozen and laborious nothings,
were what poems were to this Jesuit,
Which he reduced to strategems.

There was no music in his soul, just a vain
herbarium of metaphors and witticisms.]

Borges, *El otro, el mismo* (1964); *Obras completas,* vol. 2, p. 259.

26. Emir Rodríguez Monegal, *Jorge Luis Borges: A Literary Biography* (New York: Dutton, 1978), p. 213.

27. Beatriz Sarlo cites a 1969 interview, in which Borges acknowledged this trajectory:

Es curiosa la suerte del escritor. Al principio es barroco, vanidosamente barroco, y al cabo de los años puede lograr . . . no la sencillez que no es nada, sino la modesta y secreta complejidad.

[The fate of the writer is strange. At first he is arrogantly baroque, and at length he achieves . . . not simplicity, which is nothing, but a modest and secret complexity.]

Sarlo recognizes this "secret complexity"—this secret baroque—in Borges's work, specifically in his story "Emma Zunz," where she notes that "La trama es barroca aunque la maestría de Borges la presente sencillamente" (The plot is Baroque although the masterful technique of Borges presents it simply). *La pasión y la excepción* (Buenos Aires: Siglo XXI Argentina, 2003), p. 122.

28. Borges, "Prólogo a la edición de 1954," *Historia universal de la infamia* (1935); *Obras completas,* vol. 1, p. 291.

29. Borges, preface to the 1954 edition, *A Universal History of Infamy,* trans. Norman Thomas di Giovanni (London: Penguin Books, 1970), p. 11. Borges's formulation is familiar to readers of contemporary U.S. literature through John Barth's use of the phrase in his influential essay, "The Literature of Exhaustion," *Atlantic* (August 1967): 29–34, reprinted in *The American Novel since World War II,* ed. Marcus Klein (New York: Fawcett Publications, 1969), pp. 267–79.

30. Borges was consistent in his depreciation of the Baroque as a general stylistic category, though there are occasional moments of ambivalence. For example, in a 1974 interview about film, Borges says about Josef von Sternberg:

su estilo narrativo se convirtió después en nada más que barroquismo, pero pienso que sin esa etapa no se hubiese llegado a Orson Welles quien, con otros elementos y por otro camino, ejercitó también un estilo barroco. Confieso que fui injusto con *El ciudadano,* al que juzgo ahora realmente importante.

[his narrative style later became merely Baroque, but I think that without that stage Orson Welles wouldn't have been possible; with other elements and by another path, he also exercised a Baroque style. I confess that I was unfair about *Citizen Kane*, which I now consider very important.]

Borges, "Cine: Conversación con Borges," *Borges en Sur (1931–1980)*, pp. 318–19.

31. Gonzalo Celorio, "Del barroco al neobarroco," *Ensayo de contraconquista* (Mexico City: Tusquets, 2001), p. 100.

32. In fact, Celorio's full statement in *Ensayo de contraconquista* echoes Borges:

> Así considerada, la parodia implica un doble discurso, una doble textualidad: un discurso referencial, previo, conocido y reconocible, que es deformado, alterado, escarnecido, llevado a sus extremos por el discurso del barroco. Tal operación supone un retorno; es en sí misma un retorno. La parodia, según entiendo, no es otra cosa que llegar, *de regreso*, al punto de partida y recuperarlo—esto es preservarlo, enriquecerlo—con los beneficios adquiridos en semejante periplo: la crítica (del sentido del humor, el homenaje) que la distancia y la perspectiva otorgan. (101, author's emphasis)

> [From this point of view, parody implies a double discourse, a double textuality: a prior, known, and recognizable referential discourse is deformed, altered, mocked, and taken to an extreme by the discourse of the Baroque. An operation of this kind implies a return; it is in itself already a return. Parody, as I understand it, is nothing other than a *going back* to the point of departure in order to recover it—that is, to preserve and enrich it with the benefits derived from the journey itself—and the critical perspective (the sense of humor, the act of homage) that distance and a different point of view provide.]

This essay is translated by Maarten van Delden, in *Baroque New Worlds*, forthcoming.

33. Irlemar Chiampi, *Barroco y modernidad* (Mexico City: Fonds de Cultura Económica, 2000), p. 29.

34. James Woodall, *The Man in the Mirror of the Book: A Life of Jorge Luis Borges* (London: Hodder and Stoughton, 1996), pp. 176–77; 181–83.

35. Borges examines the relations between pictorial and narrative illusionism in two essays to which I refer below. Also, see my essay, "The Visualizing Capacity of Magical Realism: Objects and Expression in the Work of Jorge Luis Borges," *Janus Head: An Interdisciplinary Journal* 5, 2 (2002): 21–37.

36. Vladimir Nabokov, *Despair* (New York: G. P. Putnam's Sons, 1965), p. 26.

37. Michel Foucault, *The Order of Things: An Archaeology of the Human Sciences* (1966; New York: Vintage, 1973), p. 51, my emphasis.

38. Though the development of trompe l'oeil devices during the seventeenth century first consolidates the mode as a subversive subcategory of pictorial realism, these devices are known from antiquity, and certainly they continued after the Baroque period, having another moment of popularity during the nineteenth-century, especially in the United States, and then in Surrealism and Pop art in the work of Magritte and Warhol, among others. For a discussion of trompe l'oeil devices over time, see the exhibition catalogue and accompanying essays in Sybille Ebert-Schifferer, *Deceptions and Illusions: Five Centuries of Trompe l'Oeil Painting* (Washington, D.C.: The National Gallery of Art, 2002).

39. See Leon Battista Alberti (1401–72), *On Painting*, trans. John R. Spencer (New Haven: Yale University Press, 1966). Sybille Ebert-Shifferer describes Albertian perspective, which continues to define pictorial realism to our day: "For the scene to appear real, the perspective must be based on the viewer's position; the imaginary window intersects a visual pyramid [that lies horizontally] between the eye and the central vanishing point [the tip of the pyramid]. In this metaphor the picture surface becomes a membrane, which, although transparent, separates the viewer's space from that of the image in an ideally palpable way (Alberti speaks of glass)." "Trompe l'Oeil: The Underestimated Trick," in *Deceptions and Illusions*, p. 21.

40. Jean Baudrillard, "The Trompe l'Oeil," in *Calligram: Essays in New Art History from France*, ed. Norman Bryson (Cambridge: Harvard University Press, 1988), p. 58.

41. John Rupert Martin, *Baroque* (New York: Harper and Row, 1977), p. 155.

42. Sybille Ebert-Schifferer, "Trompe l'Oeil: The Underestimated Trick," *Deceptions and Illusions*, p. 22.

43. Julie Stone Peters, *Theatre of the Book 1480–1880: Print, Text, and Performance in Europe* (New York: Oxford University Press, 2000), p. 183. See ch. 9, "Framing Space: Time, Perspective, and Motion in the Image," pp. 181–200.

44. Henri Lefebvre, *The Production of Space* (1974), trans. Donald Nicholson-Smith (Oxford: Blackwell, 1991), p. 273.

45. See Norman Bryson's discussion of Sánchez Cotán and Francisco Zurburán in *Looking at the Overlooked: Four Essays on Still Life Painting* (Cambridge: Harvard University Press, 1990), pp. 60 ff. Baroque still life reflects the new interest in natural history; during this period, it attained the status of an autonomous genre, though it was not yet considered on an equal plane with historical, mythological and religious paintings.

46. Deleuze, *The Fold: Leibniz and the Baroque*, p. 123.

47. I cited Frank J. Warnke on this matter in the previous chapter; Warnke notes that the intellectual activity leading to ecstatic experience was often exercised in a rigidly formal manner, a detail that conforms to Hladik's rigorous literary enterprise in this story. *Versions of Baroque* (New Haven: Yale University Press, 1972), p. 52.

48. King Christian V of Denmark is pictured in Roman dress in the lower left-hand corner, and above him is an oval portrait of his father, King Frederik III. Christian V commissioned the painting, and his name appears in large script on the unfolded document in the center of the composition. See Anna Tummers's textual note on this painting in *Deceptions and Illusions: Five Centuries of Trompe l'Oeil Painting*, p. 188.

49. Borges, "Tlön, Uqbar, Orbis Tertius," trans. James E. Irby, *Labyrinths*, ed. Donald A. Yates and James E. Irby (New York: New Directions, 1962), p. 16.

50. I am grateful to Evelyn Fishburn for calling this point to my attention. See her article, "A Footnote to Borges Studies: A Study of the Footnotes," University of London Institute of Latin American Studies, Occasional Papers No. 26, p. 11. Fishburn writes about Borges's footnotes in terms of "layers of interpretation," asserting that they "stand as intermediaries between author and reader; they are both inner and outer directed" (13).

51. Deleuze, *The Fold: Leibniz and the Baroque*, p. 5.

52. John Rupert Martin's describes the Baroque "principle of co-extensive space" as a reaction to scientific discoveries, in *Baroque*, pp. 155, 161.

53. Borges, "La esfera de Pascal," *Otras inquisiciones* (1952); *Obras completas*, vol. 2, p. 16; "Pascal's Sphere," trans. Eliot Weinberger, *Selected Non-Fictions*, p. 353.

54. Borges has been compared to Escher in this regard. See, for example, Adriana González Mateos, *Borges y Escher: Un doble recorrido por el laberinto* (Mexico City: Aldus/INBA, 1998).

55. Borges, "La biblioteca de Babel," *Ficciones* (1944); *Obras completas*, vol. 1, p. 465.

56. Borges, "The Library of Babel," trans. James E. Irby, *Labyrinths*, p. 52.

57. Borges, "Pascal's Sphere," *Selected Non-Fictions*, p. 353. In *The Production of Space*, Henri Lefebvre writes: "With the advent of Cartesian logic . . . space had entered the realm of the absolute. As Object opposed to Subject, as *res extensa* opposed to, and present to, *res cogitans*, space came to dominate, by containing them, all senses and all bodies." Outlining briefly the discussion of space in Spinoza, Leibniz, Newton and Kant, Lefebvre concludes: "These protracted debates marked the shift from the philosophy to the science of space" (1–2).

58. Borges, "Pascal," *Otras inquisiciones* (1952); *Obras completas*, vol. 2, p. 81; "Pascal," *Other Inquisitions*, p. 94.

59. In "Pascal," Borges's narrator writes about Pascal's sphere that "the metaphor Pascal uses to define space was used by those who preceded him (and by Sir Thomas Browne in *Religio Medici*) to define the divinity. The grandeur that affects Pascal is not the grandeur of the Creator, but that of Creation." *Other Inquisitions*, p. 94.

60. Borges, "The Aleph," trans. Norman Thomas di Giovanni, *The Aleph and Other Stories: 1933–1969*, p. 29.

61. Borges, "Parábola del palacio," *El hacedor* (1960), *Obras completas*, vol. 2, p. 179; "Parable of the Palace," *Dreamtigers*, trans. Mildred Boyer and Harold Morland (New York: E. P. Dutton, 1970), p. 44.

62. Borges, "La escritura del dios," *El aleph* (1949); *Obras completas*, vol. 1, p. 599; "The God's Script," trans. L. A. Murillo, *Labyrinths*, p. 173.

63. Picón-Salas refers to the philosopher Alejandro Korn's assertion; see *A Cultural History of Spanish America: From Conquest to Independence* (1944), trans. Irving A. Leonard (Berkeley: University of California Press, 1962), p. 93.

64. Octavio Paz, *Sor Juana, or the Traps of Faith*, trans. Margaret Sayers Peden (Cambridge: Harvard University Press, 1988), p. 158.

65. The first phrase is from Borges's essay "Personality and the Buddha," trans. Suzanne Jill Levine, *Selected Non-Fictions*, p. 350; the second, which I cite in full below, is from "A Postulation of Reality," trans. Esther Allen, *Selected Non-Fictions*, p. 61.

66. Kristin Lohse Belkin, *Rubens* (London: Phaidon Press, 1998) pp. 125, 92. Not just Rubens but all Baroque artists "reformulated the canonical models of the High Renaissance. It was in the very act of transgression that Caravaggio secured the admiration of the cognoscenti." Keith Christiansen, *Going for Baroque: Bringing Seventeenth-Century Masters to the Met*, p. 32. Severo Sarduy, quoting Robert Jammes, refers to this Baroque strategy as "reading in filigree" and "disfigurement." See "Lo barroco y lo neobarroco," in *América latina en su literatura.*, ed. César Fernández Moreno (Mexico City: Siglo XXI, 1972), p. 175, 174. This essay is translated by Christopher Leland Winks, in *Baroque New Worlds*, forthcoming.

67. Borges, "La postulación de la realidad," *Discusión* (1932), *Obras completas*, vol. 1, p. 219.

68. Borges, "The Postulation of Reality," *Selected Non-Fictions*, p. 61.

69. Borges, "La busca de Averroes," *El aleph* (1949); *Obras completas*, vol. 1, p. 586; "Averroës' Search," trans. Andrew Hurley, *Collected Fictions* (New York: Penguin Books, 1999), p. 240.

70. Borges, "Prólogo," *Ficciones* (1944); *Obras completas*, vol. 1, p. 429.

71. Borges, "Forward," trans. Andrew Hurley, *Collected Fictions*, p. 67, Borges's emphasis.

72. Irlemar Chiampi, *Barroco y modernidad*, pp. 93–94. Chiampi refers to Sarduy's essay, "Lautréamont y el barroco," in *Lautréamont austral*, ed. Leyla Perrone Moisés and Emir Rodríguez Monegal (Montevideo: Brecha, 1995), p. 121.

73. Evelyn Fishburn, "Hidden Pleasures in Borges's Allusions," in *Borges and Europe Revisited*, pp. 49–59. The quoted phrase is from "Pierre Menard, Author of the Quixote," trans. James E. Irby, *Labyrinths*, p. 44.

74. Borges, "Cuando la ficción vive en la ficción," *Textos cautivos: Ensayos y reseñas en El hogar, (1936–1939),* ed. Enrique Sacerio-Garí and Emir Rodriguéz Monegal (Barcelona: Tusquets, 1986), p. 325; "When Fiction Lives in Fiction," trans. Esther Allen, *Selected Non-Fictions,* p. 160, Borges's ellipsis.

75. Borges, "Pascal," *Other Inquisitions,* p. 96.

76. Borges, "Magias parciales del Quijote," *Otras inquisiciones* (1952); *Obras completas,* vol. 2, p. 47; "Partial Magic in the Quixote," trans. James E. Irby, *Labyrinths,* p. 196.

77. Norman Bryson, *Looking at the Overlooked,* p. 144.

78. Heinrich Wölfflin, *Principles of Art History: The Problem in the Development of Style in Later Art,* p. 3.

79. Jon Thiem, "The Textualization of the Reader in Magical Realist Fiction," in *Magical Realism: Theory, History, Community,* ed. Lois Parkinson Zamora and Wendy B. Faris (Durham, NC: Duke University Press, 1995), p. 244.

80. An exception is Gregg Lambert, who discusses Borges's philosophy of language in terms of seventeenth-century ideas, asserting that "Borges is the precursor of Leibniz; it was not possible for Deleuze to read Leibniz without Borges." *The Non-Philosophy of Gilles Deleuze* (New York: Continuum, 2002), p. 89; see ch. 8, "The Baroque Detective: Borges as Precursor," pp. 73–89.

81. Borges, "Del culto de los libros," *Otras inquisiciones* (1952); *Obras completas,* vol. 2, p. 93; "On the Cult of Books," trans. Eliot Weinberger, *Selected Non-Fictions,* p. 361.

82. See, for example, Frances Yates, *Giordano Bruno and the Hermetic Tradition* (Chicago: University of Chicago, 1964).

83. Paz discusses seventeenth-century hermeticism, based on the second-century texts referred to collectively as the *Corpus hermeticum,* and in particular the work of the Jesuit Athanasius Kircher, an essential source for Sor Juana. *Sor Juana, or the Traps of Faith,* pp. 162–79. Interestingly, he stresses the mathematical version of the Baroque textualization fable: "The Pythagorean and Neoplatonic vision of the universe as number and proportion stimulated Galileo, Copernicus, Kepler, and others. Galileo said that the book of nature was written with mathematical signs, an idea that would have seemed blasphemous to Dante" (256).

84. Elena Isabel Estrada de Gerlero, "El nombre y su morada: Los monogramas de los nombres sagrados en el arte de la nueva y primitiva iglesia de Indias," in *Parábola novohispana: Cristo en el arte virreinal,* ed. Elisa Vargaslugo (Mexico City: Fomento Cultural Banamex, 2000), pp. 177–203.

85. Borges, "Las ruinas circulares," *Ficciones* (1944); *Obras completas,* vol. 1, p. 453

86. Borges, "The Circular Ruins," *Labyrinths,* p. 48

87. Borges, "Nueva refutación del tiempo," *Otras inquisiciones* (1952); *Obras completas,* vol. 2, p. 146.

88. Borges, "A New Refutation of Time," trans. Esther Allen, *Selected Non-Fictions,* p. 329.

89. Octavio Paz, *Sor Juana, or the Traps of Faith,* p. 369. I have revised this translation by substituting the word "dream" for "sleep" in the second sentence. As we have noted, *sueño* means both sleep and dream, and surely Paz refers to Freud's view of dream, not sleep. In the third sentence, the Spanish word *sueño* is maintained in the English translation.

90. Walter Benjamin's *The Origin of German Tragic Drama* (1928), trans. John Osborne (London: Verso, 1977), p. 178.

91. Octavio Paz, *Sor Juana, or the Traps of Faith,* p. 257.

92. In the context of her discussion of Benjamin, Christine Buci-Glucksmann writes that "allegory brushes aside all essentiality, all identity or uniqueness, in accordance with its almost etymological nature: the Greek *allegoria* coming from *allos* ('other') and *agoreuein* ('to speak'). For allegory consists precisely in saying something other than what one means, or in saying one thing so that, by oblique procedure, *another* thing will be understood. But this *discourse through the other* is also *discourse of the Other.*" *Baroque Reason: The Aesthetics of Modernity* (1984), trans. Bryan S. Turner (London: Sage Publications, 1994), p. 138, Buci-Glucksmann's emphasis.

93. Borges, "La conducta novelística de Cervantes" (1928), *El idioma de los argentinos,* p. 123, my translation. In "From Allegories to Novels" (1949, included in *Otras inquisiciones,* 1952), Borges contrasts G. K. Chesterton's understanding of allegory to Benedetto Croce's. According to Borges, Croce refuses allegory "because it aspires to encipher two contents in one form: the immediate or literal one . . . and the figurative one" (155); on the contrary, and to Borges's lifelong approbation, Chesterton embraces the excessive meaning of allegory. Chesterton's work denies "that language is the only way to express reality. . . . With one form of communication declared to be insufficient, there is room for others; allegory may be one of them, like architecture or music" (155). He then cites verbatim a lengthy passage from Chesterton's 1904 study of the English painter G. F. Watts, using Chesterton's metaphor of seeing and painting (tints, colors, tones and semi-tones) to make his point. In fact, he cites this same passage in two other essays, "Nathaniel Hawthorne," and "The Analytical Language of John Wilkins." "From Allegories to Novels," trans. Eliot Weinberger, *Jorge Luis Borges: Selected Non-Fictions,* pp. 337–40.

94. George Steiner, introduction to Walter Benjamin's *The Origin of German Tragic Drama,* p. 9.

95. In his introduction to *The Origin of German Tragic Drama,* Steiner writes about Panofsky's lack of receptivity: "This marks, I think, the most ominous moment in Walter Benjamin's career. It is the Aby Warburg group, first in Germany and later at the Warburg Institute in London, which would have afforded Benjamin a genuine intellectual,

psychological home, not the Horkheimer-Adorno Institute for Research in the Social Sciences with which his relations were to prove so ambivalent and, during his life time, sterile. Panofsky could have rescued Benjamin from isolation; an invitation to London might have averted his early death" (19).

96. Walter Benjamin, *The Origin of German Tragic Drama*, p. 178.

97. For Benjamin, allegory is "a successively progressing, dramatically mobile, dynamic representation of ideas, which has acquired the very fluidity of time"; it "immerses itself into the depths which separate visual being from meaning." *The Origin of German Tragic Drama*, p. 165. In the first sentence of the passage quoted above, Benjamin approvingly quotes Friedrich Creuzer's study of symbol and myth, in which Creuzer links allegory to myth as follows: "There [in the symbol] we have momentary totality; here [in allegory] we have progression in a series of moments; and for this reason, it is allegory, and not the symbol, which embraces myth" (165).

98. Borges, "Pedro Salvadores," *Elogio de la Sombra* (1969); *Obras completas*, vol. 2, p. 373; "Pedro Salvadores," trans. Norman Thomas di Giovanni, *The Aleph and Other Stories: 1933–1969*, p. 189.

99. In "The Wall and the Books," Borges writes: "Music, states of happiness, mythology, faces belabored by time, certain twilights and certain places try to tell us something, or have said something we should not have missed, or about to say something; this imminence of a revelation which does not occur is, perhaps, the aesthetic phenomenon." Trans. James E. Irby, *Labyrinths*, p. 188.

100. Jameson, "Third-World Literature in the Era of Multinational Capitalism," *Social Text* 15 (Fall 1986): 65–88. Jameson writes: "All third-world texts are necessarily, I want to argue, allegorical, and in a very specific way: they are to be read as what I will call *national allegories*, even when, or perhaps I should say, particularly when their forms develop out of predominantly western machineries of representation, such as the novel" (69). Jameson's generalization has rightly elicited refutation; see, for example, Aijaz Ahmad, "Jameson's Rhetoric of Otherness and the 'National Allegory,'" *Social Text* 17 (Fall 1987): 3–27.

101. Theresa M. Kelley, *Reinventing Allegory* (Cambridge: Cambridge University Press, 1997), p. 251. In *Italian Baroque Sculpture,* Bruce Boucher emphasizes the inextricable connection between allegory and emblems: "One of the greatest gulfs between our world and that of the Baroque stems from the decline of allegory as a literary and artistic form. . . . Indeed, allegory was understood as a way of penetrating the mysteries of the natural world which antiquity had enveloped in myth. . . . The popularity of allegory in this period was attested by numerous compilations of mythology; the single most influential volume was, undoubtedly, Cesare Ripa's *Iconologia*" (pp. 18–20, 19 is an illustration).

102. See Oliver Sacks's discussion of the pictorial imagination of the blind and, more generally, the relation of internal representations to abstract thought, in "The Mind's Eye: What the Blind See," *New Yorker* (28 July 2003): 48–59. Sacks quotes one man's expe-

rience of blindness that seems especially relevant: "My [mental] screen was always as big as I needed it to be. Because it was nowhere in space, it was everywhere at the same time. . . . Nothing entered my mind without being bathed in a certain amount of light. . . . In a few months my personal world had turned into a painter's studio" (56).

103. Mariano Picón-Salas, *A Cultural History of Spanish America*, p. 91.

104. Studies of New World *emblemática* abound, most of them informed by Panofsky's work in Baroque iconography. On the nature and use of emblematic images in the literature of New Spain, see José Pascula Buxó, *El resplandor intelectual de las imágenes: Estudios de emblemática y literatura novohispana* (México: Universidad Nacional Autónoma de México, 2002); on the visual nature of emblems during the same period, in *Juegos de ingenio y agudeza: La pintura emblemática de la Nueva España*, ed. Rafael Tovar et al. (Mexico City: Museo Nacional de Arte, 1994), see the essays by Jaime Cuadriello, "Los jeroglíficos de la Nueva España," pp. 84–111, and María Isabel Grañén Porrúa, "El grabado libresco en la Nueva España, sus emblemas y alegorías," pp. 117–31. Marta Fajardo de Rueda focuses on emblems in New Granada in *El arte colonial neogranadino: A la luz del estudio iconográfico e iconológico* (Bogotá: Convenio Andrés Bello, 1999), ch. 4, "La cultura emblemática," pp. 85–113. See also Octavio Paz's discussion of emblematic understanding in seventeenth-century New Spain, in *Sor Juana, or the Traps of Faith*, ch. 11, "The World as Hieroglyph," pp. 155–68.

The art of emblems also flourished in Protestant Europe, as Mario Praz and Albrecht Schoene amply confirm. See Mario Praz, *Studies in Seventeenth-Century Imagery* (Rome: Edizioni de Storia e Litteratura, 1964), translated into Spanish as *Imágenes del barroco: Estudios de emblemática*, trans. José María Parreño (Madrid: Ediciones Siruela, 1989), and Albrecht Schoene, *Emblematick und Drama im Zeitalter des Barock* (Munich: C. H. Beck, 1993).

105. Gerhart Hoffmeister describes the popularity of the emblematic tradition in Europe:

> The humanists had an especially keen interest in the sign languages of the ancients, for example in Egyptian hieroglyphs. In 1505 the Christian interpretation of Horapolon's *Hieroglyphica* was published. Inspired by hieroglyphics, by the epigrams of the Greek Anthology . . . and by the *Physiologus* (second century A.D.), Italian humanists began to produce emblem books constructed in the manner of lexicons; the first and most successful was by A. Alciatus, whose *Emblematum liber*, printed in Augsburg in 1531, became the model of the emblem books and the foundational book of European poetry from the Renaissance to the Pre-Romantic period. Alciatus' book received over one-hundred and seventy editions, and his approximately six hundred followers produced over two thousand emblem books.

Gerhart Hoffmeister, *Deutsche und europäeische Barockliteratur* (Stuttgart: Matzler, 1987), p. 136, trans. Monika Kaup.

106. Carlos Sigüenza y Góngora and Sor Juana Inés de la Cruz both created works of ephemeral architecture. See Octavio Paz's discussion of both in *Sor Juana, or the Traps of Faith*, pp. 149–62.

107. An array of examples can be seen in *Juegos de ingenio y agudeza: La pintura emblemática de la Nueva España,* cited above.

108. Benjamin's full statement is as follows: "For sacred script always takes the form of certain complexes of words which ultimately constitute, or aspire to become, one single and inalterable complex. . . . These latter take the form of hieroglyphics. The desire to guarantee the sacred character of any script—there will always be a conflict between sacred standing and profane comprehensibility—leads to complexes, to hieroglyphics" (175).

109. Borges, "El aleph," *El aleph* (1949); *Obras completas,* vol. 1, p. 624; "The Aleph," trans. Norman Thomas di Giovanni, *The Aleph and Other Stories 1933–1969,* p. 26, my emphasis.

110. Borges, "El idioma analítico de John Wilkins," *Otras inquisiciones* (1952); *Obras completas,* vol. 2, p. 86; "The Analytical Language of John Wilkins," *Other Inquisitions,* p. 103.

111. Michel Foucault, *The Order of Things,* p. xvii.

112. I am indebted to Silvia Spitta, and her discussion of Borges's story and *Wunderkammern* in her preface to *Misplaced Objects/Europe and the Americas post 1492* (Austin: University of Texas Press, forthcoming).

113. The German art historian Franz Roh refers to the altarpiece in similar terms in his 1925 essay defining magical realism in art: "On entering the church, the ensemble of an altar painting unfolded its essential meaning at a hundred paces, and then, as the distance diminished, revealed little by little the new world of the very small in successive planes of details, details that were symbolic of all true *spiritual* knowledge of the world because they always remained subordinate to the total structure. Thus the viewer could satiate himself with minutiae, with the thickness and density of all cosmic relationships.") Franz Roh, "Magical Realism: Post-Expression," trans. Wendy B. Faris, in *Magical Realism: Theory, History, Community,* ed. Lois Parkinson Zamora and Wendy B. Faris (Durham, NC: Duke University Press, 1995), p. 30.

CONCLUSION

1. Julio Cortázar, *Realidad y literatura en América Latina/Reality and Literature in Latin America,* The Jacob C. Saposnekow Memorial Lecture, 1980, ed. and trans. Gabriella de Beer and Raquel Chang-Rodríguez (New York: City College, 1982), p. 13.

2. Irlemar Chiampi, *Barroco y modernidad* (Mexico City: Fondo de Cultura Económica, 2000), p. 29, my translation. The conceptual genealogy that follows is informed by Chiampi's excellent overview of the matter in ch. 1, "El barroco en el ocaso de la modernidad," pp. 17–41.

3. Severo Sarduy, "El barroco y el neobarroco," in *América latina en su literatura,* ed. César Fernández Moreno (Mexico City: Siglo XXI, 1972), p. 183; "The Baroque and the Neobaroque," trans. Mary G. Berg, in *Latin America in its Literature,* ed. César Fernández

Moreno et al. (New York: Holmes and Meier Publishers, 1980), p. 131. I cite Christopher Leland Winks's translation of this essay, to be included in *Baroque New Worlds*, ed. Lois Parkinson Zamora and Monika Kaup (Durham, NC: Duke University Press, forthcoming).

4. Enrico Mario Santí, *Escritura y tradición: Texto, crítica y poética en la literatura hispanoamericana* (Barcelona: Laia, 1987), pp. 155–56.

5. Many important Baroque interiors were replaced by Neoclassical structures during the nineteenth century. Less important churches (and less prosperous ones) tended to escape this fate, but contemporary Latin American art historians nonetheless lament the loss. Guillermo Tovar de Teresa fulminates: "in Mexico, as in Spain and the West, the nineteenth century destroyed buildings and art work from this past, saying that its creations were ridiculous; its fervent critics, using the methods of entomologists, entertained themselves by disqualifying and discarding an entire cultural heritage." "El arte novohispano en el espejo de su literatura," in *La literatura novohispana: Revisión crítica y propuestas metodológicas,* ed. José Pascual Buxó and Arnulfo Herrera (Mexico City: Universidad Nacional Autónoma de México, 1994), p. 300, my translation.

6. The order was restored in 1814.

7. Octavio Paz compares the forms of the avant garde and the historical Baroque in *Sor Juana, or the Traps of Faith,* trans. Margaret Sayers Peden (Cambridge: Harvard University Press, 1986), pp. 52–54. Having listed a number of parallels, he concludes:

> These similarities are all the more remarkable when one considers that the baroque and the avant-garde spring from totally different origins, one from mannerism, the other from romanticism. The solution to this small mystery is perhaps to be found in the role played by form in both baroque and avant-garde aesthetics. Baroque and avant-garde are both formalisms. (53)

See also my discussion of Borges's *ultraísmo* and Eliot's and Pound's Imagism, in "Borges' Monsters: Unnatural Wholes and the Transformation of Genre," in *Literary Philosophers: Borges, Calvino, Eco,* ed. Jorge Gracia, Rodolphe Gasché, and Carolyn Korsmeyer (London: Routledge, 2002), pp. 47–84.

8. See José Pascual Buxó's assiduous tracing of these events in "La historiografía literaria novohispana," in *La literatura novohispana,* pp. 13–30.

9. Angel Guido, *Descubrimiento de América en el arte* (Buenos Aires: Librería y Editorial El Ateneo, 1944), p. 33.

10. Carlos Fuentes is equally emphatic about the centrality of this edifice:

> According to myth, he went by the name of José Kondori, and in Potosí he learned to work wood and the craft of inlaying and furniture building. By 1728, this self-taught Indian architect was constructing the magnificent churches of Potosí, surely the greatest illustration of the meaning of the baroque in Latin America. Among the angels and the vines of the façade of San Lorenzo, an In-

dian princess appears, and all the symbols of the defeated Incan culture are given a new lease on life. The Indian half-moon disturbs the traditional serenity of the Corinthian vine. American jungle leaves and Mediterranean clover intertwine. The sirens of Ulysses play the Peruvian guitar. And the flora, the fauna, the music, and even the sun of the ancient Indian world are forcefully asserted. There shall be no European culture in the New World unless all of these, our native symbols, are admitted on an equal footing.

The Buried Mirror: Reflections on Spain and the New World (Boston: Houghton Mifflin, 1992), p. 196.

11. The genealogical link is most direct in the case of Lezama Lima. In chapter 3, I suggested that Lezama's term *contraconquista* was derived from Guido, despite the fact Lezama Lima mentions Werner Weisbach's *El barroco: Arte de la Contrarreforma* (1920, translated into Spanish in 1942) in this context. Whereas Weisbach stresses the repressive nature of the Baroque, Lezama Lima, like Guido, finds an implicit subversiveness in Baroque forms. Furthermore, he writes about "el señor barroco" as Guido had written about "el hombre americano," and he, too, makes this figure an archetype of New World self-consciousness and self-reflection. Also like Guido, Lezama Lima emphasizes the Andean Baroque and uses Guido's neologism *indiátide*. See José Lezama Lima, "La curiosidad barroca," *La expresión americana,* ed. Irleman Chiampi (Mexico City: Fondo de Cultura, 1993), pp. 81–83.

 Both Irlemar Chiampi and César Augusto Salgado argue that Pál Keleman's pioneering study *Baroque and Rococo in Latin America* (1951) was the source for Lezama Lima's knowledge of Kondori, but Guido's earlier text seems more likely, for the reasons I've given. See Chiampi's note 11, p. 83, in *La expression Americana,* and Salgado, "Hybridity in New World Baroque Theory," *Journal of American Folklore,* vol. 112, no. 445 (Summer 1999): 323.

12. Mariano Picón-Salas, *De la conquista a la independencia: Tres siglos de historia cultural hispanoamericana* (Mexico City: Fondo de Cultural Económica, 1944), ch. 6, "Barroco de indias," pp. 121–46. This important work was belatedly translated into English in 1962 by Irving A. Leonard under the title *A Cultural History of Spanish America: From Conquest to Independence* (University of California Press).

13. Irving A. Leonard, *Baroque Times in Old Mexico* (Ann Arbor: University of Michigan, 1959). This important work was belatedly translated into Spanish by Austín Escurdia in 1974 under the title *La época barroca en el Mexico colonial* (México, Fondo de Cultura Económica). The term *tequitqui* is José Moreno Villa's, and is discussed in chapter 3.

14. Leonardo Acosta, *El barroco de indias y otros ensayos* (Havana: Casa de las Américas, 1984), p. 24, my translation.

15. Despite this historical and aesthetic junction, German scholarship remained strongly committed to the study of the European Baroque, including several essential scholars of the Spanish Baroque, such as Leo Spitzer, K. Vossler, Werner Weisbach, Fritz Strich, Karl Otto Conrady, and Helmut Hatzfeld.

16. In her study of Sarduy's Neobaroque aesthetics, Adriana Méndez Rodenas emphasizes

the overlap of the Baroque and Neobaroque in Sarduy's parodic process of cultural critique. She signals in particular "the debt of contemporary literature to the poetic procedures of Góngora and Quevedo, and the imperative to radicalize even further these linguistic resources." *Severo Sarduy: El neobarroco de la transgresión* (Mexico City: Universidad Nacional Autónoma de México, 1983), p. 21, my translation.

17. Fredric Jameson's description of postmodernism's commodification of "heaps of fragments" is well known, but the late-capitalist, consumerist aesthetic that he critiques does not apply to Neobaroque structures, which are postcolonial rather than postmodern in any late-capitalist sense. *Postmodernism or, The Cultural Logic of Late Capitalism* (Durham: Duke University Press, 1991), p. 25.

18. Carlos Fuentes, "La novela como tragedia: William Faulkner," in *Casa con dos puertas* (Mexico City: Joaquín Mortiz, 1970), p. 67, my translation.

19. Serge Gruzinski, "From the Baroque to the Neo-Baroque: The Colonial Sources of the Postmodern Era (The Mexican Case)," in *El corazón sangrante/The Bleeding Heart* (Boston: The Institute of Contemporary Art/University of Washington Press, 1991), p. 67.

20. Octavio Paz, *Children of the Mire: Modern Poetry from Romanticism to the Avant-Garde,* trans. Rachel Phillips (Cambridge: Harvard University Press, 1974), p. 82. Latin America did have its own eighteenth-century *Ilustración* (Enlightenment) within the framework of late Baroque culture; Gonzalo Celorio explicitly contests Paz's assertion, in "El barroco y la Ilustración en la Nueva España," *Ensayos de contraconquista* (Mexico City: Tusquets, 2001), pp. 89–97. See also Jorge Cañizares-Esguerra, *How to Write the History of the New World: Histories, Epistemologies and Identities in the Eighteenth-Century Atlantic World* (Stanford: Stanford University Press, 2001), especially ch. 5, "Whose Enlightenment Was It Anyway?" pp. 266–345; and Jorge Alberto Manrique, "El mundo ilustrado," in *Historia general de México* (Mexico City: El Colegio de México, 2000), pp. 482–88.

21. Leopoldo Zea, *The Latin American Mind* (1949), trans. James H. Abbott and Lowell Dunham (Norman: University of Oklahoma Press, 1963).

22. Gilles Deleuze, *The Fold: Leibniz and the Baroque* (1988), trans. Tom Conley (Minneapolis: University of Minnesota Press, 1993), pp. 67, 68.

23. Lois Parkinson Zamora, *The Usable Past: The Imagination of History in Recent Fiction of the Americas* (Cambridge: Cambridge University Press, 1997), "Comparative Conclusions: Baroque New Worlds," pp. 196–210.

24. Carlos Fuentes, "José Lezama Lima: Cuerpo y palabra del barroco," in *Valiente mundo nuevo: Epica, utopía y mito en la novela hispanoamericana* (Madrid: Mondadori, 1990), p. 216, my translation.

25. Eugenio d'Ors, *Lo barroco* (1935), (Madrid: Editorial Tecnos, 2002), p. 87; see d'Ors's section called "Morfología del barroco. La multipolaridad, la continuidad," pp. 84–91.

26. Alfonso Reyes, "Sabor de Góngora," in *Cuestiones gongorinas* (1928); *Obras completas*

(Mexico City: Fondo de Cultura Económica, 1958), vol. 7, p. 189. I cite Rose Dutra's translation, forthcoming in *Baroque New Worlds.*

27. On the visual arts, see Elizabeth Armstrong and Victor Zamudio-Taylor, *Ultrabaroque: Aspects of Post-Latin American Art* (La Jolla, CA: Museum of Contemporary Art, San Diego, 2000). This exhibition and its catalogue include works by Latin American and Latino artists that display a "baroque sensibility." The essays in this catalogue, by Serge Gruzinski and others, move toward a definition of the Neobaroque in contemporary art.

28. Walter Benjamin, *The Origin of Baroque Tragic Drama*, p. 178. The phrase "without any strict idea of a goal" is added to the English translation to explain *unausgesetzt haeufen,* literally, a random piling up. My thanks to Monika Kaup for her help on this point.

29. José Lezama Lima, "La curiosidad barroca," in *La expresión americana*, p. 80, 83; I cite María Pérez's translation, forthcoming in *Baroque New Worlds.*

30. The most explicit Baroque spatialization of history is the theatre of memory, and it is used explicitly by Carlos Fuentes in his Neobaroque novel *Terra nostra.* In the introduction to the novel, Fuentes cites Frances A. Yates's study as one of his two principal sources. See Frances A. Yates, *The Art of Memory* (Chicago: University of Chicago Press, 1966).

31. See, for example, Umberto Eco, *Postscript to The Name of the Rose,* trans. William Weaver (New York: Harcourt Brace Jovanovich, 1983), p. 68. Harold Bloom's use of Borges as a paragon of "anxiety of influence" is also well known.

32. Harold de Campos, "The Rule of Anthropophagy: Europe under the Sign of Devoration," trans. Maria Tai Wolff, *Latin American Literary Review* 14, 27 (1986), 54.

33. Borges, Epílogo, *El hacedor* (1960); *Obras completas* (Buenos Aires, Emecé Editores, 1974), vol. 2, p. 232.

34. Borges, epilogue to *Dreamtigers,* trans. Mildred Boyer and Harold Morland (New York: E. P. Dutton, 1970), p. 93.

35. Alfonso Reyes, "Sabor de Góngora," in *Cuestiones gongorinas,* p. 188.

36. Carlos Fuentes, *The Buried Mirror,* p. 201.

Bibliography

Primary Works

Works in Spanish are listed in the order of their date of publication; translations follow, according to date of the translation.

ARENAS, REINALDO

El mundo alucinante. Mexico City: Editorial Diógenes, 1969.
The Ill-Fated Peregrinations of Fray Servando. Translated by Andrew Hurley. New York: Avon, 1971.

BELTRÁN, ROSA

El paraíso que fuimos. Barcelona: Seix Barral, 2002.

BORGES, JORGE LUIS

Inquisiciones (1925). Madrid: Alianza Editores, 1998.
El tamaño de mi esperanza (1926). Barcelona: Seix Barral, 1994.
El idioma de los argentinos (1928). Madrid: Alianza Editorial, 1998.
Textos cautivos: Ensayos y reseñas en El hogar, *(1936–1939).* Edited by Enrique Sacerio-Garí and Emir Rodriguéz Monegal. Barcelona: Tusquets, 1986.
Borges en Sur (1931–1980). Buenos Aires: Emecé, 1999.
Obra poética. Buenos Aires: Emecé, 1972.
Obras completas. 4 vols. Buenos Aires: Emecé, 1974.

Labyrinths. Edited and translated by Donald A. Yates and James E. Irby. New York: New Directions, 1962.

Other Inquisitions (1937–1952). Translated by Ruth L. C. Sims. Austin: University of Texas Press, 1965.

The Aleph and Other Stories (1933–1969). Translated by Norman Thomas di Giovanni. New York: E. P. Dutton, 1970.

Dreamtigers. Translated by Mildred Boyer and Harold Morland. New York: E. P. Dutton, 1970.

A Universal History of Infamy. Translated by Norman Thomas di Giovanni. London: Penguin Books, 1970.

Borges: A Reader. Edited by Emir Rodríguez Monegal and Alastair Reid. New York: Dutton, 1981.

Collected Fictions. Translated by Andrew Hurley. New York: Penguin Books, 1999.

Selected Non-Fictions. Edited by Eliot Weinberger. New York: Viking, 1999.

CABRERA INFANTE, GUILLERMO

Vidas para leerlas. Madrid: Alfaguara, 1992.

CARPENTIER, ALEJO

"Diego Rivera" (August 25, 1927). *Revista de Avance.* Prologue and selection by Martín Casanovas. Havana: Colección Orbita, 1972. Pp. 154–60.

Los pasos perdidos (1953). Montevideo: Editorial Arca, 1953.

El siglo de las luces (1962). *Obras completas.* Vol. 5. Mexico City: Siglo XXI, 1984.

Tientos y diferencias (1964). Montevideo: Editorial Arca, 1967.

La ciudad de las columnas, with photos by Paolo Gasparini. Barcelona: Editorial Lumen, 1970; a second edition was published with photos by Fotografía/Grandal. Havana: Editorial Letras Cubanas, 1982.

Recurso del método. (1974). Mexico City: Siglo XXI, 1974.

Concierto barroco (1974). *Obras completas.* Vol. 4. Mexico City: Siglo XXI, 1983.

La novela latinoamericana en vísperas de un nuevo siglo y otros ensayos. Mexico City: Siglo XXI, 1981.

Entrevistas: Alejo Carpentier. Edited by Virgilio López Lemus. Havana: Editorial Letras Cubanas, 1985.

Visión de América. Mexico City: Editorial Oceano, 1999.

The Lost Steps. Translated by Harriet de Onís. New York: Alfred A. Knopf, 1959.

Explosion in a Cathedral. Translated by John Sturrock. Boston: Little, Brown and Company, 1963.

Reasons of State. Translated by Francis Partridge. London: Writers and Readers Publishing Cooperative, 1977.

Concierto Barroco. Translated by Asa Zatz. Tulsa, OK: Council Oaks Book/University of Tulsa, 1988.

The Harp and the Shadow. Translated by Thomas Christensen and Carol Christensen. San Francisco: Mercury House, 1990.

"On the Marvelous Real in America" (1949). Translated by Tanya Huntington and Lois Parkinson Zamora. In *Magical Realism: Theory, History, Community.* Edited by Lois

Parkinson Zamora and Wendy B. Faris. Durham, NC: Duke University Press, 1995. Pp. 75–88.

"The Baroque and the Marvelous Real" (1975). Translated by Tanya Huntington and Lois Parkinson Zamora. In *Magical Realism: Theory, History, Community*. Edited by Lois Parkinson Zamora and Wendy B. Faris. Durham, NC: Duke University Press, 1995. Pp. 89–108.

CASTELLANOS, ROSARIO

Balún canán. Mexico City: Fondo de Cultura Económica, 1957.
Oficio de tinieblas. Mexico City: Joaquín Mortíz, 1962.
Mujer que sabe latín. Mexico City: Fondo de Cultura Económica, 1984.

A Rosario Castellanos Reader. Edited by Maureen Ahern. Austin: University of Texas Press, 1988.
The Book of Lamentations. Translated by Esther Allen. New York: Penguin, 1996.

FUENTES, CARLOS

Cantar de ciegos. Mexico City: Joaquín Mortiz, 1964.
El mundo de José Luis Cuevas. Translated by Consuelo de Aerenlund. New York: Tudor Publishing Co., 1969.
Casa con dos puertas. Mexico City: Joaquín Mortiz, 1970.
Terra nostra. Mexico City: Joaquín Mortiz, 1975.
Una familia lejana. Mexico City: Ediciones Era, 1980.
Agua quemada. Mexico City: Fondo de Cultura Económica, 1981.
Valiente mundo nuevo: Epica, utopía y mito en la novela hispanoamericana. Madrid: Narrativa Mondadori, 1990.
El espejo enterrado. Mexico City: Fondo de Cultura Económica, 1992.
Los años de Laura Díaz. Mexico City: Alfaguara, 1999.

Terra Nostra. Translated by Margaret Sayers Peden. New York: Farrar, Straus and Giroux, 1976.
Burnt Water. Translated by Margaret Sayers Peden. New York: Farrar, Straus and Giroux, 1980.
Distant Relations. Translated by Margaret Sayers Peden. New York: Farrar Straus Giroux, 1982.
The Buried Mirror: Reflections on Spain and the New World. Boston: Houghton Mifflin, 1992.
"The Accidents of Time." In *The Borges Tradition.* Edited by Norman Thomas di Giovanni. London: Constable, 1995. Pp. 51–69.
The Years with Laura Díaz. Translated by Alfred MacAdam. New York: Farrar, Straus and Giroux, 2000.

GALEANO, EDUARDO

Memoria del fuego I: Los nacimientos. Mexico City: Siglo XXI, 1982.
Memoria del fuego II: Las caras y las máscaras. Mexico City, Siglo XXI, 1984.
Memoria del fuego III: El siglo del viento. Mexico City: Siglo XXI, 1986.

El libro de los abrazos. Mexico City: Siglo XXI, 1989.
Patas arriba: La escuela del mundo al revés. Mexico City: Siglo XXI, 1998.

Memory of Fire: I. Genesis. Translated by Cedric Belfrage. New York: Pantheon, 1985.
Memory of Fire: II. Faces and Masks. Translated by Cedric Belfrage. New York: Pantheon, 1987.
Memory of Fire: III. Century of the Wind. Translated by Cedric Belfrage. New York: Pantheon, 1988.
The Book of Embraces. Translated by Cedric Belfrage, with Mark Schafer. New York: W. W. Norton, 1991.
Upside Down: A Primer for the Looking-Glass World. Translated by Mark Fried. New York: Henry Holt and Co., 2000.

GARCÍA MÁRQUEZ, GABRIEL

Cien años de soledad. Buenos Aires: Editorial Sudamericana, 1967.
La increíble y triste historia de la cándida Eréndira y de su abuela desalmada. Buenos Aires: Editorial Sudamericana, 1973.
El otoño del patriarca (1975). Mexico City: Editorial Diana, 1986.
"La soledad en América Latina." *Proceso* 319 (December 31, 1982): 47.
El amor en los tiempos del cólera. Barcelona: Bruguera, 1985.
Del amor y otros demonios. New York: Penguin Books, 1994.
Vivir para contarla. New York: Knopf, 2002.

One Hundred Years of Solitude. Translated by Gregory Rabassa. New York: Avon, 1970.
The Autumn of the Patriarch. Translated by Gregory Rabassa. New York: Harper and Row, 1975.
Collected Stories. Translated by Gregory Rabassa et al. New York: Harper and Row, 1984.
Love in the Time of Cholera. Translated by Edith Grossman. New York: Alfred A. Knopf, 1988.
"The Solitude of Latin America." Translated by Marina Castañeda. In *Lives on the Line: The Testimony of Contemporary Latin American Authors.* Edited by Doris Meyer. Berkeley: University of California Press, 1988. Pp. 230–34.
Of Love and Other Demons. Translated by Edith Grossman. New York: Alfred Knopf, 1995.
Living to Tell the Tale. Translated by Edith Grossman. New York: Alfred Knopf, 2003.

GARRO, ELENA

Los recuerdos del porvenir. Mexico City: Editorial Joaquín Mortiz, 1963.
La semana de colores. Mexico City: Grijalbo, 1989.

Recollections of Things to Come. Translated by Ruth L. C. Simms. Austin: University of Texas Press, 1969.

GLISSANT, EDOUARD

"Concerning a Baroque Abroad in the World." In *Poetics of Relation* (1990). Translated by Betsy Wing. Ann Arbor: University of Michigan Press, 1997.

IBARGÜENGOITIA, JORGE

Estas ruinas que ves. Mexico City: Joaquín Mortíz, 1975.

SOR JUANA INÉS DE LA CRUZ

Obras completas. Mexico City: Editorial Porrúa, 1989.

A Sor Juana Anthology. Translated by Alan Trueblood. Cambridge: Harvard University Press, 1988.

LEZAMA LIMA, JOSÉ

La expresión americana (1957). Edited by Irlemar Chiampi. Mexico City: Fondo de Cultura Económica, 1993.
Eras imaginarias. Caracas and Madrid: Editorial Fundamentos, 1971.
"Imagen de América latina." In *América latina en su literatura.* Edited by César Fernández Moreno. Mexico City: Siglo XXI, 1972. Pp. 462–68.

"Image of Latin America." Translated by Mary G. Berg. *Latin America and its Literature.* Eds. César Fernández Moreno, Julio Ortega, Ivan A. Schulman. New York: Holmes and Meier Publishers, 1980. Pp. 321–27.
"Summa Critica of American Culture." Translated by Mark Schafer. *The Oxford Book of Latin American Essays.* Edited by Ilan Stavans. New York: Oxford University Press, 1997. Pp. 244–59.

MASTRETTA, ANGELES

Arráncame la vida (1988). Mexico City: Cal y Arena, 1990.
Mujeres de ojos grandes. Mexico City: Cal y Arena, 1990.

Tear Out This Heart. Trans Margaret Sayers Peden. New York: Riverhead Books, 1997.
Women with Big Eyes. Translated by Amy Schildhouse Greenberg. New York: Riverhead Books, 2003.

PAZ, OCTAVIO

El laberinto de la soledad (1950). Rev. ed. Mexico City: Fondo de Cultura Económica, 1981.
"Crítica de la pirámide." In *Posdata.* Mexico City: Siglo XXI, 1970. Pp. 103–55.
Sor Juana Inés de la Cruz: Las trampas de la fe. Mexico City: Fondo de Cultura Económica, 1982.
"Orfandad y legitimidad." In *México en la obra de Octavio Paz.* "El peregrino en su patria: Historia y política de México," vol. 1. Mexico City: Fondo de Cultura Económica, 1987. Pp. 174–88.

The Labyrinth of Solitude (1950). Translated by Lysander Kemp et al. Rev. ed. New York: Grove Weidenfeld, 1985.
"Critique of the Pyramid." Translated by Lysander Kemp. In *The Labyrinth of Solitude* (1950). Rev. ed. New York: Grove Weidenfeld, 1985. Pp. 284–326.

Alternating Current. Translated by Helen R. Lane. New York: Seaver Books, 1967.

"The Flight of Quetzalcóatl and the Quest for Legitimacy." Foreword to Jacques Lafaye, *Quetzalcóatl and Guadalupe: The Formation of Mexican National Consciousness 1531–1813.* Translated by Benjamin Keen. Chicago: University of Chicago Press, 1976. Pp. ix–xxii.

Sor Juana, or the Traps of Faith. Translated by Margaret Sayers Peden. Cambridge: Harvard University Press, 1988.

"Will for Form." In *Mexico: Splendors of Thirty Centuries.* New York: The Metropolitan Museum of Art/Little Brown and Company, 1990. Pp. 3–38.

Essays on Mexican Art. Translated by Helen Lane. New York: Harcourt Brace, 1993.

PONIATOWSKA, ELENA

Hasta no verte Jesús mío (1969). Mexico City: Ediciones Era, 1972.

Querido Diego te abraza Quiela (1976). Mexico City: Ediciones Era, 1978.

Dear Diego. Translated by Katherine Silver. New York: Pantheon Books, 1986.

Here's to You, Jesusa! Translated by Deanna Heikkinen. New York: Farrar, Straus & Giroux, 2001.

RULFO, JUAN

El llano en llamas. Barcelona: Editorial Planeta, 1953.

Pedro Páramo. Mexico City: Fondo de Cultura Económica, 1955

Pedro Páramo. Translated by Lysander Kemp. New York: Grove Press, 1959.

The Burning Plain. Translated by George D. Schade. Austin: University of Texas Press, 1985.

SARDUY, SEVERO

"El barroco y el neobarroco." In *América latina en su literatura.* Edited by César Fernández Moreno. Mexico City: Siglo XXI, 1972. Pp. 167–84.

Barroco. Buenos Aires: Editorial Sudamericana, 1974. Included in Severo Sarduy. *Ensayos generales sobre el barroco.* Mexico City: Fondo de Cultura Económica, 1987. Pp. 143–224.

"Lautréamont y el barroco." In *Lautréamont austral.* Edited by Leyla Perrone Moisés and Emir Rodríguez Monegal. Montevideo: Brecha, 1995. Pp. 115–22.

"The Baroque and the Neobaroque." Translated by Mary G. Berg. *Latin America and its Literature.* Edited by César Fernández Moreno, Julio Ortega, Ivan A. Schulman. New York: Holmes and Meier Publishers, 1980. Pp. 115–32.

VARGAS LLOSA, MARIO

"Social Commitment and the Latin American Writer." In *Lives on the Line: The Testimony of Contemporary Latin American Authors.* Edited by Doris Meyer. Berkeley: University of California Press, 1988. Pp. 128–36.

"El inca Garcilaso y la lengua de todos." In *Iberoamérica mestiza: Encuentro de pueblos y culturas.* Madrid and Mexico City: Centro Cultural de la Villa/Instituto Nacional de Antropología e Historia, 2003. Pp. 37–48.

Secondary works

Acosta, Leonard. *El barroco de indias y otros ensayos.* Havana: Casa de las Américas, 1984.

Ades, Dawn. *Art in Latin America.* New Haven: Yale University Press, 1989.

Ahmad, Aijaz. "Jameson's Rhetoric of Otherness and the 'National Allegory,'" *Social Text* 17 (Fall 1987): 3–27.

Aínsa, Fernando. *Los buscadores de la utopía.* Caracas: Monte Avila, 1977.

Alarcón, Norma. "Gloria Anzaldúa's *Borderlands/La Fontera:* Cultural Studies, 'Difference,' and the Non-Unitary Subject." In *Contemporary American Women Writers: Gender, Class, Ethnicity.* Edited by Lois Parkinson Zamora. London: Addison Wesley Longman, 1998. Pp. 11–31.

Alberti, Leon Battista. *On Painting.* Translated by John R. Spencer. New Haven: Yale University Press, 1966.

Alcina Franch, José. *Códices mexicanos.* Madrid: Editorial Mapfre, 1992.

Anaya Rodríguez, Edgar. "¡Feliz cumpleaños, Don Gregorio!" *México desconocido* (March 2001): 26–37.

Anzaldúa, Gloria. *Borderlands/La frontera: The New Mestiza.* San Francisco: Spinsters/ Aunt Lute, 1987.

Apuleyo Mendoza, Plinio. *The Fragrance of the Guayaba.* Translated by Ann Wright. London: Verso, 1983.

Armstrong, Elizabeth, and Victor Zamudio-Taylor. *Ultrabaroque: Aspects of Post-Latin American Art.* La Jolla, CA: Museum of Contemporary Art, San Diego, 2002.

Arnheim, Rudolph. "Space as an Image of Time." In *Images of Romanticism: Verbal and Visual Affinities.* Edited by Karl Kroeber and William Walling. New Haven: Yale University Press, 1978. Pp. 1–12.

Arnulfo, Miguel Angel. "Cartagena de Indias en la ficción garciamarquiana: *Del amor y otros demonios.*" *Revista casa del tiempo:* http://www.difusioncultural.uam.mx/revista/mar2001/ arnulfo.html.

Ashcroft, Bill. *Post-colonial Transformation.* London: Routledge, 2001.

Aste Tönnsmann, José. *Los ojos de la Virgen de Guadalupe.* Mexico City: Editorial Diana, 1981.

Bailey, Gauvin Alexander. *Art of Colonial Latin America.* London: Phaidon Press, 2005.

Bakhtin, Mikhail. *Rabelais and his World* (1965). Translated by Hélène Iswolsky. Bloomington: Indiana University Press, 1984.

Ballón Aguirre, Enrique. *Desconcierto barroco.* Mexico City: Universidad Nacional Autónoma de México, 2001.

———— and Oscar Rivera Rodas, eds. *De palabras, imágenes y símbolos: Homenaje a José Pascual Buxó.* Mexico City: Universidad Nacional Autónoma de México, 2002.

Barili, Amelia. *Jorge Luis Borges y Alfonso Reyes: La cuestión de la identidad del escritor latinoamericano.* Mexico City: Fondo de Cultura Económica, 1999.

Barnstone, Willis, ed. *Borges at Eighty: Conversations.* Bloomington: Indiana University Press, 1982.

Baroque to Folk/De lo barroco a lo popular. Santa Fe: Museum of New Mexico Press, 1980.

Barth, John. "The Literature of Exhaustion." In *The American Novel since World War II.* Edited by Marcus Klein. New York: Fawcett Publications, 1969. Pp. 267–79.

Barthes, Roland. "Rhetoric of the Image." In *Image Music Text.* Translated by Stephen Heath. New York: Hill and Wang, 1977. Pp. 32–51.

Bartra, Eli. *Frida Kahlo: Mujer, ideología, arte.* Barcelona: Icaria, 1994.

Barzun, Jacques. *From Dawn to Decadence: 500 Years of Western Cultural Life: 1500 to the Present.* New York: HarperCollins, 2000.

Baudez, Claude-François. "Los templos enmascarados de Yucatán." *Arqueología mexicana* VII, 37 (May-June 1999): 54–59.

Baudrillard, Jean. "The Trompe l'Oeil." In *Calligram: Essays in New Art History from France.* Edited by Norman Bryson. Cambridge: Harvard University Press, 1988. Pp. 53–62.

Bauer, Ralph. *The Cultural Geography of Colonial American Literatures: Empire, Travel, Modernity.* Cambridge: Cambridge University Press, 2003.

Beardsell, Peter. *Europe and Latin America: Returning the Gaze.* Manchester and New York: Manchester University Press, 2000.

Belkin, Kristin Lohse. *Rubens.* London: Phaidon Press, 1998.

Belting, Hans. *Likeness and Presence: A History of the Image before the Era of Art.* Translated by Edmund Jephcott. Chicago: University of Chicago Press, 1994.

Benjamin, Walter. *The Origin of the German Tragic Drama.* Translated by John Osborne. London: Verso, 1977.

Bernand, Carmen, and Serge Gruzinski. *De la idolatría: Una arqueología de las ciencias religiosas.* Translated by Diana Sánchez F. Mexico City: Fondo de Cultura Económica, 1993.

Besançon, Alain. *The Forbidden Image: An Intellectual History of Iconoclasm* (1994). Translated by Jane Marie Todd. Chicago: University of Chicago Press, 2000.

Beverley, John. "Barroco de estado: Góngora y el Gongorismo." In *Del Lazarillo al Sandinismo: Estudios sobre la función ideológica de la literatura española e hispanoamericana.* Minneapolis: The Prisma Institute, 1987. Pp. 77–97.

Bhabha, Homi K. *The Location of Culture.* London: Routledge, 1994.

Bierhorst, John, ed. and trans. *History and Mythology of the Aztecs: The Codex Chimalpopoca.* Tucson: University of Arizona Press, 1992.

Bitrán, Yael, ed. *México: Historia y alteridad: Perspectivas multidisciplinarias sobre la cuestión indígena.* Mexico City: Universidad Iberoamericana, 2001.

Blanco, José Joaquín. *Se llamaba Vasconcelos: Una evocación crítica.* Mexico City: Fondo de Cultura Económica, 1977.

Boone, Elizabeth Hill. "Introduction: Writing and Recording Knowledge." In *Writing Without Words: Alternative Literacies in Mesoamerica and the Andes.* Edited by Elizabeth Hill Boone and Walter D. Mignolo. Durham, NC: Duke University Press, 1994. Pp. 3–26.

———. "Painted Manuscripts." In *Mexico: Splendors of Thirty Centuries.* New York: The Metropolitan Museum of Art/Little Brown and Company, 1990. Pp. 168–79.

———. *Stories in Red and Black: Pictorial Histories of the Aztecs and Mixtecs.* Austin: University of Texas Press, 2000.

———. "The Structures of the Mexican *Tonalamatl.*" In *Acercarse y mirar: Homenaje a Beatriz de la Fuente.* Edited by María Meresa Uriarte and Leticia Staines Cicero. Mexico City: Universidad Nacional Autónoma de México, 2004. Pp. 377–401.

Boucher, Bruce. *Italian Baroque Sculpture.* London: Thames and Hudson, 1998.

Brading, David. *Mexican Phoenix: Our Lady of Guadalupe: Image and Tradition Across Five Centuries.* Cambridge: Cambridge University Press, 2001.

Braider, Christopher. *Baroque Self-Invention and Historical Truth: Hercules at the Crossroads.* Aldershot, England: Ashgate, 2004.

———. "The Fountain of Narcissus: The Invention of Subjectivity and the Pauline Ontology of Art in Caravaggio and Rembrandt." *Comparative Literature* 50, 4 (1998): 286–315.

Braun, Barbara. "Diego Rivera's Collection: Pre-Columbian Art as a Political and Artistic

Legacy." In *Collecting the Pre-Columbian Past.* Edited by Elizabeth Hill Boone. Washington, D.C.: Dumbarton Oaks Research Library and Collection, 1993. Pp. 251–70.

Bricker, Victoria R. "The Structure of Almanacs in the Madrid Codex." In *Papers on the Madrid Codex.* Edited by Victoria R. Bricker and Gabrielle Vail. New Orleans: Tulane University Press, 1997. Pp. 1–25.

Brésil baroque: Entre ciel et terre (exhibition catalogue). Paris: Union Latine, 1999.

Brotherston, Gordon. *Painted Books from Mexico: Codices in UK Collections and the World They Represent.* London: The British Museum Press, 1995.

Brotherson, Gordon, and Lúcia de Sá. "First Peoples of the Americas and their Literature." In *Comparative Cultural Studies and Latin America.* Edited by Sophia A. McClennan and Earl E. Fitz. West Lafayette, IN: Purdue, University Press, 2004. Pp. 8–33.

Brown, Betty Ann. "The Past Idealized: Diego Rivera's Use of Pre-Columbian Imagery." In *Diego Rivera: A Retrospective.* New York: Detroit Institute of Arts/W.W. Norton, 1986. Pp. 138–55.

Brown, Jonathan. *Images and Ideas in Seventeenth-Century Spanish Painting.* Princeton: Princeton University Press, 1978.

Bryson, Norman. *Looking at the Overlooked: Four Essays on Still Life Painting.* Cambridge: Harvard University Press, 1990.

Buci-Glucksmann, Christine. *Baroque Reason: The Aesthetics of Modernity* (1984). Translated by Bryan S. Turner. London: Sage Publications, 1994

———. *La Folie du voir: De l'esthétique baroque.* Paris: Editions Galilée, 1986.

Burke, Marcus B. *Pintura y escultura en Nueva España: El Barroco.* Mexico City: Azabache, 1992.

———. *Treasures of Mexican Colonial Painting.* Museum of New Mexico Press/Davenport Museum of Art, 1998.

Burkhart, Louise. *The Slippery Earth: Nahua-Christian Moral Dialogue in the Sixteenth Century.* Tucson: University of Arizona Press, 1989.

Calabrese, Omar. *Neo-Baroque: A Sign of the Times* (1987). Translated by Charles Lambert. Princeton: Princeton University Press, 1992.

Camayd-Freixas, Erik. *Realismo mágico y primitivismo: Relecturas de Carpentier, Asturias, Rulfo y García Márquez.* Lanham, Maryland: University Press of America, 1998.

Campos, Haroldo de. "The Rule of Anthropophagy: Europe Under the Sign of Devoration." Translated by Maria Tai Wolff. *Latin American Literary Review* 14, 27(1986): 42–60.

Cañizares-Esguerra, Jorge. *How to Write the History of the New World: Histories, Epistemologies and Identities in the Eighteenth-Century Atlantic World.* Stanford: Stanford University Press, 2001.

Capistrán, Miguel. *Borges y México.* Mexico City: Plaza y Janés, 1999.

Carbó, Teresa. "Notas para una historia discursiva del indigenismo mexicano." *México: Historia y alteridad: Perspectivas multidisiplinarias sobre la cuestión indígena.* Edited by Yael Bitrán. Mexico City: Universidad Iberoamericana, 2001. Pp. 265–98.

Castañon, Adolfo. "Presentación." *Códice Borgia.* Vol. 1. Mexico City: Fondo de Cultura Económica, 1980.

Celorio, Gonzalo. *Ensayo de contraconquista.* Mexico City: Tusquets, 2001.

Certeau, Michel de. *The Practice of Everyday Life.* Translated by Steven Rendall. Berkeley: University of California Press, 1984.

Chamberlain, Daniel Frank. *Narrative Perspective in Fiction: A Phenomenological Mediation of Reader, Text, and World.* Toronto: University of Toronto Press, 1990.

Chanady, Amaryll, ed. *Latin American Identity and Constructions of Diffierence.* Minneapolis: University of Minnesota Press, 1994.

———. "The Territorialization of the Imaginary: Self-Affirmation and Resistance to Metropolitan Paradigms." In *Magical Realism: Theory, History, Community.* Edited by Lois Parkinson Zamora and Wendy B. Faris. Durham, NC: Duke University Press, 1995. Pp. 125–44.

Chiampi, Irlemar. *Barroco y modernidad.* México City: Fondo de Cultura Económica, 2000.

Christiansen, Keith. *Going for Baroque: Bringing Seventeenth Century Masters to the Met. The Metropolitan Museum of Art Bulletin* 62, 3 (2005).

Christensen, Bodil, and Samuel Martí. *Witchcraft and Pre-Colombian Paper/Brujerías y papel precolombino* (1971). Mexico City: Ediciones Euroamericans Klaus Thiele, 1988.

Cirlot, J. E. *A Dictionary of Symbols.* Translated by Jack Sage. London: Routledge and Kegan Paul, 1962.

Cixous, Hélène, and Katherine Clément. *The Newly Born Woman.* Translated by Betsy Wing. Minneapolis: University of Minnesota Press, 1986.

Clendinnen, Inga. *Aztecs: An Interpretation.* Cambridge: Cambridge University Press, 1991.

Clifton, James. *The Body of Christ in the Art of Europe and New Spain, 1150–1800.* Munich and New York: Prestel, 1997.

Códice Chimalpopoca; Anales de Cuauhtitlán; Leyendas de los soles (1945). Translated by Primo Feliciano Velásquez. Mexico City: Universidad Nacional Autónoma de México, 1992.

Coe, Michael D. *Mexico.* London: Thames and Hudson, 1984.

Collis, John, and David M. Jones. *Blue Guide: Mexico.* New York: W.W. Norton, 1997.

Cortázar, Julio. *Realidad y literatura en América Latina/Reality and Literature in Latin America.* The Jacob C. Saposnekow Memorial Lectures, 1980. Edited and translated by Gabriella de Beer and Raquel Chang-Rodríguez. New York: City College, April, 1982.

Cortés, Hernán. *Fernando Cortés: His Five Letters of Relation to the Emperor Charles V.* Translated by F. A. MacNutt. New York: G. P. Putnam's Sons, 1908. Rpt. Glorieta, NM: Rio Grande Press, 1977.

Cortínez, Carlos. *Borges the Poet.* Fayetteville: University of Arkansas Press, 1986.

Costigan, Lúcia Helena. "La cultura barroca y el nacimiento de la conciencia criolla en el Brasil." In *Relecturas del barroco de Indias.* Edited by Mabel Moraña. Hanover, NH: Ediciones del Norte, 1994.

Council of Trent Decrees. http://history.hanover.edu/texts/trent.html

Cuadriello, Jaime Genaro. *Catálogo comentado del acervo del Museo Nacional de Arte: Nueva España.* Mexico City: Universidad Nacional Autónoma de México/Conaculta-Instituto Nacional de Bellas Artes, 1999.

———. "Los jeroglíficos de la Nueva España." In *Juegos de ingenio y agudeza: La pintura emblemática de la Nueva España.* Edited by Rafael Tovar et al. Mexico City: Museo Nacional de Arte, 1994.

———. "Los pinceles de Dios Padre." In *Maravilla americana: Variantes de la iconografía guadalupana, Siglos XVII-XIX.* Guadalajara: Patrimonio Cultural del Occidente, A.C., 1989.

Cummins, Thomas. "From Lies to Truth: Colonial Ekphrasis and the Act of Crosscultural Translation." In *Reframing the Renaissance: Visual Culture in Europe and Latin America 1450–1650.* Edited by Claire Farago. New Haven: Yale University Press, 1995. Pp. 152–74.

Day, Anthony, and Marjorie Miller. "Gabo Talks," *Los Angeles Times Magazine,* Sept. 2, 1990. Pp. 11–16, 33–35.

Dean, Carolyn S. *Inka Bodies and the Body of Christ: Corpus Christi in Colonial Cuzco, Peru.* Durham, NC: Duke University Press, 1999.

———. "Praying with Pictures: A Reading of the *Libro de Oraciones*," *Journal of Latin American Lore* 15, 2 (1989): 211–73.

Debroise Curare, Olivier. "Imaginario fronterizo/identidades en tránsito: El caso de los murales de San Miguel Itzmiquilpan." In *Arte, historia e identidad en América: Visiones comparativas*. Vol 1. Mexico City: Universidad Nacional Autónoma de México, 1994. Pp. 155–69.

Del istmo y sus mujeres: Tehuanas en el arte mexicano (exhibition catalogue). Mexico City: Museo Nacional de Arte, 1991.

Deleuze, Gilles. *The Fold: Leibniz and the Baroque* (1988). Translated by Tom Conley. Minneapolis: University of Minnesota Press, 1993.

Díaz, Maria Elena. "Rethinking Tradition and Identity: The Virgin of Charity of El Cobre." In *Cuba: The Elusive Nation*. Edited by Damian Fernández and Madeline Camara Betancourt. Gainesville: University of Florida Press, 2000. Pp. 43–59.

Díaz del Castillo, Bernal. *The Conquest of New Spain* (1568). Translated by J. M. Cohen. New York: Penguin, 1963.

———. *Historia verdadera de la conquista de la Nueva España* (1568). Mexico City: Editorial Porrúa, 1986.

Dollimore, John. *Radical Tragedy: Religion, Ideology and Power in the Drama of Shakespeare and His Contemporaries*. London: Palgrave, 1984.

d'Ors, Eugenio. *Cupole et monarchie*. Paris: Librairie de France, 1926.

———. *Du Baroque*. Paris: Gallimard, 1935.

———. *Las ideas y las formas: Estudios sobre la morfología de la cultura*. Madrid: Páez Editores, 1928.

———. *Lo barroco* (1935; 1944). Madrid: Editorial Tecnos, 2002.

Dussel, Enrique. "Beyond Eurocentrism: The World System and the Limits of Modernity." In *The Cultures of Globalization*. Edited by Fredric Jameson and Masao Miyoshi. Durham, NC: Duke University Press, 1998. Pp. 3–31.

———. *The Invention of the Americas: Eclipse of "the Other" and the Myth of Modernity*. New York: Continuum, 1995. Pp. 3–31.

Ebert-Schifferer, Sybille. *Deceptions and Illusions: Five Centuries of Trompe l'Oeil Painting*. Washington, DC: The National Gallery of Art, 2002.

Echeverría, Bolívar. *La modernidad de lo barroco*. Mexico City: Ediciones Era and Universidad Nacional Autónoma de México, 1998.

———, ed. *Modernidad, mestizaje cultural, ethos barroco*, Mexico City: Universidad Nacional Autónoma de México, 1994.

Eco, Umberto. *Art and Beauty in the Middle Ages* (1959). Translated by Hugh Bredin. New Haven: Yale University Press, 1986.

———. "The Poetics of the Open Work." In *The Role of the Reader*. Translated by Bruce Merry. Bloomington: Indiana University Press, 1979. Pp. 47–66.

———. *Postscript to The Name of the Rose*. Translated by William Weaver. New York: Harcourt Brace Jovanovich, 1983.

Egan, Martha J. *Relicarios: Devotional Miniatures from the Americas*. Santa Fe, NM: Museum of New Mexico Press, 1993.

Estrada de Gerlero, Elena Isabel. "El friso monumental de Itzmiquilpan," *Actes du XLVII Congrès International des Americanistes* (1976), pp. 9–19.

———. "El nombre y su morada: Los monogramas de los nombres sagrados en el arte de la nueva y primitiva iglesia de Indias." In *Parábola novohispana: Cristo en el arte virreinal*. Edited by Elisa Vargaslugo. Mexico City: Fomento Cultural Banamex, 2000. Pp. 177–203.

———. "Los protomártires del Japón en la hagiografía novohispana." In Rafael Tovar et al. *Los pinceles de la historia II: De la patria criolla a la nación mexicana: 1750–1860.* Mexico City: Instituto Nacional de Bellas Artes, 2000. Pp. 72–89.

Fajardo de Rueda, Marta. *El arte colonial neogranadino: A la luz del estudio iconográfico e icono-lógico.* Bogotá: Convenio Andrés Bello, 1999.

Fane, Diane, ed. *Converging Cultures: Art and Identity in Spanish America.* New York: The Brooklyn Museum / Abrams, 1996.

Faris, Wendy B. "Larger than Life: The Hyperbolic Realities of Gabriel García Márquez and Fernando Botero." *Word & Image* 17, 4 (2001): 339–59.

———. "Primitivist Construction of Identity in the Work of Frida Kahlo." In *Primitivism and Identity in Latin America.* Edited by Erik Camayd-Freixas and José Eduardo González. Tucson: University of Arizona Press, 2000. Pp. 221–40.

Farriss, Nancy. *Maya Society under Colonial Rule: The Collective Enterprise of Survival.* Princeton: Princeton University Press, 1984.

Fernández, Miguel Angel. *La Jerusalén indiana: Los conventos-fortaleza mexicanos del siglo XVI.* Mexico City: Smurfit Cartón y Papel de México, 1992.

Fernández-Braso, Miguel. *Gabriel García Márquez: Una conversación infinita.* Madrid: Editorial Azur, 1969.

Fishburn, Evelyn. "A Footnote to Borges Studies: A Study of the Footnotes." University of London Institute of Latin American Studies, Occasional Papers No. 26. Pp. 1–23.

———. "Hidden Pleasures in Borges's Allusions." In *Borges and Europe Revisited.* Edited by Evelyn Fishburn. London: Institute of Latin American Studies/University of London, 1998. Pp. 49–59.

Flor, Fernando R. de la. *Barroco: Representación e ideología en el mundo hispánico (1580–1680).* Madrid: Cátedra, 2002.

Florescano, Enrique. *Memoria indígena.* Mexico City: Taurus, 1999.

———. *Memory, Myth, and Time in Mexico: From the Aztecs to Independence.* Translated by Albert G. Bork. Austin: University of Texas Press, 1994.

Florescano, Enrique. *The Myth of Quetzalcóatl* (1995). Translated by Lysa Hochroth. Baltimore: Johns Hopkins University Press, 1999.

Foucault, Michel. "Of Other Spaces." *Diacritics,* 16, 1 (Spring 1986): 22–27.

———. *The Order of Things: An Archaeology of the Human Sciences* (1966). New York: Vintage Books, 1973.

———. "Questions on Geography." In *Power/Knowledge: Selected Interviews and Other Writings, 1972–1977.* Edited by Colin Gordon. New York: Pantheon, 1980. Pp. 63–77.

Franco, Jean. *Plotting Women: Gender and Representation in Mexico.* New York: Columbia University Press, 1989.

Furst, Jill Leslie McKeever. *The Natural History of the Soul in Ancient Mexico.* New Haven: Yale University Press, 1995.

Galarza, Joaquín. *Códices Testerianos.* Mexico City: TAVA Editorial, 1992.

Galera Lamadrid, Jesús. *Nican mopohua: Breve análisis literario e histórico.* Mexico City: Editorial Jus, 1991. http://www.interlupe.com.mx/4.html

Gallo, Marta. *Reflexiones sobre espejos: La imagen especular: Cuatro siglos en su trayectoria literaria hispanoamericana.* Guadalajara: Universidad de Guadalajara, 1993.

García, David. "Juan Diego será santo." *La Reforma.* 8 December 2001, p. C4.

García, Marta. "Los códices de Guerrero: La historia detrás del glifo." *El Nacional* (13, 14, 15 February 1993).

García Icazbalceta, Joaquín. *Carta acerca del origen de la imagen de Nuestra Señora de Guadalupe de México* (1896). Mexico City: Miguel Angel Porrúa, 1982.

García Lorca, Federico. "La imagen poética de Don Luis de Góngora" (1927). *Obras completas.* Madrid: Aguilar, 1967. Pp. 64–88.

García Maroto, Gabriel. "La obra de Diego Rivera." *Contemporáneos* (June, July, August, 1928): 43–75.

Gariano, Carmelo. "La dimensión grotesca del barroco en *Cien años de soledad.*" In *El barroco en América* (XVII Instituto Internacional de Literatura Iberoamericana), vol. 1. Madrid: Universidad Complutense, 1978. Pp. 695–706.

Gibson, Charles. *The Aztecs under Spanish Rule: The History of the Indians of the Valley of Mexico 1519–1810.* Stanford: Stanford University Press, 1964.

Giffords, Gloria Fraser et al. *The Art of Private Devotion: Retablo Painting of Mexico.* Fort Worth: Meadows Museum/Southern Methodist University, 1991.

Gingerich, Willard. "Quetzalcóatl and the Agon of Time: A Literary Reading of the *Anales de Cuauhtilán.*" *New Scholar* 10, 1–2 (1986): 41–60.

González Echevarría, Roberto. *Alejo Carpentier: The Pilgrim at Home.* Ithaca, NY: Cornell University Press, 1977.

———. "The Novel as Myth and Archive: Ruins and Relics of Tlön." In *Myth and Archive: A Theory of Latin American Narrative.* Cambridge: Cambridge University Press, 1990. Pp. 142–86.

———. *Relecturas: Estudios sobre literatura cubana.* Caracas: Monte Avila, 1976.

———. "Socrates among the Weeds: Blacks and History in Carpentier's *El siglo de las luces.*" In *Celestina's Brood: Continuities of the Baroque in Spanish and Latin American Literature.* Durham, NC: Duke University Press, 1993. Pp. 170–93.

González Mateos, Adriana. *Borges y Escher: Un doble recorrido por el laberinto.* Mexico City: Aldus/Instituto Nacional de Bellas Artes, 1998.

Grañén Porrúa, María Isabel. "El grabado libresco en la Nueva España, sus emblemas y alegorías." In *Juegos de ingenio y agudeza: La pintura emblemática de la Nueva España.* Edited by Rafael Tovar et al. Mexico City: Museo Nacional de Arte, 1994. Pp. 117–31.

Greenberg, Mitchell. *Baroque Bodies: Psycholanalysis and the Culture of French Absolutism.* Ithaca, NY: Cornell University Press, 2001.

Greenleaf, Richard E. *La inquisición en Nueva España, Siglo XVI* (1969). Translated by Carlos Valdés. Mexico City: Fondo de Cultura Económica, 1981.

Greer, Margaret Rich. *María de Zayas tells Baroque Tales of Love and the Cruelty of Men.* University Park: Pennsylvania State University Press, 2000.

———. "Spanish Golden Age Tragedy from Cervantes to Calderón." In *A Companion to Tragedy.* Edited by Rebecca Bushnell. Oxford: Blackwell, 2005. Pp. 351–69.

Gruzinski, Serge. *El águila y la sibila: Frescos indios de México.* Barcelona: M. Moleiro Editor, 1994.

———. "From the Baroque to the Neo-Baroque: The Colonial Sources of the Postmodern Era (The Mexican Case)." In *El corazón sangrante/The Bleeding Heart.* Boston: The Institute of Contemporary Art/University of Washington Press, 1991. Pp. 62–89.

———. *La colonización de lo imaginario: Sociedades indígenas y occidentalización en el México español. Siglos XVI–XVIII* (1988). Translated by Jorge Ferreiro. Mexico City: Fondo de Cultura Económica, 1991.

———. *Painting the Conquest: The Mexican Indians and the European Renaissance.* Translated by Deke Dusinberre. Paris: Unesco/Flammarion, 1992.

Guido, Angel. *Redescubrimiento de América en el arte.* Buenos Aires: F. y M. Mercatali, 1944.

Guerrero, Gustavo. *La estrategia neobarroca.* Barcelona, Edicions del Mall, 1987.

Hagerman-Young, Anita M. and Kerry Wilks. "The Theatre of the World: Staging Baroque

Hierarchies." In *The Theatrical Baroque.* Edited by Larry Norman. Chicago: University of Chicago Press, 2001. Pp. 36–45.

Hamill, Pete. *Diego Rivera.* New York: Harry N. Abrams, 1999.

Hammer, Kirsten. "*Monjas coronadas:* The Crowned Nuns of Viceregal Mexico." In *Retratos: 2,000 Years of Latin American Portraits.* New Haven: Yale University Press, 2004. Pp. 86–101.

Handley, George. *Postslavery Literatures in the Americas: Family Portraits in Black and White.* Charlottesville: University of Virginia Press, 2000.

Harbison, Robert. *The Built, the Unbuilt and the Unbuildable: In Pursuit of Architectural Meaning.* Cambridge: MIT Press, 1991.

———. *Reflections on Baroque.* Chicago: University of Chicago Press, 2000.

Hardin, Michael. "Inscribing and Incorporating the Marginal: (P)recreating the Female Artist in Elena Garro's *Recollections of Things to Come.*" *Hispanic Journal* 16, i (1995): 147–59.

Harss, Luis, and Barbara Dohmann. *Into the Mainstream: Conversations with Latin American Writers.* New York: Harper and Row, 1966.

Haskins, Susan. *Mary Magdalen: Myth and Metaphor.* New York: Riverhead Books, 1993.

Hauser, Arnold. *Mannerism: The Crisis of the Renaissance and the Origin of Modern Art.* Cambridge: Harvard University Press, 1986.

Hermengildo Bustos: 1832–1907 (exhibition catalogue). Mexico City: Museo Nacional de Arte, 1993.

Herrera, Hayden. *Frida: A Biography of Frida Kahlo.* New York: Harper and Row, 1983.

Hersey, George L. *Architecture and Geometry in the Age of the Baroque.* Chicago: University of Chicago Press, 2000.

Hoffmeister, Gerhart. *Deutsche und europäische Barockliteratur.* Stuttgart: Matzler, 1987.

Houston, Stephen, and David Stuart. "The Ancient Maya Self." *RES* 33 (Spring 1998): 73–101.

Huddleston, Robert. "Baroque Space and the Art of the Infinite." In *The Theatrical Baroque.* Edited by Larry Norman. Chicago: University of Chicago Press, 2001. Pp. 13–9.

Huerta, David. "La querella hispánica de Borges." *Letras libres* 1, no. 8 (August 1999): 50–53.

Hunbatz Men and Charles Bensinger, *Mayan Vision Quest: Mystical Initiations in Mesoamerica.* Translated by Louise Montez. San Francisco: Harper, 1991.

Iberoamérica mestiza: Encuentro de pueblos y culturas (exhibition catalogue). Madrid and Mexico City: Centro Cultural de la Villa/Instituto Nacional de Antropología e Historia, 2003.

Jameson, Fredric. *Postmodernism or, The Cultural Logic of Late Capitalism.* Durham, NC: Duke University Press, 1991.

———. "Third-World Literature in the Era of Multinational Capitalism." *Social Text* 15 (Fall 1986): 65–88.

Jansen, André. "Procesos humorísticos de *Cien años de soledad* y sus relaciones con el barroco." In *El barroco en América* (XVII Congreso del Instituto Internacional de Literatura Iberoamericana), vol. 1. Madrid: Universidad Complutense, 1978. Pp. 681–693.

Jansen, Katherine Ludwig. *The Making of the Magdalen: Preaching and Popular Devotion in the Middle Ages.* New Jersey: Princeton University Press, 2000.

Jara, René, and Nicholas Spadaccini, eds. *Amerindian Images and the Legacy of Columbus.* Minneapolis: University of Minnesota Press, 1992.

Jardine, Alice. *Gynesis: Configurations of Woman and Modernity.* Ithaca: Cornell University Press, 1985.

Kadir, Djelal. *Questing Fictions: Latin America's Family Romance.* Minneapolis: University of Minnesota Press, 1986.

Kaminsky, Amy. *Reading the Body Politic: Feminist Criticism and Latin American Women Writers.* Minneapolis: University of Minnesota Press, 1993.

Keleman, Pál. *Baroque and Rococo in Latin America.* New York: McMillan, 1951.

Kelley, Theresa M. *Reinventing Allegory.* Cambridge: Cambridge University Press, 1997.

Kersten, Fred. *Galileo and the 'Invention' of Opera: A Study in the Phenomenology of Consciousness.* Dordrecht/London: Kluwer Academic Publishers, 1997.

King, Mark. "Hearing the Echoes of the Verbal Art in Mixtec Writing." *Writing without Words: Alternative Literacies in Mesoamerica and the Andes.* Edited by Elizabeth Hill Boone and Walter D. Mignolo. Durham, NC: Duke University Press, 1994. Pp. 102–36.

Krauze, Enrique. "Guerrilla Dandy." *New Republic,* 27 June 1988, pp. 28–38.

Kristal, Efraín. *Invisible Work: Borges and Translation.* Nashville: Vanderbilt University Press, 2002.

Kubler, George. *Esthetic Recognition of Ancient Amerindian Art.* New Haven: Yale University Press, 1991.

———. *The Shape of Time: Remarks on the History of Things.* New Haven: Yale University Press, 1962.

Kurnitzky, Horst. "Barroco y postmodernismo: Una confrontación postergada." In *Modernidad, mestizaje cultural, ethos barroco.* Edited by Bolívar Echeverría. Mexico City: Universidad Nacional Autónoma de México, 1994. Pp. 73–92.

Kutzinski, Vera. "The Logic of Wings: Gabriel García Márquez and Afro-American Literature." In *García Márquez.* Edited by Robin Fiddian. London: Longman, 1995. Pp. 214–28.

Lafaye, Jacques. *Quetzalcóatl and Guadalupe: The Formation of Mexican National Consciousness 1531–1813* (1974). Translated by Benjamin Keen. Chicago: University of Chicago Press, 1976.

Lambert, Gregg. *The Non-Philosophy of Gilles Deleuze.* New York: Continuum, 2002.

Landa, Diego de. *Yucatan Before and After the Conquest.* Translated by William Gates. New York: Dover Publications, 1978.

Langdon, Helen. *Caravaggio: A Life.* London: Chatto and Windus, 1998.

Lange-Churión, Pedro. "Neobaroque: Latin America's Postmodernity?" In *Latin America and Postmodernity: A Contemporary Reader.* Edited by Pedro Lange-Churión and Eduardo Mendieta. Amherst: Humanity Books, 2001. Pp. 253–73.

Lefebvre, Henri. *The Production of Space* (1974). Translated by Donald Nicholson-Smith. Oxford: Blackwell, 1991.

León-Portilla, Miguel. *Aztec Thought and Culture: A Study of the Ancient Nahua Mind.* Translated by Jack Emory Davis. Norman: University of Oklahoma, 1963.

———. "Bernardino de Sahagún: Pionero de la antropología." *Arqueología mexicana* IV, 36 (March-April 1999): 9.

———. *Códices: Los antiguos libros del nuevo mundo.* Mexico City: Aguilar, 2003.

———. *El destino de la palabra: De la oralidad y los códices mesoamericanos a la escritura alfabética.* Mexico City: El Colegio Nacional/Fondo de Cultura Económica, 1996.

———. *Los antiguos mexicanos a través de sus crónicas y cantares.* Mexico City: Fondo de Cultura Económica, 1961.

———. *Pre-Columbian Literatures of Mexico.* Translated by Grace Lobanov. Norman: University of Oklahoma Press, 1969.

———. *Quince poetas del mundo náhuatl.* Mexico City: Editorial Diana, 1993.

———. *Tonantzin Guadalupe: Pensamiento náhuatl y mensaje cristiano en el* Nican mopohua. Mexico City: Fondo de Cultura Económica, 2000.

Leonard, Irving A. *Baroque Times in Old Mexico: Seventeenth-Century Persons, Places, and Practices.* Ann Arbor: University of Michigan, 1959.

Lockhart, James. *The Nahuas after the Conquest: A Social and Cultural History of the Indians of Central Mexico, Sixteenth through Eighteenth Centuries.* Stanford: Stanford University Press, 1992.

Lomas, David. "Body Languages: Kahlo and Medical Imagery." In *The Body Imaged: The Human Form and Visual Culture since the Renaissance.* Edited by Kathleen Adler and Marcia Pointon. Cambridge: Cambridge University Press, 1993. Pp. 5–19.

López Austin, Alfredo. *Cuerpo humano e ideología: las concepciones de los antiguos nahuas.* 2 vols. Mexico City: Universidad Nacional Autónoma de México, 1980.

———. *Hombre-Dios: Religión y política en el mundo náhuatl.* Mexico City: Universidad Nacional Autónoma de México, 1973.

López Luján, Leonardo, Robert H. Cobean T., and Alba Guadalupe Mastache R. *Xochicalco y Tula.* Mexico City: Consejo Nacional para la Cultura y las Artes, 2001.

López Quintas, A. *El pensamiento filosófico de Ortega y d'Ors.* Madrid: Guadarrama, 1972.

López Rangel, Rafael. *Diego Rivera: Architectura mexicana.* Mexico City: Secretaría de Educación Pública, 1986.

Love, Bruce. *The Paris Codex: Handbook for a Maya Priest.* Austin: University of Texas Press, 1994.

Loyola, Ignatius de. *Powers of Imagining: Ignatius de Loyola: A Philosophical Hermeneutic of Imagining through the Collected Works of Ignatius de Loyola, with a Translation of These Works.* Translated by Antonio T. de Nicolas. Foreword by Patrick Heelan, S.J. Albany, NY: SUNY Press, 1986.

Ludovitch, Dalia. *Subjectivity and Representation in Descartes.* Cambridge: Cambridge University Press, 1988.

Malcuzynski, Marie-Pierrette. "Le (Neo)Baroque: Enquête critique sûr la transformation et l'application d'un champ notionnel." *Imprévue* 1 (1987): 11–43.

Mâle, Emile. *L'Art religieux après le Concile de Trente.* Paris: Librarie Armand Colin, 1932.

Manrique, Jorge Alberto. "Del barroco a la Ilustración." In *Historia general de México,* edited by Ignacio Bernal et al. Mexico City: El Colegio de México, 2000. Pp. 431–85.

Maquívar, María del Consuelo. *El imaginero novohispano y su obra.* Mexico City: Instituto Nacional de Antropología e Historia, 1995.

Marandel, J. Patrice. *François de Nomé: Mysteries of a Seventeenth-Century Neapolitan Painter.* Houston: The Menil Collection, 1991.

Maravall, José Antonio. *La cultura del barroco: Análisis de una estructura histórica.* Barcelona: Ariel, 1975.

———. *Culture of the Baroque: Analysis of a Historical Structure* (1975). Translated by Terry Cochran. Minneapolis: University of Minnesota Press, 1986.

Marcus, Joyce. *Mesoamerican Writing Systems: Propaganda, Myth, and History in Four Ancient Civilizations (Zapotec, Maya, Mixtec, and Teotihuacano).* Princeton: Princeton University Press, 1992.

Margadant, Guillermo Floris. *Autos seguidos por algunos de los naturales del pueblo de Chamula en contra de su cura don José Ordóñez y Aguiar por varios excesos que le suponían, 1779.* Mexico City: Universidad Autónoma de Chiapas/Miguel Angel Porrúa, 1992.

María Magdalena: Extasis y arrepentimiento (exhibition catalogue). Mexico City: Conaculta/Instituto Nacional de Bellas Artes, 2001.

Marin, Louis. "Classical, Baroque: Versailles, or the Architecture of the Prince." In *Baroque Topographies.* Edited by Timothy Hampton. New Haven: Yale University Press, 1991. Pp. 167–82.

Markman, Roberta H., and Peter T. Markman. *The Flayed God: The Mesoamerican Mythological Tradition.* New York: HarperCollins Publishers, 1992.

Marnham, Patrick. *Dreaming with his Eyes Wide Open: A Life of Diego Rivera.* Berkeley: University of California Press, 1998.

Márquez Rodríguez, Alexis. *La obra narrativa de Alejo Carpentier.* Caracas: Ediciones de la Biblioteca de la Universidad Central de Venezuela, 1970.

Martin, John Rupert. *Baroque.* New York: Harper and Row, 1977.

Maza, Francisco de la. *Guadalupanismo mexicano.* Mexico City: Fondo de Cultura Económica, 1953.

McAndrew, John. *The Open-Air Churches of Sixteenth-Century Mexico.* Cambridge: Harvard University Press, 1965.

McKendrick, Melveena. *Playing the King: Lope de Vega and the Limits of Conformity.* London: Tamesis, 2000.

Méndez Ramírez, Hugo. *Neruda's Ekphrastic Experience: Mural Art and* Canto general. Lewisburg, PA: Bucknell University Press, 1999.

Méndez Rodenas, Adriana. *Severo Sarduy: El neobarroco de la transgresión.* Mexico City: Universidad Nacional Autónoma de México, 1983.

Merleau-Ponty, Maurice. "Eye and Mind." In *The Essential Writings of Merleau-Ponty.* Edited by Alden L. Fisher. New York: Harcourt, Brace and World, 1969.

Meyer, Doris, ed. *Lives on the Line: The Testimony of Contemporary Latin American Authors.* Berkeley: University of California Press, 1988.

Meyer, Jean A. *The Cristero Rebellion: The Mexican People between Church and State, 1926–1929.* Cambridge: Cambridge University Press, 1976.

Mignolo, Walter D. *The Darker Side of the Renaissance: Literacy, Territoriality, and Colonization.* Ann Arbor: University of Michigan Press, 1995.

———. "The Movable Center: Geographical Discourses and Territoriality During the Expansion of the Spanish Empire." In *Coded Encounters: Writing, Gender and Ethnicity in Colonial Latin America.* Edited by Francisco Javier Cevallos-Candau et al. Amherst: University of Massachusetts Press, 1994. Pp. 15–45.

———. "Signs and their Transmission: The Question of the Book in the New World." In *Writing Without Words: Alternative Literacies in Mesoamerica and the Andes.* Edited by Elizabeth Hill Boone and Walter D. Mignolo. Durham, NC: Duke University Press, 1994. Pp. 220–70.

Milano, Peppi Battaglini. *Abel Quesada: The Muse Hunter.* Mexico City: Joaquín Mortiz, 1989.

Miles, Margaret R. *Image as Insight: Visual Understanding in Western Christianity and Secular Culture.* Boston: Beacon Press, 1985.

Miller, Mary Ellen, and Karl Taube. *The Gods and Symbols of Ancient Mexico and the Maya: An Illustrated Dictionary of Mesoamerican Religion.* London: Thames & Hudson, 1993.

Mirollo, James V. "The Death of Venus: Right Reading of Baroque Verbal and Visual Texts." In *The Image of the Baroque.* Edited by Adlo Scaglione and Gianni Eugenio Viola. New York: Peter Lang, 1995. Pp. 203–19.

Mitchell, W. J. T. "What Is an Image?" In *Iconology: Image, Text, Ideology.* Chicago: University of Chicago Press, 1986. Pp. 7–46.

Montaigne, Michel de. *The Complete Essays of Montaigne.* Translated by Donald M. Frame. Stanford: Stanford University Press, 1943.

Moraña, Mabel. "Barroco y conciencia criolla en hispanoamérica," *Revista de crítica literaria latinoamericana* XIV, no. 28 (1988): 229–51.

————. *Viaje al silencio: Exploraciones del discurso barroco.* Mexico City: Universidad Nacional Autónoma de México, 1998.

————, ed. *Relecturas del Barroco de Indias.* Hanover, NH: Ediciones del Norte, 1994.

Moreno Villa, José. *Lo mexicano en las artes plásticas.* Mexico City: Fondo de Cultura Económica, 1948.

Moser, Walter. "Le baroque: Pour fair et défaires des identités culturelles." In *L'Interculturel au coeur des Amériques.* Ed. D. Castillo Durante and Patrick Imbert. Ottawa: Legas, 2003. Pp. 101–18.

Mullen, Robert. *Architecture and its Sculpture in Viceregal Mexico.* Austin: University of Texas Press, 1994.

Murray, Peter and Linda Murray, eds. *The Oxford Companion to Christian Art and Architecture.* New York: Oxford University Press, 1996.

Navarro de Anda, Ramiro. "Efemérides Guadalupanas." In *Album del 450 aniversario de las apariciones de nuestra Señora de Guadalupe.* Edited by José Ignacio Echeagaray. Mexico City: Ediciones Buena Nueva, 1981. Pp. 271–89.

Nebel, Richard. *Santa María Tonantzin Virgen de Guadalupe: Continuidad y transformación religiosa en México* (1992). Translated by Carlos Warnholtz Bustillos. Mexico City: Fondo de Cultura Económica, 1995.

Nichols, Aiden. *The Art of God Incarnate: Theology and Image in Christian Tradition.* London: Darton, Longman, and Todd, 1981.

Niles, Susan. "Inca Architecture and Sacred Landscape." In *The Ancient Americas.* Edited by Richard F. Townsend. Chicago: Art Institute of Chicago, 1992. Pp. 347–57.

Norman, Larry F., ed. *The Theatrical Baroque.* Chicago: University of Chicago Press, 2001.

O território do barroco no século XXI, a symposium issue of the journal *Barroco.* Vol. 18. Ouro Preto, Brazil: Cultural Institute Flávio Gutierrez, 1997–2000.

O'Gorman, Edmundo. *Destierro de sombras: Luz en el origen de la imagen y culto de Nuestra Señora de Guadalupe del Tepeyac.* Mexico City: Universidad Nacional Autónoma de México, 1986.

Ortega y Gasset, José. *Papeles sobre Velázquez y Goya.* Madrid: Revista de Occidente, 1950.

Palmer, Gabrielle, and Donna Pierce. *Cambios: The Spirit of Transformation in Spanish Colonial Art.* Santa Barbara: The Santa Barbara Museum of Art/University of New Mexico Press, 1992.

Panofsky, Erwin. *Perspective as Symbolic Form* (1927). New York: Zone Books, 1991.

————. *Studies in Iconology: Humanistic Themes in the Art of the Renaissance* (1939). New York: Harper and Row, 1962.

————. "What is Baroque?" (1934). In *Three Essays on Style.* Edited by Irving Levin. Cambridge: MIT Press, 1993. Pp. 19–88.

Pascal, Blaise. *Thoughts, Letters, Minor Works.* Translated by W. F. Trotter. New York: P. F. Collier and Son, 1910.

Pascual Buxó, José. "El arte novohispano en el espejo de su literatura." In *La literatura novohispana: Revisión crítica y propuestas metodológicas.* Edited by José Pascual Buxó and Arnulfo Herrera. Mexico City, 1994. Pp. 289–302.

————. *El resplandor intelectual de las imágenes: Estudios de emblemática y literatura novohispana.* México: Universidad Nacional Autónoma de México, 2002.

————. "La historiografía literaria novohispana." In *La literatura novohispana: Revisión crítica y propuestas metodológicas.* Edited by José Pascual Buxó and Arnulfo Herrera. Mexico City: Universidad Nacional Autónoma de México, 1994. Pp. 13–30.

Pauly, Arabella. *Neobarroco: Zur Wesensbestimmung Lateinamerikas und seiner Literatur.* Frankfurt: Peter Lang, 1993.

Pellicer, Rosa. "Borges, lector de Gracián: Laberintos, retruécanos, emblemas," http://www.hum.au.dk/romansk/borges/bsol/rp1.htm.

Perlongher, Néstor. "Neobarroco y neobarroso." Prologue to *Medusario: Muestra de poesía latinoamericana.* Edited by Roberto Echavarren, José Kozer, and Jacobo Sefamí. Mexico City: Fondo de Cultura Económica, 1996. Pp. 19–30.

Peters, Julie Stone. *Theatre of the Book 1480–1880: Print, Text, and Performance in Europe.* Oxford and New York: Oxford University Press, 2000.

Phillips, J. *The Reformation of Images: Destruction in Art in England, 1535–1660.* Berkeley: University of California Press, 1973.

Picón-Salas, Mariano. *A Cultural History of Spanish America: From Conquest to Independence* (1944). Translated by Irving A. Leonard. Berkeley: University of California Press, 1962.

———. *De la conquista a la independencia: Tres siglos de historia cultural hispanoamericana.* Mexico City: Fondo de Cultural Económica, 1944.

Pierce, Donna, Rogelio Ruiz Gomar, and Clara Bargellini. *Painting the New World: Mexican Art and Life 1521–1821.* Denver and Austin: The Denver Art Museum/University of Texas Press, 2004.

Piña Chan, Román. *Quetzalcóatl: Serpiente emplumada.* Mexico City: Fondo de Cultura Económica, 1977.

Pohl, John, and Bruce E. Byland. "The Mixteca-Puebla Style and Early Postclassic Socio-Political Interaction." In *Mixteca-Puebla: Discoveries and Research in Mesoamerican Art and Archeology.* Edited by H. B. Nicolson and E. Quiñone Keber. Culver City, CA: Labyrinthos Press, 1994. Pp. 189–99.

Poole, Stafford. *Our Lady of Guadalupe: The Origins and Sources of a Mexican National Symbol, 1531–1797.* Tucson: University of Arizona Press, 1995.

Popol Vuh: The Mayan Book of the Dawn of Life. Translated and with an introduction by Dennis Tedlock. New York: Simon and Schuster, 1985.

Praz, Mario. *Imágenes del barroco: Estudios de emblemática* (1964). Translated by José María Parreño. Madrid: Ediciones Siruela, 1989.

———. *Studies in Seventeenth-Century Imagery.* Rome: Edizioni de Storia e Litteratura, 1964.

Pupo-Walker, Enrique. "El carnero y una forma seminal del relato afro-hispánico." In *Homenaje a Lydia Cabrera.* Edited by Reinaldo Sánchez and José A. Madrigal. Barcelona: Ediciones Universal, 1977. Pp. 251–57.

Rama, Angel. *La ciudad letrada.* Hanover, NH: Ediciones de Norte, 1984.

———. *The Lettered City* (1984). Translated by John Charles Chasteen. Durham, NC: Duke University Press, 1996.

———. *Transculturación narrativa en América Latina.* Mexico City: Siglo XXI, 1982.

Ranum, Orest. "Encrustation and Power in Early Modern French Baroque Culture." In *Baroque Topographies.* Edited by Timothy Hampton. New Haven: Yale University Press, 1991. Pp. 202–26.

Réau, Louis. *Iconologie de l'art chrétien.* In *Iconologie des saints,* vol. 2. Paris: Université de Paris, 1957.

Relación histórica y moral de la portentosa imagen de N. Sr. Jesucristo crucificado aparecida en una de las cuevas de S. Miguel de Chalma (1910). Mexico City: Impresos Olalde, 1984.

Reyes, Alfonso. *Cuestiones gongorinas* (1923). In *Obras completas,* vol 7. Mexico City: Fondo de Cultura Económica, 1958. Pp. 11–167.

Reyes-Valerio, Constantino. *Arte indocristiano* (1978). Mexico City: Instituto Nacional de Antropología e Historia, 2000.

Ricard, Robert. *La conquista espiritual de México: Ensayo sobre el apostolado y los métodos mi-

sioneros de las órdenes mendicantes en la Nueva España de 1523–1524 a 1572 (1947). Translated by Angel María Garibay K. Mexico City: Fondo de Cultura Económica, 1986.

Reiman, Karen Cordero. "Dos figuraciones de modernidad: Retrato de Adolfo Best Maugard (1913) de Diego Rivera y autoretrato (1923) de Adolfo Best Maugard." *Memoria* No. 6 (1995): 5–21.

Ringle, William, Tomás Gallareta Negrón, and George J. Bey III. "The Return of Quetzalcóatl: Evidence for the Spread of a World Religion during the Epiclassic Period." *Ancient Mesoamerica* 9 (1998): 183–232.

Rivera, Diego. *Textos de arte.* Edited by Xavier Moyssén. Mexico City: Universidad Nacional Autónoma de México, 1986.

Robertson, Donald. *Mexican Manuscript Painting of the Early Colonial Period: The Metropolitan Schools* (1959). Norman: University of Oklahoma, 1994.

Rodríguez, Antonio. *Canto a la tierra: Los murales de Diego Rivera en la Capilla de Chapingo.* Mexico City: Universidad Autónoma de Chapingo, 1986.

Rodríguez Monegal, Emir. "Borges and Politics." *Diacritics* 8, 4 (Winter 1978): 55–69.

———. "Borges, lector del barroco español." In *El barroco en América* (XVII Congreso del Instituto Internacional de Literatura Iberoamericana), vol. 1. Madrid: Universidad Complutense, 1978. Pp. 453–69.

———. *Jorge Luis Borges: A Literary Biography.* New York: Dutton, 1978.

Roh, Franz. "Magical Realism: Post-Expression." Translated by Wendy B. Faris. In *Magical Realism: Theory, History, Community.* Edited by Lois Parkinson Zamora and Wendy B. Faris. Durham, NC: Duke University Press, 1995. Pp. 15–32.

Ross, Kathleen. *The Baroque Narrative of Carlos de Sigüenza y Góngora: A New World Paradise.* Cambridge: Cambridge University Press, 1993.

Rubial García, Antonio. *Santa María Tonantzintla: Un pueblo, un templo.* Mexico City: Universidad Iberoamericana, 1991.

Sacks, Oliver. "The Mind's Eye: What the Blind See." *New Yorker* (28 July 2003): 48–59.

Salazar, Carmen. "*In illo tempore:* Elena Garro's *La semana de colores.*" In *In Retrospect: Essays on Latin American Literature: In Memory of Willis Knapp Jones.* Edited by Elizabeth S. Rogers and Timothy J. Rogers. York, SC: Spanish Literature Publications Company, 1987. Pp. 121–27.

Salgado, César Augusto. "Hybridity in New World Baroque Theory." *The Journal of American Folklore* 112, no. 445 (Summer 1999): 316–331.

Sánchez, Napoleón N. "Lo real maravilloso americano o La americanización del surrealism." *Cuadernos americanos,* no. 219 (July-August 1978): 69–95.

Sandoval Pérez, Margarito. *Arte y folklore en Mexican Folkways.* Mexico City: Universidad Nacional Autónoma de México, 1998.

Santí, Enrico Mario. *Escritura y tradición: Texto, crítica y poética en la literatura hispanoamericana.* Barcelona: Laia, 1987.

Sarlo, Beatriz. "Un ultraísta en Buenos Aires," *Letras libres* 1, 8 (August 1999): 42–45.

———. *La pasión y la excepción.* Buenos Aires: Siglo XXI Argentina, 2003.

Schele, Linda, and Mary Ellen Miller. *The Blood of Kings: Dynasty and Ritual in Maya Art.* New York: George Braziller, 1986.

Schoene, Albrecht. *Emblematick und Drama im Zeitalter des Barock.* Munich: C.H. Beck, 1993.

Schumm, Petra, ed. *Barrocos y modernos: Nuevos caminos en la investigación del barroco iberoamericano.* Frankfurt: Vervuert/Madrid: Iberoamericana, 1998.

Schuessler, Michael. "Géneros re-nacientes de la Nueva España: Teatro misionero y pintura mural." In *La cultura literaria de la América virreinal: Concurrencias y diferencias.* Edited

by José Pascual Buxó. Mexico City: Universidad Nacional Autonoma de México, 1996. Pp. 269–77.

———. "Iconografía y evangelización: Observaciones sobre la pintura mural en la Nueva España." In *La literatura novohispana: Revisión crítica y propuestas metodológicas.* Edited by José Pascual Buxó and Arnulfo Herrera. Mexico City: Universidad Nacional Autónoma de México, 1994. Pp. 255–76.

Sebastián, Santiago. *Contrarreforma y barroco.* Madrid: Editorial Alianza, 1985.

———. *El barroco iberoamericano: Mensaje iconográfico.* Mexico City: Ediciones Encuentro, 1992.

———. *Iconografía e iconología del arte novohispano.* Mexico City: Grupo Azabache, 1992.

Seghers, Pierre. *Monsù Desiderio ou le théatre de la fin du monde.* Paris: R. Laffont, 1981.

Seler, Eduard Georg. *Comentarios al Códice Borgia.* 3 vols. México: Fondo de Cultura Económica, 1963.

Silva Cáceres, Raúl. "Un desplazamiento metonímico como base de la teoría de la visión en *El siglo de las luces.*" *Revista Iberoamericana,* nos. 123–24 (April/September 1983): 487–96.

Simmons, Marlise. "García Márquez on Love, Plagues, and Politics." *New York Times Book Review,* 21 February 1988, 23.

Simón, Pedro, ed. *Recopilación de textos sobre José Lezama Lima.* Havana: Casa de las Américas, 1970.

Sluys, Felix. *Didier Barra et François de Nomé dits Monsù Desiderio.* Paris: Editions du Minotaure, 1961.

Snyder, Joel. "*Las meninas* and the Mirror of the Prince." *Critical Inquiry* 11 (June, 1985): 539–72.

Sobel, Dava. *Galileo's Daughter: A Historical Memoir of Science, Faith, and Love.* New York: Penguin Books, 1999.

Sousa, Lisa, Stafford Poole, and James Lockhart. *The Story of Guadalupe: Luis Laso de la Vega's 'Huei tlamahuiçoltica' of 1649.* Stanford: Stanford University Press, 1998.

Spengler, Oswald. *The Decline of the West* (1918). 2 vols. Translated by Charles Francis Atkinson. New York: Alfred A. Knopf, 1980.

Spitta, Silvia. *Between Two Waters: Narratives of Transculturation in Latin America.* Houston: Rice University Press, 1994.

———. "Desdoblamientos calibanescos: Hacia lo complejo." In *Roberto Fernández Retamar y los estudios latinoamericanos.* Edited by Elzbieta Sklodowska and Ben A. Heller. Pittsburgh: Serie Críticas, 2000. Pp. 275–98.

———. Preface to *Más allá de la ciudad letrada: crónicas y espacios urbanos.* Edited by Boris Muñoz and Silvia Spitta. Pittsburgh: University of Pittsburgh Press, Biblioteca de América, 2003. Pp. 7–23.

Steinberg, Leo. *The Sexuality of Christ in Renaissance Art and in Modern Oblivion.* New York: Pantheon, 1983.

Sten, María, Oscar Armando García, and Alejandro Ortiz Bullé-Goyri, eds. *El teatro franciscano en la Nueva España: Fuentes y ensayos para el estudio del teatro de evangelización en el siglo 16.* Mexico City: Universidad Nacional Autónoma de México, 2000.

Stern, Steve. *Peru's Indian Peoples and the Challenge of Conquest: Huamanga to 1640.* Madison: University of Wisconsin Press, 1982.

Stoichita, Victor I. *Visionary Experience in the Golden Age of Spanish Art.* London: Reaktion Books, 1995.

Stoll, Anita, ed. *A Different Reality: Studies on the Work of Elena Garro.* Lewisburg, PA: Bucknell University Press, 1990.

Strong, Beret. *The Poetic Avant-Garde: The Groups of Borges, Auden and Breton.* Evanston: Northwestern University Press, 1997.

Taube, Karl. "The Iconography of Mirrors at Teotihuacán." In *Art, Ideology, and the City of Teotihuacán.* Edited by Janet Catherine Berlo. Washington, D.C.: Dumbarton Oaks, 1992. Pp. 169–204

Thiem, Jon. "The Textualization of the Reader in Magical Realist Fiction." In *Magical Realism: Theory, History, Community.* Edited by Lois Parkinson Zamora and Wendy B. Faris. Durham, NC: Duke University Press, 1995. Pp. 235–47.

Tibol, Raquel. *Hermenegildo Bustos: Pintor de pueblo.* Mexico City: Ediciones Era, 1981.

Tinterow, Gary and Geneviève Wilson-Bareau. *Manet/Velázquez: The French Taste for Spanish Painting.* New York and New Haven: The Metropolitan Museum of Art/Yale University Press, 2002.

Todorov, Tvetan. *The Conquest of America: The Question of the Other.* Translated by Richard Howard. New York: Harper Torchbooks, 1984.

Torre Villar, Ernesto de la. *Breve historia del libro en México.* Mexico City: Universidad Nacional Autónoma de México, 1987.

Tovar de Teresa, Guillermo. "El arte novohispano en el espejo de su literatura." In *La literatura novohispana: Revisión crítica y propuestas metodológicas.* Edited by José Pascual Buxó and Arnulfo Herrera. Mexico City: Universidad Nacional Autónoma de México, 1994. Pp. 289–302

———. *México barroco.* Mexico City: SAHOP, 1981.

Tovar, Rafael, et al. *Los pinceles de la historia I: El origen del reino de la Nueva España, 1680–1750.* Mexico City: Instituto Nacional de Bellas Artes, 1999.

———. *Los pinceles de la historia II: De la patria criolla a la nación mexicana: 1750–1860.* Mexico City: Instituto Nacional de Bellas Artes, 2000.

———. *Los pinceles de la historia III: La fabricación del estado: 1864–1910.* Mexico City: Instituto Nacional de Bellas Artes, 2003.

Trejo, Silvia. *Dioses, mitos, y ritos del México antiguo.* Mexico City: Miguel Angel Porrúa, 2000.

Turner, Kay F. "The Cultural Semiosis of Religious Icons: La Virgen de San Juan de los Lagos," *Semiotica* 47, 1–4 (1983): 317–61.

Urslar Pietri, Arturo. *Letras y hombres de Venezuela.* Mexico City: Fondo de Cultura Económica, 1948.

Van de Wetering, Ernst. "The Multiple Functions of Rembrandt's Self Portraits." In *Rembrandt by Himself.* Edited by Christopher White and Quentin Buvelot. London: The Hague and National Gallery Publications, 1999. Pp. 8–37.

Van der Loo, Peter L. "Voicing the Painted Image: A Suggestion for Reading the Reverse of the Codex Cospi." In *Writing without Words: Alternative Literacies in Mesoamerica and the Andes.* Edited by Elizabeth Hill Boone and Walter D. Mignolo. Durham, NC: Duke University Press, 1994. Pp. 77–86.

Vanderwood, Paul J. *The Power of God against the Guns of Government: Religious Upheaval in Mexico at the Turn of the Nineteenth Century.* Stanford: Stanford University Press, 1998.

Vargaslugo, Elisa. ". . . El más hermoso de los hijos de los hombres . . ." In *Parábola novohispana: Cristo en el arte virreinal.* Edited by Elisa Vargaslugo. Mexico City: Fomento Cultural Banamex, 2000. Pp. 75–116.

Vásquez, María Esther. *Borges, sus días y su tiempo.* Buenos Aires: Javier Vergara Editor, 1999.

Viqueira Albán, Juan Pedro. *María de la Candelaria: India natural de Cancuc.* Mexico City: Fondo de Cultura Económica, 1993.

Voragine, Jacobus de. *The Golden Legend: Readings on the Saints.* 2 Vols. Translated by William Granger Ryan. Princeton: Princeton University Press, 1993.

Warnke, Frank J. *Versions of Baroque: European Literature in the Seventeenth Century.* New Haven: Yale University Press, 1972.

Weisbach, Werner. *El barroco: Arte de la Contrarreforma* (1920). Madrid: Espasa-Calpe, 1942.

Weismann, Elizabeth Wilder. *Art and Time in Mexico: From the Conquest to the Revolution.* New York: Harper and Row, 1985.

Westermann, Mariët. *A Worldly Art: The Dutch Republic 1585–1718.* New Haven: Yale University Press, 1996.

Williams, Adriana. *Covarrubias.* Translated by Julio Colón Gómez. Mexico City: Fondo de Cultura Económica, 1999.

Wilson, Jason. "Jorge Luis Borges and the European Avant-Garde." In *Borges and Europe Revisited.* Edited by Evelyn Fishburn. London: Institute of Latin American Studies/University of London, 1998. Pp. 68–80.

Wimsatt, William, Jr., and Cleanth Brooks, *Literary Criticism: A Short History.* New York: Vintage, 1957.

Wölfflin, Heinrich. *Principles of Art History: The Problem in the Development of Style in Later Art* (1915). Translated by M.D. Hottinger. New York: Dover, 1950.

———. *Renaissance and Baroque* (1888). Translated by Kathrin Simon. Ithaca: Cornell University Press, 1965.

Woodall, James. *The Man in the Mirror of the Book: A Life of Jorge Luis Borges.* London: Hodder and Stoughton, 1996.

Wright, Christopher. *The French Painters of the Seventeenth Century.* Boston: Little Brown and Company, 1985.

Yates, Frances A. *The Art of Memory.* Chicago: University of Chicago Press, 1966.

———. *Giordano Bruno and the Hermetic Tradition.* Chicago: University of Chicago Press, 1964.

Zamora, Lois Parkinson. "Borges' Monsters: Unnatural Wholes and the Transformation of Genre." In *Literary Philosophers: Borges, Calvino, Eco.* Edited by Jorge Gracia, Rodolphe Gasché, and Carolyn Korsmeyer. London: Routledge, 2002. Pp. 47–84.

———. "Magical Romance/Magical Realism: Ghosts in U.S. and Latin American Fiction." In *Magical Realism: Theory, History, Community.* Edited by Lois Parkinson Zamora and Wendy B. Faris. Durham, NC: Duke University Press, 1995. Pp. 497–550.

———. *The Usable Past: The Imagination of History in Recent Fiction of the Americas.* Cambridge: Cambridge University Press, 1997.

———. "Vargas Llosa Speaks about Dictator Novels, Globalization, and Writing as Reverse Strip Tease" *Hotel Amerika* I: 2 (Spring 2003): 27–37.

———. "The Visualizing Capacity of Magical Realism: Objects and Expression in the Work of Jorge Luis Borges." *Janus Head: An Interdisciplinary Journal,* 5 ii (2002): 21–37.

———. *Writing the Apocalypse: Historical Vision in Contemporary U.S. and Latin American Fiction.* Cambridge: Cambridge University Press, 1989.

Zamora, Lois Parkinson, and Monika Kaup, eds. *Baroque New Worlds: Representation, Transculturation, Counterconquest.* Durham, NC: Duke University Press, forthcoming.

Zamora, Marta. *Frida: El pincel de la angustia.* Mexico City: 1987.

Zea, Leopoldo. *The Latin American Mind* (1949). Translated by James H. Abbott and Lowell Dunham. Norman: University of Oklahoma Press, 1963.

Index

architecture: bodily metaphors for Maya buildings, 10; ephemeral (temporary), 278; as "frozen" music, 342–43n108; illusions of, 246–47, 256–60; integration of painting and sculpture with, 88–92, 323n35; killing rituals of buildings, 11; Rivera's murals and, 78, 88; symbolic source of, 317–18n93. *See also* Baroque art and architecture; curtains; *specific buildings*

Arco, Alonso del, 226, *227*

Arenas, Reinaldo, 111, 220, 294

Argentina: *criollo* culture in, 358n23; limited Baroque influence in, 238; prose style in, 239

Aristotle: archetypes of, 215, 349n59; conception of nature, 26–27, 29, 147; on imitation, 313n64

Armstrong, Louis, 163, 164, 165

Arnheim, Rudolph, 105, 107

art: absence of boundaries in Latin America between visual and verbal, xx–xxi, 151, 154, 162–63, 342–43n108; art about, 252–53, *253, 254,* 265, 300–301; still life, 361–62n45. *See also* aesthetics; artists; Baroque art and architecture; color; illusionism; muralist movement; *specific artists*

artifice: as aesthetic virtue (Reyes), 301–2; nature juxtaposed to, 146, 243–44, 249–50, 267; Sarduy on Baroque, 120, 141–42

artists: manuals for, 175, 313n64, 345n17; role of, xix–xxi; success and dexterity of, 249–50; as teachers, 79. *See also* indigenous artisans (*imagineros*); *tlacuilo; specific artists*

Ashcroft, Bill, 326n56

astronomical observations: codices as epitomizing genius of, 64–65, 67–68; implications of discoveries in, 134

Asturias, Miguel Angel, 120, 216, 330–31n21

attention: changing forms of, xxiii, 306n6; European forms of, 71–72; integration and translation of, 105; to meanings in visual structures, 55–56

audience: disruptions for, 253, 255–56, 270–71; doubts about existence of, 244; as identifying with subject, 243;

questioning space of, 247, *248,* 249, 251; Rivera's murals as incorporating, 89, 90–92; as subjects vs. objects, 106–7

avant garde movement: Baroque compared with, 288, 369n7; Borges and, 238, 287, 357n19

Averroës, 262

Bach, Johann Sebastian, 163, 282

Baciccio (Giovanni Battista Gaulli), 246

Bacon, Francis, 268

Bakhtin, Mikhail, 350n65

Balbás, Jerónimo de, 313n62

Balcells, Carmen, 221

Ballón Aguirre, Enrique, 342n104

bark paper (*amate*): painting on, 94; Rivera's depiction of production, *81, 82;* transcultural uses of, 76–77

baroco (term): allegory compared with, 272; mnemonic device, 234; syllogistic structure of, 234–35

Baroque: alternative rationality of, 242–43, 296–98; definition of, 112, 125, 236; depreciation of, 132, 134, 144, 156, 235–36, 238–42, 285–86, 334n48, 334n53, 343n111; dynamism of, 145, 160, 247, 249; epistemological crisis and, 242–43, 255, 263, 276, 282; eroticism and otherworldliness of, 178, 180, 301, 346n28, 351n76; etymology of, 233–35; extreme physicality of, 37, *38,* 39, 177–78, 217–18, 301; geographic, cultural, and aesthetic boundaries transcended by, xx–xxi, 151, 154, 162–65, 342–43n108; *horror vacui* (horror of a vacuum) as characteristic of, 112–13, 119–21, 137–38, 218, 231, 240, 263–64, 273–74, 295; image of setting as key to understanding, 168, 343n3; Mannerism vs., 178; originality as conceived in, 260, 262, 263; recodification of, by Neobaroque, 219–20; sensuousness of, 31–32, 37, 173–75, 178, *179,* 180, 230–31, 235, 301; "Soul" of, 164, 165; as spirit rather than historical period, xvii–xviii, 115, 126–27, 293; texture of, 121, 231; theatricality of, 32, 231, 235; transhistorical reconception of, 126–29; twentieth-century recovery of,

135–36, 237–38, 286–92. *See also* artifice; Baroque themes; Baroque self; Baroque space; body and embodiment; Counter-Reformation; ecstatic experience; folk Baroque; martyrs and martyrdom; Neobaroque; New World Baroque; perspective; proliferation and permutation; senses; theatre and theatrical performance

Baroque art and architecture: as art in motion, 140; chiaroscuro, 139; explicit physical depiction as invention of, 30; function of, xix, xvii–xviii, 128–29; as measuring the far by the near, 343n111; metonymic displacement in, 141–46, 255; mirror as negative in, 17, *18;* sensuousness of, 235, 301. *See also* columns; folds; folk Baroque; illusionism; religious images; *retablos;* sculpture; trompe l'oeil; *specific artists and buildings*

Baroque conceit (*coincidentia oppositorum*): Classical architecture and Baroque music in, 164–65; Coatlicue as, 156–57; complementarity of opposites, 297–98; definition of, 146–48; ecstasy as, 180; marvelous real and, 146–49, 151, 154, 156–58, 160, 338–39n78; parody of Classical column as, 161; reason and, 296–98; in ugliness and beauty, 234, 354n5

Baroque self: artifice, emotionalism, and, 301–2; in context of saints' lives, 177–82; instability of, 231; modern conception vs., 216, 218–19; multiplicity of, 182–85; parts/whole relation and, 185–87; self's consciousness of, 169–75; self's examination of, 167–68; volatility of, 175. *See also* ecstatic experience

Baroque space: allegory as mediating, 273–75; as coextensive vs. discontinuous, 255, 362n52; depiction of, 129–41; deployment of history in, 104–6, 167–68, 299, 372n30; dynamic forms of, 232, 299; generative capacity of, 144; graphic potential of textual, 257–58; horror of unfilled and impulse to fill, 119–21, 137–38, 148, 218, 231, 263–64, 295; as infinite yet measurable, 256–57,

258, 259–60; kinetic, 119, 138, *138;* movement in, 139–40, *140,* 145–46, 161–65; preoccupation with, 280–81; as transcendental, 244, 247, 363n59; transgression of, 247, *248,* 249. *See also* illusionism; perspective; space/time/ spirit; trompe l'oeil

Baroque themes: act of envisioning, 35; allegory of the five senses, 314n72; architecture as "frozen" music, 342–43n108; asymmetries, 234; Classicism and emotionalism, 132, *133;* connection and continuity, 255–56; conversion and penance, 173, *174,* 175; García Márquez's uses of, 208–9, 211–14; imaginary architecture, 318n93; indirection, 134; infinity, 244; mobility and inclusiveness, 132, 134, 146–48, 235; mutability (life as dream or stage), 135–37, 255–56, 268–71; pantheistic tendencies, 154; self-reflexivity, 239–41; simple/spare or exuberant/emotional, 236–37; suffering and pain, 182–85, 199. *See also* Baroque conceit (*coincidentia oppositorum*); blood and suffering; caricatures; curtains; doublings and dualism; ecstatic experience; emotionalism; folds; illusionism; proliferation and permutation; ruins; space/time/spirit

barroco de indias, 187, 292

Barth, John, 359–60n29

Barzun, Jacques: on Baroque, 215, 236, 355n9; on religious reform movements, 37; on Rubens, 132; on salvation doctrine, 174; on science and superstition, 228, 353n88

Basilica of Guadalupe, *43,* 59

Baudrillard, Jean, 243–44

Beardsell, Peter, 305n10

Beethoven, Ludwig von, 163, 242, 343n112

Belfrage, Cedric, 105

Belkin, Kristin Lohse, 334n48

Belli, Carlos Germán, 294

Beltrán, Rosa, 229

Benedict XIV (pope), 55

Benjamin, Walter: on allegory, 271, 272–74, 275, 282, 366n97; on Baroque, 168, 294, 343n3; on history merging into setting,

Coatlicue: changing cultural functions of, 2; duality of, xii, *xii*, xv, 156–57; Kahlo compared with Saturnino Herrán's painting "Coatlicue Transformed," 197; sculpted figure of, *xiv*, 2; as symbol of cultural syncretism, xiii, xv, 157, *158, 159*

Codex Borbonicus: detail of, *82;* Hernández Xochitiotzin's depiction of, 93, *94, 95;* origin of, 82; Rivera's depiction of, 79, *81*

Codex Borgia: calendric notations in, 63, *63,* 65–67, *67;* description of, 63–64, 320–21n12; embodiments of Venus in, *63,* 65, *66,* 97; space/time/spirit of, 65; Tezcatlipoca depicted in, 6, *7;* world-directions depicted in, *66,* 68

Codex Cospi, *14*

Codex Fejérváry-Mayer, 68–70, *69*

Codex Mendoza, 72, 320n6

Codex Selden, 71

Codex Telleriano-Remensis, 72, *73*

Códice Chimalpopoca, 3, 5, 307n12

codices: Carpentier on, 154; continued use of, 322n29; destruction of, 19, 110; functions of, 64, 65, 72; Galeano's engagement with, 109, 111; Garro's engagement with, 94, 96–103; Hernández Xochitiotzin's (re)conception of, 92–93, *94–95;* of Maya, xix–xx, 321n15; multidimensionality of, 65; physical structure of, 62, 72; popular visual echoes of, 93–94; Rivera's (re)conception of, 78–88; scholarship on, 64, 320n6; screenfold (term), 62; space/time/spirit of, 62–77; styles of, 63–64; Testerian, 76; visual vocabulary of, xix–xx, 62–63; Westernization of, 71–72, *73, 74, 74, 75;* world-directions in, *66,* 68. *See also* calendrical cycles (Mesoamerican); *specific codices*

coincidentia oppositorum. See Baroque conceit (*coincidentia oppositorum*)

Colegio Imperial de Santa Cruz de Tlatelolco, 72, 74

collection and cataloguing: of dictators, 219; in García Márquez's writing, 209. *See also* proliferation and permutation

Collyer, Edward, 251–52, *252*

Colombia. *See* Cartagena (Colombia)

colonialism: images privileged in, 310n45; *Of Love and Other Demons* as engagement of, 230; reviving forms of, in constructing postcolonialism, 120–21; role of colonizing clergy in, 3, 19–20, 72, 74, 76. *See also* Catholic Church; conquest/*conquista;* counterconquest/*contraconquista*

color: in Borges's architectural illusions, 258; in embodiments of Tezcatlipoca, 307–8n18; of Garro's Days, 100–101; Nahua underworld and, 326n59

Columbus, Christopher, 43, 161

columns: Baroque, 160–61; Classical vs. Baroque, 341n100; of Havana and Cuban Baroque, 160–61; in de Nomé's *Explosion in a Cathedral,* 130–31, 135

communal life: Fuentes and Rivera focused on, 103–4; murals as shared visual language in, 77; murals' audience in, 106–7

conquest/*conquista:* hermeneutic, 18; of orality by print culture, 62, 103. *See also* counterconquest/*contraconquista;* Spanish conquest

Copernican Revolution, 119, 144, 329n11. *See also* scientific developments

Corneille, Pierre, 265

Correa, Juan, 17, *18,* 173

corridos, murals as, 121

Cortázar, Julio, 120, 285, 330–31n21

Cortés, Hernán: depiction of, 72, *74;* Mesoamerican "idols" and, 3, 18–19; pilgrimage of, 43, 316n86

cosmic race (*la raza cósmica*), 79

cosmology, 64–65, 141–42

Council of Trent: on Eucharist, 30–32; on image production and consumption, 32, 34; on images, 21, 173, 311n50, 311–12n53; on relics, saints, and images, 29–30, 177

counterconquest/*contraconquista:* concept of, xvi, 126, 286, 332n32; Kahlo and García Márquez and, 169; origin of term, 370n11; as recovery and subversion, 293–94

Counter-Reformation: consolidation of, 34; folk Baroque and, 39, 201–2; image privileged over text in, 35, 37; imagination

of Kahlo's self-portraits, 183, 189–90, *191*, 192, 193; of limited/unlimited, 164; in mise en abîme, 264–67; painting as metaphor and, 167, 171–72, *172;* of Quetzalcóatl as deity and human, 3; in sculptural transgression of space, 249; of sentience and spirit in saints' lives, 177–78; time and, 99–101; in trompe l'oeil, 247. *See also* Baroque conceit (*coincidentia oppositorum*)

Ebert-Schifferer, Sybille, 246–47, 361n39
Echave Ibía, Baltasar de, 180, *181*, 223, *224*, 243
Echave Orio, Baltasar de, 180
Echave y Rioja, Baltasar de, 180, 193, *200*
Echevarría, Bolívar, 126
Eco, Umberto, 134, 144, 145
ecstatic experience: Bernini's depiction of, 178, *179*, 180; Borges's engagement with, 250–51; of saints, 177–82, 209, 345n21; transcendence by means of, 180, 362n47. *See also* Baroque self
Eliot, T. S., 286
emblems: allegory projected in, 274–75; concept of, 260; displacement/ relocation of, 260; "From War, Peace," 276, *277;* function of, 261–62; lists as, 280–82; manuals on, 175, 276, *277, 278,* 345n17; *retablos* as, 282, *283,* 284; traditions of, 367n104, 367–68n105; variety and complexity of, 278, *279,* 280. *See also* Alciato, Andrea; Ripa, Cesare
emotionalism: as Baroque strategy, 301–2; caricature and, 214–15; Classicism combined with, 132, *133;* expanded range of, in Baroque art, 178; hyperbolic, 199, 202; naturalism and, 169–75; de Nomé's appeal to, 137, 138, *138. See also* blood and suffering; ecstatic experience
Enlightenment: Baroque compared with, 286–87, 292, 371n20; hybridity extinguished in, 288; in Latin America, 296, 371n20; resistance to, 296–98; sober style of, 287
Eucharist, Catholic decree on, 30–32
Europe: anti-Baroque fervor in, 287; Carpentier's time in, 116; emblematic

tradition in, 367n104, 367–68n105; literary functions in, 304–5n6; orality/print shift in, 61–62; postwar aesthetics of, 294; *quadratura* in, 246; trompe l'oeil in, 251. *See also* Italy; Spain
Explosion in a Cathedral (El siglo de las luces, Carpentier*):* conch shell as emblem in, 144–45, 337–38n72; *Concierto barroco* compared with, 162; inordinate cultural perspective in, 116; on de Nomé's painting, 129, 135, 137, 139, 140–41, *141,* 144, 335n55; publishing history of, 335–36n63
ex-votos, 192, 347n41
eye: Catholic vs. Protestant, 35, 37; of Garro's characters, 98–99; as intellectual instrument, 16. *See also* mirrors; seeing

family/genealogical trees, 184, *184, 185*
Fargue, Léon-Paul, 158, 160
Faris, Wendy B., 343n4, 351n69
feminist forms of self-representation, 187, 189, 228–29
Fernández, Miguel Angel, 317–18n93
film, 219, 247, 335n55
Fishburn, Evelyn, 263, 362n50
Fitzwilliam Museum (Cambridge, England), 130, *131,* 134–35
Florentine Codex, 72, 74, *75,* 76, 94
Florescano, Enrique, 64, 317n91
folds: of codices, 85; concept of, 142, 233, 337n69; as signal of interconnectedness, 125, 255; textual, 267–68; waking/ dreaming structure and, 268–71. *See also* curtains
folk Baroque: as alternative strategy, 298; Church's use of, 201–2; essence of, 199, 201; Kahlo's self-portraits and, 199, 207; limits of, 182; persistence of, 287
Foucault, Michel: on Baroque, 113, 169; on Borges, 243, 281–82; on confining structures, 228; on epistemological crisis of Baroque period, 242–43, 255; on time and space, 100
fragments and fragmentation: accumulations and juxtapositions of, 104–7, 109, 111, 299; allegories and, 275;

fragments and fragmentation (*continued*)
integration and, 186, 187; multiplicity
possible in, 298–99; power of, 273;
textual recuperation of, 260–64. *See
also* ruins
Franciscan order: concerns about idolatry,
317n91; group portrait of, 184, *184;*
mission churches of, 32, *33;* schools of,
72, 74; spiritual conquest mission of, 34
Franco, Jean, 96
French Revolution: anticlericalism in, 135;
in Caribbean context, 139; as historical
rupture, 140–41; secularism of, 287. *See
also* Carpentier, Alejo; *Explosion in a
Cathedral (El siglo de las luces,*
Carpentier*)*
Freud, Sigmund, 271
Fuentes, Carlos: on Argentina, 238; on
Baroque *horror vacui,* 295; on Borges,
237; Carpentier as precursor to, 116,
292; Carpentier on, 120, 330–31n21;
on cultural continuity, 126;
de-psychologized entities of, 220; on
knowing, 297; on Lezama Lima, 120;
linear time displaced by, 111; on
memory, 327n64; Paz's rupture with,
103–4, 326n61; on Quetzalcóatl's mirror,
5–6; on roundness of Baroque, 302; on
San Lorenzo Potosí, 370n10; use of
theatre of memory trope, 105; works:
Terra nostra, 105, 111, 220, 350n64,
372n30
Furst, Jill Leslie McKeever, 325–26n55

Galeano, Eduardo: accumulations and
fragmentary juxtapositions of, 104–7,
109, 111, 299; Carpentier as precursor
to, 116, 292; on Mesoamerican codices,
109–10; on Pérez Holguín, 107; on
Sahagún, 76; works: *Memory of Fire,*
94, 103–7, 109, 111
Galilei, Galileo, 120, 268
Galves, count of, 142, *143*
García Lorca, Federico, 125
García Márquez, Gabriel: allegory and,
272; archetypes of, 211–12, 301; on
Baroque, 207, 348n48; Baroque
elements of, 208–9, 211–14, 230–32;
Borges compared with, 241; on
boundlessness, xxii; childhood of,
212–14, 222, 353–54n91; on
disproportionate nature of Latin
American reality, 305n9; doubling and
proliferation of, 208, 299; emblematic
physicality of, 177; Galeano's quoting
of, 106–7; *horror vacui* in, 218, 231–32;
inspiration for, xx, 222–23, 352n81; as
ironizing interiority, 169; Neobaroque
parody and, 294; precursor to, 116; on
self and subjectivity, 185, 216, 218–19,
220, 301; works: The *Autumn of the
Patriarch,* 208, 216–19, 221, 231; *The
General in His Labyrinth,* 219; *Living to
Tell the Tale* (autobiography), 207, 212,
230; *Love in the Time of Cholera,* 208,
209, 211, 231–32. See also *Of Love and
Other Demons* (García Márquez); *One
Hundred Years of Solitude* (García
Márquez)
Garibay, Angel María, 324n47
Garro, Elena: characters of, 301; cultural
specificity and, 101–3; on fall of
Tenochtitlán, 72; Galeano compared
with, 104; narrative eye of, 98–99, 157;
precursor to, 116, 292; sources available
to, 324n47; time materialized/visualized
by, 96–103, 299; works: *La semana de
colores,* 94, 96, 100–103; *Recollections of
Things to Come (Los recuerdos del
porvenir),* 94, 96–100, 157
Gasparini, Paolo, 160, 161
gaze: alternative concept to, xxii–xxiii
Generation of '27, 12
Gijsbrechts, Cornelius, 252, *253,* 258
Giotto, 92
Girard, René, 228
Gisbert, Teresa, 178, 318n93
Giusti, Alvise, 162
Glanvill, Joseph, 353n88
Glissant, Edouard, 126
Góngora, Luis de: Borges on, 235, 238,
357–58n21; García Lorca and, 125;
metaphors of, 261–62; recovering works
of, 286, 287; Reyes on, 125, 301
González Echevarría, Roberto, xx, 116, 162,
342n106
Goya y Lucientes, Francisco José de, 144,
164

Keleman, Pál, 199, 340n90
Kelley, Theresa, 274–75
Kennedy, Diana, 94
Kepler, Johann, 120
Kersten, Fred, 343n111
Kircher, Athanasius, 364n83
knowing: Borges's skepticism about, 241–42, 256; nonrational, intuitive forms of, 296–98
Kondori, José, 288, *289, 290, 291,* 298, 370n10
Krauze, Enrique, 103–4, 326n61
Kristal, Enrique, 355n10
Kristeva, Julia, 96
Kubler, George, 234
Kurasawa, Akira, 219

Lady Xoc (Shield Jaguar's wife), 11, *12*
Lafaye, Jacques, 1–2, 40, 43–44
La Malinche, 72, *74*
Lambert, Gregg, 364n80
Landa, Diego de, 19–20, 21, 32, 110, 311n50
Latin America: anti-Baroque fervor in, 287, 369n5; boundless realities of, xxii; dynamic indeterminacy of, 148, 286–87; Enlightenment in, 296, 371n20; inclusive *conjunto* of, 148, 163–65; mobility among media in, xix–xxi; recurring engagement of Baroque in, xvii, 126–29; resources of, 340n90
Lefebvre, Henry, 247, 362n57
Leonard, Irving A., 221, 292–93, 352n79
Leonardo da Vinci, xiii, 214, 302
León-Portilla, Miguel: as influence on Garro, 324n47; on miracle of the roses, 316–17n90; on Nahua conception of the underworld, 326n59; on Náhuatl literature, 10, 49–51; on postconquest alphabetic texts, 307n12, 309–10n38; on space/time/spirit, 64–65; on Tezcatlipoca, 68; on Valeriano, 318n96
Lezama Lima, José: Baroque amplified/reconstituted by, 126, 288; on Baroque and Classicism, 132, 134; on counterconquest, xvi, 286; Fuentes on, 297; on gnostic space, 119–20, 329–30n16; ideology and aesthetics of cultural difference of, 116; on image and

myth, 1; on parts/whole, 299; plotonism (concept), 299; precursor to, 292, 370n11; repression and subversion linked by, 293–94; on Surrealism, 146–47; on syncretism of Sigüenza y Góngora and Sor Juana, 40; works: *Paradiso,* 142, 337n68. *See also* Kondori, José; Neobaroque; New World Baroque
Lienzo of Tlaxcala, 72, *74*
literature: accumulation and juxtaposition in, 103–7, 109, 111; aesthetic renovation in, 287–88; Baroque traditions in, xvii, 207, 348n48; discourse on Spanish Baroque, 124–25; mise en abîme in, 265–67; narrative folds in, 267–68; oral and visual context of, xx–xxi; political allegory in, 216–17; postscripts in, 253, 255; space/time/spirit of, 94, 96–103; subversive, inclusive strategies in, 296–302; ways of seeing as conditioning, xv. *See also* caricatures; dictator novels; *specific writers*
López, Andrés, 182, *183*
López, Carlos Clemente, 35, *36*
López de Arteaga, Sebastián, 41, *42,* 243
Loreto, litany of, 16–17, 310n43
Louis XIII (king of France), 217
Louis XIV (king of France), 216
Louvre (Paris), 235
Love, Bruce, 321n15
Luther, Martin, 37

Machete, El (periodical), 117
magical practices: revivification of, 228, 353n88
magical realism: in art, 368n113; Baroque caricature and, 169; Neobaroque and, 230–31, 297
Malcuzynski, Marie-Pierrette, 332n34, 354–55n8
Mâle, Emile, 345n17, 345n21
Malkovich, John, 247
Mannerism, 132, 178
Manrique, Jorge Alberto, 39–40, 160
maps, 134, 264
Maquívar, María del Consuelo, 311n47
Marandel, J. Patrice, 131, 137, 335n58

Maravall, José Antonio, 236–37, 270

Marcus, Joyce, 64

Margadant, Guillermo Floris, 312n56

Marín, Lupe, 91

Markman, Peter and Robert, 10

Marnham, Patrick, 92

Márquez Rodríguez, Alexis, 339n79

Martí, José, 148

Martin, John Rupert: on allegory, 216, 271; on caricature, 215; on doublings and Baroque, 171; on emblem books, 276; on infinite in Baroque, 244; on plurality in unity, 148; on representation of interiority, 169; on Ripa's manual, 345n17; on seeing and meditation, 34–35

Martínez Montañés, Juan, 34–35

martyrs and martyrdom: archetype of, 173; cult of cruelty and, 217–18; etymology of, 177–78; García Márquez's invocation of, 208, 221–30; graphic representations of, 175, *176*, 177–82, 345n21; Jesuit training and, 316n83; Kahlo's allusions to, 182; de Nomé's depiction of, 138, *138*

marvelous real (*lo real maravilloso*): American-ness of, 238–39, 286, 288; Carpentier's Baroque and, 146–49, 151, 154, 156–58, 160, 338–39n78, 339n79; example of, 149; Surrealism vs., 147

Mary Magdalene: as composite figure, 345n19; depictions of, 17, *18*, 173, *174*, 175, *223, 224, 226, 227,* 243; exhibitions on, 344n15; García Márquez's Sierva María compared with, 221–30; hair of, 223–25; mirror of, 17, *18*; pearls and necklaces of, 175, 225–26, *227*; suffering of, 223, *224.* See also *Of Love and Other Demons* (García Márquez); saints

masks: Quetzalcóatl's, 6–7, *8*; of temples, 10; theatrical, 211

Mastretta, Angeles, 229, 301

Maya culture: codices of, xix–xx, 321n15; creation narrative of, 9–10; hieroglyphics of, 10, 63; idols as repositories of spirit in, 20; king as sacred conduit in, 11; literature of, burned, 110; meanings of stones for, 325–26n55; *Popol Vuh* (council book)

of, 84–85, *85*; rituals of blood in, 70, 315n75. *See also* Mesoamerica; Nahua culture

McAndrew, John, 312n55

medallions: Kahlo's use of, 189, *190*; saints' images on (*relicarios*), 346–47n33; Sor Juana's, 187, *188,* 189

Medici, Marie de', 217

memory: collective cultural and individual, 327n64; recovery of, 287–88, 292–94; as surviving in orality, 109, 111; theatre of (trope), 105, 372n30; variegated mirror of, 99

Méndez Plancarte, Alfonso, 288

Méndez Rodenas, Adriana, 371n16

Mendieta, Gerónimo de, 76, 317–18n93

Menil, Dominique and Jean de, 135

Mérida, Carlos, 323n34

Merleau-Ponty, Maurice, 61

Mesoamerica: artists' role in, xix–xx; bloodletting rituals in, 315n75; Catholic accommodation to/appropriation of, 39–41; cosmology, astrology, and history conjoined in, 64–65; first European encounter with, 3; human and nature joined in, 99–100; human sacrifice in, 21, 79, *81,* 315n75; metamorphosing of deities in, 9–10, 15, 21, 23, 51, 99–100; role of reflecting stone and water in, 307n17; spirit and physical joined in, 10–11. *See also* codices; space/time/spirit; *specific deities*

mestizaje, 78, 82, 154, 156

metaphysics: allegory's mediation in, 272; cosmology linked to, 141–42; fusion of physical and, 171, 173, 175, 226; of illusionism, 259; metaphor of dream and, 269–70; painting as, 61; trompe l'oeil linked to, 243–44

metonymic displacement: Carpentier's Baroque strategy of, 143–46; concept of, 141–42, 336n65; contact necessary to, 255; examples of, 242n106, 285; parody of, 142–43

Mexican Folkways (magazine), 323n35

Mexican Revolution: polemical art of, 111; Rivera's depiction of, 78, 88–92, *90, 91, 93*

Mexico: anti-Baroque fervor in, 369n5; Carpentier's "initiation" in, 117–19, 149; as chosen land, 47, 49, 317–18n93; Cuba compared with, 117–19, 328n9; indigenous saints of, 47, 317n92; painting and nationalism joined in, 44, *45*

Mexico City/Tenochtitlán: echoes of codices in, 94; exhibitions on political role of painting in, 44; fall of, 72; iconography of embodiment in, 197; Institute of Cardiology in, 85, *86–87; *Juan Diego's vision near, 1–2, 41; Ministry of Education in, 88, 121–22, *122, 123,* 324n46; National Palace of, 78–84

Michelangelo, 178

Miles, Margaret R., 27, 29, 37, 316n83, 345n21

Miller, Mary Ellen, 6, 11, 64

Milton, John, 357n17

mimesis (concept), 15–16

miracles, 47, *48,* 57, 59, 249–50

mirrors: "colonizer's," xxii; Guadalupe's eye and, 3, 57, 59; images as re-presentations via, 15–17; multiple self-portraits as, 189–90, 192; Quetzalcóatl's, 2–3, 5–7, 9–10, 15, 16; reflecting stone and water as, 307n17; *regressus ad infinitum* and, 264, 265, 266; in *retablos, 283,* 284; trompe l'oeil and, 246; "variegated," in Garro's work, 98–99

mise en abîme, 264–69

Mitla (Oaxaca), 151, 343n112

Moctezuma, 19, 162, 164, 342n104

modernity: alternative vision of, 296–302; dream theory in, 271; Neobaroque as subverting, 285–86; Neobaroque distinguished from, 241; Neobaroque's challenge to, 295–96; self as viewed in, 169–70, 216, 218–19

monjas coronadas, Kahlo's use of, *191,* 192

monstrosity, xx, 6, 216, 219, 349n59

Montaigne, Michel de: on alphabetic systems, 62, 319n3; fragmentation/integration and, 186; physicality of, 208; on self-examination, 167, 171, 174;

self-portraits of, 182; on self's relation to others, 215, 216; use of the word Baroque, 234; Vivaldi linked to, 342n104

Montaño, Otilio, 92, *93*

Montenegro, Roberto, 323n34

Monteverde, Claudio, 163

Montúfar, Alonso de, 49

Moreno Villa, José, 154, 156, 340n91

Morlete Ruiz, Juan Patricio, 197, *203, 204*

mudéjar (vassal), 340n91

Mullen, Robert, 313n62

muralist movement: Carpentier on, 117–21, 330–31n21; in Galeano's work, 106; history and myth joined in, 77–78; parodies of, 111–12, 327n71; as reconquest, 292. *See also* Orozco, José Clemente; Rivera, Diego; Siqueiros, David Alfaro

mural painting: architecture's relation to, 78, 88; codices (re)conceived in, 78–88, 92–93, *94–95;* as *corridos,* 121; Galeano's engagement with, 94, 104–6; history and myth joined in, 299; as metatexts, 79; on *pulquerías,* 111–12; realism of, 118–19; as transcending boundaries, xxi; as transcultural documents, 23–25, *24, 25;* trompe l'oeil in (U.S.), 247; use of space in, 118–19, 120–21, 330–31n21

music: architecture as "frozen," 342–43n108; Baroque vs. Classical structures of, 220, 342n107; as movement in space, 161–65

mythology: history linked to, 77–78, 94, 96, 299; Ibargüengoitia's parody of, 111–12; of Narcissus, 16, 191–92; preservation of, 3; sibyls of, 39

Nabokov, Vladimir, 242, 255, 345n22

Nahua culture: color symbolism and, 326n59; meanings of stones for, 325–26n55; poetry of, 10, 49–51, 154; principle of movement, 9; Venus as crucial to, 97. *See also* Maya culture; Mesoamerica

Náhuatl (language): "codices" in, 70; current speakers of, 306n11; Popocatépetl in, 13–14; text on Juan Diego's vision in, 49–52; Tezcatlipoca in, 5–6; *tonalamatl* in, 65–66

Of Love and Other Demons (García
 Márquez): Baroque elements of, 230;
 setting of, 221, 352–53n86; syncretism
 and sainthood in, 212, 221–26, 228–30.
 See also hagiography; Mary Magdalene;
 saints
O'Gorman, Edmundo, 318n95, 324n44
Olivé, León, 339–40n85
Olmec culture, 8
Ometéotl/Tezcatlanextía (deity), 68
One Hundred Years of Solitude (García
 Márquez): archetypes of, 211–12;
 Baroque elements of, 230–32; caricature
 in, 219–20; doubling in, 208; *Of Love
 and Other Demons* compared with, 223;
 self-reflexive ending of, 265
opposites: conjoining of, 146–48, 156–57.
 See also Baroque conceit (*coincidentia
 oppositorum*)
orality: codices and, 70–71; image-as-
 presence in, 13–15; memory's survival in,
 109, 111; traces of, in print culture,
 61–62. *See also* theatre and theatrical
 performances
original/copy dichotomy: Borges's textual
 reworking and, 260–64; Kahlo's
 self-portraits and, 189–90, *191*, 192;
 Neobaroque version of, 300–301
ornamentation: Baroque privileging of,
 134; function of, 341n100; of Hindu
 temples, 142–44; moving/melting/
 multiplying of, 145–46; of pyramids,
 149, 151, *153*, 154; ruins of, 136–37. *See
 also* Baroque themes; Churrigueresque
 style; *specific churches*
Orozco, José Clemente, 92, 106, 118
Ortega y Gasset, José, 167, 229, 332n37,
 342n106
Otomí people, 76–77
Oviedo, José Miguel, 339–40n85
Oviedo y Baños, José de, 126

Pacheco, Francisco, 313n64
Padilla, Heberto, 335–36n63
Pagden, Anthony, 311n49
painted books, xx, 62, 71. *See also* codices
painting: artist's workshop as visual trope
 in, 52, *53*, 55, 318–19n100; church
 interiors as settings, 130–31;

codification of, 313n64; interiority in,
 21; as metaphor for knowing self, 167,
 171–72, *172*; miniatures, 346–47n33;
 mirror as moralizing emblem in, 17, *18*;
 painting of a, 252–53, *253*, *254*, 265;
 political role of, 44; as text, 79; textual
 inscriptions on, *53*, *54*, 55–56; of vistas,
 46, 47, 52, *54*; vistas on, 47, 49. *See also*
 illusionism; mural painting; religious
 images
Panofsky, Erwin: on Baroque as
 recuperation of Classicism, 132; on
 Baroque *horror vacui*, 119; Benjamin
 rejected by, 272, 366n95; on caricature,
 214–15; on origins of "Baroque,"
 234; on perspective, 310n40; on self-
 consciousness and doubling, 169–71
parody: Baroque's self-reflexivity as, 239–41;
 of Baroque themes, 136–37; Borges's
 inclusiveness as, 237; of Classical
 column, 161; double textuality implied
 in, 360n32; function of, 294; García
 Márquez's use of, 208, 219, 294;
 Hogarth and, 209, 211, *211*; of
 metonymic displacement, 142–43; of
 muralist movement, 111–12, 327n71
parts/whole relation: Baroque interrogation
 of, 185–87; double portraits and, 183–84;
 inclusive *conjunto* of, 148, 163–65;
 instability of, 263; multiplicity possible
 in, 298–99; Neobaroque and, 295;
 restructuring of, 134. *See also* fragments
 and fragmentation; ruins
Pascal, Blaise: Borges on, 235, 266; death
 of, 344n10; on *esprit* (spirit), 126–27;
 fragmentation/integration and, 186,
 187; quantifiable space and, 257; on self
 and subjectivity, 137–38, 170, 216, 247
Paz, Octavio: on allegory, 271; on avant
 garde and Baroque, 369n7; on Baroque
 conceit, 146; on Bustos, 348n47; on
 Catholicism and images, 44; on
 Coatlicue, 157; dance metaphor
 of, 64, 70–71; on embodiments of
 Tezcatlipoca, 307–8n18; on
 Enlightenment, 296; Fuentes's rupture
 with, 103–4, 326n61; Guido as precursor
 to, 292; on hermeticism, 364n83; on
 Lezama Lima, 142, 337n68; on Maya

Rivera, Diego (*continued*)
murals, 78–84; *Popol Vuh* illustrations, 84–85, *85; Ribbon of Dance,* 121, *122; Tarascan Civilization,* 79, *80. See also* muralist movement; mural painting; perspective
Roa Bastos, Augusto, 350n64
Rodríguez, Lorenzo, 313n62
Rodríguez Monegal, Emir, 239
Roh, Franz, 368n113
Rome (Italy): as artistic center, 131–32; Naples compared with, 137
Rosary Chapel (Church of Santo Domingo, Puebla), 154, *155,* 156
Rubens, Peter Paul: appropriation of precursors by, 261, 363n66; background of, 131–32, 334n47; Borges and, 242; Classicism and emotionalism of, 132, 334n48; García Márquez and, 217; sources utilized by, 134; works: *Descent from the Cross,* 132, *133;* Medici cycle, Palais de Luxembourg, 216–17, 218
ruins: allegories compared with, 273–75, 298–99; multiplicity possible in, 294, 298–99; of ornaments not buildings, 136–37; trope of, 335n57. *See also* fragments and fragmentation
Rulfo, Juan, 111

Saavedra Fajardo, Diego de, 235
Sacks, Oliver, 367n102
Sagrario Metropolitano (Mexico City), 32, 313n62
Sahagún, Bernardino de, 72, 74, 76
saints: Borges's use of, 250–51; caricature of, 211, *211,* 214; Catholic decree on, 29–30; childhood stories about, 212–14; ecstasy of, 177–82, 209, 345n21; García Márquez's use of, 216, 221–30; *The Golden Legend* (lives and legends) on, 178; medallions with images of, 346–7n33; multiple histories of, 13; de Nomé's depiction of, 138, *138;* popular portraiture of, 201–2, *206;* prescription for identifying with and learning from, 173, *174,* 175, 178. *See also* hagiography; *specific saints (e.g., St. Lucy)*
Salgado, César Augusto, 328n3, 370n11
San Agustín Acolman, 22, 315n78

Sánchez, Luis Rafael, 294
Sánchez Cotán, Juan, 249, *250*
Sanctuary of the Virgin of Ocotlán, 25–26, *27*
San Francisco Javier Tepotzotlán, 149, *150, 151,* 282, *283,* 284
San Lorenzo Potosí, 288, *289, 290, 291,* 298, 370n10
San Luis Potosí, 26, *28*
San Miguel, Andrés de, 317–18n93
San Miguel Arcángel Itzmiquilpan, 23–24, *24,* 156
San Miguel Zinacantepec, 184, *184*
San Pablo Yuriria, 149, *152*
Santa María Tonantzintla, 24–25, *25,* 156, 298
Santa María Xoxoteca, *38*
Santí, Enrico Mario, 286
Sardo, Joaquín, 23
Sarduy, Severo: on Baroque as postcolonial strategy, 120; on Baroque hyperbole and eroticism, 351n76; on Baroque proliferation, 141–42, 220, 338n73; on Baroque space, 119, 120, 332n34; on Baroque vs. Classicism, 132; on chain of signifiers, 141–42, 168, 220, 237; on "dethronement" and "dispute," 286; on "disharmonies," 297; on etymology of "Baroque," 233; ideology and aesthetics of cultural difference of, 116, 371n16; on Neobaroque, 286, 294; on parts and wholes, 263; works: "The Baroque and the Neobaroque," 141, 294; *Barroco,* 120, 142, 233, 294
Sarlo, Beatriz, 238, 239, 359n27
Scarlatti, Domenico, 163, 221
Scarry, Elaine, 228
Schele, Linda, 11
Schoenberg, Arnold Franz Walter, 343n112
scholasticism, 234–35, 354–55n8
Schopenhauer, Arthur, 268
scientific developments: Baroque *horror vacui* linked to, 119; as breaking whole into parts, 185–86; epistemological crisis and, 242–43, 255, 263, 276, 282; magic revived in reaction to, 228, 353n88; in optical devices, 247; quantifiable yet infinite space and, 257, 362n57; theology linked to, 177;

St. Peter Claver, 225–26, 352–53n86

St. Philip Neri, 346n27

St. Rita of Casia, 214

St. Rosa of Lima, xx

St. Sebastian, 173

St. Teresa of Avila, 178, *179*, 180, 209, 221, 346n27

St. Thomas Apostle (Doubting Thomas), 2, 40–41, *42*, 243

St. Thomas Aquinas: conception of visual image, 26–27, 29, 147; on demons, 221; order of, 34; on resurrected bodies, 222

Steiner, George, 272, 366n95

Sternberg, Josef von, 360n30

still life: letter rack genre and, 251–52, *252, 253*; status of, 361–62n45; trompe l'oeil of, 249, *250*

stone, 99–100, 103, 325–26n55

Stravinsky, Igor, 164, 165

Strich, Fritz, 371n15

Strong, Beret, 358n24

Stuart, David, 10

Sturrock, John, 129

stylemes (concept), 218–19

Sucre, Guillermo, 297

Surrealism: Carpentier and, 134–35, 334–35n54; Kahlo and, 168; Lezama Lima and, 146–47

syncretism: of African and Spanish cultures, 212, 221, 224–26, 230; as Catholic policy and practice, 39–41; concept of, xv; curtains and, 32, 34; in García Márquez's *Of Love and Other Demons*, 221–26, 228–30; of metropolitan and indigenous/mestizo norms, 201; power of, 2; texture of, 121. *See also* sibyls; transculturation; Virgin of Guadalupe

Tamayo, Rufino, 92

Taube, Karl, 64

technology: Ibargüengoitia's parody of, 111–12; Rivera's depiction of, *91*, 91–92, 157, *158, 159*

Tehuanas, 189, *190*, 201, 348n46

temple of Solomon, New Spain sites as, 47, 317–18n93

Tenochtitlán. *See* Mexico City/ Tenochtitlán

Teotihuacán: Quetzalcóatl and Tlaloc of, 149, 151, *153*; temple dedicated to Quetzalcóatl at, 8

tequitqui (concept), 154, 156, 293, 370n13

Testera, Jacobo de, 76

Testerian codices, 76

texts: boundaries assumed in, 61; ephemeral architecture in, 278; as images, 105; images generated by, 79; imagined, 263; oral traces in, 61–62; potential space of, 257–58; recuperation/reworking of, 260–64, 300; within texts, 265–67. *See also* alphabetic systems; codices; painted books

textual inscriptions: in emblem manuals, 276, *277, 278, 279, 280*; on Hernández Xochitiotzin's murals, 92–93, *94–95*; in letter rack genre, 251–52, *252, 253*; on paintings of Virgin of Guadalupe, *53, 54*, 55–56; on phylacteries, 55–56, 121, 192–93, *194, 196*; in Westernized codices, 72, *73, 74*

textualization fable (concept), 267

Tezcatlipoca (deity): depiction of, 68; meanings of, 5–6; shifting forms/colors of, 6, *7*, 68, 307–8n18

theatre and theatrical performances: archetypes in, 215, 349n59; architectural illusionism and, 247; Baroque theatricality and, 32, 231, 235; curtains' role in, 32, 313–14n66; life as, 135–37, 255–56, 268–71; physical cruelty shown in, 177

Theophrastus, 349n59

Thiem, Jon, 267

Thomas, Lucian Paul, 215

Thousand and One Nights, The, 265

time: alternative vision of, 102–3; complementary duality and, 99–101; linearity of, displaced, 111; as perpetual movement/dance, 70–71; as stone, 103; as visualized/spatialized, 65–67. *See also* space/time/spirit

tlacuilo: after European contact, 23–24, 70; description of, xix–xx, 14, 65–66; Galeano's depiction of, 111; Hernández Xochitiotzin's continuity with, 93; oral performance and scribal activity of,

70–71; Rivera's continuity with, 78–94; social standing of, 323n36; transcultural integrations of, 322n22. *See also* indigenous artisans (*imagineros*)

Tlaloc (deity), 149, 151, *153*

Tlaxcala: Municipal Palace in, 92–93, *94–95;* Sanctuary of the Virgin of Ocotlán of, 25–26, *27*

Tlazoltéotl (goddess), 193, 348n43

Tochihuitzin Coyolchiuhqui (Nahua poet), 50

Todorov, Tzvetan, 18

tonalamatl, 65–66, 101–2. *See also* codices

Tonantzín/Cihuacóatl (goddess), 2, 41, 52

Torre Villar, Ernesto de la, xx

Tovar de Teresa, Guillermo, 136, 369n5

transcendental naturalism (concept), 173, 180, *181*, 182, 338n76

transculturation: Baroque intensified in, 149, 151, *153;* of codices, 71–77; definition of, xv–xvi; in Galeano's work, 107, 109, 111; Guido on, 288, 292; in indigenous worship practices, 21, 23; inordinate cultural perspective of, 116; *Nican mopohua* (text) as example of, 49–52; in postconquest recording of informants' preconquest culture, 14–15; of visual images, 2. *See also* syncretism

transubstantiation, 30–32, 92, *93*

Trinity, 182, *183*

trompe l'oeil: allegory compared with, 272; of architectural illusionism, 246–47; consciousness of game/artifice in, 243–44; as debate of art with itself, 243–44; development of, 242–43; fantastic intrusions into, 253, 255; function of, 26, 131; history of, 361n38; letter rack genre in, 251–52, *252, 253;* mise en abîme compared with, 264; *quadratura* and, 244, *245,* 246–47; recession/projection oscillation in, 258–59; sculpture and, 247, *248,* 249; of still life, 249, *250;* of trompe l'oeil painting, 252–53, *253, 254;* as veiled threat, 266; waking/dreaming structure and, 268. *See also* illusionism; mise en abîme

Trueblood, Alan, 347n37

ultrabaroque (term), 288, 372n27

universalizing impulse: of Baroque, 240–41; of Borges, 237, 239, 260–61, 298; Virgin of Guadalupe and, 57, *58*

Universidad Autónoma de Chapingo, 88–89. *See also* Chapel at Chapingo (Mexico)

Urban VIII (pope), 346n27

Uslar Pietri, Arturo, 126, 127

Uxmal: temple at, 8

Valeriano, Antonio, 49, 318n96

Valéry, Paul, 342–43n108

Vargas Llosa, Mario, 111, 120, 330–31n21, 350n64

Vasconcelos, José, 77, 78, 79, 88, 323n34

Vega, Garcilaso de la, 226, 228

Vega, Lope de, 215, 216

Velázquez, Diego: Borges on, 264–65; doubling and, 171; fragmentation/integration and, 186; Rubens's influence on, 334n47; subjectivity and, 216; works: *Las Meninas*, 171–72, *172,* 264–65, 284

veneration vs. worship, 311–12n53

Venus, *63, 65, 66,* 97

Villalpando, Juan Bautista, 318n93

Villavicencio, Manuel, 193, *196*

Villegas, Joaquín, 52, *54*

Viqueira Albán, Juan Pedro, 312n56

Virgin Mary: Cortés's image of, 19; earth linked to, 107, 109, *110;* Kahlo's use of iconography of, 193; levitating, as archetype, 211–12; mirrors associated with, 16–17; sacred heart of, 197, *204;* suffering of, depicted, 175, *176*, 193, 197, *200*, 347n42

Virgin of Actopan, 192–93, *194*

Virgin of Charity of El Cobre, xx, 44

Virgin of Guadalupe: Carpentier's marvelous real and, 147; cultural and political contexts of, 1; double miracle of, 47, *48;* God/Christ as painter of, 52, *53, 54,* 55–57, *56;* as inspiration for other apparitions, 317n91; as meta-image, 44, *46,* 47; Mexican revision of, 43–44; ontology of presence in images of, 51–52; original image of, *43;* political uses of, 44, *45;* popularity of, 57, *59;*